Encyclopedia of
American Silver
Manufacturers

Fourth Edition

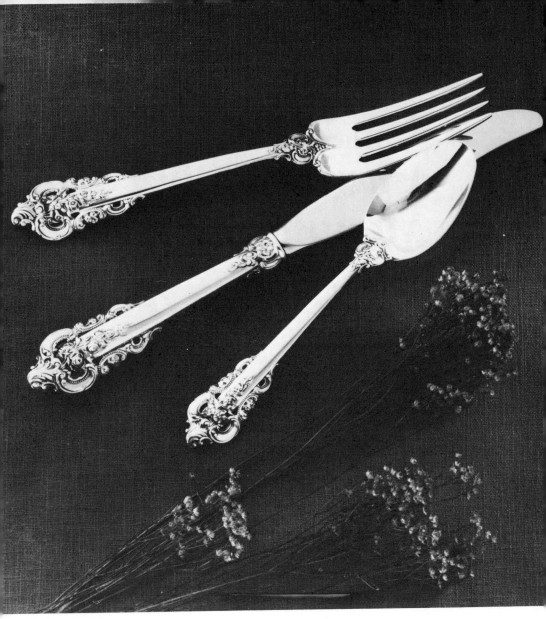

"Grand Baroque" sterling flatware by Wallace International. *(Photo courtesy of Wallace Silversmiths.)*

Encyclopedia of
American Silver
Manufacturers

Fourth Edition

Dorothy T. Rainwater and Judy Redfield

4880 Lower Valley Road, Atglen, PA 19310 USA

Library of Congress Catalogin-in-Publication Data

Rainwater, Dorothy T.
Encyclopedia of American silver manufacturers / Dorothy T. Rainwater and Judy Redfield. -- 4th ed.
p. cm.
Includes bibliographical references.
ISBN 0-7643-0602-2 (pbk.)
1. Silversmiths--United States. 2. Hallmarks--United States.
I. Redfield, Judy. II. Title.
NK7112.R3 1998
739.2'3733--dc21 98-24606
CIP

Cover photo: Webster Manufacturing Company giant bull and cala lily tureen. Giant animal pieces such as this were produced briefly c. 1870. Courtesy of Chelsea Kehde. (Photo by Judy Redfield)

Designed by Bonnie M. Hensley
Type set in Zapf Chancery Bd BT/Times New Roman

ISBN: 0-7643-0602-2
Printed in the China

Published by Schiffer Publishing Ltd. 4880 Lower Valley Road Atglen, PA 19310 Phone: (610) 593-1777; Fax: (610) 593-2002 E-mail: Schifferbk@aol.com Please visit our web site catalog at **www.schifferbooks.com**	In Europe, Schiffer books are distributed by Bushwood Books 6 Marksbury Avenue Kew Gardens Surrey TW9 4JF England Phone: 44 (0)181 392-8585; Fax: 44 (0)181 392-9876 E-mail: Bushwd@aol.com

This book may be purchased from the publisher.
Include $3.95 for shipping. Please try your bookstore first.
We are interested in hearing from authors with book ideas on related subjects.
You may write for a free printed catalog.

Contents

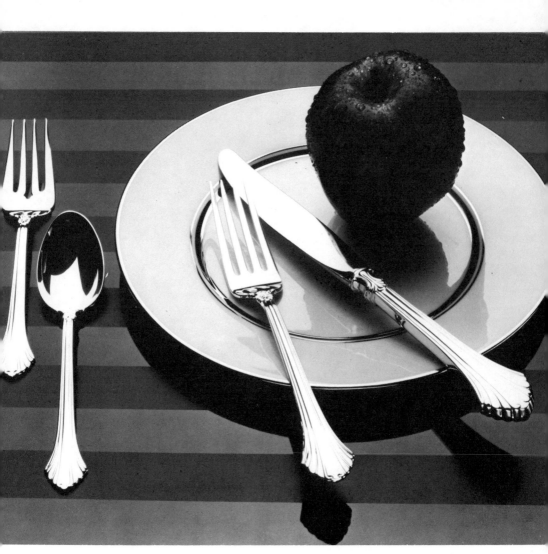

"Beauvoir" sterling flatware by Wallace International. (Photo courtesy of Wallace Silversmiths)

Author's Preface

The identification and dating of American silver presents problems because, unlike England and a few other countries, no official stamps or date letters were used. Nor was there ever established a guild hall for keeping records. Therefore, it is only through the identification of maker's marks and trademarks that the names of silversmiths and manufacturers can be traced.

The *manufacture* of silverware in the United States began about 1842. Prior to that time there were no real factories in this country. Almost all the silver was custom made with the buyer dealing directly with the silversmith. With the rise of manufactured goods, a new relationship of manufacturer-wholesaler-retailer-consumer developed. Many of these wholesalers and retailers had their own marks put on articles made for them or to be sold by them exclusively. In addition, there were some manufacturing companies who made nickel silver wares that were sold "in the metal" for plating by jobbing firms who then stamped them with their own or with retailers, marks. For the purpose of identification some of these trademarks are included. Many manufacturing jewelers also made various types of silver products. Some of the jewelry marks included in this book appear on silver articles and may, or may not, also be stamped "STERLING." The products of some foreign firms appear in such large quantities in this country that they have also been included. Most of them registered their trademarks in the United States Patent Office.

The first major effort to collect American silver manufacturers' trademarks was the publication in 1896, by the JEWELERS, CIRCULAR (now the JEWELERS, CIRCULAR-KEYSTONE) of *Trade-Marks of the Jewelry and Kindred Trades*. This was followed by editions in 1898, 1904, 1909, 1915, 1943, 1950, 1965, 1969, and 1973. Many of the trademarks illustrated here are from the 1896-1915 editions and are reproduced by the permission of the former Editor, Donald S. McNeil. Other trademarks were obtained from the United States Patent Office records, from silver and jewelry manufacturers, from old company catalogs, from actual pieces of silver and from photographs.

A number of trade journals and their related directories and indices are the principal source of trademarks and dates used in this book. The dates given are those of the various editions and are not to be construed as actual dates a particular company was in business unless specifically stated. To simplify the listings the following abbreviations are used:

AHR: American Horological Review
JBG: Jewelers' Buyers Guide
JC: Jewelers' Circular
JC&HR: Jewelers' Circular & Horological Review
JC-K: Jewelers' Circular-Keystone
JC-W: Jewelers' Circular-Weekly
JKD: National Jewelers' Trade and Trade-Mark Directory
JR: Jewelers' Review
JW: Jewelers' Weekly
KJI: Keystone Jewelers' Index
KS: The Keystone
NJSB: National Jewelers, Speed Book

How To Use This Book

There are many tradenames used which do not include the name of the company concerned, these and brand names are grouped together in a separate section with the name of the company following. To locate the company that used the brand name DIAMOND EDGE, for instance, consult this alphabetical listing and find that it was used by the Shapleigh Hardware Company.

Most of the trademarks have letters or words giving at least a clue to the letter of the alphabet with which the company name begins; a few do not. These are grouped together in the back of the book with the company name and are also illustrated within the regular company listing.

Very few of the trademarks illustrated in this volume appear exactly as they do when actually stamped on a piece of silver. Allowance must be made for imperfect stamping, and very often, for simplification of the stamped mark. Many of the illustrations are from printed sources and show more detail than is possible when stamped on silver. Varying angles of light on a mark can cause it to have a different appearance also.

Lettering for some of the marks drawn from actual specimens was sometimes done by the author with Artype, Prestype or similar graphic art products.

Acknowledgements to the Second Edition

This book could never have been written without the generous help of others. My deepest debt of gratitude is to Edmund P. Hogan of the International Silver Company who opened up the historical files to me and allowed me to draw freely from notes compiled by the late Wm. G. Snow. Mr. Hogan also has been unfailing in his encouragement and friendship.

A special note of thanks is due Kenneth K. Deibel, Dallas, Texas, for the loan of scarce and important research materials.

My sincere thanks go to Dr. Elliot A.P. Evans, Orinda, California, for notes about California silversmiths derived from his as yet unpublished material.

For biographical notes about some Boston silversmiths I am deeply indebted to J. Herbert Gebelein of that city.

The generosity of Charles A. McCarthy, Seattle, Washington, in supplying photographs from which I drew a number of the marks is exceeded only by his enthusiasm for the entire project. Both are much appreciated.

My warmest thanks and deepest appreciation go to the following librarians, representatives of silver manufacturers and collectors: A. Abrahamsen, John Arcate, James Avery, Swift C. Barnes, Fred M. Birch, John R. Blackinton, Patricia Blanchard, Mrs. H. Batterson Boger, RADMJ. F. Bowling, USN, RET., Helen K. Butler, Louis Cantor, Nathalie Caron, Elizabeth T. Casey, Nancy F. Chudacoff, Bert Cohen, C.F.W. Coker, David M. Doskow, CMDR Frederick F. Duggan, Jr., Bernice Egbert, William Felker, George Fina, Michael C. Fina, Mrs. Olin M. Fisk, Mrs. Leonard I. Freedman, Paul A. Frey, George F. Gee, German Embassy, Herman W. Glendenning, Mrs. J.A. Greeley, Mrs. Mildred T. Guisti, Albert T. Gunner, Virginia Gunner, Margaret Smith Gunsler, Robert Haftel, Nancy L. Harvey, Bruce A. Hauman, K.J. Herman, Beulah D. Hodgson, R.W. House, Rufus Jacoby, D. Wayne Johnson, K. Kovvalski, Charles Lamoureaux, Joan B. Lehner, Joseph McCullough, James D. McPherson, Helena Matlack, Mrs. William B. Mebane, Harold A. Milbrath, Dwane F. Miller, Mrs. Hester Miller, John G. Miller, Mrs. J.C. Mitchell, Dr. James Mitchell, B.J. Murphy, Dan Nagin, Helen Norris, Leonard E. Padgett, Don Parker, Enoch Pratt Free Library, Mrs. John H. Prest, Mrs. J.O. Randahl, Jr., Shirley Robertson, George S. Rogers, W.E. Rooks, Virginia Schmid, Stephen Schuldenfrei, Edwin Sellkregg, R. Champlin Sheridan, Jr., Jules Silverstein, Stanley S. Smith, Mrs. Clyde H. Smith, Charles C. Stieff II, Rodney G. Stieff, Peter J. Texier, Ernest T. Thompson, Jr., Le Roy Timmer, L. R. Titcomb, Albert S. Tufts, Ruth Van Meter, Mrs. Bert Welch, Rufus F. Wells, Elizabeth Willard, Harold Wolfson and Roland H. Wordwell.

Most of all, I am indebted to my husband, Ivan, who through the years has traveled thousands of miles with me, walked the halls of countless museums, tape recorded innumerable interviews and photographed thousands of silver articles and their marks to assist me, all with unfailing cheerfulness and good humor.

Acknowledgements to the Third Edition

The addition of new material to this third edition would not have been possible without the assistance of the following: Elenita C. Chickering, Etna, New Hampshire; Frances Downing, Assistant Curator of Decorative Arts, New York Historical Society; Dr. Elliot A.P. Evans, Orinda, California; Betty Grissom, Peoria, Illinois; Edgar W. Morse, San Francisco, California; Noralynn Naughton, Customer Service, Gorham Division of Textron, Inc.; Patrice Phillips, Director, Public Relations, Reed & Barton Silversmiths; A. Christian Revi, Hanover, Pennsylvania; Barbara L. Shaw, Publicity Manager, Oneida, Ltd.; Don A. Soeffing, New York City; Joseph F. Spears, Alexandria, Virginia; Rodney G. Stieff, Chief Executive Officer, Kirk-Stieff; Eileen Terrill, Lunt Silversmiths; Michele Tinker, Advertising, Wallace-International; Bennett W. Trupin, Norwalk, Connecticut; Ruth Van Meter, Yucaipa, California and Russell H. Weldon, Vice President Marketing Service, World Tableware International. Also Robert C. Gill, Gahanna, Ohio; John R. McGrew, Hanover, Pennsylvania. Charles C. Williams, Washington, D.C.

Special appreciation is due Mrs. Alden Redfield, Columbia, Missouri, for the photographic reproductions of trademarks and information concerning Redfield & Rice and related companies.

Diana Cramer, editor of SILVER has been most generous in giving permission to reprint marks and other material from that magazine.

Once again, Edmund P. Hogan, Meriden, Connecticut, has been unfailing in giving freely of information concerning the many changes in ownership of silver manufacturing companies. His enthusiasm and knowledge have made this book possible. His is a very special friendship.

I wish to thank Nancy and Peter B. Schiffer, Schiffer Publishing, Ltd. without whose guidance and encouragement this book could not have been completed.

My particular thanks go to attorney Daniel P. Mannix, V, West Chester, Pennsylvania, for legal advice.

And, as always, my husband, Ivan, has endured the disruption of household affairs without complaint.

Acknowledgements to the Fourth Edition

Many wonderful people have contributed their time and effort to help bring the fourth edition of this book to reality.

Some have generously shared information not previously recorded in the book: Sharon Mackie, Art Craft Silversmiths, Portland, Oregon; Ernest Ceder, Municipal Historian, Torrington, Connecticut; Elenita C. Chickering, Etna, New Hampshire; Stephen N. Dennis,Washington, D. C.; Dr. Graham Dry, Munich, Germany; Laura Linard, Reference Archivist, R. G. Dun & Co. Collection, Baker Library, Harvard; Benjamin A. Randolph, Eden Sterling , Cincinatti, Ohio; Peter Erickson, Gardner, Massachusetts; Chip deMatteo, Hand & Hammer, Woodbridge, Virginia; Leo G. Fernandez, San Francisco, California; Windsor Robinson, Gardner Museum, Gardner, Massachusetts; Jerry Mixon, Hartsville Museum, Hartsville, South Carolina; Suzy McLennan-Anderson, Heritage Antiques, Holmdel, New Jersey; Catherine B. Hollan, Alexandria, Virginia; Frank Holmes, Bath, Ontario, Canada; Carol Hoyt, Palo Alto, California; Nancy Impastato, Alexandria, Virginia; Janet Loop, Saugerties, New York; Charlie B. Cantrell, Metal Arts Group, Ltd., Seattle, Washington; Max Kaiser, Mueller Kaiser Plating Co., St. Louis, Missouri; Dr. Ali Mehrizi, Easton, Maryland; John Celardo, Assistant Director, National Archives Northeast Region, New York, New York; Gary Niederkorn, Philadelphia, Pennsylvania; Bruce and Tasha Piontkowski, San Carlos, California; T. R. L. Randall, Coalhurst, Canada; Thomas C. Rhodes, Greenville, Rhode Island; David L. Thomas, Gebelein Silversmiths, East Arlington, Vermont; Rod Tinkler, The Silver Vault, Barrington, Illinois; Gail Kruppa, Torrington Historical Society, Torrington, Connecticut; Warren R. Weldon, Yucaipa, California.

Others have opened their homes or places of business to the junior author, to allow her to photograph marks on items in their possession: Terry L. Vaughn, Alton Antique Center, Alton, Illinois; Annette Buckland, The Antique Showrooms in the Mews, New Harmony, Indiana; Central Ohio Antique Center, Springfield, Ohio; A. L. and Helen Chute, Loretto, Ontario Canada; Cookstown Antique Market, Cookstown, Ontario, Canada; Cranberry Corners Antique Mall, Waynesville, Ohio; Jack and Priscilla Nixon, Den of Antiquities, Oklahoma City, Oklahoma; Dr. Denny Donnell, Columbia, Missouri; John Hall, Josh's Antiques, Sunrise Beach, Missouri; Geneva Henderson, Henderson's Antiques, Rocheport, Missouri; Clark and Margaret Kelly, Jefferson City, Missouri; Chelsea Kehde, Sedalia, Missouri, Sarah Land, Land of Yesteryear, Osage Beach, Missouri; Louisville Antique Mall, Louisville, Kentucky; Missouri River City Antique Mall, Rocheport, Missouri; Chuck Price's Antiques, Rocheport, Missouri; Riverfront Antique Mall, New Philadelphia, Ohio; Dorothy M. Stephens, St. Louis, Missouri; T/G Antique Mall, Pocahontas, Illinois; Webb's Antique Mall, Centerville, Indiana; Eleanor Rullestad, Valley Antiques, West Des Moines, Iowa; Randy & Donna Long, Victorian Lace Antiques, Ash Flat, Arkansas.

A special "thank you" to the all volunteer staff of the Family History Center, Church of Jesus Christ of Latter Day Saints, Columbia, Missouri, who donate their time to make their research facilities freely available to others.

We greatly appreciate the efforts of Robert M. Johnston of Baltimore, Maryland, in contacting major present-day silver manufacturers to obtain information to update their listings.

Special thanks to Connie McNally, editor of *Silver Magazine*, for her encouragement, and her permission to use information from back issues of *Silver.*

A special debt of gratitude is owed to Rowena Olegario of Cambridge, Massachusetts for her meticulous work in ferreting out information about the Redfield related companies from the Dun Collection materials.

A very special thank you to D. Albert Soeffing of New York for his many helpful suggestions, his willingness to share his knowledge of American solid silver manufacturers, and for illustrations of objects from his personal collection.

Last but not least, a very special vote of thanks to my husband, Alden Redfield, and my son, Edmund, who made this book possible by their dedicated assistance with the countless little details involved in its production.

Introduction to the Fourth Edition

When Dorothy Rainwater first suggested that I should work with her to produce a Fourth Edition of The Encyclopedia of American Silver Manufacturers, I was dumbstruck. From time to time over a twenty year period we had corresponded back and forth on silver and other topics. Frequently I had asked her questions, and always received a friendly, interesting, and well researched response.

In the process of researching articles on early American Silverplate for *Silver Magazine* and tracing the history of my special interest, the Redfield Companies, I had uncovered a great deal of information about other early silver manufacturers as well. Information not included in Dorothy's book. When I offered to share this data with her, she suggested that I should write it up myself. After thinking the idea over, I decided to accept the challenge.

Working on the book has given me a wonderful opportunity to learn about aspects of the silver industry that I was not previously familiar with. Since the third edition was produced, many new resources have become available, and access to some older original resources has become easier to achieve. The R. G. Dun & Co. Collection, though only briefly sampled here, is a prime example.

A conscious effort has been made in this edition to expand the coverage of certain specific facets of the silver industry, notably early solid silver manufacturers, arts and crafts movement manufacturers, and Canadian silver manufacturers.

Throughout the preparation of this work, Dorothy has proved an invaluable source of information and encouragement, while at the same time giving me basically a free hand to explore whatever avenues I wished.

An important point to note is that a book like this one is never truly "finished" in the sense of containing all that there is to know on the subject. Readers of this edition will find many revisions in existing entries, as well as many entries for previously unreported firms. But there is still much work to be done. More than any one person could hope to do in a lifetime.

If you know of a firm that has not been covered in the book, or if you have some additional information on one that is already in there, please let us know, so that it can be included in a future edition.

Judy Redfield
Columbia, Missouri

Post Script:
After my husband's death in December, 1994, I thought I would not be doing any more writing as I had relied on him because of my physical limits. I thought of Judy Redfield who had so willingly searched out and sent to me material on the Redfield & Rice companies. She readily agreed to take on the project. Through we are separated on the map by more than a thousand miles, her enthusiasm and dedication have overcome what might have been a problem. Judy Redfield deserves a big thank you.

And, as always, Peter and Nancy Schiffer have given us encouragement, advice, and suggestions which make this book possible. No mere words can suffice.

Dorothy T. Rainwater
Bowie, Maryland

Manufacturing
19th Century Silver

While we all tend to admire finished articles of silver, some may not be aware of the various processes involved in their production. Over the years the techniques of silver manufacturing have changed considerably. Fortunately, some contemporary accounts of how the work was done during the nineteenth century still survive. Such descriptions provide both an insight into the techniques involved, and the attitudes of the public of the time toward the work that was taking place.

Take for example this description of the production of handwrought solid silver flatware, as reported in the *Hartford Daily Courant,* December 12, 1848.

Notes by a Man About Town
Number VI

In our last number we had not completed our exploration of the old jail building and its environs. We will this morning look a little farther among the various colonies which swarm this busy hive. And first we will step into the Spoon Manufactory of Mr. O. D. Seymour - Silversmith.

The 'raw material' here consists of pure coin, mostly American half dollars - rather a queer article to be sure, and confounding some of our previous notions as to the meaning of the term 'raw material.' Just see those bags of Uncle Sam's precious metal - all of them doomed to be here melted down with as little remorse as the nabob's son usually melts down the dollars of his father.

Some fifty of those half dollars are run into a bar of about eighteen inches in length. This bar is passed through a steam rolling mill and flattened, and afterwards hammered into a strip of the proper thickness for a spoon, and about half an inch in width, it is now cut into pieces, each piece designed for a spoon, but having no 'spoon fashion' or shape, about it. One end of this then, by a succession of blows skillfully applied with a 'peen' or oval faced hammer, spread out into the shape of a leaf for the bowl, and the other end formed in like manner for the handle. The whole spoon is then smooth hammered or planished upon an anvil, and brought to a uniform thickness and perfectly flat. During this process the silver by repeated heatings has become blackened to the color of iron. By boiling it in vitriol the white color is again restored.

The bowl is now shaped and the tip formed in a die by 'swedging' or forcing these parts with a steel die into a spoon shaped cavity or matrix, formed in a block of lead. This completes the form. They now go into the hands of the filer, who trims them - next to a brush scouring wheel, which revolves rapidly in a lathe, where they are scoured smooth by a mixture of scotch stone in oil; and thence to the hands of the 'finisher" who either polishes or burnishes them as the purchaser may direct, or as fancy may dictate.

That lady who has just entered, you see has a broken spoon in her hand. She very honestly supposes that spoons are run in a mould, and has brought hers to be run over. She is not alone in the error—others are calling in constantly on the same errand, and probably nine tenths of our good citizens who are in the constant use of this now common utensil, entertain a like opinion—block tin, iron or pewter spoons, are indeed cast; but silver ones are always wrought with a hammer, and generally in the mode described.

The polishing dust and oil, after use, become so imbued with particles, as to sell at the rate of six dollars per pound; and the very sweepings of the floor and common rubbish of the room are all saved for the filings and impalpable silver dust which they contain, and sold for $25 per hogshead.

This concern employs from twelve to fourteen hands; feeds some fifty or more persons dependent; and turns off per annum $25,000 worth of silverware, consisting of tea and tablespoons, cream and sugar spoons, dessert knives and forks, etc. &c., &c., which find a market all over the States of New England and New York, and to some extent over other portions of the Union .

Just examine those elegant silver and pearl handled butter knives. What beautiful things! How finely formed and highly wrought."

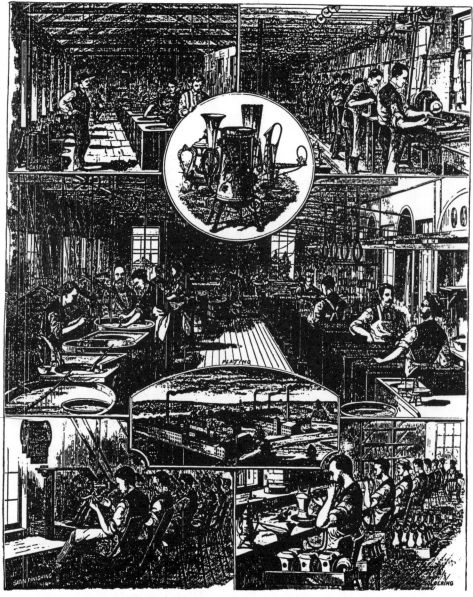

REED & BARTON'S SILVER PLATE WORKS AT TAUNTON, MASS.—[See page 296.]

Reed & Barton factory illustration, showing the various processes used in manufacturing silverplate holloware.

By contrast, the manufacture of silverplated holloware was a much more complex operation. While many small shops were capable of producing their own handwrought solid silver flatware from start to finish, only a few, very large, more highly mechanized shops could produce silverplate holloware from scratch. Many silverplating businesses listed in this book were simply "jobbers" or platers of holloware, who obtained their pieces "in the metal" from large producers like Reed and Barton.

Scientific American reported on the production of silverplated holloware at Reed & Barton on November 8, 1879.

AMERICAN INDUSTRIES, - No. 22
THE MANUFACTURE OF SILVER-PLATED WARE

"From the plain porcelain and pottery of bygone times we have passed to more and more elegant articles of table furniture and ornament, until neither art nor imagination can suggest anything more exquisite and tasteful than some of the modern articles of silver-plated ware made for use, and for the adornment of the table and sideboard. The large and still growing industry, which we have chosen as subject for illustration, is one that may be regarded as an index of growth in refinement, for as tastes in household matters are cultivated and manners become more refined, the progress is sure to exhibit itself in the appointments of the table.

"Formerly the costliness of solid plate confined the luxury of a beautiful and well furnished table to the wealthy; but since the advent of electro-plated ware, almost any one may possess needed articles of table furniture having the most elegant of modern designs and being equal in appearance to the solid silver ware.

"In the manufactory of Messrs. Reed & Barton, located in the quaint little city of Taunton, the work of making plated ware is carried on by an army of men and women, numbering in all about six hundred.

"The foundation of this business was laid as far back as 1824, and, after passing through several hands, it came into the possession of its present owners in 1837. At that time the manufacturing was all done in one small three-story brick building, and one of the present members of the firm, who had learned the business as an employé (sic.) of the original owners, took upon himself the practical direction of the work, and has retained it until the present time. His love for the work is very strong, and he may be found employed now here, now there, suggesting, watching, and showing with his own hands how the work should properly be done.

"The metals used in this factory for making the alloys are obtained in pigs as they come from the mines. The white metal, as it is called, is composed of tin, copper, and antimony.

"These metals are broken into fragments and purified by smelting; they are afterward mixed in proper proportions and transferred to a large iron cauldron, where the alloy is kept at a suitable temperature to prevent the formation of dross. From this cauldron the metal is dipped and poured into moulds forming ingots; these are rolled into thick sheets, which are scraped on either side to remove scale, dross, etc. and are then again rolled to the proper thickness for use. Some of the metal is compounded expressly for casting, the mixture being such as to run sharply in the moulds. Metallic moulds are used in casting handles, spouts, legs, etc., and the castings are made hollow by pouring the melted metal into the moulds, then immediately pouring out as much as will run out. This leaves a thin shell of metal of the required thickness adhering to the sides of the mold. The department in which the casting is done is shown in one of the upper views of the engraving.

"The first operation in making a piece of table ware is to make a perfect mold in wax, then a cast in plaster, from which the mould is made. The artistic part of the work falls upon the designer, the rest is purely mechanical.

"The sheets of metal, after rolling, are cut either into strips or discs, according to the use to which they are to be applied. The strips are passed between engraved rollers which press upon them the figures of leaves, vines, flowers, or other ornamentation. The discs are stamped on a drop press, then spun into shape on a lathe. ..."

"After spinning, the trimmings formed of the ornamental strips are inserted, and the legs, handles, spouts etc. are soldered on. This operation is carried on in the department shown in one of the lower views. The soldering is done with blowpipes attached to flexible tubes, which supply both air and gas. The solder used is similar to the white metal forming the body of the vessel.

"After soldering, the piece is ornamented by chasing or by hand or machine engraving. The piece to be chased is filled with pitch, which, after hardening, gives a solid support to the sides of the vessel; the design is traced by small steel punches, which are rapidly struck by small hammers, quickly developing the pattern by indenting the surface of the metal. Hand engraving is done by the well-known method, and the machine engraving, or engine turning, is done by an intricate piece of machinery which forms those beautiful waved and striated surfaces seen on some of the finer kinds of ware.

"The satin finish, now so much in vogue, is produced by a curious device consisting of a great number of steel wires jointed loosely to a spindle which revolves with great velocity. The work is held just below the spindle, so that the ends of the wires strike thousands of little blows upon the article held within the path described by the ends of the wires. The department in which this work is done is shown in one of the lower views, and just above the lathe carrying the satin finishing tool will be seen one of these tools at rest.

"The ware, after these several operations, is cleaned and polished and conveyed to the plating department shown in the larger view. Here the articles are submitted to a further cleaning, and then placed in a striking bath where they receive the first coating of silver. The bath is composed of the double cyanide of potassium and silver; the article is hung from one electrode, and a huge plate of silver from the other. The electrical current for plating purposes is now generated by means of the dynamo-electric machine, instead of the disagreeable and expensive batteries of former years.

"After a very short treatment in the striking bath, the articles are washed in both warm and cold water and brushed; they are then placed in the plating bath, where they remain until the desired thickness of silver has been deposited.

"The gold lining of vessels is applied by placing the gold solution in the vessel and using the vessel as one pole and stirring the solution about with a piece of gold attached to the other pole.

"If it be desired to plate one portion of an article with silver and another with gold, or with two shades of gold, they (sic.) are taken over to a bench, at which women paint the parts with a 'resist,' as it is called, of black varnish. After the exposed parts are plated, this is easily removed, and other portions treated in the same way., while those at first covered receive another color.

"When the deposition of silver is complete the article is removed from the plating vat and plunged in cold water for a moment, and then into hot, and handed over to a polisher, who holds it for another moment against a rapidly revolving fine wire brush, which partially removes the white bloom from its surface, and it is then ready to be burnished.

"The surface of the work is burnished by rubbing it over with a set of polished steel tools so formed as to fit into all of the intricate curves in the ornamentation. The surface of the article is kept wet with soap and water. Spherical articles, having a considerable plain surface, are placed on a lathe and burnished while in rapid motion. In this case the burnishing tool is a piece of highly polished bloodstone cemented to a wooden handle, and the article is kept wet with stale beer.

"After burnishing the articles then go into the papering room, where girls are busy all day long in wrapping the finished ware in several thicknesses of tissue paper, sealing these up in heavy wrappers, and marking them with the number of the pattern and other data. At last they are entered on the stock books and placed in the warerooms, and when sold are packed in tin lined wooden cases,and shipped to all parts of the world.

"Some of this ware is represented in the upper central figure of the engraving, and the extensive establishment of Messrs. Reed & Barton is shown below.

"We have recently had the pleasure of examining some of the ware made by this firm, and were impressed with the truly artistic character of the work. Their improvements in the construction of the ware, together with new and unique designs, indicate that this firm are thoroughly alive to the demands of trade."

Alphabetical Listing of Manufacturers

A

ABBOTT SILVERSMITHS, INC.
New York, New York

Listed JBG 1957-61 as manufacturers of silverware.

ALBERT ABRECHT
Newark, New Jersey

CHRONOLOGY
Abrecht & Sulzberger	1896
Abrecht & Co.	1896-1904+?
Albert Abrecht	? before 1915-1936

Listed in the Jewelers' Weekly in 1896 as Abrecht & Sulsberger. Listed in JC as Abrecht & Co., 1896-1904; succeeded by Albert Abrecht before 1915. Manufacturers of sterling and plated silver, gold chains, pendants, scarf pins and brooches. Last listing found was 1936-37.

 A & S

ACADEMY SILVER CO. (Showroom)
New York, New York

Listed JBG 1951-1961 as manufacturers of silverware.

ACME SILVER COMPANY
Toronto, Ontario, Canada
See Standard Silver Co.

Manufacturers of silverplated wares c .1885. Liquidated May 2, 1893. Sold to W. K. George and others who formed the Standard Silver Co., Toronto Ltd., later part of the International Silver Company of Canada Ltd.

ACME SILVER PLATE CO.
Boston, Massachusetts

Made plated silverware c. 1885. Not listed in U.S. Patent Office records.

C.C. ADAMS
Brooklyn, New York
See Adams & Shaw

Caleb Cushing Adams was born in Newburyport, Massachusetts, March 25, 1833. He received his education at the famous colonial institution, Dummer Academy. While still a boy he started his business life in the employ of Joseph Moulton, an old jeweler in Newburyport. At the age of about 17 he went to New York City and became a salesman for Ball, Black & Co., where he remained about three years. His next post was Columbus, Georgia where he established a jewelry store. He sold his interest in a little more than a year and returned to New York taking a position with Roberts & Bro.

In 1858, while working for Fellows & Co., he was listed as the agent for the Rogers Brothers Manufacturing Co. in the New York City Directory. That same year he joined the Gorham Company as a traveler.

By 1861 he was in charge of Gorham's offices in New York City, maintaining a showroom at 3 Maiden Lane. About 1870 the firm moved to 1 Bond Street. Adams remained with Gorham until about 1876.

That year he went into partnership with Thomas Shaw, forming the firm of Adams & Shaw (q.v.) also at the 1 Bond St. address, a large office structure known as the Waltham Building. When the building burned in 1877, the company moved to Newark. Adams and Shaw continued in business until about 1880.

Following the closing of Adams & Shaw, Adams was connected with Leroy W. Fairchild & Co., (q. v.) and became buyer for N. Matson & Co., Chicago, Illinois. After about a year he became a partner in the Eugene Jaccard Jewelry Co., St. Louis, Missouri. In 1886 he again returned to New York City and formed the firm of C.C. Adams & Co., which soon became one of the leading jewelry firms there. He remained head of this firm until his death December 13, 1893. Unfortunately, the firm did not long survive him.

"C.C. Adams, one of the largest and most prominent retail jewelers houses of Brooklyn, N.Y. have gone into the hands of a receiver. Stockholders are Sarah F. Adams, Cushing Adams, and Geo. S. Adams. The business was founded by the late Caleb Cushing Adams in 1887. He died Dec. 13, 1893, and since then the business has been in charge of his son, Cushing Adams." (JC 12-30-1896, p. 18)
The name is found impressed on flatware.

GEORGE C. ADAMS
Baltimore, Maryland

Listed in the 1864 Baltimore City Directory as a silversmith.

H.E. ADAMS
Rutland and Burlington, Vermont
See Clark Brothers

CHRONOLOGY
Clarks, Giddings & Adams	1868
Giddings & Adams	1869
Clark Bros. & Adams	1870
H.E. Adams	1871-1872
H.E. Adams & Son	1873
H.E. Adams	1874-1879
H.E. Adams & Son	1879-1886+?

Hiram Ebenezer Adams was born in 1828. In the 1850s he worked in Bartonsville Vermont in a general store where he also dealt in jewelry. By 1868 he had moved to Rutland, where he entered into partnership with the Clark Brothers (q.v.) and S.P. Giddings 2nd.
In 1869 the Clark Brothers left the firm and it became Giddings & Adams. In 1870 Giddings left and the Clark Brothers re-joined the company, along with A.S. Marshall, and the firm became Clark Bros. & Adams.
The company dealt in a general line of fancy goods and guns. An ad for Clarks, Giddings & Adams reads, "Dealers in Watches, Clocks, Fine Jewelry, Silver and Plated Ware, Spectacles, Portmonnaies, Combs, Table and Pocket Cutlery, Fishing Tackle, Shotguns, Revolvers, Cartridges, and ten thousand other articles."
In 1871 Adams left the firm and went into business on his own. In 1873 he was joined by his son Frank E. Adams and the firm became H.E. Adams & Son. Frank E. Adams left the following year, and H.E. Adams continued in business alone.
In 1879 H.E. Adams and another son, Mark Adams, established a new jewelry business in Burlington, Vermont. By 1886 they were doing $20,000 business annually. H.E. Adams died in 1904. (Carlisle, *Silver* Jan.-Feb. 1988 p. 21)

H E A D A M S

JOHN P. ADAMS
New York, New York

CHRONOLOGY
Adams, Price & Co.	1867-1868
Adams, Chandler & Co	1869-1870
Adams, Hallock & Co.	1871-1876+?

John P. Adams, the brother of C.C. Adams (q.v.) first appears in the New York City directories in 1867 as a member of the firm of Adams, Price & Co. with Benjamin S. Price as his partner. The firm had a salesroom at 20 John St., New York and a factory in Brooklyn. It ran a variety of small ads in the *New York Times* in December, 1868, offering "Plated ware guaranteed the finest white metal", "The 'Guaranteed' Silver-plated Spoons & Forks" and "Gorham Plate". The Gorham Plate was probably obtained through his brother's association with that firm.
On December 28, 1868, Adams & Price offered "Silver Plated Coffee Urns, Wine Stands, Oyster Dishes, &c., for furnishing and decorating New-Year's Tables."
In 1869 Adams acquired a new partner, Henry S. Chandler. A December 15, 1869 *New York Times* ad proudly proclaimed "Adams, Chandler & Co. offer an unequalled assortment of fine Silver-plated Ware of their own manufacture, ...and guarantee every article." Another ad again offered Gorham Plate.
By 1871 Adams had entered into a partnership with Lucius E. Hallock, and the firm became known as Adams, Hallock & Co.
John P. Adams took an active part in the manufacturing end of the silverplating business. He had a particular interest in ice-water pitchers, and obtained his own invention patent, No.93,575, for a revolving, tilting pitcher design. His version was an improvement on an earlier design by Ira Yeamans.
He also obtained the rights to Kingston Goddard's patents for "cryptochylon" (= concealed wood) ice-water pitchers. On these pieces, a layer of wood, rather than an air space, acted as the insulator.
Adams' companies apparently supplied some of the silverplated ware sold by Tiffany & Co., as a Tiffany ad in the *New York Times* April 26, 1872, offers the cryptochylon ice-pitcher for sale.
An ad in the 1873 Brooklyn Directory reads, "Adams, Hallock & Co., Manufacturers of Cryptochylon Ice Pitchers and Communion

Services. Special attention given to re-plating of old ware."

John P. Adams moved the company's New York Offices to 1 Bond St., the Waltham Building where his brother's business was located, in 1873.

Not followed beyond 1876.

An 1894 account notes, "John P. Adams, brother of Caleb Cushing Adams of Brooklyn, was recently deceased." (JCW, 2-7-1894, p. 6)

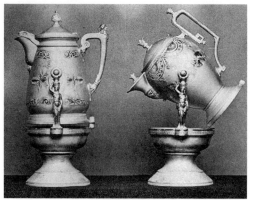

John P. Adams' ice pitcher stand, Invention Patent No. 93,575, as shown in the Redfield & Rice Catalog, 1870. (Photo by Judy Redfield)

WILLIAM ADAMS
New York, New York

William Adams was both a highly talented silversmith and an active political figure. His working life extended from about 1829 to 1862. He held a variety of political offices in New York City: assistant alderman (1840-42), president of the board of aldermen (1842-43), alderman (1847-48), and commissioner of repairs and supplies (1850,1852)

Due in part to his political connections, he received some highly important commissions. In 1841 he received an order to create a silver mace for the House of Representatives, to replace the original destroyed in the War of 1812. In 1845 he was asked to produce the presentation urn given to Henry Clay by the Gold and Silver Artizans of the City of New York, in appreciation for Clay's work to increase the tariff on foreign gold and silver goods. (Soeffing, in Venable's *Silver in America,* 1994, biographical section , p. 314)

Adams reportedly received his training from "Peter Chicotree, a Frenchman." (JC&HR, 8-5-1896) This individual was probably actually Peter Chitry, whose name is found with many variant spellings. Chitry, a Frenchman by birth, came to the United States via Santa Domingo, escaping after the bloody 1791 uprising there. (Soeffing, ibid.)

About 1853, Adams entered into a partnership with Edmond Kidney (q.v.) who had been working for him earlier. The business remained Adams and Kidney until Adams' death about 1862.

WILLIAM ADAMS, INC.
New York, New York
Birmingham, England

Founded in 1865 by William Adams. Specialized in the making of compasses from which their trademark (compass Birmingham) was derived.

Much of their reproduction sterling silver was exported around the world, especially to the United States. They also made masonic jewels and mounted ceramics. They were later purchased by Henry Jenkins & Sons, Ltd. (Jones, *The Silversmiths of Birmingham and their Marks, 1750-1980*)

They advertised that they were, "Master craftsmen since 1854." (JC-K March 1966, p. 78) Importers of English Sheffield silverplate. Manufacturers of antique English silver and Sheffield plate.

In 1932 and 1950 registered a trademark in this country, for which they claimed use since Dec. 1, 1899.

ADAMS & FARNSWORTH
Boston, Massachusetts

George Edward Adams and John C. Farnsworth were associated in the jewelry and silversmithing business from 1844 through 1848 (no directories available 1849-53), after which time Farnsworth was listed alone until 1857.

The firm began in 1839 under the name A.L. (Aaron L.) Dennison who was listed as an importer of watches. (It was Dennison who, in 1846, visited the Springfield Armory in Massachusetts and was impressed by the mass production or "interchangeable system" used there in the manufacture of weapons.) Four years later he and others applied the same principles when they launched The American Horologe Co. in Roxbury, which eventually became the Waltham Watch Co. By 1843 the firm had become A.L. Dennison, Adams & Co., jewelers, silversmiths and watchmakers. From1846 to1848 the firm name was Adams & Farnsworth.

ADAMS & KIDNEY
New York, New York
See William Adams
See Edmond Kidney

Partnership formed about 1853 by William Adams (q.v.) and Edmond Kidney (q. v.)who had been working for Adams in his shop at least as early as 1852. Lasted until the death of William Adams about 1862.

The firm advertised in the New York City Directory (1858) as: "Manufacturers of Silver Ware, 38 White Street, West of Broadway, New York. Vases, Pitchers, Waiters, Dishes, Urns, Tea Sets, Cups, Forks, and Spoons, and all articles in the above line, on the most reasonable terms. N.B. Old Plate manufactured into the newest patterns."

ADAMS & SHAW
New York, New York
Newark, New Jersey
See C.C. Adams

Firm formed in 1876 by C.C. Adams (q.v.) and Thomas Shaw. Adams served as president.

Thomas Shaw, head of manufacturing, had learned electroplating at Elkington's of Birmingham, England, and came to America about 1860. He settled first in Providence, Rhode Island, where he worked for the Gorham Company, which was then trying to break into the trade in electroplate. In connection with Tiffany & Company, Shaw formed the manufacturing company of Thomas Shaw & Company. By 1876 it was listed as Adams & Shaw. There was a notice (JC&HR, August 1876, p. 99) of the opening of the Adams & Shaw sample offices at No.1 Bond St., New York City, the Waltham Building, for wholesale orders of sterling and electroplate. Following the fire in the Waltham Building in 1877, the factory moved to Newark, New Jersey and located at Park Street, corner of Mulberry, 1878-1880.

Both Adams and Shaw were skilled designers and both had worked for the Gorham Company. For 18 years Adams held the position of general manager there before he was succeeded by Edward Holbrook.

Adams and Shaw also each had relatives associated in silversmithing. John P. Adams, (q. v.) brother of C.C. Adams, headed a silverplating firm. Shaw had a son, Frank, also a fine designer, whose promising career was cut short.

In 1880 the Adams & Shaw Company was bought out by Dominick & Haff (Obit of Isaac Mills, JC&HR, 3-6-1895, p. 15). Their flatware patterns and dies had been acquired from John R. Wendt & Co., New York, and eventually passed to Dominick & Haff.

The Carpenters' (see *Tiffany Silver*) findings concerning the disposition of Adams & Shaw were as follows: "The Adams & Shaw operation was absorbed into Tiffany & Co., probably in the 1880s, with Mr. Shaw becoming superintendent of the Tiffany plant."

ADAMS, CHANDLER & CO.
New York, New York
See John P. Adams

ADAMS, HALLOCK & CO.
New York, New York
See John P. Adams

ADAMS, PRICE & CO.
New York, New York
See John P. Adams

ADAMS MANUFACTURING CO.
Location unknown

Mark found on a silverplated souvenir spoon from the Panama-Pacific Exposition, 1915.

JOHN ADAMSON
New York, New York

John Adamson is listed as a silversmith in the New York City directories at least as early as 1852. Not found after 1853.

ADELPHI SILVER PLATE CO.
New York, New York

First record, 1890. Listed in the Jewelers' Weekly in 1896. John Schimpf & Sons, proprietors. They designed and made gold, sterling and plated silver holloware. Advertised "sterling silver mountings for cut glass a specialty."

A billhead dating from 1912 published in *Silver* (Sept.-Oct. 1989, p. 13) describes the firm as "Manufacturers of Silver Plated Hollow Ware, High Grade Sheffield Ware, Prize Cups and Trophies of all Kinds" In addition to the main office and factory in Brooklyn, the company also main-

dent and Treasurer, and Frederick Hodum as Secretary of the company.

Out of business by 1915.

Quadruple Ware

Holloware

Special Goods in Holloware.

ADIE BROTHERS, LTD.
Birmingham, England

Founded in 1879, (Krekel-Aalberse, Annalies, *Art Nouveau and Art Deco Silver,* 1989, p. 251)

Incorporated in 1906 as a limited company to manufacture jewelry, gold and silver wares and as dealers. Directors were Percy James Adie, Hubert and William Adie, and James Percy Alderson. Manufacturers of a great variety of fancy goods, presentation pieces,, reproductions of antique, dinner and dessert services, tea and coffee services as well as a line of silverplated items. In 1963 Adie Brothers, Ltd. became a part of British Silverware, which closed in 1968. (Culme, *The Directory of Gold & Silversmiths,* 1987, reprinted 1992, p. 5)

Registered trade mark in this country for flatware and holloware made of or plated with precious metal. Filed Sept. 1, 1948.

ALLAN ADLER, INC.
Los Angeles, California
See Porter Blanchard

Allan Wilbur Adler was born May 8, 1916 in Hamilton, Montana, son of August Martin Adler and Daisy Beatrice Fox. The family soon moved to Burbank, California where he grew up and became a successful home builder. On March 24, 1938 he married Rebecca Blanchard, daughter of Porter Blanchard (q.v.) Blanchard taught his sons-in-law silversmithing. Adler became skilled in all phases of silversmithing and began his own business in 1939. He was joined by his brother Kenneth. The business was later expanded into wholesale marketing, servicing such stores as Marshall Field, Neiman-Marcus and B. Altman Co.

Adler's flatware patterns include *Chinese Key, Modern Georgian, Round End, Starlit, Sunset and Swedish Modern.* The Adler line also includes holloware, gift items, key rings and an extensive line of jewelry.

All pieces are marked ALLAN ADLER or with the trademark of a square formed of "A's" or a double "A A."

AHRENDT & TAYLOR CO., INC.
Newark, New Jersey

First listed as Ahrendt & Kautzman; succeeded by Wm. G. Ahrendt and became Ahrendt & Taylor Co., Inc. between 1922-36. Not listed after 1943. Manufacturers and distributors of sterling silver novelties.

AKRON SILVER PLATE CO.
Akron, Ohio

An 1898 account notes, "Akron Silver Plate Co., Akron, Ohio in hand of receivers." (JC&HR 6-8-1898, p. 16)

ALBANY SILVER PLATE CO.
See Barbour Silver Co.
See International Silver Co.
See I. J. Steane Co.

**ALBANY SILVER PLATE CO.
TRIPLE PLATE.**

ALBERT BROS.
Cincinnati, Ohio

Wholesale jewelers who advertised that their silverplated holloware patterns were made especially for them. (JC&HR 11-6-1895, p 35)

ALDEN & CO.
New York, New York

Silverplating firm formed October 15, 1867, by Orlando T. Alden, a man named Rogers, and S. Scofield.[1] Alden had previously worked for Redfield & Rice, according to the New York City Directories. Alden & Co. was a small firm of modest means[1].

In 1868 and 1869 Orlando T. Alden is shown in the New York City Directories as operating the business in his own name. Not found after 1869.

Item noted above references the R. G. Dun & Co. Collection, Baker Library, Harvard University Graduate School of Business Administration. Volume and page number are given below.
[1]NYC Vol. 407, p.122

ALDEN & BARRETT
New York, New York

Clinton W. Alden and Francis J. Barrett formed the firm of Alden & Barrett, listed in the New York City Directory published in 1865 as "platers" at 4 Liberty Place. The following year the company's business is described as "silver"

at 6 Liberty Place, the same building. No company listing after 1866. Neither man is subsequently listed in the silver business.

THOMAS ALLAN & CO.
Montreal, Quebec, Canada

Thomas Allan, originally from England, apprenticed with Savage & Lyman (q.v.) in Montreal in 1857, the same year that Henry Birks (q. v) joined that firm. Allan was later a partner with Wood & Wood. In 1866-67 the firm was known as Wood & Allan. About 1870 Allan purchased the business of W. Learmont and renamed the firm T. Allan & Co. In 1888 he purchased the business of T.A. Adkins. Allan died in 1899. (Unitt & Worrall, *Unitt's Book of Marks*, 1995, p. 56)

C.A. ALLEN
Chicago, Illinois

Specialized in plating pieces "in the metal" manufactured by others. Said to have been in the wholesale business from 1887 to c. 1900.

T.V. ALLEN CO.
Los Angeles, California

Listed as manufacturers of silver medals and trophies in 1931.

ALLSOPP-STELLER, INC.
Newark, New Jersey

The following company names were found:

Wordley, Allsopp & Bliss Co. Inc.	1915 JC
(Allsopp-Bliss & Co. successors)	
Allsopp & Allsopp	1927 KJI
Allsopp- Bliss	1927 KJI
Allsopp Bros.	1927 KJI
Allsopp-Bliss Co.	1931 NJSB

| Allsopp Bros. | 1931 NJSB |
| Allsopp-Steller, Inc. | 1943-1973 JC-K |

Listed as manufacturers of sterling novelties.

In the 1922 and 1924 KJI Allsopp & Allsopp, Allsopp-Bliss & Co. and Alsopp Bros. appear as jewelry manufacturers.

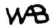 *On sterling novelties.*

ALVIN CORPORATION
Providence, Rhode Island
See Fahys Watch-Case Co.
See Gorham Corporation

CHRONOLOGY
Alvin Mfg. Co.	1886-1893
Alvin-Beiderhase Co.	1893-1919
Alvin Silver Co.	1919-1928
Alvin Corporation	1928-present

Organized as Alvin Mfg. Co., in Irvington, New Jersey, by Wm. H. Jamouneau in 1886. Jamouneau was president until his retirement in 1898. A note in JC&HR (4-19-1893, p. 44) states that "The Alvin Mfg. Co., has been changed to the Alvin-Beiderhase Co., Wm. H. Jamouneau, Henry L. Leibe and George B. Beiderhase all of Newark, incorporated to manufacture metal, plated and other goods and novelties."

In 1895 the Alvin factory was moved from Irvington, New Jersey, to Sag Harbor, Long Island. It was purchased by Joseph Fahys & Co., (q. v.) watch-case manufacturer in 1897 and operated as a branch of that firm c. 1898-1910.

The name of the company was changed to the Alvin Silver Co. in 1919. They were makers of sterling silver flatware, holloware, dresserware, silver deposit ware and plated silver flatware. Certain assets, dies and patterns were purchased by the Gorham company in 1928 and the name changed to the Alvin Corporation. It still functions as a division of the Gorham company.

In addition to the manufacture of electroplated wares by the old methods, the Alvin company patented (January 5, 1886) a new process for depositing pure silver on both metalic and non-metallic surfaces. The first articles produced in this country by the process were cane and umbrella handles. In this process, the article was first coated with silver and afterwards a part of the coating was cut away, thus exposing the base, as in pierced work.

ALVIN-BEIDERHASE CO.
New York. New York
See Alvin Corp.

Made Official World's Fair souvenir spoons for the Columbian Exposition held in Chicago 1893-94.

AMERICAN GLASS SILVERING COMPANY
New York, New York

The American Glass Silvering Company first appears in the New York City directories in 1854. The firm claimed to have exclusive rights

to its silvering process in both Europe and America.

In addition to the standard work of silvering mirrors and reflectors, the company also offered, in a full page ad in the Brooklyn city directory published in 1856, the following: "CRYSTAL SILVER WARE, Viz: Bowls for Baptismal Purposes, Ice Bowls, Syllabub and Punch Bowls, Fruit, Cake, Jelly, and Butter Dishes, Celery Vases, Goblets, Custard Cups, Egg Cups, Family Salt Cellars and Cups, and Independent Setts; Flower vases, with stands and shades, including the newest and most beautiful varieties of Flowers; Trays for Flowers and Fruit; Card Trays and Stands; Candle Sticks; Elegant and Rich Mantel Ornaments, Crystal Silver Balls, Globes, etc.

"DOOR KNOBS AND PLATES, Furniture Knobs, Curtain Pins; Rich signs, in Crystal Silver Letters, for Stores, Offices, etc. Ornamental and Plain Panelling, for Ship's Cabins, Parlor Doors etc. Rich Pieces for inlaying Secretaries, Étagères, Center Tables, and all other descriptions of Furniture suitable for this finish."

The company is not found in the New York City directories after 1856.

AMERICAN HOSPITAL SUPPLY CORPORATION
Location unknown

Mark found on a silverplated cup dating circa 1930s.

AMERICAN PLATE CO.
Location unknown

Mark found on a silverplated ice-water pitcher dating circa the late 1870s.

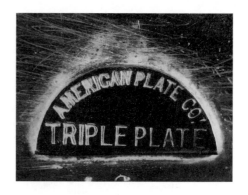

AMERICAN RING CO.
Waterbury, Connecticut

Manufacturers of plated silverware c.1920.

AMERICAN SILVER CO.
Bristol, Connecticut
See Bristol Brass & Clock Co.
See Holmes & Tuttle Mfg. Co.
See International Silver Co.

Established in 1901 as successor to Holmes & Tuttle Mfg. Co. and Bristol Brass & Clock Company. Bought by International Silver Co. in 1935.

AMERICAN SILVER CO.
12 DWT
A. S. CO.
BRISTOL CUTLERY CO.
NEW ENGLAND CUTLERY CO.
OLD ENGLISH BRAND, B.
BEACON SILVER CO.
CROWN SILVER CO.
1857 WELCH-ATKINS
EASTERN SILVER CO.
H. & T. MFG. CO.
NEW ENGLAND SILVER PLATE CO.
PEQUABUCK MFG. CO.
ROYAL PLATE CO.
WELCH SILVER
 CROWN SILVER PLATE CO.
 STERLING PLATE ◁B▷
 (Flatware)

AMERICAN SILVER COMPANY
Wallingford, Connecticut
See also World Tableware International

The American Silver Company was established in 1983 by A. Reed Hayes and Robert Bartlett, Jr. to acquire World Tableware International (WTI) (q.v.) from Insilco Corporation. Hayes became WTI's president and Bartlett, executive vice president and chief financial officer.

They took the name American Silver from the name of a company which was once part of International Silver Company. Although AMSCo is technically a newly formed corporation, the American Silver Company name has appeared frequently in the history of Connecti-

cut silversmithing. Originally founded in 1851 as Holmes & Tuttle in Bristol, the company was purchased by Bristol Brass & Clock Company in 1857. In 1901 the name was changed to American Silver Company, and it was operated continuously under this name as a unit of Bristol Brass & Clock Company until 1935 when the company was purchased by International Silver Company.

American Silver was an active trademark of International Silver Company for many years thereafter, and the American Silver name was originally used in connection with a number of WTI's current products. Their products are distributed only in the foodservice industry.

AMERICAN SILVER PLATE CO.
See Northampton Cutlery Co.

AMERICAN SILVER PLATE CO.
See Simpson, Hall, Miller & Co.

AMERICAN SOUVENIR CO.
Location unknown

Mark found on a silverplate souvenir spoon from the Pan American Exposition, 1901.

AMERICAN STERLING CO.
Naubuc, Connecticut
See Curtisville Mfg. Co.
See Thomas J. Vail
See Williams Bros. Mfg. Co.

Reportedly successor to the Curtisville Mfg. Co. (q. v) in 1871. However, that firm may have gone out of business several years earlier. In business until 1880 when it was bought by James B. and William Williams and the name changed to Williams Bros. Mfg. Co.

Manufacturers of German silver and plated ware, not solid silver wares.

AMES MFG. COMPANY
Chicopee, Massachusetts

Nathan Peabody Ames and James Tyler Ames, founders of the Ames Mfg. Co. in 1829, began with the production of swords and sabers, many of which were presentation pieces for such eminent figures as Ulysses S. Grant and Zachary Taylor.

It was at the Ames company that the process of electroplating was introduced into the United States, according to Chicopee historian, Ted M. Szetela. His account says that Charles R. Woodworth, an artist employed by Ames, was the pioneer plater of the country. They made silver services for the nation's leading hotels. Among the elaborate plated silverware they exhibited at the New York World's Fair, 1853-54, were a wine cooler, a sword and standing salt cellar.

James T. Ames became head of the company after the death of his elder brother in 1847.

In 1853, the company added the manufacture of bronze statuary, becoming the first company in the United States to cast bronze statues. The bronze doors of the United States Capitol in Washington, D.C. were cast at Ames from designs by Thomas Crawford, American sculptor. These were commissioned in 1853. The East doors were installed in 1868 and the West doors in 1905. Both sets of doors are made up of panels which depict scenes of important events in American history.

During the Civil War, Ames became the largest producers of light artillery and third largest supplier of heavy ordnance.

James T. Ames retired in 1874 and was succeeded by his son-in-law, Albert C. Woodworth. The company was later owned by Emerson Gaylord and James C. Buckley and went out of business in 1920. It is thought that they discontinued the manufacture of silverplate wares about 1872. The silverplate aspect of the business is believed to have been transferred to the Meriden Britannia Company while the sterling and bronze departments were transferred to Providence where the Gorham Company developed them in later years. No records in the Meriden Britannia Company offices substantiate this.

AMIOT, LAURENT
Quebec City, Quebec, Canada

Laurent Amiot was born in Quebec in 1764 and died in 1838. In addition to his apprenticiship with I.F. Ranvoyze, he also studied in France. Amiot worked in Quebec for many years, and is particularly known for his beautiful church silver. Ambroise Lafrance later obtained his punch and used it at times with a "Napoleonic" head. (Unitt & Worrall, *Unitt's Book of Marks*, 1995, p. 74)

AMITY SILVER INC.
Brooklyn, New York

Manufacturers of sterling silver c. 1950.

AMSTON SILVER CO., INC.
Meriden, Connecticut

Manufacturers of sterling and plated wares. Listed 1965 JC-K as a division of Ellmore Silver Co. Out of business c. 1960. Flatware dies purchased by Crown Silver Co., Inc.

Amston *Amston*

STERLING FINE SILVER PLATE

ANCHOR SILVER PLATE CO.
Muncie, Indiana and St. Paul, Minnesota

Listed in 1898 and 1904 JC. Listed in 1909 JC as out of business.

INDIANA BRAND

ANCHOR BRAND

ANCHOR SILVER PLATE CO.

On Quadruple Plate

ANCHOR SILVERWARE CO.
Oswego, New York

An 1896 account states, "The company formerly known as the Seliger-Toothill Novelty Company will hereafter be known as the Anchor Silverware Co. The former was a stock company incorporated in New Jersey with head offices in Newark and factory in Oswego, N.Y." (JC&HR 11-11-1896, p. 6).

ANCO SILVER CO.
New York, New York

Manufacturers of sterling silverware c.1920-1927.

DAVID ANDERSEN
Oslo, Norway

Established in 1876 as a retail and manufacturing firm by David Andersen. Especially noted for filigree work and enamel. Firm presently (1975) directed by sons, grandson and great grandson. Distributed in the U.S. by the Norwegian Silver Corporation.

L.D. ANDERSON JLY. CO.
Reading, Pennsylvania

In business c. 1910. Louis D. Anderson was listed in the Reading City Directories from 1914-1939 as a manufacturer of jewelry and souvenir spoons. Listed again 1941-44. No further listing and no record of store.

In KJI for 1922 the firm is also listed as producing sterling silver.

L. D. A.

ANDOVER SILVER COMPANY
Andover, Massachusetts

Manufacturers of silverplate c. 1950.

ANDOVER SILVER PLATE CO.
See R. Wallace & Sons Mfg. Co.

APOLLO SILVER CO.
New York, New York
See Bernard Rice's Sons

Succeeded by Bernard Rice's Sons before 1899. Sterling dies now owned by Garden Silver Co.

28

ARCHIBALD-KLEMENT CO., INC.
Newark, New Jersey

Successor to C.F. Kees & Co. c. 1909.

An advertisement for the company in *The Jewelry Buyer's Guide* for March-April 1911 depicts an assortment of silver deposit wares, including an electrolier (an electrified glass table lamp), and a variety of tablewares and dresserwares. (*Silver*, Nov.-Dec. 1991, p. 39)

No record after 1922. Trademark shown here used on sterling and gold lorgnettes.

ARGENTUM SILVER COMPANY
New York, New York

Listed 1958 JBG and 1965-73 JC-K.

DEKRA

ARISTON SILVERSMITH CORP.
New York, New York

Listed 1931 NJSB as manufacturers of sterling silver holloware.

JAMES R. ARMIGER
Baltimore, Maryland

Successors to Justis & Armiger in 1892. Armiger was born in Baltimore in 1835. He received his training as a watchmaker from his foster father, John F. Plummer, jeweler. Was later employed by Canfield Bros. & Co., Baltimore. During the early part of the Civil War he moved to Magnolia, Harford County, Maryland, remaining there only a year. He returned to Baltimore and once again entered the employ of Canfield, where he remained until May 1, 1878 when he went into partnership with John C. Justis, the firm succeeding Justis & Co. This partnership continued for 14 years. Then Justis retired and Armiger conducted the business until his death February 23, 1896 in a fire that destroyed his home.

According to an article in the JCW (2-5-1919) the Armiger company was a direct descendant of B. Larmour & Co., in business in Baltimore at least as early as 1869. This article states that in 1874 the Larmour firm was succeeded by W.M. Justis and was styled Justis & Co. A few years later James R. Armiger became associated with the business and it was then known as Justis

& Armiger. This was succeeded by James R. Armiger in 1892 and was incorporated as the James R. Armiger Co. in 1896. It continued to be listed in Baltimore City Directories until 1936.

ARMOR SILVER CO.
Location unknown

Marks found on silverplated holloware pieces dated ca.1930s.

ARROWSMITH SILVER CORP.
Brooklyn, New York

Listed as manufacturers of sterling silver c. 1960-66. Succeeded by Garden Silversmiths Ltd.

ART CRAFT PRODUCTS CO.
Sycamore, Illinois

Listed KJI 1922 as a manufacturer of art metal goods In 1924 the listing describes the company as "Manufacturers of art metal novelties, Dutch silver (genuine and imitation), lamps, novelties, book ends, silver deposit ware, silverplated holloware, smokers' articles." Listed 1927

KJI as manufacturers of art metal novelties; silver deposit ware and silverplated holloware.

ART CRAFT SILVERSMITHS
Portland, Oregon

Established as B.L. Foote in 1914. Foote made his own set of silversmith's hammers which are still in use in the shop today. He restored flatware and holloware for hotels and religious institutions as well as the general public. After Foote retired in 1936, the firm's name was changed Art Craft Silversmiths.

In the 1940s the business was purchased and operated by Harry Hillyard and his wife, Florie, focussing on instrument repair. After they died in 1979, the business continued to be operated by their estate for three years.

James R. Mackie went to work for the Hillyards in 1974. In 1979 shortly before their deaths, he left to go to work for a design jeweler. There he learned stone setting and jewelry design, and perfected his mold work in lost wax.

In 1982 Mackie and his wife Sharon purchased Art Craft Silversmiths. Initially he did all the silversmithing work, but Sharon has learned to do polishing and plating. They began by concentrating on repair, polishing and re-silvering. They now also restore sterling, pewter, brass, copper and lead.

Mackie has always enjoyed designing and creating items in metal and wood. He produces his own line of sterling jewelry which bears the J M mark.

In 1989 he turned his attention to trying to design and manufacture Victorian style silverplate figural napkin rings. In 1992 his first two recreations, the squirrel and the chickadee, went into production. The company now offers twenty different recreations of old Victorian figural napkin rings, developed from designs shown in old catalogs. These recreations all bear either his original makers mark, J M, or his newer J (crown) M mark, whichever best fits on the piece. These marks should prevent any possibility of confusion with original old napkin rings.

ART MFG. CO.
Meriden, Connecticut
See International Silver Co.

Name used on sterling silver match boxes.

ART METAL STUDIOS
Chicago, Illinois

Founded by Edmund Boker (b. 1886; retired 1977) and Ernest Gould (1884-1954) as the Chicago Art Silver Shop in 1912. It became the Art Silver Shop in 1918 and changed to Art Metal Studios, the name under which it still operates (1986). Boker and Gould came to this country from Hungary in 1907 where they had received their training in a Budapest factory. Boker did the designing and Gould executed the designs. During the depression of the 1930s they began the production of wholesale jewelry, manufacturing under the name Art Metal Studios. Marshall Field & Company and Lord & Taylor were among the department stores which carried their line including key chains, money clips and perfume funnels. They also made beautiful handmade silver jewelry and bronze jewelry inset or overlaid with sterling ornamented with pierced or applied monograms.

ART STAMPING & MFG. CO.
Philadelphia, Pennsylvania

Listed in 1909 JC as manufacturers of sterling and plated silverware. No record after 1915.

A. S. & M. CO.

ART STERLING SILVER CO., INC.
New York, New York

Their 1968 catalog says "Manufacturing & Importers of Fine Sterling Silver." About half the catalog is devoted to Judaica. Some other articles made by Weidlich Sterling Company.

ARTCRAFT SILVERSMITH CO., INC.
New York, New York

Listed with manufacturers of sterling holloware 1927 KJI and 1931 NJSB.

ASSOCIATED SILVER CO.
Chicago, Illinois

Listed 1915 and 1922 JC, 1922, 1931 KJI as manufacturers of plated silver flatware. An advertisement on p. 51 of the 1922 KJI announces "The Silver Plated Knife that cannot wear black like all others must do."

SILVERSEAL
YOUREX

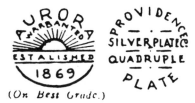

H.F. ATKINSON & CO.
Baltimore, Maryland

Listed in Baltimore City Directories 1887-1889 under plated silverware.

ATTLEBORO CHAIN CO.
Attleboro, Massachusetts

Listed in JC 1909-1915. Trademark used on sterling dresserwares.

ATTLEBORO MFG. CO.
Attleboro, Massachusetts

Listed in JC 1898-1915, as manufacturers of sterling silver novelties. Out of business before 1922.

 Novelties

(Novelties.)

AULD CRAFTERS, INC.
Columbus, Ohio

Manufacturers of pewterware.

AURORA SILVER PLATE CO.
Aurora, Illinois
See Mulholland Bros., Inc.

Organized under a charter from the Illinois Legislature in 1869 when the city's industries were few in number and the population of the city was only 10,000. It employed 65 people at the start. The company was an important factor in the development of the city. Its rolling mill was "the only one west of Cincinnati" at that time. They made plated silver flatware and holloware. Succeeded by Mulholland Bros., Inc. in 1919.

Built on Stolph's Island, the business was founded by J.G. Stolph (president for several years). Charles L. Burphee, Daniel Volintine, George W. Quereau, A.N. Shedd, D.W. Young, Charles Wheaton, Samuel McCarty, M.L. Baxter, William Lawrence, William J. Strong and James G. Barr.

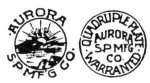

(On Best Grade.)

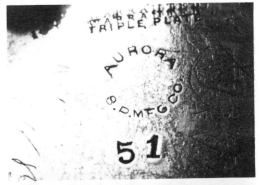

(Holloware.)

1869
AURORA SILVER PLATE M'F'G. CO.
12 Dwt.
(Flatware.)

AVERBECK & AVERBECK
New York, New York

"Manufacturers of Easter spoons, book marks, paper cutters, etc." (Adv. JCW 3-30-1898, p. 14)

JAMES AVERY, CRAFTSMAN, INC.
Kerrville, Texas

James Avery taught design at the Universities of Iowa, Colorado and Minnesota from 1946-54. He first set up shop with a small investment and built a workbench and a few hand tools, and "with a few scraps of silver and copper set up shop in a garage near Kerrville, Texas." For three years he worked alone and in 1957 hired his first employee. Today (1975) there are more than 125 designers, craftsmen, management and support personnel. Their work is primarily jewelry of gold and sterling silver, much of it handcrafted and with a sculptural look. Their outstanding line is their Christian jewelry, all of it symbolic and inspirational.

B

J. A. BABCOCK & CO.
New York, New York
See Knickerbocker Silver Co.

The firm first appears in the New York City Directories in 1861 as J. A. Babcock. In the 1862 directory, James A. Babcock is listed as a "Manufacturer of Silverplated Ware Of Every Description, Urns, Waiters, Tea Sets, Ice Pitchers, Castors, Spoons, Forks, &c." He also offered replating services. The firm is listed simply as J. A. Babcock through 1874, as far as it has been followed in detail currently. No information as to when it became J. A. Babcock & Co.

The animal head mark below was found on a cake basket dating c. 1870. The oval mark was from a figural toothpick holder dating c. 1890.

The company was dissolved in 1894. The business was continued by Wm. Tuscano under the style of the Knickerbocker Manufacturing Co. (JC&HR 2-7-1894, p.94)

BACHRACH & FREEDMAN
New York, New York

Listed in 1896 JC under sterling silver. Succeeded by E. & J. Bass in 1900.

BRADBURY M. BAILEY
Rutland, Vermont

CHRONOLOGY
B.M. Bailey	1848-1868
Bailey & Parker	1868-1871
Bailey & Parmenter	1871-1874
B.M. Bailey	1875-1885

Bradbury M. Bailey was born in 1824, and tried farming before deciding to learn silversmithing. He apprenticed himself to his cousin and brother-in-law, Roswell H. Bailey, in Woodstock, Vermont. He completed his apprenticeship in three years, and continued as a journeyman in the shop until about 1848, when he set up in business himself in Ludlow, Vermont.

About 1852 he arrived in Rutland ahead of the railroad, and built a three storey shop building where he employed eight journeymen and two or three apprentices. When fire destroyed his shop in 1868 he decided to re-build.

Shortly thereafter, he went into partnership with Wilbur F. Parker. The new firm advertised as watchmakers, jewelers and silversmiths. Bailey continued to do silversmithing while Parker was the watchmaker. Parker had previously been a junior partner of Ben K. Chase (q.v.). Parker remained with the firm until 1871, when he moved to Fair Haven, Vermont, and went into business on his own.

Bailey then entered into partnership with Chester Parmenter, who had served as a journeyman in his shop. By 1874 Parmenter left the firm to go into the business of selling novelties. He later became a successful insurance executive.

Bailey continued in business alone. However, manufacturing spoons was no longer profitable, so the business became simply a jewelry store.

Exactly when Bailey had given up silversmithing on a regular basis is unclear, though he continued into the 1870s. In 1875, some time after regular production had ceased, he went to the shop, symbolically made two more spoons, and closed it down. The jewelry business continued for a number of years until he retired. Bailey died in New York, where he had

moved after retirement, in 1913. (Carlisle, *Silver* Mar.-Apr. 1988, pp.8-11)

ROSWELL H. BAILEY
Woodstock, Vermont
See Bradbury M. Bailey

Roswell Bailey established his own large shop in 1839 and kept a dozen journeymen and apprentices busy. His apprentices made doll-size spoons as evidence of their craftsmanship and were allowed to sell them for their own profit for 25 cents each.

BAILEY & CO.
Philadelphia, Pennsylvania
See George C. Sharp
See Taylor & Lawrie

CHRONOLOGY

Bailey & Kitchen	1832-48
Bailey & Company	1848-78
Bailey, Banks & Biddle	1878-94
Bailey, Banks & Biddle Co.	1894-present

On September 20, 1832 Joseph Trowbridge Bailey and Andrew B. Kitchen formed a partnership under the firm name of Bailey & Kitchen for the manufacture and sale of silverware, jewelry and kindred articles and began business at 136 Chestnut Street, Philadelphia.

Mr. Kitchen died in1840. In 1841 Joseph's brother, Eli Westcott Bailey, a New York jeweler and importer, joined the firm. However the business was continued under the name of Bailey & Kitchen until 1848. (Soeffing in Venable's *Silver in America* ,1994, biographical section, p. 315) In 1848 , E.W. Bailey, J.T. Bailey, Jeremiah Robbins and James Gallagher formed a new partnership under the name of Bailey & Company and continued business at the same location until 1859 when they constructed a new building at 819 Chestnut St.

Joseph Trowbridge Bailey, II, entered the business in 1851 and was admitted into partnership at the age of twenty-one in 1856. His father died March 15, 1854.

In 1878 Joseph T. Bailey, II, George Banks of J.E. Caldwell & Co. and Samuel Biddle of Robbins, Clark & Biddle, formed a partnership under the name of Bailey, Banks and Biddle.

"Born in Philadelphia, July 10, 1844, Samuel Biddle began his career by buying the business of Thomas G. Garrett, silversmith, and forming the firm of Clark & Biddle. Later this firm was changed to Robbins, Clark & Biddle." (Obituary, JCW March 12, 1919, p. 63.) Mr. Biddle retired in 1893 and on March 2,1894 the business was incorporated with J.T. Bailey, II as president, Charles Weaver Bailey, grandson of the founder, as vice-president and treasurer, and Clement Weaver as secretary.

In 1903 and 1904 a new modern 10-story building was erected at 1218-20-22 Chestnut Street with a floor space of 76 x 230 feet and an eight-story factory.

In old City Directories the firm was listed primarily as jewelers, but from 1839 through 1846 they were listed as jewelers and silversmiths.

The firm of Taylor & Lawrie (q.v.) apparently manufactured much of the silver sold by the company until 1852. In that year, Taylor and Lawrie left their old location at 25 Library St. and moved to a new factory.

Joint marking by Taylor and Lawrie and Bailey and Kitchen.

Bailey & Co. took over the Library St. factory, and employed George C. Sharp (q.v.) to run their silversmithing operation. In the mid 1860s, Bailey & Co. sold the manufacturing business to Sharp. (Soeffing, *Silver,* Nov.-Dec. 1995, pp. 13-14)

In 1871 Bailey & Company published their *History of Silver, Ancient and Modern.* This is a 54-page booklet measuring about four by six inches. There is only one illustration of a Bailey & Company article but on p. 21 there is the statement, "The advent of Messrs. Bailey & Company, in the year 1832, with new and improved machinery, created quite a revolution in the art of manufacturing silverware. They immediately took the lead in this department of industry which they have steadily maintained.

"They claim the distinction, and without cavil, of having first introduced silver of the full British standard of 925-1000 the American standard being but 900. The advantages of raising the standard are that it prevents the importation from abroad, and especially from British workshops, for purchasers are assured by a guarantee of receiving silver, pure as that stamped by the English government. Besides, the quality of the

silver renders the article more brilliant, whiter, and more susceptible of a higher finish, and obviates discoloration from exposure."

And on a later page, "Messers Bailey and Company, formerly Bailey & Kitchen, as old and reliable manufacturers of Silverware for the past *forty years,* desire, in connection with the foregoing interesting sketch, to direct especial attention to the following list of articles with prices appended." Eighteen pages of price lists follow.

Silverplate ware received attention also for toward the back of the brochure we find, "PLATED WARE—Of our own manufacture, of every style, constantly in store and warranted equal to any sold in this country. Guaranteed in every particular. Information sent upon inquiry."

While Bailey & Co. was producing its own silver, it apparently decided to mark the pieces as to the quality of silver they contained. The mark that the firm used to indicate the American Coin Standard (.900 fine) was "Eagle, U, Shield" and may have been introduced as early as 1852 when the manufacturing business began.

The mark denoting goods produced to the British Sterling Standard (.925 fine), was "Lion, S, Shield", which was introduced January 1, 1855. By 1858, Bailey & Co. had apparently stopped using the coin standard mark. However it continued producing sterling standard articles, and marking them with the standard marks, until it ceased directly manufacturing silver in 1866 or 1867. (Soeffing, *Silver,* Nov.-Dec. 1995, p. 14)

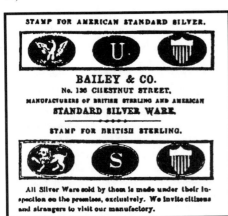

Bailey & Co. Standard Marks from a billhead.

The "Lion, S, Shield" mark had previously been thought by some to represent a manufacturer's mark of George C. Sharp, who worked for Bailey & Co. from 1852 to 1866-7.

BAILEY & PARKER
Ludlow, Vermont
See Bradbury M. Bailey

B A I L E Y & P A R K E R

BAILEY & PARMENTER
Ludlow, Vermont
See Bradbury M. Bailey

BAIRD-NORTH CO.
Salem, Massachusetts
Providence, Rhode Island

A half page advertisement in *McClure's Magazine,* May 1898, depicts a variety of small jewelry items, rings, brooches, studs, hatpins, and stickpins. The firm describes itself as Gold and Silversmiths in Salem, Massachusetts offering fine gold jewelry and sterling silver by mail. "You save one-third by buying direct from factory."

The company published a 200 page free catalog in 1912 in Providence, Rhode Island in which they described themselves as manufacturers of jewelry. However, they also sold a variety of silver holloware, flatware and novelty items.

BENJAMIN B. BAKER
Hartford, Connecticut

Benjamin B. Baker is listed in the Hartford city directory for 1869 as a silverplater working for R.Ewins & Son (q.v.) By the following year

he was operating his own silverplating business, which he continued to do through 1874.

C. F. BAKER
Hartford, Connecticut

Charles F. Baker first appears operating a gold and silver plating business in the Hartford city directory published in 1876. In 1881 he placed the following ad in the Hartford directory: "C.F. Baker, Licenced by the United Nickel Co. Gold, Silver and Nickel Plating on hollow or solid ware; Shop at Colt's Factory, Hartford, Ct. ..." Not followed beyond 1881.

THE GEORGE BAKER SILVER PLATE CO.
Location unknown

Mark found on a silverplate butter dish dating c. 1900.

BAKER-MANCHESTER MFG. CO.
Providence, Rhode Island
See Manchester Silver Co.

In operation from c.1914-1915 to the early 1930s. Manufacturers of sterling silver fancy flatware, souvenir spoons, holloware and novelties.

BALDWIN & CO.
Newark, New Jersey

CHRONOLOGY
Taylor, Baldwin & Co. c. 1825-41
Baldwin & Co. c. 1841-69

Manufacturing jewelers around1840-69. Established by Isaac Baldwin, formerly with Taylor, Baldwin, & Co. c. 1825-41 . (He had also been a partner with James M. Durand in Baldwin & Durand c. 1845-50.)

After the death of Isaac Baldwin, the business was continued by his son, Wickliffe. Sold to Thomas G. Brown in 1869.

BALDWIN & JONES
See Shreve, Crump & Low Co., Inc.

BALDWIN & JONES

BALDWIN & MILLER INC.
Newark, New Jersey

Manufacturing silversmiths. They produce sterling and pewter holloware, novelties and special trophy items—cups, trays, etc., to order.

The company was founded by Fred W. Miller, Sr. and Milton Baldwin. It began as a partnership in 1920 supplying retail stores with special order sterling silver holloware and stock items. Following Mr. Baldwin's death in 1939 the Miller family purchased all stock in the business. The firm is now in the third generation and is still in the hands of the Miller family. (1975)

Not related to Baldwin, Miller Co., Indianapolis, nor to Baldwin & Co., Newark.

B & M
On sterling and on pewter.

BALDWIN, FORD & CO.
New York, New York
See Cohen & Rosenberger
See Ford & Carpenter

Listed in the 1896 JC as Baldwin, Ford and Co. Succeeded by Ford & Carpenter before 1904. They, in turn, were succeeded by Cohen & Rosenberger before 1915. Baldwin, Ford & Co., whose factory was in Providence, Rhode Island, advertised that they made "the only one piece stud in the market", patented May 6, 1884.

BALDWIN, MILLER CO., INC.
Indianapolis, Indiana

First established in 1883 . Manufacturers, wholesalers, and jobbers of silverware, jewelry, clocks, and appliances. Their early trademarks have been found on souvenir spoons. Still in business. (1975)

B. M. CO.
Not used after 1915

B. & M.
Present trademark

BALDWIN SILVER CORP.
New York, New York

Listed JBG 1957-61as manufacturers.

EDWARD BALL CO.
New York, New York

Manufacturers of sterling silverware. Listed JKD 1918-19 as silversmiths. Listed KJI 1924 as manufacturers of silverware.

BALL, BLACK & COMPANY
New York, New York
See Ball, Tompkins & Black
See Black, Starr & Frost, Ltd.

Successors to Ball, Tompkins & Black in 1851. Partners were Henry Ball and William Black. In 1852 Ebenezer Monroe joined the company.

The firm was the leading jewelry house in the nation prior to the rise of Tiffany & Co. and it received many important commissions.

By 1860 it had constructed, at the corner of Broadway & Prince Streets, a marble "palace" that was hailed as the first completely fireproof building in America, complete with imported French plate glass windows and a steam driven elevator.

The building also housed the first modern safe deposit vault system. The basement extended under the entire structure and the surrounding pavement as well. A portion of this area, 50 feet long, 25 feet wide and 16 feet high was cordoned off by heavy bars of "chilled iron" and designated a "safe". Inside was a smaller, burglarproof vault. The area was guarded at all times by a heavily armed group of six men. The valuables of a number of prominent Southern families were reportedly safeguarded in the vault during the Civil War.

Over the years the firm retailed large quantities of solid silver, manufactured by William Gale, Nicholas Bogert, John Moore, and Michael Gibney, among others. John R. Wendt, one of the most important and least known of these manufacturers, occupied two floors of factory space in the building from 1860 through 1871. (Soeffing in Venable's *Silver in America* , 1994, biographical section, p. 315)

In the 1860s Ball, Black & Co. bought Reed & Barton wares "in the metal" and operated their own plating establishment. The firm is listed as "jewelers & silversmiths" in the New York City directories from 1865 through 1871.

Succeeded by Black, Starr & Frost in 1874.

BALL, TOMPKINS & BLACK
New York, New York
See Black, Starr & Frost, Ltd.

Successors to Marquand & Co. in 1839. Partners were Henry Ball, Erastus O. Tompkins and William Black. Succeeded by Ball, Black & Co. in 1851.

BALL TOMPKINS&BLACK

B. A. BALLOU & CO., INC.
Providence, Rhode Island

Listed in KJI 1924 as manufacturers of gold, gold-filled and sterling silver jewelry, materials and findings.

THE BALLOU MFG. CO.
Attleboro, Massachusetts

Manufacturers of gold, gold-filled and sterling silver jewelry, materials and findings. Listed in JC 1915 and 1922; JKI 1927.

BALTES-CHANCE CO., INC.
Irvington, New Jersey

Manufacturers of sterling silver novelties. First record found in early 1920s. Succeeded by Baltes Mfg. Co. before 1927.

BALTIMORE NICKEL PLATING WORKS
Baltimore, Maryland

Listed in Baltimore City Directories 1874-1886 as silverplaters.

BALTIMORE SILVER CO.
Baltimore, Maryland

Listed in Baltimore City Directories 1906-1908 as silverplaters. Successors to Baltimore Silver Plating Co.

BALTIMORE SILVER PLATE CO.
Baltimore, Maryland
See Baltimore Silver Plating Co.

Listed in Baltimore City Directories as silverplaters 1894-1907. Succeeded by Baltimore Silver Plating Company.

BALTIMORE SILVER PLATING CO.
Baltimore, Maryland

In business from 1905-1907 as successors to the Baltimore Silver Plate Company which was first listed in 1894. Succeeded by the Baltimore Silver Co.

BALTIMORE SILVERSMITHS MFG. CO.
Baltimore, Maryland
See Heer-Schofield Co.
See Schofield Co., Inc.

BALTIMORE STERLING SILVER BUCKLE CO.
Baltimore, Maryland

Listed c. 1900-1904 at the same address as the Baltimore Sterling Silver Co.

BALTIMORE STERLING SILVER CO.
Baltimore, Maryland
See Stieff Co.

C.A. BAMEN
Boston, Massachusetts

Listed as specialist in plating c. 1860.

BANCROFT, REDFIELD & RICE
New York, New York
See Redfield & Rice Manufacturing Co.

William Bancroft, from Chesterfield, Massachusetts, bought out the interest of Edward P. Bray in the silverplating firm of Bray, Redfield & Co. on June 5, 1856. Bancroft, Redfield & Rice was the name adopted by the new firm.[1] Under Bancroft's management the company expanded and prospered.

In 1863, Bancroft withdrew from active participation in the firm, and returned to Massachussetts. From this point on, the name of the company was listed as Redfield & Rice in the New York City Directories. Bancroft maintained a financial interest in the firm until December 1865.[2] On February 26, 1866, the Redfield & Rice Manufacturing Co. was incorporated.[3]

Items noted above reference the R. G. Dun & Co. Collection, Baker Library, Harvard University Graduate School of Business Administration. Volume and page numbers are given below.
[1]NYC Vol. 317, p.296
[2]NYC Vol. 317, p.300J
[3]NYC Vol. 373, p.1354

BANCROFT R&R A1

BARBOUR BROS. CO.
Hartford, Connecticut
See Barbour Silver Co.
See I.J. Steane & Co.

Samuel L. Barbour, of Chicago, moved to New Haven, Conn. about 1881-82, to join his brother Charles who was in business there. They marketed the plated silverware produced by I.J. Steane & Co. Succeeded by Barbour Silver Co. in 1892.

BARBOUR HOBSON CO.
Hartford, Connecticut
See Barbour Silver Co.

The Barbour Hobson Company was organized in 1890 for manufacturing sterling silver. The interests of I.J. Steane, the Barbour Bros. Co. and the Barbour Hobson Co. were so nearly identical that it was thought best to unite them and the Barbour Silver Co. was the result.

BARBOUR SILVER CO.
Hartford, Connecticut
See International Silver Co.

When the Barbour Silver Co. was organized in 1892 by Samuel L. Barbour, Isaac J. Steane and J.L. Daigleish, they succeeded I.J. Steane & Co., Barbour Hobson Co. and Barbour Bros. Co. In August of 1893, they took over at least some of the machinery and stock of the Hartford Silver Plate Co., organized in 1882 and believed to have been carried on for a short time under the name of Hartford Silver Co.

When the International Silver Co. was formed in 1898, Samuel L. Barbour, who had

been active head of the Barbour Silver Co. for several years, continued as manager of that branch (known as Factory "A") and was made a director of the new company and remained in that capacity for several years after the plant was moved to Meriden to the buildings formerly occupied by the Meriden Silver Plate Co.

Samuel L. Barbour was born in Norwalk, Conn., about 1865 and died in San Francisco, Nov. 11, 1925. He was identified with A.I. Hall & Son.

Barbour Silver Co. was one of the original companies to become part of the International Silver Co. in 1898.

The "half circle" trademark was first used in 1921 but not registered until 1923.

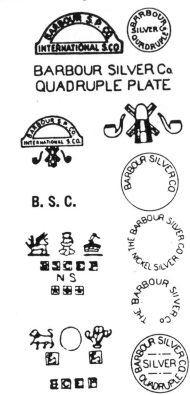

JAMES H. BARCLAY
New York, New York

James H. Barclay first appears in the New York City directories in 1862 with his business listed as "silver". In 1867 his business was listed as jewelry. In 1868 he entered into partnership with Charles W. Cary to form the firm of Barclay & Cary (q.v.) manufacturers of silverplated goods. By 1869 he was operating independently as a silverplater. Not in the silverplating business after 1870.

BARCLAY & CARY
New York, New York

Firm formed by James H. Barclay and Charles W. Cary about 1868. An ad in the *New York Times*, December 28, 1868 reads: "BARCLAY & CARY Manufacturers of the finest grades of SILVER PLATED WARES.

"These goods are manufactured by ourselves, and are unsurpassed for quality and beauty of finish by any in the market.

"A large and varied assortment of the choicest patterns always on hand, and each article warranted by our trademark.

"N.B. - A fine assortment of Electro Plate on Nickel Silver, far superior to the best imported ware and equal to the finest home-made."

Neither the firm nor Charles W. Cary appear in the directories after 1868.

BARDEN, BLAKE & CO.
Plainville, Massachusetts
See Chapman & Barden

B. B. & CO.
STERLING.

BARKER BROS. SILVER CO., INC.
New York, New York
Birmingham, England
See Ellis-Barker Silver Co.

Begun in 1901 by Mary Barker as manufacturers and later electroplaters of buttons and other small articles. The business was continued by her son, William Barker, under the name Barker & Creed. The grandson and great grandson, William Thomas Barker and Matthias Barker, operated as Barker Brothers, mainly for the production of electroplate.

The absolution of the duty on silver (1880) brought about an increased demand for silver objects. Barker Bros. acquired various other firms, among them were Salaman & Levi in 1921 and Ellis & Co., 1931-32, with the name then becoming Barker Ellis Silver Co., Ltd. [For some reason in this country the name has been known as Ellis-Barker rather than the British form.]

Several changes in ownership were the result of financial and other problems. Since 1973 they have been a subsidiary of Pentos Garden & Leisure Products Group, Ltd. (Culme, *The Directory of Gold and Silversmiths*, 1987 reprinted 1992, pp. 26-27)

Barker Bros. Silver Co. are recorded as makers of sterling and plated silver wares, wholesalers and importers. Registered trademark Feb.

10, 1935 for silverplated holloware and flatware for table, toilet, or ornamental use. Claims use since Oct. 1, 1934.

Barker's export trade to the United States began about 1905, and by 1925 approximately 60% of their turnover was exported here.

For further information see Culme, *The Directory of Gold and Silversmiths*, 1987 reprinted 1992 pp. 26-27.

(Sterling)

(Silverplate)

C.E. BARKER MFG. CO.
New York, New York

Manufacturers of sterling (?) and plated silverware. First listed in JC in 1896. Out of business before 1915.

JAMES MADISON BARLOW
Salt Lake City, Utah

Barlow was born in Georgetown, Kentucky on July 9, 1812. He and his father, Thomas, became famous for their many inventions, a cradling harvester, the Barlow knife, a locomotive, a cannon and an instrument used in the study of astronomy.

Barlow, traditionally, is referred to as Utah's pioneer silversmith. Also, according to tradition, Henry Barlow, James' grandfather, and the earliest of the Barlows to arrive in Kentucky, was also a gold and silversmith.

Whether in search of wealth, or just to turn his back on his wife, cousin Betsey Barlow, he left in 1850 to join the Latter Day Saints in Salt Lake City. His Kentucky family refused to join him. He then married a widow with three children in 1851. She died soon afterwards and he married again late in 1852 and again in 1856.

The two later marriages were to sisters, Susanna and Electa Mott, domestics in the home of Brigham Young.

Barlow's first work in Utah was in fixing and extracting teeth, mending watches and clocks and making a small amount of custom jewelry. This work in precious metals established his reputation as a fine craftsman. Utah's first silver tableware was the coin spoons he made. According to tradition, these spoons were given to Brigham Young for use in his Beehive House.

In 1860 Barlow was asked by Young to design and mint five dollar gold pieces. A temporary mint was set up in his jewelry shop. Between February 28 and March 8, 1861, 472 coins with a face value of $2,360 were stamped by Barlow and his assistant Douglas Brown.

Twelve silver cups he made in 1867 for communion service in the new "Great Tabernacle" were his best known works. For 25 years the congregation received communion in them. Soon after 1900 the cups were presented to a local congregation which used them until the influenza epidemic of 1918. They are now part of the pioneer relics exhibited in the LDS Church Museum in the Temple Square, Salt Lake City.

GEORGE BARRETT
Baltimore, Maryland

Listed in the Baltimore City Directories 1873-1898 as silverplaters (electroplate). Successors to Barrett & Rosedorn who were first listed in 1871 as silversmiths.

BARRETT & ROSENDORN
Baltimore, Maryland

Listed 1871-1872 as silversmiths and silverplaters. Succeeded by George Barrett in 1873.

H.F. BARROWS & CO.
North Attleboro, Massachusetts

Organized by Henry F. Barrows and James Sturdy in 1851 under the firm name of Barrows & Sturdy. Sturdy withdrew and the business became H.F. Barrows & Company. They acquired Ripley & Gowen Company, Inc., Attleboro, in 1968. Barrows Industries manufactures the R.L. Griffith lines of charms and earrings. Their emblematic division, the Williams & Anderson Company, makes service awards, medals, etc.

Barrows are manufacturers of sterling silver and gold-filled 10k and 14k gold jewelry. They began a line of religious medals and sym-

bols c. 1965. In 1969 E.N. Riley assumed ownership of H. F. Barrows.

A stone marker at the present factory site in North Attleboro marks the spot where American jewelry making began in 1789.

N. BARSTOW & CO.
Providence, Rhode Island

Successors c. 1904 to Barstow & Williams.

BARSTOW & WILLIAMS
Providence, Rhode Island
See N. Barstow Co.

About 1880 Nathaniel Barstow began the manufacture of jewelry and in 1888 Walter S. Williams joined him to create the firm of Barstow & Williams. They added the manufacture of silver novelties to their line which then formed a complete line of jewelry and silver ornaments. Apparently Williams dropped out, because by 1904 the firm name was once again N. Barstow & Co.

In the mark photo below, the company mark and the word "Sterling" were struck separately from separate dies oriented in opposite directions.

E. BARTON & COMPANY
New York, New York
See Black, Starr & Frost, Ltd.

In business 1815-1823. Partners were Erastus Barton and Isaac Marquand.

BASCH BROS. & CO.
New York, New York

Listed in 1904 JC under sterling silverware. Out of business before 1915.

E. & J. BASS
New York, New York

Manufacturers of sterling silver wares, sterling silver deposit wares and plated silver and jewelry. In business from 1890-c. 1930.

A 1900 account states: "E. & J. Bass, New York manufacturers of silver novelties, announce they have purchased from Reeves & Browne, Newark, N.J., the entire outfit of tools and dies used in the manufacture of silver novelties and have purchased the dies, tools, trademarks, etc., of Bachrach & Freedman." (JC-W 5-9-1900, p. 33)

THE BASSETT JEWELRY CO.
Providence, Rhode Island

Manufacturers of sterling silver and gold jewelry. Listed in JC 1896-1943. They took over the plant and stock of Kent & Stanley in 1894.

J.C. BATES
Northfield, Vermont

Advertised in 1859 and 1860 that he sold watches, jewelry, silver clocks, toys and fancy goods.

BATES & KLINKE, INC.
Attleboro, Massachusetts

Established in 1919 as a die cutting and jobbing firm by Harold Bates and Oscar F. Klinke. Both were accomplished die cutters who served their apprenticeship before World War I. After serving in the army, they started business in November, 1919. The company was incorporated in 1929. The company gradually moved into the jewelry business. They now (1975) manufacture convention and special jewelry and souvenir spoons, mostly of sterling silver.

BATTIN & CO.
Newark, New Jersey

Listed in JC 1896-1922. Manufacturers of 14k and sterling silver match boxes, cigarette cases, eyeglass cases, belt buckles and pocket knives. KJI 1927.

BAY STATE JEWELRY & SILVERSMITHS CO.
Attleboro, Massachusetts

Trade Mark Patent No. 104,012. Registered April 27, 1915. Application filed October 20, 1914. Serial No. 82,010. Trademark used continuously since August 1, 1914. For jewelry and precious metal ware; silver novelties, match boxes, purses, dresserware, cigarette cases, vanity cases and coin holders. Filed by Carrie L. Saart, Treasurer.

BAY STATE SILVER CO.
North Attleboro, Massachusetts

In business 1890-93. Made bracelets and novelties. (JC-W 4-13-1898, p. 28)

GEORGE BAYLEY
Brooklyn, New York

George D. Bayley is first found (spelled Bailey) listed as a silverplater in the Brooklyn

city directory published in 1873. Directories for the previous two years were unavailable. Listings continue through 1876. Not followed further.

BEAUCRAFT INC.
Providence, Rhode Island

Listed 1950-65 as manufacturers of sterling novelties.

Registered trademark 1948 for costume jewelry. Claims use since Aug. 5, 1947.

BECHARD MFG. CO.
Chicago, Illinois

Manufacturers of plated wares c.1943-45 .

BECHT & HARTL, INC.
Newark, New Jersey

Manufacturers of sterling silver c. 1935-50.

JOHN BEDNALL
Brooklyn, New York

John Bednall first appears in the Brooklyn city directory published in 1875 listed as a nickelplater. In 1876 his business is listed as silverplating. Not followed further.

BEIDERHASE & CO.
New York, New York

CHRONOLOGY

Copeland & Beiderhase	1851-1856
Bernard D. Beiderhase (chaser)	1857-1860
Employee of John R. Wendt	1861-1865
Partner in John R. Wendt & Co.	1866-1871
B.D. Beiderhase & Co.	1871-1874

Bernard D. Beiderhase was a German immigrant silversmith. As early as 1851 he was in partnership with Robert Copeland, manufacturing silverware on a modest scale. He apparently left the partnership to start his own chasing business by 1857.

By 1861 he was working for John R. Wendt (q.v.) and by 1866 he had become a partner in the firm, along with Charles Witteck.

Between 1866 and 1874 he provided financial backing for William Bogert & Co. (q.v.)

Beiderhase received design patents for at least six flatware patterns, two of which he obtained while working for Wendt. In addition, he and Witteck held patents for the production of "satin" and "pearl" finishes. Tiffany & Co. claimed that these patents infringed on an earlier patent that it had purchased, and sued. Tiffany also claimed Beiderhase's Design Patent No. 5,876, called "Bird" infringed on its "Japanese" pattern. Tiffany won both cases, resulting in injunctions and financial penalties against Beiderhase & Co.

Bernard D.Beiderhase died in 1874. (Soeffing in Venable's *Silver in America*, 1994, biographical section, pp. 315-316 with additions from patent records and New York City directories)

ERNST GIDEON BEK, INC.
Pforzheim, Germany
See Binder Bros., Inc.

Manufacturers of sterling silver, gold and platinum mesh bags. Prior to World War I, Bek's was represented in the United States by Binder Bros., Inc. Following the war, Binders purchased the Bek stock from the alien custodian. The German company is thought to be still in operation. (1975) Pforzheim is the center of the German silver industry.

BELKNAP HARDWARE & MFG. CO.
Louisville, Kentucky

Silverplate flatware with their imprint was sold. Identical patterns bore the imprint of the Rockford Silver Co. and were probably made by the Williams Bros. Co. The Belknap Co. is still in business. (1975)

BELL BROS.
Ogdenburg, New York

An 1898 account states:"Bell Bros. silver ware factory, Ogdensburg, N.Y. has been sold. Purchasers are Messrs. Tucker & Parkhurst, Concord, N.H." (JC-W 3-3-1898, p. 17)

GEORGE BELL CO.
Denver, Colorado

Retail jewelry company. Listed in JC 1904-1922. Their trademark was found on souvenir spoons.

O.E. BELL COMPANY
Cincinnati, Ohio
See Cincinnati Silver Co.

Founded in 1892 as the Cincinnati Silver Company. O.E. Bell was general manager in 1898 and took over the company in 1899. They were manufacturers of plated silver holloware and novelties. Out of business c. 1900.

BELL TRADING POST
Albuquerque, New Mexico

A division of Sunbell Corporation. In business since 1932. Manufacturers of sterling silver, tuquoise, copper and nickel silver jewelry and souvenir spoons. (1975)

W. BELL & COMPANY
Rockville, Maryland

Founded in 1950 by Walter Bell. For several years operated as a catalog source for high-quality, high-value gift items and premiums. Sales efforts formerly directed primarily toward businesses and organizations. In 1971 their marketing activities were expanded and services extended. Twenty-one showrooms are scattered throughout the country.

Besides sterling, silverplate and pewter made by several outstanding firms under their own names and trademarks, they also market WARWICK sterling silver and SOMERSET silverplated holloware in exclusive designs made for them by various manufacturers. (1975)

Warwick *Sterling silver*

Somerset *Silver plated holloware*

JOHN O. BELLIS
San Francisco, California

In 1894, John O. Bellis began work as a jeweler. Shortly thereafter he was employed by Shreve. He established his own factory after 1906, attracting a variety of important commissions.

His work is characterized by "hammered" surfaces. While the basic forms were spun, they were then meticulously hand chased, making it hard to decide whether they should be classified as man- or machine made.

He "hammered" and applied his mark to considerable quantities of flatware and holloware which had originally been mass produced plain by eastern manufacturers.

However, he was also capable of producing large pieces in traditional designs, as evidenced by a copy he made of a vase produced by Vanderslice about 1870.

Bellis died in 1943. (Morse in Morse, ed. *Silver in the Golden State*, 1986, pp. 20-22)

BENEDICT & McFARLANE CO.
Bridgeport, Connecticut

An 1899 account states:"The Benedict & McFarlane Co. has been organized to manufacture silverplated flatware. The company gets its name from M.S. Benedict of the M.S. Benedict Mfg. Co., Syracuse; and F.H. McFarlane, treasurer and manager of the Bridgeport Silver Plate Co. of Norfolk, Virginia. The Benedict Mfg. Co. will purchase the entire outfit of the new company." (JW 10-4-1899, p. 9)

BENEDICT MFG. CO.
East Syracuse, New York
See Benedict-Proctor Mfg. Co.

Organized in 1894 as the M. S. Benedict Mfg. Co., with M. Stewart Benedict as president.

Incorporated in 1902 and reorganized in 1906 as T.N. Benedict Mfg. Co.

Their principal business at the start was silverplated holloware and they continued this line of goods which was adapted to household purposes and gradually included a line of holloware for hotel and restaurant use. Later they added a line of holloware plated on a nickel silver base, and a variety of equipment for soda fountains.

By 1897 the firm was also offering "Spoons and Forks, made of Solid Electric Silver Metal" according to a company brochure. This new special formula for nickle silver was advertised to "preserve its white and attractive appearance for ever."

In addition to the firm's headquarters in East Syracuse, the company had also established offices in New York and Chicago by 1897.

In 1910 the firm set up a branch factory in Canada. They continued to produce the lines mentioned above until 1942 when much of their plant facilities was converted to war work. Out of business in 1953.

In the consolidation of January 1912, they absorbed the Hamilton Silver Mfg. Co. of New York, the Benedict Dunn Co., Bridgeport, Connecticut, and the Benjamin Clark Silver Co., Ottawa, Illinois (founded 1890). Most of these factories were moved and merged with the East Syracuse plant.

T.N. BENEDICT MFG. CO.
East Syracuse, New York
See Benedict Mfg. Co.

BENEDICT-PROCTOR MFG. CO.
Trenton, Ontario, Canada
See Benedict Mfg. Co.

Manufacturers of silverplated ware, flatware and novelties. KJI 1924 states that this firm was a branch of the Benedict Manufacturing Co. of East Syracuse, New York.

This branch was established about 1910. In business until about 1970. (End date from Unitt & Worrall, *Unitt's Book of Marks*, 1995, p. 54)

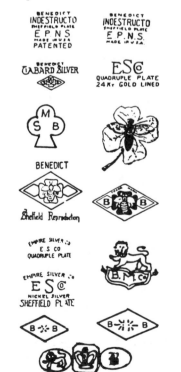

BENNETT-MERWIN SILVER CO.
New Milford, Connecticut
See Merwin-Wilson Co., Inc.

U.S. Trade Mark Patent No. 91,548, May 13, 1913, registered for use on plated silver flat, hollow and tableware.

WM. BENS CO., INC.
Providence, Rhode Island

Listed 1915-c. 1920 as manufacturers of sterling silver dresser-ware.

JOHN DEAN BENTON
Providence, Rhode Island

Listed as a jeweler in city directories of Providence, Rhode Island 1855-1858 and 1862; Wilmington, Delaware 1864-1870 and Philadelphia, Pennsylvania 1874-1877.

Among the silver articles for which he became famous were gold and silver models of railroad locomotives. He is thought to have made 13 such models, among them the *Daniel Webster* for the Philadelphia, Wilmington & Baltimore Railroad, the *Charles Morgan,* made in 1866 and now in the Marine Museum of Fall River, Massachusetts.Of the 13 known models, only seven, or possibly eight, are known to be still in existence, some of them are thought to have burned in the fire which destroyed the Crystal Palace in New York. He also built gold models of the ironclads *Monitor* and *Roanoke* and a gold and silver model of the steamer *Commonwealth.*

FREDERICK BERENBROICK
New York, New York
Weehawken, New Jersey

Established c. 1840 at 15 John Street, New York by Frederick Berenbroick, the pioneer maker of filigree in the United States. In 1858 the business was taken over by his nephew, Gottlieb Berenbroick, who made filigree and silver jewelry and novelties at 78 Duane St., according to one account.

In the New York City directories, which have not yet been checked prior to 1852, the firm is listed as Berenbroick & Co. or Frederick Berenbroick & Co. and described as silversmiths and metal gilders, located at the rear of 83 Duane St. Gottlieb Berenbroick is listed as a silversmith working for the firm as early as 1853.

By 1859 the business had moved to the rear of 73 Greene St., Frederick Berenbroick's residence, where it remained through 1866. Frederick Berenbroick is shown working continuously for the firm through 1861, and again in 1865 and 1866, after which he apparently retired.

Gottlieb Berenbroick resided in New Jersey from 1856, commuting to New York to work for the business. By 1867 he was apparently in business by himself, listed as a gilder working at 38 White St. He seems to have continued at that location at least through 1873, although he is not found in the directories published in 1870 and 1871. Not found in the directory published in 1874, and not followed further in the New York City directories.

In 1889, at the death of Gottlieb, the business was taken over by Berenbroick & Martin, Frederick Berenbroick and Max Martin. Max Martin retired in 1919 and Frederick Berenbroick continued. The last listing found was 1935. He manufactured reproductions of old Dutch, English and French silverware.

ODO BERGMANN
Baltimore, Maryland

Listed in Baltimore City Directories 1897-1900 under silverware, solid and plated.

BERNDORF METAL WORKS
Berndorf, Austria
(Arthur Krupp)

Manufacturers of plated silverware c. 1910. No record after 1915.

SAMUEL E. BERNSTEIN
New York, New York
See National Silver Co.

Founded in 1890 and succeeded by the National Silver Company in 1904.

BEVAN & CO.
Baltimore, Maryland

Listed in 1872 Baltimore City Directory as silverplaters.

BIGELOW, KENNARD & COMPANY, INC.
Boston, Massachusetts

The firm began in 1830 when John Bigelow opened a jewelry store near the head of State Street in Boston. Soon afterwards he was joined by his brother, Alanson Bigelow, and the firm name was changed to John Bigelow & Company. Later Abraham O. Bigelow, brother, and M.P. Kennard, William H. Kennard and F.P. Bemis became members of the firm and the name was changed to Bigelow, Kennard & Company. They moved to Boylston Street in 1869, which at the time was considered the southerly limit of the business district and friends predicted disaster.

An ad in the *Boston Evening Transcript*, December 10, 1868 stated that the company's stock included, " ...an unrivalled variety of American Watches, Fine Jewelry, Sterling Silver, and Silver Plated Ware, the productions of their own and other American Artisans and Manufacturers, ..."

Alanson Bigelow died in 1884, Abraham O. Bigelow and M.P. Kennard retired from the firm, both of them dying a few years later. Bemis died, leaving then Alanson Bigelow, Jr. , who was joined in 1895 by his son, a third Alanson Bigelow. Another son, Homer Lane Bigelow, be-

came a member of the firm in 1899, retiring a few years later, at which time Reginald C. Heath, a son-in-law, was admitted. The business was incorporated in 1912 and went out of business in January 1922.

I. BIGGERS SILVER CO.
Taunton, Massachusetts

Manufacturers of silverplated novelties c. 1895.

I. BIGGERS SILVER CO. TAUNTON

BIGGINS - RODGERS CO.
Wallingford, Connecticut
See Hartford Silver Plate Co.

Founded May 18, 1894 to manufacture sterling, silverplated and metal goods. Founders were Henry E. Biggins, president, former superintendent of Hartford Silver Plate Co., Frank L. Rodgers, treasurer, descendant of Joseph Rodgers, of Joseph Rodgers & Sons, well-known English firm and Henry B. Hall, secretary, formerly with R. Wallace & Sons. They purchased the machinery of the Hartford Silver Plate Co. and installed it in their new factory building. Succeeded by Dowd-Rodgers Co., c. 1915-20.

D

BINDER BROS. INC.
New York, New York
See Ernest Gideon Bek, Inc.

Prior to 1919, Binder Brothers Incorporated were the exclusive American agents for Ernst Gideon Bek, Inc., Pforzheim, Germany. To their knowledge the Bek Company is still doing business in Germany today.

Since 1919, when Binder Brothers Incorporated purchased the Ernst Gideon Bek stock from the alien custodians who had taken it over during World War I, Binder has manufactured, imported and had made up exclusively under its own trademark, jewelry, watchbands, sterling novelties, etc. (1975)

JAMES BINGHAM
Philadelphia, Pennsylvania

Listed from 1896 to c. 1910 as manufacturer of sterling silverware and jewelry.

FRED M. BIRCH CO., INC.
Providence, Rhode Island

Manufacturer of gold filled and mens' sterling jewelry only from 1959 to 1971. Have since diversified and are now (1975) making ladies' gold filled and sterling lockets, crosses, pins, etc.; also brass items.

HENRY BIRKS & SONS
Montreal, Quebec, Canada

CHRONOLOGY
Henry Birks & Co. 1879-1893
Henry Birks & Sons 1893-1905
Henry Birks & Sons, Ltd. 1905-present

Henry Birks was born in Montreal in 1840, the son of English immigrants. In 1857 he became a junior partner in the firm of Savage & Lyman (q. v.)

Birks married in January of 1868. By 1872 he was the father of three sons, William Massey Birks, John Henry Metcalf Birks, and Gerald Walter Birks.

In 1877 he sold his interest in Savage & Lyman to make good a note he had endorsed for his brother, but remained with the firm as store manager. When the company failed in 1878, he carried out the liquidation for the liquidator.

In 1879 he established his own firm, Henry Birks & Co. with just three employees, a watchmaker, a bookeeper-salesman and a messenger boy. Various firms he had dealt with while store manager for Savage & Lyman gave him agencies, among them Gorham, Nardin Watches, and Reed & Barton. His business policy was one of cash for all purchases and no price haggling. In his first year of business he turned over his inventory seven and a half times, and was well on the road to success.

By 1885 the firm had moved to a new larger location and employed a staff of 10. It also added china, crystal, and leather goods departments. In 1887 the firm opened its first factory, to produce jewelry.

In 1893 Henry Birks admitted his three sons to full partnership, and the firm became Henry Birks & Sons.

In 1898 Birks and the silver manufacturing firm of Hendery & Leslie (q.v.) reached an agreement, making Birks the firm's exclusive customer in Montreal. In 1899 Henry Birks & Sons purchased Hendery & Leslie. John Leslie, the former owner, remained in charge of the factory until 1925.

Henry Birks & Sons, Ltd. was incorporated in 1905. The firm's first directors were Henry Birks, his three sons, and William H. Lavery, who had been the original messenger boy in 1879.

In 1907 the firm purchased the Gorham Company of Canada, Ltd., acquired the dies for the *Chantilly* and *Louis XIV* patterns, and obtained an agreement from the parent company that it would stay out of the Canadian market for ten years.

Over the next few years the company spread all across Canada, buying up smaller firms, but typically leaving the previous owners in charge, as they had earlier done with Leslie.

In 1912 the company endowed the Birks Chair in Metallurgy at McGill University in Montreal.

In 1925 Birks registered three trade marks for silver: Garb of Wheat, Birks' Coat of Arms, and Canada Lynx Standant. In 1926 the company began using date letters on silver based on the London Key - retarded one year in 1967.

Henry Birks died in 1928. In 1935 William M. Birks was admitted as a liveryman to the Goldsmith's Guild in London, England. Henry G. Birks became a liveryman in 1949 and Drummond Birks in 1955. (Unitt & Worrall, *Unitt's Book of Marks*, 1995 pp. 64-73)

BIRKS STERLING

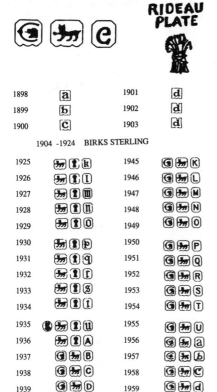

1898	a	1901	d
1899	b	1902	d
1900	c	1903	d

1904 -1924 BIRKS STERLING

1925	🦁Ⓣⓚ	1945	Ⓖ🦁Ⓚ
1926	🦁Ⓣⓛ	1946	Ⓖ🦁Ⓛ
1927	🦁Ⓣⓜ	1947	Ⓖ🦁Ⓜ
1928	🦁Ⓣⓝ	1948	Ⓖ🦁Ⓝ
1929	🦁Ⓣⓞ	1949	Ⓖ🦁Ⓞ
1930	🦁Ⓣⓟ	1950	Ⓖ🦁Ⓟ
1931	🦁Ⓣⓠ	1951	Ⓖ🦁Ⓠ
1932	🦁Ⓣⓡ	1952	Ⓖ🦁Ⓡ
1933	🦁Ⓣⓢ	1953	Ⓖ🦁Ⓢ
1934	🦁Ⓣⓣ	1954	Ⓖ🦁Ⓣ
1935	ⓢ🦁Ⓣⓤ	1955	Ⓖ🦁Ⓤ
1936	🦁ⓉⒶ	1956	Ⓖ🦁ⓐ
1937	Ⓖ🦁Ⓑ	1957	Ⓖ🦁ⓑ
1938	Ⓖ🦁Ⓒ	1958	Ⓖ🦁ⓒ
1939	Ⓖ🦁Ⓓ	1959	Ⓖ🦁ⓓ
1940	Ⓖ🦁Ⓔ	1960	Ⓖ🦁ⓔ
1941	Ⓖ🦁Ⓕ	1961	Ⓖ🦁ⓕ
1942	Ⓖ🦁Ⓖ	1962	Ⓖ🦁ⓖ
1943	Ⓖ🦁Ⓗ		
1944	Ⓖ🦁Ⓘ		

BIRMINGHAM SILVER CO., INC.
Yalesville, Connecticut
See Goldfeder Silverware Co.

Successors to Goldfeder Silverware Co. Manufacturers of sterling silver and silverplate.
A 1974 account states: " ...Sol Goldfeder - newly married and with $150 in his pocket - launched a small silver holloware company anyway. He still recalls his first order. 'It was $30, may be $31. We sold it to M.A. Cohen & Sons.' The sale was a good omen. Soon Goldfeder owned a

prospering factory in Brooklyn. In 1957, after 25 years there, his firm, now named Birmingham Silver Co., shifted operations to Yalesville, CT. Now the firm has added a New York address." (JC-K July 1974, p. 223)

Sterling and Silverplate *Silverplate*

BISKY & KURTZ
New York, New York

Louis Bisky and Frederick Kurtz were partners in the firm of Bisky & Kurtz which first appeared in the New York City directories in 1860. An ad in the directory published in 1861 lists the firm as "Electroplaters of Gold, Silver, Bronze, Copper, and Aluminum. Also Manufacturers of Stencil Work." Not found after 1861.

BIXBY SILVER CO.
Providence, Rhode Island

Listed in JC as manufacturers of sterling silverware 1896-c. 1909.

B. S. C.

SPE ET LABORE

S.H. BLACK
New York, New York

Samuel H. Black first appears in the New York City directory as an electrotyper in 1857 with no business address given, so presumably working for someone else. From 1858 through 1860 he is listed as an electrotyper apparently with his own shop. He is not found in the directories for 1861, 1862 or 1864. In the 1863 directory there is a Samuel H. Black shown as operating an "eatinghouse" but it is not clear whether this is the same person.
In 1865 S.H. Black is listed as an electrotyper and silverplater, and in subsequent years as either one or the other. Presumably he continued to practice both techniques. In 1873 he listed himself as a gilder. Not followed after 1874.

His ad in the New York City directory produced in 1866 describes him as "Electrotyper, and Electro Silver and Gold Plater ...Old Ware Repaired and Replated, equal to new. Plate (sic.) Ware manufactured to order."

BLACK, STARR & FROST, LTD.
New York, New York

CHRONOLOGY

Marquand & Co.	1823-1839
Ball. Tompkins & Black	1839-1851
Ball, Black & Co.	1851-1874
Black, Starr & Frost	1874-1908
Black, Starr & Frost, Inc.	1908-1929
Black, Starr & Frost-Gorham Inc.	1929-1940
Black, Starr & Gorham, Inc.	1940-1962
Black, Starr & Frost Ltd.	1962-present

Black, Starr & Frost traces its history to Marquand & Paulding who began their partnership in Savannah, Georgia in 1801. Several related firms were established in Savannah, New Orleans and New York. For a complete account see *The Silversmiths of Georgia,* by George Barton Cutten .

Marquand & Co. in its early days may have produced some of its own silver. However, its successors, while they did manufacure jewelry, were only retailers of silver. (Soeffing, in Venable's *Silver In America,* 1994, biographical section, p. 315)

The present firm uses the trademarks shown.

B S & F

Black Starr

Black, Starr & Frost Ltd

R. BLACKINTON & CO.
North Attleboro, Massachusetts
See Raimond Silver Mfg. Co.

Founded in 1862 by Walter Ballou and Roswell Blackinton in North Attleboro, Massachusetts and owned and operated by members of the same two families for many years. The original trademark was used until c. 1900. Their products have consisted mostly of sterling silver and 14 karat gold novelties, flatware, holloware and dresserware, with a small amount of costume jewelry.

Bought by Wells, Inc. Attleboro, Mass. June 1967. About 1965-66 their *Marie Louise* flat-

ware pattern was sold to the U.S. State Department for use in all United States embassies throughout the world.

PONTIFEX
On dresserware

MARIE LOUISE
On dresserware

Nethersole Bracelets

W. & S. BLACKINTON CO.
Meriden, Connecticut
See Raimond Silver Mfg. Co.

Founded in 1865 by the Blackinton brothers who specialized in gold jewelry. Acquired by the Ellmore Silver Co. in 1938. While owned by Ellmore, operations expanded to include plated silver holloware. Production was curtailed during World War II and resumed with new lines in 1945. Independently owned since 1961. Incorporated between 1961-65. Purchased by Raimond Silver Mfg. Co., Meriden, Connecticut in 1966 and moved to Chelsea, Massachusetts.

W. & S. BLACKINTON

BLACKSTONE SILVER CO.
Bridgeport (Stratford), Connecticut

Started by E.H.H. Smith, formerly of Meriden, Connecticut, when he did business alone or under the name E.H.H. Smith Silver Co. The firm went into receivership April 12, 1914 and was reorganized as Blackstone Silver Co. It was backed to some extent by Albert Pick & Co.,

Chicago for whom it had been making hotel ware. The Blackstone Silver Co. was sold in 1943 to Bernstein (of National Silver Co.?)

CHARLES BLAKE
Baltimore, Maryland

Silverplaters listed in Baltimore City Directories as Charles Blake 1868-1876, and as Charles W. Blake 1877-1886.

JAMES E. BLAKE CO.
Attleboro, Massachusetts

The Manufacturing Jeweler (10-25-1894) called James E. Blake one of the "pioneer silversmiths of Attleboro." It commented on the increased use of silver for useful and ornamental purposes and credited the firm of Blake & Claflin as being one of the most successful in its efforts in that direction.

James E. Blake, senior partner, was born in Chicopee Falls, Massachusetts in 1851. In 1879 he was married to a daughter of C.H. Sturdy, a member of the old firm of Sturdy Bros. & Co., manufacturing jewelers, established in Attleboro in 1859. In 1880 he joined the Sturdy firm and the following year entered into partnership with Edward P. Claflin, the foreman of the old firm, and Albert W. Sturdy, one of the Sturdy brothers under the firm name of Blake & Claflin. Blake & Claflin thus succeeded to the business of Sturdy Bros. & Co.

About 1889 the firm began the manufacture of articles in silver, match boxes being among their first products. Various other novelties were added from time to time. In 1898 James E. Blake, William H. Blake and Lefferts S. Hoffman filed papers of incorporation under the name James E. Blake Co. The firm name continued to be listed until 1936.
On January 31, 1905 they were granted a Trade Mark patent (No. 44,102) for the manufacture of sterling silver and silver inlaid with 14k gold cigarette and vaniety cases, match boxes, men's belt buckles and pocket knives. Their factory building is now occupied by Bates & Klinke.

The company's "SterlinE" mark, used on German Silver novelty and dresserware items, is sometimes mistaken for the word "Sterling."

PORTER BLANCHARD
Burbank, California
Calabasas, California

Porter George Blanchard, son of silversmith George Porter Blanchard, was born in 1886 in Gardiner, Massachusetts. When his father opened a shop specializing in flatware in 1909, both Porter and his brother Richard joined the firm. In 1914, all three were listed as members of the Society of Arts and Crafts in Boston. That same year, Porter took over the management of the family shop. He became a member of the Detroit Society of Arts and Crafts in 1916 as well. (Bowman, in Morse ed., *Silver in the Golden State* , 1986, pp. 47-48)

Due in part to ill health, Porter Blanchard moved to California in 1923. During his convalescence he developed many new design ideas. (*Silver*, Nov.-Dec. 1988, p. 31) He was also undoubtedly attracted by the state's "Land of Oz" image. (Bowman, ibid)

Blanchard settled in Burbank, and by 1925 his father and brother had joined him. The firm was listed as "Blanchard Brothers" in the 1926 city directory, but Porter was clearly the one in charge.

Blanchard initially followed the colonial revival style in his work, focussing on simplicity of decoration. The embellishment that did appear on his pieces was usually integrally related to the object's form.

By 1930 he was also producing modernized traditional forms with Bauhaus inspired patterns. The transition was easy, as he had always emphasized line and form over decoration.

In 1924 he helped to organize the Arts and Crafts Society of Southern California, and served as its first president. Its aim was to stimulate interest in Crafts, increase the numbers of Crafts workers, and, of course, provide a place where Crafts items could be displayed and sold. Unfortunately, it did not survive past 1930.

Blanchard marketed his work through various shops and studios in Los Angeles, and Arts and Crafts galleries in other cities. He also sold goods through department stores, reaching a broader clientele. While he had many outlets in Los Angeles, in other major cities there was only a single outlet, usually the most exclusive shop, permitted to carry his wares.

He also maintained a retail shop at his studio in Burbank, where he catered to a screen star clientele, capitalizing on its publicity value. In 1933 he opened a retail shop at 6605 Sunset Boulevard near the major studios "to be near folks who had enough money to indulge in such a luxury as high class silverware, especially during hard times." In 1936 he moved the shop to a

more prestigious location, near to the stars' agents. In time he became the silversmith to the stars.

Porter Blanchard was elected a Medalist of the Boston Society of Arts and Crafts in 1944, the Society's highest rank.

He continued as an active and practicing silversmith until his death in 1973. His company continues in business, a monument to his artistic and business skills, working as silversmiths and pewterers, and specialists in restoration and handwrought flatware and holloware.

Blanchard's earliest mark on silver was a PB in an oval. By 1933 it had been replaced by the silhouette mark shown below. Occasionally some pieces are marked with an additional letter "R" for his brother Richard, or other initials of some other workman. (Bowman, ibid pp. 46-55. Mark p. 107)

E.A. BLISS CO.
Meriden, Connecticut
See Napier Company

Founded in 1875 by E.A. Bliss and J.E. Carpenter in North Attleboro, Massachusetts when they took over Whitney & Rice Co. where Bliss had been a traveling salesman: succeeded by E.A. Bliss in 1883. Moved to Meriden, Connecticut in 1890. Began the manufacture of sterling silver in 1893. Succeeded by Napier-Bliss Co., c. 1915.

(Stamped on Nickel Silver Wares.)

Used on World's Fair souvenirs, Chicago, 1893 (U. S. Patent 18,479, September 30, 1890.)

BLIVEN & CULLEN
New York, New York

The firm of Bliven & Cullen first appears in the New York City directories in 1867. Henry C. Bliven and Michael C. Cullen were the partners. An ad in the 1870 New York City directory describes the firm as "Bliven & Cullen, Gold and Silver Platers, 143 Fulton St., New York. Spoons, Forks, Castors, Cake Baskets, &c. &c. , Replated and made equal to new." Not found after 1871.

L.D. BLOCH & CO.
New York. New York

Manufactured plated silver novelties c.1920.

BONTON
B
SILVERPLATE

BLUE RIBBON SILVER MANUFACTURERS, INC.
New York, New York

Max Sherman, Brooklyn, New York, founded the firm of Blue Ribbon Mfgrs. Sept.13,1921. He also received Design Pat. No. 62,036, March 6, 1923, for a fruit basket of pierced design; not assigned.

J.C. BOARDMAN & CO.
S. Wallingford, Connecticut

The company was founded in 1949 by Joseph C. Boardman as the Crest Silver Plate Co. It changed its name to J.C. Boardman & Co., Silversmiths in 1953. Originally located in New Haven, Connecticut, the firm moved to Wallingford, Connecticut in 1961. (Zebora in the *Meriden Record-Journal*, Meriden, Ct., Oct. 25, 1991)

The firm originally manufactured silverplated novelties and unweighted (no artificial weight such as pitch or plaster of Paris) sterling holloware. With the increased price of silver, the temptation to weight the product was something to which all but a few in the industry succumbed.

Boardman was one of the first American manufacturers to recognize the revival of pewter in 1956 and at one time manufactured America's most complete pewter line—more than 300 items. Although the name is the same, they are not direct descendants of the Thomas and Sherman Boardman (q.v.) line.

"The Boardman Co. is perhaps best known to the general public for its famous silver trophies including those for the Super Bowl, Wimbledon and U.S. Open tennis tournaments and the Miss America Pageant." (*Record-Journal*, Meriden, Ct., November 26, 1985).

J.C. Boardman Co. bought the F.B. Rogers Co. in 1985.

The J.C. Boardman Co. then purchased the Manchester Silver Co. of Providence, R.I. in 1986. In addition to new rolling mills (needed to produce thinner strips of silver for flatware) and drop hammers, Boardman also obtained the rights to all the Manchester patterns. (Zebora, ibid.) As a result of this purchase, the company added 16,000 square feet to its factory for flatware production, and began building a retail network in the Western United States.

Out of business by 1992.

LUTHER BOARDMAN & SON
East Haddam, Connecticut

The company was founded by Luther Boardman in the 1820s; became L. Boardman & Son between 1840-44 and went out of business about 1905.

Luther Boardman was born at Rocky Hill, Connecticut, December 26, 1812. He was apprenticed to Ashbil Griswold at Meriden, Connecticut, where he learned the britannia trade. In 1833 he worked for Burrage Yale at South Reading, Massachusetts and became owner of the shop in 1836. In 1837 he returned to Meriden and married Lydia Ann Frary. In 1838 he worked for Russell & Beach at Chester, Connecticut and later made britannia spoons in his own shop there. In 1842 he moved to East Haddam, Connecticut. Most of his work after this time was silverplated britannia. In 1864 his son was made a partner and the name of the firm changed to L. Boardman and Son which was continued for some time after his death in 1887. In 1866 a new plant was built for making nickel silver, silverplated spoons. The business was discontinued shortly before the death of Norman S. Boardman in 1905.

T.D. & S. BOARDMAN
Hartford, Connecticut

CHRONOLOGY
T.D & S. Boardman ?1840-1860
Thomas D. Boardman 1861-1873

The firm of T.D & S. Boardman appears in the Hartford city directories at least as early as 1840 as manufacturers of block tin and pewterware. By 1850, the firm was manufacturing britanniaware:

"T.D. & S. Boardman, Manufacturers and Dealers in Britanniaware, would invite the attention of the public to their large stock of ware now on hand, consisting partly of Coffee Pots, Tea Pots, Sugar Bowls, Creamers, Slop bowls, Ladles, Pitchers, Oil and Fluid Lamps, Candlesticks, Molasses Cups, Flagons, Plates, Goblets, Baptismal Fonts &c. &c.

"Having enlarged their facilities for manufacturing, they are now ready to fill all orders at short notice.

"N.B. Particular attention paid to repairing Britannia, Silver and Plated Ware. Also oil lamps re-fitted for burning fluid.

"An excellent quality of burning fluid can be obtained at their establishment, No. 274 1/2 Main Street."

Their 1859 ad reads: "T.D. & S. Boardman, Manufacturers of Britannia ware of superior quality, patent fireproof tea and coffee pots, warranted to stand the heat of a red hot stove. Britannia pitchers of various sizes, &c. &c. sold at wholesale at the factory at the rear of 485 Main St.; at retail by D.R. Tefft, 487 Main St. Britannia, plated or silver ware left at the store or factory will be repaired at short notice."

Sherman Boardman was deceased by 1861. Thomas D. Boardman continued to be a britannia ware manufacturer through 1873.

L. BOARDMAN & SON

WILLIAM BOGERT
Albany, Newburgh, and New York, New York

William Bogert was the most prominent of the three silversmithing sons of Nicholas J. Bogert. Little is known of his early history. He was probably the "William Bogert, silversmith" listed in the Albany directories in the late 1830s and early 1840s. From there he went to New York City to work with William Forbes, a member of the Forbes silversmithing family which was related to the Bogerts by marriage, and by the fact that William's father had apprenticed with W.G. Forbes.

In the mid 1850s William Bogert moved to Newburgh, New York and went into business with his brother-in-law, John Gordon, and a man named Eaton. The partnership had problems, and Bogert ended up as the sole proprietor. Nevertheless, the firm, during this period, was a supplier of the leading retail houses, including Ball, Black & Co.

He returned to New York City in 1866 and bought out the estate of Charles Grosjean, a leading manufacturer for Tiffany & Co. His new firm was William Bogert & Co., and the "& Co." was Bernard D. Beiderhase (q.v.) who at the same time was a partner in John R. Wendt & Co. Bogert took Grosjean's place manufacturing expensive, high end silverware exclusively for Tiffany & Co. When Tiffany & Co. formed its own silver works in 1869, Bogert, like many other former suppliers, was cast aside.

By 1871 he had entered into a partnership with John Polhamus (q.v.) as John Polhamus & Co. The relationship did not go well, and Bogert subsequently sued Polhamus and won.

William Bogert died in 1881. (Soeffing, in Venable's *Silver in America,* 1994, biographical section, p. 316)

Pyramid made of copper and silver with a base of ebonized wood. Made by William Bogert shortly before his death and subsequently turned into a memorial piece, as indicated by the inscription. (Photo courtesy D. Albert Soeffing.)

BOGUE SILVER COMPANY
Chicago, Illinois

In business ca. 1896. A billhead for the company, which was not incorporated, listed its business as "Manufacturers of High Grade Electro Gold and Silver Plated Ware" with an office and salesroom at 147 to 153 Fifth Avenue, Chicago. Managers of the firm were C.B. Bogue and O.G. Meacham.

(TRADE MARK)

PETER BOHLE
Montreal, Quebec, Canada
See Robert Hendery

Peter Bohle was born in 1786. Between 1800 and 1807 he apprenticed with Robert Cruickshank. Between 1837 and 1840 and again between 1850 and 1856 he was in partnership with Robert Hendery. They worked as silversmiths to the trade supplying such firms a Savage and Lyman. About 1862 Bohle went to work for Maysenhoelder & Baddley. He died in 1865. (Unitt & Worrall, *Unitt's Book of Marks,* 1995, pp. 58, 67)

PB

Used with Leopard's Head and Lion stamps.

EDWIN BOLLES
Hartford, Connecticut

Edwin Bolles first appears in the Hartford city directories in 1845 listed as a machinist. By 1847 he was listed as both a machinist and a

maker of harness trim. By 1849 the firm had become E. Bolles & Co. and was listed as a platers and harness trimmers.

By 1852 Edwin Bolles was again working alone, listed as a plater. His listing continued as "plater" through 1870. From 1871 through 1878 the business was described as "harness trim". Bolles apparently retired in 1879 and is not found in the directories after 1880.

BOSTON SILVER CO.
Boston, Massachusetts?

Manufacturer of silverplate holloware. Mark found on a silverplate creamer dated circa 1890-1910. The individual who made the die for the company's mark apparently came up with his own version of "quadruple plate".

Z. BOSTWICK
New York, New York

Zalmon Bostwick advertised in *The New York Mercantile Register* 1848-49 as "successor to Thompson", and that he "Would inform the public generally that he has made extensive preparation for the manufacture of SILVER WARE, in all its branches."

The Thompson referred to in the advertisement was most likely William Thompson, last listed in the New York City directories in 1844-45.

From information provided by the Industrial Census of 1850 Bostwick appears to have been a medium-sized producer. He employed four men, used hand power, and produced $14,000 worth of goods annually, manufacturing both flatware and holloware.

Last found in the directories in 1852. (Soeffing, in Venable's *Silver in America,* 1994, biographical section, p. 316)

F.L. BOSWORTH CO.
Minneapolis, Minnesota

Founded 1900. Jobbers and wholesale jewelers. They bought wares "in the metal" from manufacturers and plated them in their own shop. Succeeded by P. M. Vermaas c. 1915. Vermaas was president when Bosworth died in 1914.

BOTT SILVERSMITHS, INC.
New York, New York

Listed 1961 JBG as manufacturers of silver wares.

D.C. BOURQUIN
Port Richmond, New York

Founding date not known. Listed in JC 1904, under sterling and jewelry. Out of business before 1909. Trademark identical to Wortz & Voorhis.

BOWLER & BURDICK CO.
Cleveland, Ohio

Listed in JC 1904-1922. Wholesaler whose trademark was found on souvenir spoons. In business before 1890.

JANET PAYNE BOWLES
Indianapolis, Indiana

Janet Payne Bowles was born about 1872. She, along with her husband, Joseph Moore Bowles, became leading advocates for the Arts and Crafts movement in the Indianapolis area. She applied the movement's underlying principles to her work in a variety of media, metalwork, manuscript illumination, and ceramics. Much of her work contains traditional Celtic and Mediaeval motifs.

A chance meeting with a Russian metalsmith in the late 1890s led to her interest in the art. She apprenticed with him and others to master the necessary techniques.

In 1910 she participated in the Fourth Annual Exhibition of the National Society of Craftsmen, attracting increasing public interest in her work. That same year she was commissioned to design and produce handcrafted costume jewelry for the actress, Maude Adams. In addition, she is reported to have designed spoons and other objects for the private collection of J. Pierpoint Morgan.

By 1912 her marriage to Joseph had ended. She returned to Indianapolis to teach metalsmithing and later ceramics at the high school she had formerly attended. There she remained until her retirement in 1942.

In 1920 she received the first prize offered by Florentine art patron Bosselini for a gold chalice. During the 1920s her work was displayed several times at the Art Center in New York City, including a solo exhibition in 1929-30. She died in Indianapolis in 1948. (*Silver*, May-June 1994, pp. 19-20)

JANET
PAYNE
BOWLES

JACK BOWLING
Philadelphia, Pennsylvania

Silversmith, designer and lecturer on silver and silver work. His own works are included in the permanent collections of the Honolulu Academy of Arts and the Library of Congress. He has won numerous awards for excellence and is noted especially for his handwrought ecclesiastic silver.

Admiral Bowling, while still a lieutenant, gained an international reputation as an engraver and print maker but found rough seas unsuitable for the pursuit of these skills. He turned then to metal work and started with the handiest material—tin cans, and soon graduated to gold and silver. He made a silver ladle while at sea on an anti-submarine patrol in 1943 and was impressed with the time and patience required. It was then that he selected his "turtle" maker's mark, chosen because of its significance that "slow and steady does it." - a most appropriate symbol on handwrought silver. The two stars were added on his promotion to Rear Admiral and retirement from the Navy in 1947. In addition, he engraves "jack bowling - philadelphia" and the date of completion on finished articles when suitable. This is not a stamp but an actual signature.

The turtle mark is used with 14k, 10k on gold; with STERLING on silver.

WM. N. BOYNTON
Manchester, Iowa

Registered trademark June 27, 1882 for manufacture of gold, silver and plated ware. This is essentially the same trademark used by the United States Jewelers' Guild until c. 1904. This latter mark was also used by J.H. Purdy & Co., wholesale and retail jeweler in Chicago, listed c. 1896-1924. It was also used by others who belonged to the Guild.

BRAINARD & WILSON
Danbury, Connecticut

Listed 1909-1922 in JC under plated silver wares.

B. & W.

On silver plated art ware.

W.J. BRAITSCH & CO.
Providence, Rhode Island

Silversmiths before 1895. They were manufacturers of sterling dresserware. In 1898 they introduced a new type of dresserware of 14k gold plate which they guaranteed to wear ten years. An ingot of gold was welded to an ingot of gun metal, both were then rolled into sheets of the desired thickness and then made into backs for brushes, mirrors, trophies, etc. They were hand chased and either a gold or gold plated shield was inserted. The process was somewhat related to the "Old Sheffield Plate" process. Out of business before 1922.

TRADE MARK

STERLING

GUSTAVE BRAUNE
Eutaw, Alabama

Born in 1822 in Freiburg, Saxony, Germany, Gustave Braune came to America at age 14 and settled in Milwaukee, Wisconsin. From there, after a time, he moved to Georgia, in the Athens-Rome area. In 1856 he moved to Eutaw, Alabama, the residential center of a rich agricultural area known as the "Black Belt".

Braune apparently had received some training in watch and jewelry repair and also had some knowledge of silver prior to his arrival

there, as he was soon advertising his services and offering a variety of silver items for sale. Much of this silver was manufactured by Theodore Evans & Co. in New York. Braune had lost his left arm early in his adult life. However, he apparently overcame this disability, and engraved, marked, and by several accounts manufactured flatware in his own shop as well.

Through the years, like many other small town jewelers, Braune continued to offer his customers a good varied selection of quality merchandise. How long he continued in business, and what ultimately happened to the business are not known. Braune was also a founder and board member of the First National Bank of Eutaw. He owned an opera house in the town until 1889, and was associated with a cotton seed oil business as well. Braune died in 1898. (Cormany, *Silver,* Nov.-Dec. 1994, pp. 37-39)

G.BRAUNE

G.BRAUNE

E. P. BRAY & DAUCHY
New York, New York
See Redfield & Rice Manufacturing Co.

CHRONOLOGY:

Dater, Bray & Co.	1854
Bray, Redfield & Co.	1854-1856
Bray, Kellogg & Co. (hardware)	1856-1857
E. P. Bray & Dauchy	1857-1859
Bray & Manvel	1859-1860
Bray, Sollace & Dauchy	1860
Bray, Dauchy & Jaques	1860
Dauchy & Jaques	1861

In December 1856, about six months after he withdrew from Bray, Redfield & Co., Edward P. Bray entered into the hardware business in the firm of Bray, Kellogg & Co. with John Q. Kellogg and Kellogg's brother-in-law, Samuel T. Dauchy. In October, 1857, the firm failed and was bought up by Bray's father-in-law, Cyrus Manvel.[1] The firm was re-organized as E. P. Bray & Dauchy, and operated a silverplating business with Bray & Dauchy doing the work, but officially acting as agents for Manvel.[2]

An advertisement in Harper's Weekly (12-4-1858) lists the firm as "agts., Manufacturers... We *Manufacture and Plate* our own Ware, and are thus enabled to offer...Coffee, Tea, and Hot Water Urns... Liquor or Cordial Stands; Magic perfumery and Cigar Stands with Thermometer attached; Magic Castors and Egg Stands combined; complete with Cups and Spoons; Fillagree (sic!) Card and Sugar Baskets; Wine Syphons; Champagne and Hock Bottle Holders; New Style

French 3 and 4 Ring Breakfast Castors, &c., &c." The references to "Magic" castors, perfumery stands and the like suggest that the firm probably was obtaining its holloware "in the metal" from Roswell Gleason & Sons. (q. v.)

The business was dissolved May 1, 1859 and succeeded by Bray & Manvel.[2]

Items noted above reference the R. G. Dun & Co. Collection, Baker Library, Harvard University Graduate School of Business Administration. Volumes and page numbers are given below.
[1]NYC Vol. 376, p.271
[2]NYC Vol. 376, p.241

BRAY, DAUCHY & JAQUES
New York, New York
See Bray, Sollace & Dauchy

This silverplating firm was formed October 1, 1860. Edward P. Bray and Samuel T. Dauchy, having resolved their earlier debts, became official owner-partners in the firm, along with a young man by the name of William L. Jaques, whose father invested $10,000 in the firm on his behalf. Bray and Dauchy contributed similar amounts and Cyrus Manvel continued to stand ready to support the firm if need be. On January 1, 1861, Bray sold out his interest to his partners, who continued the firm as Dauchy & Jaques.[1]

In May of 1861 Bray entered into partnership with Joseph Merwin to form the firm of Merwin & Bray, gun dealers.[2] He took no further part in silverware manufacture.

Items noted above reference the R. G. Dun & Co. Collection, Baker Library, Harvard University Graduate School of Business Administration. Volumes and page numbers are given below.
[1]NYC Vol. 324, p. 916
[2]NYC Vol. 324, p. 925

BRAY & MANVEL
New York, New York
See E. P. Bray & Dauchy

The silverplating firm of Bray & Manvel succeeded E. P. Bray & Dauchy on May 1, 1859. John E. Bray of Connecticut, the father of Edward P. Bray, and Cyrus Manvel of New Jersey, Bray's father-in-law, were officially the principals. Edward P. Bray served as superintendent, while Samuel T. Dauchy acted as clerk for the new firm. This arrangement was necessary as Bray and Dauchy were not entirely clear of their earlier financial liabilities.

A listing in Gobright's *The New York Sketch Book and Merchant's Guide* published in 1859 offers an unusually wide variety of both holloware and flatware, and indicates that the firm catered particularly to customers from the southern states. The same publication illustrates a tea service by the company, heavily embossed with hunting scenes, suggesting that this firm, like its predecessor, may also have obtained holloware "in the metal" from Roswell Gleason & Sons (q. v.). In addition, the company claimed to be "Importers of English, French and German Goods."

Bray and Manvel was succeeded by Bray, Sollace & Dauchy on January 6, 1860.[1]

The item noted above references the R. G. Dun & Co. Collection, Baker Library, Harvard University Graduate School of Business Administration. Volume and page number are given below.
[1]NTC Vol. 376 p. 245

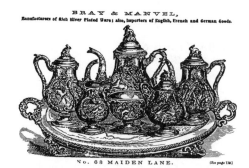

Illustration from an advertisement for the firm of Bray & Manvel from Gobright's New York Sketch Book and Merchant's Guide, 1859. This tea service with its elaborately chased hunting scenes was manufactured "in the metal" by another, larger firm, possibly Roswell Gleason & Sons, then plated by Bray & Manvel. (Courtesy D. Albert Soeffing)

BRAY, SOLLACE & DAUCHY
New York, New York
See Bray & Manvel

The silverplating firm of Bray & Manvel was reorganized on January 6, 1860, into the firm of Bray, Sollace and Dauchy. John E. Bray of Connecticut, the father of E. P. Bray, and Burr Dauchy of Troy, N.Y., the brother of Samuel T. Dauchy, were officially the partners, along with Roland D. Sollace of New York City. Sollace, E. P. Bray and S. T. Dauchy actually ran the business.

Unfortunately, Sollace died in May 1860. However his will stated that his assets were to remain with the business until the partnership dissolved. The firm continued in business until

October 1, 1860, when it was succeeded by Bray, Dauchy & Jaques.[1]

The item noted above references the R. G. Dun & Co. Collection, Baker Library, Harvard University Graduate School of Business Administration. Volume and page number are given below.
[1]NYC Vol. 376, p.245

BREADNER CO. LTD.
Hull, Quebec, Canada

In 1903 Samuel Breadner and a group of investors formed the Breadner Manufacturing Co. The company acquired a selection of souvenir spoon dies from the bankrupt Dominion Jewelers in 1910. The firm became the Breadner Co. Ltd. in 1930 with Samuel Breadner as president. After the Second World War, Samuel Breadner retired and his son, Jack Breadner, took over the company.

The firm acquired the souvenir spoon dies of the Electric Chain Co. (q.v.) of Toronto in the early 1950s. Some of these may originally have come from Bennett of Toronto. About 1970 they acquired the dies of C. Lamond Fils (q.v.) of Montreal. Some of those dies had originally belonged to Caron Bros. (q.v.) Although the firm has over 200 spoon dies, many of them have not been used. The company currently manufactures mainly silverplate and nickle plate souvenir and commemorative spoons. (Pack, *Collector's Guide to Canadian Souvenir Spoons*, 1988, pp. 66-67, 76)

In addition to souvenir spoons, the firm also manufactures souvenir jewelry. During World War II it suspended jewelry production and manufactured badges and emblems for the Canadian Armed Forces. (Unitt and Worrall, *Unitt's Book of Marks*, 1995, p. 55)

STERLING *BMCo* MADE in CANADA

RAYMOND BRENNER, INC.
Youngstown, Ohio

Registered trademark for sterling silverware, silverplated holloware, flatware and table cutlery. Claims use since August 29, 1949.

CHAS. C. BRIDDELL, INC.
Crisfield, Maryland
See Carvel Hall
See Towle Silversmiths

Started in business in 1895 and originally made oyster knives and other seafood tools and implements for the watermen who worked the lower Chesapeake Bay area. In 1905 the firm registered the trademark "Carvel Hall" to be used on cutlery, machinery and tools. The name, Carvel Hall, was chosen many years ago by a designer for the company who was visiting Annapolis. While there, he noticed the elegant designs on the massive doors of the Carvel Hall Hotel and returned to Crisfield with the suggestion that the name be used on the line of knives being made by the firm.

The company was purchased by Towle Silversmiths in 1961.

BRIDE & TINCKLER
New York, New York

Wholesalers of sterling silverware and jewelry. Listed JC 1896-1922.

BRIDGEPORT SILVER CO.
Bridgeport, Connecticut

In business in 1880. President, James Staples; sec-treas., superintendent, Samuel Larkin. About 1882 there was a report that they were to merge with the F.B. Rogers Silver Co. Business continued until 1884 or longer.

BRIDGEPORT SILVER PLATE CO.
Bridgeport, Connecticut
Lambert's Point, near Norfolk, West Virginia

Incorporated January 15, 1891 with George A. Leonard of Boston as president; treasurer, F.H. MacFarlane; sec., Thomas F. MacFarlane. Moved to Lambert's Point, near Norfolk, West Virginia in 1898 although in 1910 there was a MacFarlane Mfg. Co. listed in the Bridgeport Directory. In 1894 there was a Bridgeport Silver Plate Co., probably controlled by MacFarlane. In 1913 there was a firm, MacFarlane, Brothers Mfg. Co. In August 1913 the deeds, tools, etc., were given to the Newfield Silver Co.

The Cellar Shops

BRINSMAID
Burlington, Vermont

CHRONOLOGY

Pangborn & Brinsmaid	1833-1843
J. E. Brinsmaid & Brothers	1843
Brinsmaid & Bros.	1843-1850
Brinsmaid, Brother & Co.	1850-1854
James E. Brinsmaid	1854-1884
Brinsmaid & Hildreth	1854-1902

The Brinsmaid name has been connected with silversmithing in Burlington since c. 1795 when Abram Brinsmaid, from Great Barrington, Massachusetts, settled there. His three sons, James Edgar, Sedgwick Swift and William Bliss, set up in business in 1843 at the old stand of Pangborn & Brinsmaid under the name J.E. Brinsmaid & Brothers, a name soon shortened to Brinsmaid & Bros. Sedgwick left the partnership in 1850 and the two remaining brothers took into partnership Chester Hildreth under the new firm name of Brinsmaid, Brother & Co.

In 1854 James Edgar announced that he was opening his own business as successor to Brinsmaid, Brother & Co. William Brinsmaid and Chester Hildreth went into business together under the name of, Brinsmaid & Hildreth. Both new firms claimed to be successors to Pangborn & Brinsmaid, Brinsmaid & Bros. and Brinsmaid, Bros. & Co. James E. Brinsmaid retired in 1884. Brinsmaid & Hildreth continued in business until 1902 when it was sold to Nelson A. Bero.

BRISTOL BRASS & CLOCK CO.
Bristol, Connecticut
See American Silver Co.
See International Silver Co.

Organized in 1856. They furnished Holmes & Tuttle with their metal. Successor to Holmes & Tuttle Mfg. Co. in 1857. In 1901 became The American Silver Co. which was bought by International Silver Co. in 1935. Bristol Brass & Clock Co. owned the entire stock of American Silver Co. until 1913 when a distribution of stock was made.

Makers of silver tableware, solid and plated. Trade Mark Patent 26,297, March 26, 1895.

BRISTOL MFG. CO.
Attleboro, Massachusetts

Founding date not known. They were manufacturers of plated silverware, cut and plain glass. Succeeded by Bristol Silver Co. c. 1895.

BRISTOL SILVER COMPANY
Attleboro, Massachusetts

Successors to Bristol Mfg. Co. Out of business before 1915.

(Sterling Finish.)

BRISTOL SILVER CORP.
Taunton, Massachusetts
See Poole Silver Company, Inc.

BRITANNIA ARTISTIC SILVER
See M. T. Goldsmith

BRITANNIA ARTISTIC SILVER

BRITANNIA METAL CO.
See Van Bergh Silver Plate Co.

THOMAS F. BROGAN
New York, New York

Listed JC 1896-1930 under sterling silverware and jewelry.

J.S. & E. BROMLEY
New Haven, Connecticut.

In 1859, Joseph S. and Edward Bromley placed an ad in the Brooklyn city directory to

publicise the opening of their silverplating firm's New York City branch office. In that ad they indicated that their company had been in business in New Haven, Connecticut, for 15 years, giving it a beginning date of 1844.

The ad reads: "ELEGANT SILVER PLATED WARE of our own manufacture comprising every description of articles.

"Those having goods with the silver worn off can have them REPLATED in a superior manner, and warranted.

"All of our Silver Plated Ware we will warrant to wear several years; as it has stood the test of hard usage in a number of Hotels Eight Years.

"Parties desiring to purchase any articles in our line, will be well repaid for calling on us, as our goods are sold at Wholesale Prices.

"Having been in the business in New Haven fifteen years, and being not only theoretical but practical manufacturers, we feel confident that our goods will not be found inferior to the best. Please call and examine our stock.

"We refer to the following gentlemen: Rev. Dr. Samuel Cooke, of St. Bartholomew's, and Rev. Dr. William F. Morgan, of St. Thomas' Church, New York City; and Commander A. H. Foote, U.S. Navy Yard, Brooklyn."

The firm is not found in the New York City directories after 1859.

D.L. BROMWELL, INC.
Washington, D.C.

Founded in 1873 by James Bromwell as a small silver and nickel-plating plant. Wet cells were used for the electroplating process, but the buffing wheels that were used to develop the gleaming finish employed a huge mastiff dog, named Cleo, as the motive power. So well did Cleo love the work that it was a problem getting the dog out of the wheel when his efforts were no longer needed. An old-style gas engine was installed later to replace Cleo's power potential, but it broke down periodically and Cleo was allowed to return to the beloved wheel.

James Bromwell's shop, which was capable of making or repairing almost anything, soon became the popular refuge of inventors, who would bring their problems there to be solved. One inventor was trying to develop a gramaphone at about the time Edison was perfecting his. While working with the inventor on the basis of a coated cylinder to retain the sound impressions, James discovered how to plate baby shoes with precious metals, a branch of the business which is still active.

Requests for repair and replacement of antique door knockers, fireplace andirons, fenders and fire tools led to new fields and the development of a bewildering array of metal products spread the fame of the establishment all over the country.

In 1907 James Bromwell died, and his son, Dwight, took over the business. His own son, Berton also began to learn the business, but his interests were in its administration. In 1924 the firm was incorporated under its present name. It is presently operated by the fourth generation of Bromwells. They no longer do their own plating and now specialize in fireplace fixtures.

J.T. BROMWELL
Baltimore, Maryland

Listed in the Baltimore City Directories 1881-1888 under the name J.T. Bromwell, silver plater; listed 1889 as Bromwell Plating Works; 1898-1901 as John T. Bromwell and 1902-04 as Bromwell Plating Works.

BRONZART METALS CO.
New York, New York

Listed among manufacturers of silver c. 1940.

BRONZART

BROOKLYN SILVER CO.
See Schade & Co.

The mark shown below appears on a figural spoonholder dated ca. 1870.

BROOKLYN SILVER PLATE CO.
Brooklyn, New York

In business c. 1890. "Brooklyn S.P. Co. Quadruple Plate" mark used on napkin rings made by E.G. Webster & Son c.1895-1900.

59

BROWER & RUSHER

New York, New York
See Walter S. Brower

Listed in New York City Directories 1837-1842 as retailers for S.D. Brower; Hall, Hewson & Co.; Hall, Hewson & Brower.

WALTER S. BROWER

Albany, New York

CHRONOLOGY

Carson & Hall	1810-1818
Hall & Hewson	1818-1829
Hall, Hewson & Co.	1839-1842
Hall & Hewson (again)	1842-1847
Hall, Hewson & Co.	1847-1850
Hall, Hewson & Merrifield	c.1845
Hall, Hewson & Brower	1849-1850
Hall & Brower	1852-1854
Hall, Brower & Co.	1854
S.D. Brower & Son	1850
Walter S. Brower	1850-1898

The history of the Walter S. Brower Company of Albany, New York can be traced to Carson & Hall (Thomas Carson & Green Hall, 1810-1818); Hall & Hewson (Green Hall & John D. Hewson, listed in City Directories 1818-1829; 1842-1847); Hall, Hewson & Co. (Green Hall, John D. Hewson and S. Douglas Brower, listed in the City Directories 1839-1842; 1847-1850); Hall, Hewson & Merrifield (Green Hall, John D. Hewson & Thomas V.Z. Merrifield, in business c. 1845); Hall, Hewson & Brower (Green Hall, John D. Hewson & S.D. Brower listed in the City Directory 1849-1850); Hall & Brower (Green Hall & S. Douglas Brower & Co. (Green Hall and S.D. Brower, listed in City Directories after 1854); S.D. Brower & Son (S.D. Brower & Walter S. Brower, in business around 1850) and finally Walter S. Brower, who began around 1850 in Albany.

Walter S. Brower was the son of S. Douglas Brower, who had been apprenticed to Hall & Hewson before setting up his own shop in Troy, New York in 1834. S. Douglas retired to a farm temporarily and then returned to silversmithing with the firm of Hall, Hewson & Brower c. 1849-50. Father and son were in business together soon afterwards. Walter S. Brower retired in 1898.

HENRY S. BROWN

Utica, New York
See Maynard & Taylor
See Charles C. Shaver

CHRONOLOGY

Brown & Shaver	1856-1858
Henry S. Brown	1858-1863

Henry S. Brown was born in Wayne Co., New York, in 1833. By 1851 he is shown working as an apprentice for Norton & Seymour (q.v.) in Syracuse, New York. By 1853 he had moved to Utica to work for the firm of Maynard & Taylor (q.v.)

Charles C. Shaver was born in Germany in 1835 and came with his family to Manlius, New York in 1847. In 1849 he began his apprenticeship at Willard & Hawley (q.v.) He and Brown presumably became friends during their apprenticeships in Syracuse. In 1854 Shaver also moved to Utica, to work for Maynard & Taylor.

In 1856 Brown and Shaver bought out the silver manufacturing portion of the business of Maynard and Taylor. Unfortunately, in 1858, Shaver contracted a serious case of typhoid fever and was forced to retire from the business, selling his interest to Brown.

According to the Federal Industrial Census of 1860, Brown's firm had a capital investment of $4,500, a "forge" and six male employees, and produced $10,000 worth of "spoons &c." annually. Although Brown's advertisements offer "ornamental silverware", plain patterned spoonwork is all that has been found to have been produced by the company so far. The mark he used was a pseudo-hallmark: Eagle, HSB, Head.

In 1863 Brown sold out his business to his former partner, Charles C. Shaver. No further record of Brown has been found. (Soeffing, *Silver*, Mar.-Apr.1996, pp. 26-31)

MICHAEL SEPTIMUS BROWN

Halifax, Nova Scotia, Canada

Michael Septimus Brown was born in 1818. He apprenticed under Peter Nordbeck. In 1840 he established his own business. In 1851 he took his nephew, Thomas Brown, as an apprentice. Thomas Brown succeeded him when he retired. Michael Septimus Brown died in 1886. (Unitt & Worall, *Unitt's Book of Marks*, 1995, p. 13)

"This concern started in Newark c.1801-02 and has been in existence for 98 or 99 years, thus outdating all others." (Letter from T.G. Brown & Sons, JC-W 5-16-1900, p. 52)

The sons were Thomas B. and William A. Brown.

(Goods made for Gorham Mfg Co.)

BROWN & BROS.
Waterbury, Connecticut

Established in 1851. They originally produced brass and German silver. September 21, 1875, they registered a trade mark patent for brass, German silver and plated silver goods.

In 1874 they engaged LeRoy S. White, who had been with Rogers & Brother for 17 years and earlier with the Hartford Mfg. Co., to start making silverplated flatware. White obtained a number of flatware design patents. The business continued for about ten years but was not too successful and the entire business discontinued in 1884 or 1885.

No successor of their silverplated line was recorded. In 1886 Randolph and Cough took over the plant but evidently did not continue making silverplated flatware.

THOMAS G. BROWN & SONS
New York, New York

CHRONOLOGY

Hinsdale & Taylor	1807-1817
Taylor, Baldwin & Co.	1817-1841
Baldwin & Co.	c.1840-1869
Thomas G. Brown	1869-1881
Thomas G. Brown &. Sons	1881-c. 1915

Manufacturers of some sterling goods for Gorham Mfg. Co., which were so marked.

Two 1896 accounts note: "Justus Verschuur, for several years connected with the Alvin Mfg. Co., is now connected with Thomas G. Brown & Sons." (JC&HR 3-18-1896, p. 24)

"William A. Brown, New York, formerly of Thomas G. Brown & Sons, and Frederick T. Ward, formerly of Cox, Cooper, Ward & Young, have formed a partnership and started in business to manufacture high class novelties in sterling silver." (JC&HR 3-25-1896, p. 24)

THOMAS J. BROWN
Baltimore, Maryland

Listed in Baltimore City Directories 1867-1874 as a goldsmith and silversmith. The company name was changed to Thomas J. Brown & Son in 1875 and continued under this listing through 1883.

BROWN & SHARP
Warren, Rhode Island
Pawtucket, Rhode Island
Providence, Rhode Island

"Brown & Sharp, established in 1804 by David Brown, jeweler and silverware, in Warren, Rhode Island. When business failed he traveled through the valley of the Connecticut and ground razors and fine cutlery. He also carried with him silverware of his own manufacture. He followed this itinerant occupation for 3 years. In 1828, he moved from Warren, Rhode Island to Pawtucket, Rhode Island and five years later, in 1833, formed a co-partnership with his son Joseph P. Brown and not long afterwards founded in Providence the establishment which became incorporated in 1868 as Brown & Sharpe Mfg. Co. still in business in 1919." (JC-W 2-5-1919)

BROWN & WARD
New York, New York
See Thomas G. Brown & Sons

Listed JC 1896 under sterling silver. Out of business before 1904.

BROWN, RUSSELL & BARCLAY
Boston, Massachussetts

Advertised as manufacturers and dealers in "Fine Silver Plated Ware" in the *Boston Evening Transcript*, December 7, 1867. The firm also offered "Jobbing and Replating done at short notice."

The firm name became Brown & Russell in 1868 as listed in another ad in the *Boston Evening Transcript* December 1 of that year.

BROWNE, JENNINGS & LAUTER
New York, New York
See Jennings & Lauter

BRUN-MILL CO.
Pittsfield, Illinois

Manufacturers of plated silverware c. 1920

FRED BUCHER
Baltimore, Maryland

Listed in Baltimore City Directories 1877-79 as a goldsmith and silversmith.

BUCK SILVER COMPANY
Killbuck, New York
Salamanca, New York

Listed as Buck Silver Company c. 1900-1914 when it became Buck Plating Co. Out of business before 1922. According to an unidentified newspaper clipping dated 1908, they made an extensive line of plated holloware.

BUCKER & ROHLEDER
Baltimore, Maryland

Listed in Baltimore City Directories 1901-04 as silverplaters.

SILAS E. BUCKER
Baltimore, Maryland

Listed in Baltimore city directories 1907-13 as a silverplater.

FRANCIS A. BUNNELL(E)
Syracuse, New York
See Hotchkiss & Schreuder
See Clemens Oskamp

CHRONOLOGY

Bunnelle & Schreuder	?1853-1857
Joseph Seymour & Co.	1857-1862?
F.A. Bunnell	1862?-1866
F.A. Bunnell & Co.	1866-1871

Francis A. Bunnelle was born in Orville, New York in 1830. (Ives, *Silver,* Nov.-Dec. 1991, p. 13) About 1853 he entered into partnership with Andrew B. Schreuder forming the firm of Bunnelle & Schreuder to manufacture solid silver flatware. Schreuder had previously worked in Utica, New York. This partnership was dissolved on October 16, 1857 when Bunnelle left the business. Shortly afterwards, Schreuder entered into a partnership with David Hotchkiss to form the firm of Hotchkiss & Schreuder (q.v.). (Soeffing, *Silver,* Jan.-Feb. 1990, p. 18)

Bunnelle apparently went to work with Joseph Seymour (q.v.) after his partnership with Schrueder was dissolved. He appears as a witness on a patent that Seymour obtained for a "set of rolls" for making spoons in 1859. Some time about 1860, he dropped the use of the final "e" in his name. He went into business on his own about 1862.

By 1864 Bunnell had taken over the manufacturing portion of the business of Willard & Hawley (q.v.). His Syracuse directory listing for 1864-65 advertises "Plain, Figured, Engraved and Twisted knives, forks, spoons, &c." (Ives, *Silver,* Mar.-Apr. 1990, p. 21)

By 1866 he had formed the firm of F.A. Bunnell & Co. James Appleton from New York City was the "company" in this case, and probably served simply as a financial backer. By 1869 two local businessmen, Joseph E. Masters, a printer, and Charles L. Chandler, a dentist had replaced Appleton. Bunnell's silverware manufactory had been located at the same address as the printing shop since 1867. Bunnell apparently

stopped manufacturing about 1871 and turned to farming instead.(Ives, ibid.).

About 1874 the business was sold to Clemens Oskamp (q.v.) of Cincinnati, Ohio, a retail jeweler and watchmaker. Bunnell apparently went to Cincinatti to help set up the factory at the new location, as he appears in the Cincinatti directory for 1875. Bunnell returned to the Syracuse area and farming after a short time. He died in 1896. (Ives, *Silver*, Nov.-Dec. 1991, pp. 13-15)

F.A.B& CO

BUNNELLE & SCHREUDER
Syracuse, New York
See F.A. Bunnelle
See Hotchkiss & Schreuder

The marks shown below are from Soeffing (*Silver*, Jan.-Feb. 1990, p. 16)

CALEB H. BURGESS
Baltimore, Maryland

Listed in 1864 Baltimore City Directory as a silverplater. Listed as Caleb H. & John Burgess 1865-1883; Caleb H. Burgess 1884-89.

JOHN BURGESS
Baltimore, Maryland

Listed in 1864 Baltimore City Directory as a silverplater.

OWEN D. BURGESS
Baltimore, Maryland

Listed in Baltimore City Directories 1894-1899 as a silverplater.

BUTLER, McCARTY & CO.
Philadelphia, Pennsylvania

CHRONOLOGY
Butler & McCarty	1849-1868
Butler, McCarty & Co.	1868-1876
McCarty & Hurlburt	1876-?

Franklin Butler appears in the Philadelphia directories as a watchmaker and jeweler as early as 1846. Edward McCarty appears as a silversmith beginning in 1845. The two became partners in 1849 or early 1850. The firm retailed watches and jewelry and manufactured small silver items such as pencil cases and thimbles.

Henry O. Hurlburt joined the firm in 1868, and it became Butler, McCarty & Co. Butler died in an accident in 1870, but the firm continued under the same name until 1876, when it became McCarty & Hurlburt. (Soeffing in Venable's *Silver in America*, 1994, biographical section pp. 316-317)

CHAS. B. BYRON CO.
New York, New York

Successors to Byron & Vail Co. before 1909.

BYRON & VAIL CO.
New York, New York
See Chas. B. Byron Co.

Succeeded by Chas. B. Byron Co. Founding date not known. Manufacturers of sterling silverware, gold and platinum cigarette and vanity cases, match boxes and powder boxes.

C

CALBERT MFG. CO.
New York, New York

Listed JC 1915 as manufacturers of plated silver. Out of business before 1922.

GONDOLA SILVER

J.E. CALDWELL
Philadelphia, Pennsylvania

CHRONOLOGY
James E. Caldwell	1839-1843
Bennett & Caldwell	1843-1848
J.E. Caldwell & Co.	1848-?
J.E. Caldwell Co.	?-present

James Emmett Caldwell was born in 1813 in Poughkeepsie, New York. He apprenticed with Peter B. Hayes there to learn the jewelry trade, specializing as a watchmaker. For a short time after completing his training he worked in New York City.

He moved to Philadelphia by the mid 1830s, and in 1839 opened his own shop. Exactly when he went into partnership with Mr. Bennett is unclear. Possibly it was earlier than the date given above. Between May 1848 and May 1856 John C. Farr was Caldwell's partner. Various others succeeded him.

A Caldwell advertisement from the early 1850s indicates that the firm manufactured silver flatware and holloware for a time. How long they did so is uncertain, but the word "manufacturer", referring to silverware, is not used in their advertising beyond the late 1850s.

For the bulk of its history the company appears to have been a retailer of silver rather than a manufacturer. By the 1850s Caldwell's, along with Bailey & Co. (q.v.), had become major jewelry and silver retailers in Philadelphia.

When fire gutted the firm's recently built marble palace in 1868 as a result of a failed burglary attempt, the losses were over $1 million, but the company was insured and able to rebuild within a few months.

Caldwell's introduced a number of business practices that were new to Philadelphia. These included a one price system in place of bargaining, shorter and more regular work hours, and a policy of having salesmen wait in readiness rather than try to push a sale. (Soeffing, in Venable's *Silver in America*, 1994, biographical section, p. 317)

James E. Caldwell died in 1881 and was succeeded in the business by his son J. Albert Caldwell. He in turn ran the business until his death in 1914, and was succeeded by his son J. Emmett Caldwell.

J. E. C. & CO.

CAMDEN HALL INC.
New York, New York

Importers. Listed JC-K 1964 in New York; no further listing.

J.D. CAMIRAND & CO.
Montreal, Canada

Manufacturers of plated silver c. 1920. (Unitt & Worrall, *Unitt's Book of Marks*, 1995, p. 58)

MADE BY J. D. CAMIRAND & CO. MONTREAL

A. CAMPBELL
Chicago, Illinois

Listed in Chicago City Directories 1853-1855 as a silverplater.

ARCHIBOLD CAMPBELL
Baltimore, Maryland

Listed in 1864 Baltimore City Directory as a silverplater.

JAMES J. CAMPBELL
Baltimore, Maryland

Listed in Baltimore City Directories 1874-1877 as silverplaters.

JOHN CAMPBELL
Columbia, South Carolina
Montgomery, Alabama

CHRONOLOGY
Campbell & Yongue	1847-1849
John Campbell	1849-?
Campbell & Wyman	?-1859?
Campbell, Wyman & Co.	?1859

John Campbell was born in 1824 on Sullivan's Island, South Carolina. His parents died within a few years and he was bound out as an orphan in 1832. Nothing further is known of his youth. In 1843 he entered The Citadel in Charleston as a student, but left the following year to join the U.S. Army, serving in the Mexican War from 1844 to 1847.

He then went to Columbia, South Carolina, where he worked as a silversmith and a jeweler from 1847 to 1849. Where he received his training as a silversmith is not known. His partner during this time was a man by the name of Yongue who has not been further identified.

In 1849 Campbell moved to Montgomery Alabama and worked alone for a time there. He then formed a partnership with J.E. Wyman, a member of a pioneer Alabama family. Near the end of his stay in Montgomery, George Sayre also joined the partnership.

The first three firms, Campbell & Yongue, John Campbell, and Campbell & Wyman are known to have manufactured both flatware and holloware. Campbell, Wyman & Co. (or Campbell, Wyman & Sayre) was in business only briefly, and no pieces bearing that company's mark have yet been found. Campbell probably manufactured his own fiddle pattern flatware, but may have obtained pieces in the "Fiddle Thread" and "Josephine" patterns from northern manufacturers.

Besides manufacturing silver, the firms also sold a typical jewelry store line of goods. An ad for Campbell, Wyman & Co. lists the firm as "Importers and dealers in Watches, Fine Jewelry, Fancy Goods, Guns, Silver and Plated Ware, &c."

In 1859 Campbell sold his interest in the business to his other two partners, and moved to a plantation where he raised cotton and corn. He served the South in the Civil war as a Lieutenant and Captain of Company B, 61st Regiment, Alabama Infantry. He was discharged after being wounded in 1865, and returned to run his plantation after the war. He was elected a Probate Judge in 1886 and died in 1887. (Cormany, *Silver*, May-June 1992, pp. 8-11)

SAMUEL K. CAMPBELL
Baltimore, Maryland

Listed in 1864 Baltimore City Directory as a silverplater.

CAMPBELL-METCALF SILVER CO.
Providence, Rhode Island

Founded by Ernest W. Campbell and Joseph M. Metcalf. Campbell was born in Providence, Rhode Island April 11, 1860. He studied

art at Brown University, and started in the silver manufacturing business as a designer and superintendent at "one of the prominent Providence silver manufactories" (probably Gorham).

Metcalf was born in Brooklyn, Connecticut in 1861 and received his education in Providence. His first business experience was as a salesman for a drug firm. Campbell and Metcalf joined together under the name Campbell-Metcalf Silver Company in 1892 to manufacture sterling silver goods.

"The Campbell-Metcalf Silver Co. was adjudged insolvent." (JC&HR 6-8-1898, p. 17) In 1900 Campbell designed silverware for W.H. Manchester Co.

CANADA MFG. CO.
Montreal, Quebec, Canada
Toronto, Ontario, Canada

Sterling silver manufacturer in business circa 1890. (Unitt & Worrall, *Unitt's Book of Marks*, 1995, p. 42)

THE CANADA PLATING CO.
Montreal, Quebec, Canada

Mark found on a silverplate toothpick holder dated circa 1890-1910.

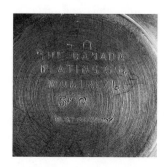

65

CANADIAN JEWELERS, LTD.
Montreal, Quebec, Canada

Manufacturers of silver deposit ware 1912-1923. Successors to Hemming Mfg. Co.

DEPOS-ART

CANADIAN WM. A. ROGERS CO., LTD.
Toronto, Canada
See Oneida Silversmiths
See Wm. A. Rogers Co.
See Toronto Silver Plate Co.

In 1914, William A. Rogers purchased the Toronto Silver Plate Co., and it became the Canadian division of William A. Rogers. Between 1914 and 1916 the firm obtained Canadian copyrights for a number of flatware designs. In 1929 this firm, along with the William A. Rogers Co. was purchased by Oneida Ltd. (Pack, *Collectors Guide to Canadian Souvenir Spoons,* 1988, p. 14.)

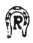
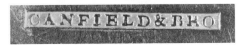

CANFIELD & BROTHER
Baltimore, Maryland

Ira B. Canfield and William B. Canfield, silversmiths in Baltimore c. 1830.

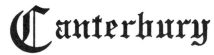

CANFIELD BRO. & CO.
Baltimore, Maryland

Ira B. Canfield, Wm. B. Canfield and J.H. Meredith. Importers and manufacturers of watches, jewelry and silverware, "Albata & Plated ware." Listed in Baltimore City Directories 1850-81 Succeeded by Welsh & Bro.

JOHN CANN
New York, New York
See Charters, Cann & Dunn
See Kidney, Cann & Johnson

CHRONOLOGY

Charters, Cann & Dunn	1848-1856
Cann & Dunn	1856-1860
John Cann	1860-1863
Kidney, Cann & Johnson	1863
Kidney & Cann	1864
Kidney, Cann & Johnson	1865-1867

John Cann was a manufacturer of solid silver holloware who initially entered into a partnership with Thomas Charters, Jr., and David Dunn to form the firm of Charters, Cann & Dunn (q.v.). When Charters left the firm in 1856, it became Cann & Dunn. In 1860 Dunn also left the firm and for a time John Cann was in business by himself.

His ads in the New York City directories list the firm as a "Manufacturer of Sterling Silver Ware, No. 110 & 112 Greene St., *Sign of the Golden Pitcher,* (Between Spring and Prince Sts.,) New York. Vases, Pitchers, Tea services, Cups, &c."

When Cann became a member of the firm of Kidney, Cann & Johnson in 1863, the firm continued to use the *"Sign of the Golden Pitcher"* in its advertising. John Cann is not found in the New York City directories after 1867.

CANTERBURY SILVERSMITHS, INC.
Brooklyn, New York

Manufacturers of sterling and plated wares.

ℭanterbury

Trademark filed Nov. 12, 1948; use claimed since February 1946. For use on silverplated and sterling silver holloware, namely, serving trays, bread trays, water pitchers, food serving dishes, table platters and plates.

1950 trademark on sterling and plated wares.

CANTRELL COMPANY

Seattle Washington
See Joseph Mayer & Bros.
See Metal Arts Group, Inc.
See E.J. Towle Mfg. Co.

CHRONOLOGY

Joseph Mayer & Bros.	1895-1920
Joseph Mayer, Inc.	1920-19??
Northern Stamping & Mfg Co.	19??-1945
E.J. Towle Mfg. Co.	1945-1980
West Earth, Inc.	1980-1985
Metal Arts Group, Ltd.	1985-present
Cantrell Co. (subdivn. MAG)	1994-present

Charles B. Cantrell marketed his first jewelry designs nationally at the age of 17. He studied under world renowned jewelry designer Pilar Ramallo. In 1980, in partnership with Raoul Leblanc, he purchased the former E. J.Towle Mfg. Co., and re-named the company West Earth, Inc. In 1985, he bought out Raoul Leblanc's interest in that firm, and re-named the company Metal Arts Group, Ltd. The company focusses primarily on the production of museum quality Northwest Coast Native Jewelry. Its Charles Cantrell, Ltd. subdivision produces 14K and 18K gold designer Jewelry.

Both West Earth and Metal Arts Group had produced limited quantities of sterling collector spoons. In April, 1994, Cantrell organized a new subdivision of his firm, Cantrell Company, to specialize in collector spoon production. For this he uses the dies of his firm's predecessors, Joseph Mayer & Bros. and E.J. Towle. The company currently (1995) is in the process of developing a new spoon design for Starbucks Coffee Company for distribution through its stores.

American Legacy
Metal Arts Group

Charles Cantrell
Fine Jewelry Designs

OSCAR CAPLAN & SONS

Baltimore, Maryland

Silversmiths, established 1905.

DAVID CARLSON

Gardner, Massachusetts

Listed KJI 1927 as manufacturer of handwrought sterling silverware.

CARON BROS.

Montreal, Quebec, Canada

Pack (*Collectors Guide to Canadian Souvenir Spoons*, 1988, p. 16) reports Caron Brothers as manufacturers of sterling silver and silver plate wares between 1878 and 1920. However the firm is listed as manufacturers of metal products and jewelry in JC through 1931.

Caron Bros. received three Canadian copyrights for souvenir spoon designs between 1903 and 1905. Two of these were full figure handles with a shield above, one representing a woman, the other an Indian. The company produced a wide selection of other Canadian souvenir spoons as well. Spoons from their dies were later manufactured by C. Lamond Fils., another Montreal firm. (Pack, ibid, pp.16, 17, 76) Additional marks from Unitt & Worrall, *Unitt' Book of Marks*, 1995, p.59.

CARONFRERES
STERLING ⑬

CARPENTER & BLISS

North Attleboro, Massachusetts
See Napier Company

Began business as Carpenter & Bliss in 1875 in North Attleboro, Massachusetts. Succeeded by E.A. Bliss Co. in 1883.

M.W. CARR & CO., INC.

West Somerville, Massachusetts

Listed from c. 1920 to the present (1975) as manufacturers of bag frames, dorine boxes, vanity cases, match boxes, jewel boxes, Dutch reproductions, pewterware, photo frames and other novelties.

CARR CRAFT

SANDERS W. CARR
Baltimore, Maryland

Listed in 1876 Baltimore City Directory as a silverplater. Succeeded by W.S. Carr & Co. in 1877.

W.S. CARR & CO.
Baltimore, Maryland

Successors to Sanders W. Carr, silverplater, first listed in 1876 Baltimore City Directory. In business through 1886.

JOHN CARROW
Philadelphia, Pennsylvania

In business about 1884.

JOHN CARROW. PHILA. QUAD. H.W.M.

CARTER-CRUME CO.
Niagara Falls, New York
See Niagara Silver Co.

Listed in the Niagara Falls City Directory as the earliest manufacturers of salesbooks in this country. Succeeded by American Salesbook Co., now Moore Business Forms, Inc.

They were also listed in the 1898 JC as manufacturers of plated flatware.

These two trademarks were registered at the U.S. Patent Office for use on plated flatware.

The Niagara Silver Co. (Wm. A. Jameson, manager) was a branch of Carter-Crume.

EXTRA {COIN SILVER M.S.R} PLATE

U.S. Trade Mark Patent 30,185, June 15, 1897 to be used on spoons, forks, knives and plated flatware. RSMC

U.S. Trade Mark Patent 30,962, December 14, 1897, to be used on blades of knives, shanks of spoons and forks.

CARVEL HALL
Crisfield, Maryland
See Chas. C. Briddell, Inc.
See Towle Silversmiths

Began as Chas. C. Briddell, Inc. in 1895 a blacksmith shop and manufacturer of seafood harvesting tools. In 1905 that firm registered the trade mark "Carvel Hall" for use on cutlery, machinery and tools. Briddell chose the name due to his admiration for the quality look of the Carvel Hall Hotel in Annapolis, Maryland.

During World War II, the firm turned its efforts to producing anti-tank rocket shells, and machetes for export to South America. After the war the company engaged in manufacturing dinner knives and carving knives.

Towle Silversmiths purchased Carvel Hall in 1961. When Towle entered bankruptcy proceedings in 1986, it chose to retain Carvel Hall, but closed the plant after it re-entered bankruptcy in 1989. A Group of local investors, led by James A. Hart the former plant manager, and assisted with a loan from the Maryland Industrial Land Act fund, re-opened the plant about 1991. (Silver, *Washington Post*?, ca. 1991)

H.A. CARY CO.
Albany, New York

An account from 1900 states, "H.A. Cary formerly of Phelps & Cary Co. has gone into business for himself. Incorporated at Albany (New York) Friday. They will engage in the business of silversmithing." (JC-W 6-6-1900, p. 34)

LEWIS CARY
Boston, Massachusetts

Silversmith c. 1820. One of his apprentices was Newell Harding.

CASE & CO.
New York, New York

CHRONOLOGY
Henry G. Case & Co.	1853
Horace G. Case	1854-1855
Case & Crawford	1856
Horace G. Case	1857-1860
H.G. Case & Co.	1861
Horace G. Case	1862-1863
Case & Co.	1864-1874+?

The firm first appears in the 1853 New York City Directory listed as Henry G. Case & Co., platers. The following year the business was in

the hands of Horace G. Case. In 1856 Horace G. Case formed a partnership with James Crawford, creating the firm of Case & Crawford.

The following year Horace G. Case was working independently again, and he continued in that fashion until 1861. That year the firm became H.G. Case & Co., when he was joined by T.R. Clute (q.v.) who also continued his own separate business as well. In 1863 and 1864 it was back to Horace G. Case again.

By 1864 the firm had become Case & Co. Over the years various members of the Case family were associated with Horace G. Case in the business. Henry G. Case appears associated with the firm in 1853 and 1859. Catherine L. Case was part of the firm from 1862 through 1865. George C. Case was associated with the company from 1854 through 1856 and later from 1869 through 1871. By 1873 he had established his own separate jewelry store.

The directory listings for the company throughout the period covered describe the business as "platers", "silver" or "silverware". The first mark shown below is from a silverplated icewater pitcher dating from the 1870s, indicating that the company produced silverplate holloware.

Circa 1870 the firm also offered flatware, obtained "in the metal" from Redfield & Rice.

CASE & Cº

CASTLE SILVER CORP.
New York, New York

Manufacturers of silverplated wares c. 1950.

CATTARAUGUS CUTLERY CO.
Little Valley, New York

In 1904 advertised "Manufacturers of fine cutlery since 1876." No record after 1910.

YUKON SILVER
98-100 FINE.

CELLINI CRAFT, LTD.
Chicago, Illinois

Founded by Ernest Gerlach as The Cellini Shops in 1914 and named for the celebrated Renaissance goldsmith, Benvenuto Cellini. Gerlach had received his training as metalsmith in the Craft Shop at Marshall Field & Company. He served in the Navy during WWI and left the shop in charge of Wilhelmina Coultas. Following the war, his brother, Walter, who had studied jewelry making at the Chicago Art Institute, joined him. Hans Gregg and William Conrad, both from Germany, and other European jewelers and silversmiths joined the firm.

During the Depression it was necessary to find a less expensive medium than silver for their work. In 1934 Walter Gerlach and Hans Gregg established Cellini Craft, Inc. and added a line of holloware and flatware called Argental, made from an aluminum alloy. This soon replaced their handwrought jewelry and silver as their principal product.

In 1957 the Randahl Company bought Cellini Craft and moved the workshop to Skokie, Illinois. The Randahls sold their patterns and designs to Reed & Barton in 1965 where a few of the original Cellini silver designs continued to be made. In 1969 the Randahl Company purchased the Cellini Shop and discontinued its custom workshop. The retail part is still in operation. (1986)

CENTRAL STERLING CO.
Brooklyn, New York
See J. Wagner & Son, Inc..

Discontinued between 1909-14.

CENTURY SILVER MFG. CO.
New York, New York

Listed 1927 and 1931 KJI as manufacturers of silverplated wares.

FREDERICK CHAFFEE
Rutland, Vermont

Born in 1823, Frederick Chaffee entered into partnership with Washington Root in Pittsfield, Massachusetts in the 1840s. In 1849 he came to Rutland, Vermont, to open a branch store.

By 1852 he was in business for himself. He was a prolific and talented silversmith, producing a broad variety of types of flatware pieces: tea and table spoons, salt and sugar shovels, sugar shells and gravy or cream ladles.

However, his business was not limited to silversmithing. An 1856 advertisement lists him as a "Manufacturer and Wholesale Dealer in Ready-Made Clothing, Gold and Silver Watches, Silver spoons and Fancy Goods Generally".

He became a wealthy landowner and bank director and served on various public committees. Chaffee died in 1891. (Carlisle, *Silver* Jan.-Feb. 1988, pp.19-20)

LASSLO CHANDOR
New York, New York
See Jenkins & Co.

Lasslo Chandor appears in the New York City directories at least as early as 1852. At that time Chandor had his factory at 212 Center, but also sold his wares and took orders through Jenkins & Co., 291 Broadway.

An ad in Rode's New York City directory published in 1852 reads: "CHANDOR'S SILVER PLATED WARE. The attention of the public is particularly directed to the above named Ware, as being in every respect a more beautiful and desirable article, than any other now manufactured, and as this Ware is plated by a process (only known to Mr. Lasslo Chandor, the manufacturer) whereby a great saving is effected over all other methods, it can be sold for much less rates than is usually charged for an article greatly inferior.

"All kinds of Metal, Military, Harness, and Gun Mountings, Plumbers' Fixtures, Beer Pumps, Soda Founts, Tea Setts (sic.), Coffee Urns, Trays, Cake Baskets, Spoons, Forks, Bouquet Holders, Castors, Butter and Fish Knives, Door Number and Coffin Plates, Decanter Tops, Candelabra, Stair Rods, &c., &c., Silver Plated or Gold Plated, to order at very short notice.

"Every description of old Ware re-plated equal to new. Steamboats, Packet Ships, Hotels, and Private Families, may have their Wares re-plated with Silver or Gold, equal to new, at about one fourth of the original cost.

"Britannia Ware Plated."

By the following year, Chandor was no longer associated with Jenkins. He continued to be listed as a plater or "chemist" through 1856. For the next three years he appears in the directories as a "broker". Not found after 1859.

HUMESTON CHAPIN
New York, New York

Humeston Chapin first appears in the New York City Directories as a dealer in fancy goods in 1853. By 1856 his business is listed as plated ware. That same year Mason's Bros. Business Directory lists him as a "Manufacturer, Importer, and Dealer, in Silver and German Silver Ware." In 1859 the New York City Directory describes the firm as dealing in "gold, silver & plated ware, spectacles, thimbles, etc." Last listed in 1863 as a dealer in plated goods.

CHAPIN & HOLLISTER CO.
Providence, Rhode Island

Listed in JC 1915-22. Manufacturers of gold, silver and gold-filled knives and jewelry.

C. &. H. Co.

CHAPMAN & BARDEN
Attleboro, Massachusetts
See Barden, Blake & Co.

C. & B.

CHARTER COMPANY
See International Silver Company

Trademarks used on sterling reproductions of early Colonial silver. Made in the Barbour Silver Co. plant c.1930-33. When that division was closed, the Charter line was moved to the sterling division in Wallingford. Discontinued about 1942.

CHARTERS & BROTHER
New York, New York
See Charters, Cann & Dunn

Silverplating firm formed by Thomas Charters and his brother William in 1856. This Thomas Charters is probably the same individual who earlier was a partner in the firm of Charters, Cann & Dunn (q.v.) The firm is initially shown with three different addresses, one of which apparently was its factory.

The following year John S. Charters, another brother, joined the firm and it became Charters and Brothers. In 1858 the firm was again listed simply as Charters and Brother in the New

York City directory, although John S. Charters was still listed as a merchant at the firm's showroom location.

Charters and Brother last appears in the New York City Directories in 1859. Neither Thomas nor William Charters are found in the directories after that point. However John S. Charters alone is listed as "plated ware" in the 1860 directory.

CHARTERS, CANN & DUNN
New York, New York
See John Cann

CHRONOLOGY
Charters, Cann & Dunn	1848-1856
Cann & Dunn	1856-1860
John Cann	1860-1863

Firm formed in 1848 by Thomas Charters, Jr., John Cann and David Dunn. (Soeffing, in Venable's *Silver in America*, 1994, biographical section p. 317) Manufacturers of solid silver holloware. Thomas Charters left the firm about 1856 and it became Cann & Dunn.

Cann & Dunn initially had their factory and salesrooms in Brooklyn at 144 and 146 Jay Street. Dunn lived at the same address. By 1858 the firm had moved to 64 Duane St., New York.

Advertisements in the Brooklyn City directories for 1856 through 1858 were illustrated with cuts depicting examples of the company's wares. The ornate vase shown in 1858 was drawn so large that it had to be placed sideways to fit the ad space. Each ad assured the public that the company "will be prepared to fulfill, as usual, all Orders from the Trade for Vases, Urns, Salvers, Pitchers, Tea and Coffee Services, Trumpets, Plates, Goblets, Cups, &c."

In their 1859 Brooklyn directory ad, Cann & Dunn advertised themselves as "Manufacturers of Sterling Silver Ware", one of the earliest firms to do so.

Cann & Dunn was known for the high quality of its products and received a number of commissions for presentation pieces.

Charters, Cann & Dunn used a mark consisting of (lion) CC&D (arm and hammer). (Soeffing, ibid.)

BENJAMIN K. CHASE
Rutland Vermont

Benjamin K. Chase was born in New Hampshire in 1831. In 1856 he is listed as a merchant of watches and jewelry in Brattleboro, Vermont. Between 1858 and 1861 he was in partnership with Charles A. Tripp under the firm name of Chase & Tripp. When the partnership dissolved, Tripp continued on in Brattleboro while Chase moved to Rutland.

After the move in 1861, Chase advertised himself as a jeweler, watchmaker and optician, selling gold and silver watches, sterling silver goods, rich gold jewelry and plated, fancy and toilet articles. In 1863 he took on Wilbur F. Parker as a junior partner. Parker kept the business going while Chase served as a Captain in the Civil War. Parker left in 1867 to go into business with B.M. Bailey (q.v.)

From 1868 to 1870 Chase was in business alone. In November 1870 he formed Ben K. Chase & Company in association with E.M. Edgerton. By 1875 Chase was again working alone. He went bankrupt in January 1877. His stock was sold at a private sale and purchased by F.H. Wheeler, who continued the business. (Carlisle, *Silver* Mar.-Apr. 1988, p.11)

ARMAND CHASSAGNE
New Orleans, Louisiana

Armand Chassagne was born about 1776 and was working in New Orleans about 1820. He made solid silver holloware. (Bacot, *Silver,* Sept.-Oct. 1986, p. 23)

JOHN CHATTELLIER
Newark, New Jersey

Manufacturer of sterling cigar, cigarette and clock cases, razor sets, jewel, match and cigarette boxes, picture frames and watch cases. Listed in KJI 1922 and 1924.

CHELTENHAM & CO., LTD.
Sheffield, England
See National Silver Co.

CHICAGO ART SILVER SHOP
Chicago, Illinois
See Art Metal Studios

The Chicago Art Silver Shop was founded by Edmund Boker (b. 1886; retired 1977) and Ernest Gould (1884-1954) in 1912. It changed its name to the Art Silver Shop in 1918, and later became Art Metal Studios.

CHICAGO MONOGRAM STUDIOS
Chicago, Illinois

Listed 1922 JC as manufacturers of sterling, 10, 12 and 14k gold buckles, belt and trouser chains. Successors to Chicago Monogram Jewelry Works. William Nicholls registered their Silvergrams trademark in 1948 and claimed that it had been in use since Oct. 23,1947. It was for monograms in the form of initials made of, or plated with precious metal, to be attached to automobiles.

CHICAGO SILVER CO.
Chicago, Illinois

Listed in business c. 1925-1950 as manufacturers of sterling silverware.

CHICAGO SILVER PLATE COMPANY
Chicago, Illinois
See Aurora Silver Plate Co.

Founded in 1868 and a year later moved to Aurora, Illinois and renamed the Aurora Silver Plate Company (q.v.)

SAMUEL CHILD & CO.
Baltimore, Maryland

Listed in Baltimore City Directories 1868-1886 as silverplaters.

CHILDS & DICKENSON
Hartford, Connecticut

Firm formed about 1841 by Lucius B. Childs and John C. Dickinson. Advertised in Geer's 1842 Hartford Directory as "Wholesale dealers in Staple & Fancy Dry Goods, Silver and German Silver Spoons, Spectacles, &c. Jewelry, Cutlery, Combs, Needles &c..." It is not clear whether the firm manufactured any of the items that it sold. Lucius B. Childs was deceased by 1844. Neither the firm nor his partner appear in the directories after 1843.

KURT ERIC CHRISTOFFERSEN
Meriden, Connecticut

Kurt Eric Christoffersen was born in Ringsted, Denmark. He began his apprenticeship with the firm of Petersen & Lassen, Goldsmiths in Copenhagen. In 1949 he graduated from the Academy of Arts & Crafts, receiving the Danish Gold and Silversmiths Guild's highest award, the Silver Medal for Excellence. He received further training with A. Michelsen, Jewelers to the Royal House of Denmark.

Upon his arrival in the United States he went to work for one of the country's finest jewelry stores to learn American tastes in Jewelry. In January 1955 he joined International Sterling Crafts Associates, a division of the International Silver Company. For them he created an outstanding collection of jewelry, candlesticks, bowls, coffee sets, trays, vases, and bar accessories, using original and imaginative designs.

Many of his jewelry designs had a special regional or topical interest. He produced pieces appropriate for both formal and casual wear and made a point of providing matching designs in men's and women's jewelry.

Unfortunately International Sterling Crafts Associates did not last much beyond the mid 1950s. The various lines were moved to the regular sterling plant of the International Silver Company. What became of Christoffersen after that time is not known. (Rainwater, *Silver,* July-Aug. 1995, pp. 10-13)

CHRISTOFLE
Paris, France

Founded in 1839 by Charles Christofle. He was the founder of the plated and gilded silverware industry of France. He bought up all the French electroplate patents then extant and started his own silver and gold plating industry.

Later he branched out into sterling and gold wares.

The company wasted no time in attempting to enter the American market . In the early 1850's the firm of Gaime, Guillemot & Co. (q.v.) served as agents for Christofle in New York. It is not clear whether Christofle continued to have an agency in New York for a time after Gaime, Guillemot & Co. dissolved about 1854.

Workmanship of the Christofle firm has always been outstanding. The firm is still considered one of the leaders in world silver design. They are currently (1986) represented in the U.S. by Christofle at Baccarat, New York.

July 9, 1949 Christolfle filed application for a trademark in the U.S. to be used on gold and sterling silver flatware and holloware.

CHURCH & BATTERSON
Hartford, Connecticut

Lorenzo Church appears in the Hartford City Directories as early as 1843 as a watchmaker. Hermon G. Batterson appears in the directories as early as 1845 listed as a clerk, but his place of employment is not given.

By 1851 the two had gone into partnership in the firm of Church and Batterson. An ad in The Hartford City Directory published in 1852 lists the company as "Dealers in Watches, Clocks, Jewelry, Silver Spoons, Forks, Cups, &c. Plated & Britannia ware, Table & Pocket Cutlery, Japanned Tea Trays, Shell, Buffalo, and Horn Combs, and Rich Fancy Goods at the lowest cash prices. Watches repaired & warranted. 194 Main St."

By 1855 Church was deceased. No further listings for Batterson or the firm are found.

CHURCH & ROGERS
Hartford, Connecticut
See Rogers Brothers

Joseph Church was born in East Hartford, Connecticut in 1794. He was raised in Lee, Massachusetts, but returned to Hartford to learn the silversmith's trade, probably as an apprentice to Jacob Sargeant. William Rogers (q.v.) served his apprenticeship under Church beginning in 1820.

In 1826 Church took Rogers into partnership with him. They produced coin silver spoons stamped CHURCH & ROGERS. William's

brothers Asa, Jr. and Simeon also worked for the firm. The partnership was dissolved in 1836 when William Rogers went into business for himself. (Rainwater, *Silver,* Jan.-Feb. 1996, pp.16-17.)

LOREY CHURCHILL
Baltimore, Maryland

Listed in Baltimore City Directories 1864-1868 as a silverplater.

CINCINNATI SILVER CO.
Cincinnati, Ohio
See O.E. Bell Co.

FREDERICK H. CLARK
Newark, New Jersey

Listed in JC 1915 as manufacturer of sterling silverware. Out of business before 1922.

GABRIEL D. CLARK
Baltimore, Maryland

Silversmith in Baltimore 1830-1896 associated with James A. Foxcroft 1831-1839 in the firm of Foxcroft & Clark. Born 1813 - died 1896.

G. D. CLARK

CLARK & BROS.
Rutland, Vermont
See H.E. Adams
See Marshall & Cady

CHRONOLOGY
Clark & Bros.	1853-1867
Clarks, Giddings & Adams	1868
Giddings & Adams	1869
Clark Bros. & Adams	1870
Clark Bros. & Marshall	1871-1872

Firm formed in 1853 by H.G. Clark, watchmaker and jeweler, formerly of Weston, Vermont, and his brother, Norman Clark, a jeweler from Ludlow. Another brother, A.W. Clark, joined them the following year. From the beginning, the firm sold fancy goods and guns in addition to their silverware.

In an 1861 ad, the firm offered an assortment of silver spoons; forks; pie, butter and fruit knives; children's mugs and salt cellars. Throughout its history the company continued to offer a general line of fancy goods and guns: Watches, Clocks, Fine Jewelry, Silver & Plated Ware, Spectacles, Cutlery, Fishing Tackle, Rifles, Shotguns, Revolvers, Cartridges etc etc. They even offered a local specialty: Rutland marble jewelry in Vermont gold.

A.W. Clark left the firm some time between 1862 and 1870, and other partners were taken into the business. S.P. Giddings 2nd and H.E. Adams joined the firm in 1868 and it became Clarks, Giddings & Adams. In 1869 the remaining Clarks left, and the firm became simply Giddings amd Adams.

When Giddings left in 1870, H.G. and Norman Clark returned to partnership with Adams, who was also joined by Albert S. Marshall, and the firm became Clark Bros. & Adams. Adams left in 1871, and the firm became Clark Brothers and Marshall. In 1873 the Clark Brothers retired for good, and Albert S. Marshall went into partnership with Ernest C. Cady. (Carlisle, *Silver,* Jan.-Feb.1988, pp. 20-22)

CLARK & NOON
Newark, New Jersey

First listed in JC as W.F. Cory & Bros., Newark, New Jersey in 1896. Clark & Noon are listed as successors in 1915 and not listed after 1922. Makers of sterling silverware and 14 and 18k gold jewelry.

BENJAMIN CLARK SILVER CO.
Ottawa, Illinois
See Benedict Mfg. Co.

CLIFF SILVER CO.
New York, New York

They advertised (*Antiques,* Nov. 1929, p. 407) that they specialized in "Reproducing by hand sterling or Sheffield Plate." The ad says "Established 1905."

CLIMAX MESH BAG CO.
Newark, New Jersey

Listed in JC in 1915. Out of business before 1922.

C.M. CLUTE & CO.
New York, New York
See T.R. Clute

Caroline M. Clute, the wife of John B.T. Clute, and mother of Theodore R. Clute first appears in the New York City directories in 1866, heading C.M. Clute & Co., platers. This company occupied T.R. Clute's original location at 52 Macdougal. In business through 1873.

John B.T. Clute, her husband, appears associated with the firm throughout its existence except for the year 1868 when he is not found in the directory.

T.R. CLUTE
New York, New York
See Case & Co.

Theodore R. Clute first appears in the New York City Directories in 1858 as a plater. However he and his parents, John B.T. Clute and Caroline Clute were living in New York as early as 1850 according to the census. Theodore R. Clute and his father both worked for the T. R. Clute firm. John B.T. Clute had appeared earlier in the New York City directories in 1855 and 1856 as a clerk.

In 1861, in addition to operating this business, T.R. Clute was also a partner in another silverplating firm, R.G. Case & Co. (q. v.)

An 1865 ad in the New York City directory reads as follows: "T.R. Clute, Silver and Gold Plating No. 52 Macdougal St., New York. Door Plates, Spoons, Forks, Castors, Tea Ware, Plumber's Work, &c. Plated in the most approved style, at reasonable prices. Old work replated."

In 1866 the firm became T.R. Clute & Co. and moved to 112 Bleecker. Not found after 1866.

J. COATSWORTH & SON
Galena, Illinois

Manufacturer, (probably simply a plater) of silverplate holloware circa 1875-1880.

COBB, GOULD & CO.
Attleboro, Massachusetts
See Wallace Silversmiths
See Watson Co.

Founded in 1874 in Attleboro, Massachusetts. Succeeded by Watson & Newell in 1894, the Watson Company in 1919 and Wallace Silversmiths in 1955.

HERBERT COCKSHAW, JR.
New York, New York

Listed in 1904 as Howard & Cockshaw; Herbert Cockshaw successor in 1915 and Herbert Cockshaw, Jr. in 1936-37 in the Jobbers' Handbook.

D.D. CODDING
North Attleboro, Massachusetts

Listed in JC in 1896 as manufacturers of sterling silverware. Out of business before 1904.

STERLING
D. D. C.

CODDING BROS. & HEILBORN
North Attleboro, Massachusetts

Codding Bros. & Heilborn were manufacturers of silver novelties, founded in 1879 in North Attleboro, Massachusetts. In 1882 their business was burned out and they erected a new factory that same year. Leo A. Heilborn was admitted to the Firm in 1891. In 1895 the members of the firm were Arthur E. Codding, James A. Codding, Edwin A. Codding and Leo A. Heilborn. C.A. Vanderbilt (q.v.) was in charge of the domestic trade office from 1893.

A note from early 1897 states that "Codding Bros. & Heilborn, Providence, incorporated for the manufacture and selling of jewelry and silverware and novelties." (JC 4-28-1897, p. 28).

An ad in The Keystone in August of 1897 gives the firm's name as "Codding & Heilborn Co." Another ad from May of that year lists some of the firms products: Chain Purses; Silk and Leather belts; Harness Buckles; Silver, Gold-Plate and Ribbon Guard Chains; Chatelaines; Belt Holders; Souvenir Spoons; Stone Links and Waist Sets. (*Silver,* May-June 1991, pp. 37-38)

The firm went out of business in May 1918.

C. B. & H.
STERLING.

COHANNET SILVER CO.
Taunton, Massachusetts

Catalog published 1896. Illustrated candlesticks, fern dishes, shaving mugs, tea sets, pickle casters with glass inserts, etc.

A. COHEN & SONS CORP.
New York, New York

Founded in 1911 by Hyman J. Cohen, Samuel Cohen, Harry Cohen and Abraham Cohen. They are the largest wholesale jewelry distributors in the world catering to the retail jewelers. A division of Cohen-Hatfield Industries, Inc. Wholesalers of sterling and silverplated holloware and flatware which is produced under contract for them.

CROSBY KRANSHIRE

L.H. COHEN
New York, New York

Listed in the Jeweler's Weekly 1896 as manufacturers of sterling silverware. Listed in JC 1904. Succeeded by L.H. Cohen Co., Inc. between 1909-1915 . Last listing was in 1922.

COHEN & ROSENBERGER
New York, New York

Listed in JC as Baldwin, Ford & Co. 1896; Ford & Carpenter in 1904 and Baldwin, Ford & Co. 1915-1943. Advertised imitation pearls, novelty jewelry and beads. Listed in sterling silver section until 1943.

S. COHEN & SON
Boston, Massachusetts

A jobbing concern that specialized primarily in plating about 1856.

J.J. COHN
New York, New York

Listed in Jewelers' Weekly,1896, in sterling section. Also listed in JC 1896, leather goods.

L. COHN
Baltimore, Maryland

Listed in 1868-69 Baltimore City Directory as a silverplater.

JOHN A. COLE
New York, New York

John A. Cole appears in the New York City directories listed as a silversmith at least as early as 1852. With the exception of 1855, he appears continuously through 1858. Most of this time his shop was located at 8 Liberty Place. Not found after 1858.

WILLIAM H. COLE & SONS
Baltimore, Maryland

Listed in 1895 Baltimore City Directory. Advertised plated silverware.

ALBERT COLES & CO.
New York, New York

Albert Coles was born in 1815. By 1835 he had established his silversmithing business, which focussed on the production of flatware. However the firm also manufactured a variety of holloware items, including cups, goblets, napkin rings, snuff and tobacco boxes, matchboxes, portmonnaies, bouquet holders, children's rattles, nutmeg graters, and coffin plates.

A specialty of the firm from early on was the production of various forms of hollow handled knives with silver blades. Coles received a gold medal for his knives from the American Institute at several annual exhibitions. (Soeffing, in Venable's *Silver in America*, 1994, biographical section, p. 317)

Coles sold his own silver retail at his factory at 4 and 6 Liberty Place as well as wholesaling it to other retailers.

At various times other family members worked for the business. His son, Albert L. Coles, was part of the firm. His nephews, Gilbert E. Coles of Coles & Reynolds (q.v.) and William L. Coles of Coles & Vancourt (q.v.) trained in his factory and were employed by him at various points during their careers. (Soeffing, ibid.)

In 1877 the machinery, tools, fixtures and stock of Albert Coles & Co. were sold to a firm called Montgomery & Co. This firm was composed of Samuel Montgomery, a former salesman for Albert Coles, and Morgan Morgans, Jr., (q.v.) his financial backer. By 1878 Morgan Mor-

gans, Jr., had taken control of the company. The business was not financially successful, and by 1883 it had been sold to George Shiebler. (Soeffing, ibid, p. 321)

Coles' spoon designs were continued by the Shiebler company for many years, some of them being quite popular as late as 1895.

From 1880 until his death November 27,1885, Coles was listed only at his residence, 225 West 39th St.

COLES & REYNOLDS
New York, New York
See A. & W. Wood
See George Shiebler

Firm formed by Gilbert E. Coles and David I. Reynolds about 1872, according to the New York City directories. Coles & Reynolds succeeded to the solid silverware business of A. & W. Wood (q.v.) and initially occupied the same business location at the corner of Franklin and Elm. Gilbert Coles may originally have operated the business by himself in 1871, as the New York City directory for that year shows Coles at the Franklin and Elm address and the Woods gone, but no sign of Reynolds. In 1874 the firm changed its address to 23 Maiden Lane.

The partnership was bought out by George Shiebler (q.v.) on March 4, 1876, when he decided to start his own silverware manufacturing business. (Soeffing, *Silver,* July-Aug. 1990, p. 11)

COLES & VANCOURT
New York, New York
See James S. Vancourt

In 1848 William L. Coles, a nephew of Albert Coles (q.v.), and James S. Vancourt formed a partnership that lasted until 1852. They produced a general line of flatware, specializing in hollow handled knives for butter, fruit, and dessert. (Soeffing, in Venable's *Silver in America,* 1994, biographical section, p. 322)

C&V

COLONIAL SILVER COMPANY, INC.
Portland, Maine

Successor to the Stevens Silver Co. in 1899. They were manufacturers of plated silverware and pewter. Gold and silver and nickel plating done to order. In business until 1943.

Plated Holloware *Nickel Silver Holloware*

On White Metal *White Metal Holloware*

COLUMBIA MFG. CO.
Gowanda, New York

An 1892 account states:"The Columbia Mfg. Co. of Gowanda, New York has been incorporated with a capital stock of $15,000 for the purpose of manufacturing plated ware. The company will at once begin constructing a factory." (JW 6-1-1892)

COLUMBIA SILVER CO.
Location unknown

Mark found on a silverplate syrup pitcher dated circa 1890-1910.

COLUMBIA SILVER CO.
Brooklyn, New York

Listed 1957-61 JBG as manufacturers of silver.

COLUMBIA SILVERSMITHS
New York, New York

Listed 1957-61 as manufacturers of silver.

COMMONWEALTH SILVER CO.
Los Angeles, California

Manufacturers of sterling silverware 1905-c.1920.

CONCORD SILVERSMITHS, LTD.
Concord, New Hampshire
See Ellmore Silver Co., Inc.

Began as Concord Silver Co. in 1925 using the old Durgin factory. In 1939 a new concern was organized under the name of Concord Silversmiths, Ltd., and bought the plant, machinery, tools of the Concord Silver Co., then in bankruptcy. They were to manufacture heavy sterling flatware only. In September of 1942 they discontinued the manufacture of sterling for the duration of the war. Ellmore Silver Co. took over the business and produced their patterns. Dies purchased by Crown Silver Co.

J. CONNING
Mobile, Alabama

Born in New York in 1813, James Conning was working as a silversmith in New York City in 1840. Shortly thereafter he left New York and moved to Mobile, Alabama, where he opened a shop in 1842. Mobile was the only port and the financial center of the state, making it an excellent place to sell luxury goods, of which he handled a general line. By 1850 he employed his nephew William from New York. In succeeding years William V. Moore, Jacob Fraser, his own son William, James M. Williams and his brother-in-law, John Pippen, also went to work for him.

Conning is believed to have both made and sold large quantities of silver articles. However, because much of what he sold was manufactured by Wood & Hughes (q.v.), some speculate that he was simply a retailer. But Cormany (*Silver,* Jan.-Feb. 1993, p. 11) cites hand made fiddle handle flatware, and hand chased holloware in the form of cups, pitchers and tea sets that bear only the mark "J. Conning, Mobile" as evidence for him being a manufacturer.

With the outbreak of the Civil War in 1861, Conning drastically reduced his silver and jewelry production and expanded his facilities for manufacturing swords which he sold to the Confederate government. Federal Government blockades soon reduced his supply of steel, and though he could sell swords as fast as he could produce them, his total output was probably small.

When the war was over, Conning returned to the jewelry business, and resumed his ties with Wood & Hughes. He apparently no longer made handwrought silver. When he died in 1872 his brother-in-law James Pippen took over the business and operated it until about 1880. (Cormany, *Silver,* Jan.-Feb. 1993, pp. 10-13)

CONTINENTAL MFG. CO.
New York, New York

Listed 1927 KJI as manufacturers of silverplated flatware and holloware.

CONTINENTAL SHEFFIELD SILVER CO.
Brooklyn, New York
See Continental Silver Co.

CONTINENTAL SILVER CO.
New York, New York

The Continental Silver Co. of New York and the Continental Sheffield Silver Co. are related. The former being the sales office of the latter. Listed as manufacturers of plated silver holloware on nickel silver base c. 1920 to 1950.

JOHN COOK
New York, New York
See Theo. Evans & Co.
See Philo B. Gilbert

John Cook worked as a foreman for Wm. Gale & Son (q.v.) until 1855. He then entered into partnership with Theodore Evans, who had been a salesman for the same firm, to form Theodore Evans & Co. (q.v.) In 1864 Theodore Evans & Co. changed its name to Evans & Cook when Jas. E. Johnson joined the partnership. Evans retired in 1868 and John Cook went into business on his own.

In early 1868 Philo B. Gilbert (q.v.) went into bankruptcy. Cook apparently bought up Gilbert's dies and continued their use. He remained in business through about 1880. George W. Shiebler (q.v.) appears to have later acquired the rights to Gilbert's mark. (Soeffing, *Silver Medallion Flatware,* 1988, p. 48)

In 1869 John Cook received Design Patent No. 3,384 for "Table-Set for Silver and Plated Ware".

P.A. COON SILVER MFG. CO.
Syracuse, New York

Manufacturers of plated silverware. Successor to Albert G. Finn Silver Co. between 1904 and 1909. Out of business before 1915.

FRANCIS W. COOPER
New York, New York

Although a small manufacturer, Francis W. Cooper produced a wide variety of solid silver holloware and flatware items between 1842 and 1891. Many of his pieces were sold through major retailers, such as Ball, Black & Co. and Tiffany & Co. Such pieces frequently bear only the retailer's mark, which may explain why pieces marked as his are seldom found today. Fancy presentation goblets, cups, and ecclesiastical plate are the identifiable items most likely to be seen. (Soeffing, in Venable's *Silver In America* ,1994, biographical section, p. 318)

Between 1855 and 1862, according to the New York City directories, Richard Fisher served as his partner. Fisher's son, Richard, Jr., also worked briefly in the shop. Fisher was a retired jeweler, and apparently provided the capital for the operation while Cooper did the practical work.

A disastrous fire late in 1890 lead to the closing of the business. (Soeffing, ibid.)

In an ad in the 1865 New York City directory, Cooper lists himself as a "Silver & Goldsmith, Manufacturer of Silver Ware, Waiters, Pitchers, Tea-Sets, and Communion Service; also Cups, Napkin Rings, Ladles, Spoons and Forks."

COPELAND & BEIDERHASE
New York, New York
See Beiderhase & Co.

Partnership of Robert Copeland and Bernard D. Beiderhase lasting from about 1851 through 1856. Copeland & Beiderhase manufactured solid silver holloware. An advertisement in Trow's New York City Directory published in 1853 describes the firm as "Manufacturers of tea sets, cups, &c."

After the partnership dissolved, Copeland continued in business by himself through about 1860. He is not found in the New York City Directories after that date.

J. CORDUAN & BRO.
New York, New York

CHRONOLOGY

J. Corduan & Bro.	?1852-1858
B. Corduan	1859-1861

The firm of J. Corduan & Bro. appears in the New York City Directories at least as early as 1852 listed as silverplaters. Joseph and Benjamin Corduan were the partners. Joseph

Corduan had left the firm by 1859. Benjamin Corduan continued the business at a new location through 1861. Succeeded by J.W. Robinson.

JULIUS CORNELIUS
Halifax, Nova Scotia, Canada

Julius Cornelius was born in Prussia in 1825 and won a prize for design at the Berlin Art School. After serving an apprenticeship with a manufacturing jeweler named Rhode, he travelled extensively. He worked for Tiffany & Co. in New York in 1853 and 1854, and settled in Halifax in 1855.

Widely regarded as one of the finest craftsmen in Canada, he and his workmen were particularly noted for making exquisite jewelry from Nova Scotia Gold set with precious gems.

In 1905 Cornelius decided to retire, and turned his business over to his son, Herman Cornelius, who established the firm of Cornelius & Co. Julius Cornelius died in 1916. (Unitt & Worrall, *Unitt's Book of Marks*, 1995, p.15)

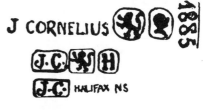

CORNELIUS & COMPANY
Philadelphia, Pennsylvania

Christian Cornelius, born in the Netherlands, arrived in Philadelphia in 1783. He began working as a silversmith in 1810, became a silver plater and patent lamp manufacturer in 1825 and later operated under the name of Cornelius & Company. He left a dynasty of lampmakers who worked late into the 19th century. One of their c.1875 catalogs shows that they were influenced by the Gothic Revival designs of Charles Eastlake.

In 1857 in the *Annals of Philadelphia,* John F. Watson wrote that, "Mr. Cornelius now makes the most elegant mantel and hanging lamps; his manner of succeeding in that, and in silverplating, is a very curious history, and would deserve to be told at great length."

CORONET SILVER CO., INC.
Brooklyn, New York

Manufacturer of silverplated wares c. 1950.

CORONET

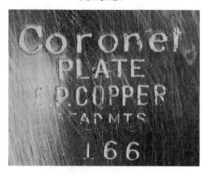

CORTLAN & CO.
Baltimore, Maryland

Listed in Baltimore City Directories 1868-1870 as silverplaters.

W.F. CORY & BRO.
Newark, New Jersey
See Clark & Noon

 STERLING.

Not used after 1904

COSMOPOLITAN SILVER CO.
New York, New York

Listed KJI 1922 and 1924 as manufacturers of silverplated holloware. Their ad in the 1922 KJI offers, "Newest designs in Sheffield Hollow Ware plated on copper. Exceptional values that will stimulate silverware sales. Original Designs, Fine Workmanship, Unsurpassed Quality. Jobbing Trade Sold Exclusively."

S. COTTLE CO.
New York, New York
See Hale & Mulford
See Howard Sterling Co.

CHRONOLOGY
Lewis J. Mulford	1865-1870
Mulford & Co.	1871-1872
Mulford, Hale & Cottle	1873-1877
S. Cottle Co.	1877-1920

Although S. Cottle Company claimed to have been in business since 1865, that date actually refers to the founding of the firm's prede-

cessor, the jewelry business of Lewis J. Mulford. According to the New York City directories, Shubael Cottle joined Mulford & Co. in 1872. By 1873 Seth W. Hale had joined the firm, and it became known as Mulford, Hale & Cottle.

Shubael Cottle left the partnership to form S. Cottle Co. in early 1877, shortly before a disastrous fire destroyed the Waltham building in which the remaining partnership, Hale & Mulford, was located. (Cramer, *Silver,* May-June 1991, p. 33)

He obtained Invention Patent No. 237,823 for a die for making bracelets on February 15, 1881.

Cottle also invented a machine for making a collar button which became the specialty of Howard & Son about the same time.

An 1894 account describes the firm as "S. Cottle, manufacturer of paper knives, pen trays, penwiper stands, letter files, candlesticks, mounted inkstands in sterling silver, etc. ..." (JC&HR 2-4-1894, p. 4)

In 1911, S. Cottle Company advertised "Fashionable Novelties in Gold & Silver": "...Bags, Vanity Cases, Chatelaines, Card Cases, Cigarette Cases, Puff Boxes, etc. ..." in the Jewelry Buyer's Guide. (Cramer, ibid.) The same advertisement lists the company's officers for that year as I. N. Levinson, President and H.S. Morris, Secretary and Treasurer. The firm is not found after 1920.

M.A. COURTRODE
New York, New York

Listed JKD 1918 as silversmiths.

COWLES MFG. CO.
Granby, Connecticut
See International Silver Co.
See Rogers Brothers

Rev. Whitfield Cowles began silverplating in 1843. After he died his son, William B. Cowles, continued the experiments. In 1845 the Cowles Mfg. Co. was organized with Asa Rogers, James H. Isaacson and John D. Johnson. They used German silver as the base for their silverplated wares. In business only a few years.

The Cowles' business led to the first real development in commercial silverplating in this country.

ROYAL COWLES
Cleveland, Ohio

Royal Cowles set up shop as a silversmith in the 1840s. In 1849 he took Joseph R. Albertson of Fellow, Wadsworth & Co., of New York into partnership. This partnership lasted for nine years after which each set up his own business; the jewelry firm of Cowles & Company being formed in 1857. The other member of the firm was Homer Goodwin. Cowles continued in business until 1889 when he moved to New York City. He died there in 1897.

Royal Cowles was the son of Ralph Cowles who was a well known surveyor and county auditor. Some confusion has arisen, presumably because father and son had the same initials and the same address. William G. Rose, in his history of Cleveland substantiates that the silversmith's name was Royal, not Ralph.

About 1861 George Cowell and his son, Herbert, started a jewelry business, H. Cowell & Co., and took over the business of Royal Cowles. In this way, one of Cleveland's largest and most exclusive jewelry stores had its beginning in the business of one of the city's early silversmiths.

W.I. COWLISHAW
Boston, Massachusetts

Cowlishaw was in business at least as early as 1898 and was known especially for his pewter reproductions of early pieces which were made by the traditional methods of casting and spinning.

He was succeeded by Morton Wheelock c. 1930. Wheelock continued to use the Cowlishaw name but changed the mark to a shield with the name enclosed. He made newer forms rather than reproductions and continued the business until the 1940s. Pieces marked with small circular mark with initials "W.I.C." and an eagle. (Used c. 1898-1930)

Used ca. 1930 - ca. 1940-45

COYWELL SPECIALTY CO.
New York, New York

Listed in 1915 JC as manufacturers of sterling silverware. Out of business before 1922.

COYWELL
PLATNOID

CRAIG SILVER CO.
Bridgeport, Connecticut

An 1894 account states: "A concern operating under the name of Craig Silver Co. has been in existence in Bridgeport for some time." (JW 6-6-1894)

The firm manufactured German silver flatware.

CRAIGHEAD SILVER PLATE CO.
Bridgeport, Connecticut

An 1895 account states, "The report of the receiver is that employees of the defunct concern received only 7 percent of the money they earned." (JC&HR 12-4-1895, p. 19)

CRESCENT SILVERWARE MFG. CO., INC.
Port Jervis, New York

Founded in 1922 in New York City. Moved to Port Jervis, New York in 1939. Manufacturers of silverplated holloware and during their early years also made pewter and chrome-plated items. Since about 1935 they have made only silverplated holloware. Later they manufactured about 450 different items. They took over the Knickerbocker Silver Co.

Sold to Samuel Kirk & Son. Inc. in 1977.

CRESCENT

CROMWELL PLATE CO.
Cromwell, Connecticut
See Barbour Silver Co.
See I.J. Steane & Co.

Organized in 1881 to manufacture a variety of silverplated wares. In that same year John A. Eades received three Invention Patents, No. 246,377 for a butter dish, No. 246,668 for a jewel casket and No. 248,090 for a covered dish, all of which he assigned to the Cromwell Plate Co.

Sold to I.J. Steane & Co. before 1885.

CROSBY
See A.H. Cohen & Sons, Corp.

SAMUEL T. CROSBY
Boston, Massachusetts

CHRONOLOGY

Crosby & Brown	1849-1853
Samuel T. Crosby	1854-1859
Samuel T. Crosby & Co.	1859-1861
Crosby, Hunnewell &	
Morse(Henry D.)	1861-1864
Crosby & Morse	1864-1869
Crosby, Morse & Foss(Charles M.)	1869-1875
Crosby & Foss	1875-?

According to an 1856 report, Samuel T. Crosby succeeded Obadiah Rich in 1849. The early firms prior to the 1860s appear from their advertisements to have been manufacturers of silverware. By the early 1860's the firms' status as manufacturers is in doubt. Later advertisements suggest that the company became a general retail jeweler. (Soeffing, in Venable's *Silver in America,* 1994, biographical section, p. 318)

CROWN MFG. CO.
North Attleboro, Massachusetts

Listed in 1915 JC as manufacturers of plated silverware. Out of business before1922.

C. M. C.

CROWN PLATE CO.
Boston, Massachussetts
See Standard Silver Ware Co.

Name used by the Standard Silver Ware Co. on its triple plated flatware.

CROWN SILVER CO., INC.
Brookline, Massachusetts

Listed 1936-37 Jobber's Handbook and 1950 JC-K as manufacturers of platedwares.

CROWN SILVER INC.
New York, New York

The Hasselbring Silver Company, founded in Brooklyn about 1890 by John Hasselbring; the Revere Silver Company, successor to Revere Silversmiths Inc., founded in Brooklyn about 1914 and the Wolfenden Silver Company, successor to J.W. Wolfenden Corporation became divisions of Crown Silver Inc. in 1955. Manufacturers of sterling silver wares. They own the dies of Amston Co. and bought the F.M. Whiting Co. dies for sterling flatware when the Ellmore Silver Co. went out of business in 1960.

CROWN SILVER PLATE CO.
Bristol, Connecticut
See American Silver Co.

CROWN SILVER PLATE CO.
New York, New York
See J. W. Johnson

An 1898 account states: "There is no longer any Crown Silver Plate Co. but J.W. Johnson stamps this name on plated silver ware." (JC&HR 4-17-1898, p. 23)

CROWN SILVER PLATE CO.
Toronto, Ontario, Canada

Listed in JC 1909-15. Out of business before 1922. Larger mark from Unitt & Worrall, *Unitt's Book of Marks*, 1995, p. 43.

H.C. CULMAN
Honolulu, Hawaii

Listed JC 1909. Out of business c. 1919. Manufacturing jewelers. Trademark found on Hawaiian souvenir spoons.

H. C.

J. F. CURRAN & CO.
New York, New York
See E. P. Bray & Dauchy

John F. Curran began his silverplating career as a clerk for E. P. Bray and Dauchy about 1858 and remained with that firm for the next few years as it underwent various name changes. About 1865 he formed J. F. Curran & Co. In the 1865 New York City Directory this firm is listed as "Manufacturers and Importers of Fine Silver Plated Ware, Including Tea Sets, Urns, Salvers, Cake Baskets, Sugar Baskets, Casters, Butter Coolers, Cups, Goblets, Ice pitchers, Salt Cellars, Gravy Boats, Spoons, Forks Etc." Not found in the directory in 1874. Not followed beyond that date.

Butter Dish with Rotating Cover marked J.F.Curran & Co. c. 1870. Note the unusual swan head knife rests and openwork band decoration on the base. The openwork band base was a highly impractical design feature as it was easily damaged. Manufactured "in the metal" by Reed & Barton. (Photo by Judy Redfield)

CURRIER & ROBY
New York, New York
See Elgin Silversmith Company

Currier & Roby, New York silversmiths, was headed by Ernest M. Currier. It was founded in 1900 when Currier was 33 years of age. It was incorporated in 1901. They specialized in the reproduction of antique silver holloware and flatware, mostly English and American. Currier was also the author of *Marks of Early American Silversmiths,* published posthumously, two years after his death in 1936.

Currier & Roby succeeded in George A. Henckel & Co. (q.v.) in 1940 and they, in turn, became a division of Elgin Silversmith Co., Inc. (q.v.) which went out of business in 1976.

There are in existence a number of small sketches that are dated as early as 1895 but are believed to have been done by Currier since Roby was chiefly a silversmith and not a designer. It is possible that Currier and Roby met as early as 1885 when Currier would have been only 18 years old, and possibly served his apprenticeship as a designer. Roby was 23 years old and already a silversmith foreman.

Harry E. Roby was born at Concord, New Hampshire on June 6, 1862, son of Harrison A. Roby and Sophronia (Sarbent) Roby. He was apprenticed to William B. Durgin (q.v.) and then en-

tered the employ of J. B. & S. M. Knowles (q.v.) and later the Van Sant Co. (Vansant) (q.v.) of Philadelphia. In 1885 he moved to Newburyport, Massachusetts as silversmith foreman for A.F. Towle & Son Co. (q.v.) where he remained until 1890. That year he became superintendent of the Wendell Mfg. Co. (q.v.) of Chicago where he remained until 1900. For a short time he was head of the sample making department of the Towle Mfg. Co. (q.v.) of Newburyport, Massachusetts and in 1901 with E.M. Currier established Currier & Roby in New York to make sterling holloware.

Currier was an authority on early American silver and had one of the largest collections of marks in the United States. His collection of record drawings of antique silver along with his photograph collection was also the largest known outside of the large museum collections.

The United States Amateur Championship Golf Trophy, made about 1925 for the U. S. Golf Association, is considered Currier's masterpiece. The design was inspired by the classical period of the Renaissance, a high standing urn made entirely of 18k gold. After the completion of Currier's drawings for the trophy, someone tampered with the design, an action which met with his disfavor. It was with much reluctance that he completed the project and after it was finished, the shop drawings, molds, patterns and templates disappeared from the shop. Their only record is an 8" x l0" black and white photograph. The trophy itself is in the museum vault of the U.S. Golf Association in New Jersey and recently was used in the competition each year, photographed with the winner and returned to the vault. It is now permanently on display in the museum Golf House.

Currier & Roby Trademarks: (a) Trademark used on all silver and gold articles made by Currier & Roby. (b) Probably C&R original trademark used when organized in 1901. We recall this C&R mark with lion's head within broken rectangle drawn by hand on early working drawings of that date. (c) Typical art-deco hand drawn ornament (one of several designs) as used on the front cover of 4x6 promotional booklets by Currier. (d) Signature of E.M. Currier occasionally found on the back of sketches, sometimes accompanied by a rubber stamp of Currier & Roby, Silversmiths, with address. (e) Trademark used on copyright 5x7 promotional quatrefoil folders by Currier. (Silver, May-June 1983, by permission)

CURTIN & CLAKE HARDWARE CO.
St. Joseph, Missouri

Listed in JC 1909-22 as silverplaters.

JAMES CURTIS
Chicago, Illinois

Listed in 1854-1855 Chicago Directory as a silverplater.

STEPHEN CURTIS, JR.
New York, New York
See Edwin H.Rowley
See Shields & Casey
See Yale & Curtis

CHRONOLOGY

Yale & Curtis	? before 1852-1866
Curtis & Co.	1867
Stephen Curtis, Jr., & Co.	1868
Stephen Curtis, Jr.	1869-1870
Shields & Casey	1871-1872
Curtis & Rowley	1873-1874+?

Stephen Curtis, Jr. was in partnership with Henry A. Yale in the britanniaware business from at least as early as 1852 through 1866. When Yale left the business, it became Curtis & Co. in 1867. In 1868 it was Stephen Curtis, Jr., & Co. In 1869 and 1870 the firm was known simply by the name of Stephen Curtis Jr. During this period the company is listed in the New York

(a)

(b) STERLING

(c)

(d)

(e)

City directories variously, as dealing in britanniaware, metals and plate.

In 1871, the silverplating firm of Shields & Casey (q.v.) moved to the location of Stephen Curtis, Jr., at 90 Fulton and 45 Gold, and set up business there. Stephen Curtis Jr. may have worked for Shields and Casey as he is still listed at the same address during this time. Edwin H. Rowley joined the business then as well.

Shields and Casey is not found in the New York City directories after 1872. Curtis and Rowley formed a partnership and continued in the plated goods business at the same address. Casey apparently was still with the firm in 1873, but is not found in 1874. Curtis & Rowley continued in business at least into 1874. The firm has not been followed beyond that date.

F. CURTIS & CO.
Hartford, Connecticut
See American Sterling Co.
See Curtisville Manufacturing Co.
See Williams Bros. Mfg. Co.

Frederick Curtis first appears in the Hartford directories in 1842, listed as a silversmith with his own shop location. The following year he is listed as a silversmith, but no shop location is given, suggesting he was working for someone else. Between 1844 and 1848 he had his own shop and was listed as a manufacturer of German silverware, spoons and spectacles.

His brother Joseph F. Curtis also appears in the directories first in 1842 listed as a silversmith, but no shop location. He continued to reside in Hartford, but the only other listing of his occupation prior to 1848 occurred in 1844, when it appeared as "plated ware" at 1 Asylum, his brother's business address.

Although the first notice of the partnership of the brothers as F. Curtis & Co. is reported to have appeared January 24, 1848, the City Directory, compiled later in that year, still lists the company name as simply F. Curtis. The appearance of a typical detailed introductory ad in conjunction with the first listing of F. Curtis & Co. in 1849 suggests that the firm may have been formed later than previously reported.

According to the 1849 listing, F. Curtis & Co. were "Manufacturers of German silver and fine silver plated goods, Spoons, Forks, Butter Knives, Castors, Spectacles, Spec. Cases, Tobacco Boxes, Silver Spectacles &c. Wholesale dealers in sewing silk, ivory combs &c."

Company offices and presumably showrooms were located at Hartford while manufacturing operations took place at Curtisville-that section of Glastonbury (at that time spelled Glastenbury) which today comprises a part of Naubuc. By 1857 the locale was called Curtisville and had its own postmaster. "The Memorial History of Hartford County" states that at Curtisville was manufactured the first German Silver in America. The silver-white metal, an alloy of copper, zinc and nickel, was hauled by wagon to Waterbury and there rolled to the desired thickness *(Retrospect,* A publication of the Historical Society of Glastonbury, No. 10, Feb. 1948.)

F. Curtis & Co. continued to maintain its offices in Hartford into 1858, and continued to be listed as a manufacturer. Previously the firm was reported to have become the Curtisville Manufacturing Co. in 1854. While the two firms were definitely associated in some fashion, apparently sharing the same office space, they appear to have remained distinct entities into 1858. F. Curtis & Co. and the Curtis brothers are not found in the Hartford directories after that year.

H.H. CURTIS & CO.
North Attleboro, Massachusetts

The earliest record found was a Patent Office registration of the trademark in the name of Curtis and Wilkinson, November 3, 1891 to be used on jewelry, table and flatware. The company was sold at auction in May 1915.

Note that the trademark is similar to those of the W.H. Glenny & Company and the Waldo Foundry.

TRADE MARK

STERLING.

H. H. C. CO.
(German Silver Bags.)

CURTIS & DUNNING
Burlington, Vermont

Lemuel Curtis and Joseph N. Dunning advertised that their "silver spoons are made from crowns, without the least alloy." In partnership 1822-32.

CURTISVILLE MFG. CO.
Glastonbury and Hartford, Connecticut
See American Sterling Co.
See F. Curtis & Co.
See Williams Bros. Mfg. Co.
See Thomas J. Vail

The Curtisville Mfg. Co. was organized on July 1, 1854 with Charles Benedict as President and R. F. Fowler, Sec. and Treas. Although pre-

viously reported as the successor to F. Curtis & Co. in that year, the two firms, at least into 1858, continued to maintain their separate existence. Benedict and Fowler remained the company's officers throughout this time.

By 1859 the Curtisville Manufacturing Co. had been purchased by another group of investors, lead by Thomas J. Vail who became the new president. J.T. Carpenter served as Secretary & Treasurer. The Board of Directors consisted of Thomas J. Vail, Henry French, William B. Smith, Joseph A. Veazie and Geo. H. Fox.

In the early 1860s the firm advertised itself as "Manufacturers of SILVER PLATED GOODS in great variety: including the latest styles of Spoons, Forks, Ladles; Pie Cake and Ice Cream Knives; Tea Sets, Casters, Cake Baskets, Communion Sets, Cups, Goblets, Waiters, Soup Tureens, Vegetable Dishes &c. &c. Plated on the best quality of metals and *warranted full weight of silver*. Also German Silver, Plated and Steel Framed *Spectacles* of all kinds. Also Spectacle Cases and Tobacco Boxes."

By 1864 Curtisville had become known as Naubuc and Thomas J. Vail had a new interest, manufacturing arms. He became President of The Connecticut Arms Co. and Veazie became its Treasurer, a new man, George T. Thompson became secretary of the arms firm. Thompson also became President of the Curtisville Manufacturing Co. The rest of the officers and directors of the silverplating company remained the same.

The Curtisville Manufacturing Co. is last found in the Hartford Directory published in 1865, but it may possibly have continued operations in Naubuc for a time.

Thomas J. Vail is listed under his own name in the Hartford Directories as a manufacturer of German Silver and plated ware in 1868, but whether this operation is directly related to the Curtisville Manufacturing Co. is unclear. Vail's business was purchased by the American Sterling Co.(q.v.) in 1871.

D

DAMAKS REFINING CO.
New York, New York

Manufacturers of sterling holloware c. 1950.

JOHN DANFORTH
Hartford, Connecticut

CHRONOLOGY

John Danforth	1841
Danforth & Hollister	1842
John Danforth	1843
Danforth & Brewer	1844-1845

John Danforth first appears in the Hartford city directories as a jeweler in 1841. By 1842 he had gone into partnership with Gilson D. Hollister. They described themselves as "Dealers in Clocks, Watches, Jewelry, Fancy Goods, Spoons, &c. also manufacturers of Gold & Silver spectacles." In 1843 Danforth was on his own again, but using the same advertisement.

In 1844 he went into partnership with Samuel Brewer. The new firm no longer advertised as manufacturers. Instead the business was described as "dealers in Clocks, Watches, Jewelry, Fancy Goods, Silver and plated spoons, Gold & Silver Spectacles &c." Not found after 1845.

THE DANFORTH COMPANY
See Merwin-Wilson Co., Inc.

DANIEL AND ARTER GLOBE NEVADA SILVER WORKS
Birmingham, England

The Daniel and Arter Globe Nevada Silver Works produced great quantities of flatware bearing their trademarks and various tradenames which included the word "silver." These terms refer to alloys, none of which contain any silver, though some were plated with it.

ALUMINUM SILVER
ARGENLINE
BURMAROID
INDIAN SILVER
JAPANESE SILVER
LAXEY SILVER
NEVADA SILVER

DART CRAFTSMAN CORP.
New York, New York

Manufacturers of silverplated novelties c. 1950.

DAUCHY & JAQUES
New York, New York
See Bray, Dauchy & Jaques

Silverplating firm formed January 1, 1861, as successor to Bray, Dauchy & Jaques, by Samuel T. Dauchy and William L. Jaques.[1]. Not found in the New York City directory compiled in 1862.

The item noted above references the R. G. Dun & Co. Collection, Baker Library, Harvard University Graduate School of Business Administration. Volume and page number are given below.
[1]NYC Vol. 324, p. 916

HENRY DAVID
New York, New York.

Henry David is reported to appear as early as 1846 in the New York City directories according to an article in *Silver,* Jan.-Feb. 1993, p. 35. From at least 1852 through 1863 he apparently had his own shop and is listed in the directories variously as "silver", "silversmith", and "knives".

From 1864 through 1867 he is still listed as "silver" or "smith" without a shop location, suggesting that at that time he was working for someone else. Only a home address is given for 1868. He is not found in 1869 and 1870. In 1871 he re-appears in business at 38 White, apparently working for Kidney & Johnson (q.v.) In 1872 and 1873 only a home address is listed. Not found in 1874.

A. DAVIS CO.
Chicago, Illinois

Successors to M.C. Eppenstein & Co. before 1904. Out of business shortly afterwards.

R. COIN **R. SPECIAL**

R. DAVIS
New York, New York

Robert Davis' business is listed as "housefurnishings" in Trow's New York City directory published in 1856. In Mason's Business Directory published that same year he lists himself as: "R. Davis, Manufacturer & Dealer in Plated Ware of every Kind & Variety". Not found in 1857. In 1858 there is a listing in Trow's Directory for Robert Davis as "housefurnishings" with a different address. Not found further.

DAVIS & GALT
Philadelphia, Pennsylvania

Registered U.S. Trade Mark Patent No. 22,275, January 3, 1893 for manufacture of sterling silverware. Patent Office records show this trademark in use since July 21, 1888. Listed in JC 1896-1915. Out of business between 1915-22.

Junius H. Davis and Charles E. Galt first listed in 1889 as Davis & Galt in the Philadelphia City Directory. In 1887 and 1888 the Directories list Junius H. Davis as a silversmith with no associate. The 1880 Directory lists Hamilton & Davis (Matthew F. Hamilton and Junius H. Davis) as silversmiths.

An 1894 note states,"Davis & Galt have dissolved partnership." (JC&HR 5-30-94, p.30)

In 1896 came another note,"Wm. Linker of Davis & Galt has returned from a successful business trip." (JC&HR 3-4-96 p. 25) Apparently, the company itself continued for some time after the partnership was dissolved. Charles E. Galt was related to the Galt family (See Galt & Bro.) in Washington, D. C. He was mentioned in a Dec. 19, 1902 newspaper item about the Washington Galts as being deceased. Junius H. Davis was associated with M. F. Hamilton in the firm of Hamilton & Diesinger.

JAMES J. DAWSON CO.
New York, New York

Listed in JC 1904 in plated silverware section. Out of business before 1915.

NORTH AMERICA

DAWSON COMPANY MANUFACTURERS
Cleveland, Ohio

Organized in the middle 1920s by Irwin H. Dawson to make fraternity, school, and other special pattern jewelry and allied products. These include plaques, pins, emblems, medals, trophies and some other items of sterling silver, gold plate and other metals. Sterling silver plaques with crests and trademarks thereon are one of their specialties.

DAY, CLARK & CO.
Newark, New Jersey
New York, New York

Manufacturers and distributors of sterling and jewelry. The trademark was first used in 1895. Last record found was 1935.

E. L. DEACON JEWELRY CO.
Denver, Colorado

Listed in JC 1909; Eugene L. Deacon, successor before 1915 with address given as Los Angeles, California.

E. L. D.
(Souvenir Spoons.)

DECOREX INDUSTRIES, INC.
Meriden, Connecticut

Formed by the merger of the Rockwell Silver Co. (q.v.) and Silver City Glass Co. April 19, 1978. Manufacturers of sterling silver decorated crystal items.

I. N. DEITSCH
New York, New York

Listed in JC 1904—15 as manufacturers of sterling silverware. No records after c. 1920.

DEITSCH BROS.
New York, New York

Patent office records show they were manufacturers of leather articles with sterling silver mountings, September 8, 1896. Listed in JC 1896-1922.

DELAWARE SILVER CO.
Location unknown

Found on grape design sterling and plated flatware of c. 1895-1900.

DELAWARE SILVER CO.

DELLI SILVER PLATE
San Francisco, California

Succeeded by Leonard Silver Mfg Co. 1974.

CHIP DeMATTEO
Woodbridge, Virginia

Chip deMatteo is a third generation silversmith, son of William L. deMatteo (q.v.) and grandson of William G. deMatteo (q v.). Born in 1955, he was working in silver by the age of eight under the guidance of his father and grandfather, and his father's partner, Phillip Thorp.

About 1975 he began working independently as a silversmith in Washington, D.C. In 1979 he received a large order from the Smithsonian Museum Gift Division. At about the same time, his father, William L. deMatteo decided to retire from working at Colonial Williamsburg. With Philip Thorp who had also worked there, the deMatteos formed a partnership called Hand and Hammer. After the death of William L. deMatteo in 1988, the firm moved to Woodbridge, Virginia.

Hand and Hammer designs and produces special commissions for individuals, corporations, and the federal government. Members of the deMatteo family have produced gifts for each president since John F. Kennedy. Hand and Hammer operates a wholesale business only, designing jewelry and small items for museum shops and special retail stores. (Hollan, *Three Centu-*

ries of Alexandria Silver, 1995) A more detailed account of the firm's history can be found under the listing for William L. deMatteo.

WILLIAM G. DeMATTEO
Bergenfield, New Jersey

William G. deMatteo (1895-1980) was born in Italy and came to this country as a boy. He was first interested in medicine but made a chance visit to a silversmith's shop in New York City which changed his life's direction. He was apprenticed at Reed & Barton's New York shop in 1911. He went into business for himself in 1919, and, in 1921 moved his shop to Bergenfield, New Jersey. He worked there until he retired in 1968.

During that period he produced literally thousands and thousands of hand wrought pieces of holloware: trays, tea sets, centerpieces, etc. Also included were silver and gold chalices used by churches all over the world, silver surgical instruments and silver plates for bone replacement following surgery. All of his silver objects were his own original designs.

A major contribution to the silversmiths' art was the thorough training he gave to his son, William L. deMatteo (q.v.)

His marks: deM Studio, D in a wheel and DEMATTEO.

WILLIAM L. DeMATTEO
Alexandria, Virginia

William L. deMatteo (1923-1988) was a Master Silversmith. The term "master" and the tradition it represents are quickly disappearing. He apprenticed to his father (q.v.), the premier silversmith of his generation in New York, who passed on to him the skills of the Master Craftsman and a love for the remarkable properties of silver and gold.

After leaving his father's studio he became the Master Silversmith at Colonial Williamsburg While there, deMatteo supervised the interpretation of silver craftsmanship to hundreds of visitors daily, trained apprentices in his shop, and produced many variations of silver in reproductions of 18th century work as well as in modern sculptural forms.

DeMatteo made special gifts for many important foreign leaders, including a matching set of riding crops for Queen Elizabeth II and Prince Philip; a miniature tea service for Queen Elizabeth the Queen Mother to be given to Princess Anne; and gifts for King Baudoin of the Belgians, King Hussein of Jordan and the presidents of several countries.

Among his noteworthy accomplishments was a hand-hammered replica of a silver Town Crier's bell, presented to the late Sir Winston Churchill as the symbol of the Williamsburg Award for outstanding achievement in advancing the principles of liberty and human freedom.

In 1973 he created an adaptation of an 18th century inkwell in the form of a globe. This creation took about 200 hours work and perhaps a hundred thousand hammer blows. It was presented to former President Nixon by the White House Correspondents Association.

During his career, deMatteo was commissioned to design and fashion unique sterling silver gifts for every President from John F. Kennedy.

In 1979 with his long-time partner, Philip Thorp, and his son, Chip, he founded Hand & Hammer. This firm specially developed hundreds of jewelry designs for the museum merchandising programs at the Smithsonian Institution, Colonial Williamsburg, Boston Museum of Fine Arts, Art Institute of Chicago, National Trust for Historic Preservation and more than 50 other museums. Hand & Hammer's Collection also includes handmade Christmas ornaments based on motifs and designs found in America's important museums. Most are of sterling silver while some are crafted in pewter.

Phi Beta Kappa has designated Hand & Hammer sole supplier of their keys to their initiates. The firm also has many important corporate and commercial customers. These include Tiffany & Co.; AT&T, for whom an abstract sculpture was designed to mark the company's 100th anniversary; the Masters' Golf Tournament; Mass Mutual Insurance Company; Lord & Taylor; The Horchow Collection and many others.

The American Institute of Architects awarded William L.deMatteo its Craftsman Medal for high achievement in the field of industrial arts and in 1975 he became the first American silversmith to be honored by an Associate Membership in the Goldsmiths' Company in London.

William L. deMatteo's mark: deM as recorded at the Goldsmiths' Company in London.

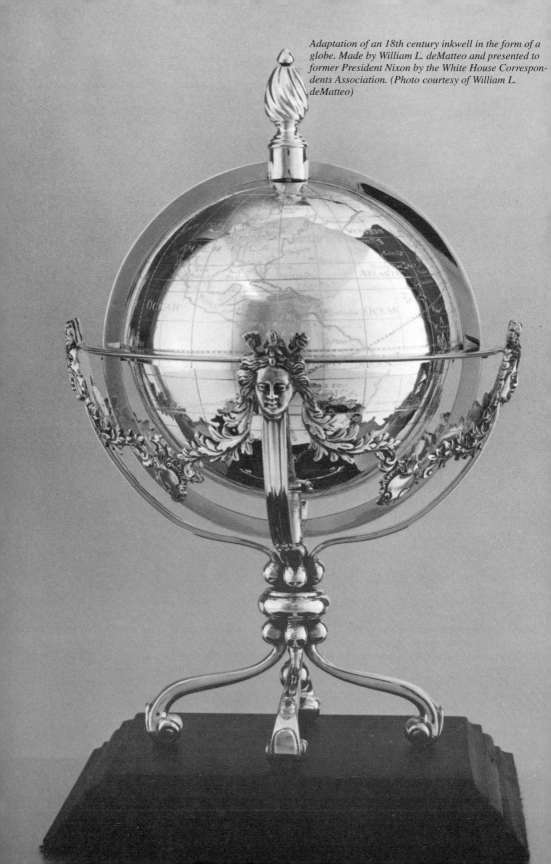

DEMOULIN BROS. & CO.
Greenville, Illinois

Manufacturers of silverplate trophies. Mark found on a Woodmen of the World trophy dating circa 1900s.

DEPASSE MFG. CO.
New York, New York

Manufacturers of sterling silver deposit and gold encrusted ware. Listed in JC 1909-15. Succeeded by Depasse, Pearsall Silver Co. before 1922.

DEPASSE, PEARSALL SILVER CO.
New York, New York

Successors to Depasse Mfg. Co. between 1915-1922. Last record was 1935.

DERBY SILVER CO.
Derby (Birmingham) Connecticut
See International Silver Co.
See Redfield & Rice Manufacturing Co.
See Rogers & Brittin

Founded in 1873 by Edwin N. Shelton, Watson J. Miller and Thomas H. Newcomb. The firm purchased the tools and materials from the Wolcottville flatware factory of the Redfield & Rice Manufacturing Co. which had gone bankrupt the previous year. Edwin L. Brittin, former salesman for Redfield & Rice, arranged the purchase. He also joined the new firm and became a stockholder. He worked in various capacities for the company, serving at different times as salesman and plant manager.

Initially the firm continued production of the Redfield & Rice flatware patterns, but be-

fore long it decided to develop some new patterns of its own as well. In 1875, Joseph F. Fradley (q.v.) was commissioned to design a variable floral flatware pattern for the company. Design patents Nos. 8,369 and 8,370 were issued for the pattern, which was subsequently christened "Bouquet". Brittin's acquaintanceship with Fradley when they had both worked in the Redfield & Rice offices in 1871 probably led to this commission.

Shortly afterwards, Brittin obtained Design Patent No. 8,846 on his own, a design for a nut pick for the "Bouquet" pattern. Then, in partnership with Edward Schott, he received three highly unusual flatware design patents, numbers 8,909 to 8,911 for another variable flatware pattern depicting dead fish and game. Following this, Brittin obtained four additional flatware design patents for Derby in partnership with George Gill, a designer who had previously worked for Reed & Barton.

The company's flatware received the highest award of merit at the Centennial Exposition in Philadelphia in 1876. The quality of the metal and the plating of the flatware was judged to be "unsurpassed" at the American Institute Fair in New York in 1877. Such commendations were proudly noted in the company's catalog for 1883.

But even as it was winning awards, Derby was starting to de-emphasize the production of flatware and move towards the development of holloware. This policy accelerated when Colonel Watson J. Miller came to Derby from New York in 1879. That same year holloware designer Henry Berry joined the firm, receiving the first of many holloware patents he was to obtain for the company. Also about this time, Brittin decided to leave and form his own firm, Rogers & Brittin (q.v.), taking George Gill with him.

Derby was soon producing a wide variety of holloware, included a large line of plated tablewares and dresserwares.

The company also later developed a line of sterling silver decorative wares. U.S. Trade Mark Patent No. 15,642, was registered June 26, 1888, by Watson J. Miller and Henry Berry for M & B sterling, for use on forks, spoons, tea sets, brushes, mirrors and pitchers. The sterling mark was not used after about 1895.

Derby was one of the original firms which formed the International Silver Co. in 1898. The factory continued to operate in Birmingham (Derby) until July 1933 when it was consolidated with other plants in Meriden.

The "half circle" trade mark was first used in 1921 but not registered until 1923.

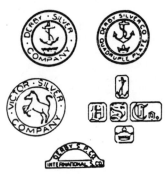

Silverplate Holloware

STERLING

Sterling Holloware

 ALDEN

Pewter Holloware

DERBY SILVER CO. (CANADA)
Toronto, Ontario, Canada

Firm formed in 1881 in response to the Canadian Government's 1879 National Policy. Canadian Division of the Derby Silver Co., Derby, Connecticut. Out of business by 1884.(Unitt & Worrall, *Unitt's Book of Marks*, 1995, p. 43.)

ADAM DEUPERT
Baltimore, Maryland

Listed in Baltimore City Directories 1875-1882 as a gold and silversmith (gold leaf).

DIAMOND SILVER CO.
Lambertville, New Jersey

In business in the 1930s. Clipping from the *Lambertville Beacon*,New Jersey (1-4-1949) says that the Diamond Silver Co. is now part of Ekco Products Co., Chicago, Illinois. (Nickel silver and silverplated flatware)

MISS SARAH B. DICKINSON
Niagara Falls,New York
See Mrs. Sarah B. Dickinson Wood
See Thomas V. Dickinson

THOMAS V. DICKINSON
Buffalo, New York
See Mrs. Sarah B. Dickinson Wood

U.S. Trade Mark Patent No. 19,905, registered July 21, 1891 for silver, flat and tableware. The mark is the same as that used by Mrs. Sarah B. Dickinson Wood.

RICHARD DIMES COMPANY
South Boston, Massachusetts

Founded in 1908 according to one account and in 1923 by another. Sold to the King Silver Company in October 1955, which was acquired by Rogers, Lunt & Bowlen (Lunt Silversmiths) soon afterwards. They made sterling silver holloware and flatware and the trademark is registered with the U.S. Patent Office, No. 755,049, by Rogers, Lunt & Bowlen for use on sterlng holloware and novelty items.

Manchester Silver Company in 1955 or 1956 acquired the tools, dies and rights to the flatware patterns formerly produced by Richard Dimes. Richard Dimes in 1890 started the holloware room of the Towle Mfg. Co. He later went to Frank W. Smith Co. and finally started his own business.

AUGUST DINGELDEIN & SON
New York, New York

Factories in Hannau am Main and Idar, Germany. Manufacturers of handmade sterling holloware. Listed in Keystone 1931 as manufacturers in New York.

DINGLEDEIN STUDIO INC.
Cape Girardeau, Missouri

"Silversmiths since 1852" according to advertisement in 1977 catalog.

DIRIGO DISTRIBUTING CO.
New York, New York
See Dirilyte Co. of Amcrica

DIRIGOLD

DIRILYTE COMPANY OF AMERICA, INC.
Kokomo, Indiana

Began in 1926 under the tradename DIRIGOLD. Their wares are of gold color, not plated, but solid metal developed in Sweden. Objection to the name was raised by the U.S. Patent Office as it implied that gold was included in its composition when there was none. In 1937 the name was changed to DIRILYTE. Both flatware and holloware are still being made. (1975) Since 1961 a process called Bonded Protection has been used to protect the finish which is tarnish free but loses its luster in the dishwasher. Dirilyte made prior to 1961 may have this finish applied at the factory.

DIRKSEN SILVER FILIGREE CO.
Freeport, Illinois

Founded by Gerritt Dirksen, born Emden, Germany, 1818. Though a silversmith by trade, when he and his wife came to this country c. 1844 they settled on a farm in Ridott Township, Illinois. Several years later they moved to Freeport where he established a grocery business and was first listed in the city directories in 1872. In the back of the store Dirksen set up a small silversmith shop where he created many pieces of filigree ware.

By 1890 the silverware business had prospered so that the grocery line was terminated and the entire two-story frame building converted into a silver filigree factory. This business was given a tremendous boost by the World's Columbian Exposition held in Chicago 1893-94. Gerritt and his two sons designed, made and exhibited some very elaborate pieces in a booth at the Fair. The elder son, John, a jewelry salesman, sold the Dirksen line with his other merchandise and Richard D., the younger son, assisted his father and eventually managed the shop. The elder Dirksen' s work was more delicate than that of his son or the other employees.

The 1900-01 city directory lists the firm as Dirksen Silver Co. (G. and R.D. Dirksen). The following year R.D. Dirksen is listed as proprietor. The elder Dirksen died in 1903. Demand for the delicate filigree work lessened and in l905 the company closed. Dirksen filigree silver is plentiful in the Freeport, Illinois area and pieces are included in the collections of the Stephenson County Museum.

D. S. F. CO.

J. DIXON & SONS
Sheffield, England

Known as Dixon & Smith c. 1806 to c. 1823; Dixon & Son, c. 1823 to c. 1835; James Dixon & Sons, c. 1835 to c. 1920 and James Dixon & Sons, Ltd. 1920 to the present. (Culme, *The Directory of Gold & Silversmiths*, 1987, reprinted 1992, p.121)

Well-known firm of manufacturing silversmiths, platers and britannia makers, originally made britannia metal goods only. From small beginnings their success was such that by 1823 they employed about 100. In 1836 the production of nickel silver spoons and forks began, and by 1889 this department alone employed more than 150.

The old established firm of William Hutton & Sons, Ltd., manufacturers and platers, was absorbed by James Dixon & Sons, Ltd. in 1930. Recent years have brought financial difficulties, and a receiver was appointed February 19, 1976. The fortunes of the company were revived, but suffered near collapse again in 1982. The management launched a new company of Betashire, Ltd., operating as James Dixon & sons. (Culme, ibid.)

Dixons were among the first in Britain to manufacture "Old Sheffield Plate" and britannia wares. They were the leading makers of britannia and silver-plated wares imported to this country from about 1830 to the 1860s. At least one American firm frankly copied Dixon designs as fast as they reached this country.

Registered U. S. Trade Mark Patent No. 14,806 for the manufacture of silver, nickel-silver, britannia and plated goods, Oct. 11, 1887.

For further information see Culme, *The Directory of Gold & Silversmiths*, 1987, reprinted 1992, pp. 121-123.

PLATED SILVER STERLING SILVER

JAMES M. DIXON
Chicago, Illinois

Listed in 1854-55 Chicago Directory as a silverplater.

TIMOTHY DIXON
New York, New York

Timothy Dixon appears in the Brooklyn city directory in 1864 as a silverplater with no work address given. He next appears in the 1866 Brooklyn city directory working for the Redfield & Rice Manufacturing Co. (q.v.) at their Brooklyn factory.

Some time in 1867 he apparently decided to open his own shop in New York. He appears in the Brooklyn directory as still working for Redfield & Rice, but in the New York City directory as having his own shop at 17 John St. In the 1868 New York City directory he advertised himself as an "Electro Gold and Silver Plater of all kinds of Metal". In business at least through 1874. Not followed further.

WILLIAM WALDO DODGE, JR.
Asheville, North Carolina

William Waldo Dodge, Jr. was born in Washington, D.C. on February 6, 1895, son of William W. Dodge and Mary Amelia Parker Dodge. He attended Princeton University and later graduated from the Massachusetts Institute of Technology in Architecture in 1916; He subsequently earned a Masters Degree from MIT.

Critically injured while fighting in France in World War I, Dodge was sent to Oteen Military Hospital near Ashville, North Carolina, to recuperate. While there, as part of his occupational therapy, he was taught silversmithing by Miss Margaret Wheeler Robinson. They were married in 1921.

In 1924 he opened a small silversmith shop next to the Grove Park Inn, where he made sterling silver bowls, platters, buckles and flatware using his first shopmark: ASHEVILLE SILVERCRAFT.

Dodge also worked as an architect. In 1925 he received his first architectural commission, a two storey Tudor Residence designed following the principles of the Arts and Crafts movement, which he espoused.

With his architectural success and the growing popularity of his silver he moved his shop and architectural office to Biltmore Forest, a new development south of Asheville. By 1928 he had changed his shopmark to DODGE/BY HAND.

During the late 1920s and early 1930s he designed numerous presentation pieces, bowls, platters and cups, for various clubs and organizations. Perhaps his most notable effort was the Mayflower Cup, a two-handled piece 20 inches tall adorned with a model replica of the Mayflower, commissioned by the Society of Mayflower Descendants in North Carolina. A smaller version of this cup was presented annually by the North Carolina Literary and Historical Association for the finest work of non-fiction by a North Carolina resident.

In the course of his work, Dodge developed a number of different styles of hammering techniques. In 1931 he received a design patent for the one he used used to produce his "waterfall" effect.

World War II with the drafting of his workers and its accompanying precious metals shortage virtually closed his silver shop. In 1942 he and five other architects formed a firm called Six Associates. After the war Dodge resumed his independent architectural practice. The Silver Shop never re-opened. Dodge retired in 1958 and died in 1971. (Johnson, *Silver*, July-Aug. 1994, pp. 32-33)

DODGE, INC.
Los Angeles, California

Listed in city directories 1940s to present (1975) in Chicago, Dallas, Los Angeles, Miami and Newark, as manufacturer to wholesaler. Sterling and silverplate.

(Sterling) *(Silverplate)*

DOMINICK & HAFF
New York
See William Gale
See Reed and Barton

CHRONOLOGY
For earlier history see William Gale

William Gale & Son	1862-1866
William Gale Jr.	1866
William Gale Jr. & Co.	1867-68
Dominick & Corning (James W. Dominick & Edward Corning)	1867
Gale, North & Dominick (H.B. Dominick)	1868-1869
Gale & Corning	1869-1870
Gale, Dominick & Haff (H.B. Dominick & Leroy B. Haff)	1870-1872
Dominick & Haff	1872-1928
Purchased by Reed & Barton	1928

The firm of Dominick & Haff was established by H. Blanchard Dominick, descendant of George Dominick, French Huguenot, who came to this country in 1740, and Leroy B. Haff, who is reported to have first entered the silversmithing business in the retail department of William Gale in 1867. Both Dominick and Haff first appear in the New York City directories published in 1870. The James W. Dominick who is associated with the firm in 1867 appears to be a relative of H. B. Dominick. James W. Dominick went on to become a banker.

In their early days Dominick & Haff devoted themselves to the manufacture of small silverwares and became especially noted for their vinaigrettes, chatelaines and other fancy articles. Following a disastrous fire in 1877, they moved to a new factory and began to manufacture all kinds of articles in silver.

An 1877 advertisement describes the company as, "makers of wares in sterling silver, also fancy goods and novelties in silver, including bangles in endless varieties of styles and prices, dime holders, dress holders, worsted holders, chatelaines, purses, bachelor's pin cushions, scarf pins, lace pins, belt buckles, combs &c." (Soeffing, in Venable's *Silver in America*, 1994, biographical section, p. 318)

In 1880 Dominick & Haff purchased the flatware dies of Adams & Shaw (q.v.), which had earlier obtained the dies of John R. Wendt & Co. (q.v.) and its successors. The rest of Adams and Shaw's materials went to the Whiting Mfg. Co.

Dominick & Haff had a well-deserved reputation for quality design and excellent execution. In addition to the flatware dies the company purchased, it also developed many fine designs of its own. (Soeffing, ibid.)

Dominick & Haff was sold to Reed & Barton in 1928 and consolidated with that firm. There were also connections with the McChesney Company, formed in 1921 by Samuel D. McChesney whose brother was Wm. F. McChesney, treasurer and later president of Dominick & Haff. At the death of Samuel D. McChesney, his business was taken over by Dominick & Haff. What was left of that business was acquired by Reed & Barton in 1928.

"Four silver-gilt decorative spoons, the pierced terminals of flowers enamelled in blue, white and green, with the mark of J. R. Tennant for Dominick & Haff, London, 1898, have been noted." (Culme, *The Directory of Gold & Silversmiths*, 1987, reprinted 1992, p.126)

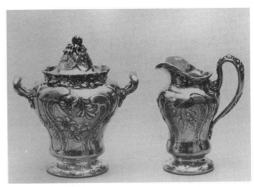

Sugar bowl and creamer by Dominick & Haff, dated 1901. (Photo courtesy Diana Cramer, editor, SILVER)

DOMINION JEWELRY MANUFACTURING CO.
Toronto, Ontario, Canada

Souvenir spoon manufacturer during the 1900s. The company's spoons bore various decorative motifs: Indians, Maple Leaves, and Provincial and Dominion Arms. The company went bankrupt about 1910, and its dies were acquired by Breadner Mfg. Co. (q.v.) (Pack, *Collectors Guide to Canadian Souvenir Spoons*, 1988, p.67)

DOUGLAS DONALDSON
Los Angeles, California

Douglas Donaldson, Master Craftsman Boston Society of Arts and Crafts, was a working silversmith between 1909 and 1972. He was also a teacher and a color consultant.

For the 1915 Panama-Pacific Exhibition in San Diego he designed a covered chalice-shaped cup for which he won a gold medal. The piece had an opal bird on the cover and was decorated with moonstones, turquoise, emeralds, and periodots, along with enamel bosses. The cup was purchased by Harvard College as a perpetual trophy for the college musical society.

An exhibit that won the Albert H. Loeb prize at the Chicago Art Institute in 1916 included a pedestalled fruit dish ornamented with a border of California fruits. Also part of the same display was a picture enamel produced using the champlevé technique.

Donaldson was associated with Porter Blanchard (q.v.) during the late 1920s. (*Silver,* Nov.-Dec. 1987, pp. 16-17)

DORLING COMPANY OF AMERICA, INC.
Jenkintown, Pennsylvania

Registered trademark for use on flatware. Claims use since August 24, 1949.

Dorling

DORST CO.
Cincinnati, Ohio

Successors (?) to Jonas, Dorst & Co. in business 1896. Manufacturers and retailers of sterling and plated silverware, and jewelry. Succeeded c. 1940 by Dorst Jewelry Co. which is still in business. (1975)

STERLING SILVER

LEONORE DOSKOW, INC.
Montrose, New York

Founded in 1934 by Leonore and David Doskow. All pieces are designed by Leonore Doskow and made under her supervision. The company moved from New York City in 1942 and occupied its own building in Montrose, New York. They manufacture sterling and gold jewelry and novelty items. The line today (1975) comprises two thousand sterling silver pieces ranging from boxes to yoyos. Concentration is on the unusual—sets of measuring spoons, cookie cutters, melon scoops, collar stays, toothpicks, sport jewelry, desk accessories, etc.

 LEONORE DOSKOW
HANDMADE STERLING

DOWD-RODGERS CO.
Wallingford, Connecticut

Listed in the City Directory 1915/16-1937. Not listed in 1939. Directories published every two years. Jobbers of plated silverware. Listed as manufacturers of silverplated bread trays, sandwich trays, shaving sets, smoking sets, child's cups, tea sets and novelties, KJI 1924.

TRADE **D** MARK

DROBENARE BROS. INC.
New York, New York

Listed directories 1960s through 1973 as manufacturers of sterling silver.

DUCHIN
Location unknown

Manufacturer of sterling holloware circa 1950s.

THE DUHME COMPANY
Cincinnati, Ohio

Herman Duhme was born in Osnabruck, Hanover, Germany, June 14, 1819, the son of Herman H. and Margaret Duhme. Herman H. Duhme came to the United States in August 1834 and brought his family. He was accompanied by some 100 other emigrants, the voyage being made from Bremen to New York in a small vessel chartered by Duhme. They settled in Ohio in a colony at Springfield. Young Herman Duhme was then 15 years of age. He began his business life with Griffith Foos whose wife took a motherly interest in him, teaching him English and social usage.

In 1840 Herman Duhme moved to Cincinnati and became a salesman in a dry goods store but a year later accepted a position in a jewelry store. He saved his money and three years later opened a small store which later expanded to become one of the largest jewelry stores in the midwest. It had its own manufacturing plant.

The company continued after his death August 21, 1888. In 1896 the firm name was changed to The Duhme Jewelry Company. By 1899 there were two Duhme firms listed—one the Duhme Brothers, operated by Frank and Herman, sons of Herman Sr., and The Duhme Jewelry Company, run by Herman and Oscar Keck. The Duhme Brothers was last listed in 1904 city directories; The Duhme Jewelry Company continued until 1910.

The Duhme Jewelry Company was incorporated January 22, 1898 for the manufacture of gold and silver articles. A notice in the *Jewelers Circular* (1-26-1898) states that "The Duhme Company have purchased the mfg. concern of Neuhaus, Lakin & Co. and will remove the plant to their building and begin the mfg. of sterling silver." Four months later there was a note that "The Kecks are in full possession of Duhme Firm. Duhmes to open again under the name Duhme Bros." About 1893 the title of the firm was again changed to The Duhme Company and this listing continued in the city directories until 1907.

All but the last mark shown below are from *Silver*, March-April 1988, p. 34.

DUHME & CO.

RUFUS DUNHAM
See Stevens and Smart
See New England Silver Co.

Made britannia and plated ware 1863-1875. In 1877 the company became Rufus Dunham & Sons and continued this same name until 1883 with sons Joseph S., Charles A. and John associated with the firm. In 1894 Joseph S. formed the New England Silver Company.

DUNKIRK SILVERSMITHS, INC.
Meriden, Connecticut

Successors c. 1945-50 to Gold Recovery & Refining Corp.

BENEDICT DUNN
See Benedict Mfg. Co.

L.F. DUNN
Niagara Falls, New York

Registered U.S. Trade Mark Patent No. 10,765 for the manufacture of knives, forks and spoons, Dec. 4, 1883. Not listed in City Directory (1886 Directory is the earliest available).

CARBON

DURAND & COMPANY
Newark, New Jersey

CHRONOLOGY

James M. Durand	1838
Durand & Annin	1852
Durand, Carter & Co.	1859
Durand & Co.	1864
Durand & Co., Inc.	1892-1919

The firm of Durand & Co., manufacturing jewelers and silversmiths 1838-1919, was a culmination of seven successive generations of manufacturing jewelers. The Durand name is a very old one, dating back to 1100 A.D. in France and Italy; Durante being the Italian spelling of the name of which "Dante" is a corruption.

For many generations the Durands were identified with the artistic side of the jewelry trade as watchmakers, engravers, jewelers and

silversmiths, sometimes one man being proficient in all these. Dr. Jean Durand, the Huguenot progenitor of the Durand family in America, was born in France in 1667 and came to this country in 1685. He died in Derby, Connecticut in 1727.

His son, Samuel, born in Derby in 1713, was the first of the Durands in America to engage in jewelry manufacturing. He left Derby in 1740 for New York where he stayed for ten years as a farmer, watchmaker and jeweler. In 1750 he moved to Newark and then to South Orange where he died in 1787.

John Durand, son of Samuel, was a jeweler and watchmaker. During the Revolutionary War he was highly praised by George Washington for his skill in repairing field glasses. John Durand's son, Henry, was a manufacturer of jewelry, silverware and crystals for watches.

James Madison Durand, son of Henry Durand, founded the firm of Durand & Co. in 1843. He learned his trade with Taylor & Baldwin of Newark. From 1820 to 1840 he was engaged as an engraver, engine turner, watchcase maker and jeweler. His son, Wickliffe Baldwin Durand, became head of the partnership in 1880. Harry Durand entered the partnership in 1882 as purchaser and became secretary and treasurer. Harry Durand, Jr. was interested in the selling end of the business. Wallace Durand was associated with his father and brothers in the firm and became its president in 1892.

Perhaps the best known of the Durand family was Asher Brown Durand (1796-1886) who was first an engraver. He later took up the engraving of plates from which pictures were printed. Many of these are in the National Portrait Gallery, the most famous one being Trumbull's "The Signing of the Declaration of Independence." From 1835 he devoted his time to painting, mainly landscapes, and with Thomas Cole is credited with founding the Hudson River school of painting.

Among the many items made by the Durand company were scarf pins, silver links, studs, collar buttons, brooches, pendants, necklaces, lorgnettes, vanity cases, purses, mouchoir bags, rings, vest chains, cigarette cases and other novelties.

F.A. DURGIN
St. Louis, Missouri

Founded by Freeman A. Durgin in St. Louis in 1858. The 1859-1860 St. Louis Directory lists him as a member of the firm, Durgin & Burtt. Although better known as a solid silver manufacturer, by the early 1870s he listed himself in the St. Louis city directories as a manufacturer of silverplate. In 1875 he changed his listing to solid silver manufacturer. However between 1878 and 1880 he listed himself as a manufacturer of both solid silver and silverplate.

In 1881 he went to work for the E. Jaccard Jewelry Co. and temporarily gave up his independent shop. Although he was still working for E. Jaccard in 1883, he had re-opened his own shop again. From 1884 through 1888 he advertised himself as "Mnfr. of Sterling Silver and Fine Electro Plate, ..." From 1889-1911 he was a salesman for the Jaccard jewelry firm.

Much silver, especially solid silver flatware, is found with his name.

<div align="center">

F. A. DURGIN
ST. LOUIS

</div>

DURGIN & BURTT
St. Louis, Missouri
See F.A. Durgin

Listed in St. Louis City Directory 1859-60 as manufacturers of silver and plated silverware.

WM. B. DURGIN CO.
Concord, New Hampshire
Providence, Rhode Island
See Gorham Corporation

CHRONOLOGY

William B. Durgin	1853-1898
William B. Durgin Co. (Inc.)	1898-1905
Durgin Division of Gorham	1905+

Founded in 1853 by William B. Durgin in Concord, New Hampshire. Durgin had been born in Compton Village, New Hampshire in 1833 and left his mountain home at the age of 16 to seek his fortune in Boston. He apprenticed himself to Newell Harding.

On completion of his apprenticeship he set himself up in business in Concord. He soon purchased the tools of the two jeweler-spoonmakers of that town. Not long afterwards he also bought the tools of a retail jeweler in Claremont, New Hampshire, effectively removing his local competition.

His initial order was given by Carter Bros., then in business in Concord and later in Portland, Maine. This order was for six sets of teaspoons. During his early days as a spoon maker,

Durgin would make up a lot of spoons and pack them in a hand satchel or small trunk and start out with a horse and wagon to sell them, sometimes taking old silver in barter.

By the 1860s Durgin had a prosperous business, producing sophisticated, die struck patterns of sterling silverware. In time, the firm became one of the largest producers of full lines of flatware and holloware in the country.

Durgin maintained strong ties with Boston, where he had apprenticed. His firm attracted many skilled workmen from there. He also marketed large quantities of his goods through Boston retailers.

In 1903 and 1904, pressed for space by its continuing expansion, the company built a large new factory in Concord. At that time the business employed 300 men and was using about 12,000 ounces of silver per week. Unfortunately, both William B. Durgin and his son George F. Durgin died in 1905. The firm was then acquired by the Gorham Company. (Soeffing, in Venable's *Silver in America*, 1994, biographical section, p. 318) It continued to operate in Concord until 1931 when it was moved to Providence, Rhode Island.

Top mark shown below is from *Silver*, Jan.-Feb. 1993, p. 31.

CROMWELL DISCOVERY
WATTEAU *(Discontinued.)*

DURHAM SILVER CO.
New York, New York

Listed in directories in the 1950s and 1960s as manufacturers.

JOSEPH DYAR
Middlebury, Vermont

Advertised from 1822 through 1845 that his table and teaspoons, cream and salt spoons, sugar tongs, thimbles and gold beads were of first quality and workmanship. He was born in 1804 and died in 1851.

E

EAGLE SILVER CO.
Providence, Rhode Island

Listed in Providence City Directories 1922-1953 as manufacturers of silver novelties. Owners—Memelaus Sava and Ignatius H. Findan. Manufactured sterling silver cigarette cases, vanity cases, whiskey flasks, match safes, 14k gold inlaid and onyx inlaid wares.

E.S.C.O.

EAGLE SPOON COMPANY
Bridgeport, Connecticut

A 1900 account reads:"Articles of association of the Eagle Spoon Company were filed in Bridgeport last week. The purpose of the association is to manufacture and sell all kinds of personal property, including spoons and forks and other flatware. Stockholders are William H. Waterman, Hartford; George C. Edwards and C.A. Hamilton, Bridgeport; and James G. Ludlum and Thomas B. Lashar." (JCW 5-30-1900, p. 47) Succeeded by Housatonic Mfg. Co.

EAGLE STERLING CO.
Glastonbury, Connecticut
See W. L & H. E. Pitkin

Successors to W.L. & H.E. Pitkin, July 1, 1894. Organized in 1894 by William H. Watrous and others to manufacture silverware. Listed in 1896 JC in plated silver section. Out of business before 1904.

GEORGE EAKINS
Philadelphia, Pennsylvania

Advertised in *Jewellers, Silversmiths & Watchmakers,* December 1877 as "Mfg. of silver plated ware and dealer in cut glass bottles ."

SAMUEL EAKINS
Philadelphia, Pennsylvania

Silverplate manufacturer in business in the mid-1850s. On June 26, 1855, Eakins received

Invention Patent No. 13,125 for a self-closing spout cover for icewater pitchers.

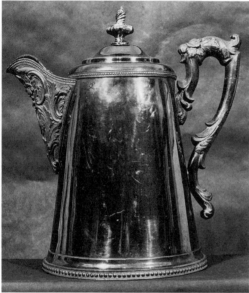

Ice-water pitcher manufactured by Samuel Eakins of Philadephia according to his Invention Patent No. 13,125 granted June 26, 1855. The spout cover on the pitcher closed automatically, thanks to an attached small weight. (Photo by Judy Redfield)

EARLY AMERICAN PEWTER CO.
Boston, Massachusetts

Advertised in the 1940s.

EASTERLING COMPANY
Chicago, Illinois
See Westerling Company

 Used since December 1944. Sterling silver flatware and holloware.

EASTERN CAROLINA SILVER CO.
Hartsville, South Carolina

The Eastern Carolina Silver Co. received its corporate charter on March 5, 1907. The firm was organized by C.W. Coker, W.F. Smith, Edwin Perry and Andrew Lowden. J.L. Coker served as president, W.L. Smith as Vice-President, and C.W. Coker as Secretary-Treasurer. Smith, Lowden and Perry, plus a number of skilled craftsmen, moved to Hartsville, South Carolina, from New Bedford, Massachusetts, to operate the business. The company built houses for the workmen to live in.

The firm manufactured silverplated holloware made on a copper alloy base. The pieces were made in classic forms decorated with floral motifs, featuring southern flowers, cotton flowers and bolls, and grapevines. In 1908 the company issued a catalog illustrating over 150 different pieces. The firm also manufactured pieces on commission.

Unfortunately, the workmen became discontented, and decided to return to New Bedford. The business was discontinued in 1909 and the firm's assets were transferred to the Southern Novelty Co. (Hartsville Museum Brochure, undated, 1980s?)

EASTERN CAROLINA SIL. CO.

EASTWOOD-PARK COMPANY
Newark, New Jersey

Manufacturers of exclusive designs in sterling silverware, dresserware, novelties, mesh bags and jewelry for the wholesale trade.

Listed JC 1909-1915. Out of business before 1922.

GEORGE S. EATON
Brooklyn, New York
New York, New York

George S. Eaton first appears in the Brooklyn City Directories listed as a plater in 1868. As no business location is given for him for that year or the following one, he was presumably working for someone else.

In 1870 he is shown as a silverplater working at 346 Broome in New York City. In the 1871 New York City Directory he is shown as a gilder working at 223 Bowery. In 1872 he is again listed as a plater at 117 Bowery.

By 1873 he had returned to Brooklyn where he went into partnership with Frank N. McLure to form the firm of Eaton & McClure, gold and silver platers. The following year he was back in business by himself. For 1875 and 1876 he is listed as a silverplater and a moulder. Not followed beyond 1876.

EATON & MCLURE
Brooklyn, New York
See George S. Eaton

EAVES & NYE
Sacramento, California

Born in England, Eaves worked in Cincinnati, Lexington, and St. Louis prior to his arrival in California in 1849. During the 1850s, the firm manufactured solid silver spoons in a style characteristic of the midwest . Mark: "EAVES & NYE Sac. 134 J. St."(Morse, in Morse ed. *Silver in the Golden State*, 1986, p. 3)

ECCLESIASTIC SILVERSMITHS
Wallingford, Connecticut

A 1979 account states: "International Silver Company sold its Ecclesiastic division to Ecclesiastic Silversmiths, a new company in Wallingford, Connecticut. The new company will be a division of Lamson-Goodnow Mfg. Co., which is affiliated with Voos Industries, Inc. (JC-K April 1979, p. 144)

Dissolved on April 10, 1981.

ECKFELDT & ACKLEY
Newark, New Jersey

Listed in 1896 Jewelers' Weekly in sterling silverware section. Listed 1898-1915 JC as jewelers. Listed as manufacturers of jewelry and novelties in KJI 1924. Last record found c. 1935.

EDSON MFG. CO.
New York, New York
Newark, New Jersey

"The Edson Mfg. Co., New York, was incorporated Feb. 16, 1893 for the manufacture of silver novelties with a factory in Newark. Franklin Edson, Sr., president; Albert E. Coon, sec. & treas., and Henry T. Edson, Manager." (JC&HR 3-1-1893, p. 28)

JAMES A. EDWARDS
Brooklyn, New York

James A. Edwards first appears in the Brooklyn City Directory as a silverplater in 1873. He continues to be listed through 1876, as far as he has currently been followed.

EDWARDS, HORTON & EDWARDS
Chicago, Illinois

Silversmiths c. 1850.

EISENBERG-LOZANO, INC.
New York, New York
See Samuel Kirk & Son
See Kirk International

Founded by Arthur Eisenberg and Neal Lozano in 1953. Purchased by The Kirk Corporation in 1970 after the deaths of the founders.

WM. J. EISENHARDT
Baltimore, Maryland

Listed in Baltimore City Directories 1887-1888 as a silverplater.

M. EISENSTADT JEWELRY CO.
St. Louis, Missouri

M. Eisenstadt Company (Wholesale distributors of silverware and jewelry). Founded in 1853 by Michael Gabriel Eisenstadt. First appeared in St. Louis directory in 1866.

From 1904 the firm is listed as M. Eisenstadt Manufacturing Co., and from 1908 on they are listed as manufacturers of jewelry, jobbers of watches and importers of diamonds. In the 1920s,1930s and 1940s they are listed as M. Eisenstadt Mfg. Co. and they are still (1975) in business as M. Eisenstadt, wholesale jewelry.

Plated Silver Holloware

Their logo of a capital E sitting on a carpenter's square—the "E on the square," stood for straight-forward, honest dealings and has been used by the firm since the 1880s. (JC-K May 1982)

SETH EK
Boston, Massachusetts
See Handicraft Shop

One of the silversmiths who worked in the Handicraft Shop in the early 1900s. A member of the Arts and Crafts movement. The "H anvil S" mark is the mark of the Handicraft Shop (q.v.). The letter "E" is the initial of Ek's last name, indicating that he manufactured the piece on which the mark was found. (Williams, *Silver,* May-June 1988, p. 18)

STERLING
1903
E

ELDRIDGE & CO.
Taunton, Massachusetts

Listed in Taunton City Directories from 1800-1884 as silver manufacturers "at Britanniaville, near R.R. crossing Reed & Barton."

ELECTRIC CHAIN COMPANY OF CANADA
Toronto, Ontario, Canada

Firm established about 1916 under the management of F.W. Day. Manufacturer of Sterling Souvenir Spoons. Electric Chain Co. was taken over by Rembrandt Jewelry Manufacturing Ltd. in the 1950s and its spoon dies were acquired by the Breadner Manufacturing Co. (q.v.) (Pack, *Collectors Guide to Canadian Souvenir Spoons,* 1988 pp. 68; 77)

ECCO

ELECTROLYTIC ART METAL CO.
Trenton, New Jersey

Listed in JC 1915 with manufacturers of sterling silverware. No record after 1920.

ELEDER-HICKOK CO.
Newark, New Jersey
See Hickok-Matthews Co. Silversmiths

Originally Lebkuecher & Co.; the name was changed by law to F.A. Lester after 1915 and was taken over by the Eleder Co. in 1918. By 1922 it had become the Eleder-Hickok Co. It merged with the Matthews Company after 1931 to form the Hickok-Matthews Company, manufacturers of sterling silver novelties.

WM. R. ELFERS CO., INC.
New York, New York

Listed in 1931 NJSB and KS as manufacturers of sterling silver holloware, candlesticks, vases, salt and pepper shakers, sherbet compotes, centerpieces, etc.

wEr

ELGIN-AMERICAN MANUFACTURING COMPANY
Elgin, Illinois

Began business in 1887. An undated Elgin-American catalog (with illustrations of souvenirs engraved "Remember the Maine" and desk calendars dated January 1898) includes flatware of plated silver, smoking sets, jewel cases, bracelets, dresser sets, match safes and novelties.

Registered U.S. Trade Mark Patent No. 103,053, March 16, 1915 for manufacture of silverware.

Became a division of Illinois Watch Case Company before 1950. Observed their 65th anniversary in 1952. This is the last record found.

On plated silver knives about 1898.

ELGIN SILVERSMITH CO., INC.
New York, New York
See Redlich & Co.

Founded by two partners, Ludwig & Redlich, and operated under that name until 1892 when Mr. Ludwig sold his interest to three of his old employees and it became Redlich & Co., Inc. It was taken over by Elgin Silversmith Co., Inc. in 1946. Products are sterling flatware, holloware and 14k goldwares. The Redlich trademark has not been changed and is still used by the firm to the present day. (1975) Currier & Roby is now a Division of Elgin Silversmiths.

Sterling.

ELKINGTON & CO., LTD.
Birmingham, England

George Richards Elkington was apprenticed at 14 to his two uncles, Josiah and George Richards to learn silverplating. This was in 1815 and the silverplating process he learned was "close plating"- hammering thin layers of silver over base metal, with adhesion being by soldering. His cousin, Henry Elkington, joined him about 1829-30 in the making of small articles. They were constantly doing research towards better methods of gilding base metals.

Between 1836 and 1839 the firm of G R & H Elkington took out various patents, including one for "electrogilding" Therefore, they are usually credited with the invention of electroplating. John Wright discovered the need for cyanide of potassium in the plating solution and submitted his process to the Elkington company who embodied it in their patent of 1840. This process was available to other manufacturers on a royalty basis.

A third partner, Josiah Mason, was admitted in 1842 and the firm became Elkington, Mason & Company. Beginning then, their electroplate was marked with "E & Co." in a shield, and "E M & Co." in three separate shields, together with their company date letters. Mason left the firm about 1859 but his initial was not dropped from the marks until 1864. The Crown, long used as part of many silverplaters' marks, was dropped from Elkington's "E & Co." mark in 1896.

In 1963 Elkington and Mappin & Webb merged to form British Silverware Ltd. Soon

afterwards they acquired Walker & Hall, Adie Bros., and Gladwyn Ltd. Products of all four firms are now sold under the Elkington name.

Through changes in Elkington's trademarks it is possible to date their products with reasonable accuracy. They first used "E & Co., crowned" within a shield and ELEC TRO PLATE. In 1842 a series of numbers was added to the trademark. The numbers ran from 1 to 8 with the number 6 being reversed. In 1849, letters of the alphabet were substituted for the numbers, beginning with the letter K. A new series of letters began in 1865 with a change in the trademark. Letters B, C, and J were omitted. The letter Q was not used by the sheet department and used on only part of the cast articles. The letter Q as well as R was used from 1900 onwards. Both numbers and letters are enclosed within shapes that aid in their dating.

For further information see Culme, *The Directory of Gold & Silversmiths,* 1987, reprinted 1992, pp. 140-142.

JAMES ELLIS
Quebec City, Quebec, Canada

Manufacturer of solid silver flatware c.1820 (Williams, *Silver,* Jan.-Feb. 1984, p. 32)

J.E. ELLIS & CO.
Toronto, Ontario, Canada

James E. Ellis moved from Liverpool, England, to Canada in 1848 and was associated with Rossin Bros. until 1852. He bought into that business that year. Ellis' son joined him in 1862. The firm name became J.E. Ellis & Co. in 1877 when M.T. Cain became a partner. It continued until 1901 when it was sold at auction.

The mark shown below is from Unitt & Worrall, *Unitt's Book of Marks,* 1995, p. 45.

P.W. ELLIS & CO.
Toronto, Ontario, Canada

P.W. Ellis & Co., the partnership of Phillip W. Ellis, Matthew C. Ellis and Richard Y. Ellis, was reported by Aaron (*Silver,* Sept.-Oct. 1985, p. 20) to have been founded in 1877.

Pack (*Collectors Guide to Canadian Souvenir Spoons,* 1988, p.19) illustrates a billhead from the company, dating from the 1890s, on which it described its business as "Manufacturing & Wholesale Jewelers, Medalists &c.". They were importers and wholesalers of watches, clocks, sterling and plated silverware, china and cut glass, artware, jewelry, diamonds, tools, materials and supplies.

Between 1891 and 1901, P.W. Ellis & Co. received twenty different copyrights for souvenir spoon designs. Most featured crest designs on the handles, but one was for a bust of Sir John A. Macdonald, Canada's first Prime Minister. (Pack, ibid., pp. 20-27).

The company was incorporated in 1901. It maintained its own factory and warehouse in Toronto.(Aaron, *Silver* Sept.-Oct. 1985 p. 20)

In 1904 the firm was sued by Gorham, which claimed that the company's trademark, "Anchor, E on Maple Leaf, Lion" was an attempt to immitate Gorham"s "Lion, Anchor, G" mark. Gorham lost. (Aaron, ibid. pp. 20-21)

The company continued in business until 1928, when it was liquidated and taken over by Birks (q.v.).

SOVEREIGN PLATE

P. W. ELLIS STERLING

ELLIS SILVER COMPANY, INC.
New York, New York
See Ellis-Barker

Established in New York c. 1900 as a branch of Ellis & Co., Birmingham, England.

ELLIS-BARKER SILVER COMPANIES
Birmingham, England
New York,New York
See Barker Brothers Silver Co.

The Ellis-Barker Company can trace its history to a partnership c. 1820 by partners Barker and Creed. It became Barker Bros. (William and Matthias Barker) c. 1860.

Encouraged by their success in England, they opened an American branch in 1897 (Samuel Buckley & Co., New York) where a full line was introduced. Among the pieces offered were trays, candelabra, candlesticks, plates, urns and bottlestands. These articles were copper, heavily electroplated with silver and mounted with handles, borders and edges of sterling silver.

In 1921 Barker Bros. was joined by Levi & Salamon, specialists in dresserware and by Potosi Silver Co., spoon and fork makers. In 1931 they purchased the Ellis Silver Co. (Ellis & Co., Birmingham, being the parent) and the firm has been known since then as Ellis-Barker. They are noted especially for their beautiful reproductions of antique silver.

A 1978 advertisement says "Division of Towle."

For further information see Culme, *The Directory of Gold & Silversmiths*, 1987, reprinted 1992, pp. 26-27 under the name Barker Brothers.

FOR SILVER AND ELECTROPLATED TRAYS, WAITERS, CANDLESTICKS, CANDELABRA, DINNER SETS, FLOWER-STANDS, COFFEE AND TEA SERVICES, VASES, WINE-COOLERS, TEA-URNS, INK-STANDS, DECANTER-STANDS, DINNER-PLATES, MEAT-DISHES, ENTRÉE DISHES, BOT-TLE-STANDS, CAKE-BASKETS, SIPHON-HOLDERS, BOWLS. JUGS, TEA-CADDIES, BOXES, FRUIT-STANDS, AND FRUIT-BASKETS.
Claims use since October 1906.

FOR TRAYS. WAITERS. CANDLESTICKS, CANDELA-BRA. DINNER SETS. FLOWER-STANDS, DINNER-PLATES. BOTTLE-STANDS, VASES, TEA AND COFFEE SERVICES, WINE-COOLERS, TEA-URNS. INK-STANDS, DECANTER-STANDS. MEAT-DISHES, CAKE-STANDS. SIPHON-HOLDERS, FRUIT STANDS AND BASKETS. BOWLS. JUGS. TEA CADDIES. BOXES, AND ENTRÉE-DISHES. ALL MADE OF PRECIOUS METALS OR PLATED WITH PRECIOUS METALS.
Claims use since August 1912.

FOR CAKE-BASKETS, CRUETS, CUPS, DISH-COVERS. MEAT-DISHES, ENTRÉE-DISHES, EGG-FRAMES. TEA AND COFFEE SERVICES. WINE-COOLERS, INKSTANDS. LIQUOR-FRAMES, MUSTARD-POTS, MUFFINEERS. SALT-CELLARS, SAUCE-BOATS, SOUP-TUREENS. SI-PHON-STANDS, SWEET-DISHES, TEA-URNS, TOAST-RACKS. TEA-CADDIES. TRAYS, VASES AND WAITERS. ALL MADE OF SILVER OR PLATED WITH SILVER.
Claims use since November 1912.

FOR SILVER-PLATED HOLLOWARE.
Claims use since 1912.

FOR SILVER PLATED HOLLOWARE AND FLATWARE
Claims use since Mar. 2, 1932.

ELLMORE SILVER CO., INC.
Meriden, Connecticut
See Concord Silver Co.
See G.H. French & Co.
See Frank M. Whiting Co.

Founded c. 1935 by I.A. Lipman who rented space in the old C.F. Monroe factory and took over F.M. Whiting Co. of N. Attleboro, G.H.

105

French & Co., New York, and Concord Silver-smiths, Ltd., Concord, New Hampshire, about 1939. Whiting had been making sterling flatware and some holloware. French made novelties and dresserware. With these lines added, the Ellmore company increased production and established branch offices in New York, Los Angeles and Chicago.

The W.S. Blackinton Co. became a division of the Ellmore Co. in the 1940s. The Ellmore Co. went out of business in 1960. The Blackinton Co. was purchased by Raimond Silver Mfg. Co., Meriden, Connecticut, in 1966 and moved to Chelsea, Massachusetts. The sterling flatware dies of the Whiting Company were bought by the Crown Silver Co., New York. It is believed that they are no longer being used.

 SILVER HARVEST

HARVEST

Used since 1950.

ARNOLD ELTONHEAD
Baltimore, Maryland

Listed as a silversmith in the 1850 census. Born Pennsylvania.

EMPIRE ART METAL WORKS
New York, New York

Listed 1909 JC in plated silver section.

EMPIRE CRAFTS CORP.
Newark, New York

Manufacturers of silverplated flatware 1930s to 1950s. Later controlled by Oneida Silversmiths.

NOBILITY PLATE

(Silverplate)

EMPIRE SILVER PLATE CO.
Brooklyn, New York

Advertised in 1896 JW and JC&HR as manufacturers and importers of silverplated holloware. Listed in KJI in the 1920s as repairers and replaters. Last record found 1931.

ENGLISH SILVER MFG. CORP.
Brooklyn, New York
See Leonard Silver Mfg. Co.

Manufacturers and importers of silverplated wares from c. 1950. Still in directories. (1975)

ENTERPRISE PLATING WORKS
Baltimore, Maryland

Listed in Baltimore City Directories 1894-1916 as silverplaters.

M.C. EPPENSTEIN & CO.
Chicago, Illinois
See A. Davis & Co.

Earliest record found was Patent Office Trade Mark Registration No. 24,525, April 17, 1894 for use on plated silver tableware. Succeeded by A. Davis & Co. c. 1904.

R. COIN.

ERICKSON SILVER SHOP
Gardner, Massachusetts

George C. Erickson was born in Sweden and came to this country when six months of age. He served his apprenticeship under Arthur J. Stone (q.v.) where he developed into a master craftsman in the production of sterling silver flatware.

In 1932 Erickson bought from the heirs of the late David Carlson, the shop which Carlson had run for several years and even during the Depression days was able to build a successful

business. His first mark, "G. C. E.," used in 1932 was soon changed to "Erickson Sterling." Also during the 1930s, George Erickson and Herman Glendenning joined together and made silver using the mark "Erickson Handwrought." In 1971 Glendenning set up his own shop.

In January 1977 the business was handed over to Peter G. Erickson, the grandson of the founder. Peter continues making the same line of handwrought sterling silver flatware and jewelry as his grandfather did. He uses the mark "Erickson Sterling Handwrought." Peter G. Erickson is a member of the Society of American Silversmiths.

PAUL ERNEST
Brooklyn, New York

Paul Ernest first appears in the Brooklyn City Directories in 1867 in partnership with George Naundorf in the firm of P. Ernest and G. Naundorf, advertised as britannia and silverplaters. He and the firm are not found in the directories the following year.

In 1869 and 1870 Ernest is listed as a silverplater working independently. The Directories for 1871 and 1872 are unavailable, and he is not found in subsequent directories.

P. ERNEST & G. NAUNDORF
Brooklyn, New York
See Paul Ernest

ESSAY
Toronto?, Ontario?, Canada

Mark found on silverplated holloware dating circa 1950s.

ETON SILVER INC.
Glendale, New York

Listed in directories from the 1960s to the present (1975) as manufacturers and importers.

EUREKA MFG. CO.
Taunton, Massachusetts

Listed in directories from the 1950s through the 1960s as manufacturers of silverware.

THEODORE EVANS & CO.
New York, New York
See Evans & Anderson

CHRONOLOGY
Theodore Evans & Co.	1855-1863
Evans & Cook	1864-1867
John Cook	1868-1874+?

An 1897 account says: "An old-time silversmithing house was that of Theodore Evans & Co. who started business in 1855 at 6 Liberty Place, New York. The firm was composed of Theodore Evans and John Cook. Mr. Evans was a salesman for Wm. Gale & Son from 1850 to 1855, while Mr. Cook was foreman for the same firm, but in '55 they joined forces and started for themselves, soon doing a large southern business in flat and hollow wares. They manufactured many of the old patterns: Plain, Tipped, French Thread, Plain Thread, Oval Thread, Mayflower, Shell, Grape, as well as a patented one named Ribbon...Many of their goods are still extant in the south.

"In 1865 the firm name was changed to Evans & Cook, Jas. E. Johnson having been admitted as a special partner. In 1869 Mr. Evans retired and John Cook continued for several years. In their prosperous days everything in their line, from a thirty inch tray to a salt spoon, could be found in their safes, and in no instance was a piece issued which was not up to the standard at that time—that of New York coins. They lost heavily through the war, as most of the silverware houses did, the south before the war being fond of luxuries." (JC&HR 6-30-1897, pp. 33-34)

According to the New York City Directories, Evans & Cook was formed in 1864 and Theodore Evans had left the firm by 1868, in each case one year earlier than reported in the above account.

On March 4, 1856 Theodore Evans received Design Patent No. 769 for a silver flatware pattern.

T. EVANS & CO.

EVANS & ANDERSON
Newark, New Jersey
See Theodore Evans & Co.

Horace B. Anderson and Theodore Evans, siversmiths, worked 1864-c. 1866. Listed in Newark City Directory as "Evans and Anderson, Successors to Henry Evans.
Dealers in Clocks, Watches, Jewelry, etc. and manufacturers of Sterling silver wares." Succeeded by Horace B. Anderson and operated under his name.

EVANS & ANDERSON

EVANS CASE CO.
North Attleboro, Massachusetts

Listed in the 1920s as D. Evans Case Co. Still in business (1975) as a division of the Hilsingor Corp., Plainville, Massachusetts.

HENRY W. EWINS
Hartford, Connecticut
See Ewins & Son

Firm formed about 1874 by Henry W. Ewins. His father, Richard Ewins, who had formerly been associated with him in the firm of Ewins & Son (q.v.) was also involved in the business. Both men were listed as "silversmiths". After 1876 Richard Ewins disappeared from the firm and from the Hartford City Directories.
Henry W. Ewins continued as a silversmith at least through 1881. His history has not been followed further.

EWINS & SON
Hartford, Connecticut
See Henry W. Ewins
See Hartford German Silver & Britannia Works

Richard Ewins and his son Henry William Ewins both appear in the Hartford City Directories compiled for 1858 and again for 1860 through 1863 listed as "silversmiths" but with no work location given, suggesting they were employed by someone else during this time. In the directory compiled for 1864, the firm of Ewins & Son appears, listed as being in the German silverware business.

For the directory compiled in 1865, the firm is listed as, "R. Ewins, all descriptions of Plated Ware, German Silver, Tea Sets, Castors, Cake and Fruit Baskets, Goblets, Cups, Napkin Rings, Etc. and work in metals. Sample room 219 Main St., upstairs near City Hotel. This ware is made to order and warranted superior and cheap as any in market. Hartford German Silver and Britannia Works, 219 Main and 18 Gold Sts." Similar ads ran through 1868.

Between 1864 and 1872 the firm is listed variously as R. Ewins or Ewins & Son in the directories, although both men worked continously for the business. The 1867 directory lists the firm as both Ewins & Son and R. Ewins. After 1868, both men are again listed in the directories as "silversmiths".

The Directory compiled in 1873 does not give a business location for either of the men. However, by 1874, a firm under the name of Henry W. Ewins (q.v.) was formed, with both men shown working for it.

F

OTTO G. FABER
Baltimore, Maryland

Listed in Baltimore City Directories 1895-1910 as a silversmith, goldsmith and jeweler. Some of his pieces bear a marked similarity to designs made by Samuel Kirk & Son.

WILLIAM FABER & SONS
Philadelphia, Pennsylvania

Silversmiths and silverplaters 1828- 1887.

FAHYS WATCH-CASE CO.
New York, New York
See Alvin Corporation

Listed in 1896 as Jos. Fahys & Co.; 1922 as Jos. Fahys & Co., Inc.

In 1897 Jos. Fahys & Co. purchased the Alvin-Beiderhase Co. and moved its factory to Sag Harbor, Long Island. It continued to operate Alvin-Beiderhase as a branch of its own business until 1910.

Design patents Nos. 32,914, July 10, 1900 and 38,583, May 28, 1907 for spoons, forks or similar articles were taken out by Fred Habensack, Sag Harbor, New York and assigned to the Fahys Watch-Case Co., presumably for use by its Alvin-Beiderhase subsidiary.

FAIRCHILD & CO.
New York, New York

CHRONOLOGY

Randall & Fairchild	1837-1843
LeRoy W. Fairchild	1843-1863
LeRoy W. Fairchild & Co.	1864-1874
L.W. Fairchild	1874-1886
L.W. Fairchild & Sons	1886-1889
LeRoy Fairchild & Co.	1889-1898
Fairchild & Johnson	1898-1919?
Fairchild & Company	1919-1922?

Founded in 1837 as Randall & Fairchild. From 1843, known as LeRoy W. Fairchild; 1864-1874 as LeRoy W. Fairchild & Co.; 1874-1886 as L.W. Fairchild; 1886, L.W. Fairchild & Sons; 1889 it was incorporated as LeRoy Fairchild & Co.; in 1896 Harry P. Fairchild bought out the business and in 1898 he formed the corporation of Fairchild & Johnson. In 1919 it was known as Fairchild & Co., and went out of business c.1922.

Through 1874 the firm is listed in the New York City Directories as manufacturers of gold pens. At some point the firm also became makers of sterling silverware.

In 1889 Leroy W. Fairchild & Co. of New York and Paris was one of five American Silver Manufacturing firms to take part in the International Exposition in Paris, France, and one of four to win a prize there. At that time the firm was producing "gold and silver novelty goods such as pencil and cigarette cases, penholders, pocket knives, cigar cutters, and flasks." (Venable, *Silver in America,* 1994, pp. 114-115)

L. W. FAIRCHILD & CO.

FAIRCHILD & JOHNSON CO.

LEROY C. FAIRCHILD CO.
New York, New York

An 1897 account states: "Leroy C. Fairchild Co., manufacturers of gold pens and novelties, recently incorporated. Directors are Julia L.M. Fairchild, W. Clifford Moore and Leonard S. Wheeler. They purchased the machinery,tools, etc. used by the defunct Leroy W. Fairchild & Co. Leroy C. Fairchild, president of the old company, is now in charge of the new corporation's selling and manufacturing departments. (JC&HR 6-9-1897, p.23)

FARBER BROS.
New York, New York

Manufacturers and jobbers of plated silver holloware c. 1920-1950. Now (1975) a division of LCA Corp.

Silvercraft

(On silverplated holloware)

FARNHAM & SPENCER
Hartford, Connecticut

John M. Farnham and James Spencer operated a gold and silverplating business at 71 Asylum St. in 1876. Spencer disappears from the record the following year, and Farnham continues on at the same location doing musical instrument repair.

FARRINGTON & HUNNEWELL
Boston, Massachusetts

Silversmiths 1835-85. Great quantities of flatware turn up with their (Star) F & H (Star) trademark, often accompanied by the mark of another as retailer.

In the early 1860s the firm was the leading manufacturer of silverware in Boston. Pieces in the Olive pattern are commonly found. A vintage pattern was also produced. Their medallion pattern, manufactured about 1864, uses a variety of different classical portraits. (Soeffing, *Silver Medallion Flatware*, 1988, p. 42)

FEDERAL SILVER COMPANY
New York, New York

Listed from c. 1920 to 1961 as manufacturers of sterling and plated wares.

The trademark at right appears under the name Jones & Woodland, Newark, New Jersey in 1896-1915 JC and 1950 JC-K.

(On silverplate)

(On sterling)

W.J. FEELEY CO.
Providence, Rhode Island

One account says that the company was founded in 1875 by Michael Feeley. Another says it was established by W.J. Feeley in 1875 and incorporated in 1892. According to this account, W.J. Feeley was born in Providence, January 19,1855 and learned the trade of silversmithing from Knowles & Webster; worked several years as a journeyman before beginning business on his own account.

They were manufacturers of gold and silver ecclesiastical goods. City Directories list the company from 1875 to 1920 as manufacturing jewelers and silversmiths. Listed in 1936-1937 Jobbers' Handbook.

ALBERT FELDENHEIMER
Portland, Oregon

U.S. Trade Mark Patents registered April 28, 1891 and January 1892 for sterling souvenir flatware and jewelry. Became A. & C. Feldenheimer between 1896-1904. Last record c. 1904.

FRANCES FELTEN
Winstead, Connecticut

Pewterer, currently (1975) in business.

FENNIMAN CO.
New York, New York

Listed JC 1915 in sterling silver section. Out of business before 1922.

PETER FERRARI
Baltimore, Maryland

Listed in Baltimore City Directories 1887-89 as a silverplater.

FESSENDEN & COMPANY
Providence, Rhode Island

CHRONOLOGY

Whiting, Fessenden & Cowan	before 1858
Wm. P. Fessenden & Co.	1858-1860
Fessenden & Company	1860-1922

In April 1858 William B. Fessenden, who had at one time been a member of the firm of Whiting, Fessenden & Cowan, moved to Providence and established a silverware factory there. He took into partnership his son, Thomas F. and started as Wm. P. Fessenden & Co., in the manufacture of fancy flat and staple hollowares. In 1860 the father sold out his interest to his son and retired. Soon afterwards, Thomas took Giles Manchester as partner, who remained in charge of the manufacturing department until his death in 1886. In 1876, Silas H. Manchester, a brother of Giles, joined the firm and later became a partner and assumed management. Silas Manchester became sole owner about 1895. On his death in 1905 the company was incorporated. It continued to be listed in business until 1922.

**925
STERLING
1000**

MARSHALL FIELD & CO.
Chicago, Illinois

Began business in 1864 as Farwell, Field & Company. In 1865 the company became Field, Palmer & Leiter; Potter Palmer sold out his interests in 1866 and the firm name became Field, Leiter & Company. Marshall Field became sole owner in 1881 and gave the firm its present name.

Marshall Field's was one of the first large department stores to have many articles stamped with trademarks registered for its own use. U.S. Trade Mark No. 146,536, September 6, 1921 was registered for their use on silverware, both sterling and plated.

An advertisement in a 1966 Chicago(?) paper read as follows: "Silver is a glittering thread interwoven with the history of Britain. The ancient craft of the English silversmith has been regulated by Royal Ordinances and Acts of Parliment since the late 12th century. Since 1935, the Marshall Field & Company hallmark has been registered at the Worshipful Company of Goldsmiths in London. In all the world, we are one of the few non-British companies privileged to have our own shield put on silver made for us in England. This mark of quality distinguishes a pattern of silver flatware made expressly for Field's in England."

**(Used since June 1935)
(On sterling silver table articles)**

FIFTH AVENUE SILVER CO., INC.
Taunton, Massachusetts

The company was founded September 1948 by Manuel J. Andrade of Taunton, a spinner by trade. It was first named the Pilgram Silver Company, that name being soon changed because of a conflict with a tradename already in use. The name was changed to Prospect Silver Company in the early 1950s but was again changed to Fifth Avenue Silver Company. In 1960 the company changed ownership and was incorporated. The new owners were Leon J. and Mildred A. Bunk

and Frank and Joanna Todorsky. Mr. Bunk served as general manager and president. From the beginning the company has been manufacturers and wholesale distributors of silverplate and pewter hollowares.

5 TH AVE	5 TH AVE
SILVER CO.	SILVER CO.
SILVER PLATED	SILVER ON COPPER

**LEXINGTON
PEWTER
(On pewter)**

HARVEY FILLEY & SONS
Philadelphia, Pennsylvania

Silver platers c. 1859 - c.1900.

FILLEY & MEAD
Philadelphia, Pennsylvania
See John O. Mead

FILLEY, MEAD & CALDWELL
Philadelphia, Pennsylvania
See John O. Mead

FILLKWIK CO.
Attleboro, Massachusetts
See Shields Inc.

Founded c. 1920. In the 1922 KJI the company is listed as manufacturing nickel, silver and aluminum cigarette cases. By the 1924 KJI listing, gold filled and sterling cigarette cases had been added to the line. The firm was incorporated as Shields, Inc. in 1936.

MICHAEL C. FINA CO., INC.
New York, New York

Founded December 1935 by Rose Fina and Michael C. Fina. Manufacturers and wholesalers of sterling and silverplate holloware.

111

WILLIAM C. FINCK CO.
Elizabeth, New Jersey

Listed in JC 1896-1904. Out of business before 1915. Manufacturers of sterling silverware. Among their products were sterling souvenir spoons.

FINE ARTS STERLING SILVER COMPANY
Morgantown, Pennsylvania

Founded in Philadelphia in 1944 by Jerry N. Ashway. They were sole distributors of six sterling flatware patterns manufactured by the International Silver Company and distributed through direct sales.

The company was moved from Philadelphia to Morgantown, Pennsylvania in 1972.

The founder and board chariman, aged 66, died November 1973 at his home in Glenside, Pennsylvania.

Moved to Jenkintown, Pennsylvania, in 1977. Out of business in September 1979.

(Used since January 24, 1949 on children's tableware)

ALBERT G. FINN SILVER CO.
Syracuse, New York
See P.A. Coon Silver Mfg. Co.

Manufacturers of plated silverware. Founding date not known. Listed JC 1904. Succeeded by P.A. Coon Silver Mfg. Co. between 1904-1909.

ALBERT G. FINN SILVER CO.
CRESCENT SILVER CO.

TRADE-MARK

FISHEL, NESSLER & CO.
New York, New York
See Majestic Mfg. Co.

Firm established about 1886. Manufacturers of sterling silver and rhinestone-set jewelry, platenoid rhinestone-set jewelry, plated jewelry and card jewelry. Registered U.S. Trade Mark Patent No. 23,016 for use on jewelry, May 16, 1893.

The company received two invention patents for a "Breakless" Bar Pin on April 12 and July 26, 1904. as noted in *Silver,* July-Aug. 1992, p. 38

"Established over 45 years." (Adv. KJI 1931) Last listing found was 1936-1937.

Sterling Goods Plated Goods

FISHER SILVERSMITHS, INC.
Jersey City, New Jersey
New York, New York

Successors to M. Fred Hirsch Co. Manufacturers of sterling and silver plated flatware and holloware since 1936 or earlier. Still in business. (1975) No longer manufacturing.

(On sterling)

FISHER, COLTON & KINSON
Montpelier, Vermont

An 1877 account states: "Fisher, Colton & Kinson, silverplaters Montpelier Vermont, have sold out to Fisher & Colton." (*Jeweller, Silversmith & Watchmaker,* Nov. 1877)

FLAGG & HOMAN
Cincinnati, Ohio
See Homan Mfg. Co.

(Pewter)

112

W.L. FLETCHER
South Chatham, Massachusetts

Pewterer, currently in business. (1975)

FLORENCE SILVER PLATE CO.
Baltimore, Maryland

Listed in Baltimore City Directories 1894-1942 as silverplaters. No City Directories available 1942-1955.

E.B. FLOYD
Burlington, Vermont

Worked as late as 1868 in coin silver.

A.W. FLYE
Gloucester, Massachusetts

Flye advertised in the June 1899 issue of Keystone a sterling souvenir spoon with fish and boat oar handle motif. He offered to produce a custom "bowl die at one-half regular price, $5.00, for name of any place desired". For July of that year he advertised a fish and banner stickpin. Noted in *Silver*, May-June 1991, p. 37.

FOOT & COLSON
Chicago, Illinois

Listed in 1854-1855 Chicago Directory as silverplaters. In 1856 Foot was listed as working alone.

WILLIAM FORBES
New York, New York

Listed as a silversmith in the New York City Directories at least as early as 1852. He operated his business at the rear of his residence at 277 Spring St. By 1860 he had moved his home to New Jersey, but the shop remained at the same location. The business last appears in the directory published in 1863. In 1864 Forbes is listed as a "smith" but was apparently working for someone else. Not found after 1864.

FORBES & FLETCHER
Boston, Massachusetts

They advertised themselves as "Manufacturers of Albata German Silver and Plated Goods, consisting of the 'Medallion' Pattern

spoons, Forks, Butter Knives, Soup Ladles, &c. Also Ice Pitchers, Tea Sets, Cake Baskets, Butter Coolers, Casters, &c." in the *Boston Evening Transcript*, December 3, 1867.

FORBES SILVER CO.
Meriden, Connecticut
See International Silver Co.

Organized in 1894 as a department of Meriden Britannia Co. for holloware silverplating. One of the original companies which formed the International Silver Co.

(This mark sometimes used with the words SHEFFIELD REPRODUCTION.)

FORD & CARPENTER
New York, New York
See Cohen & Rosenberger.

Succeeded Baldwin, Ford & Co. between 1896 and 1904 and were succeeded by Cohen & Rosenberger before 1915.

FORD & TUPPER
New York, New York

CHRONOLOGY
J.C.H. Tupper	1866
Ford, Tupper & Behan	1866-1867
Ford & Tupper	1867-1874
Patrick Ford	1874-1881

Jonas C.H. Tupper first appears in the New York City directories in the lumber business in 1860 and 1861 along with other members of his family as part of the firm of Tupper and Wilcox. When he next appears, in 1866, his occcupation is listed as "silver" and his address as 609 Broadway.

Soeffing, in Venable's *Silver in America*, 1994, biographical section, p. 319, indicates that he was joined that year by Patrick Ford and William Behan, both former employees of the William Gale firm. (q v.) By 1867 the business was known as Ford and Tupper. With a prime location in the heart of the city's major shopping area,

the firm did a large retail business.

Products of various manufacturers are commonly found bearing the company's retail stamp. There have been some questions raised as to whether the firm actually did any manufacturing of its own. However, an advertisement in the *New York Times*, December 7, 1868 urges customers to, "Buy Your Silverware From the Manufacturers, Ford and Tupper." Another ad in the *Times*, December 4, 1869, describes the firm as "Ford and Tupper, Manufacturing Silversmiths". Unfortunately no details are given to indicate what kinds of items the firm may have produced on its own.

BEN FORMAN & SONS, INC.
New York, New York

In directories 1950s and 1960s as manufacturers of silverwares.

FOSTER & BAILEY
Providence, Rhode Island
See Theodore W. Foster & Bro. Co.

Theodore W. Foster and Samuel H. Bailey. Succeeded by Theodore W. Foster & Bro. Co.

THEODORE W. FOSTER & BROS. CO.
Providence, Rhode Island

CHRONOLOGY
White & Foster	1873-1878
Foster & Bailey	1878-1898
Theodore Foster & Bros. Co.	1898-1951

Established January 1, 1873 under the name White & Foster. Walter E. White had been listed previously as a jeweler from 1869-1872. The name was later changed to White, Foster & Co. and in 1878 when White withdrew, the name became Foster & Bailey. (S.H. Bailey) In May 1898 the company was incorporated under the name Theodore Foster & Bros., Co.

They were among the largest manufacturers of jewelry and sterling silver goods in Providence. Among the goods were gold filled, electroplated and sterling silver vanity cases, cigarette cases, clock cases, ecclesiastical goods, cigar and cigarette holders, knives, medals, pens and pencils, photo frames, dresserware and candlesticks for which U.S. Trade Mark Patent 28,069, April 17, 1896 was registered. This last listing continued until 1951.

F. & B.

J.F. FRADLEY & CO.
New York, New York

CHRONOLOGY
Joseph F. Fradley	1866-1870
Fradley & Burr	1871
J.F. Fradley & Locklin	1872-1873
J.F. Fradley	1874-1888?
J.F. Fradley & Co.	1888?-1936

In 1866 Joseph F. Fradley, who had completed his apprenticeship as a chaser in the silverware factory of Wood & Hughes, opened a small workshop in Brooklyn and began doing chasing for the trade. He soon had a staff of 25-30 chasers in his employ.

In 1870 he opened a small factory for the production of gold-headed canes.

About 1871 he entered into partnership with Samuel B. Burr, a cousin of James H. Redfield, and rented salesroom space in Redfield & Rice's (q.v.) salesrooms at 4 Maiden Lane, New York. While there, he obtained a Design Patent, No. 5,298, for the Lily pattern of silverplate flatware which was subsequently produced by the Redfield & Rice Manufacturing Co.

By 1872, his partnership with Burr was dissolved and he had entered into partnership with Francis P. Locklin to form the firm of J.F. Fradley & Locklin. Fradley and Locklin continued in partnership into 1873, but by 1874 they had gone their separate ways.

Fradley's cane manufacturing venture proved so successful that in 1873 he moved to larger quarters and added all kinds of silver novelties to his productions.

In 1875 he received two more patents for silverplate flatware designs, numbers 8,369 and 8,370. These floral motif designs were manufactured by the Derby Silver Co. and marketed under the pattern name of "Bouquet". Fradley's connection with Derby was probably through Edwin L. Brittin, the plant manager there, who had formerly worked for Redfield & Rice.

J. F. Fradley & Co. was one of five American silver manufacturing firms to Exhibit at the 1889 Exposition in Paris, France. (Venable, *Silver in America*, 1994, p. 114)

The business was incorporated in 1890. Fradley retired in 1902 but the firm continued under the same name with Geo. F. Fradley, a son of the founder. The last record found was 1936. Among the articles made were 14k gold and sterling silver cane and umbrella handles; 14k dresserwares and novelties; sterling photo frames, vases, desk accessories and other novelties.

TRADE MARK

AUG. C. FRANK CO., INC.
Philadelphia, Pennsylvania

Founded in 1894 by a German-born engraver, August Conrad Frank. As his two sons, Herman and Edwin, grew up, he taught them engraving and brought them into the company. In 1942 the business was made a partnership with the father and two sons under the Aug. C. Frank name. Today (1975), Edwin Frank is the only survivor. The senior Frank died Oct. 31, 1946 at the age of 83, and the eldest son, Herman, died May 24, 1966 at the age of 68. The present firm was incorporated May 1, 1971.

The Frank company had a fine tradition of excellent medallic work in the Philadelphia area. Custom medals, sports awards, badges, advertising coins and plaques were produced.

On September 15, 1972 the Frank company medal division was purchased by Medallic Art Company of Danbury, Connecticut. The dies, medal presses and other equipment were immediately moved to their Danbury, Connecticut factory. The purchase did not include the non-medallic business of the Aug. C. Frank firm, which was to continue in other areas in which it engaged, including plastic thermomolding, light metal stamping and their tool and die business.

THE FRANKLIN MINT
Franklin Center, Pennsylvania

The Franklin mint was founded in 1963 by Joseph M. Segel and has become the world's largest and foremost private mint. It is the principal operating division of the Franklin Mint Corporation and the only non-government mint in the United States that produces legal tender for foreign countries. It is best known for its many series of commemorative and art medals, which are usually struck in sterling silver and issued in limited editions.

The Franklin Mint specializes in *proof* quality coins and medals. *Proofs* bear the "FM" mark and are characterized by flawlessly minted detail on a brilliant, mirrorlike background and are highly prized by collectors everywhere.

The Franklin Mint is the official minter for many important series of commemorative medals such as those for the Bicentennial Council of the Thirteen Original States, the White House Historical Association, Postmasters of America, the National Governors' Conference, the National Audubon Society and the United Nations.

In 1973 they entered the field of signed art prints with the formation of the Franklin Mint Gallery of American Art. Early in 1974 they began the publication of luxury editions of books of proven literary importance and the creation of limited edition sculptures of fine pewter. On July 10, 1973, they dedicated the Franklin Mint Museum of Medallic Art which houses a most complete collection of Franklin Mint issues.

Their extensive sculpturing and engraving staff is augmented by more than 100 distinguished sculptors working in their own studios, thus making the Mint an important patron of the arts and largely responsible for the modern renaissance in medallic art.

FRANKLIN SILVER PLATE COMPANY
Greenfield, Massachusetts
See Lunt Silversmiths

Incorporated in Greenfield, Massachusetts in 1912. Ceased operations between 1920-22. They were manufacturers of plated silver holloware. The trademark was taken over by Rogers, Lunt & Bowlen (Lunt Silversmiths) c. 1922, but with minor exceptions has not been used.

FRARY & CLARK & SMITH
Meriden, Connecicut

In business c. 1850-65. Merged with Landers & Smith in 1865 to form Landers, Frary & Clark.

PETER FREDERICK
New Orleans, Louisiana

Listed in New Orleans city directories as a silversmith in 1871.

FRENCH & FRANKLIN
North Attleboro, Massachusetts

Listed in Jewelers' Weekly, 1896, as manufacturers of sterling silverware.

G.H. FRENCH & CO.
North Attleboro, Massachusetts
See Ellmore Silver Co., Inc.

Earliest record found c. 1920. Manufacturers of sterling silver novelties, cigarette and vanity cases, cups and tableware. Succeeded by Ellmore Silver Company, Inc., between 1935-43.

FRIED, MILLS & CO. INC.
Irvington, New Jersey

Listed in JC 1915 in sterling silver section. Last record found c. 1935.

CLEMENS FRIEDELL
Pasadena, California

Born in 1872 in Gretna, Louisiana, Clemens Friedell returned with his family to Vienna, Austria in 1875. There he studied music and completed his apprenticeship as a silversmith, before coming back to the United States with his family in 1892. The family bought a farm near San Antonio, Texas. Friedell was initially unable to find work as a silversmith, and ended up teaching music.

In 1901 he obtained a job with the Gorham Company and moved to Providence, Rhode Island. There he worked, probably as a chaser, producing Gorham's hand wrought Martelé silver until 1908. After a brief attempt at operating his own shop, he returned to Texas and farming.

In 1910 he moved to Los Angeles and began selling ashtrays and trinkets on consignment through a local department store. Learning of the wealthy residents and visitors to Pasadena, he moved there the following year.

By 1912 he had established his reputation with the carriage trade by creating an artistic loving cup, several feet high, reportedly for Miss Phoebe Hearst. That same year he received a commission from E.R. Maier to produce a complete dinner service for Maier's mother's birthday. Friedel produced a 107 piece service for 18, complete with serving bowls, salts, peppers, tureens, trays, and a twenty-eight inch tall centerpiece, chasing more than 10,000 orange blossoms onto the pieces. This work, entirely hand-wrought in the Martelé style, became known as "the orange blossom set". Equine portrait plaques, featuring the prize steeds of the local equestrian aristocracy became a staple product of his commission work.

In 1915 he entered a punch bowl, a coffee set and several plaques in the Panama-California Exposition held in San Diego, and earned a gold medal for his efforts.

Trophies were a prominent part of his business. He even donated one to the 1914 Tournament of Roses for the "best decorated four passenger automobile".

In 1916 he rented retail space at the Hotel Maryland, one of Pasadena's premium resorts. He was so successful that in 1921 he decided to retire and move to Texas where he bought a ranch. After his first marriage ended in divorce in 1927, he returned to Pasadena and the silver business.

The Great Depression of the 1930's had no serious effect on him, as enough wealthy Pasadenans remained to maintain a demand for his work. During this time he completed his famous "Bottoms Up!" cocktail shaker liberally decorated with cast female nudes, a definite departure from the Martelé style.

While much of his work prior to the move to Texas had been done on commission, his second period of production involved much more ready-made goods for sale. In addition to the Martelé work he enjoyed, his shop now included neo-classical and lobed style pieces as well.

Business remained lucrative throughout his career. He died in 1963 leaving no successor, as he had trained none. (Bowman, in Morse ed., *Silver in the Golden State*, 1986, pp. 41-46)

FRIEDMAN SILVER CO., INC.
Brooklyn, New York
See Gorham Corporation

Creators of fine holloware since 1908. Bought by the Gorham Corporation in 1960.

Much of their holloware bore pastoral Dutch designs.

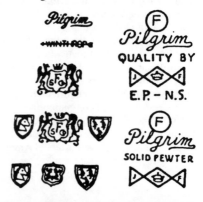

BENJAMIN FROBISHER
Boston, Massachusetts

Benjamin Frobisher was a silversmith and jeweler. Though britannia wares are generally thought not to have been made in this country until 1835 or afterwards, according to the late Carl Dreppard, Frobisher advertised them as early as 1829.

B.A. FRYER & CO.
Hartford, Connecticut

Firm formed by B.A. Fryer and J.J. Ryan. Listed as silverplaters in the Hartford City Directory produced in 1879. Not found subsequently.

FERD. FUCHS & BROS.
New York, New York
See Fuchs & Biederhase

Ferdinand Fuchs and his brothers came to this country from Germany about 1835. They were in business first in Boston and later moved to New York.

This particular firm was composed of Ferdinand and Rudolph Fuchs (possibly sons of the original Ferdinand?) and was established in 1884 for the manufacture of sterling silverware. Richard Fuchs was sales representative in Baltimore, Philadelphia and the West. Pierre Joseph Cheron designed some of their wares. The partnership was dissolved in 1891.

FUCHS & BEIDERHASE
New York, New York

Founded by Rudolph Fuchs and George B. Beiderhase in 1891. Makers of sterling holloware, cups, napkin rings, dresserware, library articles and novelties. Succeeded by Alvin Mfg. Co. before 1896.

According to an 1893 account:"Rudolph Fuchs, president of Fuchs & Beiderhase, silversmiths, died Thursday morning. Only 34 years old he had been connected with the silverware business for 18 years. He served his apprenticeship with B.D. Beiderhase & Co., New York and was afterwards connected with Adams & Shore (Shaw?), Dominick & Haff and J.F. Fradley & Co. When he left the latter firm in 1884 he went into partnership with his brother under the firm name of Ferdinand Fuchs & Bro. The partnership was dissolved in 1891, and Mr. Fuchs and Mr. Beiderhase formed the firm of Fuchs & Biederhase, incorporated last April. Mr. Fuchs was president." (JC&HR 1-18-1893, p. 5)

G

JOHN GAILLISSAIRE
Baltimore, Maryland

Listed in Baltimore City Directory as a silverplater in 1864.

GAIME, GUILLEMOT & CO.
New York, New York
See Christofle

Hippolyte Gaime and Charles Guillemot operated a jewelry business in New York City at least as early as 1852 according to the New York City directories. The firm served as the agents for Christofle & Co. (q.v.) in New York. An advertisement in the *New York Tribune*, January 1, 1853, reads in part, "Always on hand for sale, a large assortment of Tea Sets, Trays, Candelabras, Forks & Spoons and everything which belongs to the table service.

"All these goods are warranted superior by their nature and plating to any other similar.

"They can both support a very high degree of heat and be replated always when used up. ..."

By 1855, Gaime had left the business. Guillemot continued on as a jeweler, but apparently no longer had the Christofle agency.

GALE & HAYDEN
New York, New York
See William Gale

William Gale and Nathaniel Hayden are recorded in New York City directories from 1845 to 1849 as retailers of silverware. Gale had formerly been associated with Jacob Wood and Jasper W. Hughes. After the dissolution of the firm of Gale & Hayden, he continued to deal in silverware with his son William Gale, Jr. while Hayden became a banker.

Some of the flatware sold by them bears marks of Gale & Hughes. Gale & Hayden obtained Design Patents #149 and #150, September 11, 1847 for flatware.

Mark below is from Fennimore, *Silver* Mar.-Apr. 1985, p. 14.

Date 1849 in diamond indicates year the piece was made.

WM. GALE
New York, New York
See Dominick & Haff
See Gorham Corporation
See Graff, Washbourne & Dunn
See Wood & Hughes

CHRONOLOGY

Gale & Stickler	
(William Gale & John Stickler)	1822-1823
John L. & W. Gale	1825-1827
Gale & Moseley	
(Wm. Gale & Joseph Moseley)	1828-1833
Gale, Wood & Hughes (Wm. Gale, Jacob	
Wood, Jasper W. Hughes)	1833-1845
Gale & Hayden	
(William Gale & Nathaniel Hayden)	1845-1849
William Gale, Son & Co.	1850-1853
William Gale & Son	1853-1859
Gale & Willis	
(John R. Willis, Gale's son-in-law)	1859-1862
William Gale & Son	1862-1866
William Gale Jr.	1866
William Gale Jr. & Co.	1867-1868
Dominick & Corning	
(James W. Dominick & Edward Corning)	1867
Gale, North & Dominick	
(H.B.Dominick)	1868-1869
Gale & Corning	
(Edward Corning)	1869-1870
Gale, Dominick & Haff	
(H.B. Dominick & Leroy B. Haff)	1870-1872
Dominick & Haff	1872-1928
Purchased by Reed & Barton	1928

The above chronology is based largely on that provided by Soeffing in Venable's *Silver in America,* 1994, biographical section p. 319, with two additions from the New York City Directories. From the directory published in 1866, "Established in 1821, William Gale Jr., (late Wm. Gale & Son) silversmith, 572 & 574 Broadway. ..." From the directory published in 1867 comes

the listing for Dominick & Corning. James W. Dominick appears to have been a relative of H. B. Dominick.

William Gale was born in Orange County, New York, on April 5, 1799. He died December 17, 1867. His son, William Gale, Jr., was born in 1825 and became a partner with his father after reaching his maturity.

William Gale invented and patented, on December 7, 1826, a process for making spoons with ornamental patterns by cutting the ornament on rollers, both the upper and lower rollers being cut with the pattern. This made the production of pattern spoons much less expensive than the former method of hand hammering patterns by the use of dies. During the fourteen years Gale controlled this patent, he became the largest manufacturer of spoons in the country. The process was superseded by the mechanical perfection of the drop hammer, spoons then being made from flat dies, the upper and lower dies containing the ornament. Shaped dies were a still later development.

In addition to his successful silverware business, William Gale, Sr. also profited from investments in New York City real estate. His estate was evaluated at several hundred thousand dollars on his death, the equivalent of millions of dollars today.

William Gale, Jr. (1825-1885) continued the business for a time after his father's retirement and death, but the operation, though large, did not compare with that in his father's day. (Soeffing, ibid.)

Although known primarily for its production of solid silver wares, the firm also produced and marketed silverplated wares. An ad in the *New York Times* dated December 17, 1865, for William Gale & Son lists "...STERLING SILVER, Tea Services, Tureens, Dishes, Salvers, Pitchers, Goblets, Cups and Children's Sets, Fruit Sets, Forks, Spoons, &c. &c. also, a fine assortment of RICH PLATED WARES..." A December 15, 1866 ad for William Gale Jr. in *Harper's Weekly*, also offers a "choice stock of Silver and Plated Wares of the newest and finest designs." An example of a silverplate pie server in the company's own "Mayflower" pattern, bearing the mark "Wm. Gale & Son" has been found by Judy Redfield.

The marks below for Gale, Son & Co. and William Gale & Son are from Cramer, *Silver* May-June 1991, pp. 28-29.

William Gale.

 Gale, Wood & Hughes

 Gale, Son & Co. with an 1853 year date stamp.

These marks appear together on a mustard pot, with an 1856 year date stamp, by William Gale & Son.

GALT & BRO., INC.
Washington, D.C.

CHRONOLOGY

James Galt	1802-1847
M.W. Galt & Bro.	1847-1879
M.W. Galt, Bro. & Co.	1879-1892
Galt & Bro.	1892-1934
Galt & Bro., Inc.	1934- present

James Galt moved from Georgetown to Alexandria in 1802 and established his business which included the making of watches, and later fine silver pieces.

In 1847 James Galt died and ownership of the business passed into the hands of Matthew W. Galt and William Galt, his sons. Among their patrons were Abraham Lincoln and Jefferson Davis.

In 1879 William Galt withdrew from the firm. The following year M. W. Galt retired and turned over to Norman Galt, one of his sons, the responsiblity for maintaining the prestige and respect which the House of Galt had earned. Norman Galt was assisted by Henry C. Bergheimer.

About 1900, Galt and Brother was chosen to execute a bowl which was presented to Postmaster Charles Emory Smith for his efforts in establishing a rural mail system. This piece of work brought a special congratulatory note from President Roosevelt in 1902, the one hundredth anniversary of Galt and Brother.

In 1908 Norman Galt died and Henry C. Bergheimer became the first to manage the business without bearing the founder's name. That year they began automobile delivery service. In 1923, Henry C. Bergheimer died and the management was carried on under William H. Wright. In 1934 Galt & Brother was incorporated when Norman Galt's widow, Edith Bolling Galt Wilson (Mrs. Woodrow Wilson), turned the firm over to the employees. The firm is still in business today.

U.S. Trade Mark Patent No. 19,421, May 5, 1891. Portrait of Christopher Columbus, a copy of M. Maelia's engraved picture of Columbus published by Joseph Delaplaine, Philadelphia and later given to the U.S. Navy Department.

U.S. Trade Mark Patent No. 20,488, December 8, 1891. Landing of Columbus. Facsimile of the famous painting later placed in the U.S. Capitol.

Both trademarks were used on gold, silver and plated silver articles, presumably of the souvenir type.

The George and Martha Washington medallions were registered trademarks for use on souvenir spoons conceived by M.W. Galt. The first of these was a ladle that was an exact facsimile of the Washington ladle preserved in the National Museum, with the addition of the Washington medallion stamped in the bowl.

GALT & BRO.

ALBERT J. GANNON
Philadelphia, Pennsylvania

The Philadelphia City Directory lists Albert J. Gannon as a salesman in 1905; as a silversmith between 1906-1910 and lists Albert J. Gannon Company silversmiths from 1911-1914. This is the last listing.

GARDEN SILVERSMITHS
New York, New York

Listed in directories 1960s and in 1973 JC-K. Successors to Arrowsmith Silver Corp. They own the dies for sterling silver wares formerly made by Apollo and Bernard Rice's Sons.

GARRETT & SONS
Philadelphia, Pennsylvania

In the 1860s they purchased Reed & Barton wares "in the metal" and operated their own plating establishment.

GEBELEIN SILVERSMITHS
Boston, Massachusetts
East Arlington, Vermont

Gebelein Silversmiths was founded by George C. Gebelein who was born near Bayreuth, Bavaria, in 1878 and was brought to this country when a year old, so his training was entirely American. He was apprenticed at the age of 14 to Goodnow & Jenks (q.v.). He concluded his apprenticeship in November 1897 and went to work for Tiffany & Company in their new (1895) factory at Forest Hills, New Jersey.

According to J. Herbert Gebelein (*Silver,* July-Aug.1985, p. 23), when George Gebelein first applied to work for Tiffany, he was rejected, on the grounds that a 19 year old could not possibly measure up to Tiffany's standards. However, he was given a chance to demonstrate his skill by making a handwrought object of Tiffany's choosing. He proved himself, and for the next twenty-seven months he worked in Tiffany's Silver Room.

He returned to New England to work for William B. Durgin (q.v.) in 1900 before starting out for himself as a member of The Handicraft Shop of Boston (q.v.) at the end of the year 1903.

In 1909 he set up a shop of his own at the foot of Beacon Hill. He accepted students, and as his business grew, he hired journeymen. Initially he marketed his production by consigning articles to Arts and Crafts societies and other exhibiting studios. As he became better known, direct patronage largely replaced sales through agents. (Gebelein, ibid., p. 25)

Besides making fine reproductions and adaptations, Gebelein was a collector and dealer in old American and European silver, becoming a recognized authority on silver. He was one of the early recipients of the medal for excellence presented by the Society of Arts and Crafts of Boston. The Williamsburg Communion set is one of his best-known productions.

His son, J. Herbert Gebelein, followed him in the silversmithing craft.

After George Gebelein's death in 1945, the company was incorporated under family directorship as Gebelein Silversmiths Inc. with J. Herbert Gebelein in charge. Production began to dwindle. There were journeymen silversmiths who stayed on into the 1950's and perhaps even

the 1960's, but J. Herbert Gebelein chose to focus more on silver scholarship than silversmithing.

Gebelein Silversmiths was purchased from the family by David L. Thomas on March 1, 1984, and a new corporation was formed. J. Herbert Gebelein continued with the firm, but no longer as manager, until his death in 1986.

On April 1, 1986, the firm was moved to East Arlington, Vermont, and incorporated again there. Gebelein Silversmiths now only buys and sells silver, specializing in early American, American arts and crafts, and Chinese export pieces.

The marks shown below are based on photos in Gebelein's 1985 *Silver* article.

120

A: Earliest Gebelein marks were G or GG with year and The Handicraft Shop's "H Anvil S" psuedohallmark.
B: From 1908 the incised name in an outlined box was used on large and medium pieces.
C: From 1909 the incised name occurred on medium and small pieces.
D: Matte background and raised letters in an outline.
E: Small old English G was used on small work.
F: Textured background with a modern G in oval frame was used on handhammered silver-lined copper bowls, silverplate products and pewter "reproductions" or specialty items.
G: Since 1927 handwrought flatware was marked with raised letters:"Sterling GEBELEIN Boston" in rectangular outlines.
H: Fancy frame, textured background, and raised letters were used for larger, usually handcrafted items, starting around 1929.

Mark found on a 1904 Louisiana Purchase Exposition souvenir spoon.

GELSTON & GOULD
Baltimore, Maryland
See Gould & Ward

GEM SILVER CO.
See International Silver Co.

Trademark of Wilcox Silver Plate Co. for dresserware and several flatware patterns.

GEM SILVER CO.

GENOVA SILVER CO., INC.
New York, New York

Manufacturers of sterling silver c. 1950.

ARTHUR R. GEOFFROY
New York, New York

Listed in JC 1896 as manufacturer of sterling silverware. Out of business before 1904. Advertised as maker of wares in sterling silver for the trade only.

GERITY PRODUCTS, INC.
Toledo, Ohio

Their advertising reads, "Custom platers since 1898."

GEORGE E. GERMER
Boston, Massachusetts

George E. Germer was born in 1868, the son of a Berlin jeweler. Even before his apprenticeship, he showed a love of silver. Otto Gericke of Berlin was his teacher, and from him he learned chasing and modeling. He came to the United States in 1893 and for nearly 20 years worked in New York, Providence and Boston. After 1912 he worked independently, producing mostly ecclesiastical silver.

During his latter years, he moved his shop to Mason, New Hampshire, and produced more silver for churches, some of which is now in museums.

FRANCIS S. GIBNEY
New York, New York

Francis S. Gibney's occupation is listed as "silver" in the New York City directories published in 1866 and 1867. A listing for a "Francis H. Gibney" in 1865 may also refer to him. For 1868 no business address is given for him. Not found after 1868.

MICHAEL GIBNEY
New York, New York

Michael Gibney was listed in the New York City Directories 1836-45 and 1849-60. He was

issued the first Design Patent for a flatware design in this country (Design Patent No. 26, Dec. 4, 1844). Pieces in this pattern are marked "Ball, Black & Co.", "Ball, Thompkins & Black" with a "Y", or completely unmarked.

Gibney was also issued other Design Patents. One, *Tuscan* (Design Patent No. 59, July 10, 1846) was designed at the request of E.K. Collins, noted shipbuilder, who wished to equip a new vessel with a silver service with "a pattern different from the old ones then prevailing." The order was placed through Marquand & Co. (q.v.) The pattern was later marketed by them and eventually became one of the first standard patterns issued by the Whiting Mfg. Co.

Gibney's other flatware design patents were No. 124 granted June 13, 1848, and No. 1,241 granted May 15, 1860. He was the assignee for Design patent No. 698, obtained by Henry Biggins April 3, 1855.

Gibney was a designer for the trade as well.

Not found in the New York City Directories after 1860.

F.S. GILBERT
North Attleboro, Massachusetts

Listed JC 1904 as manufacturer of sterling silverware. Out of business before 1915.

PHILO B. GILBERT
New York, New York
See John Cook

Philo B. Gilbert was a prominent New York City manufacturer who began working in the late 1830's. His business was located at 6 Liberty Place in the 1850's and 8 Liberty place in the 1860's both part of a large building that housed a number of other well known silver manufacturers.

On May 7, 1867, he obtained Design Patent No. 2,646 for a silver medallion flatware pattern.

Soeffing (*Silver Medallion Flatware*, 1988, p. 48) notes that Gilbert went bankrupt in 1868. Since many pieces following his design bear the mark of John Cook (q.v.), and Cook went into business for himself at about the same time, it appears likely that Cook bought up Gilbert's dies.

Soeffing also states (ibid.): "A listing in the 1896 and 1915 editions of *Trademarks of the Jewelry and Kindred Trades* seems to link Gilbert's mark with George W. Shiebler. It is possible, and indeed likely that Shiebler bought out Cook or another heir to the Gilbert business, thereby indirectly acquiring Gilbert's dies and/or his mark."

The marks shown below are from Soeffing's *Silver Medallion Flatware*, 1988.

Early mark, circa 1839-1865.

 Later mark, circa 1865-1868.

GILBERTSON & SON
Chicago, Illinois

In business in the 1920s as silversmiths, platers and finishers, mesh bag repairers and electroplaters.

GINNELL MFG. CO.
Brooklyn, New York

Listed in JC 1915-22 as a manufacturer of sterling silverware and jewelry.

G. MFG. CO.

GLASTONBURY SILVER CO.
Chicago, Illinois

Listed in JC 1922-1950 as manufacturers of plated silver flatware and holloware. Between 1931-1950 the company name became Glastonbury, Inc.

GEE-ESCO

ARROW PLATE
On plated flatware

R. GLEASON & SONS
Dorchester, Massachusetts

Roswell Gleason was born in Vermont about 1801. He had become a tin worker by 1822 and was first listed as a pewterer about 1830. He was noted for the extremely fine quality of his work, which carried over into his britannia work later, when the business became one of the largest and most important in Dorchester.

The 1850 Census lists Gleason as a britannia ware and solar lamp manufacturer, and owner of real estate valued at $50,000, a substantial fortune at that time. The same Census lists his two oldest sons, Roswell, Jr., and Edward, as clerks, presumably working in the family business. The date at which these two were taken into partnership by their father is not yet known, but it was some time prior to February 12, 1856, when Roswell Gleason, Jr. assigned a design patent to the family firm under the joint name.

Gleason's sons, Roswell, Jr., and Edward, received a variety of patents for unusual table casters in the late 1850's. Two were combination table casters and egg stands. Three other patents related to a cathedral shaped stand that kept the caster bottles concealed inside until a mechanism was activated to open the doors hiding the bottles. Roswell Gleason, Jr., also received an invention patent for a cake stand.

Interestingly, Roswell Gleason, Jr.'s first invention patent, No.14,451 granted in 1856, was for an "elastic" figure and valve for a fountain ink stand, an item apparently unrelated to the silver business.

After 1850 the firm's products were mostly silverplated. The business closed in 1871.

This "Indian" mark is Gleason's mark. Attribution to Manhattan Silverplate Company in 1904 JC is incorrect. The Manhattan Plate mark is the arms of Manhattan, which includes a different Indian figure. See the Manhattan Plate Company (q.v.) for its actual mark.

HERMAN W. GLENDENNING
Gardner, Massachusetts

Herman W. Glendenning was a native of Gardner, Massachusetts. As a young boy he lived across the street from Arthur J. Stone (q.v.) Master Craftsman in the Handwrought Sterling Silver business. As a teenager he worked intermittently for Stone, but he did not enter his apprenticeship until after he graduated from Gardner High School in 1920. He was first instructed in making flatware, forging with a three or four pound hammer. He then progressed to holloware, which he preferred, as there was more variety in its design and execution . When he was judged proficient, he was permitted to put his "G" under the Stone trademark. In 1927 Stone bestowed on him the title of Master Craftsman. After Stone's retirement, Mr. Glendenning became the designer and producer of holloware at the Erickson Shop (q.v.) where he worked for about thirty-five years.

In 1971 he retired from the Erickson Shop and set up his own studio. In the following years he tried to educate people about Handwrought Sterling Silver through giving lectures and teaching adult education classes.

Over the years a number of students apprenticed with him, and produced a variety of interesting pieces, but none completed the full seven year course.

Herman Glendenning finally retired in 1985, and two years later moved to Saugerties, New York. He sold his flatware tools to a former student. His holloware tools went to a member of the Society of American Silversmiths. His designs and other records have been given to the Gardner Museum, Gardner, Massachusetts.

Glendenning Sterling Handwrought

Used 1955-1985.

W.H. GLENNY & CO.
Rochester, New York

Wholesale and retail silverware and jewelry. Note similarity of trademark to that of The Waldo Foundry, Bridgeport, Connecticut, and H.H. Curtis & Co., North Attleboro, Massachusetts.

W.H. GLENNY, SONS & CO.
Buffalo, New York

An 1898 account states: "W.H. Glenny Sons & Co., was established in 1840 in Buffalo, New York, as a crockery and glassware business. Branch stores were opened in St. Paul, Elmira and Rochester. St. Paul and Elmira stores closed several years ago but the Buffalo and Rochester stores continued until 1898 and were operated by the sons. At the time of closing of the entire business it was operated by William H. Glenny, Bryant B. Glenny, W. Henry Glenny and Francis Almy and William Keagey." (JC&HR 2-2-1898, p. 23)

They were wholesalers of silverware including souvenir spoons stamped with their trademark.

FRANCES M. GLESSNER
Chicago, Illinois

Frances Glessner was briefly a student under Madeline Wynne and later studied with A. Fogliati, metalsmith associated with Hull House. She was a socialite, Mrs. John A. Glessner, who fitted out her conservatory as a metal shop. She made silver bowls, inkstands, salt cellars, hat pins, necklaces and jars which she gave to friends and family. She received commissions to make silver platters for wedding gifts. Her silver was marked with a G enclosing a bee - the latter reflecting her other interest - bee-keeping. She continued working in silver until c. 1915.

GLOBE ART MFG. CO.
Newark, New Jersey

Listed in JC 1915-1922 as manufacturers of sterling silver and plated silverware.

GLOBE SILVER CO.
New York, New York

Listed in directories 1957-61 as manufacturers.

JACOB GMINDER
Baltimore, Maryland

Listed as a silverplater 1867-1901 in Baltimore City Directories.

GODINGER SILVER ART CO., LTD.
New York, New York

A 1974 account states, "Godinger Silver Art Co. Ltd. has moved to 37 W. 26th St. New York City. The new quarters comprise 15,000 sq. ft. - more than three times the space occupied at the firm's former address at 45 W. 45th St.

"Adjacent to the office and showroom is a new factory where most of Godinger's handcrafted silver holloware and pewter merchandise is manufactured. In addition to special order work, retail jewelers are encouraged to use the firm's personalized merchandising program: products are supplied gift boxed and printed with the store's logo.

"Godinger will exhibit its new copyrighted designs for 1975 at the Atlantic City China and Glassware Show, as well as the Spring RJA Show in January." (JC-K Dec. 1974)

GOLDFEDER SILVERWARE COMPANY, INC.
Yalesville, Connecticut
See Birmingham Silver Co.

Established in 1932. Manufacturers of silverplated hollowares, namely candelabra, trays, water pitchers, champagne buckets, vegetable platters, combination platters, lazy susans, punch bowls and cups, tea sets, sugar and creamers, tea kettles and gravy bowls.

Trademark issued to Sol Goldfeder, New York. Succeeded by Birmingham Silver Co.

Used since Jan. 1, 1947

ALEXANDER GOLDMAN
New York, New York

Listed in directories 1920s and 1930s as manufacturer of sterling holloware, sterling religious articles.

GOLDMAN SILVERSMITHS CO.
New York, New York

Manufacturers (?) of sterling silver articles c. 1940-45.

GOLD RECOVERY & REFINING CORP.
New York, New York

Manufacturer (?) of sterling and silverplate c. 1940-45. Succeeded by Dunkirk Silversmiths, Meriden, Connecticut.

M.T. GOLDSMITH
Brooklyn, New York

Established in 1864 by Marcus Goldsmith as Goldsmith Brothers Smelting & Refining Company, Lexington, Kentucky. In 1882, his sons, Moses and Simon, succeeded to the business and in 1884 moved to Chicago. In 1909, the New York branch was opened by Simon. They were known as leaders in smelting and refining gold, silver and platinum. Listed by JC as out of business in 1909.

BRITANNIA ARTISTIC SILVER

GOLDSMITH'S STOCK COMPANY OF CANADA, LTD.
Toronto, Ontario, Canada

Firm formed by Henry Smith & Harris Fudger circa 1880. The two had formerly been senior partners in Robert Wilkes and Co. Acted as Manufacturer's agents for Roden Bros. (q.v.) selling Flatware, Holloware, Enamelled Souvenir ware, Sterling Silver and Cut Glass. The company also commissioned Robert Hendery (q.v.) and Hendery and Leslie (q.v.)to manufacture silver for them, which they stamped with their own mark. (Unitt & Worrall, *Unitt's Book of Marks*, 1995, p. 45)

Listed in JC 1915-1922 in the plated silver section. Listed in KJI 1922 and 1924 as wholesalers of watches, silverware, clocks, cutlery, jewelry, phonographs, ebony and ivory goods.

NICKELITE SILVER
SHEFFIELD CUTLERY

GOLDSTEIN & SWANK CO.
Worcester, Massachusetts

Listed in JC 1915-1922 as makers of plated ware, jewelers and special order work.

Became Goldstein, Swank & Gordon before 1936. This is the last record found.

JEREMIAH GOMPH
Utica and Albany New York

Spoonmaker in Albany 1855-1862; Utica 1862- c. 1865. He later became a jeweler. (JCW 2-5-1919)

GOODBY MFG. CO.
San Francisco, California

Listed in the 1931 KJI as special order work in silver holloware and gold ware; gold and silver plating, repairing and refinishing.

A.E. GOODHUE
Quincy, Massachusetts

Listed in 1950 JC- K and 1957 JBG under sterling and silverplate.

GOODNOW & JENKS
Boston, Massachusetts

Successors to Kennard & Jenks. They were established in 1893 to manufacture and sell sterling silverware. Walter R. Goodnow, formerly of Bigelow, Kennard & Co., was a financial partner only. Barton Pickering Jenks, son of the gifted designer Lewis E. Jenks of Kennard & Jenks, received his degree in architecture from M.I.T. about 1890 after beginning his college career for a year at Harvard.

Goodnow & Jenks were the principal silverware manufacturers of their time in Boston, concerned mainly with holloware. In 1904 or 1905 Jenks resigned and went to work for Wm. B. Durgin Co.

One of the senior silversmiths at Goodnow & Jenks was George F. Hamilton, Irish-born 1831, who arrived in Boston as a boy. He served his apprenticeship with Charles West (also possibly with Newell Harding whose Court Avenue address was nearby). Hamilton had been with Haddock & Andrews (Henry Haddock, 1811-92, apprenticed to Moses Morse, Boston; Henry Andrews, 1809-93) and with Haddock, Lincoln & Foss, before going with Goodnow & Jenks. When Goodnow & Jenks closed, Hamilton went with the Tuttle Silver Co.

Another silversmith at Goodnow & Jenks was Adolph Krass, born in Westphalia, Germany, in 1833. He came to this country at the age of about twenty and was first employed by Ferdinand Fuchs & Bros. (q.v.). It was Krass from whom George C. Gebelein (q.v.) obtained special attention during his apprenticeship at Goodnow & Jenks August 1893 to November 1897.

GOODWILL MFG. CO.
Providence, Rhode Island

Listed 1924 and 1927 KJI as manufacturers of flatware, dresserware and holloware.

ALLYN GOODWIN
Hartford, Connecticut

Allyn Goodwin is listed as a silversmith with his own shop in the Hartford Directories as early as 1840. Between 1845 and 1850 he appears as a jeweler in one city directory and as a silversmith in the other. In 1851 he was employed as a "pistol plater" by some other manufacturer, possibly Colt. From 1852 through 1867 his employment is listed as "electroplater", but his employer is not identified. Deceased by 1869.

HORACE GOODWIN
Hartford, Connecticut

Horace Goodwin, was born in Hartford, Connecticut in 1787. After learning the trade of silversmithing and jewelry making, he purchased the business of Nathan Allyn in 1810 and set up his own shop. The following year he went into partnership with Thomas D. Dodd, taking over the business of Heydorn & Imlay as well. Goodwin & Dodd continued in partnership until 1821.

From 1825 onwards Goodwin was in business alone. (Rainwater, *Silver,* Jan. -Feb.1996, p.16.)

The 1840 Hartford city directory lists a Horace Goodwin 2nd (presumably his son?) advertising that he had "constantly on hand for sale at reasonable prices, Watches, Jewelry, Fancy Goods, Musical Instruments, Music and Music Books, Looking Glasses, Housekeeping Hardware, and any quantity of Military Goods." Whether the original Horace Goodwin was still manufacturing silver is unclear.

By 1845 the ads were changed to read "Wholesale and Retail Dealer in Fine Watches,

Clocks, Time Pieces, Jewelry, Silver Spoons, Britannia Ware, Cutlery, Looking Glasses, Sheet Music, Musical Instruments and Military Goods, of every description. Also, Manufacturer and Dealer in Piano Fortes."

By 1851 "Horace Goodwin 2nd" had dropped the suffix from his name, suggesting that by that time his father was deceased. He continued to stock jewelry and fancy goods through 1853, but by 1854 he had switched to being only in the music business.

FREDERICK GORDON
Baltimore, Maryland

CHRONOLOGY

George B. Gordon	1864-1879
Gordon & Company	1880-1894
F.S. Gordon	1894-1897
Frederick Gordon	1898-1899

Silverplaters.

GORHAM CORPORATION
Providence, Rhode Island

CHRONOLOGY

Gorham & Webster	1831-1837
Gorham, Webster & Price	1837-1841
J. Gorham & Son	1841-1850
Gorham & Thurber	1850-1852
Gorham & Company	1852-1865
Gorham Mfg. Company	1865-1961
Gorham Corp.	1961-present

Jabez Gorham, founder of the Gorham Corporation, was born in Providence, Rhode Island, in 1792 and at 14 began his seven year apprenticeship to Nehemiah Dodge. After serving his apprenticeship, he formed a partnership with Christopher Burr, William Hadwen, George C. Clark and Harvey G. Mumford about 1815-1818 at which time he purchased his own shop to manufacture small items and became known for his "Gorham chain," unequaled at the time.

With Stanton Beebe he made jewelry until 1831, when Henry L.Webster, formerly with Lewis Cary in Boston, joined the firm to make silver spoons. The firm name was changed to Gorham & Webster. In 1837, the firm became Gorham, Webster & Price. When Gorham's son, John, joined the firm in 1841, the name was changed to Jabez Gorham & Son. John Gorham quickly recognized the advantages of machinery, and as a result the Gorham Company was among the first to introduce factory methods to augment hand craftsmanship in production of silverware. He designed and made much of the machinery himself if none was available to suit his purposes.

In 1850, three years after Jabez Gorham retired, the company name was Gorham & Thurber. By 1852, it was Gorham & Company. The firm was chartered by the Rhode Island Legislature as the Gorham Manufacturing Company in 1863 and organized as a corporation in 1865. In 1868, they abandoned the coin silver standard (900/1000) and adopted the sterling standard of 925/1000 fine silver. At the same time, the familiar trademark—a lion, an anchor and a capital G—was adopted for use on all sterling articles. Ecclesiastical wares of gold, bronze, stone, wood and sterling were added in 1885. *L'art nouveau* designs of the talented English artist, William Christmas Codman, were added under the name "Martelé" in the late 19th century.

The Gorham Company has employed other silver designers who became well known in their own right. Among them were Erik Magnussen (q.v.) and Thomas J. Pairpoint (q.v.).

By 1863, the company decided to use its facilities for making electroplated silverwares using nickel silver as the base. Made entirely of nickel silver, these wares were processed by the same general methods used in making sterling silverware, even to the use of silver solder in assembling the component parts. The tooling and die work occupied about two years so that it was not until 1865 that the first of their silverplated line was marketed. The firm temporarily ceased production of their silverplated flatware May 1,1962 but it is now again part of their output. Silverplated holloware also continues to be produced.

Holding companies were chartered in New York during 1906 and 1907 for the purpose of acquiring the Whiting, Durgin and Kerr companies. These corporations in the order of their formation were known as the Silversmiths Stocks Company and The Silversmiths Company. In the reorganization of the Company in 1924, the Silversmiths Company was purchased, its assets taken over and the company dissolved. The Gorham Company then operated as subsidiary divisions, the Whiting Mfg. Co. (moved to Providence in 1925); William B. Kerr Company, (moved to Providence in1927); and William B. Durgin Company, (moved to Providence in 1931).

About 1913 the Gorham interests expanded to include the Mt. Vernon Company Silversmiths, Inc. which had resulted from the merging of the Roger Williams Silver Company of Providence, Rhode Island, the Mauser Manufac-

turing Company of Mt. Vernon, New York and Hayes & McFarland of New York City.

The Alvin Silver Company was acquired in 1928 and its title changed to The Alvin Corporation. Its products are made at the Providence plant, though it functions as an organization separate from The Gorham Company.

The Gorham retail store at 5th Avenue and 47th Street in New York merged with Black Starr and Frost in 1929 under the new firm name of Black, Starr and Frost-Gorham Inc. In 1962 The Gorham Company sold its interest and the name became Black, Starr & Frost, Ltd.

In 1931 the McChesney Company of Newark, New Jersey was purchased and its tools and dies moved to Providence.

The Quaker Silver Company of North Attleboro, Massachusetts, was purchased in 1959, the Friedman Company of Brooklyn, New York, in 1960 and Graff, Washbourne & Dunn of New York in 1961.

The Gorham Company was sold to Textron, Inc. in 1967. In 1989 Gorham was again sold, this time to Dansk International Designs. Dick Ryan served as president of the company from 1989 to 1991. Brown-Forman Corporation purchased Gorham and Dansk International Designs in the spring of 1991.

At all periods the Gorham Company has been noted for the fine quality of its die work as well as superior design and fine finishing of all products.

Gorham's familiar trademark was registered (#33,902) Dec. 19, 1899 at which time it was stated that it had been in use since January 1, 1853. The Gorham Company now states that this trademark was used as early as 1848 and that from 1848 to 1865 the lion faced left rather than right.

STERLING MARKS:

The Authenic trademark was used on articles that are Art Nouveau in feeling but Greek in inspiration. Sterling silver is combined with other materials.

NEWPORT STERLING
TWINKLE STERLING
VOGUE

SILVERPLATE MARKS:

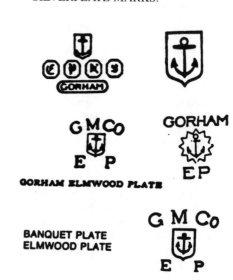

SUFFOLK SILVERPLATE

Tradename used with Gorham's silverplate mark and METROPOLITAN MUSEUM REPRODUCTION.

OTHER METAL MARKS:

Gold

GORHAM

GORHAM
Pewter

Bronze

GORHAM YEAR MARKS:

A.	1868	⚓	1902
B.	1869		1903
C.	1870		1904
D.	1871		1905
E.	1872		1906
F.	1873		1907
G.	1874		1908
H.	1875		1909
I.	1876		1910
J.	1877		1911
K.	1878		1912
L.	1879		1913
M.	1880		1914
N.	1881		1915
O.	1882		1916
P.	1883		1917
Q.	1884		

	1885		1918
	1886		1919
	1887		1920
	1888		1921
	1889		1922
	1890		1923
	1891		1924
	1892		1925
	1893		1926
	1894		1927
	1895		1928
	1896		1929
	1897		1930
	1898		1931
	1899		
	1900		
	1901		

Holloware year markings have been used since 1868. Letters of the alphabet A through Q were used from 1868 through 1884 at which time symbols were adopted for each year until 1933 at which time they were discontinued.

1932 1933

In January 1941, year markings were resumed on sterling holloware except lower priced items.

1941

The square frame indicates the decade of the 40s. The numeral indicates the year of the decade.

The pentagon indicates the decade of the 50s. The numeral indicates the year of the decade.

1950 1951

The hexagon indicates the decade of the 60s. The numeral indicates the year of the decade.

1960 1961

The heptagon indicates the decade of the 70s. The numeral indicates the year of the decade. And so on.

1970 1971

This marking will be used only on heavy sterling items such as tea sets and on specially made sterling items for individual consumers. The Christmas items such as the Snowflake will be back stamped with a four digit numeral to indicate the year of production.

At one time flatware was made in as many as five different weights for the same pattern. The letters below are those used to indicate these weights:

T for Trade
M for Medium
H for Heavy
EH for Extra Heavy

Regular weight had no marking.

Gorham's archival records are now at the John Hay Library, Brown University. Open to researchers by appointment.

For further information see Carpenter, *Gorham Silver, 1831-1981*, 1982, and Culme, *The Directory of Gold & Silversmiths*, 1987 reprinted 1992 pp. 187-188.

One of a matched pair of Gorham & Thurber goblets with chased decoration of the Arms of Smith. An example of the first holloware produced by the Gorham firm. The quality of the chasing is extraordinary. D. Albert Soeffing Collection. (Photo courtesy D. Albert Soeffing)

Martelé

950-1,000 Fine

Opposite page:

Bottom right: *Close-up of "Lady Washington" pattern. This elegant pattern appears to be scarce. (Photo by H. Ivan Rainwater)*

Bottom left: *Martelé ewer and tray designed by William C. Codman for the Gorham Company. A graceful expression of Art Nouveau. (Photo courtesy of Gorham Corporation)*

"Lady Washington" sterling flatware designed and patented by George Wilkinson for the Gorham Company. (Design Patent No. 9,420, August 1, 1876) (Photo by H. Ivan Rainwater)

GORHAM COMPANY OF CANADA
Montreal, Canada
See Gorham Corporation
See Henry Birks & Sons

Little is known about Gorham's Canadian subsidiary, which was located in Montreal, Canada in the early 1900's. George Chillas served as president of the company, which was purchased by Henry Birks and Sons about 1907. By the terms of the agreement, Gorham promised to conduct no business in Canada for ten years.

The company used the same pseudo hallmark as the parent corporation. On April 11, 1904 the firm obtained Canadian copyright No.2,156 for a spoon design with maple leaves on the handle. (Pack, *Collector's Guide to Canadian Souvenir Spoons*, 1988, p. 29)

JOHN T. GOSWELL
Baltimore, Maryland

Listed in Baltimore city directories 1864-1868 as silverplaters.

GOTHAM SILVER CO., INC.
New York, New York

Manufacturers of plated silver holloware c. 1920. Last record found was 1950.

WEAR-WELL

GOULD & WARD
Baltimore, Maryland

James Gould and William H. Ward were successors to Gelston & Gould, silversmiths, c. 1810-1820. Became Gould, Stowell & Ward, c. 1855.

GOULD, STOWELL & WARD
Baltimore, Maryland

James Gould, A. Stowell, Jr., William H. Ward, silversmiths and dealers in jewelry. Advertised silverware made to order. Listed in Baltimore City Directory 1855-1856.

GRAF & NEIMANN
Pittsburgh, Pennsylvania

Manufacturers of silverware c. 1900.

GRAFF, WASHBOURNE & DUNN
New York, New York
See Gorham Corporation
See Wood & Hughes

The predecessors of Graff, Washbourne & Dunn may be traced back to William Gale who was active in silversmithing in New York in 1833. He was followed by the firm of Wm. Gale & Son, then Gale, Wood & Hughes, and Wood & Hughes.

In 1899, Wood & Hughes sold their factory to Graff, Washbourne & Dunn who at once incorporated. Charles Graff was president, designer and factory manager. Clarence A. Dunn was vice-president and treasurer, also manager of the business and general executive. William L. Washbourne was secretary and in charge of sales. Graff died in 1931 and Washbourne in 1941.

Dunn acquired the stock of both and in 1942 became sole owner and then sold his entire holdings, including the corporate name, to Harrison W. Conrad, who became president, and Eugene Rossi, who became treasurer. The company was purchased by the Gorham Corp. in 1961. Graff, Washbourne & Dunn were makers of sterling silver holloware and novelties.

GRANAT BROS., INC.
San Francisco, California

Registered trademark for use on silver flatware, silver services, jewelry and novelties made wholly or partly of precious metal. Published Dec. 6, 1949. Granat Bros. bought Shreve, Treat & Eacret in 1941. Now (1986) owned by Bailey, Banks & Biddle.

Granat

Used since Aug. 1, 1929.

GRAVES BROS.
Brooklyn, New York

Silverplaters in business at least as early as 1873. (The 1871 and 1872 Brooklyn directories are unavailable.) George Graves and Edward Graves worked for the company in 1873. George Graves and Frank S. Graves in 1874 and 1875. In 1876 George Graves is listed as a silverplater working alone. Not followed after 1876.

R.B. GRAY & COMPANY
San Francisco, California

Listed in San Francisco city directories 1855-1872 as retailers and manufacturers of jewelry and silverware. Robert Gray, in 1868, was described as one of the "most extensive manufactories of silver ware in this city..."

GREAT EASTERN SILVERWARE CO.
Location unknown

Mark found on a silverplated butter dish dated circa 1880's.

QUADRUPLE PLATE

GREATREX LTD.
New York, New York

Trademark registered May 29, 1951 for use on sterling silver, silverplated and silver mounted flatware and holloware.

Used since 1947

GREENFIELD CUTLERY CO.
Greenfield, Massachusetts

Advertised as manufacturers of silverplated cutlery in *Harper's Weekly*, December 24, 1881, p. 880.

GREEN-SMITH CO.
Denver, Colorado
See Frederick L. Smith

GREGG SILVER CO., INC.
Taunton, Massachusetts

Manufacturers of silverplated holloware. Photographed mark is from a teapot dating mid-twentieth century.

F.L. GREGORY
Niagara Falls, New York

Listed in the 1886 Niagara Falls Directory as makers of silver and plated silverware.

CHARLES W. GRESHOFF
Baltimore, Maryland

Gold and silversmith. Listed in Baltimore City Directories 1888-1898.

FRANCIS A. GRESHOFF
Baltimore, Maryland

Gold and silversmith. Listed in Baltimore City Directories 1864-1885. Succeeded by Frances A. Greshoff & Son in 1887. This listing continued through 1894.

GRIFFIN SILVER PLATE CO.
Elgin, Illinois

An 1893 account reads:"The Griffin Silver Plate Co.'s factory, Elgin, Illinois, has started up with a small force of hands." (JC&HR 2-1-1893, p. 17)

GRIFFON CUTLERY WORKS
New York, New York

Began business before 1904 as Silberstein, Hecht & Company, soon succeeded by A. L. Silberstein and has been Griffon Cutlery Works since 1915.

ED. GRONEBERG
Baltimore, Maryland

Listed in 1855-1856 Baltimore City Directory as a manufacturer and dealer in fine gold jewelry and silverware.

GROSJEAN & WOODWARD
New York, New York
See William Bogert

Charles Grosjean was a silversmith in Wurtemberg, Germany. He came to New York in 1836. The partnership of Grosjean & Woodward was listed in Boston in 1840. Although it was previously reported that Charles Grosjean and Eli Woodward were silversmiths in New York from 1852 to 1862, the New York City directories show no record of an Eli Woodward.

The firm first appears in the New York City directories in 1853 with John H. Woodward associated with the business until 1862. When the partnership ended, Charles Grosjean apparently continued on in business by himself. In 1865 Charles T. Grosjean (a son?) is also listed as a member of the firm. Charles Grosjean last appears in the directory published in 1865. He died on January 30 of that year.

John H. Woodward is not found in the New York City directories between 1863 and 1865, but is shown working for Francis W. Cooper (q.v.) in 1866, after which he again disappears from the directories.

In 1866, William Bogert (q.v.) bought out Grosjean's estate and established the firm of William Bogert & Co. in partnership with Bernard D. Beiderhase. (Soeffing, in Venable's *Silver in America*, 1994, biographical section, p. 316)

Grosjean & Woodward was a major supplier for Tiffany & Co.

Charles Grosjean (a son?) designed the Tiffany Indian Dance spoons and patented them February 10 and 17, 1885. In addition he designed several full line flatware patterns for Tiffany.

G & W

LEWIS GUIENOT
Baltimore, Maryland

Listed in Baltimore City Directories 1870-1877 as a gold and silverplater.

PETER GUILLE LTD.
New York, New York

Mark found on a solid silver sauce boat dated circa 1920s.

A.T. GUNNER MFG. CO.
Attleboro, Massachusetts

Albert T. Gunner was born January 23, 1897, in Wallingford, Connecticut, second son of Charles R. and Etta (Simmons) Gunner. He attended public school in Providence, Rhode Island and Attleboro, Massachusetts, and, in 1919, took night courses in Accounting in New York City.

On July 5, 1912, he went to work to learn a trade as a spinner at the Watson Company in Attleboro, Massachusetts. Later he worked for F.W. Whiting Company in North Attleboro as foreman of the Spinning Department.

In 1918 he enlisted in the Army and was stationed in New York City with the Chemical Warfare Service. He was a Sergeant at the end of the war.

He then went to work as a metal spinner for the Gorham Company in New York City. Upon leaving that company, he was employed by Graff, Washbourne, & Dunn as a spinner.

In 1920 he returned to Attleboro and started his own business for the manufacture of sterling silver holloware. It has been in operation ever since. (1975)

In 1921 Mr.Gunner married Grace Elizabeth Mahler of New York City.

An ancestor by the name of Gunner, who was in the agricultural business, was given an order by the King of England in 1660 to supply cannon for the army. In recognition for this, he received the coat of arms which has been passed down in the family. The Latin inscription on it says, "We are known by our deeds." In Birmingham, England, there is a Gunner's Lane named after this ancestor.

BENJAMIN GURNEE
New York, New York
See Samuel H. Johnson

CHRONOLOGY

Benjamin Gurnee	? before 1852-1855
Johnson & Tobey	1856-1858
Gurnee & Tobey	1859-1860
Gurnee & Johnson	1861

Benjamin Gurnee is found in the New York City directories at least as early as 1852. Listed as a silversmith at 17 John Street until 1855. He disappeared from the directories for three years, and the firm of Johnson & Tobey (q.v.) occupied his location. In 1859 he re-appeared in partnership with Edward M. Tobey (formerly of Johnson & Tobey) still at the same location. By 1861 Tobey had left the firm and Samuel H. Johnson had rejoined it.

Gurnee is not found in the directories after 1861. Johnson went on to become a member of the firm of Kidney, Cann & Johnson.

GUSTERMAN'S SILVERSMITHS
Denver, Colorado

In 1951 Stig and Astrid Gusterman came to Denver, Colorado from Sweden and established Gusterman's Silversmiths. The firm began by producing sterling jewelry and church work. When Stig died in an automobile accident in 1964, Astrid chose to continue the business.

In 1970 Mary Eckles joined the firm as an apprentice to Astrid, working under her guidance until Astrid's death in 1976. In 1978 Eckles purchased the business, and has owned and operated it ever since.

She designs and produces awards, corporate pins, jewelry, sculpture, flatware and holloware, and also does some restoration work. Every fall she designs a limited edition snowflake. She also produces custom designed jewelry and objects in sterling or 14 K gold. Her style is a blend of traditional and contemporary. She uses four different sized stamps as appropriate to the piece being made, and engraves her mark on pieces too fragile to stamp.

Stig Gusterman

 ME

Mary Eckels

PIERRE A. GUY
New York, New York
See Charles E. Huntington

Pierre A. Guy appears in the New York City directories as early as 1852 as a dealer in clocks and watches. By 1855, he is listed as a gilder, and by 1857 as a plater. During the early 1860's he advertised himself in the directories as a "Manufacturer of Britannia, German Silver, and SILVER PLATED WARE, Fire Gilder, and Gold & Silver Electroplater on all kinds of metals. ..." During this time he apparently maintained a separate jewelry business as well.

In 1868 he entered into a partnership with Charles E. Huntington (q.v.) and his son Pierre A. Guy, Jr. in a firm called Huntington & Guy, perhaps in an attempt to set his son up in business. In 1869 he was apparently operating only his jewelry business. Not found after 1869.

FREDERICK J.R. GYLLENBERG
Boston Massachusetts
See Handicraft Shop

Frederick J.R. Gyllenberg was one of the silversmiths in the Handicraft Shop during the early 1900s. A member of the Arts and Crafts Movement. He later entered into a partnership with Alfred H. Swanson. The "H anvil S" in the mark shown below is the Handicraft Shop mark. The initials "FG" are Gyllenberg's personal mark denoting that he was the one who made the piece.

GYLLENBERG & SWANSON
Boston, Massachusetts

Partnership of Frederick J.R. Gyllenberg and Alfred H. Swanson at 514-516 Atlantic Avenue, Boston, in 1926. The marks of both men are shown together, with Gyllenberg's mark above Swanson's.

Gyllenberg shared facilities on Atlantic Avenue with Swanson, Leinonen and Son. Following the1930s depression, he entered the automobile service business with a garage in Islington, Dedham, Massachusetts.

H

J.H. FERD. HAHN
Baltimore, Maryland

Listed 1899-1911 Baltimore City Directory as a silverplater and metal worker.

WILLIAM E. HALE
New York, New York
See Hale Brothers

William E. Hale appears as an electroplater in the New York City directory published in 1872. He may possibly be the same William E. Hale who earlier formed part of the firm of Hale Brothers (q.v.) His ad in the directory states "W.E. Hale, Gold, Silver, and Copper ELECTROPLATER...Particular attention paid to Plating Fine Steel Work of all descriptions". He is also found in the directories published in 1873 and 1874. Not followed beyond 1874.

HALE & MULFORD
New York, New York
See S. Cottle Company

CHRONOLOGY

Lewis J. Mulford	1865-1870
Mulford & Co.	1871-1872
Mulford, Hale & Cottle	1873-1877
Hale & Mulford	1877-1882
S.W. Hale & Co.	1882-1884

The company traces its history back, in the New York City directories, to the formation of Lewis J. Mulford's jewelry business in 1865. In 1872 Shubael Cottle joined the firm of Mulford & Co. In 1873 Seth W. Hale joined the business and the firm became Mulford, Hale & Cottle.

Hale was both a jeweler and a banker. He had worked for Charles E. Hale in the jewelry business from the early 1850s through 1866. He worked as a banker between 1867 and 1871, then entered into the partnership with Mulford and Cottle in 1873.

Hale & Mulford was formed in early 1877 when Shubael Cottle retired from Mulford, Hale & Cottle. Within a few weeks of Cottle's departure, the Waltham Building at 1 Bond St. which housed the partnership, along with many other jewelry and silver firms, burned to the ground. Fortunately, Hale & Mulford had insurance.

The firm moved to the Whiting Building at Broadway and Fourth Street. It advertised "Stone & Stone Cameo Goods, Rings, Necklaces, Colored and Etruscan Work, Etc. First Class Goods of Our Own Make Exclusively." (Cramer, *Silver,* May-June 1991, p. 33)

L.J. Mulford retired in 1882, and the business became S.W. Hale & Co. In 1884 Hale gave up the business, joining with a group of friends to purchase *The Circular* from the widow of its founder, D.H. Hopkinson. Upon Hale's death in December 1888, Mulford took over the management of the journal, which had become the *Jewelers' Circular and Horological Review*, a publication which continued to be an important informational resource on the silver and jewelry trade.(Cramer, ibid., p. 35) It merged and became part of *Jeweler's Circular-Keystone* in the 1930s.

HALE BROTHERS
New York, New York

William E. Hale appears in the New York City directory published in 1855 as an electroplater in business at 59 Nassau St. The following year, his brothers Frederick E. Hale and James O. Hale joined him to form the firm of Hale Brothers.

The company's ad in the 1856 directory reads: "Hale Brothers, dealers in every description of plated German silver & Britannia ware, 59 Nassau, 4th Story. Electroplating of all kinds done in the best manner, and warranted full weight at moderate prices. None but practical workmen employed. Reference Cooper & Fellows, 11 Maiden Ln." Not found in the directories after 1857.

HALE, HENDRICK & FORD
New York, New York

Firm formed by David Hale, James A. Hendrick and Edwin L. Ford. Listed as electroplaters in New York City directory published in 1867. Succeeded by Hendrick & Deacon the following year.

WILBUR B. HALL
Meriden, Connecticut

Specialist in silverplated peppers and salts, napkin rings, cups and other small articles. He was the son of Lewis Hall, superintendent of Wilcox Silver Plate Co. The business started in 1886 and continued for about 50 years. (*Meriden Journal* Anniversary Issue, April 17, 1936)

HALL BROS. & CO.
Pittsburgh, Pennsylvania

Wholesale and retail outlet in business c. 1910-1915.

HALL, BOARDMAN CO.
New York, New York
Philadelphia, Pennsylvania

Hall, Boardman & Company and its successor, Hall and Boardman, are listed in the Philadelphia and New York City Directories from 1845 through 1856 as makers of britannia wares. The New York firm apparently was solely a retail outlet.

HALL, ELTON & CO.
Wallingford, Connecticut
See International Silver.Co.
See Maltby, Stevens & Curtiss
See Watrous Mfg. Co.

In 1837 Deacon Almer Hall, William Elton and others formed the firm of Hall, Elton & Co. for the manufacture of German silver flatware and britannia ware. The company remained focused on flatware manufacture through the early 1860s. An ad in the 1861 New York City Directory describes the firm as, "manufacturers of every description of GERMAN SILVER SPOONS AND FORKS. Also Plated Spoons and Forks of every variety of pattern, and richly plated on the best quality of German Silver."

By 1872 the firm had expanded its offerings. In Harper's Weekly for October 26 of that year they proclaimed themselves, "Manufacturers of NICKLE SILVER TABLE-WARE, heavily plated with pure silver. A full assortment of Table, Dessert, Tea, Egg, and Salt Spoons; Table, Medium, Dessert, Pie, Oyster, Pickle , and Beef Forks; Soup, Oyster, Gravy, Cream and Mustard Ladles; Butter, Tea, Dessert, Cake, Ice-Cream, Pie, Crumb, and Fish Knives; Sugar Tongs, Shells and Sifters; Berry Shells, Nut Picks, Napkin Rings, &c. &c. All Goods warranted as represented.

"Also a full line of PLATED WHITE-METAL TABLEWARE."

They made britannia spoons at least until 1875.

In 1890 the company was purchased by Maltby, Stevens & Curtiss which was in turn purchased by Watrous Mfg. Co. In 1898 they were one of the original companies to become part of the International Silver Co.

The firm registered a U .S.Trade Mark Patent, January 20, 1873 for use on flatware.

German Silver Flatware

HALL, HEWSON & BROWER
Albany, New York

Manufacturers of solid silver flatware between 1846-1852. (Kelly, *Silver*, Mar.-Apr. 1991, p. 16.)

HALLMARK SILVERSMITHS, INC.
New York, New York

An advertisement by Hallmark appeared in the *Saturday Evening Post* in 1917. The Hunt Silver Co., Inc. and Hallmark Silversmiths, Inc., merged in 1954 to form Hunt-Hallmark Co. Officials, Carl K. Klein, Joseph C. Hirsch and Irving L. Hirsch.

HALLMARK

ANTHONY HALM
New York, New York

Anthony Halm first appears in the New York City directory published in 1860 in partnership with John Hill, in the firm of Hill & Halm, platers. This John Hill may possibly be the same John Hill (q.v.) who was listed earlier as a britanniaware manufacturer.

By 1861 Halm was in business on his own. For the next few years his listings sometimes say "britannia" and other times "plated ware". In 1865 he lists himself as "Manufacturer of britanniaware, castors & cups &c." The following year he is listed as "britannia & silverplated ware". Listings for the business continue through 1868. Halm is listed in 1869 as still being in the britannia ware business, but no business location is given. Not found after 1869.

CHARLES W. HAMILL & CO.
Baltimore, Maryland

Charles W. Hamill, manufacturer of silverplated wares, was born in Baltimore, Maryland, March 2, 1845. After eleven years work-

ing for someone else he entered business for himself in 1876 with ten employees. His business increased rapidly so that by 1878 he had 40 employees. The company was listed in Baltimore City Directories from 1877 to 1884 inclusive.

C.A. HAMILTON
Waterbury, Connecticut
See Rogers & Hamilton

U.S. Trade Mark Patent No. 13,289 issued May 11, 1886, was registered by Charles Alfred Hamilton, president of Rogers & Hamilton, for the manufacture of spoons, knives, forks, ladles, cheese-scoops, tea sets, casters, pitchers, waiters and napkin rings.

HAMILTON & DIESINGER
Philadelphia, Pennsylvania
See Davis & Galt
See M.F. Hamilton & Son

Hamilton & Diesinger were successors c. 1895 to Hamilton & Davis (Matthew F. Hamilton and Junius H. Davis) listed in Philadelphia City Directories in 1880. Davis was associated briefly with Charles E. Galt in the firm of Davis & Galt (q.v.). Hamilton & Diesinger were manufacturers and retailers of both sterling and silverplated wares. The partnership was dissolved in 1899 when Hamilton's interest was bought out by Diesinger. Hamilton and his son then opened their own business under the name M.F. Hamilton & Son (q.v.). In 1900 Diesinger sold what remained of the Hamilton & Diesinger business to Gimbel Bros.

HAMILTON & HAMILTON, JR.
Providence, Rhode Island

Trade Mark Registered U.S. Patent Office, No. 49,473, February 6, 1906.

This manufacturing jewelry business was established January 1, 1871 by R.S. Hamilton, R.S. Hamilton, Jr., and George C. Hunt. They began the manufacture of ladies' jewelry sets, lace pins and gentlemen's chains - all of solid gold. Six months later they began the manufacture of rolled plate chains. They advertised that they were the first makers of gold filled chains.

On April 27, 1886 they registered a trade mark patent for jewelry, chains, trimmings, cuff buttons, bracelets, lockets, cigarette holders and cases, knives and novelties. Listed from 1921-1935 as Hamilton & Hamilton Jr., Inc. Ralph S. Hamilton is still listed (1975) as a manufacturing jeweler not associated with a particular firm.

"Hamilton & Hamilton began in 1870 as Hamilton & Hunt. The firm became Hamilton & Hamilton in 1883." (JW 3-30-1892)

An 1893 account states, "Ralph Spence Hamilton, senior member of Hamilton & Hamilton, Jr., died at the residence of his son, Ralph H. Jr., early Tuesday. He was born in St. Louis, Missouri, June 14, 1829. When quite young his parents moved to New Orleans. At age nine he accompanied his parents to Jamaica, where his father became interested in the cultivation of sugar and owned extensive plantations. Here he remained until about 16 years of age, when he started out for himself. He went to New York and apprenticed himself to learn the jewelry business. He adopted his pursuit from the interest which had been manifested in watching the native Indians of Jamaica fashion ear-rings and other trinkets out of metal by the crude method of hammering. Having concluded his apprenticeship, he went to Attleboro in the early 60's where he engaged in business for himself . In 1870 he removed to this city (Providence) and with J. Hunt formed the well known concern of that period, Hamilton & Hunt, which began the manufacturing business on a small scale on Potter Street. The business grew rapidly and new and larger quarters had to be obtained, and the firm removed to 226 Eddy St. where it remained for more than a decade.

"The firm of Hamilton & Hunt was dissolved by mutual consent early in 1883, and on July 10 of that year the firm of Hamilton & Hamilton, Jr. was organized, Mr. Hamilton taking his eldest son, Ralph S. Hamilton, Jr. into partnership with him. The business increased steadily so that when the Enterprise Building was erected in the Spring of 1888 the factory was removed to the new building." (JC&HR 2-8-1893, p. 14)

M.F. HAMILTON & SON
Philadelphia, Pennsylvania

Successors to Hamilton & Diesinger before 1904, and out of business before 1909.

HAMILTON MINT
Arlington Heights, Illinois

The Hamilton Mint was organized in 1972 by a group of men with experience in art and minting who chose to found a new private mint specializing in medallions, ingots, plates and art forms honoring man's most noteworthy accomplishments in graphic arts and sculpture.

Their first major offering was announced August 1972 and was a series of three plates adapted from Picasso paintings in the National Gallery of Art, Washington, D.C.

HAMILTON MFG. CO.
Chicago, Illinois

An 1895 article notes:"The Hamilton Mfg. Co., Chicago, incorporated Wednesday to manufacture silverware with C. Van Allen Smith, Arthur R. Wells and Frederick H. Gade." (JC&HR 5-1-1895)

HAMILTON MFG. CO.

HAMILTON SILVER MFG. CO.
New York, New York

Absorbed by T.N. Benedict Mfg. Co. in 1912 and moved to East Syracuse, New York.

HAMILTON SILVER MFG. CO.
New York

JAMES B. HAMLIN
North Bridgton, Maine

Pewterer. Currently (1975) in business.

HAMMERSMITH & FIELD
San Francisco, California

John A. Hammersmith and Hampton S. Field were listed in city directories from at least 1899 to 1908 but had terminated before 1915. Attributed to their shop are trophies for the K.T. Conclave and some souvenir spoons with the seal of the State of California on the handle.

HAMPSHIRE SILVER CO.
New York, New York

In directories c. 1950s through 1960s as manufacturers.

HAMPTON ROADS CUTLERY CO.
Norfolk, Virginia

Listed in JC 1915 and KJI 1918-19 as Hampton Roads Silver Company, manufacturers of silverplated ware and table cutlery.

HAND AND HAMMER SILVERSMITHS
Alexandria, Virginia
See Chip de Matteo
See William L. deMatteo

The firm traces its origins back to about 1975 when Chip de Matteo (q.v.) began working independently as a silversmith in Washington, D.C. In 1979 he received a large order from the Smithsonian Museum Gift Division. At about the same time, his father, William L. deMatteo (q.v.) decided to retire from working at Colonial Williamsburg. With Philip Thorp who had also worked there, the deMatteos formed a partnership called Hand and Hammer. After the death of William L. deMatteo in 1988, the firm moved to Woodbridge, Virginia.

Although small in size, having only about 18 employees, the company's achievements are impressive. This firm has specially developed hundreds of jewelry designs for the museum merchandising programs at the Smithsonian Institution, Colonial Williamsburg, Boston Museum of Fine Arts, Art Institute of Chicago, National Trust for Historic Preservation and more than 50 other museums. Hand & Hammer's Collection also includes handmade Christmas ornaments based on motifs and designs found in America's important museums. Most are of sterling silver while some are crafted in pewter.

Phi Beta Kappa has designated Hand & Hammer sole supplier of their keys to their initiates. The firm also has many important corporate and commercial customers. These include Tiffany & Co.; AT&T, for whom an abstract sculpture was designed to mark the company's 100th anniversary; the Masters' Golf Tournament; Mass Mutual Insurance Company; Lord & Taylor; The Horchow Collection and many others.

The firm marks its jewelry either H & H or Hand and Hammer. Its ornaments and holloware are usually marked de Matteo. However much of the firm's production is private label items which bear the marks of its customers.

HANDICRAFT SHOP
Boston, Massachusetts

The Handicraft Shop "was founded in 1901 as an adjunct of the Boston Society of Arts and Crafts to encourage the production of handmade silver and other metalwork. Working space was made available to qualified silversmiths who owned their own tools and created their own products independently of each other. The products were either commissioned in advance or sold through the retail shop of the Society of Arts and Crafts. Margaretha Gebelein Leighton in her biography of her father, George C. Gebelein, tells us that between 1901 and 1908 at least eight silversmiths worked at the Handicraft Shop, though only about three or four were there at any one time. These early craftsmen were: Mary Knight, who in addition to carrying on her individual work was the first manager of the shop; Karl F. Leinonen; George C. Gebelein; Frederick Gyllenberg; Adolph Kunkler; C.R. Forssen; Mary Hersey; and Seth Ek. Handicraft Shop silver normally carried the mark of HS with an anvil between, the word "sterling," the date, and the individual maker's mark which in most cases,...is a single letter, the initial letter of the maker's last name. Any one of these last three marks however, may sometimes be missing." (Williams, *Silver*, May-June 1988, p. 18)

A.H. HANLE, INC.
New York, New York
See Hanle & Debler, Inc.

Silversmith. Also listed as pewterer. Firm formed in 1935 after Debler retired from Hanle & Debler.

HANLE & DEBLER, INC.
New York, New York

Founded in 1933 by Adolf Hanle, from a family of silversmiths. He was trained as a spinner near Stuttgart, Germany. He worked from 1929 to 1932 for Samuel Kirk & Son, Inc. as a spinner. Let out for lack of work along with five other spinners, he went to New York City and started the firm of Hanle & Debler, Inc. His partner, Debler, retired in 1935 at which time the firm name became A. H. Hanle, Inc. It was operated as a small family business.

Hanle's products, reflecting Adolf Hanle's European background, are clean and tend toward the contemporary. More recently, colonial reproduction styles have met with success. Hanle products are offered in both polished and satin finishes.

In June 1971, the firm was purchased by The Kirk Corporation.

HANNA & DELAGRAVE
Quebec City, Quebec, Canada

James Godfrey Hanna worked in Quebec from 1803 to 1818. Francois Delagrave worked in Quebec from 1816 to 1831. The mark shown below dates from the period of their partnership, 1816-1818. The script JH, the V and the Lion are Hanna's marks. The FD is Delagrave's. Apparently Hanna went bankrupt in 1818 and was no longer found in the record. Delagrave continued the business at least until 1831. (Williams, *Silver* Jan.-Feb. 1986, p. 27.)

NEWELL HARDING & COMPANY
Haverhill & Boston, Massachusetts

Newell Harding (b. 10-20-1796, Haverhill, Mass.) was a silversmith who apprenticed to his brother-in-law, Hazen Morse. He went into business for himself in 1822. Under his own name and later as Newell Harding & Co., he made plain spoons in a factory in Court Street, Boston. The firm had a high reputation and did considerable business.

Harding remained active in the silversmithing industry until his death, May 31, 1862. His partner, Louis Kimball, continued the business for a short time. In 1863 the firm was taken over by Harding's three eldest sons, who continued to use the mark "N. Harding & Co." (Soeffing, *Silver Medallion Flatware*, 1988, p. 52)

By 1866 the company was advertising itself as silversmiths and silver platers, and using the trade mark "N. H. & CO. PLATED" on its plated goods, according to an advertisement in the *Boston Evening Transcript* on December 19 of that year. Their plated ware was warranted to be: "equal in thickness of Silver to any manufactured in Sheffield."

Ensko (*American Silversmiths & Their Marks III*) credits Harding with introducing power to the rolling of silver.

Gibb (*The Whitesmiths of Taunton*) identifies the Harding company as one of those who operated its own silverplating establishments and purchased goods "in the metal."

The firm remained in business until at least the late 1870's. (Soeffing, ibid)

The mark shown below is taken from a billhead.

THE HARD WHITE METAL CO.
Shelton, Connecticut

Manufacturer of silverplate holloware circa 1880.

J. L. HARLEM MFG. CO.
New York, New York

James L. Harlem first appears in the New York City directories in the early 1860's as a manufacturer of spectacle cases and leather goods. In 1865 he added silverware to his line, and from 1866 through 1870 he appears as a plater. An ad in the *New York Times* for December 22, 1866, describes the company as " Manufacturers of Silver Plated Goods, Comprising Tea Sets, Coffee Urns, Goblets, Salvers, Table and Wine Casters, Ice Pitchers, Card and Cake Baskets, Butter Dishes, &c. &c., Also Knives, Forks and Spoons". For 1871 and 1872 Harlem is listed simply as a dealer in "fancy goods". Not listed after 1872.

HARPER & McINTIRE CO.
Ottumwa, Iowa

Silverplaters c. 1920.

HAR-MAC

HARRINGTON & MILLS
Baltimore, Maryland

Listed in Baltimore City Directories 1868-1874 as silverplaters.

R. HARRIS & CO.
Washington, D.C.

Established in 1876 according to an advertisement in the November 1899 issue of *Century Magazine*. Manufacturing jewelers and silversmiths according to their catalog E, published c. 1898. The firm offered a variety of solid silver novelty items and gold jewelry. No trademark but the company name. No longer listed in the Washington, D. C. Directory.

THOMAS B. HARRIS
New Orleans, Louisiana

Listed as silversmith in New Orleans city directory in 1871.

HARRIS & SCHAFER
Washington, D.C.

Listed in the Washington, D.C. Directories 1880-1938 as Harris & Schafer, Jewelers.

Edwin Harris was born in Charles County, Maryland in 1831. Educational facilities were limited at that time, so at a very early age he went to work in the store of Galt Bros. of Washington. He was taken into partnership in 1870 and remained there in that capacity for nine years. He then sold his interest and started a store of his own.

Charles A. Schafer, the junior partner, was born in Boonsboro in Washington County, Maryland. He moved to Washington, D.C., when ten years of age. He attended both Gonzaga College and Georgetown University. He entered the employ of Galt Bros. in 1849 and remained with that firm for thirty years, mastering the jewelry making and watchmaking business. When Harris opened his own store, Schafer chose to join him as a partner.

Trademarks were registered at the U.S. Patent Office in 1891and 1892 for gold, sterling

silver and plated silver flat and tableware. These trademarks were used on souvenir silver. It is doubtful if Harris & Schafer did any manufacturing themselves. They were noted, however, for the fine quality of silver, jewelry, watches, diamonds, artwares and crystal and glassware they sold. Much of it was imported from the finest houses in Europe.

HARRISON & GROESCHEL
New York, New York

Listed in JC 1896 in sterling silver section. Out of business before 1904.

LUCIUS HART MFG. CO.
New York, New York
See Charles E Harrington

CHRONOLOGY

Boardman & Hart	1828-1850
Lucius Hart	1850-1862
Lucius Hart & Co.	1863-1870
Lucius Hart Mfg. Co.	1871-1874+?

Lucius Hart is listed in New York City Directories 1828-1850 in connection with Timothy Boardman, pewterer, under the name Boardman & Hart. From 1850 through 1862 the listing was simply Lucius Hart, usually described as a Britannia Ware Manufacturer and metals dealer. However, as early as 1856, the firm was manufacturing plated goods, as indicated in a full page ad in the Brooklyn City Directory that year. The company is reported to have bought its holloware "in the metal" from Reed & Barton during the 1860's.

For the period from 1863 to 1870 the firm was listed as Lucius Hart & Company. Lucius Hart, Jr. first appears in the New York City Directories in 1864, and it is possible that the company's name was changed to reflect his association with the firm.

It is not clear exactly when the company was first incorporated, but it first appears in the New York City Directory Corporate listings in 1868. The company name changed to the Lucius Hart Manufacturing Co. about 1871, when

Lucius Hart, Sr. left the firm and Charles E. Huntington (q.v.) assumed the presidency. Huntington had joined the firm two years previously as the superintendent of the plated ware division.

The firm's history has not been followed beyond 1874.

Lucius Hart advertised frequently in the *New York Times* during the 1860's, and some of his ads were both topical and whimsical. One, dated December 9, 1862, reads, "Since the tax upon Silver ware, what a rush there is, to be sure, for GOOD PLATED GOODS, Upon which there is no tax levied. I have only time, in the midst of hurrying business, to say, that the best place to obtain the GENUINE ARTICLE is at the well-known store of Lucius Hart, Nos. 4 and 6 Burling slip."

Another ad, from December 25, 1862 reads, "YOU WOULD BE ASTONISHED!! AT WHAT, PRAY? To learn at what moderate prices Mr. Hart sells his PLATED GOODS. Indeed they are BROADWAY GOODS AT BURLING SLIP PRICES. And it pays to go a little out of the way to trade with him..."

In an ad in Harper's Weekly, December 19, 1868, the firm claimed to be "The Oldest Plated-Ware House in New York".

R.H. & A.W. HART
Brooklyn, New York

Silverplaters c. 1860.

HARTFORD GERMAN SILVER AND BRITANNIA WORKS
Hartford, Connecticut
See Ewins & Son

Name shown in the Hartford City Directories published 1865 through 1868 for the manufacturing facility belonging Ewins & Son. (q.v.)

HARTFORD HOLLOWARE CO.
Hartford, Connecticut

Reportedly, an off-shoot by some workmen previously in business with other Hartford silverware companies. In operation c. 1888-1901.

HARTFORD MANUFACTURING CO.
Hartford, Connecticut
See Hartford Plate Company
See Redfield & Rice Manufacturing Co.

CHRONOLOGY
Edmund Hurlburt	?-1840
Hurlburt & Johnson	1841
Hurlburt & Howard	1842-1845
Ashmead & Hurlburt	1846-1863
Hartford Manufacturing Co	1854-1862

The Hartford Manufacturing Company, a silverplating firm, was incorporated on September 23, 1854, according to the Hartford City Directories. Edmund Hurlburt served as President of the company, and James H. Ashmead served as Secretary and Treasurer. John W. Webster and Egbert W. Sperry were the other two members of the Board of Directors.

Ashmead and Hurlburt had been partners as goldbeaters (manufacturers of gold leaf) since 1846 and they continued in the goldbeating business in addition to operating their new silverplating firm. Prior to his partnership with

Engraving depicting the establishment of Lucius Hart, Manufacturer and metals dealer, from Smith's Brooklyn City Directory *published in 1856.*

Ashmead, Hurlburt had been involved in the plating and saddlery firms of Hurlburt & Johnson and Hurlburt & Howard (q.v.)

Egbert W. Sperry served as the Hartford Manufacturing Company's plant superintendent. He had first appeared in the Hartford City Directories in 1851, listed as a silversmith and spoon maker working at 36 Pearl St. O.D. Seymour occupied the ground floor at that location working as a silversmith with solid silver, while Asa Rogers worked upstairs as an electroplater. Since Sperry appears to have been involved in the silverplating industry for the rest of his working life, presumably he was working for Rogers at that time.

Leroy S. White worked as a machinist in Hartford between 1856 and 1858, and while there obtained two invention patents which he assigned to the directors of the Hartford Manufacturing Company. Patent No. 17, 475, granted on June 2,1857, was for an improvement in dies for punching fork tines. Patent No. 21,304, granted on August 24, 1858, was for an improved burnishing machine. White left to go to work for Rogers, Smith & Co. by 1859.

While the company produced primarily flatware, it also offered silverplated holloware, which it obtained "in the metal" from Reed and Barton.

The Hartford Manufacturing Co. was sold to a group of investors from New York City who were associated with the Redfield & Rice Manufacturing Company (q.v.) probably sometime in early 1863. These investors re-incorporated the firm as the Hartford Plate Company (q.v.) on March 25, 1863.

Ashmead and Hurlburt dissolved their partnership by 1864 and formed two independent goldbeating firms. Hurlburt died about 1866. Ashmead, at first alone but later in partnership with one or more of his sons, continued in the goldbeating business for many years.

HARTFORD PLATE CO.
Hartford, Connecticut
See Hartford Manufacturing Co.
See Redfield & Rice Manufacturing Co.

Silverplating firm organized by James H. Redfield and a group of investors to serve as the flatware manufacturing division of Redfield & Rice. According to the Hartford City Directory, the firm was incorporated on March 25, 1863 with James H. Redfield, of Redfield & Rice (q. v.), as President, and Wilbur F. Gleason as Sec-

retary-Treasurer. Gleason was a New York City banker and real estate investor.[1] Although the factory was located in Hartford, the firm's corporate offices were located with those of Redfield & Rice in New York.

The Hartford Plate Co. bought up the tools and materials of the former Hartford Manufacturing company (q. v.), and employed Egbert W. Sperry, the manager of the earlier firm, as its agent in charge of operations. When the factory building developed structural problems, the company began looking for a new location. Gleason, on his own, purchased a factory site in Wolcottville (now Torrington), Connecticut, in October 1865.

On February 26, 1866, Redfield and Rice and the Hartford Plate Co. were consolidated and incorporated as the Redfield & Rice Manufacturing Co.[2] The flatware division was moved to Wolcottville as the Redfield & Rice Manufacturing Co. with Sperry still in charge.

The items noted above reference the R. G. Dun & Co. Collection, Baker Library, Harvard University Graduate School of Business Administration. Volumes and page numbers are given below.
[1] NYC Vol. 406, p. 100FF
[2] NYC Vol. 373, p. 1354

HARTFORD SILVER PLATE CO.
Hartford, Connecticut
See Barbour Silver Co.
See International Silver Co.
See I. J. Steane Co.

Listed in Hartford City Directories from 1881 through 1893. Each listing accompanied by a half or full page advertisement.

The 1881 listing says they were manufacturers of fine electroplated holloware. Incorporators: James G. Batterson, E.N. Welch, Henry C. Robinson, W.H. Post, Jonathan Goodwin, James L. Howard and Rush P. Chapman.

They advertised "Everything in silver plate." An 1892 account reads "The Hartford Silver Plate Co. are engaged in refinishing and replating the beautiful candelabra of the White House, Washington, D.C." (JC&HR 9-21-1892, p. 30)

The firm was absorbed by Barbour Silver Co. in 1893 which became part of the International Silver Co. in 1898.

HARTFORD STERLING COMPANY
Philadelphia, Pennsylvania
See I.J. Steane Co.
See Tennant Company
See Phelps & Cary Co.

Successors(?) to the Tennant Co., New York, 1900.

The Philadelphia City Directories list the Hartford Sterling Company from 1901-1924. In 1901 and 1902 the listing refers to foreign plated ware. Subsequent listings are for plated ware. The 1907-1912 Directory lists Isaac J. Steane (probably Isaac J. Steane, Jr.), president, Arthur B. Wells, secretary and Jacob S. Hecker, treasurer.

A 1900 article reads: "The Hartford Sterling Co. has purchased the plant and business of Phelps & Cary Co. of New York and also Jacob S. Hecker & Co., mfgrs. of silver plated holloware. H.A. Cary went into business for himself." (JC-W 7-4-1900, p. 23)

The firm was listed at 5th & Baltimore Ave., Lansdowne, Pennsylvania as manufacturers of sterling and silverplated holloware in the 1931 Keystone.

The upper trademark. is identical to those of The Tennant Co. and Phelps & Cary Co., with the exception of the initials in the shield.

PETER HARTMANN
New York, New York

Peter Hartmann appears in the New York City directories in 1853 operating a firm called Peter Hartmann & Co. listed as silversmiths. By 1855 the firm was known simply as Peter Hartmann. An ad in Mason's Bros. Business Directory published in 1856 lists "Peter Hartman (sic.), Manufacturer of Plain and Filigree Silver Work, 158 William." This firm continued in business to about 1859.

In 1859 Peter Hartmann is listed as a "plater" in the New York City directory, with no shop address given. Apparently at that time he was working for someone else.

He re-appears in business for himself in the 1860 directory. In the 1861 New York City Directory he described his business as: "PETER HARTMANN, Manufacturer of Plain, Fancy, and Filigree Silver Ware, 298 Broadway, New York. Constantly on hand, Filigree Card Cases, Boquet holders, Card & Glove Baskets, Tea Strainers &c. Fancy Napkin Rings, Cups, Snuff Boxes, Portemonnaies, &c. All kinds of plain work made and warranted as represented. Country orders giving reference attended to. All orders executed with dispatch."

Hartmann appeared regularly in the city directories after that, with his business advertised simply as "silver", with the exception of the 1865 directory in which he is not found. The lack of listing may have been an oversight due to his change of address about that time. In the 1869 directory, he ran a shorter simplified version of the ad quoted earlier.

In 1871 he is listed in the directory as a jeweler. The 1872 listing describes him as a "manufacturer and importer of fine gold, diamond & filigree silver jewelry". In 1873 and 1874 he is again listed simply as a jeweler. Not followed beyond 1874.

HARVEY & OTIS
Providence, Rhode Island

Manufacturing jeweler and silversmith. Listed JC 1896 to present.

 H-O

HENRY C. HASKELL
New York, New York

Listed in JC in sterling silver and jewelry sections 1896-1904. Out of business before 1915.

HASKELL, BEECHER & CO.
Baltimore, Maryland

Listed in Baltimore City Directories 1885-1886 as silverplaters.

JOHN HASSELBRING
Brooklyn, New York
See Crown Silver Inc.

Founded about 1890 by John Hasselbring. Purchased by Crown Silver Inc. about 1954-1955 and is now (1975) a division of that company in New York. Their products are silver peppermills, bar accessories, silver trimmed salad bowls and silver trimmed cutlery.

Another trademark, containing a deer head, has been reported but not found.

HATTERSLEY & DICKINSON
Newark, New Jersey

William Hattersley is listed as a silversmith 1854-61and as "Britannia metal works" 1852-53, as a partner in Hattersley & Dickinson 1854-56 and with J. Hattersley & Son britannia metal workers 1856-61. Charles Dickinson is listed under britannia metal 1850-57. The Patent Office records show that they were granted a patent (Design Patent No. 657, July 4, 1854) for the ornamental design for a tea or coffee pot, the type of metal not specified. This tea and coffee service is illustrated in the E. Jaccard catalog of 1856 under Solid Silver Tea Ware.

E.V. HAUGHWOUT & COMPANY
New York, New York

CHRONOLOGY
Haughwout & Dailey	?1852-1853
E.V. Haughwout	1854-1856
E.V. Haughwout & Co.	1857-1874+?

The firm appears in the New York City Directories at least as early as 1852 as Haughwout & Dailey, a partnership of Eder V. Haughwout and William J.F. Dailey. The firm is listed simply as "importers" during this time period. By 1854, Haughwout and Dailey had gone their separate ways, each forming his own company, but continuing in the same line of business, importing fancy goods.

1857, the year that the firm became E.V. Haughwout & Co., is the first year that it is listed as "Importers & manufacturers" of "china, glassware, bronzes, silverplated ware, gas fixtures & parian statuary." In 1858 "sterling silver" and "mirrors" were added to the list.

It is difficult, from such a listing, to sort out which items were simply being imported and which were actually manufactured by the company. However, E. V. Haughwout & Co. was reported, in the 1860s, to have purchased wares from Reed & Barton "in the metal" (unplated) and to have operated its own plating establishment.

An ad from the *New York Times* for December 10, 1868 supports this contention that the firm did indeed produce its own plated ware. Among other things, the ad offers: "A FULL ASSORTMENT OF GORHAM PLATED WARE, At Manufacturers' Prices, Also, FINE PLATED WARE, EXTRA QUALITY, OF OUR OWN MANUFACTURE."

In 1870, in addition to its importing business, E.V. Haughwout & Co. became agents for other firms. In 1870 and 1871, the company served as agents for the Ames Manufacturing

146

Co. (q. v.) who were noted for their swords and sabres. From 1872 through at least 1874, the firm served as agents for the Chester Emery Co. an emery manufacturer. It is not clear whether E.V. Haughwout & Co. continued to manufacture silverplate during this time. Not followed beyond 1874.

S. HAVENS
Boston Massachusetts

S. Havens, silverplater, advertised that he made "Silver Door-Plates" in the *Boston Evening Transcript*, December 12, 1868.

HAVONE CORPORATION
New York, New York
See Elgin American Mfg. Co.

Listed JC 1915 in sterling silver section. Patents and trademarks taken over by Elgin American Mfg. Co., Elgin, Illinois.

Elgin-American manufactured match boxes, vanity, photo and cigarette cases, belt buckles, cuff links, traveling clocks, photo lockets and knives.

HAWTHORNE MFG. CO.
New York, New York

Manufacturer of sterling silverware. Listed in JC 1904 as out of business.

HAYDEN MFG. CO.
Newark, New Jersey
See G. W. Parks Co., Inc.

Gold and silversmiths c. 1893. Manufacturers of sterling silverware and jewelry. Succeeded by G. W. Parks Co., Inc. between 1904 and 1909.

WILLIAM W. HAYDEN CO.
Newark, New Jersey
See G. W. Parks Co., Inc.

Listed in JC 1904 in sterling silver section. Out of business before 1909.

HAYES & MCFARLAND
Mount Vernon, New York
See Gorham Corporation
See Mt. Vernon Silversmiths, Inc.

In 1903 merged with the Mauser Manufacturing Company of New York and the Roger Williams Silver Company of Providence, Rhode Island to form the Mt. Vernon Silversmiths Company which was purchased by the Gorham Corporation in 1913.

J.R. HAYNES
Cincinnati, Ohio

Listed in Cincinnati City Directories 1850-1859 as a silversmith who operated a silverware factory.

HAYNES & LAWTON
San Francisco, California

Silverplaters, not manufacturers. In 1864-65 listed in San Francisco city directory as dealers; in 1869 as agents for electrotyping work; 1870 Benjamin Haynes & Orlando Lawton; 1871 as prop. of Pacific Plate Works; 1874 no longer listed.

An 1869 account reads: "Silverplating under the older methods has been practiced in San Francisco for a number of years, the articles being made of equal quality to the same work imported. During the past year, however, a new branch of the business, viz. electrotyping has been introduced in San Francisco by the Pacific Plate Works, Haynes & Lawton being the agents. By this process excellent work is done, the designs being elegant and the standard coating of metal of a purity and thickness not to be excelled." (Henry Langley, *The Pacific Coast Almanac for 1869*, S.F. 1869, p. 69)

C.E. HAYWARD COMPANY
Attleboro, Massachusetts
See Walter E. Hayward Co., Inc.

HAYWARD & SWEET
Attleboro, Massachusetts
See Walter E. Hayward Co., Inc.

WALTER E. HAYWARD CO., INC.
Attleboro, Massachusetts

Established in 1851 as Thompson, Hayward and Co., in Mechanicsville. Charles E. Hayward and Johnathan Briggs became partners in 1855. Charles E. Hayward was one of seven children of Abraham Hayward, captain of a privateer during the War of 1812. When Charles was 17 he was apprenticed to Tifft & Whiting to learn jewelry making.

The Hayward and Briggs partnership was dissolved in 1855 and Walter E. Hayward became associated with his father under the name of C.E. Hayward Co.

In 1887 the younger Hayward accepted George Sweet as a partner and the firm became Hayward & Sweet Company. The firm name became Walter E. Hayward Co. before 1904. Frank J. Ryder and Charles C. Wilmarth, both already associated with the firm, purchased the company in 1908.

Ryder bought out Wilmarth's interest in 1917 and remained sole owner until incorporation in 1921. Frank J. Ryder, Sr. died in 1943 and three years later his son, Frank, Jr., became president and part owner, acquiring full ownership in 1949. They are still (1975) in business manufacturing religious items of sterling silver and gold and goldfilled jewelry.

HEADLY & CARROW MFG. CO.
Philadelphia, Pennsylvania

Manufacturers of patented silversmiths' stock. Anton Weber, designer. Patent Office record, April 4, 1892.

HENRY HEBBARD & CO.
New York, New York
See John Polhamus,
See Shiebler & Co.,
See Whiting Manufacturing Co.

CHRONOLOGY

Henry Hebbard & Co.	1847-1858
Henry Hebbard	1859-1860
Hebbard & Moore	1861-1865
Hebbard, Moore & Strong	1866-1867
Hebbard & Co.	1868-1869

The firm of Henry Hebbard & Co., solid silver manufacturers, is listed in the New York City Directories beginning in 1847. John Polhamus joined the firm at some point prior to 1852. Between 1852 and 1858, he and Hebbard obtained a number of design patents for flatware together. These patents were later used by Shiebler & Co.

George E. Strong appears associated with Hebbard & Company beginning in 1854. Hebbard moved next door to his former location in 1859, while Polhamus and Strong remained where they were and formed a partnership.

Henry Hebbard continued in business by himself for two years, then entered into partnership with George E. Moore in 1861 to form Hebbard and Moore. In 1866 George E. Strong returned to the company, and it became Hebbard, Moore & Strong. In 1868 Moore left the firm and it became Hebbard & Co. again. No longer listed after 1869.

The firm may have dissolved as a result of the loss of its Tiffany & Co. account when Tiffany's purchased Edward Moore's silver manufacturing company to serve as its own manufacturing division. (Soeffing, in Venable's *Silver in America*, 1994, biographical section, p. 324)

George E. Strong joined the Whiting Manufacturing Co. by 1870. Hebbard had obtained a number of design patents on his own, both during and after his association with Polhamus. Flatware using some of Hebbard's designs was later manufactured by Whiting.

JACOB S. HECKER & CO.
Philadelphia, Pennsylvania

Manufacturers of silverplated holloware. Purchased by Hartford Sterling Co. in 1900.

HEER BROS. CO., INC.
Baltimore, Maryland

Listed in the Baltimore City Directories 1927-1928 as manufacturers of silverware.

HEER-SCHOFIELD CO.
Baltimore, Maryland
See Schofield Co. , Inc.

HEEREN BROS. & CO.
Pittsburgh, Pennsylvania

An advertisement (JR 1887) says they are manufacturers of "silver and plated ware."

Mentioned as makers of a silver trophy cup. (JC-W 5-9-1900, p. 7)

Their trademark is a cannon with the initials "P. G. H."

HERMAN HEILIG
Hendersonville, North Carolina

Herman Heilig began learning the craft of silversmithing as occupational therapy while a TB patient in the Trudeau Sanitorium in New York State in 1935 and 1936. The following year he and his family returned to his native North Carolina, where he continued his silver crafting in Black Mountain sanatorium. In the early 1940s he was gradually released from the sanatorium, and eventually joined his family in Arden, North Carolina on a permanent basis. He was then able to work full time manufacturing silver jewelry. During this period he manufactured all kinds of jewelry and small trays, which were sold wholesale to area shops.

In 1946 Heilig moved his family to Hendersonville, North Carolina, and established a shop which he called the Druid Hills Silvercraft Studio. He continued to manufacture jewelry in the basement of his home, increasingly working with setting native stones in sterling silver and 14 karat gold, doing all the work by hand himself.

Heilig's earlier work involved naturalistic designs, like the dogwood, North Carolina's state flower, or the lily. Over time his designs became more stylized and abstract, but were still fre-

quently based on natural motifs. Special earrings that he crafted, which were designed hold a few drops of perfume, were written up in National Geographic Magazine in an article titled "Perfume, the Business of Illusion" published in April 1951. He continued to work at his craft until his death in 1963. (Poret, *Silver*, Nov.-Dec. 1996, pp. 34-37)

HANDWROUGHT

JOSEPH HEINRICH
New York, New York
Paris, France

Joseph Heinrich worked as a molder and finisher of copperware in the 1880's. About 1897 he established his own business, Joseph Heinrich's, in New York. There, until about 1925, he produced exquisitely designed and beautifully detailed objects of copper, decorated at times with silver accents. Decorations on the pieces included figures of highly naturalistic people and animals moulded in the round. The company produced everything from complex casseroles, pitchers, egg coddlers and punch bowls to simple coffee services.

Heinrich's wares were retailed by such prestigious firms as Black, Starr & Frost; Cowell & Hubbard; Shreve, Crump & Low Co.; and Tiffany & Co. Most pieces are stamped only with words indicating their metal content, such as "COPPER & SILVER" and the retailer's mark. However a few are marked JOS. HEINRICHS/ PARIS + NEW YORK in addition to the metal content. Although his marks say "Heinrichs" his advertisements refer to the firm as "Heinrich's". No information is currently available about his Paris operation. (Venable, *Silver in America,* 1994, pp. 319-320)

HEINTZ ART METAL SHOP
Buffalo, New York

Listed in JC 1915-1922 in the plated silver section. Became Heintz Bros. Mfg. before 1935. This is the last listing found. Manufacturers of art metal goods and novelty jewelry.

HEIRLOOM

See Oneida Silversmiths

Heirloom is a trademark acquired by Oneida Silversmiths in 1929 through the acquisition of Wm. A. Rogers, Ltd.

HEIRLOOM

HEMILL SILVERWARE INC.
New York, New York

Manufacturers (?) or silverplaters c. 1920-1930.

SHEFFIELD H. S. CO.

SUSSEX

THE HEMMING MFG. CO.
Montreal, Quebec, Canada

Listed in JC as manufacturers of sterling silverware and jewelry c. 1909. Pack (*Collector's Guide to Canadian Souvenir Spoons*, 1988, p. 78) reports them in business 1905-1915. Their products included sterling souvenir spoons.They may have had some business connection with Richard Hemsley (q.v.) as the designs of their spoons are similar. Succeeded by Canadian Jewellers, Ltd.

The mark shown on the right is from Pack (ibid.)

RICHARD HEMSLEY
Montreal, Quebec, Canada

Richard Hemsley first set up in business about 1869. He worked as a diamond merchant, goldsmith, and silversmith.

Between 1897 and 1910 he received Canadian copyrights for twenty-six different designs for sterling souvenir spoons. Many of these designs included shield blanks topped by a crown at the end of the handle. Other handle designs include an Indian head and a man engaged in the sport of curling.

Hemsley's, a successor firm, was still in business in 1988. (Pack, *Collector's Guide to Canadian Souvenir Spoons*, 1988, pp. 33-44, 78)

GEORGE A. HENCKEL & CO.
New York. New York
See Currier & Roby, Inc.

Manufacturers of small articles in sterling silver for the trade only. Listed in JC 1909-1922.Also found in KJI 1922 and 1924. Succeeded by Currier & Roby, Inc. before 1943.

$$G$$

ROBERT HENDERY
Montreal, Quebec, Canada

A solid silver manufacturer, originally from Scotland. Robert Hendery first appears in Montreal in partnership with Peter Bohle in the firm of Bohle & Hendery from 1837 to 1840. Hendery then went into business on his own. He worked in partnership with Bohle again between 1850 and 1856. They supplied their products wholesale to the trade. Typically their work would bear both their manufacturer's mark and the mark of a retailer. He worked for both Savage & Son and Savage and Lyman (q.v.).

Hendery took John Leslie as an apprentice in 1864.

By 1867 Hendery was the leading silversmith in Quebec, and one of the few remaining independent silversmiths in the province. By the 1870s he was supplying goods to major firms like M. S. Brown & Co. and Julius Cornelius (q.v.) as far away as Halifax, Nova Scotia.

In 1887 Hendery entered into partnership with John Leslie, forming the firm of Hendery & Leslie. In 1895 Hendery retired, and Leslie became the owner of the company. Hendery died in 1897. Leslie sold the business to Birks (q.v.) in 1899. As a result, Birks obtained the marks of all the companies for whom Hendery and Hendery & Leslie had manufactured silver. (Unitt & Worrall, *Unitt's Book of Marks*, 1995, p. 67.)

$$R^H \qquad \boxed{RH}$$

Used with pseudo hallmarks.

150

HENDERY & LESLIE
Montreal, Quebec, Canada

Partnership formed in 1887 by Robert Hendery (q.v.) and John Leslie. When Robert Hendery retired in 1895, Leslie became the owner of the company. When Birks purchased the company in 1899, Leslie stayed on. He managed the factory until 1925 when he became a director of Birks. (Pack, *Collector's Guide to Canadian Souvenir Spoons*, 1988, p. 31)

Marks from Unitt & Worrall, *Unitt's Book of Marks*, 1995, p.67.

H & L
Used with pseudo hallmarks.

H & L STERLING

HENDRICK & DEACON
New York, New York

Firm formed about 1868 as a successor to Hale, Hendrick & Ford (q.v.), operating at the same location, 137 Elm. James A. Hendrick and Richard Deacon were the partners. David Hale worked for the firm in 1868, but Edwin L. Ford had left the business. Hendrick & Deacon are listed as "smiths" in the New York City directories published in 1868 and 1869, but they probably continued to manufacture silverplate. Not found after 1869.

HENNEGAN, BATES & COMPANY
Baltimore, Maryland

Established as jewelers and silversmiths in Wheeling, West Virginia, by James T. Scott in 1857. In 1859 William H. Hennegan, a native of Rochester, New York, went to Wheeling from St. Louis and became associated with Scott. The firm's name was changed to James T. Scott & Co.

In 1864 they opened a wholesale house in Pittsburgh with Hennegan in charge; Scott remained at the Wheeling store. The Pittsburgh house was known as Scott & Hennegan. This partnership was dissolved in 1869 and Hennegan took over the Wheeling business.

In 1866 James O. Bates was admitted to partnership and in 1869 John D. Reynolds joined the firm as jeweler. In 1874 Hennegan and Reynolds moved to Baltimore and opened a jobbing firm; Bates remained in charge of the Wheeling store until it was sold in 1874 to Jacob W. Grubb. Bates then moved to Baltimore where

the business was for some time both wholesale and retail. The wholesale business was dropped and only the retail remained. The last listing found in Baltimore City Directories was for c. 1930.

HENNEGAN, BATES & CO.

HERBST & WASSALL
Newark, New Jersey

Listed JC 1904-1922 as manufacturers of sterling silver goods, 14k gold ware and novelties. Last record found was 1931.

JEFFREY HERMAN
Cranston, Rhode Island

Silversmith, jeweler and designer. Studied silversmithing in London, England; silversmithing and jewelry making in Portland School of Art and Southeastern Massachusetts University. Designer, sample and model maker and technical illustrator with Gorham Company.

F.A. HERMANN CO.
Melrose Highlands, Massachusetts

Founded 1908 by F.A. Hermann. Manufacturers of sterling barrettes, brooches, bar pins, baby pins, bracelets. pendants and bookmarks, mostly enameled and handpainted.

GEORGE E. HERRING
Chicago, Illinois

Registered U.S.Trade Mark Patent No. 59,353 January 8, 1907 for use on imitation silverware. Out of business before 1915.

YOUREX

HESS & CULBERTSON
St. Louis, Missouri

Mark found on a small silverplated trophy cup dated 1910.

HIBBARD, SPENCER, BARTLETT & CO.
Chicago, Illinois

Trademark registered May 15, 1906 (No. 52,721) to be used on plated silver holloware, flatware and tableware. Used continuously since April 1, 1905. Application filed by A.M. Graves, secretary.

Trademark registered on August 7, 1906 (No. 55,072) to be used on jewelry, solid and plated, precious metalwares - silver and plated silver holloware. Used continuously since May 1884. Application filed by A.C. Bartlett, president.

This hardware firm took the entire first production of steel traps made by the Oneida Community-the success of this enterprise eventually led to Oneida's silversmithing business.

GEORGE W. HICKOK & CO.
Sante Fe, New Mexico

"Manufacturers of filigree spoons and everything in the filigree line." *Century Magazine,* April 1892. Montezuma spoon marked "Copyrighted".

HICKOK MATTHEWS COMPANY
Newark, New Jersey
See Eleder-Hickok Co.
See Lebkueker & Co.

Formed by the merger, between 1931-1943, of the Eleder-Hickok Company, manufacturers of sterling silver novelties, and the Matthews Company (incorporated in 1901). They are manufacturers of sterling holloware and presentation pieces.

Purchased in 1965 by Wolfgang K. Schroth from David M. Warren, Jr., president and owner.

Mr. Schroth was born in Frankfort, Germany and received his training under August Bock and Emil Woerner. He formed his own silver company there, but came to this country in 1955 and joined Tiffany and Company as their silversmith. In 1961 he joined Hickok-Matthews as manager and silversmith. One of the country's foremost silversmiths, Mr. Schroth lectures extensively on that subject. (1975)

(On novelties)

(On holloware)

HIGGINS, MARCHAND & CO.
Philadelphia, Pennsylvania

Charles E. Marchand, Delaware City, Delaware, was granted a Design Patent for a spoon, No. 2,788, August 27, 1867, which he assigned to Higgins, Marchand & Co.

HI-GRADE SILVER CO., INC.
New York, New York

Listed in 1927 KJI as manufacturers of sterling silver holloware.

CHARLES F. HILL
Owego, New York

Charles F. Hill was born in 1832 in Tioga, near Owego, New York. As a young man he was apprenticed to Julius Hollister (q.v.) who had come to Owego in 1846, from Hartford, Connecticut. In the early 1850s Hill went to Hartford in pursuit of his trade, and for a short time was employed by the Colt revolver factory there. In 1854 he returned to Owego to establish his own silversmith shop.

He maintained a shop on Front Street from 1854 until 1867, when the building was destroyed by fire. From 1867 until about 1875 when the business finally closed, the shop was located on Temple Street.

Not much detailed information is available concerning Hill's silver manufacturing business. Two female burnishers are shown as living in the Hill household in the New York State census in 1855. In 1872 he is reported as being an electroplater as well as a manufacturer of silver spoons. By 1875 the firm is listed as having 3 employees, two male and one female, and producing goods valued at $6,600 annually.

Hill was very active in community affairs in Owego, at various times serving as Village Clerk and chief engineer of the Owego Fire Department. From 1873 to 1877 he served as an assistant fire marshall for New York City. He later held the posts of United States Marshall and justice of the peace. His silver business was put in charge of his foreman when he left for New York City in 1873.

Hill's business was a small one, and could not effectively compete with the larger manufacturing firms. He was out of business by December 1875. Hill died in 1904. (Soeffing, *Silver*, Jan.-Feb 1992, pp. 14-16)

Mark from Soeffing, *Silver*, July-Aug 1991, p.14.

JOHN HILL
New York, New York

John Hill appears in the New York City directories at least as early as 1852 as a manufacturer of britannia ware, and continues to be listed through 1854. In 1855 he appears as a "manufacturer" but with no business location. Not found after 1855.

He may possibly be the same John Hill who went into partnership with Anthony Halm (q.v.) in 1860.

JOSEPH HILL
New York, New York

Joseph Hill first appears in the New York City Directory published in 1857 as a plater. In his ad in the directory published in 1860 he lists himself as "Joseph Hill, Gold and Silver plater on Table Cutlery, Dental and Surgical Instruments, Pistols, Scissors, and every description of Iron and Steel Goods. Particular attention paid to Job Plating and Replating. Old Goods, for Private Families, Hotels, Steamboats, and the Trade. All work warranted as represented." Not found after 1870.

H.M. HILL & CO.
Lynn, Massachusetts

Registered U.S. Trade Mark Patent No. 19,221, March 24, 1891 for manufacture of sterling souvenir flatware.

Herbert H. Hill, native of Barnstead, New Hampshire, moved to Lynn, Massachusetts c. 1889. There, he learned the jewelry and watchmaking business from John M. Humphrey with whom he was in business for about three years. Hill bought the business when Humphrey sold out and continued to operate it until 1914 when he moved to Centre Barnstead.

A. HIMMELLS SILVERWARE MANUFACTURY
New Orleans, Louisiana

Adolphe Himmel was born in Germany in 1826. In 1852 he entered into partnership with Christopf Christian Kuchler in New Orleans under the name of Kuchler & Himmel. The partnership lasted through 1853. The company served as silver manufacturers for the retail firm of Hyde & Goodrich (Bacot, *Silver*, Sept.-Oct.1987, p.26)

Himmel continued to manufacture solid silver for Hyde and Goodrich (q.v.) and for its successors, Thomas Griswold & Co. and A.B. Griswold & Co. (Bacot, ibid.) Kuchler also worked for the company from time to time between 1855 and 1861. (Bacot, *Silver*, Mar.-Apr. 1986, p. 17)

An 1871 ad in the New Orleans City Directory lists the business as providing, "Silverware of all descriptions made to Order at Short Notice. 186 Poydras St."

Himmel died in 1877. (Bacot, *Silver*, Sept.-Oct. 1987, p. 26) His mark on items produced for Hyde & Goodrich was a capital "H".

H

HIPP & COBURN
Chicago, Illinois

STERLING HIPP & COBURN CHICAGO
(Cameo marks on commemorative spoon)

MAX HIRSCH
Philadelphia, Pennsylvania

Listed as manufacturer of silverplated articles c. 1920. The trademark indicates fittings for leather goods.

M. FRED HIRSCH CO., INC.
Jersey City, New Jersey

In business c. 1920-1945 as manufacturers and jobbers of sterling silverware.

Succeeded by Fisher Silver Co.

ST. JAMES M. F. H. Co.
VIOLET

HIRSCH & OPPENHEIMER
Chicago, Illinois

Manufacturing jeweler and special order work. Listed JC 1904-22 and KJI 1927.

CHARLES E. HOCHHAUS
Baltimore, Maryland

Listed in Baltimore City Directories 1870-1871 as a silverplater.

F.B. HOFFMAN & CO.
Baltimore, Maryland

Listed in Baltimore City Directories 1870-1871 as silverplaters.

FREDERICK S. HOFFMAN
Brooklyn, New York
See Clarence B. Webster

Listed in JC 1896 in sterling silver section. Other sources indicate that these trademarks were used also on 14 and 18k gold and silver novelties and on silver mountings for leather goods. Succeeded by Clarence B. Webster before 1904.

MAX HOFFMAN
Newark, New Jersey

Jeweler and silversmith c. 1848-51 . Advertised as manufacturer of jewelry, silverware, and metal gilding.

HOFFMAN MANUFACTURING CO.
Newark, New Jersey

Listed 1927 KJI as manufacturers of sterling silver dresserware, vanity and cigarette cases, tableware and novelties.

HOLBROOK & SIMMONS
See Thornton & Company

Successors to Holbrook, Dagg & Co. An 1896 account reads: "Holbrook & Simmons, manufacturing silversmiths, 427 E. 144th Street, New York, have dissolved by mutual consent, Henry B. Simmons retiring. The remaining partners, Eugene C. Holbrook and William H. Thornton, will continue the business as before under the firm name of Holbrook & Thornton. Later Thornton & Company" (JC&HR 5-2-1896, p. 20)

H. & S.

HOLBROOK MFG. CO.
Attleboro, Massachusetts

Founded by Harry R. and Charles L. Holbrook. Listed in Attleboro City Directories from 1905-1916 as manufacturers of special machines and novelties.

HOLBROOK, WHITING & ALBEE
North Attleboro, Massachusetts
See Frank M. Whiting Co.

WILLIAM HOLBROOKE
Baltimore, Maryland

Listed 1850 census as silversmith. Born Maryland.

JOHN HOLIDAY
Baltimore, Maryland

Listed in Baltimore City Directory in 1872 as a silverplater.

JULIUS HOLLISTER
Owego, New York
See Oliver D. Seymour

Julius Hollister, a solid silver manufacturer, was born in Glastonbury, Connecticut in 1818, the son of a farmer. He was apprenticed to Asa Rogers in Hartford at the age of fifteen. After completing his training, he served as a journeyman in the Rogers' shop for an additional four years.

About 1842 he went into partnership with Oliver D. Seymour (q.v.) in the firm of Seymour and Hollister in Hartford. In 1846 he sold out his interest in the business and moved to Owego,

New York, becoming the first manufacturer of silver flatware in that town.

By 1855 his business employed four men and two women and produced about $17,000 worth of goods a year. His brother Justin, who had worked with him in Hartford at Seymour & Hollister, worked with him for a time here as well.

Between 1860 and 1867 two different shop sites of his were destroyed by fire. Some time between 1872 and 1875 the building he was using as a shop was torn down, and he moved his business into his home. By 1875 the business employed only two men, himself and his son, and produced only $3,600 worth of goods annually.

To generate more income, Hollister went into the business of selling, repairing and servicing sewing machines, in addition to his silversmithing. The front of the house served as the sewing machine showroom, while the silver business occupied the back. By the 1890s, Hollister was in the grocery business as well. He continued working until around the time of his death in 1905.

While he produced a quality product, lack of capital and machinery prevented him from developing fancy die-struck patterns and competing effectively with other, larger, producers. Although his advertisements indicate that he manufactured forks and other flatware, spoons tend to be all that are found today. His pieces are generally marked, "J. HOLLISTER PURE COIN". He apparently did not use pseudohallmarks. (Soeffing, *Silver,* March-April 1992, pp. 10-13)

JOHN W. HOLMES
Brooklyn, New York

John W. Holmes first appears as a silverplater with his own shop in the Brooklyn City Directory published in 1864. For the next three years he is listed, but without a shop location, presumably working for someone else.

By 1868 he again had a shop of his own, and continued in business at least until 1876, as far as his record has currently been followed.

WM. HOLMES
ROBERT HOLMES
Baltimore, Maryland

William Holmes, founder of the silver manufacturing business of that name in Baltimore, was born in Sheffield, England July 27, 1816 and died in Baltimore April 7, 1883.

Holmes' family had been in the silver manufacturing business in Sheffield and it was there that he learned the trade he established in Baltimore. There is a listing in Baltimore City Directories 1847-1848 as "Wm. Holmes, brass founder, patent windlass maker, composition and iron caster," which the family feels is a different William Holmes, as their records show the silver manufacturer arriving in Baltimore in 1852.

William Holmes and his wife, Ann, had at least six children, four of whom were boys. All four sons learned some branch of the silver manufacturing and plating trade. Samuel specialized in chasing, William, Jr., in buffing and polishing, Robert specialized in spinning, molding and other manufacturing processes and John was listed in City Directories as a gilder.

The manufacturing business established by William Holmes was financially successful for a number of years but failed about 1855 on account of a dishonest bookkeeper. For some years the Holmes' business was dormant until Robert decided to establish a repair, replating and limited manufacturing business (Ledlie I. Laughlin in his *Pewter in America,* Vol. II, says that Robert Holmes & Sons were makers of britannia ware in 1853 and 1854.) This new business was started in his home but as the business grew activities were transferred to more suitable locations.

William Holmes was listed in Baltimore Directories from 1865-76 at "over 12 Bank Lane" and at 46 N. Holliday, the latter apparently a factory or business location as the residence was 820 W. Baltimore. Samuel Holmes and George Holmes were listed as electroplater and britannia worker at the N. Holliday address. Other locations and company names listed were Holmes Bros. & Co., 1877-90; Holmes Nickel Plate Co., 1886; Robert Holmes, 1894; Holmes Plating Works, successor to Robert Holmes, 1895-96 and Holmes & Son, 1896-1940.

Robert Holmes had six children, three boys and three girls. All three boys entered the repair establishment with their father. They were Robert Frederick, W. Grover and Morris. Robert Frederick became the plater. Grover inherited the business after the deaths of his father, Robert Frederick and Morris, the youngest. This was carried on principally as a general repair business until Grover retired on account of age in 1960. The business was then placed in the hands of W. Stanley Rauh who had been with the firm for almost forty years. Following Mr. Rauh's death about 1967 the tools and dies were purchased by the Stieff Company of Baltimore.

WM. HOLMES

HOLMES & EDWARDS SILVER CO.
Bridgeport, Connecticut
See International Silver Co.

The Holmes & Edwards Silver Co. was started in Bridgeport, Connecticut in 1882, having taken over the business of Rogers & Brittin (q.v.), which had been in existence about two years. At first, their business was largely the making of moderate priced plated flatware, sometimes producing the blanks, oftentimes buying the blanks from other makers, plating and marketing them.

George C. Edwards, the president of the firm, had married one of the daughters of Israel Holmes. While reading the August 20, 1877 edition of *Scientific American*, he saw a report of a new technique for inlaying blocks of sterling silver at the wear points on the backs of spoons and forks prior to plating them. William A. Warner of Syracuse, New York had received invention patent No. 337,099 for the process on March 2, 1886.

Edward T. Abbott of Holmes and Edwards was sent to check out the new process. He not only liked what he saw, he felt he could improve on the techniques that Warner employed. Edwards obtained the patent rights, and Warner came to work for Holmes & Edwards. The improved process earned a gold Medal at the Columbian Exposition in 1893. (Halket , *Silver*, July-Aug.1989, pp. 17-18) Holmes & Edwards sterling inlaid flatware earned a prominent place in the silverplate industry which it maintained for many years.

The Holmes & Edwards plant was taken over by the International Silver Company in 1898 though it continued to operate in Bridgeport until moved to Meriden in 1931.

In 1956 the Holmes & Edwards "SILVER-INLAID" trademark was changed to "Holmes & Edwards Deepsilver" and in 1960 changed again to "International Deepsilver."

By 1972 the sterling inlaid feature had been discontinued. It is now (1986) marketed by Wallace International Silversmiths, Inc.

XIV

ROLLED PLATE, HOLMES & EDWARDS
EDWARDS
ORIENTAL
MEXICAN CRAIG
EDWARDS
B. S. CO.
XIV. HOLMES & EDWARDS

STERLING INLAID
HOLMES & EDWARDS
MEXICAN SILVER
AZTEC COIN METAL

INLAID
HESCO
HE

VIANDE

STRATFORD SILVER PLATE CO.
STRATFORD SILVER CO. STRATFORD PLATE

STERLING INLAID HOLMES & EDWARDS SILVER - INLAID HE
STRATFORD SILVER CO AXI HOLMES & EDWARDS INLAID
STRATFORD SILVERPLATE
WALDO HE

HOLMES & TUTTLE MFG. CO.
Bristol, Connecticut
See American Silver Co.
See Bristol Brass & Clock Co.
See International Silver Co.

Organized by Israel Holmes in 1851. Made plated silver knives, forks and spoons. Taken over by Bristol Brass & Clock Co., in 1857 and operated as their silverware department until 1901 when it became the American Silver Company which was bought by International Silver Co. in 1935.

HOLMES & TUTTLE
H. & T. MFG. CO.

HOLMES, BOOTH & HAYDENS
Waterbury, Connecticut

Israel Holmes (1800-1874) was born in Waterbury Connecticut. Orphaned at a young age after his father died of yellow fever, he endured various hardships which enhanced his competitive spirit.

Waterbury was the center of the American brass industry. As a young man Holmes travelled to England to learn improved brass manufacturing techniques. Shortly after 1830, Holmes entered into partnership with Horace Hotchkiss to manufacture brass tubing, wire and rolled plate. In 1834 he formed the Walcott Brass Company to manufacture household kettles.

About this time, James Croft and Aaron Benedict imported large, thirty by eleven inch, rolls for forming brass sheets and revolutionized

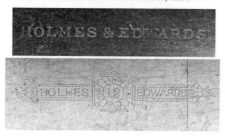

HE GERMAN SILVER 14

the industry. With the greatly expanded production caused by this innovation, manufacturers began looking for new markets for their products. One such market was the silverware industry.

Holmes became production manager of the Waterbury Brass Company, and by 1836 he had made it the largest brass mill in the United States. In 1851 he organized the firm of Holmes & Tuttle (q.v.) to manufacture plated silver knives, forks and spoons. (Halket, *Silver*, July-Aug. 1989, p. 17) This firm was sold to the Bristol Brass & Clock Co. in 1857.

In 1853 he formed the firm of Holmes, Booth & Hadens, the original purpose of which was to roll brass. His partners in this venture were John C. Booth, and a group of men, probably brothers, with the last name of Hayden: Henry H. Hayden, Hiram B. Hayden and James A. Hayden.

The company was responsible for various innovations. For example, it made plated silver copper sheets for photography which produced a better and less expensive photograph than copper plate.

During the Civil War it made brass buttons for both military and civil uniforms, brass fittings and kerosene lamps.

After the war it went into the nickel silver business and turned out huge quantities of knives, forks and spoons for silverplating.

The company designed as well as manufactured flatware. Henry H. Hayden received four patents for flatware designs between 1866 and 1868. Hiram W. Hayden received a flatware design patent in 1879.

Bought by Rogers and Hamilton c. 1886, which later became part of International Silver Company.

H. B. & H. A. 1.
SHEFFIELD PLATED CO.
STERLING SILVER PLATE CO.
UNION SILVER PLATE CO.

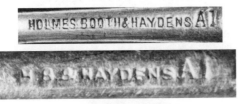

HOMAN MANUFACTURING COMPANY
Cincinnati, Ohio

Established in 1847 by Henry Homan and Asa F. Flagg.

The Cincinnati City Directories of 1842-1843 and 1846 list Asa F. Flagg as a britannia manufacturer. An English potter, he went to Cincinnati to form a partnership with Homan for the manufacture of pewter. Flagg was so devoted to his work that he was known locally as "Pewter" Flagg.

Under the firm name Homan & Co. (pieces are also found marked Flagg & Homan), they made britannia ware until Flagg's retirement in 1854.

The business continued under the Homan & Co. name. M. Miller joined the firm and remained a co-partner until the death of Henry Homan in 1865.

Homan's widow, Margaret, with their sons, Frank (who died in 1880), Louis and Joseph T., managed the firm until her retirement in 1887.

About 1864 the company gradually changed from the manufacture of pewter, britannia and German silver to electroplated silverware. They also advertised that they did gold plating.

Their regular products were ecclesiastical wares, for which they registered U.S. Trade Mark Patent 27,974, March 17, 1896, (chalices, patens, beakers, tankards, baptismal bowls, alms dishes and candlesticks); Ohio-Mississippi river boat equipment (bowls' pewter plates, beakers, trenchers, chargers, tea sets and swivel lamps); bar equipment and articles for domestic use (tea and coffee sets, cups, ewers and basins, warming pans, pitchers, jugs, sugar sifters, pewter combs, special frames, clockweights and buttons).

Around 1896 the name of the firm was the Homan Silver Plate Company which was succeeded by Homan Manufacturing Company between 1904 and 1915. Out of business in 1941.

HOMAN & COMPANY
CINCINNATI

HOMAN & COMPANY
CINCINNATI

157

HOME DECORATORS, INC.
Newark, New York

Registered trademarks for use on silverplated flat and hollow tableware.

Succeeded by Silver Counselors of Home Decorators.

State House ⚜ Sterling

PRESTIGE ★ ★ ★ ★ PLATE

(Used since Feb. 4, 1944)

DISTINCTION

(Used since March 20, 1950)

GEO. E. HOMER
Boston, Massachusetts

George E. Homer established a jewelry business with his brother, Joseph J., in 1875. The business grew rapidly and additional stores were opened in Providence, R.I., Portland, Me., and Lowell, Taunton, and Ayer, Mass. These were discontinued after Joseph's death, before 1922. The same year George completed a new building for his store at 45 Winter Street, Boston. The firm is still in business. (1975) Many souvenir spoons bear the Homer trademark.

 Souvenir Spoons

HOPEWELL SILVER COMPANY
See Reed & Barton

HOPEWELL SILVER CO.

HOPKINS & BRIELE
Baltimore, Maryland

Listed in Baltimore City Directories 1879-1886 as gold and silversmiths.

J. SETH HOPKINS & CO.
Baltimore, Maryland

Listed in Baltimore City Directories 1887-1888 under plated silverware.

HORTON & ANGELL
Attleboro, Massachusetts

Manufacturers of gold and silver goods. Listed JC-K 1896. Founded 1870. Listed in KJI for 1922 and 1924 as Horton, Angell Co. doing business as "Mfrs. of rolled gold plate and gold plated seamless wire and tubing."

HOTCHKISS & SCHREUDER
Syracuse, New York
See Francis A. Bunnelle
See Syracuse Silver Manufacturing Co.
See Lesser & Rheinauer

CHRONOLOGY

Bunnelle & Schreuder	c. 1853-1857
Hotchkiss & Schreuder	c. 1857-1871
A.B. Schreuder	1871-1895
Syracuse Silver Manufacturing Co.	1895-1897
Lesser & Rheinauer	1897-1898

David Hotchkiss was first listed as a silversmith in Palmyra, New York, working c. 1840. He advertised with Benjamin R. Norton, also of Palmyra, as jewelers in 1841-1842.

Andrew B. Schreuder worked in Utica for two years prior to his arrival in Syracuse in 1853.

At about that time he entered into partnership with Francis A. Bunnelle (q.v.) as Bunnelle & Schreuder to manufacture solid silver flatware. That partnership was dissolved on October 16, 1857. Shortly thereafter the firm of Hotchkiss & Schreuder was formed. The new firm continued the production of some of the patterns manufactured by its predecessor. (Soeffing, *Silver*, Jan.-Feb. 1990, p. 18)

It also developed a number of patterns of its own. A series of clippings from the catalog of the successor firm, Syracuse Silver Manufacturing Co., found in a scrapbook in the Gorham Archives at Brown University help identify these patterns, and indicate the company's names for them. (Soeffing, *Silver*, Jan.-Feb. 1991, pp. 9-11) The bulk of the firm's products was sold locally or shipped to midwestern markets. (Soeffing, *Silver Medallion Flatware*, 1988 p. 58)

Hotchkiss & Schreuder used different manufacturer's marks on its wares at different time periods. From 1857 to about 1864 the company's mark was an "H" in a circle followed by an "&" in a diamond and an "S" in a circle. From about 1864 to 1871 the company's mark was "H & S".

The partnership of Hotchkiss & Schreuder was dissolved on February 1, 1871. (Soeffing ibid.) Andrew B. Schreuder continued in business alone. He also continued to use the same "H & S" mark.

David Hotchkiss appears in later years to have become a clerk and then the treasurer of an "engine company."

In 1895 Schreuder sold the business to the Syracuse Silver Manufacturing Co. (q.v.) In 1897 that firm was dissolved and Lesser & Rheinauer was formed. The business closed for good on March 7, 1898. (Soeffing, ibid.)

Early Mark 1857-1864

H & S

Later Mark 1864-1871

HOUSATONIC MFG. CO.
New Haven, Connecticut

An 1896 account states: "Articles of association (were drawn for) the Housatonic Mfg. Co., Wallingford, Conn., for the making of 'German silver' brass and other metals, silverware and other goods made in whole or in part of metal, glass, china, queensware, wooden or any other kind of goods to use in combination with above, by C.A. Hamilton, N.Y., F.W. Carnell and E. A. Russell, Waterbury; Waterbury Brass Co.; Birmingham Brass Co. and C.E. Minor, New Haven." (JC&HR 9-30-1896, p. 13)

Registered Trademark No. 40,725 on July 7, 1903 for use on tableware, spoons, knives, forks, table tongs of plated ware. Used continuously in their business since April 1, 1902. Edgar A. Russsell, Treasurer.

HOWARD & COCKSHAW CO.
New York, New York
See Herbert Cockshaw, Jr.

HOWARD & CO.
New York, New York
See Arthur J. Stone

Howard & Co. was established in 1866. An 1867 advertisement in the New York City directory describes the business as "jewelers and silversmiths, Gorham plated ware, fancy goods." The firm was founded by Edward T. and Joseph P. Howard.

By the turn of the century the company had branches in Newport and London, in addition to its Fifth Avenue shop in New York. During the 1890s and the early 1900s Joseph Platt Howard and his son, Montague Howard were associated with the firm.

From about 1895 to 1897 Joseph Platt Howard and Arthur J. Stone (q. v.) were in partnership together. In 1895 Howard produced a brochure entitled *Novelties for Christmas/Solid Silver Toys*, depicting seventy-five different miniatures, many probably made by Stone. Stone also produced a variety of full sized items for the firm as well. It is not known precisely why Stone left the company to return to Gardiner, Massachusetts, but the partnership was dissolved

amicably on July 12, 1897. (Chickering, *Arthur J. Stone,* 1994, p. 7)

In addition to producing its own wares, Howard and Co. was also noted for its fine selection of quality antique silver as early as the 1880s. The company's collections served as a major resource for at least two important reference works, J. H. Buck's original *Old Plate* published in 1888 and Montague Howard's monumental *Old London Silver* published in 1903.

Montague Howard dedicated his book to his father, "as a tribute due him for his knowledge of antique silver". He further noted in his preface, when referring to the illustrations in the book, that "All the articles to which no name of owner is given are from the collection of Howard & Co." Clearly the firm was a leading American dealer in antique English silver at the time. (Dennis, personal communication, August 10, 1997)

The last listing for the company appears in 1922.

HOWARD & CO.

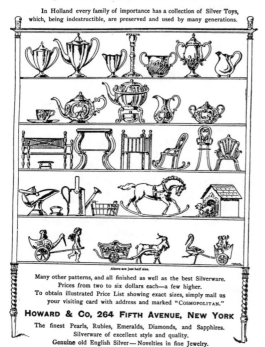
HOWARD & SCHERRIEBLE
Providence, Rhode Island
See Howard Sterling Co.
See Roger Williams Silver Co.

HOWARD & SON
Providence, Rhode Island
See Howard Sterling Co.
See Park Bros. & Rogers

The trademark is similar to that used by Parks Bros. & Rogers - a four-leaf clover partially encircled by the word "sterling" in a horseshoe arrangement.

Registered U.S. Trade Mark Patent No. 15,614, June 19, 1888 for useful or ornamental articles made of solid silver.

HOWARD CUTLERY CO.
New York, New York

Manufacturers of plated silver knives and holloware. Successor to E. Magnus before 1896. Out of business before 1909.

(Knives.)

(Hollowware.)

HOWARD STERLING CO.
Providence, Rhode Island
See S. Cottle Co.

CHRONOLOGY

H. Howard & Co.	1878-79
Howard & Scherrieble	1879-84
Howard & Son	1884-89
The Sterling Co.	1886-91
Howard Sterling Co.	1891-1901

Established January 1, 1878 as H. Howard & Co., with Hiram Howard, A.J. Scherrieble and Arnold Nicoud, to manufacture plated jewelry. January 1, 1879 Arnold Nicoud withdrew and a limited partnership was formed with Sterns Hutchins. The firm name was Howard & Scherrieble until the expiration of the limited partnership on January 1, 1884, when Hutchins

An advertisement for Howard & Co. from the December, 1895 issue of The Cosmopolitan depicting silver miniatures designed by Arthur J. Stone (q.v.) who was a member of the firm at that time.

retired and Stephen C. Howard, son of the senior member of the firm, was admitted as a partner. On February 5, 1884, Scherrieble withdrew and the firm name was changed to Howard & Son.

In July 1886 a department was established for the manufacture of sterling silverware and was conducted under the title of The Sterling Company. During the Fall of 1888 the firm discovered that their combined industries had outgrown their limited accommodations, and on January 1, 1889 they moved to a new factory. In January 1891 the concern was incorporated as Howard & Son and continued under that name until December 1891 when they disposed of the electroplated goods branch of the business to Parks Bros. & Rogers, and at the same time the name of the corporation was altered to that of Howard Sterling Co. The company went into receivership about 1901-02. Some of the patterns and dies were sold to the Roger Williams Silver Company and others.

Lever cuff and collar buttons were specialties of this company. One, in particular, the "Sensational" collar button,was constructed of rolled gold plate, the shoe and post were drawn from a single piece of stock, while the top or head was made from another piece and firmly secured without the use of solder - all the work being done by a machine invented for the purpose by S. Cottle (q.v.). They also made great quantities of silverware, both table and ornamental.

Used since 1894.

TRADE MARK

1776

G.M. HOWELL
New York, New York

George M. Howell first appears in the New York City directory in 1867. On December 19, 1867 he ran an ad in the *New York Times* featuring silver plated ware: Ice Pitchers, Gold-lined Goblets, Gold-lined Cups, Tea Sets, "Fire-proof Tea and Coffee Pots", Coffee Urns, Cake Baskets, Butter Dishes, Syrup Cups, Breakfast Castors and Dinner Castors. These items were provided, "Together with every description of Britannia and Nickle Silver-ware, Spoons, Forks, Knives, &c., warranted double plated and equal to any manufactured."

In the 1868 directory he is listed as working as the superintendent at Lucius Hart & Co. (q.v.) Not found after 1868.

H.G. HUDSON
Amesbury, Massachusetts

Trademarks in 1896-1904 editions of JC-K were parts of the designs used on the souvenir spoons sold by H.G. Hudson honoring John Greenleaf Whittier, "the Quaker Poet," who moved to Amesbury in 1836 after serving in the Massachusetts legislature. U. S. Patent Office also registered Trade Mark Patent No. 19,959, August 4, 1891. for the manufacture of flatware, spoons, knives, forks and ladles. It is doubtful that Hudson did the manufacturing himself, as numerous examples of these spoons bear the mark of the Durgin Company, now a Division of The Gorham Company.

J.B. HUDSON
Minneapolis, Minnesota

Founded in 1886 by Josiah Bell Hudson, retail jeweler. Owned by Dayton Co. since 1929. Now (1975) a division of Dayton Hudson Jewelers, a part of Dayton Hudson Corporation. Retailers of sterling, silverplate and pewter, holloware, flatware, novelties and importers of their own exclusive line.

J.B. Hudson

JBH

WALTER HUNOLD
Providence, Rhode Island

First listed in Providence City Directory in 1903 as Walter Hunold. About 1920 listed as Nussbaum & Hunold (B. Nussbaum, W. Hunold, J. Nussbaum), manufacturing jewelers. From 1921-1925 the listing was Walter Hunold. This is the last listing.

GEORGE J. HUNT
Boston, Massachusetts

George J. Hunt was born in Liverpool, England in 1865, serving the usual seven years' apprenticeship in one of the leading silversmith concerns of that city. In 1885 he came to the United States and worked in several silver factories. In 1905 he opened his own shop in Boston. His real love was teaching others the craft of silversmithing and this became his major interest. He was also a jeweler.

WM. E. HUNT CO.
Providence, Rhode Island

William Edwin Hunt was born in Pawtucket, Rhode Island, on October 26, 1881, the son of William and Annie J. Hunt. He founded his silversmithing company by the age of 30. William E. Hunt served as president of the firm, and Joseph H. Cullen as treasurer. The company produced high grade silver novelties and accessories, some under contract for other companies.

In 1912 the business is listed at 9 Calendar St. in Providence. By 1917 it was located at 93 Sabin St., a much better address. The company was doing very well until Mr. Hunt was struck down by the Spanish influenza epidemic. He died on September 20, 1918.

As he had no children, the business was sold to Joseph Cullen, who continued to operate it until the mid 1920's. The 1924 KJI lists the firm as manufacturers of 10k gold and sterling silver vanity and cigarette cases and jewelry. The 1927 KJI lists the company as manufacturers of sterling silver and white metal novelties. The firm is not found in the Providence directories after 1927. At about that time, the business was absorbed by the Joseph Lancor Manufacturing Co. (Personal communication, Rhodes, February 5, 1993)

CHARLES E. HUNTINGTON
New York, New York
See Lucius Hart Manufacturing Co.

CHRONOLOGY
Huntington, Loretz & Latimer 1865
Huntington, Loretz & Co. 1866
Charles E. Huntington 1867
Huntington & Guy 1868
Lucius Hart Manufacturing Co. 1869-1874+

Charles E. Huntington , Charles A. Loretz and Charles D. Latimer first appear in the New York City directory compiled in 1865 in a partnership called Huntington, Loretz & Latimer. By

1866 Latimer had left the firm, and it became known as Huntington, Loretz & Co. In 1867 the firm was known simply as Charles E. Huntington, although Loretz was still associated with it. In 1868 Loretz left, and Huntington went into partnership with Pierre A. Guy, Sr. (q. v.)

By 1869, Charles E Huntington had joined the Lucius Hart Manufacturing Co. (q. v.) as the superintendent of the silverplating portion of that business. By 1871 he had become president of that company, succeeding Lucius Hart, Sr. He still held that position in 1874, as far as his history has been traced to date.

HUNTINGTON & GUY
New York, New York
See Charles E. Huntington
See Pierre A. Guy

Firm formed by Charles E. Huntington and Pierre A. Guy (q.v.) about 1868. Pierre A. Guy, Jr. was also a member of the firm. Pierre A. Guy, Sr. was nearing the end of his career, and may have been trying to get his son set up in business.

The firm advertised itself as "Manufacturers of German Silver, Britannia & Silver Plated Ware, Fire Guilders, and Gold and Silver Electroplaters" in the New York City directory published in 1868. Not found in 1869. Huntington had joined the Lucius Hart Manufacturing Co. (q v.) and Pierre A. Guy Sr. was operating only his jewelry business. Pierre A. Guy, Jr. was not found in the directory.

HUNTINGTON, LORETZ & CO.
New York, New York
See Charles E. Huntington

Succeeded Huntington, Loretz & Latimer in 1866. Used the same text as the former company for their ad in the New York City Directory. Succeeded by Huntington & Guy about 1868.

HUNTINGTON, LORETZ & LATIMER
New York, New York
See Charles E. Huntington

Firm formed about 1865 by Charles E. Huntington, Charles A. Loretz and Charles D. Latimer. In the 1865 New York City Directory the firm advertised itself as "Manufacturers of Silverplated Ware...All kinds of Electro-plating done to order at short notice, and on Reasonable Terms." Succeeded by Huntington, Loretz & Co. about 1866.

HURLBURT & HOWARD
Hartford, Connecticut
See Hartford Manufacturing Co.

Edmund Hurlburt is listed as a "plater" in the Hartford City Directories as least as early as 1840. The term "plater" here probably refers to the process of "close plating", as electroplating was just being perfected in England, and had not yet been introduced in the United States.

In 1841 Hurlburt entered into a partnership with Charles B. Johnson. They advertised themselves in the Hartford City Directory as "silver and brass platers, 122 Main St. Importers of Silver, Brass and Japanned saddlery, dealers in all kinds of Harness and Carriage Trimmings. Agents for the sale of malleable iron castings, Patent Leather, Coach Lamps, Oil Cloths, Cotton Webbing, Coach Laces and Fringes, Carriage Bows, Carriage Mats, &c. &c. Also silver and brass plating of all kinds done to order, and of the best quality. Prices for the above goods as low as they can be bought in New York, Philadelphia, or Boston. Liberal discount made for cash."

By 1842 Johnson had left the firm and James L. Howard had taken his place. The company ran the same ad, substituting Howard's name for Johnson's. From 1843 through 1845 the firm was listed simply as saddlery ware and platers.

In 1846 Hurlburt and Howard went their separate ways. Howard continued in the business of saddlery and carriage hardware, and also sold insurance on the side. Hurlburt went into partnership with James H. Ashmead to form the firm of Ashmead & Hurlburt, goldbeaters.

In 1854 Hurlburt returned to the plating business, this time as an electroplater, when he and Ashmead, in addition to continuing the operation of their goldbeating business, formed the Hartford Manufacturing Co. (q.v.) to produce silverplated wares on the side.

HURLY SILVER CO.
Scriba, New York
See Benedict Mfg. Co.

Established in 1890 as John Hurly Silver Co. Purchased by Benedict Silver Co. in 1894.

J.H. HUTCHINSON & CO.
Portsmouth, New Hampshire

Registered U.S. Trade Mark Patent No. 19,770, June 30, 1891, for use on spoons, forks, bells, plates, and holloware of sterling silver and plated silver. This drawing of "Old Constitution" is the trademark registered. It is doubtful if the company actually manufactured any of the silverware. Souvenir spoons sold by him bear the Durgin Company mark. Out of business before 1915.

An 1896 obituary for J.H. Hutchinson reads: "John H. Hutchinson, b. Nelson, New Hampshire, June 6, 1838. Graduated from Dartmouth College. Took up residence in St. Johnsbury, Vermont where he began the merchant tailoring business and married Mary E. Graham a week before he was commissioned a lieutenant of Co. G, Third Vermont Volunteers and left for the front. Soon after reaching Washington he was commissioned a captain in the signal corps, was later aide-de-camp on the staff of General McClellan. "After he was mustered out of the service he returned to St. Johnsbury and on May 18, 1878 moved to Portsmouth, New Hampshire and started in the jewelry business under the firm name of Rowell & Hutchinson. Later he purchased the interest of the senior partner and became associated with James R. Connell and so continued for about ten years. Fifteen years ago last January this firm dissolved and each continued in the business, Mr. Hutchinson retaining the old stand and continuing there until two years ago. Last November he removed to the present location. Meanwhile he had associated his daughter and son-in-law with him in the firm. He also established a large florist business. He was active in various civic and charitable organizations. He died Monday morning June 9 at his summer home." (JC&HR 7-16-1896, p. 6)

OLD CONSTITUTION

WM. HUTTON & SONS, LTD.
Sheffield, England
See J. Dixon & Sons

Silversmiths, cutlers and electroplaters established by William Hutton (1774-1842) in Birmingham in 1800. Transferred to Sheffield in 1832.

After the death of the founder, the business was continued by his son, William Carr Hutton. Through the years the firm has undergone many name changes and/or partnerships. In 1930 their goodwill was transferred to James Dixon & Sons, Ltd. (q.v.) Well known as leading manufacturing silversmiths. (Culme, *The Directory of Gold & Silversmiths*, 1987, reprinted 1992, pp. 247-249)

Silversmiths, cutlers and electroplaters. Limited since 1893, when they acquired Fanvell, Elliott & Co. Made sterling silverware, nickel spoons and forks and steel cutlery.

Registered U.S. Trade Mark Patent 40,657, June 23, 1903, for silver and plated silver tableware.

For further information see Culme, (ibid.)

HYDE & GOODRICH
New Orleans, Louisiana
See A. Himmel Silver Manufactury

Hyde & Goodrich were in business at least as early as 1816. The earliest New Orleans City Directory available is for 1822, which lists James N. Hyde and C.W. Goodrich, at "15 Chartres Street; jewelry, military, and fancy hardware."

The firm name Hyde & Goodrich first appears in the 1838 directory. The company appears to have been involved primarily in the retail portion of the silver business, However it worked very closely with the firms of Kuchler & Himmel (q.v.) and later Adolphe Himmel (q.v.) which manufactured solid silver. (Bacot, *Silver,* Sept.-Oct. 1987, p. 26)

An advertisement in *The New Orleans Merchants' Diary and Guide,* 1857-58, describes the firm as, "The largest importers of jewelry, watches, plated-ware, guns and pistols and the only manufacturers of gold and silverware in the South-West," with the added claim, "established forty years in New Orleans".

The company went out of business in 1866 and was succeeded by Thomas Griswold & Co. and A.B. Griswold & Co.(Bacot, ibid.) The mark shown below is from Bacot, *Silver,* Mar.-Apr. 1986, p. 17.

I

IDEAL SILVER COMPANY
Portland, Connecticut

A short-lived company, manufacturers of silverware about 1905-06.

IKORA
New York, New York
See Württemburgische Metallwarenfabrik

Distributors for Württembergische Mettallwarenfalbrik (WMF).

IMC MINT CORP.
Salt Lake City, Utah

No response to inquiries. (1975)

INGRAHAM BROTHERS
Hartford, Connecticut
See C. Morgan

Miles and Lee Ingraham first appear in the Hartford City directories in 1858 when Miles Ingraham joined Chauncey Morgan (q.v.) to form the firm of Morgan and Ingraham. Although Morgan and Ingraham are listed as "silversmiths" in the 1858 directory, for all other years they are present and in the silver business, both Morgan and the Ingrahams are listed as platers.

Miles Ingraham is not found in the 1859 directory, and Lee Ingraham's workplace is not listed for that year.

In 1860, Miles and Lee Ingraham formed the firm of Ingraham Brothers, advertising themselves as "silver and gold platers by the electroprocess, rear 66 Asylum St. where they are prepared to carry on this business in all its various branches. Particular attention paid to silverplating of steel and iron work, replating tableware etc. Gold plating of Watches, Chains &c. Colors warranted to give satisfaction..."

Ingraham Brothers is not found after 1860. Both men are listed as platers the following year but their place of employment is not given. In 1862 they entered the photography business.

J.T. INMAN & CO.
Attleboro, Massachusetts

They were listed in JC 1896-1922 as manufacturers of sterling silver and plated silver cigarette cases, link buttons, buckles, vanity cases, dorines (powder boxes), bar pins, cuff and col-

lar pins and souvenir goods. Same listing in 1924 KJI.

Listed in the Attleboro City Directories 1892-1944 as manufacturing jewelers with James McNerney as owner. Listed from 1944-1963 with Roy W. Inman.

When the Watson Company went out of business about 1955, the Inman Company bought some of the souvenir spoon dies. (The Wallace Company took over the old Watson business.) These dies were used by the Inman Company until 1964 when Whiting & Davis Co. purchased the company and integrated the complete manufacturing facilities into its own plant.

THE INMAN CO. INC.
Attleboro, Massachusetts

Firm established? or re-established? in the early 1970s? It bought back the old Watson Company (q.v.) souvenir spoon dies that had been purchased by Whiting and Davis when it acquired J.T. Inman & Co. in 1964. Although at one time there were reportedly as many as 3000 Watson dies, many are now missing or broken. Others are old, worn, and not really usable. Dies for some of the flower designs, a few figurals, and several cities, however, do remain, stacked on shelves in the workroom. Some spokesmen for the silver industry claim it is not economically feasible to manufacture this type of quality spoons today.

The Inman Company currently makes souvenir spoons for Disney and Epcot Center among other products. The business is located in a portion of the old Mechanics Mill formerly occupied by the Watson Co. (Impastato, *Silver*, July-Aug. 1994, p. 17)

INTERNATIONAL SHEFFIELD WORKS, INC.
New York, New York

Listed in 1927 and 1931 KJI as manufacturers of plated silver holloware, pewterware and pewter lamps.

INTERNATIONAL SILVER CO.
Meriden, Connecticut
See Syratech Corporation

The International Silver Company was incorporated in 1898 by a number of independent New England silversmiths whose family backgrounds began with the earliest American settlers. International Silver became not only world renowned for the quality of its fine silver, it became the world's largest manufacturer of silverware.

The history of International Silver Company and its predecessors is a history of America's silversmithing. Early records of this industry started with Ashbil Griswold who in 1808 set up his pewter shop in Meriden, Connecticut, soon expanding his business to include britannia ware. Meriden became the center of pewter, britannia ware and silver manufacturing through the efforts of Griswold and other independent makers who joined together to finance the Yankee peddlers responsible for selling and bartering these wares.

About the same time, the growing demand for coin silver led the three Rogers brothers, Asa, Simeon and William, to open their workshop in Hartford, Connecticut. The high cost of coin silver, as well as its impractical nature for constant use, led to experimentation in the new process of electroplating spoons and forks with pure silver.

In 1847 they perfected this process and marketed their first silverware under the firm name of Rogers Bros. Their fine workmanship and high quality material soon established the name of the Rogers Bros. line throughout the country.

Britannia, more brilliant, harder and more resistant to wear then pewter, was replacing pewter in many American homes. Several small factories in Meriden turned to the production of this new ware, most of which was marketed by Horace C. and Dennis C. Wilcox under the name of H.C. Wilcox & Co. The Meriden Britannia Company which followed in 1852, offered German silver holloware and flatware for silverplating by 1855.

In 1862, the Rogers brothers, who had been making and selling plated silver ware in Hartford, were moved to Meriden and added to the Meriden Britannia Company. Their 1847 Rogers Bros. trademark was an important addition. This reputation is maintained today.

Other silversmiths, who had set up small shops in Connecticut, soon realized they could all work more efficiently and supply the demands of the public better by combining into one organization. The scope of the Meriden Britannia Co. had become international with the establishment of London and Canadian branches and sales offices in New York, Chicago and San Francisco. The Meriden Britannia Co. was the leading spirit

in the formation of The International Silver Company in November 1898.

Among the many independent companies which then or later became part of The International Silver Company, either directly or indirectly through Meriden Britannia Co., were the American Silver Co., Bristol,Conn. established in 1901 Barbour Silver Co., Hartford, 1892; Derby Silver Co., Birmingham, 1873; Forbes Silver Co., Meriden, 1894; Hall & Elton Co., Wallingford, 1837; Holmes & Edwards Silver Co., Bridgeport, 1882. Holmes & Tuttle, Bristol, 1851; International Silver Co. of Canada, Ltd., Inc., 1922; La Pierre Mfg. Co., Newark, 1895; Maltby, Stevens & Curtiss, Shelton, 1879; Manhattan Silver Plate Co., Brooklyn, 1877; Meriden Britannia Co., Meriden, 1852; Meriden Britannia Co., Ltd., Hamilton, Ont., 1879. Meriden Silver Plate Co., Meriden, 1869; Middletown Plate Co., Middletown, 1864; Norwich Cutlery Co., Norwich, 1890; Parker & Casper, Meriden, 1867; C. Rogers & Bros. , Meriden , 1866; Rogers Cutlery Co., Hartford, 1871 W. Rogers Mfg. Co., Ltd., Niagara Falls, 1911; Rogers Bros., Hartford, 1847; Rogers & Bro., Waterbury, 1858; Rogers & Hamilton Co., Waterbury, 1886; Rogers, Smith & Co., Wallingford, 1856; Simpson Nickel Silver Co., Wallingford, 1871; Standard Silver Co. of Toronto, Co., Ltd., 1895; Watrous Mfg. Co., Wallingford, 1896; E.G. Webster & Son, Brooklyn,1886; E.G. Webster & Bro., Brooklyn, 1863; Webster Mfg. Co., Brooklyn, 1859; Wilcox Britannia Co., Meriden, 1865; Wilcox Silver Plate Co., Meriden, 1867; Wilcox & Evertsen, New York, 1892 and William Rogers Mfg. Co., Hartford, 1865.

By 1900, the Meriden-Wallingford area of Connecticut had become a center for silver craftsmanship. Almost the peak of production was reached shortly before World War II.

In 1972 the Hotel division of International Silver Company became a subsidiary of that company under the name of World Tableware International (q.v.). This, in turn, was sold to two employees and private investors on October 1, 1983.

International Silver Company ceased making sterling holloware in 1976 and in 1981 sold its plated holloware business to Oneida, Ltd., Silversmiths of Oneida, New York (q.v.)

In 1984 the International Silver Company was sold to Katy Industries, Inc. of Elgin, Illinois which already owned Wallace Silversmiths. The firm name was changed to Wallace International Silversmiths, Wallingford, Connecticut (q.v.). This company markets International Sterling flatware and silverplated flatware trademarked 1847 Rogers Bros., International Deepsilver, International Silverplate and several brands of stainless steel flatware in addition to the Wallace Silversmiths' products.

In 1986 The International Silver Co. and Wallace Silversmiths were purchased by a subsidiary of Syratech Corporation. (q.v.) which continues to manufacture and market their products.

In 1925 the International Silver Company introduced a sterling pattern with an imprint of a pine tree on the back of the handle. The pine tree was similar to that on the pine tree shilling made famous through the tradition that the Mint Master, John Hull, gave his daughter her weight in shillings as a dowry upon her marriage to Samuel Sewall. When the silver pattern was introduced, the International Silver Company secured permission from the United States Treasury to reproduce in silver, the original pine tree shilling which was first made by John Hull in 1663. The reproductions were distributed for advertising.

International Silver Company weight markings on sterling flatware

The use of letters to indicate the various weights in sterling patterns cannot be answered in a general way as there are some exceptions. Variations occur, depending upon the pattern. For both Wilcox & Evertsen and Simpson, Hall, Miller & Company, in 1899 none of their price lists show what symbols or letters were used. The different weights are listed but not the symbols used.

In 1904 Simpson, Hall, Miller & Company pattern teaspoons were listed as light, medium, heavy, extra heavy and massive. In 1906 there were listed medium, heavy, extra heavy, massive and extra massive (in some patterns). In 1906 the weights were listed as trade, medium, heavy and extra heavy and in 1910 the listing was the same with the addition of massive.

In Wilcox & Evertsen patterns, in 1899 were listed regular, medium, heavy and extra heavy with a footnote to the effect that the regular weight was "small size." (Probably the five o'clock teaspoon size.) In 1901 there were listed medium, heavy, extra heavy and massive and in 1906, regular, medium, heavy and extra heavy.

Not until 1920 did the old price lists show the letters and these were basically for standard patterns. The following seem to be the most commonly used:

Teaspoon (five o'clock)	A
Trade	B
Regular	C
Heavy	D
Massive	E

In some patterns B was sometimes called medium, C was sometimes heavy and A was called regular.

For example:

Deerfield (1913) teaspoons were made in A, B, C and D weights; the only other pieces made in different weights were the dessert and tablespoons and the dessert and dinner forks, all made only in A and B weights.

Pantheon (1920) teaspoons were made in B, C, D and E weights; the other four items listed above were made only in B and C.

By 1941 only teaspoons were made in more than one weight with no consistency in the system of marking. The letters R and H were used for Regular and Heavy and also E for Extra Heavy. *Prelude* (1939) and *Gadroon* (1933) teaspoons were made in R and H. *Richelieu* (1935) and *Colonial Shell* (1941) were made just in H and E; *Continental* (1934) was made in R, H and E.

Empress (1932) and *Fontaine* (1924) had teaspoons made in Regular, Heavy and Extra Heavy but these weights were represented by the letters C, D and E. After 1945 extra weight teaspoons were discontinued but some patterns are heavier than others. Patterns are separated into Groups I through IV, all teaspoons within a group being the same weight.

Grade markings for 1847 Rogers Bros. silverplated flatware

The base metal used for these goods is 18% nickel silver - practically indestructable.... The plating on a spoon or fork is .999 pure silver.

There are three grades of plate with marks as follows:

XS
1847 ROGERS BROS. TRIPLE

This is the grade ordinarily sold and more than sufficient for any except especially hard wear. Teaspoons are plated not less than six ounces and table spoons are not less than twelve ounces to the gross (other staple pieces in proportion).

XS
1847 ROGERS BROS. XII TRIPLE

The teaspoons are plated not less than six ounces and table spoons not less than twelve ounces to the gross, and in addition the parts most exposed to wear bear an additional double plating.

xs
1847 ROGERS BROS. Quintuple

This is the heaviest grade of silver plate made and is required only by those who desire something extraordinarily heavy. It is used for the most part by hotels, railroads, etc., where the silver is subjected to constant and hard use. Teaspoons are plated not less than ten ounces and table spoons not less than twenty ounces to the gross (other staple pieces in proportion).

The above from an early 1900 pamphlet issued by the International Silver Company.

Following the formation of International Silver Company in 1898 the firm continued to use the trademarks of its predecessors. After 1917, 1847 Rogers Bros. silverplate was made in only one quality and all "quality" marks were discontinued.

The International Silver Company mark was not used until after 1928 on flatware.

INTERNATIONAL STERLING

INTERNATIONAL STERLING

INTERNATIONAL STERLING

INTERNATIONAL STERLING

 INTERNATIONAL SILVER COMPANY

I.S.CO. INTERNATIONAL SILVER CO.

INTERNATIONAL S. CO. INTERNATIONAL

L STERLING IS. CO.

INSICO

 ROGERS *L* STERLING R. & B.

INTERNATIONAL SILVER COMPANY

LA PIERRE

WILCOX & EVERTSEN

INTERNATIONAL B_C^S STERLING
1847 STERLING

1847 ROGERS BROS. STERLING

167

BREWSTER
(Pewter holloware)

ALBANY SILVER PLATE
AMERICAN SILVER CO.
AMSILCO
ATLAS SILVER PLATE
AVON SILVER PLATE
BS CO.
CAMELIA SILVERPLATE
CARV-EZE
COURT SILVER PLATE
CROWN SILVER CO.
DEEP SILVER
DEERFIELD SILVER PLATE
EASTERN SILVER CO.
1847 ROGERS BROS.
1865 WM. ROGERS MFG. CO.
EMBASSY SILVER PLATE
GEM SILVER CO.
HOLD-EDGE
HOLMES & EDWARDS
HOLMES & TUTTLE
H. & T. MFG. CO.
INDEPENDENCE TRIPLE
INLAID
INSICO
INTERNATIONAL
INTERNATIONAL SILVER CO.
I.S. CO.
I.S. CO.
KENSICO
KENSINGTON SILVER PLATE
MANOR PLATE
MELODY SILVER PLATE
N.E.S.P. CO.
NEW ENGLAND SILVER PLATE
NO-TARN
OLD COMPANY PLATE
PALLADIANT
R. & B.
R. C. CO.
REVELATION SILVER PLATE
ROGERS CUTLERY CO.
ROGERS & HAMILTON
ROYAL PLATE CO.
SILVER WELD (knives)
SOUTHINGTON COMPANY
STRAND
STRATFORD PLATE
STRATFORD SILVER PLATE CO.
SUPER-PLATE
SUPERIOR

SUPREME SILVER PLATE
VIANDE
VICTOR S. CO.
WILCOX SILVER PLATE CO.
WM. ROGERS MFG. CO.
WM. ROGERS & SON
WORLD
X S TRIPLE

INTERNATIONAL SILVER COMPANY OF CANADA, LTD.
Hamilton, Ontario
See Interational Silver Co.

Began with the establishment of the Meriden Britannia Co. Ltd. at Hamilton, Ontario in 1879. Organized to take care of the Canadian business of the International Silver Co. Was incorporated in 1925.

The business was sold to Heritage Silversmiths in June 1972.

Drawn marks below are from Unitt & Worrall, *Unitt's Book of Marks*, 1995, p. 45.

HOLMES & EDWARDS
INLAID

INTERNATIONAL-COMMONWEALTH SILVER CO.
New York, New York

Listed in JC 1915-1922 as successor to International Silver Deposit Works, founding date unknown.

POPPY
(*Deposit Ware.*)

IVES MFG. CO.
Location unknown

The mark shown below appears on a piece of medallion flatware of a style similar to those produced by other silverplate manufacturers ca. 1870.

An 1885 billhead for J. W. Johnson (q. v.) lists that firm as sole agent for the Ives Mfg. Co. It further describes the products sold by the Johnson company (and presumably produced by Ives) as "Superior Second Quality Nickel and Silver Plated Wares, Spoons, Forks, Knives, Ladles, Etc."

J

D.C. JACCARD & CO.
Saint Louis, Missouri
See Mermod, Jaccard & King

E. JACCARD & CO.
Saint Louis, Missouri
See Mermod, Jaccard & King

JACKS & WOODRUFF
San Francisco, California

William A. Woodruff began advertising "Woodruff's Jewelry Store" in August 1850. He reportedly made a gold chain that was presented to Daniel Webster. However, it is more likely that he commissioned another silversmith, Charles Hendrick, to make it for him.

When he died in 1850, his three brothers-in-law and partners, William Jacks, Hamlet Jacks, and Paulaski Jacks, took over the business, naming the firm "Jacks & Woodruff." It later became Jacks Bros.

In 1851 the firm was commissioned to produce a 30 ounce solid gold goblet that was presented to the Collector of Customs for Upper California. Not found in directories after 1854. (Morse, in Morse ed., *Silver in the Golden State*, 1986, p. 3)

HENRY JACKSON
Toronto, Ontario, Canada

Jackson was a silversmith, watchmaker and jeweler in business in Toronto from 1837 to 1869. He also manufactured silverplate. (Unitt & Worrall, *Unitt's Book of Marks*, 1995, p. 46)

H.J.TORONTO

A. JACOBI
Baltimore, Maryland
See Jacobi & Jenkins
See Jenkins & Jenkins

Founded in 1879 as manufacturing silversmiths. Company name changed to Jacobi & Co. in 1890.

JACOBI & COMPANY
Baltimore, Maryland
See Jacobi & Jenkins
See Jenkins & Jenkins

Successors to A. Jacobi in 1890; reorganized as Jacobi & Jenkins in 1894.

JACOBI & JENKINS
Baltimore, Maryland
See Jenkins & Jenkins

The business was established by A. Jacobi in 1879. The Jacobi family had been silversmiths for seven generations. A. Jacobi received his master's certificate from the silversmith's guild of Brunswick, Germany in 1858. He also held a medal of honor award from the *Academie Nationale* in Paris.

In 1890 the firm became Jacobi & Company, manufacturing sterling silverware and doing a jobbing trade in the large cities of the country.

In 1894 the partnership of A. and W. F. Jacobi with W. Armour and Talbot Winchester Jenkins was formed. The Jenkins brothers had been associated with the jewelry business in Baltimore for years, and were members of one of the oldest families in the state.

The new company focused exclusively on the production of sterling silverware. It occupied its own three story building and employed forty hands.(Englehardt, *Baltimore City Maryland*, n. d., c. 1895)

In 1895 they advertised that they were "the only silversmiths in Maryland making and retailing their own work exclusively - all articles of sterling silver."

The firm was succeeded by Jenkins and Jenkins in 1908.

RUFUS JACOBY
Silver Spring, Maryland

Silversmith, specializing in handwrought liturgical articles. Many of his chalices are a combination of silver and Macassar ebony. Though he fashions all his silver entirely by hand, his work is the essence of modern simplicity and functional design .

JACOBY HANDMADE STERLING

JACOBY BROS. LTD.
Vancouver, British Columbia, Canada

A family firm composed of four brothers and two sisters founded in 1909. Alfred (Dick) Jacoby served as President, Martin Jacoby as engraver and die maker. Shortly after the founding of the firm, the sisters married and gave up active participation in the business.

Dick Jacoby had worked for Joseph Mayer & Bros. (q. v.) in the late 1800s, and Martin may have done so as well. Dick came to Vancouver

and worked for Torief Jewelry from 1906 to 1908. That firm was later taken over by Birks (q.v.)

Jacoby Bros. produced souvenir spoons and 9K Gold "coins" for use in making jewelry. A new "coin" was issued each year.

In 1926 Martin Jacoby left the company, and from that point on no new designs of coins or spoons were developed. However production continued using the old dies.

Dick turned the business over to his two sons A. A. (Al) and R. E. (Bob) in the 1940s. He died in 1956. The firm went bankrupt in 1985.

Perhaps the best known spoon by the firm is a coffee size Totem Pole, locally engraved with town names from throughout Alaska and British Columbia.

STERLING

G.D. JARVES & CORMERAIS
Boston, Massachusetts
New York, New York

George Deming Jarves and Hugh Cormerais opened a branch office of their Boston based business in New York City about 1855. According to an ad they placed in Mason's Bros. Business Directory in 1856, the company manufactured German Silver Plated Goods. Their New York Agent was Joshua B. Graves. By 1858 the firm was listing itself in the New York City directory as a manufacturer of gas fixtures. Not found after 1859.

GUY S. JENKINS
New York, New York

Listed JKD 1918-19 as manufacturer of silverplated holloware.

JENKINS & CO.
New York, New York
See Lasslo Chandor

Jenkins & Co. were listed as in the gold and silver plating business at least as early as 1852. However the firm may have simply served as a retail outlet for Lasslo Chandor. (q.v.)

In 1853 Elisha F. Jenkins, the owner of the company, became interested in the oil business. The silverplating business, and Jenkins & Co. are not found after 1854.

JENKINS & JENKINS
Baltimore, Maryland

Originally founded as A. Jacobi in 1879, manufacturing silversmiths; changed to Jacobi & Co., 1890; reorganized as Jacobi & Jenkins in 1895; succeeded by Jenkins & Jenkins in 1908. The tools and dies were purchased c. 1915 by the Schofield Company, Inc. of Baltimore manufacturers of silverware and jewelry. The Schofield Co. was bought by Oscar Caplan & Sons in 1965 and in 1967 sold to the Stieff Co., all of Baltimore.

LEWIS E. JENKS
Boston, Massachusetts

Listed in Boston City Directory 1875 to 1885 at same address as Farrington & Hunnewell. He was also a member of the partnership of Kennard & Jenks which was bought by the Gorham Company c. 1879-80.

JENNINGS & LAUTER
New York, New York

Listed in JC 1896 as Reeves & Sillcocks; succeeded by Reeves & Browne before 1904; by Browne, Jennings & Lauter before 1915 and by Jennings & Lauter before 1922. Listed in sterling silver section.

JENNINGS BROS. MFG. CO.
Bridgeport, Connecticut

Manufacturers of silverplated toilet ware, shaving stands, shaving sets, casseroles, table holloware, clocks, lamps, Sheffield reproductions.

1890 JENNINGS BROS. A1

Trademark J B used on novelties.

JENNINGS SILVER CO.
Irvington, New Jersey

Manufacturers and jobbers of sterling and plated silver holloware. Listed JC 1915-1943.

J.S.Ĉ.

JENNINGS
(On sterling)

JESCO
(On silverplate)

GEORG JENSEN, INC.
Copenhagen, Denmark

Founded by Georg Jensen (b. 8-31-1866; d. 1935) who opened his first tiny shop at 36 Bregade, Copenhagen, in 1904. Twenty-five years later he had a staff of 250. There are now branches all over the world. Among the world's leaders in production of modern silver, they turned to stainless during World War II when silver was not available. Georg Jensen was one of the most influential designers of modern silver.

GEORG JENSEN Inc.
(On base metals)

(On articles made of or plated with precious metals)

Claims use on goods made of bronze since December 1932; on goods made of aluminum since April 1936; on goods made of pewter since October 1936; and on goods made of stainless steel since November 1940.

The above trademarks all registered in the U. S.

GEORG JENSEN INC., USA
New York, New York
See Alphonse La Paglia

A specialty offshoot of Georg Jensen Inc. devised by Frederick Lunning, the company's New York representative during World War II. Faced with a dwindling supply of merchandise from Copenhagen, in 1941 Lunning hired three American silver designers to produce jewelry "in the Jensen style": Alphonse La Paglia (q.v.), Joan Polsdorfer, and Madeline Turner.

While La Paglia is reported to have done some undercover work for the government in his native Italy during the war, he also clearly spent some time developing jewelry for Jensen, as the company's 1944 catalog features several pages of his designs. Of the three designers, his work followed the Jensen style most closely. His marks on Jensen pieces were "L P" or the same two letters with a sheaf of wheat between. When he later went to work for the International Silver Company he used the same designs and reference numbers on his pieces there as well.

Joan Polsdorfer used the maker's mark "JoPoL." Her pieces were created in a more modern, two dimensional style than La Paglia's. Although some of her work bore her mark, she was never acknowledged as a designer in the Jensen Catalogs.

Madeline Turner was noted for the meticulous hand crafting of her pieces and her fine repoussé work. However she apparently was not permitted to place her mark on any of her Jensen pieces.

Although the jewelry line proved quite successful, it did not meet with the approval of the parent company. When it belatedly discovered this offshoot after the war, the original Georg Jensen company filed a lawsuit to stop production. The case was settled in 1949-1950 and no futher "Georg Jensen Inc. USA" pieces were produced. (Moro, *Silver*, Nov.-Dec. 1996, pp. 28-35)

THE JEWELERS' CROWN GUILD
Rockford, Illinois

The Jewelers' Crown Guild appears to have been successor December 21, 1892 to the Watchmaker's and Jewelers' Guild of the United States which had been formed in 1879. The object of this organization was to combat the "catalogue nuisance," or underselling by firms who sold through catalogs and did not have the expense of maintaining retail outlets - a problem that jewelers still face today. The goods were to be distributed through certain jobbing houses who were bound by Guild restrictions to sell only to Guild members and were required to mark all goods passing through their hands as Guild goods, with certain private marks.

The Guild adopted distinctive marks which were to be stamped on all Guild goods. Thus all goods were stamped both with manufacturer and with quality marks, and their course would be easily traced through the various channels of trade in order to fix responsibility. The idea never won complete acceptance and seems to have been of short duration as no record of it has been found after 1904.

The old Guild mark was composed of lines, and it was discovered that it broke the plating on certain goods, consequently the Guild adopted as its mark the device used by J.H. Purdy when he was chief distributor for the Guild. The device was adopted by Purdy when two doves flew down and lit on his outstretched hand when he stood in front of a store in Manchester, Iowa, where he had just completed a successful business arrangement for the Guild. Perhaps Mr. Purdy had been recently hearing Lohengrin; at any rate, the incident so impressed him that he accepted it as an omen, and immediately adopted it as his private device until it was later adopted by the Guild.

UNITED STATES JEWELERS' GUILD.

C.C. JOHNSON
Chicago, Illinois

Listed in 1854-1855 Chicago Directory as a silverplater.

J. W. JOHNSON
New York, New York
See Waters & Thorp

Founded in 1869 by John Wesley Johnson who had as a boy worked for J.A. Babcock & Co. (q.v.) in the plating shop. Johnson was an agent for the Middletown Plate Company after working for Babcock.

Johnson's original shop location was at 14 John St., the former address of Josiah C. Waters, who was earlier part of Waters & Thorp (q.v.) This suggests that Johnson may have taken over Waters' business.

An 1885 billhead for the company describes the firm as providing, "Superior Second Quality Nickel and Silver Plated Wares, spoons, forks,

knives, ladles, etc." Although not indicated on the billhead, the firm provided holloware as well, as shown by the listing of items sold.

In addition, the company listed itself as sole agent for Ives Mfg. Co. (q. v.) and London Mfg. Co. (q.v.)

An 1898 account reads: "There is no longer any Crown Silver Plate Co. but J.W. Johnson stamps this name on plated silverware. " (JC&HR 4-17-1898, p. 23)

By 1919, the J.W. Johnson company was operated by the founder's son, Harry F. Johnson, still under the same name.

They were jobbers who specialized in plating and were also wholesalers of plated silverware. Last listed in 1950.

CONNECTICUT PLATE CO.
(Holloware.)

CROWN SILVER PLATE CO.
(Flatware.)

ROYAL PLATE CO.
(Flatware.)

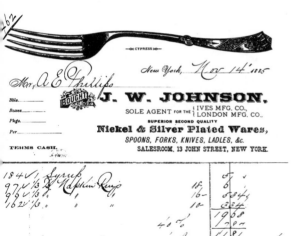

An 1885 billhead from the firm of J.W.Johnson. The reference to "Superior Second Quality" wares is unusual.

SAMUEL H. JOHNSON
New York, New York
See Benjamin Gurnee
See Edmond Kidney

CHRONOLOGY

Johnson & Tobey	1856-1858
Samuel H. Johnson?	1860
Gurnee & Johnson	1861
Samuel H. Johnson?	1862

Kidney, Cann & Johnson	1863
Kidney, Cann & Johnson	1865-1867
Kidney & Johnson	1868-1874+?

Samuel H. Johnson first appears in the New York City directories in 1856, in partnership with Edward M. Tobey in the firm of Johnson & Tobey, silversmiths. The business was located at 17 John Street, previously the site of Benjamin Gurnee's shop. Gurnee (q.v.) returned and went into partnership with Tobey in 1859, and Johnson left the firm. Johnson is not found in the directory for 1859, but he re-appears in the 1860 directory with his business listed as "cases", presumably jewelry cases. By 1861 Tobey had left his partnership with Gurnee, and Johnson had taken his place. In 1862 Gurnee left and apparently Johnson operated the business on his own.

In 1863 Samuel H. Johnson went into partnership with Edmond Kidney (q.v.),(formerly Adams & Kidney) and John Cann (q.v.) (formerly Charters, Cann & Dunn), to form the firm of Kidney, Cann & Johnson. He left the following year, and the firm became Kidney & Cann. By 1865 he had returned, and the business once again became Kidney, Cann & Johnson.

When Cann left the firm about 1868, it became known as Kidney & Johnson. It continued under that name until at least 1874.

Soeffing (*Silver Medallion Flatware*, 1988, p. 60) indicates that the firm of Kidney & Johnson dissolved at some point in the mid 1870s. Samuel H. Johnson then went into business on his own, continuing to produce many of the flatware patterns of the earlier companies.

E.S. JOHNSON & CO.
New York, New York

Listed 1896-1922 JC in sterling silver and jewelry sections.

JOHNSON & GODLEY
Albany, New York

Samuel Johnson and Richard Godley listed in Albany City Directories 1843-1850 as producing factory-made silver. Their marks consisted of the two surnames in addition to "pseudo hallmarks."

JOHNSON, HAYWARD & PIPER CO.
New York, New York

Listed in JC 1904-1915 in plated silver and jewelry sections. Were probably distributors.

DUTCH SILVER NOVELTIES

J.H. JOHNSTON & CO.
New York, New York

Established in 1844 according to their advertisement in *Harpers Weekly* 1898. This date may refer to the company's predecessor, Many & Lewis. J.H. Johnson & Co. itself appears to have started in business about 1860 as noted below.

An advertisement in the December 27, 1863 issue of the *New York Times* describes the business: "At J.H. Johnston & Co's No. 150 Bowery, Corner Broome St., N.Y.

"Fine Gold and Silver watches, rich jewelry and diamonds, sterling silver ware, bridal presents, card albums &c. &c. We manufacture our own silver plated ware, such as tea sets, urns, casters, baskets, forks, spoons, &c. We double-plate all that we sell, and our prices are as low as the lowest."

An 1897 account states: "J.H. Johnston & Co. insolvent. J.H. Johnston, president of the company started in business about 1860, succeeding Many & Lewis. About 1888 he opened the present store at 15th St. and Union Square which he conducted while Albert E. Johnston conducted the Bowery store. The latter store was given up about 1882, and the same year the business was incorporated as J.H. Johnston & Co., with J.H. Johnston becoming president and A.E. Johnston, treasurer." (JC&HR 1-13-1897, p. 17)

"A new corporation, J.H. Johnston Co. formed of creditors of the old company." (JC&HR 3-17-1897, p. 9)

By November 1899 the firm was listed as J. H. Johnston & Son as shown in an ad in *Century Magazine*.

Out of business between 1904 and 1915.

C. B. M. C.
C. P. F.
DUPICATE WEDDING PRESENTS

A.H. JONES COMPANY, INC.
Meriden, Connecticut

Listed as manufacturers of plated silver shakeless cellars and novelties 1918-31.

JONES, BALL & POOR
Boston, Massachusetts
See Shreve, Crump & Low, Inc.

CHRONOLOGY

John B. Jones	18??-1839
Jones, Low & Ball	1839-1846
Jones, Ball & Poor	1846-1853
Jones, Ball & Co.	1853-1855
Jones, Shreve, Brown & Co.	1857-1860
Shreve, Brown & Co.	1857-1860
Shreve, Stanwood & Co.	1860-1869
Shreve, Crump & Low	1869-1888
Shreve, Crump & Low Co.	1888-present

The company was a manufacturer of silver during its early years and probably continued production until at least 1860.

In 1853 Jones, Ball & Co. was an exhibitor at the New York Crystal Palace Exhibition. The company's products displayed there were described as "remarkable for their chaste style and for substantial workmanship." (Soeffing, in Venable's *Silver in America*, 1994, biographical section, p. 320)

JONES, BALL & POOR
JOHN B. JONES CO.
JONES, LOW & BALL
JONES, SHREVE, BROWN & CO.
JONES & WARD

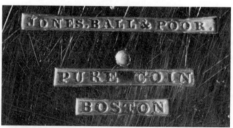

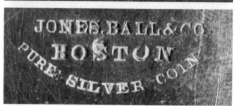

JONES & WOODLAND
Newark, New Jersey
See Federal Silver Co.

Jones & Woodland owned by Krementz since 1977.

J.G. JOSEPH & CO.
Toronto, Ontario, Canada

J.G. Joseph was a silversmith, watchmaker and jeweler reportedly in business from 1857 to at least 1877 and possibly later. He may have

been primarily a retailer. Robert Hendery (q.v.) and Hendery & Leslie manufactured silver for him. Pieces bearing his stamp show a wide variety of marks, including pseudohallmarks. (Unitt & Worrall, *Unitt's Book of Marks*, 1995, p. 46)

A.R. JUSTICE CO.
Philadelphia, Pennsylvania

The Philadelphia City Directories list the A.R.Justice Company from 1881 (hardware) through 1935-1936. The 1882 listing is in the name of Alfred R. Justice, cutlery. In 1885, the names of F. Millwood & Herbert M. Justice are added. In 1886 is the first reference to plated ware. The 1892 listing is A.R. Justice & Company (with C. Arthur Roberts added to those mentioned), silverware and cutlery. By 1895 there is reference only to silverware and plated ware and in 1899 the reference is to silversmiths. In 1910-1911 silverware and cut glass are mentioned. Further listings mention only silverware. (The name is often spelled Justus.)

(Pearl Handled Knives.)

HICKS SILVER CO.
(Hollowware.)

MEDFORD CUTLERY CO.
(Pearl Handled Knives.)

RIVERTON SILVER CO.
(Hollow and Flatware.)

JUSTIS & ARMIGER
Baltimore, Maryland
See James R. Armiger

First listed in the Baltimore City Directory in 1891 as manufacturers of silverware, solid and plated. Succeeded by James R. Armiger in 1893.

JUSTIS & ARMIGER
TRIPLE PLATE
BALTIMORE

K

LEOPOLD KAISER
New York, New York

Leopold Kaiser first appears in the New York City Directory published in 1869 listed as a plater. In the directory published in 1870 the firm is referred to as "Leopold Kaiser, Late Kaiser & Stern". However, neither Mr. Stern nor the company can be identified in the New York City directory published in 1869, so perhaps the business was located somewhere else.

In the directory published in 1870, Kaiser described himself as a "Silver Plater and Gilder on Britannia, Table Cutlery, Dental and Surgical Instruments, pistols" and indicated "Particular attention paid to Job Plating and Replating old goods, for private Families, Hotels, Steamboats and the Trade. All work warranted as represented."

Kaiser was listed as a plater again in 1871. In 1872 and 1873 he is listed as a gilder. By 1874 he was working for someone else as a plater. Not followed further.

THE KALO SHOP
Chicago, Illinois

Founded by Clara Barck Welles in 1900, it went on to become the largest and most influential producer of handwrought silverware and jewelry in the midwest. Mrs. Welles studied at the Art Institute's School of Decorative Designing and after graduation started the Kalo Shop.

Mrs. Welles retired in 1940 at the age of 72. The Kalo Shop continued in operation under the ownership of four employees, Daniel P. Pedersen, Yngve Olsson, Arne Myhre and Robert R. Bower. On the death of Olsson and Pedersen, Bower refused to lower the standards and the shop closed in 1970.

During its early years the Kalo Shop produced some novelty lines. Not until 1915 did they produce silverware exclusively.

Marks:
All Kalo silverware is marked KALO in capital letters. Large items are also marked HAND WROUGHT AT THE KALO SHOPS or THE KALO SHOP. Copper pieces and some early silver was marked only KALO. With the beginning of their silver production, a numbering system was introduced and numbers were impressed in addition to the KALO mark. These numbers soon ran into the thousands and around 1921 a new numbering system was introduced

whereby the number represented the design or pattern rather than the order number. The letters S, M and L designated different sizes of a design.

Dating Kalo Shop articles:

HAND WROUGHT AT THE KALO
SHOP, PARK RIDGE, ILLS. 1907-1914
HAND WROUGHT AT THE KALO
SHOP, CHICAGO AND NEW YORK
 1914- 1918
HAND WROUGHT AT THE KALO
SHOP, CHICAGO (or no city designation)
 1918-1970

Marks on jewelry:

STERLING/KALO with the letters S, M or L (small, medium, large) appearing on pieces from 1921 on, indicating size of design.

Their Norse line was marked: NS before the number.

KANN BROS. SILVER CO.
Baltimore, Maryland

CHRONOLOGY
Kann & Sons	1870-1885
Kann & Sons Mfg. Co.	1885-1896
Kann Bros. Silver Co.	1899-1913

Originally founded as Kann & Sons. Listed in Baltimore City Directories from 1877 but advertisements say "Established, 1870." Succeeded by Kann & Sons Mfg. Co., 1885 and by Kann Bros. Silver Co , 1899.

The firm continued to be listed as silverplaters through 1913.

E.M. KARMEL & CO.
Brooklyn. New York

Listed JC 1915-1922 in sterling section.

J. KATZ & CO.
Baltimore, Maryland

Listed in Baltimore City Directories 1901-1904 as silversmiths.

ERNEST KAUFMANN
Philadelphia, Pennsylvania

Listed Philadelphia City Directory only 1855 "brit. - tin." Advertised in *The Watchmaker & Jeweler* June 1870. Adv. has illustration of "Kaufman's (sic!) Patent Butter Dish." Also says "Manufacturers of superior silver plated & Britannia Ware. Established in 1857."

Kaufmann received a number of patents for silverplated holloware pieces. Design Patents Numbers 1,751 and 2,327 were for ornately figural icewater pitchers. Design Patent Number 1,876 was for a more conventional type of tea service. Kaufmann also received an Invention Patent in partnership with Antony Weber, Number 82,005 for a butter dish with a rotating lid, referred to in the advertisement above.

MICHAEL J.A. KEANE
New York, New York
See William Gale

Michael J. A. Keane first appears as a plater in the New York City directory published in 1866 working for someone else. In 1867 and 1868 he was working as a plater at 447 Broome, whether for himself or for one of the William Gale group of companies which were also at that address and were manufacturing their own silverplate at about that time, has not been determined.

By 1869 Keane was definitely in business for himself, advertising in the New York City directory as specializing in door and number plates, and engraving. In 1871 he was offering repair and replating services. In 1862 he described himself as a "Gold, Silver, and Nickel Electro and Hand-Plater, and Metal Sash Maker".

No business listing is given for him in 1873. By 1874 he was in the brush business.

C.F. KEES & CO.
Newark, New Jersey

Successor, before 1904, to Henry I. Leibe Mfg. Co. and were succeeded by Archibald, Klement Co. c. 1909. They were manufacturers of sterling silver and gold lorgnettes and related items.

KELLEY & MCBEAN
Niagara Falls, New York

Listed in the 1900 Niagara Falls City Directory as makers of silver and plated silverware. An 1895 account states: "Henry Kelley, senior member of Kelley & McBean, manufacturers of silver plated goods, and inventor of consider-

able prominence, died a few days ago. He was born in Toulon, Illinois. Fifteen years ago he moved to Niagara Falls where he continued to live. For many years he was superintendent of the Oneida Community mill. In 1892 he launched out with F. Woolworth under the name Kelley & Woolworth in the designing and manufacture of (silver and silverplated) novelties. The firm was changed about a year ago by the retirement of Mr. Woolworth and the succession of H.W. McBean." (JC&HR 3-2-1895, p. 5)

JACK KELLMER CO.
Philadelphia, Pennsylvania

Wholesale and retail outlet for sterling and silverplate and pewter holloware and flatware.

KENNARD & JENKS
Boston, Massachusetts

Lewis Jenks was a former employee of Bigelow Bros. & Kennard and its successor, Bigelow, Kennard & Co. (q. v.) He went into business on his own about 1872 to manufacture fine silverware.

He was joined in 1876 by Edward Kennard, the son of Martin Parry Kennard of Bigelow, Kennard & Co. which probably retailed the firm's products. The business was purchased by Gorham in 1880, and the plant was moved to Providence. (Soeffing, in Venable's *Silver in America*, 1994, biographical section, p. 320)

Mark: An incised dolphin in a shield.

MRS. ANNIE KENNEY
Baltimore, Maryland

Listed in Baltimore City Directories 1867-1873 as a goldsmith and silversmith. Her advertisement says "Mfg. of gold pens."

CHARLES KENNEY
Baltimore, Maryland

Listed in Baltimore City Directories 1867-1868 as a silverplater.

AMBROSE KENT & SONS, LTD.
Toronto, Ontario, Canada

Established in 1867 as Kent Bros. By 1900 the firm was known as Ambrose Kent & Sons, Ltd. William G. Kent served as Vice President and Treasurer, and F.A. Kent served as General Manager. They listed themselves as manufacturing jewelers. Both the factory and the store were located in Toronto.

Between 1899 and 1906 the firm received six Canadian copyrights for designs for souvenir spoons, two of them representing mining themes. (Pack, *Collectors Guide to Canadian Souvenir Spoons*, 1988, pp. 45-49, including last three marks below)

Merged with Fairweather Ltd. in 1946 and became Kent-Fairweather, Ltd. Kent sold out in late 1953 and the firm name reverted to Fairweather, Ltd. No silverware is sold there now.

KENT BROS.
Toronto, Ontario, Canada

In business ca. 1867-1897 as importers and manufacturers. The firm produced fine jewelry and emblems, specializing in high quality hand enamelled work. (Unitt & Worrall, *Unitt's Book of Marks*, 1995, p. 46)

KENT SILVERSMITHS
New York, New York

Founded in 1936 by Lewis E. Ellmore and George Fina, now (1975) president. Their factory is in Long Island City, New York. Over a period of years they have purchased the tools and dies of several old manufacturers. They are manufacturers, wholesalers and importers of sterling and silverplate, serving pieces, holloware and novelties; also pewter.

KENT & STANLEY CO., LTD.
Providence, Rhode Island

Partners were E.F. Kent and S.W. Stanley. They were successors to Wm. H. Robinson & Co. who began in 1873. The firm changed to Kent & Stanley in 1888 and was incorporated in 1891. The company owned the Enterprise Building and occupied the top floor. Also housed there were Hamilton & Hamilton, Jr., the Howard Sterling Co. and Parks Brothers & Rogers. Kent & Stanley manufactured silver souvenir articles. An ad in the City Directory says "rolled plate and silver chains as a specialty." The company failed in 1897, went into receivership. The Bassett Jewelry Company, Newark, New Jersey, took over plant and stock in 1898.

WM. B. KERR & CO.
Newark, New Jersey
See Gorham Corporation

Originally Kerr & Thiery, established by William B. Kerr in Newark, New Jersey in 1855. Makers of flat and tableware, gold dresserware and jewelry. Used **fleur-de-lis** trademark in 1892. Purchased by the Gorham Corporation in 1906 and moved to Providence, Rhode Island in 1927.

H. KESSNER & COMPANY
New York, New York

Listed at least as early as 1922 KJI and as late as 1927 KJI as manufacturers of sterling silver, nickel-plated, silver plated, German silver photo frames, mesh bags, and novelties.

KETCHAM & McDOUGALL
New York, New York
See Roshore & Ketcham

Best known as thimble makers. According to JCW 2-5-1919, "The business which is believed to have been founded somewhere between 1802 and 1803 was continued under various names but was developed by the house of Roshore and Wood which began business in 1830."

A different version came from the late Richard McFayden, who at the time of his death in 1969 was President and Chairman of the Board of Directors of Ketcham & McDougall, Inc. of Roseland, New Jersey. According to him, in 1832 John Roshore opened a small silversmith shop in New York City, taking into the business an orphan boy, Edward Ketcham, as apprentice. After the young man had served his apprenticeship, the business became Roshore & Ketcham. Hugh McDougall, another orphan, was also apprenticed. John Roshore retired about 1855 and Edward Ketcham brought his brother, Ebenezer P. Ketcham, into the business which then became known as Ketcham & Brother.

By 1858 the firm had become Ketcham Brother & Co. They advertised themselves as gold and silver thimble manufacturers in the New York City directory published in 1860.

Later they began to make gold heads for canes and walking sticks, umbrella mounts, ferrules for pipes and similar articles of gold and silver.

In 1875 the brothers took Hugh McDougall into partnership and in 1876 renamed the company Ketcham & McDougall. About this time they built a new and larger factory in Brooklyn. In 1886, Walter McDougall, Hugh's son, started work for the company. In 1894 Hugh McDougall patented a "Device for Securing Eyeglasses," developed by various members of the firm. The device consisted of a fine chain which could be reeled into a decorative case fastened to a coat lapel or lady's dress. The glasses hung on the owner's chest when not in use. This popular device was much copied, but, according to McFayden, it was never equalled.

Even before Edward Ketcham's death in 1894 and that of Hugh McDougall in 1901,

Walter McDougall had assumed the major responsibility for the business. In this, he was joined by his brother, Charles McDougall. They developed other automatic holders and continued to make fine jewelry along with these specialty lines.

During WWI Ketcham & McDougall made parts of Sperry gyroscopes, parts for early radios and other mechanical devices. The business was incorporated in the 1920s. During the depression of the 1930s sales decreased and they are no longer jewelers but are precision manufacturers of stationary, optical and marine accessories. Their factory is located in Roseland, New Jersey.

KEYSTONE SILVER CO.
Philadelphia, Pennsylvania

Manufacturing silversmiths since 1914. Makers of reproductions in silver and gold; original designing; ecclesiastical goods and restorations. (1975)

(On sterling silver) (On plated silver)

EDMOND KIDNEY
New York, New York
See Adams & Kidney
See Cann & Dunn
See Benjamin Gurnee
See Samuel H. Johnson

Edmond Kidney was working for William Adams (q.v.) at least as early as 1852. By 1853

he had entered into a partnership with Adams to form the firm of Adams & Kidney. The partnership lasted until Adams death about 1862. Kidney kept the shop at the same location and operated it for a short time on his own.

His ad in the New York City Directory for 1862 was essentially the same as the one that had run for Adams and Kidney previously: "Edmond Kidney, (late Adams & Kidney,) Manufacturers of Silver Ware, 38 White Street, (west of Broadway) New York. Vases, Pitchers, Waiters, Dishes, Urns, Tea Sets, Cups, Forks and Spoons, and all articles in the above line on the usual reasonable terms. N.B. Old plate manufactured into the newest patterns."

By 1863 he had joined forces with John Cann (formerly of Charters, Cann & Dunn) and Samuel H. Johnson (formerly of Gurnee & Johnson) as indicated in an ad in the 1863 Brooklyn directory.

Johnson apparently dropped out of the firm in 1864, and it was known then simply as Kidney & Cann.

In 1865 Samuel H. Johnson re-joined the firm, and it was again known as Kidney, Cann & Johnson. By 1868 Cann had left, and the company became Kidney & Johnson. It continued as Kidney & Johnson through at least 1874, as far as its history has currently been traced through the city directories.

Soeffing (*Silver Medallion Flatware*, 1988, p. 60) indicates that the partnership of Kidney & Johnson dissolved at some point in the mid 1870s. Following this, Johnson went into business on his own, continuing to produce some of the flatware patterns of the earlier firms.

KIDNEY & JOHNSON
New York, New York
See Edmond Kidney

Firm formed in 1868 By Edmond Kidney and Samuel H. Johnson. Manufacturers of solid silver ware. Continued in business through at least 1874, as far as its history has currently been traced.

L. KIMBALL & SON
Haverhill, Massachusetts

The business was established by Leverett Kimball in 1840. In 1850 and 1851 Mr. Kimball advertised "burning fluid, lamps, etc." In 1879 his ads were for Christmas gifts. In 1891 his ad

in the City Directory states "makers of Hannah Duston (also spelled Dustin) and the Bradford Academy souvenir spoons."

Registered U.S. Trade Mark Patent No. 19,222, March 24, 1891. The firm name is listed until 1927, with F.C. Davis and J.D. Folsom, proprietors, and called silversmiths, jewelers and opticians.

KIMBALL & RESTAURICK
Boston, Massachusetts

Listed in sterling silver section of 1904 JC as out of business.

K. & R.

STEPHEN C. KIMBLE
Baltimore, Maryland

Silversmith, listed in 1850 census. Born Maryland.

S. KIND & SON
Philadelphia, Pennsylvania

Silversmiths and jewelers. Advertised free catalog in December 1903 *Ladies, Home Journal.*

Listed in directories 1874-1892; JC 1915; K 1922. Their catalogs of 1902 and 1903 indicate that they were "jewelers and silversmiths." The 1902 catalog says they have been selling diamonds since 1872. They designed their own mountings and said they had ample facilities for making jewelry to order. Their "silversmithing" may have been limited to the making of sterling silver brooches and chatelaines, sterling silver charms and lockets, crosses and bracelets.

In the 1924 KJI the firm is listed as importers and wholesalers of jewelry and allied lines.

KING SILVER CO.
Boston, Massachusetts
See Lunt Silversmiths

Founded in 1955. They purchased Richard Dimes & Co. c. 1956, and in turn were acquired by Lunt Silversmiths about 1957.

KING'S ENAMEL & SILVERWARE, INC.
New York, New York

Listed KJI 1931 as manufacturers of handmade enamel and sterling, bronze, sterling and gold boudoir sets, frames, cigarette boxes, baby sets, etc.

EDWARD & DAVID KINSEY
Cincinatti, Ohio

Edward (b. 1810, d. 1861) (w. 1834-1861) and David (b. 1819, d. 1874) (w. 1840-1870) were sons of Thomas and Ann Kinsey. Edward learned silversmithing from Thomas and, in turn, taught David. They worked together until 1861 when Edward retired. Their silverware manufacturing plant produced the bulk of the homemade holloware and flatware of Cincinatti of their time. Said to have been the most prolific of Cincinatti silversmiths of the pre-Civil War period.

Edward Kinsey received a premium award for his silverware as early as 1838 from the Ohio Mechanics Institute Annual Fair. E. & D. Kinsey received numerous awards at later fairs. (Beckman, E.D. *An In-depth study of the Cincinatti Silversmiths, Jewelers, Watch and Clockmakers.* 1975)

Mark shown below is from Soeffing, *Silver,* July-August ,1991, p.14.

E. &D. KINSEY

H.A. KIRBY
Providence, Rhode Island

Retailer of silverware and jewelry. Established in 1886 as Kirby, Mowry & Co. Incorporated in September 1896. Advertised solid gold and diamond jewelry, earrings, scarf pins, brooches, studs, collar buttons and rings. In 1905 the listing was H.A. Kirby Co. and this listing was continued until the death of Henry A. Kirby in 1920.

KIRK & MATZ
Danbury, Connecticut

Advertise "cutlery, silverplate, brassware, Sheffield cutlery, etc." Various articles of silverplate illustrated in advertisements.

KIRK INTERNATIONAL
New York, New York

A division of The Kirk Corporation, the parent company of Samuel Kirk & Son, the sterling division, and Kirk Pewter (formerly Hanle & Debler) the domestic pewter division. Kirk International was successor to Eisenberg-Lozano in 1970 though the name was not changed until February 1973. This division was discontinued by 1979.

KIRK PEWTER, INC.
Salisbury, Maryland
See Hanle & Debler, Inc.

In February 1972 a pilot pewter plant opened in Salisbury, Maryland to work in conjunction with the New York plant until the Salisbury plant could assume the entire work load. In May 1973 that goal was accomplished.

With the purchase of Kirk by Stieff in 1979, this pewter line was absorbed into the Kirk Stieff plant in Baltimore. The tools and plant in Salisbury were purchased by a local group who operate it under the name Salisbury Pewter.

KIRK STIEFF CORPORATION
Baltimore, Maryland

ORGANIZATIONAL TITLES

Kirk & Smith	1815-1820
Samuel Kirk	1821-1846
Samuel Kirk & Son	1846-1861
Samuel Kirk & Sons	1861-1868
Samuel Kirk & Son	1868-1896
Samuel Kirk & Son Co.	1896-1924
Samuel Kirk & Son, Inc.	1924-1979
Kirk Stieff Corporation	1979-

MARKS:

1815-1818	K & S
1818-1821	Kirk & Smith
1821-1846	S. Kirk or Saml. Kirk
1846-1861	S. Kirk & Son
1861-1868	S. Kirk & Sons
1868-1896	S. Kirk & Son
1896-1925	S. Kirk & Son Co.
1925-1932	S. Kirk & Son Co. Inc. Sterling
1932-	S. Kirk & Son Sterling

The above marks were used in conjunction with Baltimore Assay Office marks 1815-1830; with 11/12 or 10.15 1830-1868 (sometimes

later); and with 925/1000 c. 1868-1890. Two other curious private marks, one a lion and the other perhaps the figure 11 with embellishment, were used 1829-1830.

In August 1815, 22-year-old Samuel Kirk opened his small shop in Baltimore and founded the oldest surviving silversmithing firm in the United States.

He was born in Doylestown, Pennsylvania in 1793. Through both parents he was descended from English silversmiths of the 17th century: Joan Kirke, registered in Goldsmiths, Hall, England 1696-1697 and Sir Francis Child, Lord Mayor of London in 1669 and founder of the Child Banking House.

At 17, Samuel was apprenticed to James Howell, silversmith of Philadelphia and on completing his apprenticeship moved to Baltimore.

In 1815, Samuel Kirk and John Smith entered into a partnership which continued until 1820. In 1846, Samuel Kirk's son, Henry Child Kirk, became a partner and the firm name was changed to Samuel Kirk & Son. In 1861, Charles D. and Clarence E. Kirk also entered the business and the name was changed to Samuel Kirk & Sons. After the Civil War, the two younger brothers left the firm and the name reverted to Samuel Kirk & Son.

After the death of Samuel Kirk in 1872, his son continued alone until 1890, when his only son, Henry Child Kirk, Jr., joined as a partner retaining the firm name, Samuel Kirk & Son. In 1896, Henry Child Kirk, Sr. formed a corporation and remained as active head until his death in 1914 when his son succeeded as president. Each of these early representatives of the Kirk family served an apprenticeship in the craft and qualified as working silversmiths.

It was Samuel Kirk who introduced the intricate and often imitated Repoussé style of ornamentation to America in 1828. It is often referred to as "Baltimore silver."

Kirk's tradition for fine craftsmanship has brought many famous people to its shop. It is not surprising that when the White House dinner service was in need of repair, Kirk's was selected to renovate the five hundred and fifty pieces of gold flatware that had been in use for state banquets since the administration of President Monroe.

Many famous trophies and presentation pieces have been designed by Kirk's. The most ambitious was the forty-eight piece dinner service commissioned for the old Cruiser **Maryland** in 1905 and now on exhibit at the State House at Annapolis. Nearly two hundred scenes and pictures present a panorama of Maryland's illustrious history.

Kirk silver has always reflected the trends of decorative design. Early pieces were made in the chaste and simple lines of the Georgian era. The China trade is reflected in delicate Oriental lines, and the elaborate ornamentation of the Victorian age produced some magnificent pieces. Contemporary simplicity produces pieces remarkably like those of the very first made by Samuel Kirk.

New techniques, progressive research and new designs have been added to Kirk silver, but the firm continues to produce prestige merchandise. They pride themselves that hand crafting techniques are still essential in the production of Kirk sterling.

In the 1970s the Kirk company added new lines. Among them are sculptures cast by the lost wax process; new lines in jewelry, some available in 14k gold as well as sterling silver; and numerous functional and decorative articles of pewter.

In 1972 the Kirk company added a line of silverplated gift wares.

In September 1979 the Stieff Company purchased the Kirk Co. The combined enterprises of the two Baltimore, Maryland makers of silver and pewter, flatware and holloware operate under the name, The Kirk Stieff Company.

In February 1990 Brown Forman Co. of Louisville, Kentucky, a whiskey distiller, purchased Kirk-Stieff from the Stieff Family.

YEAR	BALTIMORE ASSAY MARK			DOMINICAL LETTERS
1814	[mark] [mark] [B]			B
	ASSAYER'S AND MAKER'S MARKS			
1815	[K&S] [mark] [A] [Ω]			A
1816	[mark] [G] [Ω]			GF

"Dancing Surf" sterling made by Kirk Stieff. (Photo courtesy of Kirk Stieff)

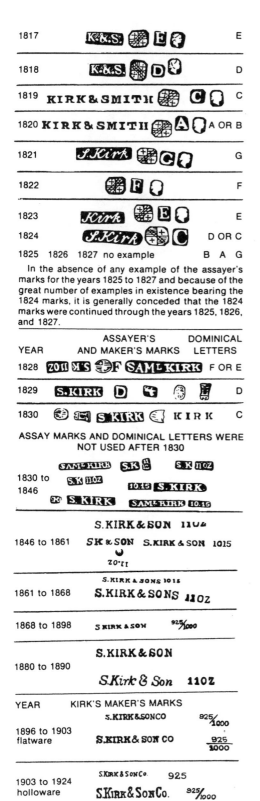

1817		E
1818		D
1819	KIRK & SMITH	C
1820	KIRK & SMITH	A OR B
1821	S.Kirk	G
1822		F
1823	Kirk	E
1824	S.Kirk	D OR C
1825 1826 1827 no example		B A G

In the absence of any example of the assayer's marks for the years 1825 to 1827 and because of the great number of examples in existence bearing the 1824 marks, it is generally conceded that the 1824 marks were continued through the years 1825, 1826, and 1827.

YEAR	ASSAYER'S AND MAKER'S MARKS	DOMINICAL LETTERS
1828	ZOII K'S F SAML KIRK	F OR E
1829	S.KIRK D	D
1830	S.KIRK KIRK	C

ASSAY MARKS AND DOMINICAL LETTERS WERE NOT USED AFTER 1830

| 1830 to 1846 | SAML KIRK S.K S.K 11OZ S.K 11OZ 10 15 S.KIRK S.KIRK SAML KIRK 10.15 | |

| 1846 to 1861 | S.KIRK & SON 11OZ S K & SON S.KIRK & SON 1015 11.OZ | |

| 1861 to 1868 | S.KIRK & SONS 1015 S.KIRK & SONS 11OZ | |

| 1868 to 1898 | S KIRK & SON 925/1000 | |

| 1880 to 1890 | S.KIRK & SON S.Kirk & Son 11OZ | |

| YEAR | KIRK'S MAKER'S MARKS | |
| 1896 to 1903 flatware | S.KIRK & SON CO 925/1000 S.KIRK & SON CO 925/1000 | |

| 1903 to 1924 holloware | S.KIRK & SON CO. 925 S.KIRK & SON Co. 925/1000 | |

| 1907 to 1914 flatware | S.KIRK & SON CO 925/1000 S.Kirk & Son Co 925/1000 | |

| 1903 to 1907 holloware | KIRK Co 925/1000 S KIRK & SON CO 925/1000 S KIRK & SON CO 925/1000 S.KIRK & SON Co | |

| 1925 to 1932 holloware | S.KIRK & SON INC. STERLING | |

| 1927 to 1961 flatware | PAT. S.KIRK & SON STERLING | |

| 1932 to 1961 flatware | S.KIRK & SON STERLING | |

| 1932 to 1961 holloware | S.KIRK & SON STERLING S.KIRK & SON STERLING | |

| 1959 to 1961 flatware | S.KIRK & SON STERLING | |

JULIUS KIRSCHNER & CO.
New York, New York

Listed JC 1915-1943 . Wholesalers of plated silverware and mesh bags.

JULCKO
(Mesh Bags.)

WILLIAM KLANK
Baltimore, Maryland

Listed in Baltimore City Directories 1895-1899 as a silversmith. Not at the same address as C. Klank & Sons.

C. KLANK & SONS
Baltimore, Maryland
See Schofield & Co., Inc.

ORGANIZATIONAL TITLES
Klank & Bro.	1872-1891
Conrad Klank &. Sons	1892
C. Klank & Sons Mfg. Co.	1893-1894
C. Klank & Sons	1895-1911

First listed in the Baltimore City Directory in 1872-1873 as Klank & Bro., silverplaters. From 1874-1892 they were listed as silversmiths. Conrad, Frederick W. and George H. Klank were listed as members of the firm.

In 1892 the firm name became Conrad Klank & Sons, silversmiths, with Conrad, Frederick and George H. Jr., listed as members of the firm. The 1893 listing was C. Klank & Sons Mfg. Co., with Conrad listed as manager.

In 1895 the listing was C. Klank & Sons, the members of the firm remaining the same until

1899 when the members were listed as Conrad, F. William, and Herbert Klank and James L. McPhail. This listing continued until 1905 when James L. McPhail, who had also been listed as a member of the firm of A.G. Schultz & Co. during the same period, was no longer listed at either. In 1905 or 1906 C. Klank & Sons was purchased by Heer-Schofield, later Schofield & Co. though it continued to be listed under its own name through 1911.

KLANK MFG. CO.
Baltimore, Maryland
See Sterling Silver Mfg. Co.

Listed in the 1892 Baltimore City Directory as silversmiths and silverplaters. George H. Klank, manager.

An 1892 note indicates that, "The Klank Mfg. Co. made an assignment for the benefit of creditors to Charles O. Stieff." (JC&HR 11-2-1892, p. 8). "The Klank Mfg. Co. was succeeded by The Sterling Silver Mfg. Co. Baltimore, Maryland (JC&HR 2-14-1894, p. 27)

KNICKERBOCKER SILVER CO.
Port Jervis, New York

Successor to J. A. Babcock & Co. in 1894 under William Tuscano as Knickerbocker Mfg. Co.; became Knickerbocker Silver Co. before 1904. Taken over by Crescent Silverware Mfg. Co., Inc. in 1962.

Not used after c. 1900.

MARY C. KNIGHT
Boston, Massachusetts

Mary C. Knight was a designer, metalworker and silversmith in the Boston Society of Arts and Crafts. She served as the first manager of the Handicraft Shop (q.v.) established by that organization. (Williams, *Silver*, May-June 1988, p. 18)

She worked at various locations in Boston between 1902 and 1927. In 1908 she shared a "Commendation" with George C. Gebelein. (q.v.) Like a number of other members of the arts and crafts movement, she sometimes dated her pieces with the year of production. (Williams, *Silver*, Mar.-Apr. 1987, p. 33)

JACOB KNIPE
Baltimore, Maryland

Listed in Baltimore City Directories 1864-1880 as a silverplater.

WM. KNOLL & CO.
New York, New York

Listed JC 1904 in sterling silver section. Out of business before 1915.

184

J.B. & S.M. KNOWLES CO.
Providence, Rhode Island
See Mauser Manufacturing Co.
See H. L. Webster & Co.

In 1854, Joseph B. Knowles joined with Henry L. Webster to form the silver manufacturing firm of H. L. Webster & Co. (q.v.). Webster sold out his interest in the business on November 7, 1864 and Knowles took on a new partner, Samuel J. Ladd, who had been an employee of the earlier firm.

The new company, Knowles & Ladd, continued in business until 1875, when Ladd retired. Nevertheless, Ladd continued to work for the firm in some capacity, obtaining Design Patent No. 10,521 for the flatware pattern called "Crescent" in 1878. Ladd died in 1886.

Stephen M. Knowles joined his brother in 1875, and the firm became known as J. B. & S. M. Knowles. When Joseph B. Knowles died in 1891, the name was changed to J. B & S.M. Knowles Co. The business was purchased by the Mauser Manufacturing Company in 1905.

The firm manufactured spoons from its beginnings in the 1850s, and probably also thimbles as well. An 1871 ad in *The Watchmaker and Jeweler* lists its products as "Spoons, Forks, Knives, Ladles, Tongs, Cups, Goblets, Card Cases and Miscellaneous Goods." A company catalog dating circa 1889 specifies some additional holloware items: card receivers, napkin rings, pitchers for cream or water, three piece tête-à-tête sets, tea caddies tobacco boxes and vases. (Soeffing, *Silver*, Sept.-Oct. 1996, pp. 30-33)

RED CROSS
(U. S. Design Patent No. 38-096, April 15, 1902 for spoons)

(On coin silver spoons)

KOECHLIN & ENGLEHARDT
Newark, New Jersey

Earliest record found is U.S. Trade Mark Patent 56,499, registered October 2, 1906 for use on sterling and plated silver flat and holloware. Out of business before 1915.

KOEHLER & RITTER
San Francisco, California

Gotthard Koehler was born in Saxony in 1823 and came to San Francisco by way of Oregon. Charles A. Ritter was born in Hesse Darmstadt about 1840. Both arrived in San Francisco about 1864 and went to work for Friedrich R. Reichel (q.v.), Koehler as shop foreman and Ritter as bookeeper. When Reichel died in 1867, Koehler & Ritter bought his stock and machinery for about $10,000. The purchase was financed in part by an $8,000 loan from Levison Brothers, Manufacturing Jewelers.

By 1870, the firm was producing about $45,000 worth of goods annually using about 9,500 ounces of silver and 400 ounces of gold. By the mid 1870s the firm employed 12 to 15 hands and had a well equipped factory powered by a ten horsepower steam engine. Koehler continued to function as the foreman of the works, while Ritter served as bookeeper, salesman and manager. By 1875 the firm was doing a retail business of $80,000 to $100,000 a year.

In April 1875 the firm completed a massive punch bowl and tray for presentation to William F. Babcock, former president of the San Francisco Spring Valley Water Co. weighing abour 460 ounces and costing $3,000. That same year the firm won a medal for "Chasteness of design, original modelling, and beauty of workmanship" at the Mechanic's Fair. In 1876 their entry won even more favorable recognition.

That year the firm decided to move to a new, more fashionable, location on Post St. They also planned to enlarge their factory facilities. However the greatly increased costs of operating at the new location were not matched by increased sales. In 1879 their financial backer, Levinson Brothers, filed a lien against them and closed them down. An agreement was worked out allowing the firm to continue operations, but that collapsed near the end of 1880, and Levinson Brothers advertised a closing out sale.

Koehler & Ritter attempted to salvage the business, but without much success. Koehler vanished, literally, in 1885. He went for a walk and did not return, and was assumed to have fallen in the bay. After that point the firm was known as "Charles A. Ritter, formerly Koehler & Ritter". Ritter retired about 1891.

The firm produced a large quantity of silverware, mostly flatware, but occasional pieces of specially commissioned holloware. They con-

tinued to produce three of Reichel's flatware patterns, as well as introducing six new ones of their own. While their holloware is well crafted and shows some distinctive designs, they also apparently cast and copied details directly from some Gorham pieces. (Morse, in Morse ed. *Silver in the Golden State*, 1986, pp. 9-12)

GUSTAVE F. KOLB
New York, New York

Manufacturer, manufacturer's representative and importer of sterling silverware at least as early as 1917.

Gustave Frederick Kolb was born in New York City. At the time the Mt. Vernon, New York, Mauser factory was erected Kolb was general superintendent and treasurer of the company. Later he left to establish his own silversmith business in New York City. He retired in 1921 but continued as a director of the George Borgfeldt Corp. of New York City until his death, August 29, 1945 when he was 80 years old.

Kolb was known not only as a manufacturer and industrialist but was prominent in civic and religious activities. While with the Mauser company he was instrumental in persuading the New York New Haven and Hartford Railroad to build the Columbus Avenue station to accommodate commuters to New York City.

KOONZ MFG. CO.
Greenfield, Massachusetts

Listed JC as manufacturers of sterling silver. Out of business before 1922.

CHARLES KRAEMER
Baltimore, Maryland

Listed in Baltimore City Directory 1882 as a silversmith.

CHARLES M. KRAMER
Baltimore, Maryland

Listed in Baltimore City Directory in 1885 as a silverplater.

KRAUS & JANTZEN
New York, New York
See Kraus, McKeever & Adams

KRAUS, KRAGEL & CO.
New York, New York
See Kraus, McKeever & Adams

KRAUS, McKEEVER & ADAMS
New York, New York.

First listed in 1896 as Kraus Kragel & Co.; in 1904 as Kraus & Jantzen and in 1922 as Kraus, McKeever & Adams. Trademarks used on sterling silver frames for handbags; 14k gold mountings and sterling silver mountings for leather articles.

KRIDER & BIDDLE
Philadelphia, Pennsylvania
See Peter L. Krider Co.

PETER L. KRIDER CO.
Philadelphia, Pennsylvania

CHRONOLOGY

Peter L. Krider	c. 1850-60
Krider & Biddle	1860-c. 1870
Peter L. Krider Co. (with Krider)	c. 1870-1888
Peter L. Krider Co. (with Weber)	1888-1903
Simons Bros. Co	1903-present

Peter L. Krider (b. Philadelphia, 1821; d. there May 12, 1895) at the age of 14 was apprenticed to John Curry, Philadelphia silversmith, whom he served for six years. On Curry's retirement, young Krider's indenture was transferred to R. & W. Wilson, also silversmiths of Philadelphia. Krider worked with them as a journeyman for 15 months and then made a four-year contract with Obadiah Rich, silversmith in Boston. Two years later Rich sold his establishment to Brackett, Crosby & Brown, Boston silversmiths, with Krider in charge of the business. He later served a short time as foreman in the factory of his old employers, R. & W. Wilson and then went into business for himself. His first order, which was for a tea set, was given by J.E. Caldwell & Co.

Krider's business expanded rapidly until he was compelled to find larger quarters and in 1859 he took into partnership John W. Biddle, the firm name becoming Krider & Biddle in 1860. During the Civil War Krider served in the army while Biddle maintained the business. Biddle retired five or six years after the War and the firm name became Peter L. Krider Co.

Cramer (*Silver*, Jan.-Feb. 1988, p. 33) suggests a different series of dates for the Krider and Biddle partnership, 1868 to 1873, based on her interpretation of information derived from the Dun Reports.

About 1888 Krider sold the business to August Weber who later took a partner, W.E. Wood. The business continued to operate under the name Peter L. Krider Co. until 1903 when it was succeeded by Simons Bros. Co., Philadelphia silversmiths established in 1840. The Krider flatware patterns and dies were later sold to the Alvin Mfg. Co. A number of flatware patterns were patented by Krider.

In addition to making a regular line of silverware, flatware as well as holloware, the Krider company was at one time perhaps the largest medal plant in the country. They manufactured medals for the Centennial Commission of 1876; those for the Cincinnati Industrial Exposition; Ohio Mechanics, Institute; National Academy of Design, New York; Georgia State Agricultural Society; Maryland State Agricultural and Mechanical Association; Virginia State Agricultural Society; Massachusetts Humane Society; Pennsylvania State Fair Association; Southern California Horticultural Society; the Agricultural and Industrial Society of Delaware Co., Pa.; Cincinnati High Schools; Industrial Cotton Exposition; the Southern Exposition; the World's Industrial and Cotton Centennial Exposition; Franklin Institute, Philadelphia; the John Scott Legacy, Philadelphia and many others.

KRONHEIMER OLDENBUSCH CO.
New York, New York

Listed in JC 1909-1922 in plated silver section.

LEONARD KROWER & SON, INC.
New Orleans, Louisiana

Established before 1896 as Leonard Krower, wholesalers and jobbers of sterling silver, plated silver, platinum, optical goods, medals, watches, clocks, pearls, diamonds, cut glass and gold jewelry. Listed in JC-K 1943 as Leonard Krower & Son and were incorporated before 1950. Acquired by the Gordon Jewelry Corporation in 1965.

KUCHLER & HIMMEL
New Orleans, Louisiana
See A. Himmel's Silverware Manufactury

Solid silver manufacturer in New Orleans, 1852-1853.

Mark is from *Bacot*, Silver, March-April 1988, p. 15

KUEHLER & JANSON
New Orleans, Louisiana

Silversmiths listed in New Orleans City Directory in 1871.

THE FRANK KURSCH & SON CO.
Newark, New Jersey

Listed in JC 1904 in sterling silver section. out of business before 1915.
Trademark identical to Shoemaker, Pickering & Co.

 Sterling

L

L'ALLEMAND MFG. CO.
New York, New York
See Stix & L'Allemand

An 1895 account notes that "Ernest A. L'Allemand, doing business as L'Allemand Mfg. Co., manufacturers of electro silver plated ware, N.Y. made an assignment to Oscar L'Allemand. Mr. L'Allemand had bought out his partner, Mr. Stix, two years ago and had not enough capital.
"The business was established many years ago and had been carried on by various firms. E.H. Rowley & Co. had it from 1862-1889 when they were succeeded by Stix & L'Allemand, who dissolved on August 31, 1893, since which time Mr. L'Allemand, carried on alone." (JC & HR 7-1-1895, p. 10) Note that the beginning date reported here for E.H. Rowley & Co. (q.v.) is incorrect.

P.W. LAMBERT & COMPANY
New York, New York

An 1896 ad describes "P.W. Lambert & Company, N.Y., mfgrs. of standard goods and introducers of novelties such as pocket books, chatelaine bags, ladies, belts - a complete line of silver novelties. In oxidized and EGYPTIAN GOLD. Established 1867." (Adv. JC&HR 11-18-1896, p. 28)

C. LAMOND FILS
Montreal, Quebec, Canada

The company manufactured souvenir spoons from about 1928 to about 1970. They apparently acquired the Caron Bros.' dies. Their dies were sold to the Breadner Manufacturing Co. in 1970. (Pack, *Collectors Guide to Canadian Souvenir Spoons,* 1988, p. 69)

FERDINAND C. LAMY
Saranac Lake, New York

Registered trademark in U.S. Patent Office No. 21,899, October 25, 1892 for use on spoons, forks, knife handles, etc. of souvenir type. Listed in JC as out of business before 1922.

LANCASTER SILVER PLATE CO.
Lancaster, Pennsylvania

An 1895 account notes that "The Lancaster Silver Plate Company was destroyed by fire September 1893." (JC&HR 2-6-1895, p. 26)

LANDERS, FRARY & CLARK
New Britain, Connecticut
See Meriden Cutlery Company

Landers, Frary & Clark began as the partnership of George M. Landers and Josiah Dewey in 1842. It became Landers & Smith Mfg. Co. in 1853 and Landers, Frary & Clark in 1865. They purchased the Meriden Cutlery Co. in 1866 and continued to use the Meriden trademark on some sterling wares. Their newly-built Aetna works held this cutlery division. The factory burned in 1874 and was immediately rebuilt.
The firm's first products were wardrobe hooks. Their line was later expanded to include other small castings such as drawer pulls, iron coffeepot stands, and sad iron holders. They began the manufacture of cutlery in 1865.
Landers, Frary & Clark discontinued flatware production c. 1950.
In 1954 the firm purchased the Dazy Corp. In 1961 control of the firm was taken over by

J.B. Williams Co., a subsidiary of Pharmaceuticals, Inc., and by the mid 1960s Landers, Frary & Clark was completely liquidated.

LANDERS FRARY & CLARK
ÆTNA WORKS

(Knife blades with solid silver ferrules; Ivoride handles)

AETNA WORKS LANDERS, FRARY & CLARK	UNIVERSAL (Used after 1897)

R. LANGE
Baltimore, Maryland

Listed in the Baltimore City Directory for 1864 as a silverplater.

RALPH LANGE
Baltimore, Maryland

Listed in Baltimore City Directories 1872-1889 as a silverplater.

RUDOLPH LANGE
Baltimore, Maryland

Listed in Baltimore City Directories 1884-1885 as a silverplater at the same address as R. Lange who was listed in 1864.

ALPHONSE LA PAGLIA
Meriden, Connecticut
See Georg Jensen Inc., USA

Alphonse La Paglia was a native born Italian who first achieved some notice by designing silver jewelry "in the Jensen style" for Georg Jensen Inc, USA during World War II. He apparently was also engaged in some undercover work for the U. S. government around the same time.

La Paglia's jewelry line included bracelets, rings, stick pins, earrings, necklaces and brooches, all handcrafted in sterling silver.

In addition to Georg Jensen, his designs were also sold by stores such as J.E. Caldwell, Philadelphia and J.B. Hudson, Minneapolis. The pieces marketed by Georg Jensen are usually marked "Georg Jensen, New York: with La Paglia's initials "L P" or "A. L. P."

When the Jensen parent company forced Georg Jensen, Inc. USA to close down, La Paglia went to work for the International Silver Company, continuing to produce many of the designs he had developed for Jensen earlier.

In 1952 he settled in Meriden, Connecticut to continue production of his handcrafted sterling silver jewelry and holloware. He was an experienced silversmith as well as a designer. Under the sponsorship of International Silver Company, a small craft shop was equipped in the rear of his home. A few silver craftsmen were associated with him in "International Sterling Craft Associates."

The International Silver Company issued a photographic catalog devoted entirely to La Paglia's distinctive holloware and jewelry, most of which was made by hand. LaPaglia created more than just beautiful designs in all his sterling, this beauty expressed a poetic idea. His bold, sculptural motifs were drawn from nature and were magnificently photographed by Peter Erik Winkler.

La Paglia died suddenly and tragically on November 19, 1953 from a bloodclot resulting from a fall at his home.

The business was purchased from his widow by International and manufacturing continued in the same shop for a short while. Eventually, the line was simplified and manufacturing moved to International's regular sterling plant. (Rainwater, *Silver,* May-June 1995, Cover and pp. 8-11; Moro, *Silver,* Nov.-Dec. 1996, pp.28-35)

LA PIERRE MFG. GO.
Newark, New Jersey
New York, New York
See International Silver Co.

The La Pierre company started as early as 1888 in New York where Frank H. La Pierre had a small shop at 18 East 14th St. making a variety of novelties and small wares. In 1895 it was incorporated in New Jersey where they had by that time included quite a variety of dresserware. At this time La Pierre was president and G.H. Henckel, secretary. In 1900 the firm was again incorporated by La Pierre and H.C. Brown.

In 1929 the La Pierre business was purchased by the International Silver Company and moved to Wallingford, Connecticut where they enlarged the line to cover more designs and pieces in dresserware.

The La Pierre trademark on sterling silver was made up by the letters F and L to represent the conventional pound sterling mark.

(Used before 1896)

TRADE *L* MARK

LA SECLA, FRIED & CO.
Newark, New Jersey

Listed in JC 1909-1915 in sterling silver section. Out of business before 1922.

L F

LAVIN & LAUER CO.
New York, New York

Mark found on a cocktail shaker dated circa 1920s.

J.B. LASH
Toronto, Ontario, Canada

J.B. Lash, a silversmith and jeweler, was a member of the firm of Lash & Co. in 1865. Lash was listed as Secretary of the Toronto Silver Plate Company in 1879. By 1887 he was in business on his own. (Unitt & Worrall, *Unitt's Book of Marks*, 1995, p. 46)

SIL VER | LASH & CO.

WILLIAM LAWLER
San Francisco, California

William Lawler was born in Ireland in 1809. In the 1840s he worked as a watchmaker and silversmith first in St. Louis, and later in New Orleans. He arrived in San Francisco by early

Sterling coffee service designed by Alphonse LaPaglia; sponsored by International Silver Company. (Photo courtesy of International Silver Company)

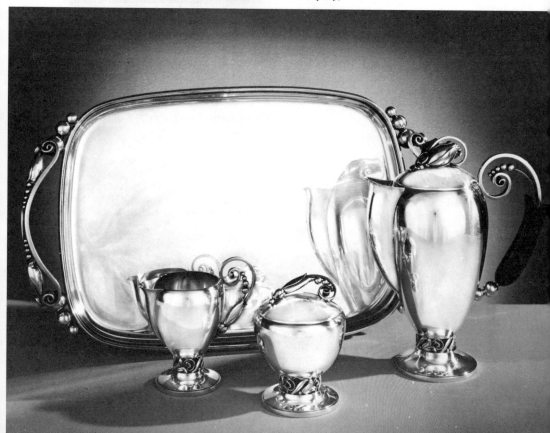

1854. In 1857 he entered examples of his gold, silver and enamel work in the first San Francisco Mechanics' Industrial Exhibition, and was awarded a diploma. He maintained his own shop until about 1860.

For the next few years he is listed as a "gold and silver worker," a boilermaker, and a gold pen maker. In 1863 he again had his own shop, but it closed within a year.

In 1867 he set up in business himself again, advertising as a "pioneer silversmith and jeweler." By 1870 he and his son Frederick were producing $20,000 worth of gold and silver work annually, all by hand. Frederick no longer appeared in the directories after 1876, and the firm was out of business by 1880. William Lawler died in 1881. (Morse, in Morse ed., *Silver in the Golden State*, 1986, p. 4)

T.B. LEAVENWORTH
Detroit, Michigan

"Silverware manufacturer 1869." (JCW 2-5-1919)

LEBKUECHER & CO.
Newark, New Jersey
See Eleder-Hickok Co., Inc.
See Hickok Matthews Company - Silversmiths

Silversmiths working c. 1896-1909. Partners were Arthur E. Lebkeucher, Francis (Frank) A. Lebkeucher and Charles C. Wientge, former superintendent and designer for Howard Sterling Company. Name changed by law to F.A. Lester. Taken over by The Eleder Co. in 1918. By 1922 it became the Eleder-Hickok Co., Inc.

TRADEMARK

LEBOLT & CO.
Chicago, Illinois

A follower of the Arts and Crafts Movement. The firm registered its trademark in U.S. Patent Office No. 70,833, October 6, 1908 for manufacture of silverware and jewelry. Listed JC 1915-1922. KJI in 1924 lists them as manufacturers of rings, platinum jewelry, silverware and watch cases, and importers of pearls and diamonds.

HAND BEATEN

LEDIG MFG. CO.
Philadelphia, Pennsylvania

Listed in JC 1896 in plated silver section. Out of business before 1904.

(*Solid Plated and Composition Ware.*)

LEHMAN BROTHERS SILVERWARE CORP.
New York, New York

Listed in 1924 and 1927 KJI, 1943-73 JCK, and 1957-61 JBG as manufacturers of silverplated holloware.

LEHMAN SILVER-CRAFT

ERNEST LEHTONEN
Gardiner, Massachusetts
See Stone Associates

Ernest Lehtonen purchased the rights to the Stone Associates (q. v.) mark after that company was disbanded in 1958. He replaced the "h in Shield" portion of the mark with an "L in Shield". He continued in business until the late 1970s. (Chickering, *Silver*, Jan.-Feb. 1986, p. 11)

HENRY L. LEIBE MFG. CO.
Newark, New Jersey
See Archibald, Klement
See C.F. Kees Co.

KARL F. LEINONEN
Boston, Massachusetts

Karl F. Leinonen was born in Turku, Finland in 1866. He served the regular seven year apprenticeship there. He came to the United States in 1893 and worked in a commercial repair shop in Boston.

In 1901, when Arthur A. Carey, president of the Boston Society of Arts & Crafts, financed the opening of the Handicraft Shop, where a large number of silversmiths had bench space, he placed Leinonen in charge. He was still in this position in 1932. His son, Edwin, became his assistant.

Now (1975) listed in the Boston Directory as Karl F. Leinonen & Sons.

THE LENAU CO.
Attleboro Falls, Massachusetts

Listed in JC in sterling silver section in 1896. Out of business before 1904.

LENOX SILVER INC.
New York, New York

Listed directories c. 1950 as manufacturers of sterling silver.

LENOX SILVER PLATE CO.
Location unknown

Manufacturer of silverplate holloware ca. 1890s.

LEONARD & WILSON
Philadelphia, Pennsylvania

Allen Leonard was listed as a silversmith in the New York directories from 1827 to 1839. He is assumed to be the same individual listed as a die sinker in the Philadelphia directories from 1844 to 1850, and also the Leonard of Leonard & Wilson, listed as silversmiths from 1847 to 1850. Nothing is known for certain concerning the Wilson involved in the firm. (Williams, *Silver*, Mar.-Apr. 1986, pp. 37-38)

LEONARD MFG. CO.
Chicago, Illinois

Manufactured plated silver spoons to commemorate the World's Columbian Exposition in Chicago, 1893. According to an advertisement appearing in *Word and Works* in May 1895, the company "made up an immense stock of magnificent and costly souvenir spoons, to be sold on the Fair grounds at $1.50 each, but the exclusive privilege of selling souvenir spoons was awarded a syndicate of private dealers."

The company turned to advertising in various publications across the country to sell the spoons, offering them in sets of six in a plush lined case for 99 cents a set. Ads for the spoons, plus testimonials, continued in *Word and Works* through January 1896. The firm also advertised

a non Fair-related silverplated children's set consisting of a knife, fork and spoon.

LEONARD, REED & BARTON
Taunton, Massachusetts
See Reed & Barton

LEONARD, REED & BARTON
(On britannia)

LEONARD SILVER MANUFACTURING COMPANY
Boston, Massachusetts
See Towle Silversmiths
See Syratech Corporation

Founded in 1969 by Leonard Florence in Chelsea, Massachusetts, to market silverplated holloware. Mr. Florence became involved in the silver industry about 1957 through helping to revive the Raimond Silver Company (q.v.) which, in the late 1950s was operating at a loss. Twelve years later the company was sold for $2.1 million with Mr. Florence receiving half the proceeds with which he started his own company.

"The Leonard Silver Manufacturing Co. first operated out of a garage in Chelsea, the ... Boston suburb that is Mr. Florence's birthplace. The entire staff wrote orders, polished silver and carried boxes to be shipped. When the company built an office building across the street, everyone helped pour concrete." (*The Wall Street Journal,* June 28, 1982, pp. 1 & 13.)

"The Leonard Silver Mfg. Co., manufacturer and distributor, purchased certain assets of Delli Silverplate, San Francisco." (JC-K 3-74, p. 105)

"Leonard Silver Mfg. Co. has entered into a five-year agreement with English Silver Corp., Brooklyn, to market that company's line of silverplated holloware."(JC-K 3-74)

Some of Leonard's products are manufactured by seven different firms in India.

In 1978 the Leonard Silver Manufacturing Company was acquired by Towle Silversmiths and company headquarters were moved to Boston shortly after the merger.

Presently, Leonard Silver is a product line of International Silver Company. The company's assets were sold in 1990 with its parent company, Towle Manufacturing Company, to a subsidiary of Syratech Corporation which already owned International Silver Company and Wallace International Silversmiths, Inc.

JOSEPH LESHER
Victor, Colorado

Joseph Lesher, a Victor real estate and mining man, picked the world's greatest gold mining district as the place to distribute his eight-sided silver dollars which he manufactured in a campaign for the free coinage of silver.

One of the rarest items sought by American numismatists, the silver pieces have achieved real value. But in 1900 and 1901, when Lesher was having the coins minted in Denver, they had a value of $1.25 and were issued to merchants to be handed out and redeemed in merchandise. From the high silver content of the coins, Lesher could not have made any money on the arrangement.

No more than 3,500 of the coins were minted. There was a total of 18 varieties, each differing in some minor detail.

The first dies were made by Frank Hurd of Denver. Later dies were made by Herman Otto. The first type, issued in 1900, was 35mm. across and was stamped one ounce silver, value $1.25. One side had the words, **Jos. Lesher, Referendum Souvenir;** the other side, **A Commodity, Will Give in Exchange for Currency Coin or Merchandise at Face Value.**

In order to avoid trouble with the U.S. Government, Lesher made his dollars eight-sided, but that did not help. Only a few days after the first coin was issued, government agents called on Lesher to see the dies. Lesher handed them over and then, he reported to the newspapers later, "they pulled out a sack in which they put the dies and walked away, and I never saw them again." The government agents claimed that the silver pieces had the function of coins and were contrary to law. Lesher appealed to Senator Teller for help. Teller took it up with the Secretary of

the Treasury and it was finally agreed that with certain changes in the design of the coin, the minting could continue.

The second set was issued for exchange of merchandise at A.B. Bumstead. Others were issued for various firms bearing the legend, Trade Mark Reg. U.S. Patent Office No. 36,192, April 9, 1901 Design Patent April 16, 1901. They also bear the altered inscription "Jos. Lesher's Referendum Silver Souvenir Medal."

REFERENDUM

LESPERANCE, PIERRE
Quebec City, Quebec, Canada

Pierre Lesperance was a nephew of Francois Sasseville. (q.v.) He received his training from his uncle, and then went into partnership with him in 1854. In 1856 he became his successor, and obtained Laurent Amiot's tools from him. He was in business until 1882. (Unitt & Worrall, *Unitt's Book of Marks*, 1995, p. 77)

LESSER & RHEINAUER
New York, New York
See Syracuse Silver Manufacturing Co.

Firm formed by A. Lesser's Sons (Simon, Solomon Harry, and Benjamin) and Maurice Rheinauer. (Soeffing, *Silver*, Jan.-Feb.1991, p. 9-11) The Lesser brothers were also the partners in the Syracuse Silver Manufacturing Co.

An 1897 account states:"Lesser & Rheinauer, silversmiths now at 427 E. 14th St., N.Y., will move their factory and office about May 1 into the Sterling Building, 14 East 17th St. where they will occupy the entire second loft. A. Lesser's Sons, wholesale jewelers of Syracuse, are members of the firm." (JC&HR 4-14-1897, p. 24)

The following year:"A. Lesser's Son's business closed by the Sheriff." (JC&HR 3-9-1898, p. 19)

F.A. LESTER COMPANY
See Eleder-Hickok Co., Inc.
See Hickok Matthews Company -Silversmiths
See Lebkuecher &Co.

S.J. LEVI & CO., LTD.
Birmingham, England

Registered trademarks in the United States. Listed in 1924 and 1927 KJI as manufacturers of silverplated tableware and cigarette cases.

LEVIATHAN
PERFECTA
SQUIRREL BRAND

LEVINE SILVERSMITH CO.
New York, New York

Listed 1927 and 1931 KJI as manufacturers of sterling holloware, carving sets and cutlery.

LESCO

LEVITT & GOLD
New York, New York

Listed in JC 1915-1922 in sterling silver section. The trademark was also used on platinum and gold novelties. By 1924 the firm was listed as Levitt & Co. in KJI, but the only products noted were the platinum and gold novelties. Still listed c.1935.

CHAS. J. LEWARD
New York, New York

Listed JC in 1896 in sterling silver section. Out of business before 1904.

TRADE MARK.

S.M. LEWIS & CO.
New York, New York

Listed 1896 JC in sterling silver section. Out of business before 1904. Address was the same as Lewis Bros.

**S. M. L. & CO.
STERLING**

LEWIS BROS.
New York, New York

Listed in 1896-1904 JC as manufacturers of sterling silver novelties and jewelry. Address was the same as S.M. Lewis & Co. Out of business before 1915.

LEXINGTON SILVER PLATE CO.
Lexington, Kentucky?

Manufacturer of silverplated holloware circa 1890s - 1900s.

J.A. L'HOMMEDIEU
Mobile, Alabama

Silversmith and jeweler c. 1839-67. Advertised "SILVER WARE, MADE FROM COIN", in the Mobile Directory in 1859. The brothers, William and John, moved to Mobile from Connecticut about 1840. William apparently left the firm about 1850 while John continued until after the close of the Civil War when he returned North and Zadek & Caldwell took over the business. In 1898 Wm. L'Hommedieu was a traveler for G.I. Mix Co.

L'HOMMEDIEU

J. A. HOMMEDIEU

LIEBS SILVER CO., INC.
New York, New York

Listed in JC 1915 as Liebs Co.; became Liebs Silver Co., Inc. before 1922. The last record found was 1931. Manufacturers of sterling silver holloware.

J. ARTHUR LIMERICK
Baltimore, Maryland

Listed in Baltimore City Directories 1903-1904 as successor to Jacob Gminder who began plating silver in 1867.

WILLIAM LINK CO.
Newark, New Jersey

Established August 1, 1871 by William Link. In 1875 John D. Nesler was admitted to the firm. Nesler retired in 1882 and Addison Conkling was admitted, the firm becoming Link & Conkling. In 1886 Mr. Conkling retired and the business was continued by Link alone until 1893 when it became Link, Angell & Weiss, Link & Angell about 1900 and finally Wm. Link Co. from c. 1910-c. 1915. Listed out of business in 1915. They were manufacturers of sterling and jewelry.

WILLIAM LINKER
Philadelphia, Pennsylvania

Registered trademark in U.S. Patent Office, No. 55,945, August 21,1906 for gold and silver flatware, holloware and tableware. Out of business between 1909 and 1915. Wm. Linker was a member of the firm of Davis & Galt in 1896.

THE LINCOLN MINT
Chicago, Illinois

No response to inquiries. (1975)

LIPMAN-LEVINTER INDUSTRIES
Toronto, Ontario, Canada

Manufacturer of silverplated holloware circa 1920s-1930s? (Unitt & Worrall, *Unitt's Book of Marks,* 1995, p. 54)

LIPPIATT SILVER PLATE AND ENGRAVING CO.
New York, New York

Thomas Lippiatt, Jr., first appears in the New York City directories as an engraver in 1853. In 1855 and 1856 he had a partner in his engraving business by the name of Schureman. In 1857 he dropped the "Jr." from his name and returned to working on his own as an engraver, continuing in this fashion through 1868.

In 1869 he entered into partnership with Ellsworth P. Maltby, probably a financial backer. One might speculate that the partnership arose due to Lippiatt's awareness of the work of a man named John Rogers, who was in the process of developing a new process that would revolutionize the silver industry, a technique for producing a "satin finish" on articles of silver plate. The process basically involved the controlled light roughening of the surface of pieces by placing them against a rotating wire brush prior to plating them.

By 1870 the Lippiatt Silver Plate and Engraving Co. had been incorporated, with Samuel F. B. Morse, the inventor of the telegraph, as president , and Ellsworth P. Maltby as treasurer. On November 1, 1870, John Rogers received Invention Patent No. 108,940 for his process, and assigned it to the Lippiatt Silver Plate and Engraving Co.

Everything seemed lined up for success. Samples of the company's wares had received a First Premium Award at the American Institute Exhibition of 1870. (Soeffing, *Silver*, July-Aug. 1995, p. 15)

However, within less than two months, James H. Reilly of Brooklyn had come up with a similar patent , which he assigned to Reed & Barton, for what amounted to a variation on Rogers original process, allowing "flying needles" to apply such a finish in an easier manner to certain types of holloware. (Soeffing, ibid) This may have been a significant factor in the demise if the Lippiatt Silver Plate and Engraving Co., which is not listed in the New York City directories after 1871.

However worse was yet to come. Unfortunately Rogers' patent mentioned only "Plated Goods" in the description of his technique. Others quickly realized that what was good for silver plate could be applied equally well to solid silver. On June 25, 1872 Richard Dimes received Invention Patent No.128,290 for an "Improvement in Apparatus for Stippling Metal Surfaces" which he assigned to Tiffany & Co. Although others patented similar processes, Tiffany & Co successfully defended their rights to the technique. (Soeffing, ibid pp. 15-19)

Lippiatt's business had become Lippiatt & Co., engravers, by 1872. It is not found in the New York City directories after 1873.

L.A. LITTLEFIELD SILVER CO.
New Bedford, Massachusetts

In an advertisement in an old (c. 1885-95 and unidentified magazine) Littlefield is called a "manufacturer and silverplater of glassware fittings." The business was established in 1884 by _ Needham and L.A. Littlefield. Needham retired in 1888.

The company was incorporated in 1905 under the name L.A. Littlefield Silver Co. It was consolidated with the Rockford Silver Plate Co. in 1909 and moved to Rockford, Illinois. Littlefield was a manufacturer of trimmings for glassware and electroplate. He supplied the silverplated tops for numerous articles of tableware.

P.H. LOCKLIN & SONS
New York, New York

Manufacturers c. 1920-1930 of sterling silverware, vases, candlesticks, salt and pepper shakers, umbrella handles, canes, riding crops, muffineers, novelties, cigar and cigarette holders, and articles of other materials mounted in 14 and 18k white gold and platinum.

MILLIE B. LOGAN
Rochester, New York

Trade mark No. 20,375 registered in the U. S. Patent Office for Millie B. Logan on November 17, 1891 for gold and silver tableware. Listed in JC 1896 among manufacturers of souvenir silverware. Rochester city directory lists her as a manufacturer of ladies fashionable hair work, hair jewelry, etc. from 1871-c. 1908.

V. LOLLO
Brooklyn, New York

Manufacturers of sterling salt and pepper shakers c. 1950.

THOMAS LONG COMPANY
Boston, Massachusetts

Registered trademark for sterling silver, silverplated flatware, holloware and jewelry. Claims use since Oct. 18, 1946.

LONGCRAFT

LONDON MFG. CO.
Location unknown

Listed as a supplier for J. W. Johnson (q. v.) on an 1885 billhead for that firm, which described itself as providing, "Superior Second Quality Nickel and Silver Plated Wares, Spoons, Forks, Knives, Ladles, etc."

LONDON SILVER PLATE CO.
Location unknown

Manufacturer of silverplate holloware circa 1880s.

H. LORD & CO.
Savannah, Georgia
See Black, Starr & Frost Ltd.

In business c. 1805. Partners were Hezekiah Lord, Cornelius Paulding and Isaac Marquand.

LOTT & SCHMITT, INC.
New York, New York

Listed JC 1915 in sterling silver section. Out of business before 1922.

LOW, BALL & CO.
See Shreve, Crump & Low Co. Inc.

DANIEL LOW & CO.
Salem, Massachusetts

Established in 1867 by Daniel Low as a small jewelry store. Low's reputation as a source of unusual gifts and fine gold and silver articles soon earned a reputation for the store and the confidence of his patrons.

In 1887, when souvenir spoons were being introduced in European cities, Daniel Low took a trip abroad and brought back the idea of making a Witch spoon as a souvenir of Salem and the Witchcraft tradition. His son, Seth F. Low, designed the first Witch spoon. It was made by the Durgin Division of The Gorham Mfg. Co. Its immediate popularity and that of the second Witch spoon which followed shortly afterwards, were largely responsible for the souvenir spoon craze that swept across the country shortly before 1900.

In 1896 Seth F. Low became a partner in the business. On September 1, 1907 the business was incorporated under the name Daniel Low & Co., Inc.

Aware that most of the goods purchased in his store were for gifts, Daniel Low decided to reach out beyond the confines of his own city and in 1893 first published a small catalog to establish a mail order business. The Daniel Low Year Book became a national institution.

The 1915 edition of the book notes that Daniel Low died in February, 1911, at which time Seth F. Low became president of the company, continuing in the family tradition of quality goods and service.

Not found in KJI 1922.

WITCH

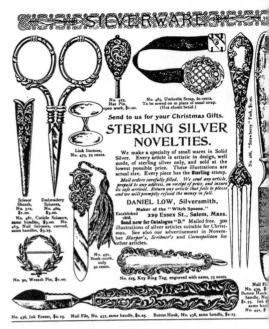

A selection of silver novelty items offered by Daniel Low in November, 1892, through an advertisement in Century Magazine.

JOHN J. LOW & CO.
See Shreve, Crump & Low

BENJAMIN F. LOWELL
Malibu Beach, California

Registered trademark for use on handwrought sterling silverware—goblets, trays and flatware. Claims use since Feb. 4, 1946.

MRS. LUCKEY
Pittsburgh, Pennsylvania

Woman silversmith who worked in Pittsburgh between 1830 and 1840.

LUDWIG, REDLICH & CO.
See Elgin Silversmith Co., Inc.
See Redlich & Co.

Registered trademark in U.S. Patent Office No. 21,423, July 5, 1892 for solid silverware and tableware.

LUNT SILVERSMITHS
Greenfield, Massachusetts
See Franklin Silver Plate Company
See Rogers, Lunt & Bowlen

Lunt Silversmiths began with the formation of the A.F. Towle & Son Mfg. Co. in 1880 in Newburyport, Massachusetts. Anthony Towle had learned the silversmithing trade from Joseph Moulton. In 1882, George C. Lunt joined the firm as an apprentice engraver.

Three years later Anthony Towle and his son left that company and built a new factory in Newburyport under the name A.F. Towle & Son Company. George Lunt joined the new firm as foreman of the engraving department.The company remained in Newburyport until 1890.

The firm was induced to move to Greenfield, Massachusetts when two farmers donated land for the shop and leading Greenfield businessmen offered financial support to construct the building. Shortly afterwards, Anthony Towle retired, and he and his son sold out to a group of local businessmen, lead by Richard N. Oakman, Jr.

1890 also marked the company's first use of a lion in a "T" as a trademark.

Oakman became intensely interested in developing and manufacturing automobiles, under the name Hertle Horseless Carriages. Lack of proper financing caused the failure of this endeavor and on November 8, 1900 the A.F. Towle & Son Co. failed. George C. Lunt, who had served as Mr. Oakman's assistant for a number of years, was called upon to liquidate the silversmithing business for the benefit of the creditors.

In May 1901, the Rogers, Lunt , & Bowlen Company was formed to purchase the tools, machinery, trade marks and good-will of A.F. Towle & Son, and resume the manufacture of sterling silver tableware. The officers of the company were George E. Rogers, President, George C. Lunt, Treasurer and General Manager, and William C. Bowlen, in charge of production. (Lunt, *Silver*, Sept.-Oct. 1985, pp. 26-27)

Since 1935 the company has used the trade-name LUNT SILVERSMITHS and have trade-marked their products LUNT STERLING but the corporate name remains the same.

The Franklin Silver Plate Company of Greenfield, Massachusetts was taken over between 1920-22. With minor exceptions their trademarks have not been used since.

About 1957 the King Silver Company of Boston, including the trademarks and assets of

"Bel Chateau" sterling flatware by Lunt Silversmiths. (Photo courtesy of Lunt Silversmiths)

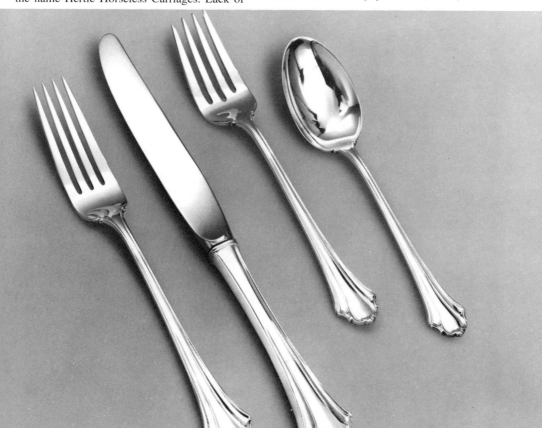

the Richard Dimes Co. was added to the firm. Lunt sterling is noted for fine craftsmanship and good taste in design.

Lunt introduced a line of stainless steel flatware in 1979 and, in 1980, a line of silverplated flatware.

LUNT STERLING

W.H. LYON
Newburgh, New York

Listed in the Newburgh City Directory 1891-1920. His advertisement in the directory stated that Lyon, the Jeweler, was sole manufacturer of the Washington Headquarters Souvenir Spoon, in Tea, Coffee, Orange and Sugar Spoons, also Butter Knives, etc. The trademark was the representation of the building known as "George Washington's Newburg(h) N.Y. headquarters." Registered in U.S. Patent Office, No. 18,906, January 17, 1891.

LYONS SILVER PLATE CO.
See Manhattan Silver Plate Co.

M

MABIE, TODD & CO.
New York, New York
See Smith & Todd
See Edward Todd & Co.

CHRONOLOGY

Mabie, Knapp & Johnston	18??-1854
Mabie, Knapp & McGovern	1855
Mabie, Smith & Co.	1857-1859
Mabie, Todd & Co.	1860-1924+?
Mabie, Todd & Bard	1874+?

According to the New York City directories, Mabie, Todd & Co.was formed about 1860 by John Mabie & Edward Todd. Todd's partner in the firm of Smith & Todd (q. v.), William P. Smith, had previously entered a partnership with Mabie in 1857 which had lasted through 1859.

Mabie, Todd & Co. manufactured gold pens and pencil cases and supplied parts wholesale to other manufacturers.

In 1871 Edward Todd established another firm, Edward Todd & Co. (q v.) The firm of Mabie, Todd & Co. continued in business. In fact it was still in business as late as 1924 according to KJI, manufacturing solid gold, 10 and 14k gold and silver fountain pens.

In 1874 the firm name Mabie, Todd & Co. was applied only to the company's factory site, while the name used at the showroom site became Mabie Todd & Bard. These firms' histories for the period between 1874 and 1924 have not been examined.

John Mabie, William P. Smith & Edward Todd were engaged in a variety of multiple simultaneous partnerships at various times. The chronologies of the different firms are recorded separately in an effort to avoid confusion.

J.S. MACDONALD CO.
Baltimore, Maryland

J. Stuart MacDonald was listed in Baltimore City Directories under plated silver wares; succeeded by J.S. MacDonald Co. in 1911. Listing continued through 1921.

MACOMBER MFG. CO.
Providence, Rhode Island

Manufacturers of plated siverware c. 1910.

MM Co.

MACFARLANE MFG. CO.
See Bridgeport Silver Plate Co.

R.H. MACY & CO.
New York, New York

Founded by Rowland Hussey Macy of Nantucket Island who went to sea as a whaler when he was only fifteen. At Macy's store he is spoken of as **Captain Macy** - a slight exaggeration.

Nantucketers still speak of "that Macy boy who went to New York and made out all right - even though he did become an off-islander."

He engaged in several business ventures. First, in Boston, he operated a thread and needle shop - a short-lived venture. His next store was Macy & Company, run in partnership with his brother in Marysville, California, where they were drawn by the Gold Rush.

The family moved back to Massachusetts and in Haverhill he opened the Haverhill Cheap Store.

Finally, in the fall of 1858, he opened his first New York store on 6th Avenue, just below 14th Street.

Macy had some unusual ideas in advertising and believed strongly in the value of this advertising. A distinctive characteristic of this was the introduction of a trademark - a red rooster - used after June 1851 in the Haverhill Store. In New York he adopted a five-pointed red star in 1862 or 1863.

Silverware was first sold in the store in 1874 and was supplied by L. Straus & Sons, wholesalers. Like other large department stores, Macy's had goods marked with their private brands and trademarks.

(On plated silver)

E. MAGNUS
New York, New York
See Howard Cutlery Co.

ERIK MAGNUSSEN
Providence, Rhode Island

Erik Magnussen was a designer for the Gorham Company from 1925 until October 1929.

He was born in Denmark May 14, 1884 and became a well known silversmith in his country of birth. His work was principally in what we now term the Art Deco style, an outgrowth of Cubism.

Magnussen's work had been widely exhibited in Copenhagen, Berlin, Paris and Rio de Janeiro.

So radically different were his designs that his association with Gorham's chief designer, William Christmas Codman, apparently was not a happy one.

After leaving the Gorham Company in 1929, Magnussen may have been associated with the shop of August Dingeldein, New York, as the 1931 Keystone shows his mark under that name. In 1932 he had his own workshop in Chicago and from 1932 to 1938 he worked in Los Angeles. He returned to Denmark in 1939 and died there on the 24th of February 1961.

ERIK MAGNUSSEN

D.J. MAHONEY
New York, New York

Listed in JC in 1896 in sterling silver section. Out of business before 1904.

M

WM. P. MAHNE SILVER COMPANY
St. Louis, Missouri

Founded 1946 by Mahne and John R. Geddis, formerly of Maschmeyer-Richards Silver Company. (JC-K 2-76)

MAJESTIC MFG. CO.
New York, New York
See Fishel, Nessler & Co.

An 1895 account states: "The Majestic Mfg. Co. of New York was incorporated to manufacture and sell sterling silver, gold and other metal ware. Directors are: Henry L. Fishel, Louis D. Nessler and Theodore F. Fishel , all of New York." (JC&HR 12-25-1895, p. 18) About 1900 the Majestic Mfg. Co. and Fishel, Nessler & Co. were at the same New York address.

This same trademark with the letters "J.O.-N.Y." replacing the word Majestic has been seen on a tea set. The trademark with the letters "F.N. & Co." replacing the word Majestic is attributed in the 1904 JC to Fishel, Nessler & Co.

MAJESTIC SILVER COMPANY
New Haven, Connecticut

Founded in 1910 as The Regal Silver Manufacturing Company by M.L. Baker. Present (1975) president is Milton Baker, son of the founder.

From 1910 till 1942 they manufactured silverplated flatware. In the late 1920s the production of stainless steel flatware was begun.

In the early 1930s a separate related firm, The Regal Specialty Mfg. Co., began the manufacture of silverplate and stainless steel flatware. At the end of World War II, silverplated flatware was discontinued and now only stainless steel flatware is made.

In late 1945, through internal corporate changes, The Majestic Silver Co. emerged as the parent company and The Regal Specialty Co. continued as the subsidiary.

MAJESTIC SILVER CO., INC.
New York, New York

Manufacturers of sterling silver holloware and pewter novelties c. 1930.

MALTBY, STEVENS & CURTISS CO.
Wallingford, Connecticut
See International Silver Co.

Successor to Maltby, Stevens & Company's spoon factory, Birmingham, Connecticut, the new company was headed by Elizur Seneca Stevens, Chapman Maltby and John Curtiss. They bought and occupied the old Hall, Elton & Co. plant and manufactured flatware for plating about 1890. In 1896 the company was purchased by the Watrous Mfg. Co., which was one of the original companies to become a part of International Silver Co. in 1898.

(On plated silver)

(On sterling silver)

W.H. MANCHESTER & CO.
Providence, Rhode Island,
See Manchester Silver Co.

Manufacturers of sterling silver fancy flatware, holloware and novelties.

MANCHESTER MFG. CO.
Providence, Rhode Island
See Baker-Manchester Mfg. Co.
See Manchester Silver Co.

Manufacturers of sterling silver fancy flatware, holloware and novelties. Baker-Manchester Mfg. Co. listed in 1922 JC as successors.

MANCHESTER SILVER CO.
Providence, Rhode Island

Founded in 1887 by William H. Manchester, descendant of an English family of silversmiths. Operations started on Stewart Street under the name W.H. Manchester & Co. They moved to Chestnut Street where Mr. Manchester was associated with a Baker family. From 1904 until 1914-1915, the company name was Manchester Mfg. Co. Manchester moved his operation to Pavilion Avenue in 1914 or 1915, while the Bakers continued for a time on Chestnut Street under the name Baker-Manchester Co. William Manchester was no longer connected with that operation.

William Manchester had an associate by the name of MacFarland. On his retirement, Frank S. Trumbull, of an industrial family from Connecticut, took his place. When Mr. Manchester and his son retired, the business was owned solely by Frank S. Trumbull until 1947, when E.B. McAlpine and his son, George Wescott McAlpine acquired an interest. Following the death of Mr. Trumbull in 1954 the McAlpine family acquired the entire stock.

Their products were sterling silver flatware and holloware. Everything is marketed under the slogan, "If it's Manchester, it's Sterling."

In 1955 or 1956 they acquired the tools, dies and rights to the flatware patterns formerly produced by Richard Dimes Co.

A 1980 account states: "Manchester Silver Co., Inc. maker of sterling silver flatware and holloware, became an early victim of chaos in the silver market. In mid-January, the firm announced it was being liquidated. Causes given: "extremely hazardous market conditions as well as important personal considerations of our president, Mrs. Phebe McAlpine Shepard." There reportedly were several prospective buyers for the company." (JC-K April 1980)

The Manchester Silver Co. was sold, late in 1985 to J.C. Boardman Co., S. Wallingford, Connecticut.

MANDALIAN & HAWKINS
North Attleboro, Massachusetts
See Mandalian Mfg. Co.

Founding date unknown. Succeeded by Mandalian Manufacturing Company before 1922.

M & H

MANDALIAN MFG. CO.
North Attleboro, Massachusetts

Successors to Mandalian & Hawkins before 1922. Last record found in 1935.

Manufacturing jewelers, makers of sterling and nickel silver mesh bags and frames.

DEBUTANTE

MANDIX COMPANY, INC.
New York, New York

Importers and wholesalers of pewterware and glassware with pewter trimming c. 1925-30.

JUST ANDERSEN

MANHATTAN PLATE CO.
New York, New York
See International Silver Co.,
See Henry C. Reed, Jr.,
See Hiram Young

CHRONOLOGY

Manhattan Plate Co.	1856-1871
Manhattan Plating Co.	1872-1877
Manhattan Silver Plate Co.	1877-1898

Established in 1856 by Hiram Young to manufacture his own private brand of silverplated holloware which he marked simply "Manhattan Plate". The company is reported to have purchased Reed & Barton wares "in the metal" and operated its own plating establishment. However, Hiram Young obtained a design patent for a teapot and an invention patent for a coffeepot, so it is probable that the firm manufactured at least some of its own products as well.

Young's business remained in his own name, but the products he sold bore the brand name until 1870 when the Manhattan Plate Co. was finally incorporated with him as president. Young disappears from the New York City directories in 1872.

The Manhattan Plating Co., also a corporation, succeeded the Manhattan Plate Co. in 1872. Morton Brock served as President, and Frederick Walker as Secretary. Walker had previously served as Treasurer of the Manhattan Plate Co. in 1870.

The company's factory was located in New York City during the time that it was named the Manhattan Plate Co. At some later point it was moved to Brooklyn.

According to the *Jewelers' Weekly* (1890) the firm was re-incorporated as the Manhattan Silver Plate Co. in 1877.

A mark identical to one used by Roswell Gleason shown in the 1904 JC appears to have been erroneously attributed to Manhattan Silver Plate Co. The Indian shown on the Gleason mark may have been confused with the Indian figure depicted as part of the Manhattan arms used in the Manhattan Plate mark in the mid 1800's, and shown above.

MANHATTAN SILVER PLATE CO.
Lyons, New York
See Manhattan Plate Co.

Incorporated in 1877 as the successor to the Manhattan Plating Co. In 1889 or 1890 the firm moved to Lyons, New York, after being bought by Orlando F. Thomas. The Jewelers' Weekly (3-6-1890) says that the "Manhattan Silver Plate Co. mark is stamped on their best grades of goods of all kinds. A new line of goods is to appear with Lyons Silver Co. as a trademark." Nearly one third of the production of the Manhattan Sil-

ver Plate Co. was exported, mainly to South America and Australia.

The firm became part of the International Silver Co. in 1898. The Manhattan trademark was not used after 1904.

MANNING, BOWMAN & CO.
Meriden, Connecticut

E.B. Manning, Middletown, Connecticut was a britannia ware maker from 1850-1875.

Robert Bowman was born in Liverpool, England in 1829 and came to this country as a boy. He learned his trade in Middletown, Conn. and after working there a while entered the employ of Samuel Simpson (later of Simpson, Hall, Miller & Co.). He also worked in Baltimore, Md. with Henry Bullard in the silverplating business. At the outbreak of the Civil War he went North again to Middletown and entered into partnership with E.B. Manning and Joseph H. Parsons.

Thaddeus Manning and Manning, Bowman & Company were listed in the Connecticut Business Directory of 1866 as britannia ware manufacturers. The company was founded in 1857 and incorporated in 1887.

Company records do not show just when the manufacture of plated silver products began, but, they are listed in JC from 1896-1915 with

trademarks for plated silver. One clue lies in the fact that they won an award at an exhibition of the American Institute of New York in 1869 for plated silverware.

Their advertisement (*Keystone* August 1906) says, "For over 40 years makers of the highest grade of wares in nickel and silverplate."

Best known for their manufacture of electrical appliances, the Manning-Bowman Company is now (1975) a division of the McGraw-Edison Company, Boonville, Missouri.

Meriden Britannia Co. was in control c. 1872 and after 1898 the International Silver Company owned more than 50% of the stock.

(Not used after 1898)

MANNING, ROBINSON & CO.
Cincinatti, Ohio

The firm manufactured "Specially Fine Electro Silverware" according to an ad it placed in Kenny's Illustrated Exposition Guide to the Cincinatti Exposition of 1874. The company produced flatware, as indicated by their whimsical trade mark of cherubs pulling and riding on a wagon formed of a knife, fork and spoon. It also advertised "New Patterns of Chaste and Elegant Articles of Ornament". All items were

manufactured only in "the highest grade of goods".

The firm also laid claim to having the "Exclusive Right of Nickel Plating in Cincinatti" at the time, and offered complete facilities for re-plating gold, silver or nickel.

WARREN MANSFIELD CO.
Portland, Maine

An advertisement in *Leslie's Magazine*, November 1904 carried the statement that they were goldsmiths and silversmiths, established in 1867.

They published an illustrated catalog with price list of jewelry, spoons, tableware, watches, etc. in 1900. Another catalog, dated 1907, illustrated an extensive line of silverware. No trademark is shown.

An advertisement in the March 1909 issue of *McClure's Magazine* offers a sterling silver Easter spoon, and encourages readers to send for a free catalog of "numerous Easter gifts and wedding presents".

MAPPIN & WEBB, LTD.
Sheffield, England

Silversmiths and electroplaters. By appointment to several members of the Royal family and foreign rulers.

John Newton Mappin left the family firm of cutlers, Mappin Bros., which he subsequently bought, to found a new firm with George Webb as his partner. Early in the 1880s they bought the old business of Stephen Smith & Sons (formerly Smith & Nicholson), of Covent Garden, London. In 1896 they bought Heeley Rolling Mills, a high quality foundry started in an old aluminum plant. In 1913 they began the manufacture of a cheaper line under the name Sheffield Silver Plate and Cutlery Company. Later part of British Silverware, Ltd. formed 1963, disbanded 1971. (Jones, *The Silversmiths of Birmingham and their Marks: 1750-1980*, 1981)

(For a full discussion of Mappin & Webb, see Culme, *The Directory of Gold & Silversmiths*, 1987 reprinted 1992, pp. 308-310)

MAPPIN & WEBB'S
PRINCE'S PLATE

TUSCA

MARCEL NOVELTY CO.
New York, New York

Listed in JC 1896-1904 in sterling silver section. Out of business before 1915.

MARCUS & CO.
New York, New York

There was an I. Marcus, 87 Nassau, New York City, in business at least from 1918-27. Manufactured 14K gold and platinum top bar pins, pendants, scarf pins, rings and cuff links.

MARCUS & CO.
New York

(Tentative)

FRED I. MARCY & CO.
Providence, Rhode Island

Frederick I. Marcy (b. Hartland, Vermont 1838; d. Providence, R.I. 1896) was employed for four years with a dealer in tinware named D. Hoisington. In 1863 he became a traveler with James H. Sturdy, jewelry manufacturer, in Attleboro, and within a year had purchased an interest in the company. In 1867, W.A. Sturdy purchased the business and James H. Sturdy and Marcy moved to Providence where they established the business of Sturdy & Marcy to manufacture jewelry. In 1878 Charles H. Smith became a partner and the name was changed to Fred

I. Marcy & Co. Smith retired in 1882 and Marcy continued the business alone.

One of their specialties was "Acme Lever" collar, cuff and sleeve buttons. This type of button was patented August 24, 1881. It was placed on the market and was an immediate success because it "saved time and vexation in dressing." Six thousand different designs were used in their ornamentation - cameos, opals, amethysts, pearls, diamonds, crystal pictures, chasing, engraving and enamel were used on the rolled plate of gold and sterling silver from which they were made. The Marcy trademark is also found on larger silver articles. The business closed shortly before Marcy's suicide in 1896.

MARION MFG. CO.
Salt Lake City, Utah

An 1886 account states: "The Marion Mfg. Co., Salt Lake City is being organized. They will make a specialty of silverware. The factory is being built like a watch factory so as to have all the light possible. The silverware will be marketed all over the western country." (JW 12-22-1886, p. 716)

MARQUAND & BROTHER
New York, New York
See Black, Starr & Frost, Ltd.

In business 1814-1831. Partners were Isaac Marquand and Frederick Marquand.

MARQUAND & COMPANY
New York, New York
See Black, Starr & Frost, Ltd.

In business 1834-1839. Partners were Frederick Marquand, Josiah P. Marquand and Erastus O. Tompkins. Famed silversmiths and jewelers.

MARQUAND & PAULDING
Savannah, Georgia
See Black,Starr & Frost, Ltd.

Founded c. 1801 and in business until 1810. Partners were Issac Marquand (who had been apprenticed to his uncle, Jacob Jenning, Norwalk, Connecticut) and Cornelius Paulding.

MARQUAND, HARRIMAN & CO.
New York, New York
See Black, Starr & Frost, Ltd.

In business c. 1809-1810. Partners were Isaac Marquand, Orlando Harriman and Cornelius Paulding.

MARQUAND, PAULDING & PENFIELD
Savannah, Georgia
See Black, Starr & Frost, Ltd.

In business c. 1810-1816. Partners were Isaac Marquand, Cornelius Paulding and Josiah Penfield.

THOMAS H. MARSHALL
Rochester, New York

Thomas Henry Marshall was born in 1809. From 1832 to 1836 he appeared as a silversmith in the Albany city directories. From 1838 to 1852 he is listed as a silversmith in Rochester. He may have been in Troy, New York in 1837.

In the 1850 Industrial census, his business is reported as employing three men and producing $2,500 worth of spoons, knives and forks per year.

Marshall died in 1852. (Soeffing, *Silver*, Nov.-Dec. 1990, p. 14)

MARSHALL & CADY
Rutland, Vermont
See Clark & Bros.

Successor to the firm of Clark Bros. & Marshall in 1873. Partnership of Albert S. Marshall and Ernest C. Cady. In business until 1876. Succeeded By Marshall, The Jeweler. (Carlisle, *Silver*, Jan.-Feb. 1988, p.20)

MARSHALL-WELLS HARDWARE CO.
Duluth, Minnesota

Began as the Chapin-Wells Hardware Company in 1886. In 1893, Albert M. Marshall, a Saginaw, Michigan merchant bought out the Chapin interest and the company became the Marshall-Wells Co., hardware wholesalers. Old city directory advertisements indicate that the

company first distributed only tools, hardware, cutlery and saddlery. Later their merchandise included everything that could be classified as hardware. It was the largest hardware wholesale distributor in the Northwest and Canada.

November 24, 1908 a trademark, No. 71,473 was registered in their name for silverplated knives, forks and spoons. In an advertisement from the *Zenith Magazine,* their monthly publication, it was noted that cutlery was stamped "manufactured exclusively for Marshall-Wells" and bore the Zenith trademark. Branch jobbing houses were located in Winnipeg (1900). Portland (1901), Spokane (1909), Edmonton (1910), Aberdeen, Seattle, Great Falls, Billings, Minneapolis and Vancouver, B.C. They also had warehouses in Moosejaw, Saskatchewan and Calgary, Alberta.

In May, 1955, the trustees of the A.M. Marshall estate sold the controlling interest to Ambrook Industries of New York. At that time Marshall-Wells was the largest wholesale hardware operation in the world.

In 1958, Marshall-Wells and Kelly-How, Thompson, a Midwest hardware distributor merged, and in August of that same year the company was sold to Coast-to-Coast stores. In 1959 Marshall-Wells closed its main office and warehouse in Duluth and moved to New York City.

A 1963 newspaper clipping indicated that the Marshall-Wells Co. of Duluth was still in business, having purchased a St. Louis, Missouri, furniture company, but no longer operated as a wholesale hardware distributor.

TH. MARTHINSEN SOLVVAREFABRIKK
Tonsberg, Norway

Established in 1883; now operated by the third generation. Manufacturers of complete lines of sterling and silverplated holloware and flatware. Known especially to collectors in this country through their limited edition enameled and silvergilt Christmas spoons. Products distributed in the U.S. through the Norwegian Silver Corporation.

S Ø L V
(On silver)

PLETT
(On silverplate)

MARYLAND SILVER CO.
Baltimore, Maryland

Listed in Baltimore City Directories 1906-1908 as silversmiths.

MARYLAND SILVER PLATE CO.
Baltimore, Maryland

Listed in Baltimore City Directories 1889-1899 under plated silverware.

MASCHMEYER RICHARDS SILVER CO.
St. Louis, Missouri

Listed in 1915 JC and 1922 and 1924 KJI as importer and wholesaler of silver, glassware, leather goods and ivory.

JOHN MASON
New York, New York

An 1890 account states, "John Mason, 246 Fifth Avenue, formerly with Tiffany & Co., having his factory and salesrooms manned almost entirely by former employees of the above firm, is enabled to furnish exactly the same quality of goods at a very much lower price. Highgrade Jewelry, Diamonds, Watches, Silverware, Fancy Goods, Cut Glassware, etc." (Adv. in *Harper's Magazine Advertiser*, November 1890)

No record of this business in New York Department of State Corporate Bureau.

MATHEWS & PRIOR
New York, New York

Founding date unknown. Listed in JC in 1904 in sterling silver section as out of business.

N. MATSON
See Spaulding & Co.

Newell Matson was a businessman, not a silversmith. He was born in Simsbury, Connecticut in 1817 and started in business at the age of

15 selling coin silver. He established a small store in Louisburg, Connecticut in 1840. In 1845 he opened a larger store in Owego, New York where he not only sold silverware, but employed several silversmiths whose main output was spoons marked with his name.

He started and sold several businesses. One was in Milwaukee, Wisconsin, where he established a partnership of Matson, Loomis & Hoes with a branch in Chicago. The Chicago store grew so rapidly that he sold the Milwaukee store only to be driven out by the fire in 1871. Soon afterwards he began business again, first in his home and later under the name N. Matson & Co., with George E. Johnson, L.J. Norton and W.E. Higby. They carried a large stock of the usual jewelers' goods - the silver being from the Gorham Mfg. Co. Later the firm name became Spaulding & Co. and then Spaulding-Gorham, Inc. from the 1920s to 1943 when the name reverted to Spaulding & Co.

MATTHEWS COMPANY
Newark, New Jersey
See Hickok Matthews Company-Silversmiths

Incorporated in 1907. Merged with Eleder-Hickok Company between 1931-1943 to become Hickok-Matthews Company. Was purchased in 1965 by Wolfgang K. Schroth and is now (1975) known as Hickok Matthews Company—Silversmiths, Montville, New Jersey.

(On sterling holloware)

THE MAUSER MANUFACTURING COMPANY
New York, New York

Frank Mauser, silversmith, began the manufacture of fine sterling silver goods in North Attleboro, Massachusetts in July 1887. In March of the following year, Frank O. Coombs became a partner. He was designer and chaser for the growing concern. They made "holloware of every description, stationery and toilet novelties and a large variety of miscellaneous articles and sets." In 1890 they were contemplating a move to New York where they planned to increase the capacity of their production. A note in the JC (1-6-1897) says that the "Mauser Mfg. Co., New York, is successor to Frank Mauser & Co."

In 1903 The Mauser Mfg. Co. merged with the Hayes & McFarland Company of Mount Vernon, New York and the Roger Williams Silver Company of Providence, Rhode Island to form the Mt. Vernon Company Silversmiths, Inc. which was purchased by the Gorham Corporation in 1913.

The diamond-enclosing-an-M trademark is still listed under Mt. Vernon Co. silversmiths.

Some of their flatware patterns were purchased by the Wendell Mfg. Co. c. 1896-97.

MAUTNER MFG. CO.
New York, New York

Manufacturers of jewelry and silverplated holloware c. 1925-35.

MOREWEAR PLATE
M. M. CO.

MAUTNER FARBER, INC.
New York, New York

Trademark found on 5-piece tea set.

SP ON COPPER

THE MAY DEPARTMENT STORES COMPANY
New York, New York
St. Louis, Missouri

Registered trademark in 1949 for use on silverplated holloware.

Maycrest

FRANK T. MAY CO.
New York, New York and
Rutherford, New Jersey

Manufacturers and distributors of sterling silver bags, 14K vanity and ladies' cigarette cases and novelties and jewelry in the 1920s. Listed in KJI in 1922 and 1924.

Listed in JC-K in 1904-1943

JOSEPH MAYER & BROS.
Seattle, Washington
See E. J. Towle Mfg. Co.
See Cantrell Company

About 1895, Joseph Mayer and his younger brothers, Albert and Marcus, emigrated from Germany's Rhineland to the Seattle area to establish a wholesale and manufacturing business. The two younger men followed the Klondyke gold rush north, while Joseph stayed behind in Seattle to manage the new firm. Instead of prospecting, however, Albert and Marcus set up a jewelry business in Dawson. Albert repaired watches, and Marcus "manufactured" jewelry from gold nuggets. Joseph shipped merchandise north to them. After a couple of years, the young men returned to Seattle. However their northern exploits were commemorated in the company's trade mark: a crossed gold miner's pick and shovel above a rising sun. (JC-K May 1982)
Some additional insights into the earlier history of the business may be gained from other sources. An 1896 note indicates that "Joseph Mayer & Bros. had been in business as Empire Jewelry Company." (JC&HR 9-16-1896, p. 20)
In 1898: "G.A. Schuman, of Attleboro, left last week for Seattle, where he will establish and manage what promises to be the largest jewelry plant on the Pacific Slope. The firm name will be Joseph Mayer & Bro. Mr. Schuman is a designer and toolmaker who has had experience with Gorham, Whiting and Tiffany, and goes under a year's contract. The arrangements as planned are for a big establishment, capable of turning out a great deal of work." (JC&HR 3-2-1898, p. 32)
"By 1900 the company employed 100 craftsmen who manufactured sets of sterling flatware, souvenir spoons, trophies, gold wedding rings, nugget jewelry and jewelers' street clocks. The company made the elaborate silver service for the battle cruiser *Washington* during President Theodore Roosevelt's term of office. They spun brass binnacles (for ships' compasses) for the U.S. Navy during World War I.
"In 1920 the brothers formed separate companies with Joseph devoting his efforts to manufacturing and Markus and Albert starting the Mayer Brothers Wholesale Jewelry Company. Albert died in 1925 but Markus continued to build up the business to include major watch, diamond and jewelry lines, as well as watch

materials. His son, Markus, Jr., succeeded him in the firm's continued growth. The firm got back into manufacturing in 1970 with the production of nugget jewelry, still one of its biggest sellers. Today Mayer Brothers employs 100 people and covers the western states, including Alaska." (JC-K May 1982)
Joseph's manufacturing firm was incorporated as Joseph Mayer, Inc. in 1920. It later became known as·the Northern Stamping and Manufacturing Co. This company was purchased by E. J. Towle in 1945. (Pack, *Collectors Guide to Canadian Souvenir Spoons*, 1988, p. 70)
Labelled marks are from Pack (ibid.)

JOSEPH MAYER

MAYER BROTHERS

JOSEPH MAYER
& BROTHERS

JOSEPH MAYER
COMPANY

JOSEPH MAYER
CORPORATION

MAYER BROTHERS WHOLESALE JEWELRY COMPANY
Seattle, Washington
See Joseph Mayer & Bros.

GEORGE MAYLAND
Brooklyn, New York

George Mayland appears in the Brooklyn city directories as a silversmith with a shop of his own at his home at least as early as 1856. From 1858 through 1873 he appears sporadically in the Brooklyn directories, listed as a silversmith but without a business location, apparently working for someone else. In 1874 he again appears to have a shop of his own, but is working for someone else in 1875. Not found in 1876 and not followed further.
On June 13, 1865 George Mayland received Invention patent No. 48,194 for a combined fruit knife and nut pick.

MAYNARD & TAYLOR
Utica, New York

Partnership of Thomas Maynard and William S. Taylor in business fom 1852 to 1857. Taylor took over the business by himself in 1857 but sold the manufacturing portion to Henry S. Brown and Charles C. Shaver shortly thereafter. Taylor continued as a "jeweler" for a number of years. (Soeffing, *Silver*, July-Aug. 1991, p. 15)

BENJAMIN MAYO
Newark, New Jersey

Silversmith, 1860-1908. Began business as Smith & Mayo in 1860, gold and silver electroplaters. Other Mayos listed at the same residence as Benjamin in the plating business were Arthur, 1869-71; William G. 1869 (moved to Rochester, N.Y., 1871); John B. 1868-71; and Samuel, 1868-71. Benjamin Mayo was listed in the 1871 Newark Directory as a silver plater and manufacturer of silver ware.

JOSEPH B. MAYO
Newark, New Jersey

An 1892 account states, "Joseph B. Mayo, an old resident of Newark and a former manufacturer of silver plated ware, but now interested in silver mining, is here (Newark) on a visit to his family." (JC&HR 9-21-1892 supplement)

Joseph B. Mayo was a silversmith, working 1868-96. He was a manufacturer of both plated and sterling wares, including cake baskets, card receivers, castors, waiters, pitchers, forks, etc. Also worked in britannia, white metal and solid silver. The compositions required were alloyed in his own factory.

MAYO & CO.
Chicago, Illinois

Listed in JC in 1896 in sterling silver section. Out of business before 1904.

JAMES EDWARD MAZURKEWICZ
Cleveland, Ohio

Silversmith. Mr. Mazurkewicz was born in Cleveland, Ohio and received his education in the Cleveland and Parma Public Schools, the Cleveland Institute of Arts and the Syracuse University School of Art. He has been awarded numerous scholarships and awards for the excellence of his work. Among these was an award from the National Sterling Silversmiths Guild of America Student Design Competition. Among his most recent exhibits (1975) was "The Goldsmith" at Renwick Gallery, Washington, D.C.

Mr. Mazurkewicz was an instructor at the Syracuse University School of Art and is presently instructor of metalsmithing, both beginning and advanced techniques, at the Cleveland Institute of Art. He was recently commissioned to make a trophy presentation piece for Scandinavian Airlines. (1975)

THE McCHESNEY CO.
Newark, New Jersey
See Gorham Corporation

Samuel D. McChesney, who died Aug. 1, 1926, age 65 had been connected with the silver business more than 35 years. In January 1890 he went with Wm. B. Kerr, his brother-in-law, founder and head of Wm. B. Kerr Co., Newark, New Jersey, for a number of years. After Kerr's death, McChesney was president of the company until he resigned December 1921 and formed the McChesney Co. which manufactured gold and silver wares in a factory in Newark. He continued there until his death.

His brother, Wm. F. McChesney, was treasurer and later president of Dominick & Haff (later sold to Reed & Barton).

It appears that after the death of Samuel D. McChesney, his business was taken over by Dominick & Haff. When that company was sold to Reed & Barton in 1928, what was left of the McChesney business was also taken over by them. The McChesney Company was sold by Reed & Barton in 1931 to the Gorham Company and Wm. F. McChesney went with Gorham. The tools and dies were moved to Providence, Rhode Island.

DAVID H. McCONNELL
New York, New York

Earliest record found was registration of U.S. Trade Mark Patent No. 32,828, May 9, 1899 for use on plated flatware. Out of business before 1915.

SO. AM.

THOMAS McCONNELL
Wilmington, Delaware
Richmond, Virginia

Thomas McConnell was born in 1776. Between 1801 and 1818 he worked in Wilmington Delaware. He then moved to Richmond, Virginia, where he worked as a silversmith and jeweler until his death in 1825. (Williams, *Silver* March-April 1991, p.31)

McCONNELL

H.A. McFARLAND
See Mount Vernon Silversmiths

JOHN M. McFARLANE
See Shreve, Crump & Low Co., Inc.

McG. C. CO.
Toronto?, Ontario?, Canada

Mark found on a silverplate souvenir spoon dated circa 1950s.

EDWARD B. McGLYNN
Newark, New Jersey

Listed 1931 KJI as manufacturer of gold and platinum mountings; special order work. In 1950 and 1965 JC-K as maker of sterling silver chalices.

McGLYNN

WALTER H. McKENNA & CO., INC.
Providence, Rhode Island

Established in 1915 as manufacturers of 14k and 10k gold, sterling silver and gold filled jewelry. Also make sterling baby spoons. Still in business. (1986)

HENRY McMANUS
New York, New York

Henry McManus first appears in the New York City Directory published in 1862 listed as a plater. Listings continue through 1868, although he is not found in the directories published in 1864 and 1866. His display ad in the directory published in 1868 lists him as a "silver plater". No further information is given.

JOHN O. MEAD
Philadelphia, Pennsylvania

Britannia ware manufacturer of Philadelphia John O. Mead laid the foundation for the important 19th century industry of electroplating silver.

Around 1830-1835, Mead was in charge of the silverplating and gilding work at the N.P. Ames Manufacturing Company of Chicopee, Massachusetts, using the old mercury and acid process.

He went to England to learn the new electroplating technique in Birmingham and continued his experiments on his return. Reputedly the first successful American electro-silver plater around 1840-1859.

He is reported to have formed a partnership in Hartford, Connecticut with William and Asa Rogers in 1845 under the name of Rogers & Mead. However, neither the partnership nor anyone named John O. Mead appears in either Hartford city directory for that year. There is a John O. Mead shown in the Hartford directories as a plater between 1846 and 1850. In 1846 this John O. Mead shared the same residence as Asa Rogers. However it appears this cannot be the same individual.

Philadelphia's John O. Mead was reported to be in Philadelphia from 1846 onwards, where he established his business under the name John O. Mead. Later it became J.O. Mead & Sons, the partners at that time being John O. Mead, J.P. Mead and Harrison Robbins. About 1850, the firm name became Filley & Mead (or Filley, Mead & Caldwell). Later still, the firm name was changed to Mead & Robbins. One account says that John O. Mead died about 1867 and that the firm of Mead & Robbins was dissolved about 1870. However, there is an item (JC&HR 10-19-1892, p. 27) that says "Frederick Robbins, Philadelphia, has withdrawn from the firm of Mead & Robbins and is making preparations for the establishment of a manufacturing and wholesale silverware house. The old firm will be conducted thereafter by Edmund P. Robbins and will

be devoted to the retail business." Mead & Robbins was succeeded by Sackett & Co. in 1893.

Mead & Sons had an extensive business. Their plant employed more than two hundred workmen and they turned out about fifty different designs in tea sets alone. Much of their ware was supplied "in the metal" by Reed & Barton, the plating being done in the Mead plant.

MEAD & ROBBINS
Philadelphia, Pennsylvania
See John O. Mead

Partnership of John O. Mead and Harrison Robbins succeeding the firm of Filley & Mead at some point after 1850. Mead & Robbins continued in business until about 1870.

Harrison Robbins had been with Harrison Robbins & Son of Philadelphia. A business notice of August 1892 refers to him as "the late Harrison Robbins."

MEADOWS & CO.
Philadelphia, Pennsylvania

Solid silver manufacturer in business circa 1860s. The "Eagle, U, Shield" portion of the mark is probably a standard mark denoting the coin silver standard. (Soeffing, *Silver*, Nov.-Dec. 1995, p.15)

MEADOWS & CO

MEALY MANUFACTURING COMPANY
Baltimore, Maryland

First listed in the Baltimore City Directory in 1900 as John W. Mealy Son & Company, jewelers. In 1906 John W. was listed as president: Edward H. as treasurer and Charles A. as secretary. In 1908 Allan B. Crouch was listed as secretary and Charles A. as treasurer.

In 1909 Crouch is no longer listed. The company name was listed through 1956.

All these listings are under the head of silversmiths. This listing, in addition to the type of trademark, indicates handwrought silver was made.

HAND /925\ WROUGHT
/1000\

MECHANICS STERLING COMPANY
Attleboro, Massachusetts
See Watson Co.

Listed as sterling manufacturer in Jewelers' Weekly 1896. Mark is identical to Watson-Newell, now part of Wallace Silversmiths - a division of Hamilton Watch Co.

"Mechanics Sterling Co. is the flatware branch of Watson, Newell Co., North Attleboro, Mass." (JC&HR 3-24-1897, p. 17)

STERLING

Flatware.
MECHANICS STERLING CO.

MEDALLIC ART COMPANY
Danbury, Connecticut

The Medallic Art Co., official medalists for the Society of Medalists, grew out of a small lower Manhattan workshop of the French-born Henri Weil, around the turn of the century. He was joined by his brother, Felix Weil, and the two craftsmen acquired the first modern die reducing machine imported into the United States prior to 1905.

The first medals were produced in 1907 and the Medallic Art Company name first appeared in 1909.

Ten years later, in 1919, an Indiana businessman, Clyde C. Trees, joined the two Weil brothers. In 1927 he assumed the presidency and built the flourishing company into the institution it is today. In 1960 Trees died and his nephew, William Trees Louth, was named president.

Medallic Art Co. is noted especially for its introduction into the United States of the diecutting process which allows fine art medals

to be reproduced from sculptor's original large size models. The work of many famous 20th century American sculptors has been reproduced by them.

In addition to finely crafted art medals, they also produce tablets, plaques, emblems and the larger medals known as medallions. Millions of service medals and decorations have been made for the U.S. government.

The key to the production of fine art medals is the Janvier reducing machine. Named after the French engraver, Victor Janvier, the device reduces a sculptor's model exactly, cutting a die automatically, (rather than by hand) in a pantographic reproduction. It is a little known fact that the Medallic Art Company personnel trained the technicians at the U.S. Mint at Philadelphia after helping that institution obtain its first Janvier machine.

Medallic Art Co. has produced many medals for important occasions, among them are those for the Pulitzer Prize and the inaugural medals for the Presidents Coolidge, Hoover, F.D. Roosevelt, Eisenhower, Kennedy, Johnson and Nixon.

They purchased the medal division of the Aug. C. Frank Co., Inc. of Philadelphia, September 15, 1972. The dies, medal presses and other equipment were incorporated into the Danbury plant soon after that date.

JAMES G. MELICK
Saint John, New Brunswick, Canada

James Godfrey Melick was born in 1802. For many years he worked as a watchmaker, jeweler and silversmith in Saint John, New Brunswick. He continued working up to the time of his death in 1885. (Unitt & Worrall, *Unitt's Book of Marks*, 1995, p. 9)

THE MELROSE SILVER CO.
Hartford, Connecticut

Manufactured inexpensive silverplate flatware c. 1900.

COLONIAL PLATE CO.

MERIDEN BRITANNIA COMPANY
Meriden, Connecticut
See International Silver Company

Organized in December 1852 by Horace C. and Dennis C. Wilcox of H.C. Wilcox & Co. Other founders were Isaac C. Lewis of I.C. Lewis & Company; James A. Frary of James A. Frary & Company; Lemuel J. Curtis; William W. Lyman of Curtis & Lyman and John Munson.

Organized for quantity production, their first products were britannia hollowares. By 1855 they were also offering plated silver holloware and flatware and German silver articles. Pearl-handled wares were added about 1861.

In 1862 the firm purchased the Rogers Brothers Manufacturing Co. Their 1847 Rogers Bros. trademark was an important addition to the Meriden Britannia Company.

In 1896 they ceased stamping their products "Quadruple" plate.

The Meriden Britannia Company officers were among the leaders in the formation of the International Silver Company in 1898.

As early as 1867 the Meriden Britannia Company had a system of stamping nickel silver, silversoldered holloware with a cipher preceding the number and by 1893, nickel silver holloware with white metal mounts had as a part of the number two ciphers. That is, on an article with white metal, 00256, etc. was stamped. This made it quickly understood by the number whether the piece was nickel silver, silver soldered or nickel silver with white metal mounts.

In the production of silverplated flatware, one of the biggest improvements was the introduction of sectional plate—depositing an extra amount of silver on spoons, forks, etc., on the parts which are given the hardest wear Marshall L. Forbes of West Meriden, Connecticut, received invention patent No. 75,258 dated March 10, 1868, for this process, and it was promptly put into use.

A catalog issued in 1871 by M. B. Co. shows a line, more extensive than previously shown, and gives this explanation as to what is meant by "Triple Plate." "A portion of the holloware was on nickel silver base, and a part on white metal, both marketed silverplated. They showed the two trademarks and say "goods carrying these trademarks are warranted triple plate and have at least three times the quantity of silver as on single plate."

In 1895 M. B. Co. bought out a small silversmith's shop in New York being run by Wilcox & Evertsen, successors to Rowan & Wilcox, making a quality line of sterling silver holloware, and moved it to Meriden. This was the start of a representative silver holloware line

213

which in 1898 was taken over by the International Silver Company. In 1897 M. B. Co. produced its first sterlng silver flatware pattern, *Revere*. M. B. Co. marks were used until the 1930s.

An advertisement promoting Meriden Britannia Co.'s "1847 Rogers" flatware from Century Magazine, *1893. The date "1847" refers to the founding of the original flatware company subsequently purchased by Meriden. It bears no relation to the year in which a piece of flatware was actually made.*

(*Spoons, Forks, Knives, etc.*)

(*Nickel Silver, White Metal Mounted Hollowware.*)

(*Solid Steel, Silver Plated Knives.*)

MERIDEN BRITᴬ CO.
(*Spoons, Forks, Knives, etc.*)

1847 ROGERS BROS. ✪ XII ᴛᴿᴵᴾ̂ˢ̧ₑ

(*Nickel Silver, Silver Soldered Hollowware.*)

STERLING

(*Standard White Metal Hollowware.*) (*Plated Ware.*)

MADE AND GUARANTEED BY

NICKEL SILVER WHITE METAL •••ROGERS BROS.
Used 1900-1917

STERLING STERLING FINE

(*Holloware.*) (*Flatware.*)

214

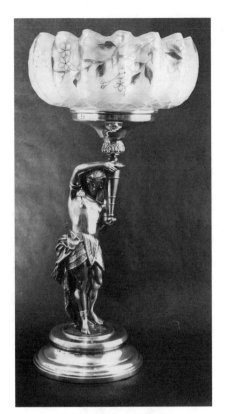

Egyptian Figural Fruit Stand by Meriden Britannia Co., c. 1880. Eighteen inches tall. Both the glass insert and the base bear the Meriden Britannia Co. mark. Courtesy Victorian Lace Antiques. (Photo by Judy Redfield)

MERIDEN BRITANNIA CO., LTD.
Hamilton, Ontario, Canada

Established in 1879 in response to the Canadian Government's National Policy. A subsidiary of Meriden Britannia Co. of Meriden Connecticut.

This firm produced 1847 Rogers Bros. silverplate, sterling silver flatware, silverplated nickel silver and white metal holloware.

"In December 1924 the International Silver Co. of Canada, Ltd.was incorporated to further the best interests of three firms - Meriden Britannia Co.; Standard Silver Co.; and William Rogers & Son. George Wilcox was the first president. ..." Copy from the Trader & Canadian Jeweler - 1929 (Quotation and marks from Unitt & Worrall,*Unitt's Book of Marks*, 1995, p. 27)

MERIDEN CUTLERY COMPANY
South Meriden, Connecticut

This firm began in 1834, when G. and D.N. Ropes manufactured cutlery in Maine. A few years later, A.R. Moen of New York manufactured table cutlery in Wethersfield, Connecticut. The business was acquired by Julius Pratt & Co. of Meriden who continued it for about two years. In 1845, these two firms were consolidated as Pratt, Ropes, Webb & Co. Mr. Ropes erected a factory in Hanover where the business continued until 1855, when the joint stock company Meriden Cutlery Company was formed. One of their specialties was pearl handled cutlery which usually carried the date 1855. The firm also provided parts wholesale to other manufacturers.

The company was purchased by Landers, Frary & Clark in 1866 which was liquidated in the 1960s.

The two trademarks below were used on carving knives with sterling silver ferrules c. 1900.

The Meriden mark was used by Landers, Frary & Clark on some sterling wares.

MERIDEN CUTLERY CO.

MERIDEN JLY. MFG. CO.
Meriden, Connecticut

Listed in JC 1915. Became Meriden Jewelry Co. before 1922. Manufacturers of sterling silver and plated silver cigarette cases, fancy pieces and flatware.

(On plated silver)

MERIDEN SIVER PLATE CO.
Meriden,Connecticut
See International Silver Co.

Organized in 1869 by Charles Casper and others. George R. Curtis was president. One of the original companies to become part of the International Silver Company in 1898.

The firm received a medal for its silver plated ware at the American Institute Fair in New York in 1874, and both a medal and diploma at the Centennial Exhibition in Philadelphia in 1876, as noted in the company's 1879 catalog.

An 1893 account notes that, "Robert G. Hill, photographer for the Meriden Silver Plate Co., is said to have discovered a new way of photographing on metal. Colors are reproduced and a likeness on the satin-finished silver background is extremely pleasing." (JC&HR 4-5-1893, p. 55)

The "half circle" trademark was first used in 1921 but not registered until 1923.

(On Cheaper Grade.)

EUREKA SILVER PLATE CO.
MERIDEN SILVER PLATE CO.

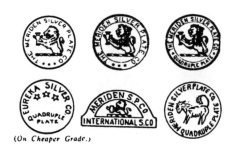

MERIDEN SILVER PLATE CO.
Toronto, Ontario, Canada

Established in Toronto in 1881 in response to the Canadian National Policy of 1879. Consolidated with the Meriden Britannia Co. and moved to Hamilton, Ontario in 1884. (Unitt & Worrall, *Unitt's Book of Marks*, 1995, p. 47)

MERIDEN STERLING CO.
Meriden, Connecticut

Listed in JC 1896 in the sterling silver section. Out of business before 1904.

MERMOD, JACCARD & KING JEWELRY CO.
St. Louis, Missouri

Established in 1829 by Louis Jaccard who was joined by A.S. Mermod in 1845. In 1848, D.C. Jaccard, relative of Louis Jaccard, joined. In 1865 Goodman King became associated with the firm.

Two catalogs issued by the company, one dated c. 1890 and the other dated c. 1909, show a good selection of sterling and silverplated items. However, when the firm's sterling flatware offerings were reviewed by Soeffing, virtually all of the patterns shown appeared to have been produced by other manufacturers. Interestingly, the names of the flatware patterns offered were sometimes changed from those used by the original manufacturer. (Soeffing, personal communications, 1995) The firm appears to have been no longer manufacturing some or all of its own silver goods by 1890.

In 1901 they absorbed the E. Jaccard Jewelry Co. and Merrick, Walsh & Phelphs Jewelry. In 1905 the name of King was added to the firm name. In 1917 they became part of Scruggs, Vandevoort & Barney but retained their identity as a separate corporate body.

MERMOD & JACCARD CO.
TRIPLE

THE MERRILL SHOPS
New York, New York

Established March 1893 as J.M. Merrill & Co. Listed 1896 as Merrill Brothers & Co., manufacturers of sterling silver and pewter. By 1922 it was The Merrill Co. and The Merrill Shops before 1931.

MERRIMAC VALLEY SILVERSMITHS

A division of Concord Silversmiths Corp., succeeded by Frank M. Whiting & Co. Dies purchased by Crown Silver Co.

MERRIMAN SILVER COMPANY
Attleboro, Massachusetts

An 1897 account notes that "The Merriman Silver Co., Attleboro, are one of the new companies recently started. Their existence dates from the first week of February. If their anticipations are realized they intend to begin the manufacture of staple goods." (JC&HR 3 - 17 - 1897, p. 22)

MERRY & PELTON SILVER CO.
St. Louis, Missouri
See Pelton Bros. Silver Plate Co.

Listed JC 1904 as manufacturers of plated silver holloware and flatware. Out of business before 1909. Not listed in St. Louis City Directories which were checked back to 1840.

(*Holloware.*)

SECTIONAL PLATE XII
STANDARD PLATE 4
TRIPLE PLATE 12
(*Flatware.*)

MERWIN-WILSON CO., INC.
New Milford, Connecticut

Company established by the Merwin brothers in 1912 as successors to Bennett Merwin Silver Company. Shortly afterwards one brother was killed.

Roy (?) Wilson joined the remaining Merwin. The company made pewter reproductions and plated silver prize cups, trophies and colonial pewter reproductions until 1935 when they sold out to Robert Oliver who operated under the name of Danforth Company. The company and its molds have changed hands several times since that time and are in use now in the manufacture of pewter reproductions by Woodbury Pewterers.

MESICK MFG. CO.
Los Angeles, California

Manufacturers of sterling and silverplated holloware c. 1950.

METAL ARTS GROUP
Seattle, Washington
See Charles B. Cantrell
See West Earth, Inc.

Firm formed by Charles B. Cantrell (q v.) after he bought out the interest of his former partner, Raoul Leblanc, in West Earth, Inc. in 1985. The company is primarily a jewelry manufacturing firm, with emphasis on museum quality Northwest Coast Native jewelry in silver. Charles Cantrell, Ltd., a subdivision of the parent firm, produces 14 K and 18K gold designer jewelry.

From 1985 to 1994 the firm produced a limited quantity of collector spoons under the American Legacy and Metal Arts Group trademarks. In 1994 the Cantrell Company was formed as the collector spoon division of the Metal Arts Group.

The firm's products are sold primarily in the United States, but the company is in the process of developing markets for its wares in Japan, England, Germany and Canada.

American Legacy
Metal Arts Group

METALLURGIC ART CO.
Baltimore, Maryland

Listed in Jewelers' Weekly as manufacturers of sterling silverware in 1896.

First listed in the Baltimore City Directory in 1895 as Victor G. Bloede, Carl Schon, jewelry manufacturers. In 1896 the listing is Metallurgic Art Company. In 1900 Bloede and Carl Schon, Jr. are listed as members of the firm.

In 1901 the Metallurgic Art Company is no longer listed. Bloede is listed as president of Victor G. Bloede, Manufacturing Chemists. Schon is not listed at all, as he moved to Detroit.

METAL PRODUCTS CORP.
Providence, Rhode Island

Manufacturers of plated silverware c. 1920. Out of business before 1922.

MPRD

GEORGE METCALF
Hartford, Connecticut
See O.D. Seymour

George Metcalf first appears as a silversmith in the Hartford city directories in 1851. From 1851 to 1853 his workplace is not indicated. However he was probably working for O.D. Seymour (q.v.) as in 1854 he appears working for Seymour and Lindsley, the successor firm.

By 1855 he was in business for himself, having taken over the 36 Pearl Street location formerly occupied by the Seymour firms. Metcalf continued in business as a silversmith through 1861.

METROPOLITAN SILVER CO.
(John Toothill)
New York, New York

Listed in JC in 1896-1904 in plated silver section. Out of business before 1915.

MEYER & WARNE
Philadelphia, Pennsylvania

Silverplaters c. 1859-1880?

WILLIAM B. MEYERS CO.
Newark, New Jersey

William B. Meyers, a noted maker of silver miniatures, was born December 1887 at New Brunswick, New Jersey.

His first workshop was set up in 1907 in Maiden Lane, New York, but he returned to New Jersey where he established the William B. Meyers Company at 50 Columbia Street. He made reproductions of antiques and ceremonial objects for Jewish temples. He began to make miniatures in 1932. His son, Joseph N. Meyers, joined the firm and also made miniatures. Meyers was noted for the fine quality, the good design and excellent craftsmanship of his pieces, many of which are unmarked. He died in 1958.

MIAMI SILVER CO.
Cincinnati, Ohio

Listed in City Directories 1903-1912 as silverplaters.

A. MICHELSEN
Copenhagen, Denmark

Anton Michelsen, founder, was born in 1809 and apprenticed to a goldsmith in Odense. He completed his training in Copenhagen, Berlin and Paris. He established his own shop in 1841 and within a few years won approval of the royal court, being designated "Insignia Jeweler" - makers of the official state decorations and Jeweler to His Majesty the King (since 1973 Jeweler to Her Majesty the Queen). The firm has won worldwide recognition for its decorative centerpieces, ornamental goblets, table services and *objets d'art* but is perhaps best known in the U.S. for the annual Christmas spoon and matching fork. Decorative spoons have been among their noted products since 1898 when

Michelsen's designed a spoon to commemorate the 80th birthday of King Christian IX. Its success and that of other commemorative spoons led them in 1910 to design and produce the first Christmas spoon, now a yearly tradition.

MIDDLETOWN PLATE CO.
Middletown, Connecticut
See International Silver Co.

One of the early silverware companies that was included in the International Silver Co. The business was first started in 1864 by Edward Payne and Henry Bullard, formerly in the employ of I.C. Lewis, of Meriden, Connecticut, one of the founders of the Meriden Britannia Co. Payne and Bullard formed a partnership doing business in the name of the former in the manufacture of britannia and plated wares in Middletown.

In 1866 the Middletown Plate Co. was incorporated and continued in operation until it became part of the International Silver Co. in 1899.

In the early years of its operation, the company obtained holloware in the metal from Reed & Barton, as evidenced by a table caster bearing the Middletown Plate Co. mark which was manufactured according to William Parkin's Design Patent No. 3421 granted March 23, 1869 and assigned to Reed & Barton.

By 1876 the company was clearly producing its own holloware. Designer Augustus Conradt, who had earlier worked for solid silver manufacturer George C. Sharp (q.v.), obtained his first holloware design patent for the company in that year. Over the next few years he received a variety of of both invention and design patents for holloware, for items ranging from salvers to jewel boxes and butter dishes.

The company not only marketed its products under its own name but also sold holloware to Rogers & Bro., New York, who finished it and marketed it with *their* trademark.

The Superior Silver Co. stamp was used by the Middletown Plate Co. on their low priced merchandise. When they moved to Meriden, June 30, 1899, the International Silver Co. was using the Gem Silver Plate Co. stamp on the Wilcox low priced merchandise, and rather than have the two competitive stamps, they used the

Superior Silver Co. stamp on both and eliminated the Gem Silver Plate Co. stamp.

This trademark adopted about 1866.

COLUMBIA

SUPERIOR

MIDDLETOWN SILVER CO.
Middletown, Connecticut

After the business of the Middletown Plate Co. had been taken over by the Internalional Silver Co. in 1899 and moved to other plants, some of the old employees arranged with others to start a new concern, hiring space in the building for-

merly used by the Middletown Plate Co. The new company went bankrupt, January 6, 1910 but after several reorganizations and changes was still in business as late as 1939. An item in the Hartford Times (1-11-1945) indicates that the company was merged with J.A. Otterbein Co. of Middletown. Believed to have been subsequently bought by Wallace Silversmiths.

MIDDLETOWN SILVERWARE

(On nickel silver)

(On britannia)

MIDDLESEX SILVER CO.

(On plated nickel silver)

HAROLD A. MILBRATH
Milwaukee, Wisconsin

Founded 1952. An individual maker specializing in sterling silver. Communion service appointments and altar appointments in brass alloys. Makers of holloware, cast and fabricated articles and special jewelry.

(Used on silver, bronze and pewter)

FREDERICK A. MILLER
Brecksville and Cleveland Ohio

Silversmith. Mr. Miller was born in Akron Ohio and is a graduate of Cleveland Institute of Art and Western Reserve University. After his discharge from the army in 1946, he joined the firm of Potter and Mellen, Inc. and is now (1975) president and designer of that firm.. He studied silversmithing briefly with Baron Erik Flemming and started working in silversmithing and jewelry following the war. He worked mostly in ster-

ling holloware until recently (1975) when he became interested in jewelry.

In 1948 Mr. Miller joined the staff of the Cleveland Museum of Art as instructor in silversmithing and jewelry, where he is presently teaching.

Mr. Miller's work has been exhibited in the Cleveland May Show from 1948 through 1972, where it has won first prize or a special award each year. He has also exhibited in the State Department Exhibition; the Designer-Craftsman Show, first Nationnal Exhibiton; Rochester Museum Show; Metropolitan Handwrought Silver Exhibition; Newark Museum Show, 1954; Wichita National Exhibiton; Los Angeles County Fair; Brussels World's Fair; Museum of Contemporary Crafts, 1961; the Henry Gallery, Seattle; Objects USA; Ohio Designer Craftsman; American Metalsmiths-DeCorelova Museum, 1974 and others.

JOHN P. MILLER
New York, New York

John P. Miller is listed in the New York City directories published from 1853 through 1855 as having his own plating business. For 1856 through 1863 (except for 1857 when he is not found) he is listed as a plater, but apparently working for someone else, as no business address is given.

From 1864 through 1866 he again operated his own plating business. His display ad in the 1866 directory lists him as a "Manufacturer of COACH PLATED WARE, Door, Number, Pew and Piano Plates, Butt Hinges and Shutter Knobs, Silver Plated Stair Rods &c."

He appears again as a plater working for someone else in the directories published in 1869 and 1872.

JOHN PAUL MILLER
Brecksville and Cleveland, Ohio

Silversmith affiliated with the Cleveland Institute of Art. Mr. Miller was born in Huntingdon, Pennsylvania and educated in Ohio Public Schools. He is a graduate of the Cleveland Institute of Art in Industrial Design. He began making jewelry in 1937 and produced holloware in the middle 1950s. Almost all of his work is done in gold.

Mr. Miller's work has been shown in many exhibitions in the United States and Europe.

Examples are in numerous private and public collections. One man shows have been held in the Museum of Contemporary Crafts, New York; the Art Institute of Chicago; the Henry Gallery, Seattle, Washington; and the Wichita Art Association Museum, Wichita, Kansas.

WILLIAM J. MILLER
New York, New York

William J. Miller appears in the New York City directories at least as early as 1852 listed as an importer. By 1858 his business is listed as plated ware.

An ad in the *New York Times*, December 24, 1863 advertises "Silver Plated Ware. William J. Miller, Importer and Manufacturer, No. 12 Maiden Lane. Extensive stock of SHEFFIELD, BIRMINGHAM and AMERICAN GOODS, of latest styles, for cash or short time.

"Tea sets, Waiters, Urns, Dishes, Casters, Tureens, Wine Stands, Butter Coolers, Ice pitchers, Cake Baskets, Fruit Stands, Egg Frames, Pickle Stands, Card Baskets, Forks, Spoons, Pearl and Ivory Knives, &c."

The firm continued to be listed as silver or plated goods through 1874. Not followed further.

WM. J. MILLER
Baltimore, Maryland

Listed in Baltimore City Directories 1904-1920 as a silversmith.

THE MILLER JLY. CO.
Cincinnati, Ohio

Listed in JC 1915 in the sterling silver section and in jewelry. Last listing in 1922.

M Sterling

WILLIAM MITCHELL, JR.
Richmond, Virginia

William Mitchell, Jr. worked as a silversmith and Jeweler in Richmond, Virginia between 1818 and 1845. In that year he sold the business to his brother, Samuel P. Mitchell, and another employee, John H. Tyler. They contin-

ued as Mitchell & Tyler until 1866 (Williams, *Silver*, Jan.-Feb. 1984, p. 31 based on Cutten: *Silversmiths of Virginia*)

MITCHELL & POOL
Baltimore, Maryland

Listed in Baltimore City Directory in 1889 as silverplaters. Succeeded by B. Pool & Company in 1894.

G.I. MIX & CO.
Yalesville, Connecticut

In 1843 Garry I. Mix began the manufacture of spoons and three years later formed a partnership with Charles Parker of Meriden.

"In 1848 Charles Parker and Garry I. Mix began the manufacture of Britannia and German silverware, continuing until 1854, when Mix retired to establish himself in business at Yalesville. Parker and Jeralds (Thomas and Bennet) continued at the old place as the Parker Mfg. Co. In 1857 the old mill and factory buildings were destroyed by fire and a new factory erected.

"In 1876 the Parker Mfg. Co. discontinued the manufacture of German silverware, but the production of Britannia spoons has since been carried on, in a limited way, by Bennet Jeralds.

G.I. Mix & Co. at Yalesville, are extensive manufacturers of Britannia goods . . . In 1886 steam power - 50 horse - was added to the water motor, and the capacity for production was increased." HISTORY OF NEW HAVEN COUNTY CONNECTICUT, Vol. 1. Edited by J.L. Rockey.

An 1892 account notes that "Garry I. Mix died Saturday (dated New Haven, Aug. 15). He was the leading manufacturer of German silver spoons and tinned ware spoons and edge tools. Some years ago was a State Senator. He built the Baptist Church at Yalesville, mainly at his own expense. In his early business life he manufactured spoons for Russell Hall of Meriden." (JC&HR 8-17-1892, p. 19)

Succeeded c. 1903 by C.I. Yale Mfg. Co., manufacturers of nickle plated copper coffee and tea pots.

	CROWN PRINCE
G. I. MIX & CO.	MALACCA PLATED
	THE COLUMBIA

JAMES MIX
Albany, New York

The James Mix who designed the James Mix "Albany" souvenir spoon c. 1890 may have been a descendant of James Mix, silversmith in Albany, New York, 1817-1850. His son, James Mix, Jr., was listed in the Albany City Directories as a manufacturing jeweler, 1846-1850.

JAMES MIX

MODERN SILVER MFG. CO., INC.,
Brooklyn, New York

Listed in 1950 JC-K and 1958 JBG as manufacturers of silverplated wares.

HEIRESS

SILVER PLATE

EDWIN MOLE
Brooklyn, New York

Listed as a silversmith in the Brooklyn city directory published in 1873.

JACOB A. MOLLER
New Rochelle, New York

Listed in 1907 New Rochelle City Directory as a silversmith. No other listing.

F.S. MONROE, JR. & CO.
Boston, Massachusetts
New York, New York

Francis S. Monroe, Jr. appears in the New York City directory in 1863, apparently trying to establish a New York office for his Boston firm. His ad in the directory describes the business as "Manufacturers and importers of Rich Silver Plated Ware". Not found in New York after 1863.

MONTGOMERY BROS.
Los Angeles, California

The Los Angeles City Directories list James Montgomery as watchmaker and jeweler from

1883-1886. The first listing for Montgomery Bros. (Jas. A. and Geo. A.) is for the year 1888. The same listing is carried for 1890. No distinction made between retailers and manufacturers in the directories.
On October 27, 1891, Montgomery Bros. registered Trade Mark Patent No. 20,270 for the manufacture of gold, silver and plated articles, flatware and jewelry. Their trademark is listed in JC souvenir section.

MONTGOMERY WARD & CO.
Chicago, Illinois

First used in 1908 on silverplated flatware made by various manufacturers.

LAKESIDE BRAND

MONTGOMERY WARD & CO.,
(First used 1887-1888)
PALACE BRAND
(Used 1886)

MONUMENTAL PLATING WORKS
Baltimore, Maryland

Listed in Baltimore City Directories 1887-1912 as silverplaters. Wm. Focke, proprietor.

EDWARD C. MOORE
New York, New York
See John Chandler Moore
See Tiffany & Co.

CHRONOLOGY
John C. Moore & Son	1848-1854
Edward C. Moore	1855-1868
Tiffany & Co.	1868-1891

Edward C. Moore, the eldest son of John Chandler Moore (q. v.), was born in 1827. He learned silversmithing from his father and became his partner in 1848. (Carpenters, *Tiffany Silver*, 1978, p. 11)

By 1855 John Chandler Moore had turned the business over to his son, although he still continued to work for the firm through about 1863.

Soeffing (in Venable's *Silver in America*, 1994, biographical section, p. 320) notes that in the 1860 Industrial Census, the firm had 50 em-

ployees and was producing about $100,000 worth of goods annually, more than three times the output of ten years before.

On May 1, 1868, Edward C. Moore sold his silver manufacturing business to Tiffany & Co. for $55,000 and sixty-one shares of Tiffany & Co. stock, formalizing an agreement that had been in place between the firms since 1851. He became Tiffany's chief silver designer and manager of their silver works. (Carpenters, *Tiffany Silver*, 1978, pp. 26, 31)

JOHN CHANDLER MOORE
New York, New York
See Edward C.Moore

John Chandler Moore was born about 1803. He began the manufacture of silverware about 1827. From 1832 to 1836 he was associated with the firm of Eoff & Moore (Garrett Eoff). He made silverware for Marquand & Co. and also for their successors, Ball, Thompkins & Black. In 1847 John Moore designed and patented a flatware pattern (Design Patent No. 124, May 29, 1847) that is similar to the *Prince Albert* design of Henry Hebbard.

In the Industrial Census for 1850 his firm is shown as having 22 employees and producing $30,000 worth of goods annually. In 1851 he is reported to have made a special agreement with Tiffany's that all his firm's production would go to them. (Soeffing, in Venable's *Silver in America*, 1994, biographical section, p. 320)

By 1848 the firm had become John C. Moore & Son. Edward C. Moore (q.v.), his eldest son, was the partner. By 1855 John C. Moore had turned over the business to his son, and the firm became known simply as Edward C. Moore.

John C. Moore disappeared from the New York City directories in 1855 as he was no longer a principal in the firm and was not a New York City resident. However the Brooklyn city directories show that he continued to work for the firm on a fairly regular basis through 1863. After this time he is no longer listed as a silversmith, but he still appears quite regularly in the Brooklyn directories to about 1870. His son John W. Moore, also a silversmith, appears from time to time at the same address.

J. C. M.

MICHAEL MOORE
Brooklyn, New York

CHRONOLOGY

Moore & Dawson	1864?-1866
Moore & Russell	1867-1868
Working at Adams, Chandler & Co.	1869-1870+?
Moore & Baxter	1873-1875
Michael Moore?	1876+?

Michael Moore first appears in the Brooklyn city directories in 1865. However he appears to have been in the silverplating business there before that time. On December 6, 1864 he received Design Patent No. 2,004 for inserting colored glass balls as decoration into the base and revolving central portion of a table caster.

In 1865 and 1866 he is shown in partnership with James Dawson in the silverplating firm of Moore & Dawson. By 1867 he had a new partner, Edward (or Edmund?) Russell, who had worked as a brassfounder previously for a number of years.

By 1869 this partnership was dissolved, and Moore had gone to work for John P. Adams (q.v.) at Adams, Chandler & Co. He stayed with Adams at least into 1870, and perhaps longer. Since the 1871 and 1872 Brooklyn directories are unavailable we do not know where he was working during those years.

By 1873 he had entered into another partnership, this time with Thomas Baxter, and was involved in both silverplating and nickel plating. In 1876 he moved his business to New York City. Not followed beyond 1876.

MOORE & HOFMAN
Newark, New Jersey
See Schmitz, Moore & Co.

Successors to Schmitz, Moore & Co. between 1915-1922. Succeeded by Moore & Son (?) before 1943.

Manufacturers of sterling silver dresserware, vanity and cigarette cases, tableware and novelties.

MOORE & LEDING, SILVERSMITHS
Washington, D.C.

Listed in the Washington, D.C. City Directories from 1882 to 1902. Listed as Moore & Leding, 1881-1899, jewelers. Listed as Robert Leding (successor to Moore & Leding (1900-1902), jeweler.

Moore & Leding marketed the "Washington City" and "Mount Vernon" souvenir spoons, both made by The Gorham Company. These two spoons were patented in 1890 and 1891, respectively, and were put on the market shortly after the first Witch spoon designed for Daniel Low Company.

MOORE BROS.
Attleboro, Massachusetts

Listed in Attleboro City Directories as manufacturing jewelers with John F. and Thomas H. Moore as owners from 1907-1916 and John F., Thomas H. and Charles E. Moore from 1916-1940.

M.B.

R.L. MOOREHEAD & CO.
Providence, Rhode Island

Listed KJI 1918-19 as manufacturers of sterling and plated wares.

C. MORGAN
Hartford, Connecticut.
See W.L & H.E. Pitkin

CHRONOLOGY

C. Morgan	1853-1857
Morgan & Ingraham	1858
Pitkin & Morgan?	1859-1862
C. Morgan	1863-1864
Chauncey Morgan	1868-1873
Morgan & Baker	1874
C. Morgan	1875-1881+?

Chauncey Morgan first appears in the Hartford city directories in 1848 listed as a "silversmith", with no indication as to which company he was working for. By 1853 he had set up in business on his own as an electroplater.

About 1858 he entered into a partnership with Miles Ingraham forming the firm of Morgan and Ingraham. They took over the 55 Pearl St. location previously occupied by Henry P. Seymour (q.v.)The partnership lasted for about a year.

William L. Pitkin reportedly took over the solid silver businesses of O.D. Seymour (q.v.) and H. I Sawyer (q.v.) He set up in business at the 55 Pearl Street location in 1859. He may have bought out Miles Ingraham's share of Morgan and Ingraham as well. Both Pitkin and Morgan occupied the same business address between 1859 and 1862, although there is no partnership listed. Chauncey Morgan continued as an "electroplater" while W. L. Pitkin was listed as "Silver spoons & forks"

By 1863 W.L. Pitkin had gone into partnership with his brother H.E. Pitkin, and Chauncey Morgan was again operating an independent shop, next door at 57 Pearl St. His advertisement in the Hartford city directory for that year reads: "Forks, Spoons, Table Cutlery, Door Knobs, Plates, Numbers, Counter and Basin Cocks, Iron, brass &c. Silverplated goods finished in superior style and warranted equal to new." Clearly he aimed at covering a broad spectrum of the silverplating business.

By 1865 he was again working for someone else. He is not found in the directories in 1866 and 1867.

In 1868 he appears again operating his own plating business. He continued in that fashion until about 1874, when he went into partnership with Sylvanus H. Baker. Baker had worked in the silver industry in Hartford as a burnisher for many years. However, the directories do not indicate who he worked for prior to his partnership with Morgan. The new firm advertised itself as gold and silver platers.

By 1875 the firm was listed simply as C. Morgan gold and silver plater. Baker was back working as a burnisher, whether for Morgan or for someone else is not known. Morgan continued to describe his business as that of a gold and silver plater until about 1880, when he dropped the word "gold" from his listing. Not followed beyond 1881.

LEWIS MORGAN
New York, New York

Lewis Morgan first appears in the New York City directories in 1856 listed simply as a "manufacturer." In 1857 he placed the following directory ad: "Lewis Morgan, Manufacturer of German Silver Ware, No. 4, over Harlem R.R. Depot, Room 26, White Street, New York. On hand and made to order, Crumb, Pie, Fish, Cake, Ice-cream, Dessert and Butter Knives, Napkin Rings, Spectacle Cases, Tobacco Boxes &c. German Silver Handles for Steel Table Cutlery. Stamping and punching done at the shortest notice. All kinds of Jobbing in Silver, German Silver and Brass."

In subsequent years the business is listed variously as "silverware", "silver" and "smith", and in 1874 as "cutlery". Not followed beyond 1874.

MORGAN SILVER PLATE CO.
Winsted, Connecticut

An 1892 note states: "The Morgan Silver Plate Co. of Winsted, Conn. recently purchased the building in which its factory is located." (JW 6-8-1892)

In 1895: "J.T. Morgan of the Morgan Silver Plate Co., Winsted, Conn. has recovered from an illness of several weeks. Arthur H. Morgan left Feb. 25 on a business trip." (JC&HR 3-6-1895, p. 20)

The Morgan Silver Plate Co. was listed as manufacturers of bookends and bridge accessories. (KJI 1931)

MORGAN MORGANS, JR.
New York, New York
See Geo. W. Shiebler & Co.

Morgan Morgans, Jr. was the son of an affluent brass foundry and hardware company owner. In 1877 Samuel Montgomery, a salesman for Albert Coles & Co., enlisted him as a financial backer in order to purchase the machinery, tools, fixtures and stock of Albert Coles. This was done under the name of Montgomery & Co. <st11>However, by 1878 Morgan Morgans, Jr. had taken control of the firm.

Morgans, Jr. is known to have obtained at least two design patents. One was for fire fenders, presumably for the foundry business. The other, Design Patent No. 10, 436 granted February 5, 1878 was for a flatware pattern named "Cupid". Morgans continued to use Coles' mark as his mark for silver, so this pattern is sometimes mistakenly attributed to Coles.
The business was not financially successful. Morgans was forced to sell it in 1883. It was purchased by George W. Shiebler. (Soeffing, in Venable's *Silver in America*, 1994, biographical section, pp. 320-321)

EDWARD M. MORPHY
Toronto, Ontario, Canada

In business by 1847. From 1851 to 1856 the firm was known as Morphy Son & Co. In 1859 it was Morphy Bros. In 1897 it was E. Morphy. (Unitt & Worrall, *Unitt's Book of Marks*, 1995, p. 48.)

E.M.M.

H.R. MORSS & CO., INC.
North Attleboro, Massachusetts

Listed c. 1930-1940. Manufacturers of sterling silver flatware, baby goods and hollow-handled knives, salad sets, etc.

MORSS

Trade Mark

MOSSBERG WRENCH COMPANY
Attleboro, Massachusetts

They advertised (*The Manufacturing Jeweler*, October 15, 1894) as manufacturers of novelties. Illustrated was a knife sharpener of silverplate for office or table use. In the advertisement the patent date of February 23, 1892 is stamped on the knife sharpeners, indicating that they were in business at least that early. A brief notice (JC&HR 2-27-1895, p. 22) states that the Mossberg Mfg. Co., Attleboro, Massachusetts, issued a catalog.
Succeeded by Mossberg & Granville Mfg. Co.

MT. VERNON COMPANY SILVERSMITHS, INC.
Mount Vernon, New York
See Gorham Corporation

Organized in 1914 with Harry A. MacFarland as president. It was the successor of Hayes & MacFarland which began in 1903. The Mauser Mfg. Company of New York and Roger Williams Silver Company of Providence, Rhode Island were part of the merger to form the Mount Vernon Company Silversmiths in 1914.
Purchased by the Gorham Corporation in 1923.

MUECK-CARY CO., INC.
New York, New York

Manufacturers of sterling wares in the 1940s and 1950s. The trademark is now owned by Towle Silversmiths.

MUELLER KAISER PLATING CO.
St. Louis, Missouri

Founded in the fall of 1911 by Otto and Emil Mueller as the Mueller Plating Co. in response to a request by church authorities for the establishment of a facility for the expert repair, plating and maintenance of sacred metalware. The firm is one of the few remaining that specialize in the skilled restoration of Ecclesiasti-

cal Metalware and vessels for churches and synagogues.

After attending Ranken Technical institute in St. Louis, Francis X. Kaiser was apprenticed to the company's founders, Otto and Emil Mueller. From them he learned many of the Old World metal arts techniques used to restore silver and fine metalware, such as hand burnishing, silver casting, smithing and fabrication, and expert plating. Max S. Kaiser attended St. Louis University, and after his early apprenticeship, acquired extensive skills in silver restoration, polishing and highlighting, plus specialized finishing skills including oxidized, contrasting, bright, satin, and Florentine finishes, and expert plating.

After the retirement of Otto and Emil Mueller in 1947, the firm was sold to son-in-law Francis X. Kaiser and his brother Max S. Kaiser, and became known as the Mueller Kaiser Plating Co. The firm continued to specialize in the skilled restoration of fine church and religious metalware for the Roman and Eastern Catholic, Lutheran, Anglican/Episcopal, Eastern Orthodox and other Churches and Jewish Congregations.

In addition, the firm has worked to restore many historical artifacts, such as the silver snuffboxes of explorer Col. Meriweather Lewis, the sword of the Marquis De Lafayette, silver from the U.S.S. Arizona and various mementos of the 1904 World's Fair and the 1893 Columbian Exposition.

There is an exhibit of the company's work at the American Silver Museum in Meriden Connecticut.

The firm provides expert restoration of secular silverware and metalware as well.

THE PETER MUELLER-MUNK STUDIO
New York, New York

Advertised in *The Antiquarian* May 1928 that "The Best traditions of the silversmith's art are mirrored in the work produced under my personal supervision. Here are designed and manufactured candlesticks, tea and coffee sets, tea caddies, bowls, vases, trays, goblets, pitchers, boudoir sets, hand mirrors, perfume bottles, loving cups, brushes, combs and many other miscellaneous items." A teapot with ebony finial and ebony handle is illustrated under the cap-

tion "Hand Wrought Silver - individual pieces or sets designed, reproduced or made to order."

MULFORD, HALE & COTTLE
New York, New York
See S. Cottle Co.
See Hale & Mulford

MULFORD, WENDELL & CO.
Albany, New York
See Wendell Manufacturing Company

Their history can be traced to William Boyd, silversmith (b. 1775-d. 1840) who entered into partnership with Robert Shepard in 1810, under the name Shepard & Boyd (c. 1810-1830).They were succeeded by Boyd & Hoyt (c. 1830-1842); Boyd & Mulford (c. 1832-1842) and Mulford, Wendell, & Co. c. 1843.

John H. Mulford and William Wendell are listed as silversmiths, as are their predecessors.

Mulford and Wendell were also jobbers who did silverplating about 1855. They published an illustrated catalog in 1859.

MULHOLLAND BROS. INC.
Aurora, Illinois

Successor to Aurora Silver Plate Company between 1915-1922. Continued the manufacture of plated flatware and holloware until 1932 when they went out of business. D.E. Mulholland, president; W.S. Mulholland, vice president.

About 1930 it was called Mulholland Silver Co.

JOHN F. MULLER ASSOC., INC.
New York, New York

Listed JBG 1950s and 1960s as manufacturers and importers of silver goods.

DAVID MURRAY
New York, New York

David Murray appears in the New York City directories at least as early as 1852 as a silverplater.

With the exception of the years 1855 & 1856 he is present continuously through at least 1874. In 1858 the firm is listed as Murray & Co. Otherwise it is in his name alone.

His ad in the 1859 New York City Directory describes him as "David Murray, Silverplater, Locksmith, Bell Hanger, &c. 616 Sixth Avenue, above 30th st. (East Side) New York. Particular attention paid to *Plumbers and Coachmaker's Work.* Jobbing in the above business promptly attended to."

WILLIAM S. MURRAY
New York, New York

William S. Murray first appears in the New York City directories in 1856 working for Lucius Hart. (q.v.) In 1857 and 1858 he is listed as a "broker" or "broker in metals". In 1859 he lists himself as an "importer of and dealer in metals, also in silverplated, rolled & britannia goods." In 1860 the listing is "plated ware; imp. and dealer in metals".

His ad in the December 30, 1861 *New York Times* states: "Silver-Plated Goods, for the Holidays. Coffee and Tea Urns, Tea Sets, Cake Baskets, Forks, Spoons, &c. &c. A great variety of first-class goods offered at prices to suit the times, at 22 John St. W.S. Murray". In 1862 his occupation is listed as "silver"; in 1863, "metals"; in 1864, "plated ware". Not found in the silver business after 1864.

MUSIC CENTER MINT
Nashville, Tennessee

No response to inquiries. (1975)

S.F. MYERS & CO.
New York, New York

Wholesale jewelers. In business about 1860 as specialists in plating. U.S. Trade Mark Patent, February 8, 1887 for jewelry and silverware, plated silver and clocks.

MYRICK, ROLLER & HOLBROOK
Philadelphia, Pennsylvania

In business before 1890. Out of business before 1904. Trademark found on souvenir spoons.

N

D. NAGIN MFG. CORP.
East Rutherford, New Jersey

Founded July 1957 by Dan Nagin under his own name. In May 1968 the company became D. Nagin Mfg. Corp. Manufacturers of sterling articles, mostly pendants.

NAPIER-BLISS CO.
Meriden, Connecticut
See Napier Co.

Successor to E.A. Bliss Inc. in 1920. Succeeded by the Napier Company in 1922.

NAPIER COMPANY
Meriden, Connecticut

CHRONOLOGY

Carpenter & Bliss	1875-82
Carpenter & Bliss, Inc.	1882-83
E.A. Bliss	1883-90
E.A. Bliss, Inc.	1891-1920
Napier-Bliss Co.	1920-1922
The Napier Company	1922

The original company started in 1875 by E.A. Bliss and J.E. Carpenter, taking over the Whitney & Rice concern where Bliss had been employed as a traveling salesman. At the start it was called Carpenter & Bliss and in 1882 was incorporated. It became the E.A. Bliss Co. by 1883. In 1890 they were offered inducements to move their factory to Meriden, where they incorporated a year later. They were making a variety of jewelry, novelties and staple goods. By 1893 they had added sterling silver novelties.

E.A. Bliss died in 1911 and his son William became active head of the company. In 1915, James H. Napier became associated with the company, and in a reorganization he became general manager. During 1918 they devoted much of their plant to the manufacture of war material. After World War I a large part of their activity was devoted to modern jewelry and many additions to their line of sterling novelties and dresserware. In 1920 Napier was elected president and the name of the company changed to Napier-Bliss Co. Two years later, the name Napier Company was adopted.

NAPIER

BLISS

by Napier

DU BARRY

NAPIER-BLISS
(novelties)

NACO

NAPIER

Evolution

PALM BEACH

SUREFIRE

NAPIER Quality

TRIANON

N.S.C.

National STERLING

(On sterling)

S.E.B.

(On sterling and
silver plate)

Nasco

Mildred Quality
Silver Plate

National Silver Plate

Lady Berkshire

 Lord Berkshire

IMPERIAL PLATE

PERMA–BRITE

GUILDCRAFT

(On discontinued flatware
produced c. 1955)

National Silver Co.

(On silverplate)

NASSAU LIGHTER CO.
New York, New York

Listed JC in sterling silver section in 1915.
Out of business before 1922.

NATIONAL SILVER COMPANY
New York, New York

Manufacturers of sterling and plated silver-
ware. Began with Samuel E. Bernstein who was
first in business in New York in 1890. Became
the National Silver Company before 1904.

Cheltenham & Company, Ltd., Sheffield,
England, became a division of National Silver
Company before 1950; the F.B. Rogers Silver
Company was added in February 1955 and in
1956 they purchased the Ontario Manufactur-
ing Company of Muncie, Indiana.

MONARCH SILVER COMPANY and
VICEROY SILVER COMPANY are two
tradenames recorded in the Trademark Division
of the Patent Office by the National Silver Com-
pany in 1943 for use on silverplated flatware and
cutlery.

They have not made flatware since 1945.

NATIONAL SILVER DEPOSIT WARE CO., INC.
New York, New York

Listed KJI 1918-19. Listed in JC 1922-1950. Manufacturers of silver and gold encrusted glassware, desk sets, ornamental serving trays and silverplated holloware.

GEORGE NAUNDORF
Brooklyn, New York
See Paul Ernest

George Naundorf first appears in the Brooklyn City Directories in 1867 in partnership with Paul Ernest in the firm of P. Ernest & G. Naundorf, Britannia and Silverplaters. By 1868 the partnership had apparently dissolved, as Naundorf is listed independently as a silverplater. 1869 is the last listing in which he appears.

NEIDERER & MOORE
Baltimore, Maryland

Listed in Baltimore City Directory in 1885 as silversmiths.

T.E. NEILL CO.
Brooklyn, New York

TENCO

NESSLER & CO.
New York, New York

The firm of Nessler & Redway, the original partnership from which Nessler & Co. reportedly grew, first appears in the New York City directories in 1869 listed as jewelers. By 1872 the firm was known as Nessler, Redway & Co. This early business may have experienced problems, as there is no business listing for it in 1873, and neither Charles Nessler nor Thomas H. Redway are found in the directory for 1874. The firm has not been followed further in the directories.

A 1919 account states:"Nessler & Company was founded in 1869 as Nessler & Redway. It was J.S. & C.L. Nessler in the 70's and Nessler & Bioren later. Still later it was Nessler & Co. It continued until c. 1907 and consisted of father and son. C.L. Nessler died in 1907 and the business was left to his son, Charles F., who continued under the same name. It was incorporated in 1912."(JC-W 2-5-1919)

NEVIUS COMPANY
New York, New York

Registered a trademark, No. 48,036, December 5, 1905 for table utensils made of sterling silver. The application was filed by Benjamin C. Nevius, treasurer, who stated that the trademark had been used continuously by them since 1897.

Out of business before 1915.

NEW AMSTERDAM SILVER CO.
New York, New York
See Knickerbocker Silver Co.

NEW ENGLAND SILVER CO.
Deering, Maine

Founded in 1894 by Joseph S. Dunham, son of Rufus Dunham. Joseph had formerly been associated with Stevens, Smart & Dunham.

NEW ENGLAND SILVER CO.
QUADRUPLE PLATE.

NEW ENGLAND SILVER PLATE CO.
New Haven, Connecticut
See Adelphi Silver Plate Co.
See American Silver Co.
See Bristol Brass & Clock Co.

Advertised in *St. Nicholas Magazine*-March 1878 that they furnish "first-class articles at a very low price. A set of six SOLID Silver Tea Spoons for $3.50" or "For 85 cents ... one set of 6 quadruple tea spoons in case. Fine and heavily plated with pure nickel and coin silver, on a new metal, called Alfenide, which is very similar to the finest English white steel. It contains no *brass* or *German silver* in its composition, and consequently *no poison,* or disagreeable taste." The ad was copyrighted in 1877.

NEW ENGLAND SILVER PLATE CO.
Bridgeport, Connecticut

An 1895 account states: "The New England Silver Plate Co., Conn. has just been organized. The works will be in West End, Bridgeport. Stockholders are S.C. Osborne, Bridgeport; James Dowdle and D.J. Toothill, Orange, New Jersey."(JC&HR 9-18-1895, p. 26). Not the same New England Silver Plate Co. that was in New Haven, Connecticut.

NEW ENGLAND SILVERSMITHS
New York, New York

Makers of sterling silver goods c. 1950.

NEW HAVEN SILVER PLATE CO.
Lyons, New York

The New Haven Silver Plate Company was established at Lyons, New York in September 1891. The business was purchased by the Manhattan Silver Plate Company of that city in November of that same year. They were successors in 1893 to A.H. Towar & Co. silverplaters in Lyons.

The Manhattan Silver Plate Company, the New Haven Silver Plate Company and A.H. Towar & Co. continued manufacturing operations after being taken over by the International Silver Company.

NEW JERSEY SILVERWARE CO.
Minneapolis, Minnesota

A piece of letterhead for this company has been found bearing the date of July 30, 1894.

NEW ORLEANS SILVERSMITHS
New Orleans, Louisiana

Manufacturers of sterling and silverplate reproductions. Founded in 1938 by Karl Dingeldein, native of Hanau, Germany, whose family had been silversmiths since 1720. Mr. Dingeldein died about 1966 and the business was purchased by another young German silversmith, Hans Leutkemeier, originally from Darmstadt. Mr. Leutkemeier began his apprenticeship in Germany in 1952, serving three and a half years as an apprentice. This was followed by five years working as a jeweler before obtaining full recognition as a goldsmith and silversmith.

(On sterling) (On silverplate)

NEW YORK SILVER DEPOSIT CO.
Jersey City, New Jersey

Began as New York Silver Deposit Co., founding date unknown. Succeeded by Imperial Art Ware before 1915 and out of business before 1922.

NEW YORK SILVER PLATE CO.
New York, New York
See E. Magnus

An 1897 account states: "The New York Silver Plate Co., manufacturers of silverplated ware made an assignment. Emil Magnus is president and Stephen C. Duval secretary. The company was incorporated Sept. 1896 and succeeded to the business carried on at 20 Warren St. by Mr. Magnus who made an assignment July 6, 1896." (JC&HR 8-18-1897, p. 9-10)

NEW YORK STAMPING CO.
Brooklyn, New York

Listed in JC in 1915-1922 in plated silver section.

(Housefurnishing Goods.)

NEWBURYPORT SILVER CO.
Keene, New Hampshire

Manufacturers of sterling silver, flat and holloware. Listed in the City Directory of Keene, New Hampshire 1905-1914.

The firm was organized in 1904 with John Currier president: George E. Stickney, treasurer; Caleb Stickney and Herbert N. Woodwell managers. Caleb Stickney was once associated with the Towle Silver Company in Newburyport , Massachusetts and was in charge of the machinery of the new company, while Mr. Woodwell did the designing and directed the finances. Woodwell had also been with the Towle Silver Co. as an engraver in charge of the engraving room - at one time a most important function. John Currier was a prosperous manufacturer of automobile bodies in Amesbury, an it is believed that he provided financial backing but took no active part in the management.

The firm was unable to obtain loans from the Newburyport banks and moved to Keene, New Hampshire early in 1905. Woodwell died March 1907 and Stickney and his son assumed full charge. Poor management led the firm into bankruptcy in 1914. The silver stock was bought by Rogers, Lunt and Bowlen.

nSco
(Sterling Silver Ware.)

N. S. C.

(On plated silver)

WILLIAM F. NEWHALL
Lynn, Massachusetts

First established as a jewelry business by Stephen Cyrus Newhall in 1872. William Frederick Newhall entered the employ of his brother at that time, and in 1885, after the death of Stephen, William succeeded to the business. In 1907 he took into partnership his eldest son, Fred Clinton Newhall. The company became W. F. Newhall and Sons Inc. before 1922.

Stephen is listed in the Lynn city directories as a clock repairer,watchmaker and jeweler. William is listed as a clerk, jeweler and optician. Newhalls' did special order work, enamelling, engraving, die sinking and gold and silverplating.

The 1896-1922 editions of JC carry a trademark (No. 19,751, June 23,1891 for flat and table ware) that is the handle of a spoon with an old woman and a cat. Newhalls sold many souvenir spoons. Some, at least, carry the Durgin Co. trademark.

There is no record of the shop after 1957.

WILLIAM HERMAN NEWMAN
Halifax, Nova Scotia, Canada

William Herman Newman was born in 1826. By 1863 he had established a shop on Granville St. in Halifax. Newman was a jeweller and a watch and clockmaker as well as a silversmith. He was particularly known for his fine jewelry and Masonic Jewels. After he died in 1894, his son continued the business until 1905. (Unitt & Worrall, *Unitt's Book of Marks*, 1995, p. 21)

E. NEWTON & CO.
New York,New York

Listed in JC 1896-1904 in the sterling silver section. Out of business before 1915.

STERLING N

NIAGARA FALLS CO.
See Oneida Silversmiths

NIAGARA SILVER CO.
New York, New York
See Oneida Silversmiths
See Wm. A. Rogers, Ltd.

An 1899 account states:"The Niagara Silver Company has been incorporated to manufacture and sell silver and silver plated ware." (JW 10-11-1899, p. 25)

In 1900: "The flatware department of the Pairpoint Mfg. Company has been purchased by the Niagara Silver Company." (JC-W 7-4-1900, p. 8)

Wm. A. Jameson was manager of the company.

R. S. MFG. CO.
COIN SILVER METAL
EXTRA COIN SILVER PLATE
EXTRA COIN SILVER No. 12 PLATE

NICHOLS BROS.
Greenfield, Massachusetts

Listed in 1896 Jewelers' Weekly as manufacturers of plated silverware.

NICHOLS BROS.
Greenfield, Mass.
12 dwt.

THE NICKEL SILVER FLATWARE CO.
Unionville, Connecticut

An 1894 account states: The Nickel Silver Flatware Co. is in production, putting out, so they claim, not alone unplated, but silverplated and sterling silver." (JC&HR 6-6-1894)

NIEDERKORN
Philadelphia, Pennsylvania

Manufacturer of solid sterling silver Christmas ornaments and novelties since 1993. 1996 marks the fourth year for their series of star Christmas ornaments, and the second year for their series of ornaments in the form of Native American Houses. The firm is planning to introduce hand wrought flatware shortly, both custom designed and in standard patterns. The President of the company is Gary Niederkorn. The firm's designer is Kurt Hiller. The company has offered antique silver for sale since 1982.

ISAAC D. NOE
New York, New York

Isaac D. Noe first appears in the New York city directories published in 1870 and 1871 with his occupation listed as "mouldings". In 1872 he was a simple clerk, and did not appear at all in the directories in 1873.

By 1874 he was operating a silverplating business in New York. By 1876 the business had moved to Brooklyn. Not followed beyond 1876.

GEBRUEDER NOELLE
Luedenschied, Germany

Registered trademark U.S. Patent Office, No. 11,800, December 16, 1884 for knives, forks and spoons. Also, No. 50,984, April 3, 1906 for knives, forks and spoons of britannia.

Listed in JC 1896-1922 in the plated silver section. No record after 1922.

(Knives, Forks, Spoons.)

CORNELIUS NOONAN & CO.
New York, New York

Listed as "platers" in the New York City directory in 1874. The Brooklyn city directory describes Cornelius Noonan as an "electroplater" in business in New York city in 1875. No business listing in the Brooklyn directory for 1876. Not followed further.

NORBERT MFG. CO.
New York, New York

Manufacturers of sterling goods since c. 1950. No longer listed by 1974.

PETER NORDBECK
Halifax, Nova Scotia, Canada

Peter Nordbeck was born in Germany in 1789, and received his training as a gilder, jeweler and silversmith there. He travelled to the West Indies in 1815. By 1819 he had arrived in Halifax. He entered into a partnership with Henry Mignowitz and a Mr. Clark that lasted until 1827. That year he established Nordbeck & Co. Michael Septimus Brown (q. v.) apprenticed with him. He died in 1861. (Unitt & Worrall, *Unitt's Book of Marks*, 1995, p. 21)

P. ADOLPHE NORMANDEAU
New York, New York

P. Adolphe Normandeau listed himself as an "Electro Gold and Silver Plater, Fire Gilder and Nickel Plater" as well as the "Sole Agent of New York Nickel Plating Co." on a series of billheads dating from 1875 through 1888.

These billheads also indicate that he provided, "A constant supply, to order, of the different patterns of Silver Plated and German Silver Spoons, Forks, Butter Knives, Soup Ladles, Fish knives, Casters, Tea Sets, &c."

NORTHAMPTON CUTLERY CO.
Northampton, Massachusetts

In 1889 this firm advertised solid steel knives and forks bearing the trade mark "American Silver Plate Co." shown in *Silver* Nov.-Dec.1991 p. 38)

NORTHAMPTON CUTLERY CO.
Chicago, Illinois

Listed KJI 1918-19 as manufacturers of plated flatware.

NORTHERN STAMPING & MFG. CO.
Seattle, Washington
See E.J. Towle Mfg. Co.

NORTON & SEYMOUR
Syracuse, New York
See Joseph Seymour & Co.

Partnership of Benjamin R. Norton & Joseph Seymour between 1849-1854. In 1854 David Hotchkiss joined the partnership, and it became Norton, Seymour & Co., which it remained until 1857. Manufacturer of solid silver wares. Succeeded by Joseph Seymour & Co.

NORWEGIAN SILVER CORP.
New York, New York
See David Andersen
See Th. Marthinsen Solvvarefabrikk

The Norwegian Silver Corporation is the U.S. distributor of sterling and silverplated holloware, flatware and jewelry made by Th. Marthinsen Solvvarefabrikk a/s, Tonsberg, Norway, established in 1883 and by David Andersen a/s, Oslo, Norway, established in 1876. Both are third generation silversmithing firms.

NORTHWEST SILVER WARE MANU-FACTURING COMPANY
Chicago, Illinois

Founded shortly after the Civil War. Burned in the Chicago fire of 1871 and not rebuilt. Manufacturers of silverplated wares.

NORWICH CUTLERY COMPANY
Norwich, Connecticut
See International Silver Company

Organized and wholly owned by William H. Watrous of Rogers Cutlery Company, Hartford, Connecticut.

Made cutlery for plating from 1889. Did not use a trademark because they sold their products to other silver manufacturers.

One of the original companies to become part of the International Silver Company in 1898.

WILLIAM NOST CO., INC.
New York, New York

William Nost was a silversmith in New York before 1915. Succeeded by William Nost Company, Inc. before 1922. They made sterling silver holloware.

NOVELTY PLATING WORKS
Baltimore, Maryland

Listed in the Baltimore City Directories 1890-1915 as successors to Schrier & Protze who began silverplating in 1888.

Anton Protze listed as proprietor 1893-1898. Louis Liepman, proprietor 1899- 1915.

NOYES BROTHERS
New York, New York

Wholesalers of silverware and novelties. Begun in New York in 1892 by Pierrepont and Holton Noyes, sons of John Humphrey Noyes, founder of the Oneida Community.

This partnership was dissolved after about two years with Holton going into the restaurant business and Pierrepont Noyes returning to Niagara Falls to develop the Oneida Community silver company.

BENJ. D. NUITZ
Baltimore, Maryland

Listed in 1893 Baltimore City Directory under plated silverware.

NUSSBAUM & HUNOLD
Providence, Rhode Island
See Walter Hunold

N &H

NUSSHOLD

STUART NYE
Asheville, North Carolina

Stuart Nye was born in 1884 in East Orange, New Jersey. After World War I he moved from his home in Brooklyn, New York to Asheville, North Carolina, to enter the Oteen Veteran's Hospital for treatment of a lung disorder. One story is that his problem was the result of a wartime gas attack, however his daughter states that his problem was actually tuberculosis. While at the hospital he met his wife-to-be, Ruth, and learned the skill of woodcarving.

After his discharge from the hospital, he worked at the Asheville Recreation Park, managing a popcorn stand. About 1931 he began selling sterling silver bangle bracelets. These he made using a set of second hand tools he had purchased from another former patient.

Although he apparently had no formal training, Nye had a natural aptitude for the silver jewelry business. In 1933 he gave up the popcorn stand, and opened up a shop in the garage of his home. Over the years the one car structure expanded to three levels.

His first floral design was the dogwood blossom, North Carolina's State Flower. Other nature motifs included the pine cone, representing the state tree, and a variety of other flower and tree related decorations. His products included ladies rings, necklaces, bracelets and earrings plus men's cuff links, tie tacks and tie bars. He also produced a limited variety of other small items such as napkin rings.

In 1937 he hired his first employee, Edgar S. ("Si") Holland, who later became his foreman. Subsequently he hired only untrained craftswomen, training them to produce pieces "the Nye way". Everything the firm made had to look both hand made and natural.

During World War II the business flourished, and he expanded production to include items of gold, copper and brass. However, gold pieces are no longer made.

In 1947 he went into partnership with Ralph D. and Annie Jo Morris, and then retired in 1948. He died in 1962.

The Morris family has continued to operate the shop since then, Ralph D. Morris, Jr. serving as the current manager. (Miller, *Silver*, Mar.-Apr. 1996, pp. 40-42) In 1981, Ralph D. Morris, Jr. began experimenting with Christmas ornaments as a new line. A cartoonist friend, Bill Harrison, developed the first ten designs. Eight additional designs have since been added. Initially produced in brass, the ornaments were subsequently made in silver. Examples of the company's ornaments have appeared on trees for

President Regan's "Pageant of Peace" and on the governor's Christmas tree in Raleigh. (Miller, *Silver*, July-Aug. 1996, pp. 40-41)

O

OLD NEW ENGLAND CRAFTSMEN, INC.
Newburyport, Massachusetts

Makers of Colonial handwrought solid silver and reproductions. Listed in 1931 KJI. Out of business for many years.

PILLSBURY

PORTSMOUTH
(Reproductions)

OLD NEWBURY CRAFTERS
Newburyport, Massachusetts
Amesbury, Massachusetts

The largest producer of handwrought silver in the United States, the company began with the partnership in 1915 of Elmer Senior, a spoon maker, and Albert S. MacBurnie, a polisher. Senior had at one time worked with the Frank Smith Silver Company (q.v.) in Gardner, Massachusetts. For four or five years he worked with George Blanchard making handwrought spoons. Apparently it was from him that he learned silversmithing.

Albert MacBurnie was born in Hantsport, Nova Scotia. From 1895 to 1909 he worked with the Frank Smith company as a polisher. In 1909 he moved to Newburyport and worked with Towle Silversmiths (q.v.) for about 10 years while on evenings and weekends he did finishing of handwrought pieces made by Senior. After four years of part-time work he left Towle and worked full time with Old Newbury Crafters. He remained with them until his death in 1944. Control of the corporation passed to his son, Everett, who, in 1950, sold out to his cousin, Reynold Senior, who operated the business until 1955.

Following the death of Elmer Senior on November 8, 1932, the business was incorporated as "The Old Newbury Crafters."

In September 1955 Reynold Senior sold 100 percent interest to Swift C. Barnes, who had been associated with Towle Silversmiths. Senior remained as Master Silversmith and shop foreman until 1959, when he was succeeded by Chester A. Dow who continued in charge of the shop until his death in 1978.

In 1979 all manufacturing assets and the name "Old Newbury Crafters" were purchased by a newly formed corporation. The business was relocated to nearby Amesbury, Massachusetts. In 1983, Donald J. Brady of Greensboro, North Carolina acquired the company by buying out the other investors. He remains the sole owner of Old Newberry Crafters. (1986)

From 1915 to 1932 the company made handmade holloware and tea ware as well as flatware. The first two patterns they made were *Moulton* and *Old Newbury*. Distribution of their products was largely through arts and crafts societies in major cities, and a few fine jewelry stores.

In 1955 they made seven handwrought flatware designs, all reproductions except *Moderne*. These were *Moulton, Old Newbury, Windsor, Fiddleback, Panel Antique* and *Old English*. In 1978 they began making *Buckingham, Antique* and *Old English* designs for Shreve & Co. (q.v.), San Francisco which had previously been made in Shreve's own factory.

In 1956, after 25 years in which the company had made only flatware, it resumed making sterling silver holloware. This activity was augmented by the acquisition of Worden-Munnis Co. (q.v.) founded in Boston in 1940, and whose operations were merged with Old Newbury Crafters.

Only sterling silver was used until 1974 when a small pewter holloware division was started, and they also began making sterling silver jewelry and karat gold jewelry.

The mark "HANDWROUGHT" was not stamped on Old Newbury silver before the end of 1955. Since October 1956 all work has been identified by this mark.

The Newbury Eagle, used extensively in their advertising, has never been used on the silver.

The company's *Wilton* pattern has been the official service in Blair House in Washington, D.C., the U.S. State Department's official residence for visiting heads of state and other high-ranking officials.

In 1965 the company started a practice then unique in the American silver industry. Since that time, every handwrought piece has been marked personally by the craftsman who made it. All

handwrought pieces made since 1965 bear the maker's signature mark as well as the company marks,"O.N.C. HANDWROUGHT", and "STERLING." Work made specifically for certain stores including Cartier, Neiman-Marcus, Shreve & Co., Shreve, Crump & Low and Spaulding & Co. also bears their name.

Personal Signature Marks of the
 Newbury Crafters

Fletcher S. Carter	▲	Robert H. Bean	🏰
Chester A. Dow	⟨⟩	Chester A. Dow	⟨⟩
James F. Harvey	🦅	James F. Harvey	🦅
Robert H. Lapham	✢	Robert H. Lapham	✦
Gayden F. Marshall	⌒	Gayden F. Marshall	⚱
Daniel S. Morrill	⌒	Daniel S. Morrill	⌒
Roger R. Rowell	⚷	Roger R. Rowell	⚷
Reynolds F. Senior	⬥	Reynolds F. Senior	⬥
George R. Woundy	⚙	George R. Woundy	⚙
In use as of June, 1965		**In use as of May, 1974**	

RICHARD KESTELL OLIVER
Toronto, Ontario, Canada

Silversmith working in Toronto between 1843 and 1860. (Unitt & Worrall, *Unitt's Book of Marks*, 1995, p. 48)

OLIVER MFG. CO.
Los Angeles, California

Manufacturers of sterling novelties c. 1950.

YNGVE OLLSON
Park Ridge, Illinois

Born in Copenhagen in 1898, Yngve Ollson apprenticed there as a silversmith before emigrating to the United States in 1917. After serving in the United States Army, he joined The Kalo Shop (q.v.) in 1919. At Kalo his career included work as a silversmith, designer, engraver, chaser and enameller. Examples of his work may be found in the collection of the Art Institute of Chicago and elsewhere. Ollson died in Chicago in 1970.

NICHOLAS ONDERDONK
New York, New York

Nicholas Onderdonk and his brother Daniel are both listed as silversmiths in the 1850 census.

Nicholas Onderdonk appears in the New York City directories at least as early as 1852 listed as a silversmith, but not with his own shop. For most of the time prior to 1867, there is no information as to who he was working for. However, in 1859 and 1860 he is shown working for William Gale (q.v.) while that firm was known as Gale & Willis. It is possible that he may have worked for William Gale throughout the entire period.

Nicholas Onderdonk was working at 125 Macdougal in 1867, whether in his own shop, or as an employee of Francis W. Cooper (q.v.) at the same address is currently unclear. In 1871 he was joined at that location by Daniel Onderdonk, his brother. Daniel is listed as a smith in 1871, but for the following two years his business is given as "shoes", although he continues at the same business address. In 1874 Daniel's business is listed as "silver" and Nicholas' as "smith". Not followed beyond 1874.

Possibly related to the firm of N. & D. Onderdonk (q.v.)

N. & D. ONDERDONK
New York, New York

N. & D. Onderdonk were silversmiths working in New York c. 1900. They are listed in JC in the sterling silver section. Out of business before 1904.

N. & D. O.

ONEIDA SILVERSMITHS
Sherrill, New York

John Humphrey Noyes and a little association of men first began their experiment in communal living at Oneida Creek about 1848.

Their first products were canned fruits and vegetables which found a ready market. Later their chief support came from the manufacture of steel traps.

In 1877 the Oneida Community embarked on the manufacture of tableware, and in 1880 incorporated in New York under the name Oneida Community Limited. The Wallingford branch made ungraded, tinned, iron spoons in two patterns called "Lily" and "Oval." These two iron spoons were the direct ancestors of the Community Plate line.

By 1878 the mill was turning out steel spoon blanks sold for plating to the Meriden Britannia Company. In 1880 the factory was moved to Niagara Falls.

M.H. Kinsley obtained the first flatware Design Patents, Nos. 12,307 and 12,308 assigned to the company in 1881.

Their first silverware could not compete with higher quality silver made by other companies. A decision was made to turn out a better quality and better designed line. Their new design called "Avalon" was exhibited in 1901 at the Buffalo Exposition.

In January 1902 the new line of Community Plate was introduced, but was not immediately successful. A complete change in advertising methods in high-priced, large-circulation magazines proved enormously effective. It was the first "pretty girl" advertising in America and it not only affected the sales of their silver, it also had a profound effect on the whole advertising business. Between 1912-1914 the silverware plant was moved from Niagara Falls to Sherrill, New York.

In 1926 they opened a plant, the Kenwood Silver Company, in Sheffield, England and in 1929 bought Wm. A Rogers, Ltd. Besides the main Wm. A. Rogers, Ltd. plant, they acquired four other factories and their brands; 1881 Rogers; Simeon L. & George H. Rogers Company and Heirloom.

On March 1, 1935, the company name was changed to Oneida, Ltd., and it is now commonly known as Oneida Silversmiths. At present the company manufactures silverplate and sterling at its plants in Sherill and Oneida, New York, and Niagara Falls, Canada.

Oneida began producing silverplated holloware in 1926, while production of sterling flatware began in 1946.

In 1965 the firm adopted as its symbol of excellence the Roman cube "tessera hospitalis," which was placed in the hands of a visitor as a pledge of hospitality and friendship. Oneida's tessera is a cube of solid silver, engraved with the company name on all planes. While this symbol is now no longer in use as part of the company logo, a simplified version is still used on some backstamps.

J. Rogers & Co.

A.1. NICKEL SILVER No. 210

CARBON

N. F. SILVER CO., 1877

SILVER METAL

210 NEARSILVER

U. S. SILVER CO.

ALPHA PLATE

COMMUNITY

COMMUNITY PLATE

DURO PLATE

N. F. NICKEL SILVER

NIAGARA FALLS CO., 1877

O. C.

O. C. LUSTRA

ONEIDA

ONEIDA COMMUNITY DIAMOND PLATE

ONEIDA COMMUNITY PAR PLATE

ONEIDA COMMUNITY RELIANCE PLATE

ONEIDA COMMUNITY SILVER PLATE

PURITAN SILVER CO.

REX PLATE

REX PLATE

RELIANCE

RELIANCE PLATE

TRIPLE PLUS

TUDOR PLATE

ONEIDACRAFT

𝕳eirloom 𝓟late
From Generation to Generation
(Used since Dec. 31, 1925)

237

ONEIDA STERLING
See Oneida Silversmiths

Production of sterling flatware was begun in 1946.

Oneida Sterling

In 1981 the following Webster Wilcox holloware pattern trademarks were purchased from International Silver Company:

WILCOX & DESIGN

CRAFTMETAL

E G W & S & DESIGN

FORBES & SHIELD & DESIGN

FEATHER-CROWN-LIO N & DESIGN

WELLINGTON

STRAFFORDSHIRE

WEBSTER WILCOX

CHIPPENDALE

ROCOCO

JO ANNE

WEBSTER WILCOX, CHIPPENDALE, ROCOCO and JO ANNE are presently (1986) in use by Oneida on holloware. In addition, they licensed certain trademarks and of those licensed trademarks, COUNTESS is presently being used on holloware.

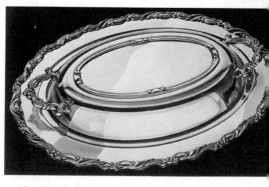

"Sea Crest" double vegetable dish in silverplate by Oneida Silversmiths. (Photo courtesy of Oneida Silversmiths)

ONODAGO SILVER MFG. CO.
Syracuse, New York

An 1896 article states:"The Onodago Silver Mfg. Co. of Syracuse have incorporated. Directors are E.P. Goodrich and C.C. Goodrich of Syracuse, George W. Hills and Frederick W. Chamberlain of Lyons, Elliott M. Tuttle of Munnsville, and S.C. Waterman of Oneida ." (JC&HR 4-15-1896, p. 17)

ONTARIO MFG. CO.
Muncie, Indiana
See National Silver Company

Founded 1897. Succeeded by National Silver Company in 1956. Manufactured plated silverware.

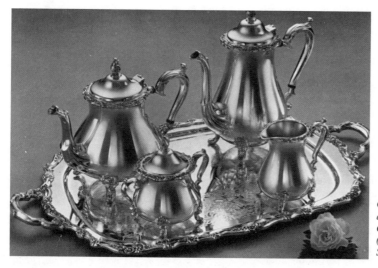

Countess" 5-piece tea and coffee service, Oneida Silversmiths. (Photo courtesy of Oneida Silversmiths)

HARVEY OSBORN SILVER CO.
Newark, New Jersey

Listed KJI 1918-19 as manufacturers of German silver brushes and mirrors and silver novelties.

OSBORN & CO.
Lancaster, Pennsylvania

Mark found on a small silverplate basket dating circa 1880s. This firm may well be related to the Osborn Company below.

OSBORN COMPANY
Lancaster, Pennsylvania

Manufacturer of silverplated holloware about 1897.

FRANK N. OSBORNE
New York, New York

Listed in JC 1904-1915. May have been wholesale jeweler or distributor.

Also used other trademarks on jewelry sold at the Chicago Columbian Exposition, 1892-1893 .

No record after 1915.

XIX CENTURY
HEIRLOOM

No. 23,729 October 24, 1893
For jewelry, spoons, forks, ladles, cutlery, etc.

HEIRLOOM

No. 23,730 October 24, 1893

CLEMENS OSCAMP
Cincinatti, Ohio
See F.A. Bunnelle

Clemens Oskamp was born in Germany, and came to Cincinatti, Ohio in 1852 to join his brother Theodore in the jewelry business. When Theodore died two years later, he became the sole owner. (Soeffing, *Silver* Nov.-Dec. 1991, p.16)

About 1874 he purchased the solid silver flatware manufacturing business of Francis A. Bunnelle (q.v.) of Syracuse, New York.

Bunnelle moved to Cincinatti temporarily, apparently to help set up the business at its new location. He is shown in the Cincinatti City Directory for 1875.

Oscamp's firm continued to produce many of the flatware patterns that had formerly been manufactured by Bunnelle. (Ives, *Silver*, Nov.-Dec. 1991, pp. 14-15)

Marks shown are from Ives (ibid.)

 C. O.

C. OSKAMP

OVIATT & WARNER
Portland, Oregon

Listed in the Portland City Directory for 1894 and 1895 only. Listed under sterling silver section of the 1896 edition of the JC as out of business in 1896. No information in the Portland newspaper index.

O. & W.

OXFORD HALL SILVERSMITHS, LTD.
New Cassel, L.I. New York

Mentioned in JC-K 1974.

OXFORD SILVER PLATE CO.
See William A. Rogers, Ltd.

239

OXFORD SILVERSMITHS CO.
New York, New York

Listed 1918-19 KJI and JC-K 1950 as manufacturers of silverplated wares.

P

PACIFIC PLATE WORKS
San Francisco, California

Working c. 1869-1873. Their plater was William Shepman who, sometime after 1874, moved to Oakland and set up his own business which he called "Pacific Gold and Silver Plate Works." Products were marked "Pacific Plate Works, S.F." or "Haynes & Lawton" (q.v.).

AMOS PAGE
Amherst, Nova Scotia, Canada

Son of David Page (q.v.) born in Truro, Nova Scotia in 1803. Three of his brothers, David, John and Thomas, were also silversmiths. He had his own shop for most of his working life, although he and his brother Thomas were in partnership briefly. Amos Page died in 1895. (Unitt & Worrall, *Unitt's Book of Marks*, 1995, p. 11)

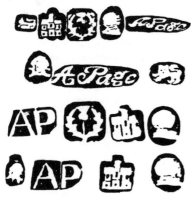

DAVID PAGE
Truro, Nova Scotia, Canada

David Page was born in 1770. Originally from Haverhill, Massachusetts, he came to Nova Scotia in 1793 and eventually settled in Truro. Four of his sons, Amos, David Jr., John and Thomas were trained as watchmakers and silversmiths. A fifth son, Benjamin, became a doctor. David Page Sr. died in 1840. (Unitt & Worrall, *Unitt's Book of Marks*, 1995, pp. 11, 26)

PAGE BROS.
Saint John, New Brunswick, Canada

Richard and Clement Page, sons of Amos Page of Amherst, Nova Scotia, (q.v.) were in business as Page Bros. from 1850 to 1870. In 1870 Clement Page retired. Richard Page's son, Henry, Richard's brother-in-law named Ferguson, and another silversmith named Smalley, formed the firm of Page, Smalley & Ferguson, which lasted to 1880. Ferguson retired, and the firm became known as Ferguson & Page. (sic.) (Unitt & Worrall, *Unitt's Book of Marks*, 1995, p. 10)

THE PAIRPOINT CORPORATION
New Bedford, Massachusetts

Organized in 1880 as the Pairpoint Mfg. Co., with Edward D. Mandel as president. Thomas J. Pairpoint, for whom the company was named, had most recently been with the Meriden Britannia Company.

Pairpoint served his apprenticeship in Paris and later worked for the prominent firm of Lambert & Rawlings in London. He was chief designer for the Gorham Manufacturing Company from about 1868 until the late 1870s. During this time he designed many pieces of the Gorham Company's regular line as well as special exhibition pieces.

While employed by the Gorham Company, Pairpoint was one of the six artists who submitted designs for the William Cullen Bryant testimonial vase, presented to the poet June 20, 1876. While he lost the competition to James H. Whitehouse, head designer of Tiffany & Company, his design received favorable press coverage. It was described (*Art Journal,* 1876) as "a poetical work of Grecian character, gracefully elongated to monumental proportions."

Pairpoint was one of the outstanding proponents of the Renaissance Revival. This was clearly illustrated in "The Century Vase" he and George Wilkinson designed for the Gorham Company and which was exhibited at the Philadelphia Centennial Exposition in 1876.

Pairpoint was among the first in this country to visualize silver as an art medium. Repoussé figures on his work were often drawn from mythology and other literature. No doubt the literary character of his work may be ascribed to his association with Morel Ladeuil from whom he gained an interest in Renaissance design.

In 1877 Pairpoint left the Gorham Company to become designer and modeler for the Meriden Britannia Company, Meriden, Connecticut. Shortly before leaving the latter, about August 1879, he prepared a series of articles, "Art Work & Silver," (*Jewelers' Circular,* September 1879 through March 1880) in which he discussed silver as an art medium. The esteem in which he was held by that publication is reflected in the editorial comment where Pairpoint is spoken of as "one of the most skillful and artistic designers of the present day, having a reputation that is world wide."

This reputation served the newly formed Pairpoint Mfg. Co. well as it soon commanded favorable attention for the design of its products. In 1882 the *Jewelers' Circular* commented editorially. "The Pairpoint Mfg. Co. is introducing new and more artistic designs by T. J. Pairpoint, a gentleman of rare ability in classical subjects."

On April 1, 1885, Pairpoint severed his connections with the company bearing his name and announced his intention of going into "manufacturing on his own account." There seems to be no record that he really did start a new business. The listing of his name in the Providence, Rhode Island City Directory which had run from 1870 through 1877 and then dropped, reappeared in 1887. The reason for leaving the company is not known. Old-timers there remembered him well but did not know the reason for his leaving.

Pairpoint's obituary (*Providence Journal,* August 30, 1902, p. 3) says that his death came with slight warning. It went on to say that "... for several years past Mr. Pairpoint had been in poor health, but not of a nature to cause great anxiety. (He is said to have been diabetic.) Mr. Pairpoint was well known locally as an expert silversmith and designer, although he had not been actively engaged in business during recent years."

Although T. J. Pairpoint left the company, the tradition of fine design he had established was maintained by the firm. They became one of the country's largest manufacturers of plated silverware and carried on an extensive export trade, especially with Australia.

In 1894 the Mount Washington Glass Company became part of the Pairpoint organization. This event and their expanded production was noted in the various trade journals.

"The Pairpoint Mfg. Co., owners of the justly celebrated Mt. Washington Glass Co., New Bedford, Mass., contemplate moving their New York business, May 1, from the old stand, 46 Murray St., to Maiden Lane. The new lines of silver plated hollow and glassware and novelties, fine decorated china and glass of this company and their aggregation of rich cut glass tableware, all at popular prices and styles distinctly original, are well calculated to keep this establishment in the front ranks of manufacturers of art wares. An important feature of this establishment is the manufacture from start to finish of special lines of rich cut glass for sterling silver mountings, and manufacturers of sterling silver can avail themselves of the prestige of this company's position to supply designs suited to their requirements and made to the patron's individual suggestions." (JC&HR 3-17-1897, p. 21)

In 1900 financial difficulties of both companies led to their merging to form the Pairpoint Corporation. The combined operations of silverplated wares and glass manufacturing continued successfully until the Depression in 1929, when the company suffered reverses from which it never recovered. Only the glass working part continued under various firm names. Finally, all operations ceased in 1958. The flatware department was purchased by the Niagara Silver Co. in 1900. Some of the dies and patterns were sold to the Rockford Silver Plate Co. Production of glassware resumed on a limited basis in the 1970s.

PAIRPOINT MFG CO

QUADRUPLE
PLATE

PAIRPOINT
FLAT 1880 WARE.
BEST
(Flatware.)

BRISTOL PLATE CO.

(Holloware.)

(Holloware.)

(On Sheffield reproductions)

Coffee service designed and patented by Albert Steffin, Assignor to the Pairpoint Corporation. (Design Patent No. 36,877; April 12, 1904) (Photo by Roy D. Greaves; courtesy of E.A.P. Evans)

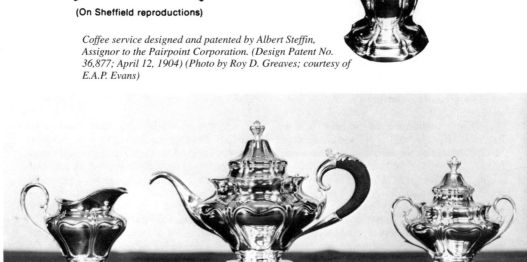

PALMER & BACHELDER
Boston, Massachusetts

In the 1860s they purchased Reed & Barton wares "in the metal" and operated their own plating establishment.

PALMER & OWEN
Cincinnati, Ohio

Listed in Cincinnati City Directories 1850-1859 as silversmiths who operated a silverware factory.

PALMER & PECKHAM
North Attleboro, Massachusetts

Listed in JC 1896. Out of business before 1904.

P & P
STERLING.

PARAGON PLATE

A private mail order company (Sears Roebuck & Co.) trademark. Used by International Silver Company c. 1910. In a spiral-bound booklet offered by Follett Studios, Moorhead, Min-

nesota, there are reprints of pages from various catalogs. On one, there is a teaspoon in the *Royal Oak* pattern "Double Triple Paragon Brand." The ad says it was manufactured by the most renowned firm of silversmiths in the country and will outwear any other brand, including any Rogers brand.

CHARLES PARKER CO.
Meriden, Connecticut

Charles Parker was involved in the silverpate flatware industry at least as early as 1870. On June 7 of that year, Bennet Jerald assigned Design Patent No. 4,096 for a spoon handle to him.

By 1880 the firm had become Charles Parker Co. Lewis F. Griswold assigned Design Patents No. 11,956 and 11,961 for spoons and forks to the company in that year.

The firm continued in business until about 1907.

PARKER & CASPER BRITANNIA CO.
See Parker & Casper Co.

PARKER & CASPER CO.
Meriden, Connecticut
See International Silver Co.
See Wilcox Silver Plate Co.

Organized by Charles Casper, John E. Parker, Edmund Parker, Philip S. Pelton and Samuel L. Dodd, Jr. Incorporated St. Louis, Mo., August 6, 1866 with Samuel Dodd, president, under the name Parker & Casper Britannia Co. In May 1867 it became Parker & Casper Co.

They were specialists in silverplated holloware.

The business was sold in 1869 to the Wilcox Silver Plate Co. which became part of International Silver Co. in 1898.

PARKER & WHIPPLE CO.
Meriden, Connecticut

"Parker & Whipple of Meriden has begun the large addition to its factory." (JW 6 July, Vol 14, no. 15, p. 12)

G.W. PARKS COMPANY
Providence, Rhode Island

Successors to Hayden Mfg. Co. before 1909. Listed in JC in 1909-1915 as manufacturers of sterling and plated silver. Out of business before 192?

(On sterling silver)

HOPE SILVER CO.
(On plated silver)

PARKS BROS. & ROGERS
Providence, Rhode Island
New York, New York

Established in 1892 by Geo. W. Parks, Wm. C. Parks and Everett I. Rogers who bought out the American Lever cuff and collar button portion of Howard & Son, the latter devoting all their interests to the silver business. Listed until c. 1930 as manufacturers of 10k, 14k gold and

goldfilled cuff buttons, collar buttons, cuff links, dress sets, collar pins and grips, bobbettes, scarf pins, lingerie and tie clasps.

PASHLEY & DAVIES
New York, New York

CHRONOLOGY
Pashley & Richmond 1870-1871
Pashley & Davies 1872-1874+?

The firm first appeared as Pashley & Richmond, composed of George Pashley and Joseph Richmond, in the New York City directories in 1870. They advertised themselves as "Manufacturers of Silverware and Fine Nickel Plated Goods, ... Tea Services, Castors, Candlesticks, Salvers, Communion Services, Spoons, Forks, and Harness Furniture repaired and re-plated. General engraving and Gilding."

By 1872 Richmond had left the firm. Pashley took on a new partner, Evan Davies, who had previously worked as a janitor. The firm became Pashley & Davies, and continued to advertise the same services as before. Not followed beyond 1874.

PATENT SILVERWARE MFG. CO.
Buffalo, New York

An 1893 account states: "The Patent Silverware Mfg. Co. was incorporated for purchasing, selling and manufacturing all kinds of silverware, and to purchase and produce patent rights, etc., patent devices of their own. Frank E. Comstock, Buffalo; B.N. Reynolds, Lakeville, N.Y., and Edith L. Johnston, Wheeling, West Virginia." (JC&HR 11-1-1893, p. 7)

PAUL REVERE SILVER CO., INC.
Boston, Massachusetts

Registered trademark U.S. Patent No. 85,612, March 5, 1912 for plated silverware. Out of business before 1922.

PAUL REVERE

PAYE & BAKER MFG. CO.
North Attleboro, Massachusetts

CHRONOLOGY
Simmons & Paye 1896-1901
Paye & Baker 1901-1960s

Charles T. Paye was born in 1874 in Providence, Rhode Island. After studying at the Rhode Island School of Design, he became an engraver and went to work in the jewelry and silver manufacturing business in Providence.

In 1896 he went into partnership with Jessie O. Simmons, forming the Simmons & Paye Co. Paye probably produced the designs while Simmons supervised the engraving.

By 1897 the firm was describing itself as "Simmons & Paye - The Souvenir House". In October of that year the firm advertised in *The Jewelers' Circular* that it had 700 distinct patterns for sterling souvenir spoon handles of different subjects, comprising various towns and cities in the United States, Canada and Mexico, plus almost 10,000 impressions from hand engraved illustrations of principal buildings all over the country.

To succeed in the Souvenir Spoon business, firms had to stay on top of the market. Within two weeks of the battle of Manila Bay in 1898, Simmons & Paye was offering a souvenir spoon related to that event.

By late 1899, the firm was expanding its novelty lines. Crystal and silver salt and pepper shakers, enamelled souvenir flag pins, souvenir heart charms, souvenir cream jars and souvenir letter openers had been added.

By 1900 Charles Paye had become president of the firm. Frank L. Baker purchased Jessie Simmons share of the company, while Simmons continued to work for the firm as an engraver. Fred. C. Paye and Harry E. Paye, probably brothers of Charles, were also part of the company which now employed 25 hands. In 1901 the firm name was formally changed to Paye & Baker Manufacturing Co.

Needing room to expand, in 1903 the company purchased the existing Gorton factory in North Attleboro Massachusetts, and moved its operations there. In July of that year a new 40-horse power steam engine was installed to operate the factory machinery. A new office building was constructed the following year, expanding the plant size by a third.

Creating or reflecting new fads was the lifeblood of the novelty business. Paye & Baker did well at both. In 1907 they were largely responsible for popularizing the Swastika as a good luck symbol, producing, pins, links, bangles, and emblems mounted on various leathergoods.

Their 1908 introduction of the Scarab as a good luck emblem was a repeat performance. By producing their own popular Bears lines in 1907 and obtaining the exclusive rights to produce "Billiken" in sterling silver and solid gold in 1908, they capitalized on fads developed by others. Apparently the firm never patented any of its own designs, so they were frequently copied. The company throve by keeping on top of popular trends. It became a major national producer of novelty items and developed a large export business as well.

In the 1913 North Attleboro city directory the firm was listed as producing fancy flatware, souvenir spoons, sterling silver jewelry and mesh bags.

Charles Paye died unexpectedly following an emergency operation in 1919. Frank Baker assumed management of the company, and immediately stopped producing silver spoons, jewelry and novelties. Paye & Baker became the only manufacturer of surgical and dental instruments in North Attleboro at the time. Baker, in turn, died unexpectedly in 1923.

Harry E. Paye, who had been vice-president and superintendent for the firm, took over, and it again became a manufacturing silver company. In 1924 it is listed in KJI as a manufacturer of silver plated table novelties, holloware, and Dutch silver reproductions.

By 1928, however, the firm was listed in the North Attleboro directory as "manufacturing jewelers" and Allan Gordon was president. It is not known what specific items the firm produced after this point. The company remained manufacturing jewelers until the death of Harry Paye in 1952. It subsequently became a division of the Bishop Company and manufactured metal (later metal and wood) photo frames. Separate records for the firm were not kept after the early 1960s. (Impastato, *Silver*, Sept.-Oct. 1990, pp. 32-35)

GEO. W. PAYSON & CO.
Baltimore, Maryland

Listed in Baltimore City Directory in 1904 as a silversmith.

C.D. PEACOCK
Chicago, Illinois

Established in 1837 by Elijah Peacock from London whose family tree has been traced back as far as Robert Peacocke, once Lord Mayor of York, who died June 15, 1570.

Elijah was born in 1818 and entered the family business of clockmaking and served his apprenticeship. He followed his brother, a former gunsmith, to the United States at the age of 19 and set up business in a wooden shanty on Lake Street in Chicago. His shop antedates Chicago's city charter by several months as it was set up in February 1830 and the city charter was not received until July. So, Peacock's can justly claim that their business is older than the city of Chicago.

Peacock sold trinkets to buckskin-clad trappers and scouts and repaired chronometers for the captains of Great Lakes' sailing vessels before Chicago was linked to the east by telegraph in 1848 or by railroad in 1852. In 1860 his son, Charles Daniel (C.D.) Peacock, took charge of the business and later he turned it over to his sons, Charles D. Jr., Robert E. and Walter C. Peacock.

When the Chicago fire in 1871 gutted downtown, everything was lost except the massive Peacock vault. Its steel door saved it from ruin. Because the diamonds, gold and a large quantity of silver had been put away in it for the night, the firm was able to start all over again. That sturdy vault still exists.

Peacock's continued to be managed by family members until it was sold in 1970 to the Dayton-Hudson Corporation, Minneapolis.

Articles sold there are often stamped with the store name. Peacock's was one of the first retail establishments to market flatware with the store name.

In 1903 they marketed Gorham's *Cambridge* pattern flatware under the name *Crofut*.

PEERLESS SILVER COMPANY
Brooklyn, New York

Listed 1936 Jobber's handbook as manufacturers of plated wares, pewter salt and pepper sets and novelties. Listed through 1960.

LA FRANCE

E.W. & O.Z. PELTON
Middletown, Connecticut

Mark found on a silverplate teapot dated circa 1870s.

PELTON BROS. SILVER PLATE CO.
St. Louis, Missouri
See Merry & Pelton Silver Co.

Listed in St. Louis City Directories, 1872-1900 as manufacturers of plated silverware. Philip S. Pelton was supervisor.

TRIPLE PLATE 12
SECTIONAL PLATE XII
STANDARD PLATE 4
(Flatware.)

(Hollowware.)

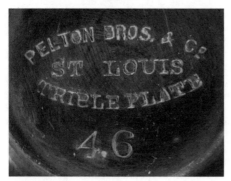

PENDLETON & CO.
New York, New York

CHRONOLOGY
Pendleton & Hudson	1866
Pendleton & Co.	1867-1868

Samuel Pendleton and Thomas Hudson formed the firm of Pendleton & Hudson in 1866. In the New York City directory for that year they advertised themselves as "Manufacturers of Silver Plated Ware of All Descriptions, also General Electro-Platers and Gilders"

By 1867 Thomas Hudson had left, and the firm became Pendleton & Co. The new firm advertised as "Manufacturers of German Silver, Albata, and Britannia Plated Ware". Not found after 1868.

J. PENFIELD & COMPANY
Savannah, Georgia
See Black, Starr & Frost, Ltd.

In business from 1820-1828. Partners were Josiah Penfield. Moses Eastman and Frederick Marquand.

J.C. PENNEY CO. INC.

The patent number indicates a date of about 1925.

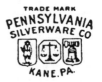

PENNSYLVANIA SILVERWARE COMPANY
Kane, Pennsylvania

Manufacturers of plated silver holloware and soda fountain supplies c. 1920-35.

PEORIA PLATING WORKS
Peoria, Illinois

Found on an individual table castor. The company was owned by the Mushard family of Peoria. The company is still in business. It was known for some years as the Central Light & Fixture Company and is presently (1986) listed as the Central Fixture Company. Their advertisements now read, "Family owned and operated in Peoria since 1898."

D.C. PERCIVAL & COMPANY
Boston, Massachusetts

David C. Percival was born April 16, 1838 in the Cape Cod town of Sandwich. He was the son of David and Sarah F. Percival. He first planned on attending Harvard but decided to begin a business career and became a salesman for the old Boston jewelry firm of Sackett, Davis & Company. He stayed with them for eight years and then embarked in business as a wholesaler in 1868, the firm name being D.C. Percival, Jr. & Co., and having as partners two young men named Morris & Salisbury. The firm occupied a place near the Old South Church but was burned out at the time of the Boston fire in 1872. After the fire Salisbury retired. The firm was reorganized as Percival & Morris. Later Daniel Morris left the firm and D.C. Percival & Co. was incorporated with D.C. and L.F. Percival entering after their graduation from college.

PETER G. PERDRIAUX
Philadelphia, Pennsylvania

Peter G. Perdriaux was born in Pennsylvania about 1829. His mother was a dressmaker who came originally from France. He is listed as a silversmith in the Philadelphia city directories from 1856 until 1865. His younger brother Laurent, also a silversmith, probably worked with him. The company manufactured flatware typical of the period including pieces with engine turned or double die stamped decoration.

The Industrial Census of 1860 lists Perdriaux' firm as employing eight workers, five men and three women. The company produced $28,000 worth of knives, forks, and spoons on an annual basis.

Peter G. Perdriaux died in November 1865, and the business apparently died with him.

In addition to the mark shown below, Perdriaux also marked some of his work with an impressed mark: P. G. PERDRIAUX. (Soeffing, *Silver*, Mar.-Apr. 1991, pp. 14-15)

L.S. PETERSON CO.
North Attleboro, Massachusetts

Manufacturers of novelties of sterling and silverplate c. 1940 to the present.

L. S. P.
L. S. P. Co.

THE PETTERSON STUDIO
Chicago, Illinois

John Pontus Petterson studied silversmithing at the Royal School of Arts and Crafts in Norway and then moved to New York where he worked as a silversmith for Tiffany & Company (q.v.) from 1905 to 1911. He moved to Chicago where he was employed in the shop of Robert Jarvie and then in 1914 established The Petterson Studio. In the 1920s he and his assistants made handwrought silver flatware and holloware, trophies and chalices, jewelry and other items to special order.

J. P. P.

W.H. PEIFFER
Niagara Falls, New York

Listed in the 1890 Niagara Falls City Directory as maker of silver and plated silverware.

F.P. PFLEGHAR & SON
New Haven, Connecticut

The company name first appeared in the New Haven City Directories in 1890. Prior to that Frank P. Pfleghar had been in business alone at that address for a few years. The 1918 Directory lists a change of ownership from Frank P. Pfleghar, Sr. and F.P. Pfleghar to Henry W. Ibelshauser and Max Voight but the business was still operating under the name F.P. Pfleghar & Son. The last listing was in 1919. The type of business was described as "machinists" then "machinists and hardware," or "machinists and hardware mfgrs."

The articles on which the imprint was found are silverplated corn holders. In the Patent Office records, Invention Patent #567,284, .Sept. 8, 1896 was taken out by Charles W. Stebbins, Hartford, Conn., and assigned to F.P. Pfleghar & Son, New Haven, Conn.

F. P. PFLEGHAR & SON
NEW HAVEN, CONN.
PAT. SEPT. 8 — 96

PHELPS & CARY CO.
New York, New York
See Hartford Sterling Co.
See The Tennant Co.

Listed in JC 1904 in sterling silver section as out of business. Trademark identical to that of Hartford Sterling Co. and The Tennant Co. except for initials in shield. Phelps & Cary business was purchased by the Hartford Sterling Company. H.A. Cary went into business for himself in 1900.

PHILADELPHIA PLATE CO.
Philadelphia, Pennsylvania?

Attributed in *Century of Silver* to a Division of the International Silver Company. Not confirmed by them.

The straight line mark below appears on a silverplate cake basket dating c. 1865-1870.

PHILΔ PLATE CO.

PHILADELPHIA SILVERSMITHING CO.
Philadelphia, Pennsylvania

In business c. 1890. Listed in JC in sterling silver section 1915-1922. Last record found was c. 1935.

THOMAS PHILE
Baltimore, Maryland

Listed in Baltimore City Directories 1871-1872, 1879-1887 as a whitesmith.

PHILLIPS MFG. CO. INC.
Meriden, Connecticut

Listed 1927 and 1931 KJI as manufacturers of plated holloware and pewterware.

PIA BROTHERS
New York, New York

The firm of Pia Brothers advertised itself as a manufacturer of toys in the New York City directories at least as early as 1852. These toys were manufactured out of pewter and included such items as miniature candelabra, teapots, cups and saucers, spoons, pitchers and baskets, as shown in the illustration for their ad run in the Brooklyn city directory published in 1856. The text of that ad, and of one published in 1861 in the New York City directory describes the firm as "Manufacturers and Wholesale Dealers in all Kinds of Pewter Toys, Tea and Coffee Setts (sic.), Holy Water Pots and Crucifixes, of different sizes."

The firm consisted of three brothers, Albert, John and Peter Pia. Albert worked continuously with the production of pewter toys. Peter took a fling in the liquor business in 1856, and operated a saloon and billiard parlour in 1861 and 1862, also called Pia Brothers. John joined in the billiards business in 1862, but by 1863 they were all back in the pewter toy business.

Andrew Pia disappeared from the New York City directories in 1864. John and Peter continued the business through 1866 advertising themselves as manufacturers of lead ornaments. Not found after 1866.

ALBERT PICK & CO.
Bridgeport, Conneeticut

Manufacturers of plated silver flatware and holloware. Successors to the E.H.H. Smith Silver Company in 1920. Last appeared in the Bridgeport City Directory in 1927. Said to be still in business. (1975)

ACORN BRAND

EVERWEAR

STERLINGUARD

J.V. PILCHER
Louisville, Kentucky

Manufacturers of plated compacts and cigarette cases c. 1940.

PILCHER

J.O. & W. PITKIN
East Hartford, Connecticut
See E. M. Roberts & Co.

CHRONOLOGY
J.O. Pitkin	1826-1830
J.O. & W. Pitkin	1830-1840
W. Pitkin	1840-1860

John Owen Pitkin (1803-1891) originally worked as a jeweler in Hartford. About 1826 he started a small silver manufacturing plant across the river in East Hartford. His brother Walter (1808-1885) became a partner in the firm in 1830.

When two of their younger brothers, Henry and James F. Pitkin, opened a watchmaking factory in East Hartford about 1834, the older brothers moved the silver manufacturing business to

the larger plant. Both businesses continued to operate in that location for about ten years. Then the watchmaking business moved to New York City.

In 1836 the brothers sold their retail operation to Thomas Steele (q.v.) In 1840 John Owen Pitkin withdrew from the partnership and went into business as a jeweler, working for a time in several other Connecticut towns, and later in Providence, Rhode Island.

Walter Pitkin successfully continued the silver manufacturing business. The firm had about 40 full time employees. All work was done by hand until 1855 when power equipment was installed.

About 1860 Walter Pitkin sold the plant to a former apprentice, Edwin M. Roberts, who went into business as E.M. Roberts & Co. (q. v.) (McGrew, *Silver*, May-June 1990, p. 17)

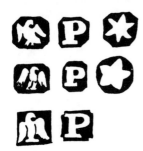

W. L. & H. E. PITKIN
Hartford, Connecticut
See Eagle Sterling Company
See C. Morgan
See H.I. Sawyer
See O.D. Seymour

CHRONOLOGY
Pitkin & Morgan?	1859-1862
W.L. & H.E. Pitkin	1863-1894

Both William Leonard and Horace Edward Pitkin first appear in the Hartford city directories in 1854. W. L. is shown as a silversmith, but H. E. appears first as a student and then as a riflemaker. No place of business is listed for either of them for the first few years indicating that they were working for others, not themselves.

1859 is the first year that William L. Pitkin is shown as having his own shop. He was reported to have bought out the businesses of O. D. Seymour and H. I. Sawyer. (JC&HR 2-27-1895, p. 9) O. D. Seymour himself last worked as a silversmith in 1854, although his son? Henry P. Seymour was in the business until 1857. H. I. Sawyer last worked as a silversmith in 1858.

Pitkin's first shop at 55 Pearl was at the site of Henry P. Seymour's former shop. Henry P. Seymour gave up silversmithing to go into the pottery business by the end of 1857. In 1858 his former shop was occupied by Chauncey Morgan and Miles Ingraham as a silverplating business. By 1859 Ingraham had left and W.L. Pitkin had come to that shop location. Although there does not appear to have been an official partnership, both Chauncey Morgan and William L. Pitkin were doing business at the same address between 1859 and 1862, Morgan listed as an electroplater and Pitkin listed as making silver spoons and forks.

By 1861 Horace E. Pitkin is shown working as a silversmith, presumably for his brother. By 1863 he had become a partner, and the business was known as W. L. & H. E. Pitkin. These Pitkin brothers were distant cousins of J.O. & W. Pitkin (McGrew, *Silver*, May-June 1990, p. 17)

When the Pitkin brothers went into partnership, Chauncey Morgan moved his silverplating shop next door.

In 1863 W.L. & H. E. Pitkin listed their business in the Hartford city directory as "Manufacturers of silver spoons, forks, ladles, butter knives &c. from pure coin. Also plated goods of all descriptions and jobbing in gold & silver plating."

By 1867 the firm had expanded its offerings, describing the business as "Manufacturers of solid silver and plated spoons, forks, knives and holloware of all descriptions. Watches repaired in the best manner and warranted."

The firm was reported to be one of the earliest in the state to produce both solid silver and silver plate. (JC&HR 2-27-1895, p.9)

By 1878 their ads had changed again. They described themselves as "Manufacturers of Sterling and Coin Solid Silver Ware and Dealers in Plated Ware." However they still offered to do gold, silver and nickel plating to order. The firm has not been followed beyond 1881 in the directories.

"... July 1, 1894 they closed out the business and sold the machinery to the Eagle Sterling Company of Glastonbury. Late in the same year both brothers formed a business engagement with the Glastonbury company and have since worked there." (JC&HR 2-27-1895, p. 9) W.L. Pitkin died in February 1895.

PITTSBURGH SILVERWARE CO.
Pittsburgh, Pennsylvania

Listed in the Pittsburgh City Directories from 1884 through 1887.

The 1884 directory lists it as the Pittsburgh Silverware Installment Company.

The 1885, 1886 and 1887 directories list it as the Pittsburgh Silverware Company.

The 1887 directory gives the last listing as follows: "Pittsburgh Silverware Company, 511 Market St ., Manufacturers' Agents for Fine Electro-Plated Ware, Silverware, watches, jewelry leased on easy payments. F.R. Jones, Manager."

No trademark shown.

PITTSBURGH SILVERWARE INSTALL-MENT COMPANY
Pittsburgh, Pennsylvania
See Pittsburgh Silverware Co.

Listed in the Pittsburgh City Directory 1884.

GUSTAVUS A. POHLMAN
Baltimore, Maryland

Listed in Baltimore City Directories 1903-1904 as a silversmith.

JOHN POLHAMUS
New York, New York
See Henry Hebbard & Co.,
See George W. Shiebler & Co.,
See Whiting Mfg. Co.

CHRONOLOGY
Van Cott & Polhamus	1833-1840
Polhamus & Strong	circa 1845
Hebbard & Co.	1852-1858
Polhamus & Strong	1859-1863
John Polhamus	1864-1870
John Polhamus & Co.	1871
John Polhamus	1872-1874

John Polhamus was a silversmith, listed in the New York City Directories 1833-40 with the firm of Van Cott & Polhamus, also Polhamus & Strong c. 1845 where he made silver for Tiffany & Co. Polhamus obtained a number of design patents in conjunction with Henry Hebbard while he worked for Hebbard's company between 1852 and 1858. These designs were later manufactured by George Shiebler & Co. Polhamus also operated his own jewelry business at a separate location between 1852 and 1860.

George E. Strong is shown working for Hebbard & Co. beginning in 1854. In 1859

Hebbard moved next door and Polhamus and Strong formed a partnership at Hebbard & Co.'s former location. In 1864 Strong left the partnership, and John Polhamus was in business on his own. He remained in business at least through 1874. Dating of the various partnerships after 1852 comes from the New York City directories.

John Polhamus & Co. represents a partnership of Polhamus and William Bogert (q.v.) This partnership did not go well. Bogert sued Polhamus and won a judgement against him shortly before Polhamus' death in 1877. (Soeffing, in Venable's *Silver in America*, 1994, biographical section, p. 316)

Polhamus obtained a number of flatware design patents in his own name between 1860 an 1874. Those dating between 1860 and 1870 were later manufactured by George W. Shiebler & Co. The 1874 design patent was later produced by the Whiting Manufacturing Co.

J P

POOL & CO.
Baltimore, Maryland

CHRONOLOGY
Mitchell & Pool	1889-1894
B. Pool & Co.	1894-1899
Pool & Company	1899-1915

Organized in 1889 as Mitchell & Pool, silverplaters; succeeded by B. Pool & Co., 1894; and, by Pool & Company in 1899.

POOLE SILVER CO.
Taunton, Massachusetts

Founded in 1893 in Taunton, Massachusetts with a small two-room factory as manufacturers of plated silverware. Originally called Poole & Roche. Mr. Poole bought out his partner Mr. Roche and was sole owner until his death when his three sons took over the active management. In 1946 they retired and sold the company to an investment group headed by Sidney A. Kane of Providence, Rhode Island. The company grew rapidly.

In 1946 a sterling silver department was added and in 1964 a brass division.

Today (1975) the company operates the Poole Silver Company for plated holloware, the Bristol Silver division, founded in 1950, for popular priced plated holloware as well as the above. Purchased by the Towle Mfg. Co. in 1971.

(On sterling silver) (*Quadruple Plate.*)

HAND HAMMERED

TRADEMARK

PEWTER *by* POOLE

(On plated silver)

BRISTOL SILVER CORP.
POOLE STERLING CO.

POPE'S ISLAND MFG. CORPORATION
New Bedford, Massachusetts

Incorporated in 1890 on the island from which it took its name. Horse bits and harness trimming were manufactured at these works. As the company was listed among manufacturers of silverplated wares by the JC 1896 until 1915, some of these trappings must have been plated silver.

FRANKLIN PORTER
Danvers, Massachusetts

Franklin Porter's early artistic training was at the Rhode Island School of Design, followed by technical training at Browne and Sharpe in Providence. For many years his artistic inclinations took second place to the need to support a family. All the while though he made brass and copper pieces and occasionally silver when he could afford the raw material.

In 1924 when he reached his fifty-fifth birthday he was released from his factory job without a pension. On that date, May 9, 1924, he purchased a copy of Bigelow's *Historic Silver of the Colonies and Its Makers* and joined the ranks of American silversmiths. In his journal, Porter wrote, "January 1, 1925. Beginning this date, I began the practice of attaching my mark to every piece of work executed by me on which it is practicable to attach same, together with 'F. Porter' and 'Sterling' in order to distinguish my work, should any of it survive, in years to come, from that of F. Porter, pewterer, of Connecticut."

Sterling F. Porter ℞

HLP

(HLP Mark of daughter, Helen Porter Philbrick, used on silver pins made in 1926)

ESDP

(ESDP Mark of adopted son, used April 1927 - May 1928 on flatware)

PORTER BRITANNIA & PLATE COMPANY
Taunton, Massachusetts

Organized in 1859. E.W. Porter, of Reed & Barton, became superintendent of the new com-

pany. Their products were similar to those made by Reed & Barton. In business at least until the 1870s.

PORTER PLATING CO.
Taunton, Massachusetts

Mark found on a silverplate pickle caster frame dating circa 1870. Possibly related to Porter Britannia & Plate Company above.

J. POSNER & SONS. INC.
New York, New York

Manufacturers of silver goods c. 1960

JORDAN POST
Toronto, Ontario, Canada

Jordan Post (1770-1853) came with his father to Toronto from Connecticut in 1787. He is reported to have been Toronto's first silversmith. His business prospered and he became a prominent public figure. Two streets are named in tribute to his family, Jordan, for himself, and Melinda, for his wife. He had his shop at different times at various locations on King St. (Unitt & Worrall, *Unitt's Book of Marks*, 1995, p. 48)

THE POTOSI SILVER CO.
Birmingham, England

Levi and Salaman who were electroplaters and silversmiths in 1870, absorbed the Potosi Silver Company in 1878.

On October 19, 1886 they registered a U.S. Trade Mark patent for plated silver on white metal.

The Potosi Silver Company name was probably derived from the Potosi Mine, discovered in 1545 in the area that was later to be named Bolivia.

It was succeeded by Barker Bros. Silversmiths, Ltd., Unity Works, Birmingham, England between 1915 and 1922.

(*White Metal.*)

S.C. POWELL
New York, New York

Catalogs of 1900 in existence showing he was in business by then as a manufacturer of sterling silver novelties. Out of business before 1909.

PREISNER SILVER COMPANY
Wallingford, Connecticut

Manufacturers of sterling silver articles c. 1935 to the present. (1975)

P S CO.

PREMIER CUTLERY INC.
New York, New York

Manufacturers of plated silver cutlery c. 1920.

PREMIER SILVER CO.
Brooklyn, New York

Manufacturers of sterling silverware c.1920

PRESSED METAL PRODUCTS
Vancouver, British Columbia, Canada

Firm formed in 1930 in Vancouver with Colin A. Macdonald as president and Frank Sarson as manager, with a staff of three. In 1931 Sarson became president of the company.

The firm produced medals, badges, name plates, class pins and society buttons, three different styles of souvenir spoons and Christmas spoons.

In 1976 the company was purchased by Allen Trammel. Souvenir spoon production ceased the same year. Now only custom order spoons are made. (Pack, *Collector's Guide to Canadian Souvenir Spoons,* 1988, pp. 72, 80)

PRESTO CIGARETTE CASE CORP.
North Attleboro, Masachusetts

In business c. 1920-1930. Listed in KJI 1924 as manufacturers of sterling silver, silver plate, nickel, 14k gold vanity and cigarette cases, flasks and other novelties.

JOHN PRICE
Newark, New Jersey

Optician and silversmith working c.1840-60. Manufacturer of gold and silver spectacles, silver spoons, etc. Succeeded by his son, Henry M. Price, c. 1860-62.

PRILL SILVER, CO., INC.
New York, New York

Edward Prill, Inc. listed in 1936-37. Prill Silver Co. successors (?) c. 1940-45. Manufacturers of sterling articles to the present. (1975)

C. B. PRIME
New York, New York

Claudius B. Prime first appears in the New York City directory published in 1859. In 1860 he advertised in the directory as a "Manufacturer of gold, silver, and steel top thimbles, Gold and Silver Shields &c." He continues to be found in the directories through 1869. Not found after that date.

JOHN PRIP
Providence, Rhode Island

John Axel (Jack) Prip, was born in 1922 in New York City. His father was a metalsmith, and when John was 10 his family moved back to their native Denmark, where his father took over the operation of John's grandfather's silversmithing factory. At age 15, Prip apprenticed to master silversmith Evald Nielsen.

In 1948 he returned to New York to teach at the fledgling School for American Craftsmen. He remained there until 1954.

From 1954 to 1960 he was Artist-Craftsman in Residence at Reed & Barton, where he designed, among other things, the *Dimension* flatware pattern, and the *Diamond* coffee service. 1960 to 1963 he spent teaching part time and travelling extensively.

From 1963 to 1981 he taught at the Rhode Island School of Design. His work shows highly developed technical skills as well as innovative design techniques. He produced a variety of jewelry and sculpture in addition to his other work.

Noted in *Silver* Nov.-Dec. 1987, pp. 24-25.

J.N. PROVENZANO
New York, New York

In business before 1896. Distributors (?) of sterling silverware, gold and platinum seed pearl and gun metal goods.

Not listed after 1904.

(On Knives.)

PROVIDENCE STOCK CO.
Providence, Rhode Island

Listed in JC 1896-1904 in sterling silver section. Subsequent listings are under jewelry and watch attachments, chains, fobs and bracelets. Last record found was 1950.

PRYOR MFG. CO., INC.
Newark, New Jersey

Listed in JC in 1915 in sterling silver section .
Consolidated with B.M. Shanley, Jr., Co. between 1915 and 1922.

PUBLIC SERVICE CUP CO.
Brooklyn, New York

Manufacturers of nickel silver and silverplate holders for Lily Cups circa 1930s.

PUTNAM & LOW
See Shreve, Crump & Low Co., Inc.

Q

QUAKER SILVER CO., INC.
North Attleboro, Massachusetts
See Gorham Corporation

Makers of sterling and silverplated holloware, trophies, novelties and pewterware. In business in North Attleboro, Massachusetts at least as early as 1926. Purchased by the Gorham Corp. in 1959.

NARRANGANSETT
(Used on pewter)

QUAKER
VOGUE

(On silverplate; used since February 1926)

QUAKER VALLEY MFG. CO.
Chicago, Illinois

Trademark used c. 1900 on silverplated articles used in direct sales.

CUVEE

QUEEN CITY SILVER CO., INC.
Cincinnati, Ohio

Manufacturers of plated silver holloware c. 1888. Listed in KJI 1922 and 1924 as a manufacturer of silverplated holloware and mahogany novelties. Liquidated in 1949.

COVENANT
(On pewterware)

QUEEN'S ART PEWTER, LTD.
Brooklyn, New York

Founded in 1920 by Anton Theurer and __ Bower (now deceased). Mr. Theurer was born in Germany and learned the trade of spinning there. He came to this country and started his own business. He is now retired. John Arcate, with the company since 1960, learned the trade from Mr. Theurer and operates the business today. (1975)

QUEEN'S ART PEWTER LTD.

R

RACINE SILVER PLATE CO.
Racine, Wisconsin
See Rockford Silver Plate Co.
See Sheets-Rockford Silver Plate Co.

Founded in 1873 in Racine, Wisconsin. Moved to Rockford, Illinois 1882 and renamed Rockford Silver Plate Co.

An 1882 account states,"The Guild Stamp Design adopted by the Executive Committee of the United States Guild for flatware, will be used by the Racine Silver Plate Co. on triple plated goods, with ten percent extra weight of silver, without any extra cost. These goods will be sold only to members of the United States and State Associations.

"Mr. Purdy of Purdy & Stein is the originator of the stamp." (*American Jeweler,* Feb. 1882, p. 44)

"The Racine Silver Plate Co. (Wisconsin) was moved to Rockford, Illinois." (*American Jeweler,* June 1882, p. 133)

RADAR SILVERSMITHS, INC.
Brooklyn, New York

Manufacturers of sterling lamps and lighters c. 1950.

RA

WILLIAM T. RAE
Newark, New Jersey

Silversmith working c. 1856-64. Successor to A.J. Williams.

RAIMOND SILVER MFG. CO.
Chelsea, Massachusetts

Advertised as manufacturers and distributors of sterling and silverplated goods in the 1960s and 1970s.

An 1966 account indicates that the firm, "Purchased W. & S. Blackinton Co., Inc. of Meriden, Connecticut, including inventory, materials, existing contracts and tradenames.

"Anthony S. Maisto, independent designer and owner of Maisto Silver, Inc., was named general manager.

"Blackinton was established in 1865 in North Attleboro and moved to Meriden after acquisition by the now defunct Ellmore Silver Co., in 1938. When Ellmore's assets were assigned to creditors in 1960, Blackinton was purchased by Alexander Land of Westport, owners of the present site, who subsequently sold it to a corporation headed by Irving R. Stich, prominent Hartford area builder and developer who backed revitalization of Blackinton in 1961." (*Meriden Journal,* April 26, 1966) Among the products advertised by Raimond's were those of Nils-Johan and Viner's of Sheffield. Sold in 1978.

HARRY S. RAINS
New York, New York

Silverplaters c. 1920.

ℒA MILITAIRE

RAND & CRANE
Boston, Massachusetts

Successors to C.W. Kennard & Co., Boston in 1886. U.S. Trade Mark Patent registration for HOLMES trademark, May 5, 1891 to be used on solid and plated souvenir spoons and forks.

The company was listed in JC 1896-1922, but the HOLMES trademark was not used after 1903.

HOLMES

THE RANDAHL SHOP
Chicago, Illinois

Julius Olaf Randahl was founder of The Randahl Shop, Park Ridge and Chicago, Illinois. Randahl was born December 21, 1880 in Oeland, Sweden, a small island in the Baltic off the coast of Kalmar. He was apprenticed to a silversmith named J.G. Henshall and after he finished his training he came to the United States in 1901. After working for Tiffany and for Gorham, he worked in the KALO SHOP which made only fine handwrought silver.

In 1910, Randahl, who made only holloware, formed a partnership with Matthias Hanck. a jeweler in Park Ridge. This partnership lasted only one year. The mark used during the partnership was JULMAT, a combination of both their first names.

In 1911 Randahl opened his own business, The Randahl Shop. The early trademark was his initials JOR with a silversmith's hammer drawn through them. Around 1915 the business was moved from Park Ridge to Chicago. It was forced to close during World War I because the men had to go into war work. It re-opened in another location in Chicago in 1919 and in 1930 in still another location closer to the downtown stores, namely Marshall Field's and Peacock's, both of which sold a lot of his silver. Sometime in the 1930s the JOR trademark was dropped and the name RANDAHL was used after that. By 1950, both sons were in business with him and they built a factory in Skokie, a suburb just west of Evanston. Randahl's sons, Julius Olaf Randahl, Jr. and E. Scott Randahl, continued the business until 1965 at which time they sold it to Reed & Barton. It is now their RANDAHL division, using the Randahl trademark. The original founder died April 1972.

Randahl Jewelers in Park Ridge and The Cellini Shop in Evanston, Illinois, are owned by the two sons. (1975)

RANDAHL

C. RAY RANDALL & CO.
North Attleboro, Massachusetts

Manufacturers of sterling silver, 10k gold and goldfilled bar pins, brooches, necklaces, belt buckles, scarf pins, links and pin sets.

Listed in JC 1915-1922. Last record found was 1935.

STERLING CRR

RANDALL & FAIRCHILD
See Fairchild & Co.

ANTHONY RASCH
Philadelphia, Pennsylvania
New Orleans, Louisiana

Anthony Rasch was born about 1780 near Passau, Bavaria, where he later learned the trade of silversmithing and goldsmithing. Sometime between 1801 and 1803 he came to Philadelphia, Where he worked for a time with Simon Chaudron, and later by himself. He was also briefly associated with George Willig, Jr.

He went to New Orleans in 1820 to see about setting up in business there, but returned to Philadelphia to complete his business there first. He moved to New Orleans permanently in 1821. With the exception of a trip to Germany and France in 1836-1837, he lived the rest of his life in New Orleans, where he died in 1858. (Bacot, *Silver*, Jan.-Feb. 1986, pp. 20-21)

ANTY RASCH

RAY SILVER CO.
Rockford, Illinois

A division of Sheets-Rockford Silver Co.

RAYMOND MANUFACTURING COMPANY
Muncie, Indiana

Silverplaters. Out of business before 1920.

SOLID YUKON SILVER WARRANTED

DAVID REAY, JR.
Baltimore, Maryland

Listed in Baltimore City Directories 1865-1873 as a silverplater.

REDDALL & CO., INC.
Newark, New Jersey

Listed as John W. Reddall & Co. in 1896 *Jewelers' Weekly*.

Listed in JC 1896-1904 in sterling silver section. Out of business before 1909.

REDFIELD & RICE MANUFACTURING CO.

New York, New York
See E. P. Bray & Dauchy
See Derby Silver Co.
See Hartford Plate Co.

CHRONOLOGY:

Dater, Bray & Co.	1854
Bray, Redfield & Co., 70 John St	1854-1856
Bancroft, Redfield & Rice, 177 Broadway	1856-1863
Redfield & Rice, 177 Broadway	1863-1865
Hartford Plate Co., office: 177 Broadway	1863-1865
Redfield & Rice Mfg Co., 4 Maiden Ln.	1866-1872

Although both James H. Redfield and the company's literature claimed that the firm had its beginnings in 1852, the farthest back it can currently be traced is to the formation of Dater, Bray & Co. on May 1, 1854.[1] Dater was originally from Troy, New York, and worked in the brokerage business in New York City. Edward P. Bray came from New Haven, Connecticut, where he had worked with the firm of "Mix & Co."[1], (probably G. I. Mix & Co., q.v.). D.H. Peck provided the manufacturing expertise for the company which was initially listed as a German Silver Manufacturer. Its first factory was located at Whitestone, Long Island.[1]

In September, 1854, Dater withdrew from active participation in the firm, but retained his financial stake in the company. James H. Redfield, formerly with S. B. Chittenden, Bro. & Co., a drygoods firm, entered the partnership along with James Rice, and the business became known as Bray, Redfield & Co. Bray and Rice were both sons-in-law of Wm. Cyrus Manvel (Bray & Manvel, q.v.), usually known as "Cyrus Manvel", a well-to-do iron manufacturer from Elizabethport, New Jersey, who provided the fledgling firm with financial assistance when necessary.[1]

On June 5, 1856, Bray retired from the company due to ill health.[1] He recovered, and about six months later went into the hardware business in partnership with John Q. Kellogg. When that business failed, its debts were bought up by his father-in-law, Cyrus Manvel. Shortly afterwards, Bray re-entered the silverplating business, forming the firm of E. P. Bray & Dauchy (q.v.).[2]

Meanwhile, William Bancroft, originally from Chesterfield, Mass., who had also worked for the Chittenden drygoods firm, took Bray's former position, and the company became known as Bancroft, Redfield & Rice. Manvel leased them factory space in Elizabethport.[1]

Bancroft was well-to-do financially, his wife having inherited $40,000 from her father.[1] He also appears to have been an astute businessman in his own right. Under his direction, the company prospered, selling over $100,000 worth of goods a year in 1859 and 1860. The firm declined an outside offer of $20,000 additional capital for a quarter interest in the business in 1859. While the beginning of the Civil War reduced the company's income somewhat, its business continued to be profitable.[3] From 1860 through about 1870 the firm remained one of the larger silverplating concerns in the country.

It was probably under Bancroft's direction that the company began to produce holloware as well as flatware. No evidence has yet been found of holloware manufactured by the earlier firms. Bancroft, Redfield & Rice obtained its holloware "in the metal" from other manufacturers, plating it and sometimes adding decoration of its own as well. Reed & Barton (q.v.) was the major, and possibly the only, holloware supplier used.

By early 1863, Bancroft had decided to return to Massachussetts, withdrawing from active participation in the firm, although he retained his financial interest in it. The company then became known as Redfield & Rice.

James H. Redfield brought together a group of new investors for the business. When he learned that the Hartford Manufacturing Co. (q.v.) of Hartford, Connecticut, was for sale, he and his friends incorporated the Hartford Plate Co. (q.v.) to purchase and operate the company as a factory for Redfield & Rice. According to the Hartford city directory, the new corporation was established on March 25, 1863, with a capital stock of $50,000. James H. Redfield served as president of the new company and Wilbur F. Gleason as Secretary-Treasurer. Gleason was a New York City banker and real estate investor.[4] James Rice apparently had no direct involvement in this manufacturing company.

The building housing the flatware factory in Hartford developed structural problems, and soon the company was looking for a new location for the plant. Gleason found a vacant factory site in Wolcottville (now Torrington), Connecticut. Records in the City Clerk's office in Torrington show that he purchased the property for himself in October 1865.

Meanwhile, Bancroft had decided to complete his withdrawal from the firm. The remaining investors chose to re-organize the company and its subsidiary, the Hartford Plate Co., into a single unit. The Redfield & Rice Manufacturing Co, was incorporated in New York City on February 26, 1866, with capital stock of $300,000. Redfield served as president and Gleason as treasurer.[5] The parent company and the subsidiary were reported to have each brought assets of $150,000 to the new business; however these figures may have been somewhat inflated.[6] The new firm's purpose was listed as selling and purchas-

257

ing Britannia and German Silver Ware and Fancy Goods, and its operations were to be principally carried on in Wolcottville, Connecticut and in New York.[5] Shortly after the incorporation, the Hartford factory was moved to Wolcottville, to the site owned by Gleason.

While flatware production remained the firm's primary focus, under Redfield's management the company expanded its holloware offerings. In addition to wares from Reed & Barton, by the mid 1860s the company was offering holloware that originated with Ernest Kaufmann (q.v.). As early as 1864, according to the Brooklyn City Directory, Redfield & Rice was operating a factory there, as well.

In 1868 Gleason's roving investment eye turned in another direction. This time he chose an iron company in Tennessee, and he sold his interest in Redfield & Rice back to the company to finance the venture. He sold the company the Wolcottville factory property as well.

James H. Redfield liked the look of the iron company too, and invested some of Redfield & Rice's money in it also. As the bankruptcy records in the custody of the National Archives-Northeast show, he made a variety of other real estate investments with company money as well.

Unfortunately, these investments did not work out as profitably as he had hoped, and the Redfield & Rice Manufacturing Company was soon experiencing cash flow problems. Redfield responded by paying some bills but not others, taking loans from his employees and trying other "creative financing" measures.

Not liking the way Redfield was conducting the business, James Rice withdrew from active participation in the company in 1871. The "Redfield & Rice Manufacturing Co." marks on holloware, rather than the simple "Redfield & Rice" which had been used earlier, were probably instituted as a result of his withdrawal.

Meanwhile the company had been working to develop its own individual product lines. On April 30, 1867, Egbert W. Sperry, the company's plant manager at Wolcottville, obtained three flatware design patents for variations on a grape design. Design Patent No. 2641 was the version finally selected for production, and it proved quite successful. Although Redfield & Rice called this pattern "Grape", it subsequently became known as "Ivy" in the trade.

In 1870 the firm commissioned a die sinker, Geo. W. Downing, to produce a design, Patent No. 4,218, later called "Empress". It closely resembled the "Persian" pattern, patented for the Meriden Britannia Co. by Horace C. Wilcox the year before. In 1871, the company arranged with Joseph Fradley (q.v.), who was subleasing a portion of the Redfield & Rice showroom area

at the time, to create a third patented design, No. 5,298, the "Lily" pattern.

As the company's finances got tighter, most suppliers allowed the firm less credit, and it was forced to purchase materials in smaller lots. This may partly explain why, by 1870, the company's catalog showed holloware originating from a variety of different major firms, such as Reed & Barton; the Meriden Britannia Co.; the Wilcox Silver Plate Co; Simpson, Hall Miller and the Webster Manufacturing Co. as well as lesser known firms like Adams, Chandler & Co.

Redfield had a talent for salesmanship and did his best to try to convince investors and creditors that things were going well, but by early 1872 he was forced to acknowledge the firm's problems. Large portions of the Brooklyn factory and the New York showroom were sublet, and the company's holloware division was sold off.[5]

The firm struggled on until November, 1872, when Osbourne, Cheesman & Co., its principal creditor, forced it into involuntary bankruptcy. The tools and materials from the factory at Wolcottville were sold to the Derby Silver Co. (q.v.) which was just starting up in business.

Redfield never returned to the silverplating business. He worked on commission, selling stores to the Navy,[5] and, according to the Brooklyn city directories, continued to dabble in Real Estate on occasion. He died in 1894.

When Rice withdrew from active participation in the silverplating company, he re-joined his brother-in-law Edward P. Bray, and they set up a business manufacturing wrenches.[7] When this venture failed, Rice worked for a time on a commission basis selling goods for Simpson, Hall, Miller and Gorham. However, this business also failed and he filed for bankruptcy in 1878.[8]

Although earlier editions of this book have stated that Redfield & Rice was a forerunner of Bernard Rice's Sons (q.v.), recent research has not been able to demonstrate a connection between the firms.

All items noted above reference the R. G. Dun & Co. Collection, Baker Library, Harvard University Graduate School of Business Administration. Volume and page numbers are given below:

[1] NYC Vol. 317, p. 296
[2] NYC Vol. 376, p. 271
[3] NYC Vol. 317, p. 272
[4] NYC Vol. 406, p. 100 FF
[5] NYC Vol. 373, p. 1354
[6] NYC Vol. 371, p. 730
[7] NJ Vol. 12, p. 414
[8] NYC Vol. 325, p. 1088

At any one time, the company had a variety of manufacturer's marks in use. These marks may be grouped into four categories:

Flatware mark above used during all time periods.

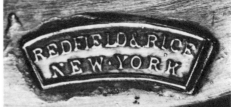

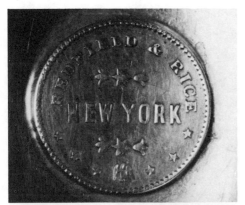

Early holloware marks above used c. 1863-1865.

Holloware marks above in general use through about 1870.

259

Holloware marks above in use c. 1871-1872.

Redfield & Rice glass lined medallion creamer manufactured between 1863 and 1865. (Photo by Judy Redfield)

REDLICH & CO.
New York, New York
See Elgin Silversmith Co. Inc.

Organized February 1890 as Ludwig, Redlich & Co. by Adolph Ludwig, who had for nine years been a designer of silver for Geo. W. Shiebler Co., and A. Alec Redlich, who had been for many years in the diamond business. In the latter part of 1895 Adolph Ludwig sold his interest and the company became Redlich & Co. This firm was taken over in 1946 by the Elgin Silversmith Co. The Redlich trademark is still used.(1975) Products are sterling silverware, holloware and 14k gold wares.

HENRY C. REED JR. & CO.
New York, New York
See Manhattan Plate Co.,
See Hiram Young

First appears in the New York City Directories in 1865. Henry C. Reed Jr. and William P. Fanning. An ad in the New York Times for December 22, 1866 offers "Silver Plated Ware. A fine assortment plated on German Silver and White Metal. Tea Sets, Casters, Cake Baskets, Cordial Stands, Soup Tureens &c. &c." In 1868 Reed went into partnership with Hiram Young under the firm name of Hiram Young and Reed.

Henry C. Reed, Jr. from New York should not be confused with Henry G. Reed of Reed & Barton (q.v.) from Taunton, Massachusetts.

REED & BARTON
Taunton, Massachusetts

Isaac Babbitt and William W. Crossman, both of Taunton, Massachusetts, formed the partnership of BABBITT & CROSSMAN in 1824 that led to what is now Reed & Barton.

Babbitt had opened a small jewelry store in 1822. The small workshop in the back held his attention more than selling jewelry and repairing watches. Aware of the public's preference for the new britannia ware, he often discussed its properties with his friend, William Porter, who was also a jeweler. Early in 1824, after much experimenting, Babbitt hit upon the right combination for producing this new alloy.

William Crossman completed his apprenticeship in the jeweler's trade; became dissatisfied with his job in Castleton, Vermont, and returned to Taunton.

Babbitt and Crossman decided to pool their resources and experience in a partnership to manufacture britannia ware, though they did not abandon the jewelry store.

They entered this new industry just at the time when mechanization put many establishments, that continued hand wrought production, out of business. Because of the uncertainty of their ability to produce and market britannia, they also turned out a great deal of pewter.

Their business prospered so that in 1826 they were able to build a new shop on Fayette Street, equipped with steam power. New machinery was made by Nathaniel Leonard of Taunton. Babbitt was superintendent: William W. Porter, foreman and it was assumed that Crossman managed the jewelry store and sales of the new factory products.

By 1827, with business increasing, more capital was needed, so William Allan West bought into the business and a new partnership was formed under the name BABBITT, CROSSMAN & CO. The jewelry store was apparently sold at this time.

On February 18, 1829, Isaac Babbitt sold his interest in the partnership and Zephaniah A. Leonard bought a one third interest. The new company of CROSSMAN, WEST & LEONARD was formed.

On February 16, 1833 the TAUNTON BRITANNIA MANUFACTURING CO. was reorganized. When it failed in November 1834, only three people had faith to continue. They were the company agent, Benjamin Pratt; Henry Reed, a spinner, and Charles E. Barton, the solderer.

Barton, brother-in-law of William Crossman, had moved to Taunton from Warren, Rhode Island and started to work in 1827 at age 19 as an apprentice.

Henry Good Reed was the son of a family prominent in Taunton for five generations.

Knowledge of britannia manufacturing was the three men's chief asset. To this, Benjamin Pratt contributed his experience in salesmanship. Once again, April 1, 1835, the TAUNTON BRITANNIA MANUFACTURING CO. was under new management.

Reed & Barton rented a few of the tools and equipment of the old company while Pratt sold what he could and tried to collect money owed to the company. By the end of 1836, the business had survived and made slight gains. Horatio Leonard transferred to his son, Gustavus, all rights, title and the stock and tools of the business. Soon afterwards an agreement was drawn up that left ownership of the factory itself in the Leonard family and granted to Reed & Barton one-third ownership each in the tools of the company as well as one-third interest in profits. The Taunton Britannia Manufacturing Company remained in legal existence only in the capacity of a landlord. The operating company was known as LEONARD, REED & BARTON and on February 20, 1837, began business under the new name.

The year 1837 was not an auspicious one for a struggling business. More than 600 banks closed their doors. Nine-tenths of the factories of the eastern states were said to have closed. Once again, they managed to survive.

By 1840, Henry Reed and Charles Barton purchased Leonard's interest in the company. Leonard continued to work for the company as salesman-treasurer and the Leonard, Reed & Barton mark was used on some company wares. However, when the company applied for a renewal of their trademark registration, they claimed that the name "REED & BARTON" had been used since August 26, 1840. Possibly both marks were used from 1840 to 1847.

By 1848, Reed & Barton were turning their attention to plated silverware. The company's first chased designs were produced in 1852.

The transition from the 1837 Reed & Barton shops to the 1859 factory was gradual, but inevitable. Specialization emerged through necessity for business growth. New marketing methods were introduced and were extremely successful.

The 1850s, with its demands far exceeding the producing capacities of some large companies, gave rise to a confusing competitive situation. Started by the Meriden Britannia Company, which purchased large quantities of wares from other manufacturers, other companies soon followed. This often placed the manufacturer in the position of competing with his own goods. Goods manufactured by Reed & Barton might be sent to Hartford for a coating of Rogers Bros. silverplate and a Rogers Bros. stamp, and appear in the market in competition with the Reed & Barton plated line.

In the middle 1860s jobbers and retailers, who operated their own plating shops purchased two-thirds of the factory output. They purchased quantities of wares "in the metal," plated them and sold them with their own trademarks. Practically none of the britannia or plated silver makers could supply a complete line. Reed & Barton bought most of its flatware from Rogers & Brother and the Hartford Manufacturing Company. They produced little of their own flatware except for the hotel trade until the 1860s. Flatware of almost all manufacturers turned up in many different catalogs and with many trademarks. Rogers & Brother, on the other hand, in 1865 was one of Reed & Barton's largest customers for holloware. That is why it is not unusual to find identical pieces of flatware and holloware bearing the trademarks of either company.

The depression of 1866 and 1867 brought about the failure of many jobbing concerns, a large number of whom abandoned plating and confined themselves to wholesale business.

On September 13, 1867, Charles Barton died with Henry Reed at his bedside. In 1868 a new partnership, consisting of Henry Reed, Henry Fish and George Babrook who had long been active in marketing, was formed. Each assumed a third interest. The name of the firm continued unchanged. In February, 1888, the company was incorporated.

The extension of the market for solid silver services led Reed & Barton into their production in 1889.

As early as 1903, Reed & Barton began to reproduce colonial pewter ware which for more than thirty years was popular and a financial success.

Sterling flat and holloware replaced plated ware in more and more homes so that by 1904 sterling had become the largest selling line produced.

In 1911 a moderately low-priced line was marketed under the name Reed Silver Company. It passed out of existence in 1913 because the ware did not come up to the standard expected of the Reed & Barton name.

In 1913 the Hopewell Silver Company was formed to market a high-quality line of small items. They also put out a line of Lenox china with silver and gold deposit. Both lines failed in 1918.

In 1928 Reed & Barton purchased the Dominick & Haff Company of Newark, New Jersey.

In the 1930s the Viking brand of plated holloware was brought out and terminated in 1941 with the revival of a demand for quality wares.

The production of stainless steel flatware at Reed & Barton began as a result of national defense requirements in the early 1940s, but soon became an important consumer product when World War II ended.

In 1950 the Webster Company became a subsidiary. During the 1950s and 1960s, Reed & Barton continued to strengthen its various product lines and increase its share of the market. This was accomplished in part through the investment of millions of dollars in new manufacturing space and equipment, expanded national advertising and design research.

Today the Reed & Barton Corporation has grown to include four divisions: Reed & Barton Silversmiths, fine silversmiths for over 170 years; The Eureka Manufacturing Company, manufacturers of wooden and fabric silverware and jewelry chests for retail and contract customers; Reed & Barton Housewares, distributors of stainless steel flatware to catalog showrooms, food service markets and housewares departments; The Sheffield Silver Company, manufacturers of silverplated holloware for retail and catalog showroom accounts.

Reed & Barton is the exclusive United States distributor of Belleek Parian China and Galway Irish Crystal and manufactures licensed products for the Ralph Lauren Home Collection, Swid Powell and the Atlanta Committee for the 1996 Olympic Games. Additionally, the company was selected to manufacture the gold, silver and bronze Olympic medals for the 1996 Atlanta Olympic Games.

The story of Reed & Barton is in many ways unique in the annals of American business; it is the oldest independent silver company in America, and continues to be one of the most

distinguished names in fine giftware today. Reed & Barton continues to be managed by the family members of Henry Reed. And perhaps it is because of these continuous, close family ties spanning many generations that the management and workers at Reed & Barton today have the same sense of unity and dedication to craftsmanship as their founding fathers.

HOPEWELL
SILVER CO.

(Registered July 29, 1890)

(On sterling silver)

Viking Brand

REED & BARTON
(Nickel Silver Flatware and Holloware.)

GOLDYN-BRONZ
(On plated silver)

REED ● BARTON
TRADE ● MARK

(White Metal Holloware.)

Trade Mark

Sterling

TRADE MARK

STERLING

REED & BARTON
(On pewter)

SILVER ARTISTS CO.

REED & BARTON
YEAR MARKS

Year	Mark		Year	Mark	
1928	⚲	👁	1944	✈	
1929			1945	Ⓐ	🔨
1930			1946	★	
1931			1947	⚖	
1932			1948	U	
1933			1949		
1934			1950		
1935			1951		
1936			1952		
1937			1953		
1938			1954		
1939			1955		
1940			1956	♡	
1941			1957		
1942	V				
1943					

From 1928 through 1957 Reed & Barton year-marked all holloware with symbols.

Reed & Barton Jewel Case manufactured according to William C. Beattie's Invention Patent No. 225,787. This particular piece is marked "Patent Applied For", indicating it was produced some time between October 16, 1879 when the patent application was filed and March 23, 1880 when the patent was granted. (Photo by Judy Redfield)

REED, BARTON & COMPANY
Taunton, Massachusetts

Set up in 1886 for electroplating. This short-lived enterprise was managed by Edward Barton, son of Charles Barton, and a Waldo Reed, no relation of Henry Reed, but a son-in-law of Charles Barton. They attempted to capitalize on the reputation of the established Reed & Barton name. Bought out in 1892 by Reed & Barton.

Engineer's working drawing for Reed & Barton's "Francis I" pattern coffee pot. (Photo courtesy of Reed & Barton Silversmiths)

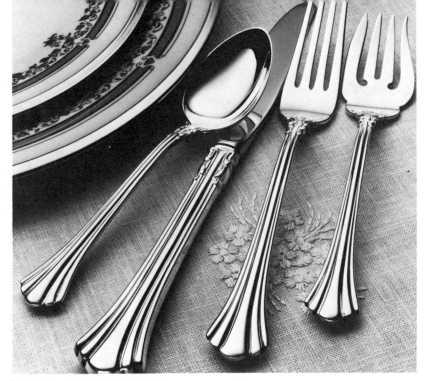

Above: *Reed & Barton's "18th Century" pattern sterling flatware. (Photo courtesy of Reed & Barton Silversmiths)*
Below: *Reed & Barton's hand chased "Francis I" coffee set in sterling. (Photo courtesy of Reed & Barton Silversmiths)*

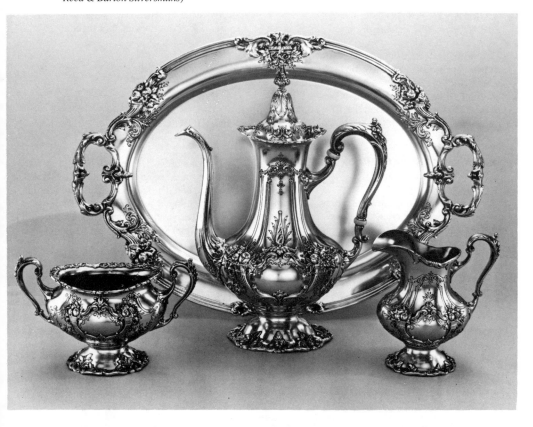

REED SILVER COMPANY
See Reed & Barton

REEVES & BROWNE
Newark, New Jersey
See Jennings & Lauter

REEVES & SILLCOCKS
New York, New York
See Jennings & Lauter

THE REGAL SILVER MFG. CO.
New Haven, Connecticut
See Majestic Silver Co..

(Used 1910 to present)

REGAL SPECIALTY MANUFACTURING COMPANY
See Majestic Silver Company

Firm associated with the Majestic Silver Co. It began manufacturing silverplate and stainless steel flatware in the 1930s. Production of silverplate flatware ceased after World War II. After a 1945 reorganization the firm continued as a subsidiary of Majestic Silver Co.

REGENT MANUFACTURING CO.
Location unknown, Canada?

Marks found on holloware pieces. The mark with the crown with circles on top was found on a piece dating c. 1870s. The other mark appears to date c. 1890s.

REIBLING-LEWIS, INC.
Providence, Rhode Island

Manufacturers of sterling holloware and jewelry c. 1950.

GOLDEN WHEEL

OTTO REICHARDT CO.
New York, New York

Listed in KJI 1922 and 1924 as a manufacturer of gold and silver cane and umbrella handles. Found in Directories through the 1960s. In 1961 listed at a Brooklyn address as manufacturers of sterling wares. Not listed in 1973.

FRIEDRICH R. REICHEL
San Francisco, California

Born about 1824, Friedrich Reichel entered the jewelry business in San Francisco by the latter part of 1856. By 1861 he was manufacturing silverware as well as jewelry. His employees included silversmiths William Schulz and Emil Fischer, jeweler-foreman Gotthard Koehler and bookkeeper Charles Ritter. Reichel's prosperous business was cut short by his death in 1867. Koehler and Ritter (q.v.) became his direct successors. Schulz and Fischer (q.v.)formed a firm of their own. (Morse, in Morse, ed. *Silver in the Golden State* 1986, p. 9)

REICHENBERG-SMITH CO.
Omaha, Nebraska
See A.F. Smith

Firm founded in 1894. Later became A. F. Smith Co.

IMPERIAL SILVER PLATE CO.

REISTLE & JOOST
Brooklyn, New York

Charles Reistle first appears in the Brooklyn city directory published in 1865 listed as a "manufacturer". The following year he appears as a silverplater, whether working for himself or someone else is unclear. By 1867 he was operating his own silverplating business. By 1868 he had gone into partnership with George Joost to form the firm of Reistle & Joost. They continued in business under the same name the following year.

By 1870 Joost had disappeared from the Brooklyn city directories, Reistle remained, but without a business listing. Records for 1871 and 1872 were unavailable. By 1873 Reistle was in the curtain ornament business. However, by 1875 he was back in the silverplating business, although no indication was given as to whom he was working for. Not yet followed beyond 1876.

Charles Reistle received two invention patents for silverplate items, Invention Patent No. 72,758 granted December 31, 1867 for a Table Caster, and Invention Patent No. 87,201 granted on February 23, 1869, for a spout for a syrup pitcher .

RENOMMEE MFG. CO.
Newark, New Jersey

Listed in JC 1896-1904 in sterling silver and sewelry sections.

R. M. CO.

RENTZ BROS.
Minneapolis, Minnesota

Listed in 1896 Jewelers' Weekly as manufacturers of sterling silverware. Also importers of jewelry. Listed KJI 1924 as a manufacturer of diamond mountings, special order work in watch cases and jewelry, medals and class pins, plus repairing and engraving. Last record found was c. 1935.

< STERLING >

REVERE SILVER CO.
Brooklyn, New York
See Crown Silver, Inc.

Revere Silversmiths Inc. was founded in Brooklyn about 1914. In 1955 it was combined with The Hasselbring Silver Co. and the J. W. Wolfenden Corporation to form Crown Silver Inc.

Revere Silver Co. succeeded Revere Silversmiths, Inc. c. 1960 as a Division of Crown Silver, Inc., New York. Manufacturers of sterling holloware. (1975)

REVERE SILVERSMITHS
Brooklyn, New York
See Crown Silver Inc.

Founded in Brooklyn about 1914.

THOMAS REYNOLDS
Brooklyn, New York

Thomas Reynolds was working as a silverplater in Brooklyn at least as early as 1856. He operated his business out of his home, and continued in business for himself through 1863. He continued to appear in the Brooklyn directories sporadically after that at least through 1876,

always as a silverplater, but with no business address given.

JOSEPH T. RICE
Albany, New York
See Mulford & Wendell

Silversmith 1815-1853. John H. Mulford was apprenticed to him.

BERNARD RICE'S SONS
New York, New York

Although this firm was previously reported to have been formed by a merger of the Apollo Silver Co., Redfield & Rice and Shepard & Rice, there is no evidence at present that Redfield & Rice (q.v.) had anything to do with this later company, and considerable evidence that it probably did not.

Redfield & Rice's tools and materials were sold to the Derby Silver Co. (q.v.) in 1873. Some of its employees went to work for Derby as well. The remainder of Redfield & Rice's assets were also sold off in an effort to meet its financial obligations.

James H. Redfield never returned to the silver business after Redfield & Rice failed. He died in 1894. James Rice struggled on, working as an agent for other silver manufacturers, but declared bankruptcy in 1878, by which time he had no assets of any kind for creditors to attach.

There appears to be, at most, only the theoretical possibility of some sort of indirect family connection between the firms. Both Redfield and Rice had at least one son each. Unless one of these sons or one of their siblings were somehow directly involved in establishing the firm of Bernard Rice's Sons, there does not currently seem to be any way for even a tenuous relationship between the companies to have existed.

The merger forming Bernard Rice's Sons, probably actually involving only the Apollo Silver Co. and Shepard & Rice, took place prior to April 18, 1899 as Patent Office records show the registration of their trademark to be used on plated silverware, under the company name.

Bernard Rice's Sons are listed in KJI 1922 and 1924 as manufacturers of silverplated holloware, shaving stands, mirrors and sets. The company went out of business before 1959.

DORANTIQUE
(Copper and Brass Novelties.)

L'Aiglon
(On silverplate)

Loraline
"BeauXardt"
"ETCHARDT"
"DUTCHARDT"
(On silverplate)

PATRICIA
(On silverplate)

PEWTER BY RICE

MARION PEWTER
(APOLLO STERLING)
(On sterling)

APOLLO STUDIO
NEW YORK
(On silverplate)

B.R.S. CO.
SHEFFIELD
U.S.A.

B R S
NICKEL SILVER

APOLLO
SHEFFIELD
MADE IN U.S.A.

OBADIAH RICH
Boston, Massachusetts
See Jones, Ball & Poor

Obadiah Rich was born in Charlestown, Massachusetts in 1809 and served his apprenticeship under Boston silversmith Moses Morse. In 1830 he set up in business on his own. From 1832 to 1835 he worked in partnership with Samuel L. Ward. After Ward left the business, Rich formed an alliance with Jones, Low and Ball, and continued to work in association with that company and its successors for the remainder of his career.

Rich was a outstanding craftsman, who during the course of his career produced a number of presentation pieces of exceptionally high quality, as well as a variety of more mundane objects. One notable piece was the Webster vase, of neo-classical design, made during his partnership with Ward and presented by the people of Boston to Daniel Webster in 1835. It was patterned after the "Warwick Vase", a large marble urn which had been excavated from the villa of the Roman emperor Hadrian in 1771. Another was the elaborately decorated two and a half foot tall rococo design cup presented by Boston merchants to Samuel Cunard in 1840 when he brought the first transatlantic mail steamship service to Boston.

Sadly, Rich's eyesight began to fail, and by about 1850 it had deteriorated to the point that he could no longer work as a silversmith. He then became a business partner in the firm of Brackett and Crosby and continued there for another fifteen years. He died in 1888. (Fales, *Silver*, July-August 1986, pp. 8-13)

RICHFIELD PLATE COMPANY
See Homan Manufacturing Company

GEO. S. RICHMOND
See L. Boardman & Sons

A catalog published by L. Boardman & Sons September 1880 says that this is a tradename used on their "second quality Britannia spoons."

RICHTER MFG. CO.
Providence, Rhode Island

Manufacturers and importers of sterling silver deposit ware, novelties, and cut glass from c. 1915 to at least 1924. Found in KJI for that year.

RICKETSON COMPANY
Taunton, Massachusetts

Listed in Directories 1955-61 as manufacturers of silverware.

JOHN H. RILEY
Baltimore, Maryland

Listed in Baltimore City Directories 1876-1883 as a goldsmith and silversmith (gold beater).

GOTTLIEB RITTER
Baltimore, Maryland

Listed in Baltimore City Directories 1895-1899 as a silversmith. Succeeded by Ritter & Sullivan in 1900.

RITTER & SULLIVAN
Baltimore, Maryland

Gottlieb Ritter listed in Baltimore City Directories as a silversmith 1895-1899. Joined by Wyndham A. Sullivan in 1900 in the firm of Ritter & Sullivan which continued in business until 1915.

TRADE ⟨R&S⟩ MARK

CHAS. M. ROBBINS
Attleboro, Massachusetts

What is now The Robbins Company was born during the election year of 1892.

Charles M. Robbins, the company's founder, became so interested in the presidential campaign that he designed and produced campaign buttons for his favorite candidate in his own simple shed workshop. This was the start of a business which grew to more than 20 general product lines.

At one time, The Robbins Company's jewelry enameling department was the largest in the world.

Principal products today (1975) are emblems, service and safety awards, badges, commemorative materials, medallions, insignia, religious and organization jewelry, advertising specialties, souvenirs, premiums and costume jewelry.

Charles Robbins was joined in 1904 by Ralph Thompson, who acquired ownership of

the company in 1910. In 1912, The Robbins Company was formed.

In October, 1961, Robbins acquired a wholly owned Canadian subsidiary, Stephenson, Robbins Company, Ltd., Montreal, Canada.

In July, 1963, The Robbins Company became a wholly owned subsidiary of Continental Communications Corporation of New York. The new owners sold the Canadian subsidiary in 1964. The firm discontinued the production of plated flatware before 1915.

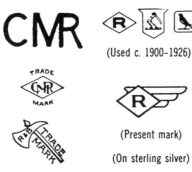

(Used c. 1900-1926)

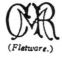

(Present mark)

(On sterling silver)

(Used before 1900)

(*Flatware.*)

(On plated silver)

E. M. ROBERTS & SON
Hartford, Connecticut
See J. O. & W. Pitkin

CHRONOLOGY
E. M. Roberts & Co.	1860-1879
E. M. Roberts	1880
E. M. Roberts & Son	1881-1890

Edwin M. Roberts began work in the silver business as an apprentice to Walter Pitkin in East Hartford. About 1860 he purchased the business from his former employer, and the firm became E. M. Roberts & Co. (McGrew, *Silver*, May-June 1990, p. 17)

By 1861 the firm was advertising itself in the Hartford city directories as "silver spoon manufacturers". By 1863 they were describing themselves as "Manufacturers of Pure Silver Ware". The ads appeared through 1868, after which the firm apparently closed its Hartford order office.

E.M. Roberts & Co. continued in operation in East Hartford until 1879 when the plant burned. (McGrew, ibid.)

In 1880 the firm moved to Trumbull St. in Hartford as E. M. Roberts. It advertised itself in the Hartford directory published in 1880 as a "Manufacturer of Solid Silver and Plated Ware of All Kinds, Old Ware Replated, Hollow Ware Repaired". The ad gave the company a founding date of 1830, the year that the firm of J. O. & W. Pitkin was formed.

By 1881 the company had moved to Market St. and become E. M. Roberts & Son. Principal partners in the new firm were Joseph W. Roberts, the son of E. M. Roberts, and Wallace N. Kenyon who had previously worked for the William Rogers Manufacturing Co. They described themselves as "Dealers in and Manufacturers of Finest Quality Solid Silver and Plated Ware", and offered "Gold, Silver, Nickel, Brass, Copper and Oreide Plating" plus repair and replating services and "Etching on Steel, Ivory, and all kinds of Metals". In addition, they listed the firm's founding date as 1825, presumably referring to the year that John Owen Pitkin first went into business. By virtue of this, they also claimed to be "The Oldest Manufacturers of Solid Silver Ware in the State".

"The business failed in 1890 and was reported to be taken by William Rogers Mfg. Co., one of the heaviest creditors." (JW 11-13-1890)

ROBESON CUTLERY CO, INC.
Perry, New York

Manufacturers of silverplated steak knives c. 1950-65

GOURMET CARVERS
ROBESON "SHUR EDGE"

J. W. ROBINSON
New York, New York
See J. Corduan & Bro.

James W. Robinson first appears in the New York City directories in 1861 listed as a plater with no business address given, but probably working for Benjamin Corduan, whose business he subsequently purchased. By 1862 he was in business for himself.

His ad in the directory published that year states: "Door, Number, Pew-Plates, Bell Pulls, Knobs &c. furnished to the trade. "Old Wares of all kinds Replated at short notice, and Warranted"

Robinson continued in business at least through 1874, as far as he has been followed currently.

JOSEPH ROBINSON & CO.
Toronto, Ontario, Canada

Joseph Robinson and his brother Charles formed Joseph Robinson & Co. about 1859. When Joseph Robinson retired in 1880, the firm became Robinson & Bro. (Unitt & Worrall, *Unitt's Book of Marks,* 1995 p. 48)

ROCHESTER STAMPING CO.
Rochester, New York

Listed in KJI 1922 as a manufacturer of silverplated holloware, nickel ware, electric table utilities, percolators and urns. An ad in the same issue promotes the firm's "Royal Rochester" Silverware line. Not found in KJI 1924.

ROCKFORD SILVER PLATE CO.
Rockford, Illinois
See Sheets-Rockford Silver Plate Co.

ROCKWELL SILVER COMPANY
Meriden, Connecticut

Organized in 1905 by Lucien Rockwell and James W. Mackay. Prior to his founding of Rockwell Silver, Lucien Rockwell had been a salesman for Chapman Manufacturing Co., which had manufactured saddle hardware and sleigh bells in Meriden.

Rockwell Silver was a manufacturer of sterling silverware, china, glassware and silver deposit ware. They merged with Silver City Glass Co. in 1978 to form Decorex Industries Inc. (q.v.)

(For glass candlesticks ornamented with applied silver. Used since August 10, 1914)

RODEN BROS., LTD.
Toronto, Ontario, Canada

The company was formed in 1891 by Thomas and Frank Roden, who went into partnership to manufacture sterling silver, silverplate and cut glass. The firm's silverplated wares were called "Dutchess Plate" (Pack, *Collector's Guide*

To Canadian Souvenir Spoons, 1988, p. 54-55)

The company became Roden Bros., Ltd. between 1904-1915.

During the early decades of the 1900s their retail agents were The Goldsmith's Stock Company of Canada (q.v.). In addition to manufacturing their own wares, Roden Bros. also produced and trade marked silver products for other companies. The firm continued in operation under Alfred J. Roden and Dudley Roden, heirs of the founders, into the late 1950's when the business was purchased by Birks (q.v.)

Between 1891 and 1907 the company copyrighted seven different designs for silver souvenir spoons including an Indian Head, a bust of Sir John A. Macdonald, Canada's first Prime minister, and a full figure of Samuel de Champlain. (Pack, ibid pp. 54-59)

Marks below, in addition to those from the previous edition are from Pack (ibid., pp. 55, 80) and Unitt & Worrall, *Unitt's Book of Marks*, 1995, p. 49.

ELECTRO PLATE

JOSEPH RODGERS & SONS
Sheffield, England

Cutlers, silversmiths and electroplaters for more than two centuries. Also manufacturers of silver and plated wares. Their trademark was probably the oldest in continuous use, being granted in 1682.

Although they registered their trademark U. S. Patent Office, No. 16,478, April 9, 1889, they had attempted to break into the American market much earlier. The firm is listed in the New York City directory published in 1869.

For the protection of their reputation for high quality, they acquired the business of all cutlery firms in Great Britain bearing the names "Rodgers" or "Rogers". They are today the best known producers of quality cutlery in Sheffield and the oldest in the world.

Apparently shortly after their arrival in the United States in the late 1860's, they attempted to supplant the American "Rogers" firms as well. An ad published in the *New York Tribune*, October 23, 1871, shows the firm's corporate mark and warns the public "not to purchase of Joseph Rodgers & Sons' goods cutlery stamped 'Rogers & Son' (note the absence of the letter D with the star and Maltese cross), for such are spurious. A suit is now pending in the Supreme Court in Washington, D. C. against the users of said marks, and Joseph Rodgers and Sons will thankfully receive from the trade information touching any such or other violation of their name and trade-marks, their determination being to continue to enforce the laws against such infringements." From the date of the above ad, it would appear that the specific attack was aimed at the firm of William Rogers & Son (q.v.) Records of this legal case and its outcome have not yet been located.

However, one need only observe the many "Rogers" companies recorded in this book to realize that Joseph Rodgers & Sons' attempt to gain control of the name in North America was completely unsuccessful.

For further information on the company see Culme, *The Directory of Gold and Silversmiths*, 1987, reprinted 1992, p. 391

✳ ✠ RODGERS

(On sterling silver) (On plated Silver)

ROEDER & KIERSKY
New York, New York

Listed in JC in 1896 in sterling silver section.

R. & K.
STERLING.

ASA ROGERS, JR. & CO.
See Rogers Brothers

Successors to Rogers & Cole on June 4, 1832, when John A. Cole retired from the firm. The business was bought by William Rogers July 28, 1838.

ROGERS & BRITTIN
West Stratford, Connecticut
See Derby Silver Co.
See Holmes & Edwards

Partnership of Samuel T. Rogers of Bridgeport, Connecticut and Edwin L. Brittin, who, at the time they joined forces and applied for a trade mark at the beginning of 1880, was still residing in Derby Connecticut.

Edwin L. Brittin began work in the silverplating business as a salesman for the Redfield & Rice Manufacturing Co. (q.v.) in 1866, according to that firm's bankruptcy records in the National Archives-Northeast. Brittin worked with the trustee on liquidating that company's assets when it was forced into bankruptcy in 1872, and arranged the sale of the tools and materials from its Wolcottville flatware plant to the Derby Silver Company (q.v.), which was just setting up in business in early 1873. He became a stockholder,[1] and also salesman and plant manager for Derby as well, according to W. G. Snow. While working for Derby he also obtained a number of design patents for flatware, both on his own, and in association with Edward Schott or George Gill.

In 1879 Brittin set out to establish his own firm, and with Lewis Hotchkiss purchased property in West Stratford, Connecticut. They also purchased tools and machinery from the William Rogers Manufacturing Co.[1] The tools and machinery had probably belonged previously to the Rogers Cutlery Co. which was consolidated with the William Rogers Manufacturing Co. at about that time. Brittin and Hotchkiss planned to form a joint stock company in which they would retain a half interest. Their original idea was to sell the other half to a New York investor.[1]

The firm of Rogers & Brittin applied for its own trade mark on January 24, 1880. This trademark for jewelry, britannia, plated silver, and solid silverware was registered on May 4, 1880. It consisted of the words, letters and figures "Rogers & Brittin U. N. X. L. D. Best" written around a Maltese cross, as shown below.

Edwin L. Brittin brought designer George Gill with him from the Derby Silver Co. to the new firm. Together they obtained a number of flatware design patents for this company as well. Gill also obtained two on his own.

Rogers & Brittin was succeeded by Holmes and Edwards when that firm was organized in 1882.

The items noted above reference the R. G. Dun & Co. Collection, Baker Library, Harvard University Graduate School of Business Administration. Volume and page number are given below.
[1]CONN Vol. 36, p. 404

ROGERS & BRO.
Waterbury, Connecticut
See Rogers Brothers

Started as a partnership with Asa and Simeon Rogers, Leroy S. White and David B. Hamilton in 1858. Their first goods were stamped (Star) Rogers & Bro. A-1, causing confusion between their stamp and the one used by the Hartford Co. which was (Star) Rogers Bros. A-1.

Hamilton's eldest son joined the business after the withdrawal of Asa and Simeon Rogers and in 1886 was one of the organizers of Rogers and Hamilton.

What is believed to be the first fancy pattern made in electroplated ware in this country was the *Olive* design, made in the blank, silverplated and finished for marketing from the Rogers & Bro. plant. Earlier, the *Olive* pattern had been sold here, the blanks being imported from England and only the plating being done in this country.

Rogers & Bro. was exclusively a flatware plant for many years, producing German silver blanks for the trade. By 1869 they were also supplying blanks for many other concerns to plate and finish after stamping them with their own trademarks. They are believed to have added holloware to their production about 1874. This was

one of the original companies that became part of the International Silver Co. in 1898.

(*Hollowware.*)

★ **ROGERS & BRO., A 1.**
(*Best Quality Flatware.*)

R. & B.
(*Second Quality Flatware.*)

★ **ROGERS & BROTHER,**
(*H. H. Knives.*)

★ **ROGERS & BROTHER, 12**
(*No. 12 Steel Knives.*)

★ **R & B**
(*Pearl Knives.*)

ROGERS & BRO.—GERMAN SILVER
(*German Silver Flatware, Unplated.*)

MANOR PLATE
(on low priced line)

Silverplated flatware patterns bearing these trademarks discontinued about 1976.

ROGERS BROS.
See Rogers Brothers

In 1847, Asa Rogers, Jr. with his brothers produced and distributed plated silver spoons carrying the ROGERS BROS. trade mark.

ROGERS BROTHERS
Hartford, Connecticut

In 1820 William, the eldest, left the parental farm to become an apprentice to Joseph Church, jeweler and silversmith in Hartford, Connecticut.

In 1825 William became Church's partner in making coin silver spoons stamped CHURCH & ROGERS. Before 1835, Asa, Jr. and Simeon Rogers were both associated with the firm. William also stamped spoons with his individual (EAGLE) WM. ROGERS (STAR) mark during this time (1825-1841). His spoons are noted for their symmetrical outline, pleasing proportions and fine finish.

Early in 1830 Asa, Jr. formed a partnership with John A. Cole, in New Britain, ROGERS & COLE, to manufacture coin silver flatware.

When Cole retired on June 4, 1832 the name of the firm was changed to ASA ROGERS, JR. & CO. with William Rogers as a partner. In 1834 William left the company, and Asa, Jr. continued the business alone, moving to Hartford.

William continued his partnership with Church while associated with Asa, Jr. in New Britain. This partnership continued until August 2, 1836, when William moved to his own shop, under the name WILLIAM ROGERS. He was one of the first in this country to advertise and manufacture tableware of sterling silver, as it had been the general practice to use coin silver.

On July 23, 1838, William bought the spoon manufactory of Asa, Jr. In 1841 Asa, Jr. returned to Hartford and advertised that he was once again making spoons.

Simeon learned the trade in William's business and in 1841 was admitted as a partner in the jewelry and silverware store WM. ROGERS & CO., with the new mark (EAGLE) WM. ROGERS & CO. (STAR) stamped on their coin silver spoons.

About 1843-1844 Asa, Jr. experimented with electroplating in association with Wm. B. Cowles and James H. Isaacson and on November 13, 1845, the COWLES MFG. Co. in Granby was formed to manufacture German silver and silverplated spoons, forks, etc. Stockholders were William B. Cowles, Asa Rogers, Jr., Jas. H. Isaacson, and John D. Johnson. In 1846 Asa, Jr., William and Isaacson left COWLES MFG. CO. and it went out of business a few years later.

Although it has been reported previously that between 1845 and 1846, William and Asa, Jr. manufactured electroplated silverware in partnership with John O. Mead (q.v.), in Hartford as ROGERS & MEAD, no listing for such a partnership can be found in the Hartford city directories. While a John O. Mead was living in the

same house as Asa Rogers, Jr. and working as a plater in 1846, he was clearly not the same John O. Mead who by 1847 had opened his own business in Philadelphia. Hartford's John O. Mead continued to reside in that city and work as a plater until 1850.

Early in 1847 Asa, Jr., in cooperation with his brothers, produced and distributed silverplated spoons carrying the ROGERS BROS. trademark. Advertisements of this period read as if WM. ROGERS & CO. (composed of William and Simeon) were the producers.

ROGERS BROS. were unable to handle their increasing volume of business, so in 1853 a new company was organized - ROGERS BROS. MFG. CO. William and Asa, Jr. were large stockholders; William was president. Simeon did not join the firm except as a stockholder a few months later.

In 1856 William Rogers left ROGERS BROS. MFG. CO. and with George W. Smith , manufacturer of silverplated holloware, organized ROGERS, SMITH & CO. The two companies were consolidated in 1861 with William as president.

In 1862 the MERIDEN BRITANNIA CO. bought the tools and dies of the company. William joined MERIDEN BRITANNIA CO. to direct production of the 1847 ROGERS BROS. line, but continued to live in Hartford.

In 1865 William became an organizer and partner in the WILLIAM ROGERS MFG. CO. Associated with him was his elder son Wm. Rogers, Jr. They manufactured plated silverware. Asa, Jr. and Simeon, still stockholders in ROGERS BROS. MFG. CO., established ROGERS & BROTHER CO. in Waterbury in 1858. It was incorporated the following year.

William H. Watrous, the nephew of Asa Rogers, Jr., organized the ROGERS CUTLERY CO. in Hartford in 1871. Frank Willson Rogers, the younger brother of William Rogers, Jr., served as secretary and a director of the firm in the late 1870s. The company manufactured silverplated flatware and steel cutlery. It was taken over by the WILLIAM ROGERS MFG. CO. in 1879. That firm became part of INTERNATIONAL SILVER CO. in 1898. William, Asa, Jr. and Simeon were all under contract with the MERIDEN BRITANNIA CO. when they died.

ROGERS BROS. MFG. CO.
See Rogers Brothers

Organized 1853 by William and Asa Rogers, Jr. Simeon Rogers became a stockholder in a few months.

According to the corporate listing in the Hartford city directory published in 1854, the firm had a capitalization of $50,000. Its original officers were William Rogers, President, T. C. Allyn Secretary, and Job Allyn, Treasurer. The Allyns had previously been involved in the grocery business.

When William Rogers left to form Rogers, Smith & Co. in 1856, Job Allyn became President, and Simeon S. Rogers took over as Treasurer. Directors were Job Allyn, Simeon S. Rogers and Asa Rogers.

By 1859 the Allyns had left the company and gone on to other business ventures. Asa Rogers also was no longer listed as associated with the company. William Rogers resumed the position of President. George W. Smith, Rogers' partner in Rogers, Smith & Co. became Secretary, and E. T. Goodrich, Treasurer. Directors were William Rogers, E.T. Goodrich, Samuel Bancroft, John P. Elton, and William H. Rogers.

The firm was consolidated with Rogers, Smith & Co., October 1, 1861 because of financial difficulties.

(Used only 1853-61)

C. ROGERS & BROS.
Meriden, Connecticut
See International Silver Co.

Organized February 26, 1866 by Cephas B. Rogers, Gilbert Rogers, and Wilbur F. Rogers when they bought the stock in trade of "one Frary" - probably James A. Frary who had died in December 1865. Their first products were casket hardware and furniture trimmings. During the 1870s the firm obtained numerous design patents for various items of coffin hardware.

Their use of "C. Rogers & Bros." trademark on silverplated spoons resulted in court action. They were permitted to use the trademark and continued to do so until the concern was bought by International Silver Co. in 1903.

Their products were considered an "imitation" of the original Rogers brothers by the owners of the Meriden Britannia Co. who were instrumental in forming the International Silver Co., and none of their trademarks were ever used by International.

SO. MERIDEN SILVER CO. QUADRUPLE

This tradename was used in a holloware catalog of 1899 with a statement that it is "nicely finished but not standard plate" and " made to supply the demand for a good quality of silver plated ware at moderate prices". This bears out the belief that there was no such thing as a standard quadruple plate.

C. ROGERS & BROS., A 1.

ROGERS & COLE
See Rogers Brothers

Organized in 1830 by Asa Rogers, Jr. and John A. Cole in New Btitain to manufacture coin silver flatware. Out of business June 4, 1832.

ROGERS CUTLERY CO.
Hartford, Connecticut
See Rogers Brothers

The Rogers Cutlery Co. was incorporated August 31, 1871 with an initial capital of $6,250. William H. Watrous served as President, and Henry H. Moore as Secretary. The directors were William H. Watrous, Theodore Rogers and Henry H. Moore. By 1873, the firm's capital value was raised to $25,000, and S.F. Watrous had replaced Theodore Rogers on the board. By 1875, the entire board was composed of members of the Watrous family, when William's mother, Julia A. Watrous, became the third director.

The firm ran illustrated ads in the Hartford directories published in 1877 and 1878 depicting some of the flatware patterns and cutlery items it produced.

F. Willson Rogers (q.v.), the younger son of Willam Rogers, became Secretary of the corporation and a member of the board in 1878, taking the position formerly held by Julia Watrous.

The Rogers Cutlery Co was consolidated with the Wm. Rogers Mfg. Co., Hartford, Connecticut in 1879. Its tools and machinery were sold to Lewis Hotchkiss and Edwin L. Brittin who went on to establish the firm of Rogers and Brittin (q.v.).

The Rogers Cutlery Co.'s marks continued to be used by the combined company. One of the original firms forming the International Silver Co. in 1898.

R. C. CO. AI PLUS

ROGERS CUTLERY CO.

F. B. ROGERS SILVER CO.
Taunton, Massachusetts

Founded 1883 in Shelburne Falls, Massachusetts. Moved to Taunton in 1886, at which time it was incorporated. Successors to West Silver Co. before 1896. Became a division of National Silver Co. in February 1955. Still in business. (1975)

276

F. WILLSON ROGERS
Hartford, Connecticut

Born in 1852, Frank Willson Rogers, who usually styled himself F. Willson Rogers, was the youngest child and second son of William (Hazen) Rogers. Eighteen years in age and six intervening sisters separated him from his elder brother, William Henry Rogers, sometimes known as William Rogers, Jr.

William Rogers, Jr. was already grown and working as a clerk for the family business before F. Willson Rogers was even born. William Rogers, Jr. had a close working relationship with their father, which, due to his age, F. Willson Rogers was unable to share. When William Rogers Sr. died in 1873, F. Willson Rogers was only 21. These factors tended to fuel an intense rivalry between the two sons.

When he apparently went into business on his own in 1875, one of F. Willson Rogers first acts was to obtain his own trade mark, shown below, proclaiming himself "William Roger's Son" and incidentally coming as close as possible to the name of his father and brother's final business venture, the silverplating business of William Rogers & Son (q.v.). It is not known whether this mark was ever actually used.

F. Willson Rogers is listed as a jeweler, though no business address is given, in the Hartford directories published in 1876 and 1877. In 1878 he advertised himself as a "manufacturer of fine electro-plated knives, forks, spoons, ladles, tea sets, castors, etc., etc." as though he were in business for himself, when he actually was working for the Rogers Cutlery Co. (q.v.)

This ad was very similar to the one his brother was running for that same year.

F. Willson Rogers appeared to take advantage of any opportunity to put his name in the limelight. Although William H. Watrous was still President of the Rogers Cutlery Co. in 1878, Rogers replaced Watrous' name as President with his own as Secretary on that company's advertisement in the city directory for that year.

In 1879 F. Willson Rogers obtained Design Patent No. 11,431 for a flatware pattern, known as "Hartford" which was subsequently produced by the William Rogers Manufacturing Co.

By 1879 he was serving as secretary for both the Rogers Cutlery Co. and The William Rogers Manufacturing Co., and advertising himself as a private individual using lettering nearly as large as that employed for the names of the two companies he represented. Meanwhile, William Rogers, Jr. was so incensed by the claims made by and about these businesses that his younger brother was associated with, that he took out large ads in the Hartford city directory to refute them, for at least three years running.

Not yet followed beyond 1881.

(Metal and Plated Ware)

Trademark registered in U. S. Patent Office Dec. 7, 1875 for metal and plated ware, to Frank W. Rogers, Hartford, Connecticut.

ROGERS & HAMILTON CO.
Waterbury, Connecticut
See Holmes, Booth & Haydens
See International Silver Co.

Rogers & Hamilton Co. was incorporated February 14, 1886 and produced silverplated flatware, taking over the spoon business of Holmes Booth & Haydens and occupying their building for eight or ten years. President and a stockholder was Charles Alfred Hamilton, who had travelled for Rogers & Brother, Waterbury, for some time. William H. Rogers was made secretary and was a stockholder. Undoubtedly asked to join the company for the use of his name as he was not a silversmith, but was a cigar dealer in Hartford.

One of the original companies to become part of International Silver Co. in 1898.

ROGERS & HAMILTON
(on regular grade)

ROGERS & HAMILTON, A 1."

ROGERS & HAMILTON 12

HAMILTON

HAMILTON.
(on finest grade)

HENRY ROGERS, SONS & CO.
Montreal, Quebec, Canada

Listed in JC in 1909 in plated silver section. No Record after c.1915.

TRADE MARK

H.R.S & C9

H.O. ROGERS SILVER CO.
Taunton, (Massachusetts?)

Stamped on a soft metal four piece tea set, two pieces have the Rogers name, while the other two are marked Newburyport Silver Co., Taunton.

H. O. ROGERS SILVER CO.
Taunton

J. ROGERS SILVER CO., INC.
See Oneida Silversmiths

ROGERS, LUNT & BOWLEN CO.
Greenfield, Massachusetts
See Lunt Silversmiths

The Pythagorean symbol R L & B Co. was the original Rogers, Lunt and Bowlen Co. registered trademark. Later, they registered the trademark "Treasure" and used it from 1921 to 1954. This has now been abandoned, and only the registered LUNT is used. "Little Men and Little Women" was used solely for sterling silver baby goods. "Wee Folks" was used on some pieces of silverplated babyware.

"Treasure" Solid Silver

Little Men and Little Women

ROGERS & MEAD
Hartford, Connecticut.
See Rogers Brothers

In 1845, William and Asa Rogers, Jr. are reported to have been in partnership with a J. O. Mead, manufacturing electroplated silverware in Hartford under the name Rogers and Mead. No direct evidence for this partnership can be found in the Hartford city directories, although a John O. Mead who was a silverplater shared the same residence as Asa Rogers in 1846. This John O. Mead is apparently not the same person as the John O. Mead (q.v.) of Philadelphia. This John O. Mead continued to live in Hartford through 1850. The partnership of Rogers & Mead was reportedly dissolved in 1846. The other John O. Mead was in Philadelphia by 1847.

ROGERS PARK SILVERWARE CO.
Chicago, Illinois

An 1895 account states that "The Rogers Park Silverware Co. of Chicago have been closed on chattel mortgages given to the Silver Metal Mfg. Co., Oswego, N. Y." (JC&HR 12-14-1895, p. 26)

ROGERS SILVER PLATE CO.
Danbury, Connecticut
See C. Rogers & Bros.

Listed in JC from 1896 through 1922 and in KJI 1922 and 1924. Founded by Nathaniel Burton Rogers in association with his brothers Cephas B. Rogers and Gilbert H. Rogers, who, with another brother, Wilbur F., were principals in the firm of C. Rogers and Bros. of Meriden, Connecticut, which later became a part of the International Silver Co.

Rogers Silver Plate Co. manufactured silverplated novelties - candlesticks, book ends, pincushions, etc. After the death of the founder, the assets of the company were purchased by Cephas B. (II), who was a manufaturer of electric lighting fixtures and lamps. The 1924 KJI indicates this addition to the business. At some point Cephus II changed to manufacturing novelties under his own name, which he continued to do until his retirement in the early 1950's.

SIMEON L. & GEO. H. ROGERS CO.
Hartford, Connecticut
See Oneida Silversmiths

In business 1900. Acquired by Wm. A. Rogers Limited in 1918. Purchased by Oneida in 1929.

ACORN

SIMEON L. & GEO. H. ROGERS CO.
◻S. L. & G. H. ROGERS CO.
S. L. & G. H. R. CO.
◻ROGERS ◻

ROGERS, SMITH & CO.
See Rogers Brothers
See Smith & Company

Organized January 1, 1857 by William Rogers, Sr. and George W. Smith to manufacture silverplated and britannia ware. The firm had a capitalization of $150,000. William Rogers served as President, George W. Smith as Secretary, and Elisha Colt as Treasurer. Directors were William Rogers, George W. Smith, Elisha Colt, Tertius Wadsworth, E. C. Roberts, Lucius Barbour and Loyal Wilcox. Only Rogers and Smith had any first-hand knowledge about the silver manufacturing business. The regular occupations of the other directors ranged from manufacturing firearms to lightning rods.

In its initial directory listing Rogers, Smith & Co is described as *"Manufacturers of the finest quality of Silver Plated Goods* of every description. In our assortment may be found Tea Sets, Urns, Tea Kettles, Cake Baskets, Pitchers, Cups, Goblets, Spoon Cups, Butter Dishes, Communion Ware, Ice pitchers, Casters, Mustard Cups, Molasses cups and plates, Salt Cellars, Lamps, Candlesticks, Wine Stands, etc., plated on fine white metal; Also Spoons, Forks, Ladles; Butter, Cake, Pie, Fish, Crumb, and Ice Cream Knives. Cake baskets, waiters, Soup Tureens, Vegetable Dishes, Cups, Goblets, Butter Dishes, Ice Pitchers, Casters, etc. plated on finest Albata and German Silver. Britannia ware in great variety and superior quality. Hartford, Conn. WM. ROGERS late senior member and president of Rogers Bros. Co. GEO. W. SMITH, late Smith & Co., Albany, N. Y."

George W. Smith was the holloware specialist in the partnership. He apparently had a particular interest in ice pitchers. In 1858 he obtained Invention Patent No. 20,592 for a triple walled ice pitcher, and Design Patent No. 1,028 for its exterior decoration. In 1860 he received another ice pitcher design patent, No. 1,219. He also created a tea service, for which he received Design Patent No. 1,096 in 1859.

However, not all the holloware sold by the firm was of its own manufacture. Some items were obtained from the Meriden Britannia Co. in the metal.

Rogers, Smith & Co. consolidated October 1, 1861 with Rogers Bros. Mfg. Co. because of financial difficulties.

By 1862 the firm's capitalization, as a result of the merger, was listed as $200,000. William Rogers was no longer shown as a member of the company's board of directors. Elisha Colt had taken over the position of President, and two new board members had replaced two of the previous incumbents.

On August 12, 1862, the flatware division was sold to the Meriden Britannia Co. and the Rogers brothers went to work for them. However, William Rogers continued to live in Hartford.

Edward Mitchell, formerly with Rogers, Smith & Co. bought the holloware division, and on November 6, 1862 organized the Rogers, Smith & Co. of New Haven for the manufacture of holloware.

On January 13, 1863, the Meriden Britannia Co. bought the holloware division of the Rogers, Smith & Co. of New Haven. The business continued in New Haven.

In June 1865 the plating shop of the Rogers, Smith & Co. of New Haven was moved to Meriden and consolidated with that of the Meriden Britannia Co. on January 1, 1866.

On May 22, 1876, the Meriden Britannia Co. directors voted to bring the business of Rogers, Smith & Co. to Meriden on January 1, 1877.

There is merchandise in existence with trademarks bearing the names of Hartford, used from 1857 to 1862; New Haven, 1862 to 1877; West Meriden from 1877 until the early 1880s (when the term West Meriden went out of general use), and Meriden, which was used from that time until about 1918. The Rogers, Smith & Co. as a separate firm was almost non-existent when the International Silver Co. was formed in 1898. It was then simply a trademark that belonged to the Meriden Britannia Co. "Geo. B. White, manager of Rogers, Smith & Co., had been with Young, Smith & Co. which firm had furnished the Rogers brothers with the first imported spoon on which plating had been done." (JC&HR 10-3-1894, p. 18)

R. S. & CO.

ROGERS & SPURR MFG. CO.
Greenfield, Massachusetts

On the 14th of February, 1879, David C. Rogers and Geo. E. Rogers of Greenfield, Massachusetts made application to the Patent Office for the registry of the trademark shown here to be used by them in the manufacture of table cutlery, forks, etc. Geo. W. Spurr was listed as president and L.C. Pratt as treasurer. They were successors to George W. Spurr & Co. who started in business c. 1873.

W. F. ROGERS
Meriden Connecticut

Mark found on a silverplate sugar bowl dating c.1890s.

WILLIAM ROGERS
Hartford, Connecticut
See Roger Brothers

(On coin silver)

WILLIAM ROGERS
Wallingford, Connecticut
See Simpson, Hall, Miller & Co.

Marks shown below came into use by Simpson, Hall, Miller & Co. after the firm reached an agreement with William Rogers, Jr. (q.v.) in 1878 permitting them to use the Rogers name.

WM. A. ROGERS, LTD.
See Oneida Silversmiths

Wm. A. Rogers as a small storekeeper in New York began to stamp the name Rogers on tinned spoons he sold when he found that they sold better with the name Rogers on them. He soon changed to German silver spoons and lightly silverplated. He was permitted to use Wm. A. Rogers on his goods if the pieces carried the same amount of silver as the well-known Rogers Bros. standard.

This firm succeeded the Niagara Silver Co. before 1904. And, by 1918 took over the business of Simeon L. & Geo. H. Rogers Co. which had started in Hartford, Conn. in 1900. Were succeeded by Oneida Silversmiths in 1929.

According to Oneida records, Wm. A. Rogers, Ltd. was an Ontario corporation with offices in New York City and factories in Niagara Falls, New York and North Hampton, Massachusetts. The company began making plated silverware in 1894.

The (R) Rogers (R) trademark was first used about 1901. The Warren Silver Plate Co. trademark first used in 1901 was apparently derived from the fact that the New York office was at 12 Warren St.

The 1881 (R) Rogers (R) trademark was first used by Wm. A. Rogers, Ltd. c. 1910.

The Niagara Silver Co. and 1877 N. F. Silver Co. are discontinued trademarks which Oneida acquired through the purchase of Wm. A. Rogers, Ltd.

(Highest Grade Flatware.)

(Cheap to medium grade)

✠ **W. R.** ▽
(Medium Grade)
(Half Plate Flatware.)

Extra { COIN SILVER } Plate
(Silver Plate on Brass Base.)

Wm. A. Rogers WM.A.ROGERS A.I.
(12 Dwt. Knives and Forks.)

Ⓡ ROGERS Ⓡ Ⓡ ROGERS Ⓡ 1881
(12 Dwt. Knives and Forks.) (Popular grade)

NIAGARA SILVER CO.
R. S. MFG. CO.
BUSTER BROWN

R. S. MFG. CO.

(Highest Grade Hollowware.)

(Special Knives and Forks Plated with 16 Dwt. Silver.)

(Light Plate Knives and Forks.)

NEW YORK
(Medium Grade Hollowware.)

(Cheaper grade)

OXFORD SILVER PLATE CO.
(Cheaper grade)

1877 N.F. Co.

WILLIAM ROGERS & CO.
Hartford, Connecticut
See Rogers Brothers

CHRONOLOGY

William Rogers	1836-1841
William Rogers & Co.	1841-1854
William Rogers	1855
William Rogers & Son (1st Part.)	1856-1861
William Rogers, Jr.	1862
E.R. Fifield & Co.	1863-1865

In 1836 William Rogers went into business for himself in Hartford. The 1840 Hartford city directory lists him as a "manufacturer of silver spoons, forks, butter knives, &c., of the latest and richest patterns, and dealer in watches, jewelry, plated and Britannia Goods, fine pocket and table cutlery, &c. Watches and timepieces of every description repaired in the best manner by experienced workmen."

In 1841 he took into partnership his brother, Simeon Rogers, who had been apprenticed to him, and the business became known as William Rogers & Co. They used the mark (Eagle) Wm. Rogers & Co. (Star) on their coin silver spoons.

In contrast with the earlier listing, this firm promoted itself primarily as a vending jeweller, rather than a manufacturer, as evidenced by its advertisement in the 1845 directory: "Watch Makers, Silver Smiths & Jewelers, No. 4 State St. Keep constantly on hand for sale, Wholesale and Retail, Fine Gold and Silver Watches, of every description, Silver Spoons, Forks &c. made only of dollars. Jewelry, Silver Plated Goods, Britannia Ware, Fine Table and Pocket Cutlery, R. Heminway's and Law's Fine Needles, Gold pens, Gold and Silver Pencils, Thimbles, &c. at the lowest prices."

In 1849, additional text was added to essentially the same advertisement: "Also manufacturers of superior quality of German Silver Plated Spoons, Forks, Butter Knives, Ladles, &c. Plated castors, Tea Sets, Urns, Communion Sets, &c., &c. heavy plate and rich patterns."

Even after William Rogers established the Rogers Bros. Manufacturing Co. (q.v.) in 1853, he continued to operate the retail jewelry business as well. The firm likewise continued after the establishment of Rogers, Smith & Co. (q.v.) in 1858.

William Henry Rogers (later known as William Rogers, Jr.) probably began working for William Rogers & Co. as a boy. By 1851 he was old enough (18) to be listed independently in the Hartford City directories, and is shown as a clerk working for the firm. By 1855 Simeon Rogers had left the company, the "& Co." was dropped from the name, and the business was known sim-

ply as William Rogers. In 1856 the business became William Rogers & Son, when William Rogers Sr. took William Henry Rogers into partnership.

WILLIAM ROGERS & SON
(First Partnership)
Hartford, Connecticut

William Rogers, Sr. entered into partnership with his son William Henry Rogers in the jewelry business in 1856, essentially a continuation of his former business, William Rogers & Co. (q.v.) The two continued in partnership in the jewelry business through 1861.

When William Rogers Sr. left Rogers, Smith & Co. (q.v.) in 1861, he also left William Rogers & Son. William Henry Rogers continued the latter business under the name of William Rogers, Jr. in 1862.

By 1863 the business had become E. R. Fifield & Co. and operated under that name through 1865. Fifield may have been a relative (nephew? son-in-law?) of William Rogers. Although he lived in the City Hotel in 1863, he boarded in the Rogers home in 1864 and 1865. The firm was apparently out of business after that year.

WILLIAM ROGERS & SON
(Second Partnership)
Hartford, Connecticut

William Rogers returned to work in Hartford in 1865 with the founding of the William Rogers Manufacturing Co. (q.v.) By 1869 he and his son, William Rogers, Jr., had apparently left the company and formed a second partnership, this time for the purpose of manufacturing silverplated goods. It must have been a small operation, as it was conducted out of their home at 136 Trumbull St. There is a business listing for the firm in the directories published in 1869 and 1870. No business listing is given for 1871 or 1872, but both men are still shown as being in the "silverplated goods" business with their home as the business address. William Rogers, Sr. died in 1873, ending the partnership.

The mark shown below is from a silverplated spooner dating c. 1870.

WILLIAM ROGERS, JR.
(William Henry Rogers)
Hartford, Connecticut
See Rogers Brothers
See Simpson, Hall, Miller & Co.

Born in 1834, William Henry Rogers was the firstborn child and elder son of William Hazen Rogers. Eighteen years in age and six intervening sisters separated him from his younger brother, Frank Willson Rogers (q.v.). William Henry Rogers went to work for his father's firm, William Rogers & Co. (q.v.) before his younger brother was born.

In 1856 he went into partnership with his father forming the firm of William Rogers & Son (q.v.) which was essentially a continuation of the business started as William Rogers & Co. This partnership lasted until 1861.

In 1862, William Henry Rogers continued the business on his own, using the name William Rogers, Jr. in order to be more closely associated with his father's well known name. Between 1863 and 1865 the firm was operated under the name of E. R. Fifield & Co. with William Rogers, Jr. continuing to work there until the business apparently closed.

William Rogers, Sr. returned to work in Hartford in 1865 and established the William Rogers Manufacturing Co. (q.v.) in association with William Rogers, Jr. and others.

By 1869, the two William Rogers' had apparently left the William Rogers Manufacturing Co. and formed the firm of William Rogers & Son (q.v.) to manufacture silverplated goods. The partnership appears to have lasted until the death of William Rogers, Sr. in 1873.

In 1868, Wm. Rogers, Jr., together with his father, made a contract with the Meriden Britannia Company for 10 years. Upon the death of his father, in 1873, the contract was to continue with the son until the expiration - which was in March of 1878. Wm. Rogers, Jr. was not successful in renewing the contract with the Meriden Britannia Co., but in that year he did make a 15-year contract with Simpson, Hall, Miller & Co. to superintend their flatware manufacturing and with his permission - to use on the silverplated flatware the trademark (Eagle) WM. ROGERS (Star). The contract with Simpson, Hall, Miller & Co. terminated in 1893. This trademark went out of use for flatware in 1976. On silverplated holloware it was first used in 1938 and was also discontinued in 1976.

In 1873 William Rogers, Jr. obtained his first flatware Design Patent, No. 6,585, under the name of William Rogers, without the "Jr.", and assigned it to his second sister, Lucy Rogers. The death of his father had made the use of "Jr."

obsolete. However he continues to be referred to as "William Rogers, Jr." in this context in an effort to prevent confusion with his parent.

For the years 1873 and 1874 William Rogers, Jr. continued to be listed in the "silverplated goods" business, but no work address was given, suggesting that although he was still living in Hartford, he was working for someone else.

By 1875, however, he was advertising himself as a "manufacturer of fine electroplated goods, spoons, forks, knives, tea sets, casters &c. of the best quality." By 1878, although using the same ad, he set it in larger type, suggesting either that the business was prospering, or that he was feeling serious competition. Even though he began working with Simpson, Hall, Miller & Co. in Wallingford in 1878, he continued to maintain a business listing under his own name in Hartford as well.

In 1880, perhaps partially influenced by the fact that his brother had obtained a flatware design patent the previous year, William Rogers, Jr. obtained two more design patents for flatware. The first, Design Patent No. 11,745 he assigned to Simpson, Hall, Miller & Co. The second, Design Patent No. 11,761 he did not assign.

By 1879 he was clearly feeling both pressured by and angry at his brother. In that year he took out a large size ad in the Hartford city directory, citing various facts and legal documents re-iterating the point that he and he alone had the right to use the William Rogers name. Apparently F. Willson Rogers, was trying to co-opt it.

William Rogers, Jr.'s advertisement reads in part: "Many enquiries have been addressed to me, if I was connected with the *Joint Stock Company*, called the William Rogers Mfg. Co., corner of Grove and Front Streets, in consequence of a statement in the daily papers that F. William Rogers was secretary of said Co. I will state that I am in no way connected with it, neither was father ever connected with this Joint Stock Co. F. *Wilson* (sic.) Rogers has recently become connected with it. Either by accident or design, several advertisements have appeared *lately*, signed 'F. William Rogers.'

"F. William Rogers is an illegal use of my name, (if used by design), liable to make confusion, and seriously interfere with my rights - -

"Therefore, I take this method of notifying all persons against infringing my rights."

Apparently William Rogers, Jr. continued to have problems with his younger brother, as similar ads appear in the directories published in 1880 and1881.

In 1883 he obtained two more flatware design patents, No. 13,838 and No. 14,245, both of which were assigned to Simpson, Hall Miller. In 1886 he received Design Patent No. 16,642 which was not listed as being assigned. Not followed in detail beyond this date.

Wm. Rogers, Jr. died in 1896.

WILLIAM ROGERS MFG. CO.
Hartford, Connecticut
See Rogers Brothers

Organized in 1865 by William Rogers and his son, Wm. Rogers, Jr. (William Henry Rogers), with Thomas Birch, William J. Pierce, and William H. Watrous as members.

On January 8, 1872 the William Rogers Manufacturing Co. was incorporated, with capital of $90,000. By this time, William Rogers and William Rogers, Jr. were no longer associated with the firm. James D. Frary was President. William J. Pierce was Secretary and Treasurer. The directors were James D. Frary, William J. Pierce, Daniel B. Hamilton, Thomas Birch and Horace C. Wilcox. In 1875 Frary died, and Daniel B. Hamilton became President . D. C. Wilcox and H. S. Lord joined the board. In 1879 William H. Watrous became President of the company. He was also President of the Rogers Cutlery Co.(q.v.) at the same time. He apparently brought his Secretary along with him as well when the two firms merged, as F. Willson Rogers (q.v.) was serving as the Secretary for both firms by 1880.

Not followed in detail beyond 1881.

They were one of the original companies to form the International Silver Company in 1898.

WM. ROGERS MFG. CO., A. A.

1846 ⚓ ROGERS ⚓ AA

⚓ **R O G E R S** ⚓

1865. WM. ROGERS M'F'G. CO.
WM. ROGERS & SON.

R. C. CO.
ROGERS NICKEL SILVER
ROGERS CUTLERY CO.

⚓ W. R. & S. **R.C. CO.**

(Jeweler's special quality, used with Anchor Rogers
Anchor Warranted)

CUNNINGHAM SILVER PLATE

(On premium flatware made for
Ocean Spray Cranberry Sauce)

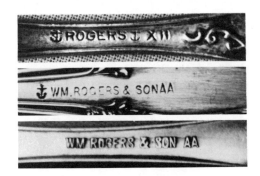

WM. ROGERS MFG. CO., LTD.
Niagara Falls, Ontario, Canada

Bought by Wm. Rogers Mfg. Co. (Division of International Silver Co., Meriden, Connecticut) in 1905.

WM. G. ROGERS

Trademark registered U.S. Patent No. 36,147, January 1, 1901 for silverware, knives, forks and spoons.

Listed 1904-1915 in JC plated silver section.

(Flatware.)

WILLIAM H. ROGERS
Hartford, Connecticut

Trademark registered U.S. Patent Office, No. 16,007. November 13, 1888 for silver and plated silverware. Out of business before 1915.

◁═◁ROGERS. A1.

(Silver and Silver Plated Ware.)

WILLIAM H. ROGERS CORPORATION
Plainfield, New Jersey

Listed in September 1901 KJI and 1904 JC in plated silver sections. No record in U.S. Patent Office.

ROGERS, WENDT & WILKINSON
New York, New York

A short-lived firm organized January 1860 to make silverware for Ball, Black & Co. The principals were Augustus Rogers and John R. Wendt (q.v.) formerly partners in a silversmithing business in Boston, who joined forces with George Wilkinson, Gorham's chief designer. The partnership was not of long duration, for in August it was dissolved, and Wilkinson returned to the Gorham Co. in Providence, Rhode Island.

HENRY J. ROHRBACH
Chicago, Illinois

"Silversmith and Manufacturing Jeweler." (Adv. JC&HR 9-27-1893, p. 28)

ROMAN SILVER-SMITHS, INC.
Brooklyn, New York

Manufacturers of silverplated goods c. 1950.

LIFETIME

ROOT & CHAFFEE
Pittsfield, Massachusetts
See Frederick Chaffee

Partnership formed in the 1840s between Washington Root and Frederick Chaffee (q.v.) In 1849 Chaffee moved to Rutland Vermont to open a branch of the business there. Partnership dissolved by 1852. (Carlisle, *Silver*, Jan.-Feb. 1988, p. 19)

ROSE SILVER CO.
New York, New York

Listed 1922 through 1931 KJI as manufacturers of plated holloware. KJI 1922 and 1924 indicate that their silverware was sold only to wholesalers.

J.W. ROSENBAUM & CO.
Newark, New Jersey

Listed JC in 1909-1915 in plated silver section. Out of business before 1922.

FRANCIS ROSENDORN
Baltimore, Maryland

Listed in Baltimore City Directories 1864-1869, 1883-1886 as a silverplater.

ROSENTHAL U.S.A. LTD.
New York, New York

The Rosenthal company was founded in 1879 by Privy Councilor Dr. Philip Rosenthal, the third generation of Westphalian potters and china traders. Rosenthal silver flatware was designed to coordinate with existing Rosenthal chinaware and glassware. The first line of flatware was Bjorn Wiinblad's *Romance* in sterling silver. To coordinate with Tapio Wirkkla's *Variation* pattern, two men, Richard Gump, famous San Francisco retailer, and Karl Gustav Hansen, Danish silversmith, worked together to produce flatware with fluted porcelain handles and contemporary sterlng cutting and serving ends. To design a flatware in keeping with its *Classic*

Modern designed by Raymond Loewy, Richard Latham of Chicago sculpted in high-gloss silverplate a set of tableware cutlery which is also available in matte finish.

FRANK H. ROSHORE
New York, New York

Frank H. Roshore first appears in the New York City directories in 1856, just after the end of the partnership of Roshore and Ketcham (q.v.), working at the same location, 4 Liberty Place. He was probably a relative of John Roshore. He is listed in the directories published in 1856 and 1857 as a silversmith. In 1858 he appears in the directories as a clerk, and in 1859 as an inspector. Not found after 1859.

ROSHORE & KETCHAM
New York, New York
See Ketcham & McDougall, Inc.
See Wood & Brother

CHRONOLOGY

Roshore & Wood	1850-1852
Roshore & Ketcham	1853-1855

According to JCW 2-5-1919, "The business, which is believed to have been founded somewhere between 1802 and 1803 was continued under various names, but was developed by the house of Roshore and Wood which began business in 1830." Other sources provide a different series of dates, noted in detail under Ketcham & McDougal, Inc. (q.v.)

John Roshore and Brewster Wood, Jr. comprised the firm of Roshore & Wood according to the 1852 New York City directory, manufacturing thimbles at 4 Liberty Place. In 1852 Edward W. Ketcham was also in the directories, listed as a silversmith with no work address given. By 1853 Wood had apparently gone into business for himself, and Roshore took on Ketcham as his new partner. The new partnership lasted until about 1855.

Richard McFayden, late President and Chairman of the Board of Ketcham & McDougall, Inc. (q.v.),who died in 1969 reported that Roshore founded the business in 1832 and took in the orphaned Edward Ketcham as an apprentice, later promoting him to partner. Exactly when Edward Ketcham joined the firm is not specified in this version of its history.

Roshore left the business about 1855 and some time thereafter went to work for Frederick Berenbroick & Co. (q.v.) as an engraver. By 1859 he had left Berenbroick and went to work as an engraver for someone else. He is not found in the New York City directories after 1860.

In 1855 Edward W. Ketcham went into partnership with his brother Ebenezer P. Ketcham to form the firm of Ketcham, Brother & Co.

ROSLYN SILVER CORP.
Taunton, Massachusetts

Manufacturers of silverplated wares c. 1950.

CHARLES ROUSH
Baltimore, Maryland

Listed in 1891 Baltimore City Directory under plated silverware.

ROWAN & WILCOX
New York, New York
See Wilcox & Evertsen

Sterling holloware manufacturer 1889-1892

E. H. ROWLEY & CO.
New York, New York
See Stephen Curtis, Jr.

Edwin H. Rowley first appears in the New York City directory published in 1860 as a britannia ware worker, with no place of employment given. However, he was probably employed by Yale & Curtis (q.v.) as he is shown working for that firm from 1861 through 1863. From 1864 through 1868 he is not listed in the New York City directories. In 1869 and 1870 he re-appears, with his occupation listed as "moulder", but no business address given.

In 1872 Rowley is shown working for Shields & Casey (q.v.) in the plated ware business. In 1873 he and Stephen Curtis, Jr. took over the firm, and it became Curtis & Rowley. The history of that company has not yet been followed in detail beyond 1874.

From an 1895 account, (JC & HR 7-1-1895, p. 10) it appears that, at some as yet undetermined point, Rowley went on to form E. H. Rowley & Co. However, the 1862 date given there for the company's beginning is obviously incorrect. In 1889 E. H. Rowley & Co.was succeeded by Stix & L'Allemand (q.v.).

ROWLEY MFG. CO.
Philadelphia, Pennsylvania

Listed in JC in 1909 in plated silver section. Out of business before 1915.

LUNA METAL
(*Seamless Nickel Silver Hollow Ware.*)

ROYAL MFG CO.
Location unknown

Mark found on a teapot dating c.1890s.

ROYAL METAL MFG. CO.
New York, New York

Listed in JC in 1909 in plated silver section. Out of business before 1915.

287

ROYAL SILVER MANUFACTURING CO.
Newark, New Jersey

Listed in KJI 1918-19 as silversmiths. In 1922 JKD as manufacturers of silver novelties and 1931 issue as makers of ladies' handbag frames.

ROYAL SILVERWARE CO.
Detroit, Michigan

"Rev. Robert J. Service, pastor, Turnbull Avenue Presbyterian Church, resigned to become manager of the business owned by Sherman R. Miller (Royal Silverware Co.) Service replaced by Aubrey W. Knowles, who resigned." (Clipping from unidentified newspaper, dated 1899)

A guarantee of quality certificate by the Royal Manufacturing Co., Detroit, Michigan dated November 28, 1900 states: "We, The Royal Manufacturing Co. of Detroit, Mich. do hereby assert and affirm as follows. Our knives are triple plate, 12 dwt. as marked and hand burnished. All hollow ware such as casters, butter dishes, etc., are triple plate, on a white metal base as marked. All plated goods are guaranteed to wear and to give perfect satisfaction to the purchaser for ten years or money refunded.

"All Brazil Silver goods are guaranteed to be the same metal all the way through as shown on the surface and to wear and to give perfect satisfaction to the purchaser for twenty-five years or money refunded. In case any of the goods should fail to prove as represented or should in any way fail to give perfect satisfaction, we hereby agree to refund all money paid or to replace with new goods as may be desired."

Signed Royal Manufacturing Co.

ROY RUBENS SILVERSMITH
Beverly Hills, California

Listed 1961 JBG as silver manufacturers.

ANTON RUBESCH
Alexandria, Virginia

Anton Rubesch was trained in Budapest. Moved to London in 1956 and later to the United States. His son, Alex Rubesch, joined him in 1968 and uses the mark of "A R" within a shield begun by his father.

While both are trained and skilled silversmiths, a large part of their present business is in repairs.

RUEFF BROS.
New York, New York

Listed in 1922 KJI as manufacturers of jewelry.

C.F. RUMPP & SONS
Philadelphia, Pennsylvania

Carl Frederich Rumpp, born in Nuertingen, Germany, arrived in this country in 1848 at the age of 20. He brought with him little else but an appreciation of this country and its opportunities, the tools of his trade and a determination to make the best leather goods his thorough apprenticeship had taught him.

Only 25 years after its founding in 1850, the fame of the company had spread through the country and it is still considered the standard by which leather goods are judged. Many desk sets, belts, writing cases and travel cases they manufacture are fitted with sterling silver mountings.

RUSSELL HARRINGTON CUTLERY CO.
Southbridge, Massachusetts

CHRONOLOGY

J. Russell & Co.	1834-1868
John Russell Manufacturing Co.	1868-1873
John Russell Cutlery Co.	1873-????
John Russell Co.	????-1932
Russell Harrington Cutlery Co.	1932-present?

The present (1975) Russell Harrington Cutlery Company was formed in 1932 through the merger of the Harrington Cutlery Co. and the John Russell Co.

Founded in 1834 by John Russell, descendant of an old New England pioneer family, it was first known as J. Russell & Company Green River Works.

The company became well known for an expression used on the American frontier in the two decades preceding the Gold Rush to California in 1849. This expression, "Up to the Green River," had two meanings - one referred to qual-

ity when traders boasted that their goods were "Up to Green River" knives; the other was used when hand-to-hand combat settled personal differences and onlookers shouted, "Give it to him - up to the Green River" - the trademark found near the hilt. (This is the Bowie knife of Texas fame.)

John Russell retired from the firm in 1868, at which time it was incorporated under the name John Russell Mfg. Co. In 1873, it was reorganized and the name was changed to John Russell Cutlery Co. Under this name, in 1881, then located in Turners Falls, they registered a Trade Mark Patent No. 8,723 for use on plated silver knives. This firm also produced silverplated holloware.

John Russell was the son of the silversmith, also named John Russell, who served his apprenticeship under Isaac Parker. The Parker-Russell Silver Shop in Old Deerfield, Massachusetts, is a tribute to Isaac Parker and the first John Russell. Through Parker and his apprentice, American silver craftsmanship can be traced by way of Russell & Ripply, J. Russell Cutlery, Towle & Sons and Rogers, Lunt & Bowlen to Lunt Silversmiths.

J. RUSSELL & CO.
GREEN RIVER WORKS

1834 J. RUSSELL & CO.

"*Professional*" Pattern

GREEN RIVER WORKS

RYRIE BROS.
Toronto, Ontario, Canada
See Henry Birks & Sons

James Ryrie started The Jewelry Business, with the added name of Diamond Hall, in 1879. In 1882 his brother Harry joined the firm. For-

mal incorporation as Ryrie Brothers came in 1897. In 1905 the firm joined the Birks (q.v.) family of companies, and was re-incorporated with James Ryrie as President and W. M. Birks as vice-president.

Between about 1914 and 1924 the firm marked its products Ryrie-Birks. After that time everything was marked Henry Birks & Sons. Ryrie Bros., Ltd. and Ryrie-Birks appear to have been retail firms which marketed goods manufactured for them by others. (Pack, *Collector's Guide to Canadian Souvenir Spoons*, 1988, p. 73)

RYRIE BROS.

S

S. & S. NOVELTY CO.
Providence, Rhode Island

Manufacturers (?) of plated silver novelties c. 1915-1922.

W.H. SAART CO.
Attleboro, Massachusetts
See Saart Bros. Co.

SAART BROS. COMPANY
Attleboro, Massachusetts
Successors to W.M. Saart Co.

Founded by William H. Saart, with his brothers, Albert and Herman. Probably in existence for some time prior to its incorporation in 1906. Frank E. Nolan became principal stockholder in 1937. The business is now (1975) conducted by R.J. Nolan, president. Makers of sterling and plated silver holloware, dresserware, cigarette and vanity cases and novelties.

SABEN GLASS CO.
New York, New York

Registered trademark for sterling coasters, holloware, handles for table knives, carving knives, forks, salad forks, silver bands for glass coasters, drinking glasses and water pitchers. Used since Oct. 16, 1949. (1975)

SACKETT & CO LTD.
Philadelphia, Pennsylvania

Successors to Mead & Robbins in 1893 as manufacturers of sterling silver. Out of business before 1904.

F.H. SADLER CO., INC.
Attleboro, Massachusetts

Listed in KJI 1922 as manufacturers of gold-filled rings. Manufacturers of vanities and compacts c. 1930.

G.T. SADTLER & SONS
Baltimore, Maryland

Philip Sadtler arrived in this country in 1799 and first opened a shop in Baltimore in 1800. For two years he was in partnership with John William Pfaltz. In 1803 he opened his own shop where he carried a full line of optical goods. While there is some question as to whether he was a working silversmith, there is a large quantity of silver bearing his initials, P S, or his full name. The sons and grandsons continued the business until 1923.

A 1919 account states: "Philip B. Sadtler, founder of the firm, was born in North Germany. He was a painstaking watchmaker and goldsmith, having obtained his training under the apprenticeship days in the finest horological workshops of Europe. On reaching Baltimore, where he came to seek his fortune in the New World, he renounced his German citizenship and embraced the political and civic faith of America. A man of military training, he deeply loved his adopted country, and in 1814 when this city was in danger of capture at the hands of the British, and during the same period of time that Francis Scott Key wrote the immortal song of the nation, Sadtler left his shop, organized and drilled the Baltimore Yeagers. He was made captain of the company which participated in the defense of the city when the British, under General Ross, made their fruitless attack.

"Captain Sadtler died in 1860, and the business which was conducted on Baltimore St., near Charles St., was continued by his son, George T. Sadtler. After the death of George T. Sadtler, in 1888, his sons, George W. and C. Herbert Sadtler, formed the firm of George T. Sadtler & Sons. C. Herbert Sadtler died in 1899 and the business was continued by George W. Sadtler and Fernando Volkmar. George W. Sadtler died two years ago, and Mr. Volkmar became head of the firm at that time." (JCW 2-5-1919, p. 318)

ST. LOUIS METALCRAFTS, INC.
St. Louis, Missouri

Manufacturers of sterling and silverplate c. 1950.

(On sterling) (On silverplate)

ST. LOUIS SILVER CO.
St. Louis, Missouri

First appeared in the 1893 St. Louis City Directory as The St. Louis Silver Plate Company at 207 Chestnut Street and in 1904 as the St. Louis Silver Company at 118 Chestnut. No listing after 1912.

SALOSICO WARE

SALES STIMULATORS, INC.
Chicago, Illinois

Registered trademarks for silverplated flatware.

(Claims use since Mar. 5, 1936, on the design; and since Sept. 1, 1948, on the mark in its entirety.)

Queen Esther
(Claims use since Sept. 1, 1948)

SALISBURY PEWTER
Salisbury, Maryland
See Kirk Pewter, Inc.

This firm was formed by local Salisbury people in 1979. It took over the plant formerly operated by Kirk Pewter Inc. in Salisbury. The Kirk business was moved to the Kirk-Stieff plant in Baltimore.

SANBORN HERMANOS, S.A.
Mexico, D.F. Mexico

Registered trademark for silverware, including holloware and flatware, made in whole or, in part of, and plated with silver, and ornamental jewelry made of silver. (1975)

SANBORNS
MEXICO

(Used since Mar. 3, 1931)

SANCRAFT INDUSTRIES
Bronx, New York

Currently (1975) doing business in sterling and enameled spoons. Spoons made to order.

SANDERSON MANUFACTURING CO.
Providence, Rhode Island

Advertised in the 1922 KJI as a manufacturer of mesh bags with a green gold or silver finish, showing a full page of examples of their work. The firm also produced "The Never-Drip Tea and Coffee Strainer" bag tops, straw-stemmed lemonade spoons, novelty tape measures and vanity and cigarette cases. Also listed in the 1924 KJI.

SANDLAND, CAPRON & CO.
North Attleboro, Massachusetts

Listed in JC in 1896-1904 in the sterling silver section. Out of business before 1909.

S. C. & Co.
STERLING

J.D. SANFORD & CO.
Granby, Connecticut

Joseph D. Sanford and Lorenzo Peck were in business before 1848 plating and marketing spoons. The business was dissolved c. 1857-58 and Sanford continued at Tariffville. He had some business association with the Cowles Mfg. Co.

FRANCOIS SASSEVILLE
Quebec City, Quebec, Canada

Francois Sasseville came from a family of silversmiths, both his father Joseph and his brother George practiced the trade. Francois worked between 1797 and 1864, the year of his death. He succeeded Laurent Amiot (q.v.) and trained his nephew, Pierre Lesperance (q.v.). He and Lesperance were in partnership from 1854 to 1856. Francois Sasseville is known particularly for his church silver. (Unitt & Worrall, *Unitt's Book of Marks,* 1995 p. 78)

E.J. SAUSE
New York, New York

Edmund J. Sause appears in the New York City directories at least as early as 1852 listed as a silverplater. He continues in business through at least 1874, as far as he has currently been followed.

His ads in the New York City directories in the late 1860s describe the business as "E.J. Sause, Silverplater, and Sheet Silver Door Plate Manufacturer, 94 Fulton St., New York. Machine and Engine Plates. Forks, Spoons, Tea Sets, Castors, &c. Old work replated."

PHILIP SAUTER
Baltimore, Maryland

Listed in Baltimore City Directories 1855-1871 as silverplater, manufacturer and dealer in door plates, bell pulls, railing knobs, silver and brass letters and numbers, coffin handles, trimmings, German silver, sheet brass and wire.

P. SAUTER & BRO.
Baltimore, Maryland

Listed in 1864 Baltimore City Directory as silverplaters.

WILLIAM SAUTER
Baltimore, Maryland

Listed in Baltimore City Directories 1865-1886 as silverplaters. Beginning in 1871, coffin trimmings are given special mention.

SAVAGE & LYMAN
Montreal, Quebec, Canada

George Savage was a skilled watchmaker from England, who arrived in Montreal about 1818. In that year he entered into partnership with Adams Dwight, but by the following year he was in business on his own. By 1823 he had two shop locations. Peter Bohle (q.v.) manufactured silver spoons etc. for him. Later, Robert Hendery (q.v.) went into partnership with Bohle in manufacturing silver.

About 1840, Savage took his eldest son Joseph into partnership, and the firm became Savage & Son. Joseph Savage married Abigail Lyman, and about 1850 her brother Theodore joined the firm, which then became Savage and Lyman.

Henry Birks (q.v.) entered the firm in 1857. By the 1860s it was considered the finest retail store in Canada. In 1867 Henry Birks and Charles W. Hagar were admitted as full partners in the firm, and its name was changed to Savage, Lyman & Co.

With the withdrawal of the British troops from Montreal in 1870, the area went into an economic decline. Conditions worsened into a full blown Depression. By 1878 the company was forced to file for bankruptcy. Henry Birks stayed on as manager to liquidate the firm before going on to establish his own business. (Unitt & Worrall, *Unitt's Book of Marks*, 1995, pp. 61-62)

FREDERICK A. SAWKINS
Baltimore, Maryland

Listed in Baltimore City Directories 1864-1896 as a silverplater.

F.F. SAWYER
New York, New York

Franklin F. Sawyer first appears in the New York City directories in 1855 as an electroplater. It is not clear at that time whether he was working for himself or for someone else. He is not found in the directories for the years preceeding or following.

In 1859 he re-appears in the New York City directories in business for himself. His ad for that year reads: : "F.F. Sawyer, No. 36 Beekman St. (Up Stairs) Manufacturer and Dealer in Silver Plated and Britannia Metal Goods, German Silver and Silver Plated Spoons and Forks, Tea Setts (sic.), Tea and Coffee Urns, Castor Frames, Goblets, Mugs, Cups, Pitchers, &c. Constantly on hand, every variety of Goods in the line. Silver Plate and Britannia Jobbing done with neatness and despatch."

Sawyer is not found in the 1860 directory. However from 1861 through 1870 he is listed in the silverplating business. In the 1862 directory he refers to his business as the "Metropolitan Plate Works". From 1871 through 1873 he is listed simply as an "agent". Not found after 1873.

H.I. SAWYER
Hartford, Connecticut
See W.L. & H.E Pitkin

Henderson I. Sawyer first appears in the Hartford city directories in 1845 listed as a spoonmaker and silversmith, with no place of business given, suggesting that he was working for someone else. By 1849 he was operating his own shop. He continued in business through 1858, when his business was reportedly purchased by W.L. Pitkin. He is not found in the Hartford directories after 1858.

WILLIAM H. SAXTON, JR.
New London, Connecticut

William H. Saxton is listed in the City Directory of New London in 1891 as Collector for the port of New London and dealer in watches, clocks and fine jewelry. William H. Saxton, Jr. is listed as watchmaker.

This Trade Mark Patent, No. 20,327 was registered in the name of William H. Saxton, Jr.,

November 3, 1891, for the manufacture of gold, silver and plated flatware and tableware. The type of trademark would indicate souvenir flatware. Listed 1896 in JC.

MURRAY L. SCHACTER & CO.
New York, New York

Manufacturers (?) of sterling wares c. 1950.

HAMPSHIRE HOUSE

HARVEY M. SCHADE
Brooklyn, New York

The factory of Henry Schade was established in 1873. The earliest listing found was the 1887 City Directory. Listed 1898-1904 in JC as Schade & Co: and variously as Harry M. Schade and Harvey M. Schade as successor before 1915 and out of business before 1922. In the JW 1890 the name is given as Henry Schade. The Brooklyn Plate Co. trademark was derived from the company of that name they succeeded before 1904.

BROOKLYN PLATE CO.

SCHAEZLEIN & BURRIDGE
San Francisco, California

Mark found on King Kamehameha Akahi Dala spoon. They were primarily platers and did repair work. Advertised special order work and badges and insignia. The firm no longer exists but descendants in a related business still advertise special order work.

Schaezlein & Burridge was started by Robert Schaezlein who moved to San Francisco in 1879 (d. c. 1932). The business was continued by his son, Robert Frederick (d. 1960) and now (1975) by Robert Frederick, Jr. The present Mr. Schaezlein makes everything he sells, mostly silver buckles with gold appliques of initials for Western outfits and special orders. Also, he produces silver (and gold with gold applique) conchos, etc., for belts and saddles. He still has the screw press his father and grandfather saved from the 1906 earthquake and fire and with which they set up shop right after the fire.

S. & B. S. F. CAL.

SCHARLING & CO.
Newark, New Jersey

John H. Scharling first established his business in 1885; incorporated in 1895. The company manufactured sterling, silverplated and pewter holloware and picture frames, novelties, antique gold and plated filigree frames and silver deposit ware.

He first registered a process for producing raised metallic designs (silver deposit) on glassware March 7, 1893; he registered a second on September 26. 1893. The last listing found for the company was 1931.

(On sterling silver, holloware, picture frames and novelties)

(On sterling silver and nickel silver match cases)

SCHARLING SILVER PLATE
(On silverplated holloware)

(On pewterware)

NIC. SCHELNIN CO.
New York, New York

Listed in JC in 1904 in the sterling silver and jewelry sections. Out of business before 1909.

WM. A. SCHENCK & COMPANY
Newark, New Jersey

Manufacturers of sterling silver and silverplated novelties. Among their products were souvenir spoons with enameling both opaque and transparent, enamel filigree, silver mounted tortoise, pearl and ivory.

In *Newark, New Jersey Illustrated,* published in 1893, the Schenck company is described as "young", suggesting that it probably started up in business some time about 1890. The quality of the firm's goods is touted as being "at the top of the silver market". In addition to producing its own line of wares, the company stood "ready at all times to make estimates and enter into contracts for solid silver novelties of every description." Potential customers were encouraged to come and tour the company's production facilities.

WILLIAM SCHIMPER & CO.
Hoboken, New Jersey

Successors (?) to William Schimper, listed as a silversmith in New York in 1841. William Schimper & Co. was listed in JC 1896-1927 as manufacturers of dresserware, bonbon baskets, picture frames, match safes, calendars and hair brushes in sterling and plated silver.

JOHN SCHIMPF & SONS
New York, New York
See Adelphi Silver Plate Co.

Made sterling silverware c. 1890-97. Later made silver and gold plated wares as Adelphi Silver Plate Co.

JEROME N. SCHIRM
Baltimore, Maryland

Listed in 1901 Baltimore City Directory as a silversmith.

CARL SCHMIDT
St. John, New Brunswick, Canada

Carl Schmidt first appears in the St. John city directories in 1886. He may have worked for Peter Schmidt, whose business he took over between 1891 and 1892. Carl Schmidt was a jeweler, manufacturer and goldsmith.

He obtained two Canadian copyrights for souvenir spoon designs in 1899. Each was a different representation of the date "1900" on which was written the words "St. John, N.B." One of these designs was also granted U.S. Design Patent No. 32,082.

Schmidt continued in business until 1922. (Pack, *Collectors Guide to Canadian Souvenir Spoons*, 1988, p. 61)

E. SCHMIDT & CO.
Philadelphia, Pennsylvania

Listed JKD 1918-19 as silversmiths.

ROBERT SCHMIDT
Brooklyn, New York

Robert Schmidt is listed in the Brooklyn city directory for 1868 as being in the silverplating business. No record of him is found there either before or after that date.

SCHMITZ, MOORE & CO.
Newark, New Jersey

Manufacturers of sterling silver dresserware. Listed in JC in 1915. Succeeded by Moore & Hofman between 1915-1922.

SCHOFIELD CO., INC.
Baltimore, Maryland
See Baltimore Silversmiths Mfg. Co.
See Jenkins & Jenkins
See C. Klank & Sons

Founded in 1903 by Frank M. Schofield as the Baltimore Silversmiths Mfg. Co.

Schofield was from a family of silversmiths and worked as a die-cutter. He is said to have cut the dies for the "Baltimore Rose" for The Steiff Company.

Heer-Schofield Co. was the company name from about 1905-1928 when it was changed to Frank M. Schofield Co.

Around 1930 it was changed to Schofield Co. and incorporated a few years later.

Manufacturers of sterling silver flatware and holloware, Schofield Co., Inc. Operated 1948-65 by Berthe M. Schofield, late widow of the founder.

Their trademark has been unchanged except that the letter B in the diamond was changed to an H when the company name was changed to Heer-Schofield.

In 1905 they bought out C. Klank & Sons which continued to be listed under its own name through 1911. Shortly after 1915 they also purchased the tools and dies of Jenkins & Jenkins and also the Farreals Co. Schofield's was purchased by Oscar Caplan & Sons in 1965.

Schofield Co. bought by the Stieff Co. in 1967.

MILTON J. SCHREIBER
New York, New York

Registered trademark for use on holloware made in part of, or plated with, precious metal. Used since April 28, 1949.

STERLON

A.B. SCHREUDER
Syracuse, New York
See F. A. Bunnelle
See Hotchkiss & Schreuder
See Syracuse Silver Mfg. Co.

Andrew B. Schreuder was born in Norway, 1828. He is listed in the Utica, New York, city directories in 1852-1853 as a silversmith.

About 1853 he moved to Syracuse and went into partnership with F.A. Bunnelle (q.v.) to form the firm of Bunnelle & Schreuder which manufactured solid silver flatware. Shortly after that firm dissolved on October 16, 1857, he entered into partnership with David Hotchkiss forming the firm of Hotchkiss & Schrueder.(q.v.) When that partnership dissolved on February 1, 1871,

he continued in business alone. (Soeffing, *Silver*, Jan.-Feb. 1991, p. 9) He also continued to use the "H & S" mark of the earlier firm.

Succeeded by Syracuse Silver Mfg. Co. in 1895.

H. & S.

SCHRIER & PROTZE
Baltimore, Maryland

Listed in 1888 Baltimore City Directory as silverplaters. Firm name changed to Novelty Plating Works in 1890.

A.G. SCHULTZ & CO.
Baltimore, Maryland

Listed in Baltimore City Directories 1899-1950 as manufacturers of sterling silver holloware.

Successors to Schultz & Tschudy & Co., first listed in 1898. Andrew G. Schultz and Otto Rosenbauer were listed as members of the firm. From 1902-1905, James L. McPhail was also listed as a member of the firm and was listed at C. Klank & Sons during those same years.

(Hollow Ware.)

SCHULTZ, TSCHUDY & CO.
Baltimore, Maryland

Listed in 1898 Baltimore City Directory as silversmiths. Succeeded by A.G. Schultz & Co. in 1899.

SCHULZ & FISCHER
San Francisco, California

CHRONOLOGY

Fischer & Schulz	1868
Schulz, Fischer & Mohrig	1869-1873
Schulz & Fischer	1873-1883
Schulz, Fischer & McCartney	1883-1888
Schulz & McCartney	1888-1893

William Schulz and Emil A. Fischer were silversmiths working with F.R. Reichel (q.v.) in San Francisco, California c. 1857-1868. Like their employer, they were natives of Germany.

After Reichel's death, they decided to go into business on their own. However they had little capital, and Koehler & Ritter (q.v.) had bought up Reichel's tools and equipment.

To obtain the necessary financing to set themselves up in business, they admitted a third partner, Christof F. Mohrig, also of German origin. Mohrig had first appeared in San Francisco in 1856 as a watchmaker and jeweler. He then left for some years, but returned about the time that Schulz and Fisher were ready to go into business. (Morse, in Morse ed., *Silver in the Golden State,* 1986, pp. 12-13) Mohrig was also a die maker and he may have made the dies for earlier Schulz & Fischer patterns.

The new company's first major commission came in 1869, for the finishing of two gold spikes for use in the ceremonial completion of the Transcontinental Railroad.

From a beginning base capital of $5,000 invested in tools and machinery, their assets had risen in 1870 to $14,000 in tools and inventory, with rented steam power to operate their machinery. The firm had 6 employees, used 7,000 ounces of silver, and produced $22,400 worth of flatware and small holloware in that year. By February 1863, Schulz & Fischer bought out Mohrig's interest for $5,400.

In 1875, the company changed from the coin to the sterling standard for the goods it produced. That same year the firm entered the Tenth Mechanics Fair exhibition, and won a diploma for work considered "... superior in engraving, original designs and fine work." The "satin finish" applied to their holloware received particular commendation in the press.

While the firm manufactured much of the goods it sold itself, it also purchased solid silver items from Gorham. By 1876 the company was retailing silverplate as well. Competitive pressure from eastern manufacturers was a major reason behind these practices.

An 1878 pamphlet offered 14 different flatware patterns. Although many patterns were derivitive, all were well executed, and some, such as "Faralone" and "Cleopatra", were quite distinctive. The pamphlet also offered a wide array of holloware. While some pieces were probably from eastern manufacturers, others were of their own production. Although their own work was often of lighter weight, they compensated for this with skillful use of techniques like ribbing and fluting that gave added structural strength to their pieces, as well as enhancing their design. (Morse, ibid pp. 13-15)

In *Commerce and Industries of the Pacific Coast* (San Francisco, 1882) John Hittell described the firm as "the heaviest producers of silverware in the city."

In 1883 Schulz & Fischer took in another financial partner, Samuel McCartney, who con-

tinued to operate his own wholesale liquor business both during and after his association with the firm. By 1885 the partners had $50,000 invested in their business which employed sixteen men and three apprentices, and paid $13,000 in wages.

By 1888 Fischer had withdrawn from the firm, and it had become Schulz and McCartney. Fischer died in 1890. Liquidating the partnership to settle Fischer's estate plus the increased competition from eastern manufacturers meant that the firm was no longer able to compete on the level that it had before. Schulz continued for a few years, but finally disappeared from the San Francisco directories in 1900. (Morse, ibid p. 15)

Of the approximately fifty coin and sterling silver flatware patterns issued by San Francisco manufacturers before 1900, Schulz & Fischer produced at least seventeen. Patterns identified as theirs include: *Thread, Eureka, Medallion, Pacific, Gem, Olympic, Faralone, Cleopatra, Antique, Occidental, Grecian, Crescent, Oriental, Granny's, Antique Wheat Engraved, Five Star* and *Rococo*. Only *Antique Wheat Engraved* has been found to bear the Schulz & McCartney mark. Much of their silver is completely unmarked, bearing no maker's name nor COIN or STERLING marks.

In addition to flatware and holloware the firm also produced presentation pieces. One of their epergnes was 27 inches high - the largest piece of its kind made on the Pacific Coast.

Berry bowls, cake stands and baskets, dinner castors, goblets, fruit stands, tea kettles, preserve dishes, butter dishes, tea sets, waiters, vegetable dishes, pap feeders, mustard pots, salt dishes and stands, card receivers and pickle dishes were among the great variety of silver holloware offered by Schulz & Fischer. Their offerings were so numerous that one may perhaps attribute the following comment to "eastern establishment" envy, although by 1897 the firm's business was definitely in decline. "Wm. Schulz, 230 Kearny St., San Francisco, California, is recorded as a manufacturing silversmith and probably has a shop on a small scale." (JC&HR 9-8-1897, p. 20)

After the business closed, Shreve & Co., San Francisco, acquired part of the Schulz & Fischer flatware dies.

The Schulz & Fischer trademark was based on the California State Seal which is reproduced here also. No matter the size of the piece of silver, the mark is always tiny - no more than 3mm. The mark illustration on the left is from Morse (ibid. p.108)

SCHWEITZER SILVER CORP.
Brooklyn, New York

Manufacturers of sterling holloware c. 1950 to the late 1960s. A division of Lord Silver, Inc.

THE F.A. SCHWILL & SON CO.
Cincinnatti, Ohio

Mark found on a small, plain silverplated ladle of undetermined date.

SCIENTIFIC SILVER SVC CORP.
New York, New York

Listed JBG 1957 and 1961 as manufacturers.

SCOFIELD & DE WYNGAERT
Newark, New Jersey

Listed 1904 JC in the sterling silver section and in 1915 in jewelry. Became F.P. Scofield & Company before 1922. F.P. Scofield & Co. are listed in the 1924 KJI as manufacturers of 14 and 18K gold jewelry.

SEARS ROEBUCK & CO.
Chicago, Illinois

A number of silverplated flatware patterns were made for them by various silver manufacturers and sold under the tradenames and trademarks illustrated here.

ALASKA METAL
(Used since 1908)

SALEM SILVER PLATE
(First used in 1914)

CAMBRIDGE SILVER PLATE
(First used c. 1909)

FASHION SILVER PLATE

PARAGON

PARAGON EXTRA

HARMONY HOUSE PLATE
(made by R. Wallace & Co.)

Joseph Seymour, in Syracuse	1846
Willard & Hawley	1846-1849
Norton & Seymour	1849-1854
Norton, Seymour & Co.	1854-1857
Joseph Seymour & Co.	1857-1870
Joseph Seymour & Son	1870-1879
Joseph Seymour & Sons	1879
Joseph Seymour & Sons Co.	1879-1898
Joseph Seymour Mfg. Co.	1898-1805

Joseph Seymour was born September 17, 1815, near Albany, New York. He received his education at the Albany Academy. While he was still young, his father died, and his mother married Joseph Harper, a silversmith, of New York City. In the early 1830s Joseph Seymour was apprenticed to his stepfather to learn the trade of silversmithing.

From about 1839 to 1846 he is reported to have been employed at the Rogers Bros. factory in Hartford, Connecticut.

When he first arrived in Syracuse, Seymour briefly worked alone. However, by June of 1846, he had joined the firm of Willard & Hawley. (q.v.). In 1849 he left that firm to go into partnership with Benjamin R. Norton. In 1854 David Hotchkiss joined Norton & Seymour, and the firm became Norton, Seymour & Co.

Business prospered, and in 1857 Seymour decided to buy out his partners. In partnership with Joseph Hall of New York City, he then formed the firm of Joseph Seymour & Co. By that time the company was already serving retailers in California and the Midwest, and even two in Canada, in addition to thirty-five dealers in New York State.

In the 1860 Industrial Census the company is shown as producing $60,000 worth of goods annually and employing nineteen people, fourteen men and five women.

On January 1, 1870, Joseph Seymour's son, Joseph, Jr. was admitted into partnership, and the firm became Joseph Seymour & Son. A second son, Edwin G. Seymour, became a partner in July 1879. Edwin G. Seymour was a noted designer of silverware and Fraternal Order Jewels. By the fall of 1879, George F. Comstock, Jr. had also been made a partner, and the firm became known as Joseph Seymour & Sons Co.

By 1879 the company was offering a wide variety of solid silver flatware and holloware, and offering to make goods to order. It was particularly noted for its production of Fraternal Order Jewels, receiving orders for them from as far away as Europe. The firm sold plated ware, supplied by Gorham, but apparently it did not manufacture its own.

1879 also marked the company's move to larger quarters, elegantly appointed offices and

JACOB SEEGER
Baltimore, Maryland

Listed in Baltimore City Directories 1864-1869 as a silverplater.

SELLEW & COMPANY
Cincinnati, Ohio

The Cincinnati City Directory lists Sellew & Company as pewterers in 1834. The 1836-1837 Directory lists Enos and Osman Sellew, makers of britannia ware.

About 1860 they discontinued making pewter and devoted their attention to britannia ware. Out of business in the late 1870s.

SELLEW & CO.
CINCINNATI
(On britannia)

SENECA SILVER CO.
Salamanca, New York

In business about 1900.

Trademark is Seneca Silver Co., Quadruple, Salamanca, N.Y. with an Indian profile in the center.

WILLIAM H. SEYFER
Baltimore, Maryland

Listed in 1884 Baltimore City Directory as a silversmith.

HENRY P. SEYMOUR
Hartford, Connecticut
See Seymour & Lindsley

JOS. SEYMOUR MFG. CO.
Syracuse, New York

CHRONOLOGY

Employee of Rogers Bros., in Hartford	1839-1846

salesrooms in the White Memorial Building in Syracuse.

The firm kept abreast of developments in the silverware industry. It introduced its own hammered ware the same year that Gorham did, 1880.

In 1882 the company purchased the jewelry business of Dennis Valentine, the largest of its kind in Syracuse, significantly expanding its retail trade. By 1887, when Joseph Seymour died, the company's goods were sold in every state and territory in the Union.

In 1898, the firm became the Joseph Seymour Manufacturing Co. About 1900 it received the contract to produce all the official souvenir spoons for the Pan-American Exposition in Buffalo in 1901. About 1905 the firm went out of business. (Soeffing, *Silver*, Nov.-Dec. 1987, pp. 30-34)

Joseph Seymour patented a process in 1859 for making spoons (Invention Patent No.25,765). He also received two design patents for spoons.

The company was one of the first to make tableware in patterns, *Cable, Bridal Wreath, Prairie Flower, Corn, Tulip, Cottage, Plain, Thread* and *Prince Albert* being among them. Regrettably, much of their tableware was made by melting down tons of old Hudson Valley silversmiths' work.

The first mark shown is from Soeffing, *Silver*, Jan.-Feb. 1990, p. 16.

J. S. & Co.

(c. 1850-1887)

✳ S ✳

(1887-c. 1900)

★ S ★

(c. 1900-c. 1909)

O.D. SEYMOUR
Hartford, Connecticut
See Julius Hollister
See Seymour & Lindsley

CHRONOLOGY

Seymour & Hollister	1843-1846
O.D. Seymour	1846-1852
Seymour & Lindsley	1854

Oliver D. Seymour first appears in the Hartford city directories in 1842, listed as a silversmith, but with no business location given, suggesting that he was working for someone else. "Someone else" may possibly have been Asa Rogers. Julius Hollister (q.v.), who became Seymour's partner by 1843, also appears for the first time in the Hartford directories in 1842, and he is reported to have worked in Rogers' shop.

The partnership of Seymour and Hollister was in business from about 1843 to 1846. Julius Hollister then sold out his interest in the business to Seymour and moved to Owego, New York (Soeffing, *Silver*, Mar.-Apr. 1992, p. 10)

From 1846 to at least 1852, O. D. Seymour was in business by himself. An account in the *Hartford Daily Courant,* December 12, 1848, describes the business as follows: "This concern employs from twelve to fourteen hands; feeds some fifty or more persons dependent; and turns off per annum $25,000 worth of silverware, consisting of tea and table spoons, cream and sugar spoons, dessert knives and forks, etc., &c., &c., which find a market all over the states of New England and New York, and to some extent over other portions of the Union."

In 1853 Oliver D. Seymour is listed in the city directory as the "city collector" (of taxes) rather than as a silversmith, however he may have been following both occupations, as in 1854 he is again shown as a "silversmith" in addition to being listed as "city collector". By then the name of the firm had changed to Seymour and Lindsley, his partner being Clark Lindsley who had worked for him for a number of years.

From 1855 onwards Seymour is listed only as "collector of taxes". He apparently gave up the silver business by that point.

SEYMOUR & LINDSLEY
Hartford, Connecticut
See O.D. Seymour

CHRONOLOGY

(O.D.) Seymour & Lindsley	1854
(H.P.) Seymour & Lindsley	1855
H.P. Seymour	1856-1857

The firm began as a partnership between O.D. Seymour (q.v.) and Clark Lindsley in 1854. Lindsley first appears in the Hartford city directories as a silversmith in 1849. By 1850 he is shown as working for O.D. Seymour.

In 1855, Seymour & Lindsley consisted of Henry P. Seymour and Clark Lindsley. Henry P. Seymour was almost certainly a relative, son? brother? of O.D. Seymour. He does not appear in the Hartford directories prior to 1855.

By 1856 Lindsley was no longer listed as a partner. However, he was still in Hartford working as a silversmith for an unspecified firm through 1858.

Henry P. Seymour was in business by himself as a silversmith in 1856 and 1857. By 1858 he had become a partner in the firm of Webster & Seymour, engaged in manufacturing pottery.

B.M. SHANLEY, JR. CO.
See Pryor Mfg. Co., Inc.

Consolidated with Pryor Mfg. Co. between 1915 and 1922. Last record found was c. 1935.

SHAPLEIGH HARDWARE COMPANY
St. Louis, Missouri

Established by A.F. Shapleigh. Their 1915-16 General Hardware Catalog has a photograph of the founder under which there is the statement "Established this Business in St. Louis, 1848." This same catalog illustrated and described "Peerless Silver Flat Ware" under the name Diamond Brand. It is described as "An entirely New Alloy of Metals Containing over 5% Sterling Silver; it is of a Pure White Silver Color Through and Through and will Retain its Luster Until Worn Out. Unlike Silver Plated Ware this Metal May be Scoured without any injury to the Surface."

They also advertised "Lashar Silver Flat Ware" as "Lashar Silveroid Metal is not Plated, but Possesses the Same Color as Pure Silver Through and Through." Nickel silver tea and tablespoons were listed under the trademark "Bridge," and "Bridge Cutlery Co." Among their other offerings were tinned steel spoons and aluminum ones.

GEORGE B. SHARP
Philadelphia, Pennsylvania
See Bailey & Co.

George B. Sharp was born in Ireland in 1819. He emigrated to the United States as a youth, and apprenticed himself in the jewelry and silverware trade on his arrival.

In 1850 he appears in the Philadelphia city directories with William Sharp, presumably a brother. They are shown in the Federal Industrial Census for that year with two businesses, a silver manufactory producing $15,000 worth of goods annually, and a jewelry manufactory with annual production valued at $5,000.

About 1852, George B. Sharp went to work exclusively for the retail firm of Bailey & Co. (q.v.)

Sharp is noted both for his innovative flatware designs, for which he received a number of patents, and for the high quality of his work. An employee of his, Augustus Conradt, also patented a number of designs which Sharp produced. (Soeffing, in Venable's *Silver in America*, 1994, biographical section, p. 321)

By early 1867 Sharp had gone into business for himself, buying up the manufacturing establishment where he had worked for Bailey & Co. (Soeffing, *Silver*, Nov.-Dec. 1995, p. 14) In the 1870 Industrial Census the firm is shown as having 45 employees and producing over $100,000 worth of goods per year. However, by 1874, the firm was out of business, a victim of the financial Panic of 1873. Sharp himself appears to have continued to operate in a limited way as a jeweler and silversmith until about 1880 when he retired. He died in 1904. (Soeffing, in Venable's *Silver in America*, 1994, biographical section p. 321)

Conradt went to work for the Middletown Plate Co. (q.v.), and obtained a number of invention and design patents for his new employer,

When George and William Sharp worked together, their silver was stamped W. & G. SHARP.

In the past there has been some confusion as to what mark George Sharp used on his work. Earlier editions of this book attributed the lion S Shield mark below to him. However that mark has now been shown instead to be a quality standard mark of Bailey & Co. for sterling. (Soeffing, *Silver*, Nov.-Dec. 1995, p. 12)

Sharp's manufacturing mark is a pair of lions looking inward flanking a letter S as shown both drawn (from *Silver,* Jan.-Feb. 1989, p. 36) and in the photograph below. The purpose of the additional large lion mark in the photograph is uncertain, but it may possibly function as a sterling standard mark. (Soeffing, ibid. p. 14)

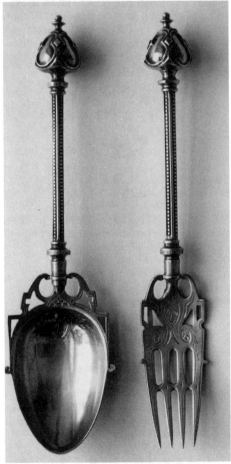

Fork and spoon from a child's set manufactured by George B. Sharp according to a design by Augustus Conradt (Design Patent No. 2,475). This pattern was made in a wide range of flatware servers and fancy pieces, but as far as is known not in regular place pieces. D. Albert Soeffing Collection. (Photo courtesy D. Albert Soeffing)

CHARLES C. SHAVER
Utica, New York
See Henry S. Brown
See Maynard & Taylor

CHRONOLOGY

Brown & Shaver	1856-1858
Joseph Seymour & Co. (employee)	1858-1860
Salesman of lawblanks	1860-1863
Charles C. Shaver	1863-1900

Charles C. Shaver was born in Germany in 1835 and came with his family to Manlius, New York in 1847. In 1849 he began his apprenticeship with Willard & Hawley (q.v.) in Syracuse. Presumably while he was there, he became friends with Henry S. Brown (q.v.) who was working as an apprentice for Norton & Seymour (q.v.) at the time.

Brown went to work for Maynard & Taylor (q.v.) in Utica, New York in 1853. The following year Shaver also joined the company. In 1856 Brown and Shaver bought out the silver manufacturing portion of the business. In 1858 Shaver contracted a serious case of typhoid fever and retired from the business, selling his interest to Brown.

After recovering from his illness, Shaver returned to Syracuse and went to work for Joseph Seymour & Co. (q.v.) There he remained until late in 1860, when he switched careers and became a travelling agent, selling lawblanks for Albany and Utica firms.

In 1863 he returned to Utica and bought up the business of his former partner, Henry S. Brown, of whom nothing more is known. Under his management the business grew steadily, from a capitalization of $6,000 and an annual product of $18,000 in 1865 to an annual production of $40,000 ten years later. Although his capital investment had increased to $25,000 by 1880, production had decreased to the same figure, reflecting the economic downturn of the era.

In addition to manufacturing, Shaver also maintained a large retail operation, selling "Plain and Ornamental Silver Spoons, forks, Knives, Ladles, &c." as well as retailing and jobbing silverplated ware. He produced a limited range of "ornamental" patterns, the most successful of which was one similar to Albert Coles "Jenny Lind". Other patterns included one with a die stamped anthemion device at the top of the handle, and common fiddle and tipt forms, frequently embelished with engraved decoration.

Shaver was a prominent member of the local community. He married Mary L. Edwards of Utica in 1864. That same year he joined the local Masonic Lodge where he subsequently attained high rank. He also served as a trustee of the Presbyterian church. He remained active in his business until his death in 1900. The business does not appear to have survived him.

Shaver's earliest mark consisted of his initials inserted between the same eagle and head that Brown had used in his mark previously. This mark continued in use at least into the early 1870s. Later marks included Crown, S, Eagle, frequently accompanied by the word "Coin"; CCS, each letter being sunk in a round shield; C.C.S plainly stamped; C.C. Shaver, plainly

stamped; and the outline of a maltese cross accompanied by the added mark "STERLING". The last mark is either late, or one used by a successor who acquired his dies after his death. (Soeffing, *Silver*, Mar.-Apr. 1996, pp. 26-31)

The first three marks illustrated are from Soeffing (ibid., p. 31)

C.C.S.

GEORGE E. SHAW
Putnam, Connecticut

Listed in JC 1896-1922 in sterling silver section .

The Gen. Putnam trademark was registered in U.S. Patent Office, No. 19,736, June 16, 1891, for flatware, solid and plated. This trademark was for two souvenir spoons to commemorate the Revolutionary hero.

GEN. PUTNAM

ALEX SHEARS
Baltimore, Maryland

Listed in the 1850 Census as a silversmith in Baltimore. Born Maryland.

SHEETS-ROCKFORD SILVER PLATE CO.
Rockford, Illinois
See Racine Silver Plate Co.

Chronology
Racine Silver Plate Co.	1873-1882
Rockford Silver Plate Co.	1882-1925
Sheets-Rockford Silver Plate Co.	1925-1956

The company was founded in 1873 as the Racine Silver Plate Co. in Racine, Wisconsin. In 1882 the factory there burned. The stockholders decided to rebuild in Rockford, Illinois and erected the new factory there that same year. They made silverwares for the United States Jewelers' Guild (also called Jewelers' Crown Guild)

which sold only through jewelry stores. About 1925 the company was bought by Raymond Sheets and became the Sheets-Rockford Silver Plate Co. The manufacture of flatware was discontinued but silverplated holloware was produced. Later Mr. Sheets operated it as a resilvering plant. The stock of the old company was purchased by S.L. & G.H. Rogers and records removed or destroyed. The Sheets-Rockford Silver Co. name appears in the City Directories through 1956.

SHEFFIELD CUTLERY CONCERN
Boston, Massachusetts

Published an illustrated catalog in 1882. Plated silver novelties, including fancy figural napkin rings were illustrated.

SHEFFIELD SILVER CO.
Brooklyn, New York

Registered trademark U.S. Patent Office, No. 107,747, December 28, 1919 for plated silverware and holloware.

Incorporated in the State of New York in 1908. Their basic product is plated silver holloware.

They were moved from New York to Norton, Massachusetts and became a division of Reed & Barton Silversmiths in 1974.

(1908-1950)

THE SHEFFIELD SILVER CO.
MADE IN U. S. A.
(1950-present)

SHELDON & FELTMAN
Albany, New York
See Smith & Company

Britannia workers 1846-1848. Thought to have made a small quantity of plated silver with the mark below. The upper ones most certainly were used only on britannia wares. Succeeded by Smith & Feltman in 1849; and by Smith & Co. in 1853.

SHEPARD & RICE
See Bernard Rice's Sons

SHEPARD MFG. CO.
Melrose Highlands, Massachusetts

Chester Shepard was working as a travelling salesman for a large silverware firm circa 1890. In the course of his business he noted that, although souvenir spoons were popular with the public, no firm was systematically producing them on a regular basis. Therefore he decided to give the idea a try himself.

He began by designing three spoons representing "America's immortals", Washington, Lincoln and Grant, and commissioning dies for the spoons to be made. The idea proved so popular that even before he got his production facilities set up he had received sufficient orders to cover all his start-up costs. This lead him to decide to establish his own factory, rather than having the spoons produced for him by others. (*Melrose Reporter*, October 12, 1901)

About the beginning of 1893 he and his son, Chester B. Shepard, came to Melrose Massachusetts from Connecticut to set up their silver manufacturing business. Originally it employed only two people.

By 1896 the firm had purchased and remodelled the old Congregational Church in Melrose Highlands for their new factory. The business was then employing 25 to 30 people and frequently working extra shifts in the evenings. The firm was reported to be "... the only concern of importance in this country which makes a specialty of souvenir spoons, although their products embrace napkin rings and other fancy articles in flat ware. They manufacture about one hundred varieties of spoons, and have an established trade for their goods in the United States, Canada, Mexico, the West Indies and abroad. ...

"The enamelling, painting and engraving on their spoons is done entirely by hand labor and the workmen in those departments are the most skilled that can be found anywhere and they command high wages. The company has ten

agents on the road and the volume of business is increasing." (*Melrose Reporter*, March 7, 1896)

Chester Shepard dealt with the designing and sales portion of the business while his son, Chester B. Shepard managed the factory. (*Melrose Reporter*, October 12, 1901)

Chester Shepard died July 11, 1902. Chester B. Shepard continued the business for several years. It then passed to a younger brother, Llewlyn, in a family disagreement . The factory closed in 1923.

On leaving the Shepard Company, Chester B. Shepard worked for several years for the Mt. Vernon Silver Co. In 1918 he founded a second Shepard Mfg. Co. in Detroit, organized for the manufacture of silverplated interior hardware for limousines such as Cadillac, Durant and LaSalle. He sold the business in 1925 and died two years later.

SHERIDAN SILVER CO., INC.
Taunton, Massachusetts

Originated in 1944 as the C & C Silver Company by Joseph Caiozzo and Harry Carmody. Incorporated in 1946 as Sheridan Silver Co., Inc. The largest of the independent silver manufacturers. Their production is limited to plated silver holloware. (1975)

SILVER ON COPPER

EMMONS F. SHERMAN
Baltimore, Maryland

Listed in 1868-1869 Baltimore City Directory as a silverplater.

GEORGE W. SHIEBLER & CO.
New York, New York

CHRONOLOGY
George W. Shiebler	1876-1891
George W. Shiebler & Co.	1891-1910

George W. Shiebler was born in 1846 in Baltimore Maryland, the son of a German immigrant, who had a number of other children as well. His older brothers, Andrew K. and William, entered the jewelry & silverware trades also, and achieved notable success. George's early education took place in Washington, D.C. where he worked for a time as a Western Union Messenger. (Soeffing, in Venable's *Silver in America*, 1994, biographical section, p. 322)

George W. Shiebler's first job in the trade was working as a travelling salesman for the gold chain manufacturing firm of Jahne, Smith & Co. in 1867. He remained with them until the deaths of both Jahne and Smith about 1870-71, then became a partner in the successor firm of Hodenpyl, Tunison & Shiebler, which continued in the gold chain business.

This firm, like many others, suffered financially as a result of the Panic of 1873. Shiebler withdrew from the business in 1874. After remaining out of business for a year, he decided to purchase the business of Coles & Reynolds (q.v.), manufacturers of silver spoons. On March 4, 1876, with a force of five men, he began business under his own name. (*Horological Review*, Sept. 14, 1892)

Over the next few years he acquired the tools and dies of a variety of important early firms. He bought out the business of John Polhamus (q.v.) in 1877. In 1883 he purchased the factory of Morgan Morgans (q.v.), who had succeeded Albert Coles (q.v.) This plant he merged with the others. (Soeffing, ibid) In addition he also managed to obtain the flatware dies of A. & W. Wood (probably through Coles & Reynolds), Henry Hebbard, Hebbard & Polhamus, and Theodore Evans & Co. A few years later he moved the factory operations to Brooklyn.

In the beginning, the Shiebler firm made only spoons and forks but its line was gradually expanded until it produced the largest line of novelties in silver extant at the time. Shiebler was a highly skilled and innovative designer and used his talents to enhance his firm's position. Over the years he obtained a number of patents for flatware patterns and souvenir spoons (Soeffing, ibid.)

The company was especially noted for its medallion work, inspired by the excavations at Pompeii and Herculanaeum, and its transparent enamel work. Raised Greek mottoes appeared on the articles giving them the appearance of the antique. This type of work was applied to brooches, sleeve buttons and bangles and was later extended to forks, spoons and holloware.

Oxidized silver had until then been a failure on the market but when introduced by Shiebler met with instant success. Another one of his innovations was silver leaves tinted in all the rich autumn colors. This work was applied to spoons, berry bowls, pitchers and other articles. Shiebler is also credited with the introduction of the Renaissance open-work style in jewelry, bonbonnieres, dishes, trays and spoons.

On January 1, 1892 the firm was incorporated as George W. Shiebler & Co. George W. Shiebler was president and Wm. F. Shiebler, treasurer. It continued in business until 1910 when Shiebler dissolved the firm and retired as a manufacturer. He spent the last ten years of his life working for Gorham (q.v.) The fate of most of the company's tools and dies is uncertain. Gorham reportedly purchased some of them. The Mauser Manufacturing Co. obtained the dies for the *American Beauty* flatware pattern. (Soeffing, ibid.)

The upper left mark is believed to have been in use c. 1878 as noted in *Silver*, Sept.-Oct. 1988, p. 38. The upper right mark is associated with the George W. Shiebler & Co. (Saunders, *Silver* Jan.-Feb. 1990, p.9)

(*Old Mark.*)

(The bottom mark is that of an old silversmith named Platt, whose business was acquired by Shiebler. Probably firm of Platt & Brothers, thimble makers, N.Y.C. 1836-46)

A set of Shiebler medallion corn holders, c. 1880s. D. Albert Soeffing Collection. (Photo courtesy D. Albert Soeffing)

SHIELDS & CASEY
New York, New York
See Stephen Curtis, Jr.

The silverplating firm of Shields & Casey (John W. Shields and John W. Casey) first appears in the New York City directory published in 1869 located at 56 Gold St. The following year the company moved its location to 72 and 74 Fulton. The firm advertised itself in the directories as the "Cheapest Plated Warehouse in America, ... Manufacturers of Fine Silver Plated Ware, All Goods stamped with our Name warranted to have the full weight of Silver".

In 1871 and 1872 the firm was located at 90 Fulton & 45 Gold, the same addresses as Stephen Curtis, Jr. (q.v.) who continued to be listed at those locations and appears to have been part the company. Shields & Casey is not found after 1872.

By 1873 Stephen Curtis Jr.and Edwin H. Rowley who had worked for Shields & Casey were in business as Curtis & Rowley at the same address. Casey was still at the same location in 1873, and appears to have been working for them. He is not found in the directory in 1874.

SHIELDS, INC.
Attleboro, Massachusetts

Founded c. 1920 as the Fillkwik Company, it was incorporated in 1936 under the present name. In January 1939 the company was bought by Rex Products Corporation of New Rochelle, New York.

During World War II, Shields produced insignia and medals, and now manufactures men's jewelry, fancy display and jewelry boxes.

SHIRLEY METALCRAFT, LTD.
Williamsburg, Virginia

Founded in 1955 by Shirley Robertson. He started working on castings in 1953 in a garage and expanded into the present location in 1955. Only the highest quality, lead-free, heavy gauge pewter is used in the handcrafted Shirley pewter. About a hundred different articles are made and include reproductions and adaptations of old designs as well as his own designs. Among them are bowls, trays, candlesticks, coffee and tea services, mugs, etc. (1975)

SHIRLEY
(Intaglio script)

Another mark: Colonial powder horn in Williamsburg with Shirley, Hand Made, Williamsburg, Va.

SHOEMAKER, PICKERING & CO.
Newark, New Jersey

Listed in JC 1896 in sterling and jewelry sections. Out of business before 1915.

Trademark identical to Frank Kursh & Son, Co.

 Sterling

SHREVE & CO.
San Francisco, California

The firm traces its origins to a jewelry business started in 1852 in San Francisco by two half-brothers, George C. Shreve and Samuel Shreve. These men were brothers of Benjamin Shreve who became associated with the prominent Boston firm of Shreve, Crump & Low. George and Samuel had worked for a time as sailors and later as wholesale jewelers in New York City before moving west.

By 1855 their jewelry business was well established, offering a wide range of European fancy goods and California Jewelry made to order. The Shreves also imported jewelry supplied by their brother Benjamin, at that time associated with Jones, Ball & Co. in Boston. In late 1857 or early 1858 Samuel Shreve was drowned at sea.

In 1859 George Shreve went into partnership with Lucius Thompson who had been an employee of the firm since about 1856. By 1867 the partnership had assets of about $100,000. The company advertised that it specialized in selling Gorham's solid silver and plated wares. In 1868 Lucius Thompson left the firm and went into partnership with W.K. Vanderslice (q.v.)

Until the 1880s the firm focussed on retailing. However, by 1881 Shreve had entered into a partnership with Albert J. Lewis and opened a factory for the production of high quality jewelry. Silversmithing began in 1883. That same year the firm was commissioned to provide trophies for the "Grand Encampment of the Knights Templar." The factory was destroyed by fire in 1885.

By April of 1886 the company had moved into a new factory, and added former workmen from Vanderslice and Schulz & Fischer (q.v.) to its workforce. In less than ten years the firm became the effective successor of all the San Francisco silversmiths. George C. Shreve died in 1893, a wealthy man.

In 1894 the firm was incorporated as Shreve & Co. with Albert J. Lewis as the majority stockholder. On the death of Mr. Lewis in 1895, George R. Shreve, the son of George C. Shreve, became president of the company.

The factory's production focussed on special order merchandise, such as a $5,000 gold cup presented to Solano county at the Midwinter Fair of 1897. The items produced were sold only through the firm's own retail shop. With the possible exception of some souvenir spoons, the firm manufactured no flatware prior to the disastrous earthquake and fire of 1906.

Fortunately Shreve & Co.'s insurance coverage made their financial loss from this cataclysmic event minor. The business set up temporary quarters in Oakland, and kept its name before the public with earthquake recovery articles in the press. Well before May 1908 their factory was back in production, as the firm had completed the silver service for the cruiser *California* by that date. The retail store celebrated its grand re-opening in early 1909. W.K. Vanderslice & Co. was not so fortunate. Their insurance provided only token coverage of their losses. What was left of the business was purchased by Shreve & Co. in 1908.

The opportunity to re-tool occasioned by the disaster also lead to Shreve & Co.'s entrance into the flatware manufacturing business. In 1909 the firm patented five flatware designs, *Louis XVI, Norman, Napoleonic, Dolores, and Mary Louise.* However, the firm's most distinctive pattern, *Fourteenth Century*, was not patented. In the ensuing years the company produced large, well illustrated catalogs, offering an endless variety of jewelry and novelties, as well as the firm's own silver flatware and holloware.

The company's Arts and Crafts style works of this period were a break from their nineteenth century tradition. Pieces featured hammered and pierced work and Mediaeval style strapwork decoration. The Art Nouveau and Colonial Revival pieces that the firm produced were similar to those produced elsewhere. Among the company's more distinctive works were its silver mounted wares, where almost any type of body, glass or ceramic, plain or exotic would be beautifully mounted in silver.

George R. Shreve sold his stock in the company in 1912 to the J.E. Hickingbotham family. With the outbreak of World War I the factory converted to war production. With the end of hostilities the firm went back to producing luxury goods. By 1921 the firm's factory occupied 100,000 square feet on six floors, had $150,000 in tools and machinery, and employed more than 600 workers.

In 1967 the Hickingbotham family sold the firm to Dayton Hudson of Minneapolis. (Morse, in Morse ed., *Silver in the Golden State*, 1986, pp. 16-20)

The upper two marks are from Morse ed., ibid. p. 108

(Little used after 1918)

SHREVE & CO.

Gᴇᴏ.C. SHREVE & CO

(Not used after January 1894)

SHREVE, CRUMP & LOW CO., INC.
Boston. Massachusetts

CHRONOLOGY

John M. McFarlane	1796
Jones & Ward	1809
Baldwin & Jones	1813
Putnam & Low	1822
John J. Low & Co,	1828
John B. Jones Co.	1838
Jones, Low and Ball	1839-1846
Low, Ball & Co.	1840
Jones, Ball & Poor	1846-1853
Harris & Stanwood	1847
Henry B. Stanwood	
Jones, Ball & Co.	1853-1855
Jones, Shreve, Brown & Co.	1857-1860
Shreve, Brown & Co.	1857-1860
Shreve, Stanwood & Co.	1860-1869
Shreve, Crump & Low Co.	1869-1888
Shreve, Crump & Low Co., Inc.	1888+

According to tradition, John McFarlane, originally from Salem, proprietor of a modest watchmaker's shop in 1796, was the founder of the company that is now known as Shreve, Crump & Low Co., Inc.

In the early 1800s Jabez Baldwin moved to Boston and formed a copartnership with a neighboring craftsman, and under the title of Baldwin & Jones continued the business begun by McFarlane.

Among the apprentices of Jabez Baldwin in Salem were John J. Low and Edward Putnam, who in 1822 established the firm of Putnam & Low. Three or four years later they separated and in 1839 John J. Low and his brother, Francis,

joined with George B. Jones, son of Mr. Baldwin's partner. In 1852 Benjamin Shreve was admitted to the firm and 17 years later Charles H. Crump joined. In 1888 the firm was incorporated as Shreve, Crump & Low Company under the law of Massachusetts, with Benjamin Shreve as president.

The Shreve, Crump & Low Company tradition so ably started by the Salem craftsmen and apprentices almost 150 years ago is being carried on today (1975) by Richard Shreve, great-grandson of the first Shreve.

The company does no manufacturing, but has always sold designs made by the finest of American silversmiths; some of the designs being created exclusively for them.

SHREVE, TREAT & EACRET
San Francisco, California

Jewelers and silversmiths. Young George Shreve withdrew from Shreve & Co. and with Treat and Eacret formed the new firm in 1912 around the corner from the old one. The company remained in business until 1941.

The firm was bought by Granat Bros. in 1941 and the silver department was closed out. Some of the employees joined Granat Bros. others went to Shreve & Co. and other firms.

VICTOR SIEDMAN MFG. CO., INC.
Brooklyn, New York

Manufacturing silversmiths c. 1920-1930. Makers of sterling silver holloware, picture frames and candlesticks.

$$\boxed{S}$$

A.L. SILBERSTEIN
New York, New York

Successor to Silberstein, Hecht & Co. before 1904.

Succeeded by Griffon Cutlery Works before 1915. Still in business under that name. (1975)

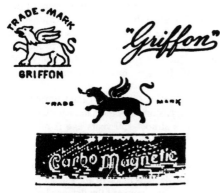

GRIFFON

"Griffon"

Carbo Magnetic

(*All Above on Cutlery.*)

SILBERSTEIN, HECHT & CO.
New York, New York

Founding date unknown. Succeeded by A.L. Silberstein before 1904. Manufacturers of sterling silverware.

SILBERSTEIN, LA PORTE & CO.
Providence, Rhode Island
New York, New York

An 1897 account describes the firm: "Silberstein, La Porte & Co. importers of cutlery, N.Y. This firm also manufacturers sterling silver cutlery, with a factory in Providence, Rhode Island. Griffen (sic!) trademark." (JC&HR 6-23-1897, p. 36) Probably related to above.

SILO SILVER MFG. CO.
New York, New York

Listed 1927 KJI as manufacturers of silverplated wares.

SILSON. INC.
New York, New York
See William Spratling

Silson, Inc. was a firm owned and operated by a man named Victor Silson. Originally from Australia, he and a brother had operated a successful diamond business in Europe. During the 1930s he and his wife came to the United States where he went into the costume jewelry business because he "wanted to do something creative".

In 1940 he entered into partnership with William Spratling (q.v.) who was by then well known for his solid silver jewelry designs with Pre-Columbian motifs. Spratling supplied design drawings and original pieces from which dies could be made. Silson manufactured the jewelry out of pot metal and then silverplated it, in workshops in New York and Rhode Island. He obtained at least fifteen design patents based on Spratling's drawings. The partnership continued until the late 1940s, when Silson went to work for his wife's aunt, Helena Rubenstein, designing cosmetic accessories. (Morrill, *Silver*, Mar.-Apr. 1995, pp. 12-14)

SILVER BROTHERS
Atlanta, Georgia

Registered trademark for sterling silver and silverplated flatware and holloware and jewelry.

(Used since June 1, 1950)

THE SILVER CITY PLATE CO.
Meriden, Connecticut

An 1895 account states: The Silver City Plate Co. has begun the manufacture of Britannia ware in Meriden. Harry Felix, formerly with the Toronto Silver Plate Co., is associated with three others in the enterprise." (JW 1-23-1895, p. 3). Eugene H. Ray, also with the company, had learned his trade from Simons & Miller Co., in Middletown.

In 1908 the International Silver Co. bought from the receivers the business and tools they could use.

SILVER COUNSELORS OF HOME DECORATORS, INC.
Newark, New York

Successors between 1943 and 1950 to Home Decorators, Inc.

State House ⚓ Sterling

Inaugural Formality

SILVERART
New York, New York

Listed 1957 and 1961 JBG as manufacturers of silverware.

SILVERCRAFT CO. INC.
Boston, Massachusetts

Listed JC-K 1950 as manufacturers. Owned now by Raimond Silver Manufacturers.

SILVERCRAFT

SILVER METAL MFG. CO.
Lyons and Oswego, New York

An 1892 account states: "A stock company has been organized to manufacture table ware from a metal recently invented by D.J. Toothill. The new firm will be known as the Silver Metal Mfg. Co. of Lyons." (JW April 1892)
"The Silver Metal Mfg. Co. recently moved from Lyons, N.Y. to Oswego, N.Y. started up last Monday." (JC&HR 8-31-1892, p. 17)

SILVER PLATE CUTLERY CO.
Birmingham, Connecticut

This concern, as the name indicates, made cutlery, and some of it was silverplated. They were in business as early as 1884 and continued until some time after 1896. In 1886 the firm obtained three design patents for knife handles. Some of their products they sold to other manufacturers, such as Holmes & Edwards, Wm. Rogers Mfg. Co., etc., furnishing lines particularly suitable for the firms doing the marketing.

SILVER PLATE C. CO.

THE SILVERSMITHS CO.
SILVERSMITHS STOCKS CO.

An 1892 account states: "The Silversmith's Co. incorporated, the present companies comprised in the new organization... Gorham, Whiting, Dominick & Haff, Geo. W. Shiebler and Towle Mfg. Co." (JC&HR 12-14-1892, p. 22)

Nothing ever came of this. A few years later, however, Wm. B. Durgin Co., W.B. Kerr Co., The Mount Vernon Co. and Whiting Mfg. Co. became a part of the Gorham Company.

F.W. SIM & CO.
Troy, New York

Registered U.S. Trademark Patent June 6, 1891 for manufacture of souvenir sterling silverware. No other record.

SIMMONS & PAYE
North Attleboro, Massachusetts
See Paye & Baker

S. & P.

SIMONS, BRO. & CO.
Philadelphia, Pennsylvania

Simons, Bro. & Co. was established in 1840 by George W. Simons, father of John F. Simons, Frederick M. Simons and Edwin S. Simons, who were later members of the firm. Some years subsequent to 1840, Peter B. Simons joined his brother, the firm becoming George W. Simons & Bro.
In 1861 Thomas Maddock was admitted to an interest in the business, and later, S.B. Opdyke, the firm name changing to Simons, Bro., Opdyke & Co. Some years later Mr. Opdyke retired, as did subsequently the elder Simons, the firm continuing under the name of Simons, Bro. & Co. It is now (1975) Simons Bros. Co.
George W. Simons was born in Philadelphia in 1819 and learned there the trade of making silver thimbles and pencils. These were the company's first products. Gradually they increased the scope of their activities and produced many exclusive patterns of tea sets and tableware, comb tops, cane and umbrella heads as well as their well-known thimbles. They were successors to Peter L. Krider Co. in 1903. Their flatware patterns and dies and Simons Bros. patterns and dies were sold to the Alvin Mfg. Co. in 1908 and they discontinued flatware manufacturing entirely.

ESTABLISHED 1840

S. B. & CO.

309

SIMONS & MILLER PLATE CO.
Middletown, Connecticut

Apparently begun by workmen previously associated with the Middletown Plate Co. Listed in the Middletown Directory in 1870. A price list for 1874 is in existence. The New England business directory for 1867 lists Simons, Lawrence & Co. Britannia makers of Middletown Conn. - probably their predecessors.

Michael Simons received two invention patents for removable strainers to keep coffee grounds and tea leaves from coming out through the spouts of coffee and tea pots: Invention Patent No. 62,697 granted March 5, 1867, and Invention Patent No. 75,651 granted March 17, 1868.

SIMPSON-BRAINERD CO.
Providence, Rhode Island

Listed JC 1915-1922 in plated silver section. In the 1924 KJI the firm is listed as manufacturers of picture frames, cigarette and children's vanity cases, bracelets, pearl goods and novelties.

ENGLISH SILVER

SIMPSON, HALL, MILLER & CO.
Wallingford, Connecticut
See International Silver Co.

Samuel Simpson was well-known for his britannia ware in Wallingford. In 1866 he organized Simpson, Hall, Miller & Co. to do silverplating. In 1878 he made a contract with William Rogers, Jr., to supervise the manufacture and marketing of Simpson, Hall, Miller & Co. Rogers "Eagle" Brand.

An 1887 description of the Simpson, Hall Miller firm states: "The works consisting of a number of large, four storey buildings, covering an area of about two and one half acres, are thoroughly equipped with the latest improvements in labor-saving machinery, operated by a steam-engine of 150 horsepower, and three hundred skilled operatives, etc. are employed in the several departments of the business.

"The output comprises immense quantities of the finest electro-plated table-ware manufac-

tured, besides the famous Wm. Rogers' spoons, forks, etc., and in quality, elegance of design, and workmanship the house successfully competes with any manufacturers of this class of merchandise at home or abroad.

"The officers of the company are as follows: President, Samuel Simpson; Treasurer, C.H. Brown; Secretary, Andrew Andrews, and Messrs. G.W. Hull and C. D. Yale, with the president and secretary constitute the board of directors.

"These gentlemen are widely known in business circles in New England, and are prominent in municipal affairs as well. Messrs. Simpson and Yale have both served with ability as wardens of the borough; and Messrs. Brown and Andrews have each filled the office of clerk of the same." (*Leading Businessmen of New Haven County*, 1887, quoted in *Silver*, Nov.-Dec. 1990, p. 30)

Last drawn mark in the group below is from *Silver* (ibid.)

(Flatware.)

(Hollowware.)

(Cheaper Grade.)

AMERICAN SILVER PLATE CO.

In 1895 the company started the manufacture of sterling silverware and were one of the original firms to become part of the International Silver Company in 1898. The Wallingford factory became International's sterling center.

 Mark used on their sterling flatware produced after 1895. The same mark was continued by the International Silver Co.

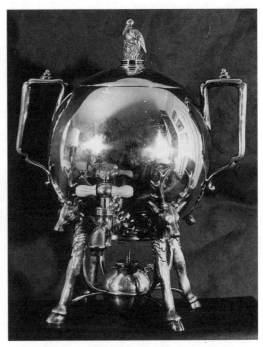

The "Eureka Condensing Tea Urn" manufactured by Simpson, Hall, Miller & Co. George Jones of New Haven, Connecticut, obtained Invention Patent No. 84,830 for this device on December 8, 1868. Its special interior design retained the aroma of the tea in the pot and kept the leaves out of the user's cups. (Photo by Judy Redfield)

SIMPSON, HALL MILLER & CO. (CANADA)
Montreal, Quebec, Canada
Toronto, Ontario, Canada

This firm was established in Montreal in 1879 in response to Canada's 1879 National Policy. It was the Canadian branch of the Wallingford, Connecticut company. Zimmerman McNaught was advertised as their agent for the province of Ontario.

By 1896 the firm listed its address as 50 Bay St., Toronto. In 1899 it became part of the International Silver Co. of Canada. (Unitt & Worrall, *Unitt's Book of Marks*, 1995, p. 63)

SIMPSON NICKEL SILVER CO.
Wallingford, Connecticut
See International Silver Co.

Incorporated in 1871 by Samuel Simpson, E.W. Sperry, Albert A. Sperry, Alfred W. Sperry and R.L. McChristie. They made nickel silver flatware blanks which were sold to Simpson,

Hall, Miller & Co. for plating and marketing. They did not use a trademark because they sold their products to other silver manufacturers.

The officers of the company in 1887 were Samuel Simpson, president, and Andrew Andrews, Secretary, both of whom held similar positions in Simpson, Hall Miller & Co. (*Leading Businessmen of New Haven County*, 1887 quoted in, *Silver,* Nov.-Dec. 1990, p. 30)

The firm began the manufacture of sterling silver flatware shortly before the organization of the International Silver Co. The nickel silver operations were moved to other factories after the company became part of the International Silver Co. in 1898.

SINCLAIR MFG. CO.
Chartley, Massachusetts

Listed in 1950 JC-K under sterling.

B. & J. SIPPEL LTD.
Sheffield, England

Registered trademark for flatware.

SIPELIA
(Used since August 13, 1934)

JAMES SISSFORD
Baltimore, Maryland

Listed in the 1850 Census as a silversmith. Born in the District of Columbia.

WM. AND GEO. SISSONS
Sheffield, England

Successors to Smith, Sissons & Co. who were makers of Sheffield plate and silversmiths in 1848.

Listed in JC 1909-1922 in sterling and plated silver sections.

For further information see Bradbury, *History of Old Sheffield Plate*, 1912, reprinted 1968, p. 39 and Culme, *The Directory of Gold & Silversmiths,* 1987, reprinted 1992, pp. 419-420.

W. S.

C. S.

(On plated silver)

(On sterling silver)

OLAF SKOOGFORS
Philadelphia, Pennsylvania

An obituary dated 1975 reads: "Philadelphia - Olaf Skoogfors, awardwinning silversmith and jeweler, died of a heart attack at his home here Saturday. He was 45.

"Best known for his goldplated silver jewelry and wrought silver, he also made hollow ware and ecclesiastical metalwork. His work was exhibited both nationally and internationally. Among his awards were first prize in the Contemporary Jewelry International in 1963 and the $1,000 Tiffany prize in 1967.

"His jewelry and hollow ware are in the permanent collections of the Philadelphia Museum of Art and the Museum of Contemporary Crafts in New York and also are included in museums in Rochester, N.Y.; St. Paul, Minn.; Atlanta, Ga., and Pforzheim, Germany.

"Mr. Skoogfors was born in Bredsjo, Sweden, and came to the United States in 1939 with his family. He trained at the Philadelphia Museum's School of Art and the Rochester, N.Y., Institute of Technology.

"He was professor and chairman of the craft department at the Philadelphia College of Art. He worked in a studio above his garage.

"Mr. Skoogfors is survived by his widow, the former Judy Gesensway, an illustrator and teacher at Moore College of Art; daughters, Kerstin and Mia; a brother, Leif, photography teacher at Moore, and his stepmother, Esther Skoogfors." (Obituary, 12-23-1975 *The Washington Post)*

He was one of the most important goldsmiths of the American craft revival.

A. F. SMITH CO.
Omaha, Nebraska

Founded in 1894 as Reichenberg-Smith Co., wholesale jewelers. A.F. Smith, President, Louis Reichenberg, Vice President and Max Reichenberg, Sec. Last listed under this name in 1905.

The 1906 City Directory carries the listing of the A.F. Smith Co. with Arthur F. Smith as President. They were incorporated in 1932. In 1936 the listing is A.F. Smith & Co. with G.A. Smith as President-treasurer; L.P. .Smith, Vice President and A.F. Smith, Secretary.

The 1938 listing is Smith & Co., with Franklin & Gordon A. Smith (sons) listed as owners. The 1941 listing is A.F. Smith & Co., Inc. and is the last listing under the Smith name.

It was later known as the Allgaier-Smith Co., Inc. in 1942; Allgaier Jewelry Co. in 1945 and John Byrne Inc. 1948-1964.

C. R. SMITH PLATING COMPANY
Providence, Rhode Island

"The C.R. Smith Plating Company was established in 1890." (JW 3-30-1892)

E. H. H. SMITH KNIFE CO.
Bridgeport, Connecticut

In business in 1899 as manufacturers of plated silver knives. Out of business before 1915.

Probably related to E.H.H. Smith Silver Co. but this could not be established.

(Knives.)

E. H. H. SMITH SILVER CO.
Bridgeport, Connecticut
See Albert Pick & Co., Inc.
See Blackstone Silver Co.

The E.H.H. Smith Silver Company was first listed in the Bridgeport City Directory in 1907. Listed in the JC in 1904. U.S. Trademark Patent No. 44,191 was issued in their name on February 14, 1905. They were manufacturers of "artistic cutlery and sterling effects in quintuple plated spoons and forks." They were last listed in the 1919 City Directory and were succeeded by the Albert Pick Company in 1920.

Reorganized as Blackstone Silver Co. in 1914. Sold to Bernstein (of National Silver Co.?) in 1943.

× ×⬓× ×

◁ S ▷

(Flatware.)

SMITH & FELTMAN
See Smith & Company

EDGAR M. SMITH
New York, New York

Edgar M. Smith is found in the New York City directories at least as early as 1852 in partnership with his brother? Gerrit Smith in the firm of G. & E.M. Smith, manufacturers of gold pens

and pencils. By the following year Gerritt Smith had left the business to become a gold bullion dealer.

Edgar M. Smith continued on by himself, describing his business as that of a manufacturer of gold pens, gold & silver pencils, jewelry & gold & silver thimbles.

In 1855 he listed his business as "real estate". For 1856 it was "gold chains". In 1857 he appeared as a jeweler working for someone else. In 1858 he was a broker. Not found in the directories after 1858.

FRANK W. SMITH SILVER CO., INC.
Gardner, Massachusetts
See The Webster Co.

Frank Wyman Smith (b. March 13, 1848; d. August 2, 1904), son of Dr. William A. and Susan F. (Durgin) Smith was born in Thornton, New Hampshire. He entered the employ of his relative, William B. Durgin, silversmith, in Concord, New Hampshire. He remained with the company in various capacities until 1886.

Smith's first wife had died in 1884. His father-in-law-to-be, Seth Heywood, contracted for the construction of a factory building in Gardner Massachusetts in May 1886. In June Frank W. Smith and Heywood's daughter Frances were married.

The shop was an instant success. In 1892 a livery stable behind the building was purchased, and the factory was expanded, doubling its capacity. The same year Seth Heywood sold his interest in the company to Frank Smith, who took control of the business himself. In 1899 the shop was expanded again.

Frank W. Smith died in 1904 and control of the firm passed to his two sons, Dr. William D. Smith and Frank H. Smith. In 1905 the firm was incorporated with William D. Smith as president and Frank Blake as secretary. In 1917 the directors of the company decided to sell it to Henry E. Heywood, a nephew of Frank W. Smith's second wife.

The firm was incorporated as a joint stock company the same year, with Henry E. Heywood as president. He continued to run the factory until 1930, when it failed as a result of the Great Depression. Frank M. Favor purchased the company, but Heywood remained as president until 1938. Favor then brought in North Royce Hotchkiss as president, while he himself continued as treasurer.

During the Second World War, the firm joined the war effort, manufacturing metal angles, braces and struts, as well as complex parts for gliders and submarines.

In 1945 Jonathan Brown III purchased Mr. Favor's interest in the company. Mr. Hotchkiss continued to serve as president until 1952, when Mr. Brown assumed the position.

Mr. Favor formed Frank W. Smith, Incorporated to manufacture screws as a direct outgrowth of the work done by the silver company during the war. This firm is today L.H. Sawin, Inc.

Jonathan Brown III served as president of the Frank W. Smith Company from 1952 to 1958 when he was forced to sell it. The firm then became the Gardner Silver Co. with Leonard Wolkoff as president. This firm sold off the Frank W. Smith Co.'s assets, machinery, patterns, tools and dies, trade name and trademark in October, 1958, to the Webster Co., a subsidiary of Reed & Barton. The flatware portion of the business was moved to North Attleboro, Massachusetts.

The Frank W. Smith Company was known throughout its existence as a producer of high quality sterling silver flatware and holloware. One of its flatware patterns, *Marie Louise*, was in use in United States enbassies around the world. The firm created presentation silver for a variety of notables, including Queen Elizabeth of England and Princess Grace of Monaco. In 1906 it manufactured the silver service for the battleship *Louisiana*. (*A Century of Gardner Sterling Silver*, Gardner Museum, 1991)

TRADE MARK.
925-1000 FINE

FREDERICK L. SMITH
Denver, Colorado

The business was first listed as the C.H. Green Jewelry Company in 1889 with F. L. Smith as secretary-treasurer and L.H. Gurnsey, manager. In 1890 it was known as the C.H. Green Jewelry Company with the Gurnsey name no longer listed. In 1892 the name was changed to the Green-Smith Watch and Diamond Company. *Harper's Magazine*, July 1892, carried an advertisement listing them as "manufacturers of souvenir spoons made of Colorado silver." "Protected by letters Patent, dated Feb. 16, 1892." In 1894 the business listing was dropped and the only entry was under Smith. In 1895 the listing was Frederick L. Smith as manager of John W. Knox - successor to Green-Smith Company.

GEORGE O. SMITH
New York, New York

George O. Smith is found in the New York City directories at least as early as 1852 listed as a silversmith.

In 1855 the business became George O. Smith & Co., and advertised as manufacturers of gold, silver and steel topped thimbles at 4 Liberty Place. By 1862, George O. Smith was back in business by himself. He continued to manufacture thimbles through at least 1874, as far as he has currently been followed.

GEORGE W. SMITH
Albany, New York
See Rogers, Smith & Co.
See Smith & Company

Holloware silverplater in Albany, New York associated with Smith & Company before he joined with Wm. Rogers and founded Rogers, Smith & Co. of Hartford, Connecticut in 1856.

While working for Rogers, Smith & Co. he obtained an invention patent, No.20,592 for a triple walled ice water pitcher. He also obtained two design patents for ice water pitchers, Nos. 1,028 and 1,219, plus one for a tea service, No. 1,096.

JOHN M. S. SMITH
New York, New York

Listed as a silverplater in the New York City directories at least as early as 1852. Not found after 1852.

LAWRENCE B. SMITH CO.
Boston, Massachusetts

Founded in Boston in 1887. Made sterling and plated silverware. Out of business about 1958.

RICHARD SMITH
Newark, New Jersey

Richard Smith was a jeweler who sold under the name of the Newark Jewelry Store 1850-1898. He had been with Baldwin & Smith. Advertised in the Newark Directory 1854 a large variety of silverware "manufactured in the best style, warranted to be of the best quality," and in the 1859 Directory "Not only do I claim superiority so far as artistic design and perfect finish are concerned but every article made is guaranteed to equal the best American coin. ..."

W. D. SMITH SILVER CO.
Chicago, Illinois

Rudolph J. Bourgeois, vice-president of the company, registered U.S. Trade Mark Patent No. 148,714 on November 22, 1921 for the manufacture of silverware, particularly holloware, flatware, jewelry and precious metal ware. In applying for this patent registration, it was stated that this trademark had been used continuously since 1913.

The company was incorporated under the laws of Delaware and was located in Chicago. Listed KJI 1922 as silversmiths, period silverware; KJI 1924 simply as manufacturers of silverware.

(Nickel Silver Holloware.) *(Plated Flatware.)*

WALTER M. SMITH
New York, New York

Walter M. Smith appears in the New York City directories at least as early as 1852 as a hardware dealer. For the next several years his business is listed as "military goods" or "importer". 1863 is the first year that the business is listed as "plate".

An ad in the New York City directory published in 1864 states: "Walter M. Smith, Silver and Plated Ware, 18 John St., Upstairs, New York. English Albata Spoons, Forks, Ladles, Table Cutlery, Fancy Silver in Cases, Spoons, &c." The use of the term "English Albata" suggests he may still have been importing his wares at this time.

By 1867 he had changed his directory ad to the following: "Walter M. Smith, Silver & Plated Ware, Tea Sets, Castors, Ice pitchers, Waiters, Communion Sets, Spoons & Forks, Cutlery, Fancy Silver Ware in Cases &c. &c. &c."

He continues to be listed in the New York City directories through 1874. Not followed further.

Whether he was at some point a manufacturer, or as his early history suggests, simply a retailer, is not clear.

SMITH & COMPANY
Albany, New York
See Rogers, Smith & Co.

Listed in the Albany City directory 1846-1848 as Sheldon & Feltman, Brittannia (sic) and Argentina Manufactory. Listed 1849-1853 as Smith & Feltman, Argentine and Brittannia Works. Listed 1853-1856 as Smith & Company, Argentine and Brittannia Works.

The Argentina and Argentine are thought to have been britannia ware plated with silver.

George W. Smith of this firm moved to Hartford, Connecticut , where he joined with William Rogers (q.v.) and others to form Rogers, Smith & Co. which was incorporated January 1, 1857.

SMITH & FELTMAN
See Smith & Company

SMITH & MAYO
Newark, New Jersey

Benjamin J. Mayo and Edwin B. Smith were gold and silverplaters c. 1860.

SMITH & SMITH
Attleboro, Massachusetts
See Wallace Silversmiths

Manufacturers of sterling cigar boxes and novelties.

Specialize in reproductions of early American, English and Dutch pieces in sterling.

A division of Wallace Silversmiths.

S & S

SMITH & TODD
New York, New York
See Mabie, Todd & Co.
See Edward Todd & Co.

William P. Smith and Edward Todd formed the firm of Smith & Todd in 1851. The firm was a successor to Bard Bros. & Co. and manufactured gold pens and pencil cases (pen-like objects designed to hold a pencil lead). In 1860 the firm was succeeded by Mabie, Todd & Co. (q.v.) However, in 1862, Edward Todd is shown as being a partner of both Mabie, Todd & Co. and a reinstated firm of Smith & Todd at the same time.

All three men, John Mabie, William P. Smith, and Edward Todd were engaged in multiple partnerships with each other simultaneously at various times. The chronology of these partnerships is documented under the different firm names in an attempt to reduce confusion.

William P. Smith does not appear associated with the businesses after 1862.

SMITH METAL ARTS COMPANY
Buffalo, New York

Registered trademark for use on trophies, vases, bowls, photograph frames, smoking accessories, desk accessories, etc., all embossed, ornamented or plated with silver.

SILVERCREST

(Used since January 1920)

SMITH, PATTERSON & CO.
Boston, Massachusetts

Founded in 1876, became part of Jordan Marsh, New England's largest department store, in 1956. Agents for "several of the best manufacturers." Importers of watches, clocks, silverware and jewelry.

ALBERT SMYTH CO., INC.
Baltimore, Maryland

Listed 1965 JC.-K. 1974 listing has no address.

S. K. SMYTH
Philadelphia, Pennsylvania

Mark found on a silverplate salt dish dating c. 1870.

S.K.SMYTH
PHILAD.

EDWIN V. SNYDER
Philadelphia, Pennsylvania

Listed JKD 1918-19 as a silversmith.

SOCIÉTÉ PICARD FRÈRES
Paris, France

Registered trademarks U. S. Patent Office No. 30,171, June 8, 1897 for table, kitchen, dresserware and utensils of copper and pure silver. No record after c. 1920.

PARIS

BI-METAL
CUIVRE
ET
ARGENT PUR

BU S G.D.S.

A.M. SOFFEL CO., INC.
Newark, New Jersey

Manufacturers (?) of sterling silverware c. 1920-30.

SOUTHERN SILCO
Hartsville, South Carolina
See Eastern Carolina Silver Co.

Name found stamped on silverware. May possibly represent wares produced by a successor firm to the East Carolina Silver Co. (q.v.)

SOUTHINGTON CO.
See Barbour Silver Co.
See International Silver Co.

Also used name of company in a circle with TRIPLE.

SOUTHINGTON CO.

SOUTHINGTON CUTLERY CO.
Location unknown

Advertised holloware and knives (JC&HR December 1886) "Mfg. fine silver Plated Ware." (Adv. JC&HR March 1887)
"The Southington Cutlery Co. sent out circulars stating that their Britannia department will be reorganized as a separate concern under the name Southington Silver Plate Co." (JC&HR 11-30-1892, p. 4)

SOUTHINGTON SILVER PLATE COM-PANY
Location unknown

The Southington Silver Plate Company was bought by Meriden Britannia Company in 1893 but their trademark was never used by Meriden.

A.S. SOUTHWICK & CO.
Providence, Rhode Island

"Established in 1874 as Vose & Southwick." (JW 3-30-1892)
Manufacturers of silverwares.

GEORGE A. SPARKS
Brooklyn, New York

Manufacturers (?) of plated silver c. 1920.

S-C-A G

J.E. SPARKS
Brooklyn, New York

Manufacturer (?) of sterling silver c . 1920.

$ Spark $

SPAULDING & CO.
Chicago, Illinois

Founded in 1855 under the name of S. Hoard & Co. In 1888 it was incorporated under the name of Spaulding & Company, Inc. taking over, at that time, the business of N. Matson & Co. (q.v.)
On November 2, 1888 Levi Leiter of Chicago and Edward Holbrook of New York, representing the interests of the Gorham Manufacturing Co. of Providence, and Henry A. Spaulding, formed a corporation to manufacture and retail watches, clocks, jewelry, diamonds, silverware, silverplated ware, objects of art and other related merchandise, with Henry A. Spaulding as its first president. In the 1920s the Gorham Mfg. Co. acquired control of Spaulding & Co. and the name changed to Spaulding-Gorham Inc.
On June 1, 1943 the entire interests of Spaulding-Gorham Inc. were acquired by Gordon Lang, at which time the name was changed to Spaulding & Co. On October 1, 1973 ownership was acquired by Stewart A. Peacock.
Spaulding & Co.'s English sterling has its own Guildhall registered London hallmark. They have long been noted for their handforged silver by Fletcher of London as well as flatware by eminent American silversmiths.

SPAULDING-GORHAM, INC.
See Spaulding & Co.

D.S. SPAULDING
Mansfield, Massachusetts

Listed in JC 1896-1922 in sterling and plated silver sections.

(Sterling Silver Top and Plated Back
(On sterling silver)

(On plated silver)

DAVID H. SPEARS
Springfield, Kentucky

David Huston Spears was born July 5, 1798, the fourth of nine children born to Jacob Spears (1757-1818) and Abigail Huston Spears, at Carpenters Station (Hustonville), Lincoln County, Kentucky. He set up shop in Springfield, Kentucky about 1815. Where he received his training and served his apprenticeship is unknown. He was en route to New Orleans to set up a shop there but stopped overnight at Gibbons Tavern in Springfield and met and fell in love with Elizabeth Carter Gibbons, daughter of the innkeeper, Arthur F. Gibbons. He stayed in Springfield and hung out his shingle there which read "D.H. Spears, Silversmith and Watchmaker."

Spears hammered and fashioned beautiful silver items from Spanish dollars obtained from New Orleans trade, and silver coins from the East which were turned in by his customers. He advertised spoons, cups, beakers, pins, brooches, wedding and mourning rings, large and small ladies' watches and clocks. He made silver spectacle frames.

David H. Spears died February 26, 1876.

He is said to have designed and made the emblems of the Springfield Masonic Order of which he was a member.

SPENCE, GAVEN & CO.
Newark, New Jersey

Listed as silversmiths 1859-1916 in Newark City Directories.

SPENCE & CO. STERLING

GAVEN & SPENCE

G. SPENCE (straight line) with pseudo hallmarks, lion, head leopard

G. SPENCE (in half circle) with lion passant, D, Head.

The business was closed in the autumn of 1918. In 1869 Gaven Spence had operated the Excelsior Jewelry Store.

BEN. SPIER CO., INC.
New York. New York

Successor to Spier & Forsheim about 1909. Wholesaler of silverware, jewelry and related articles. Listed in 1924 KJI as wholesalers of platinum and diamond jewelry.

SPIER & FORSHEIM
New York, New York
See Ben. Spier Co.

Listed JC 1896. Succeeded by Ben. Spier Co. c. 1909.

EDMUND LLOYD SPIKE
THOMAS DANIEL SPIKE
Halifax, Nova Scotia, Canada

Both Edmund Lloyd Spike and his brother, Thomas Daniel Spike served their apprenticeships under Julius Cornelius (q.v.) In the early 1860s Edmund Lloyd Spike was in business in Halifax, specializing in the manufacture of jewelry from Nova Scotia gold, and also in the production of emblems for various organizations.

In about 1867 he went into partnership with his brother Thomas. Edmund L. Spike later moved to the New York area, while his brother remained in Halifax. Edmund L. Spike died about 1900. Thomas D. Spike died in 1926. (Unitt & Worrall, *Unitt's Book of Marks*, 1995, p. 22)

WILLIAM SPRATLING
New Orleans, Louisiana
Taxco, Mexico
See Silson, Inc.

William Spratling was an architect, artist, author and instructor in the School of Architecture at Tulane University, New Orleans. During the 1920s, he spent his summers in Mexico City, teaching architectural history at the National University. By 1929 he had decided to stay in Mexico, so he purchased a house, "Las Delicias," in the silver mining town of Taxco.

Looking for a way to make a living, he decided to open a small silver workshop to produce items of his own design. He began by having two goldsmiths from the nearby town of Iguala come and instruct a group of six young boys in how to work silver following his design drawings.

Spratling based his designs on Pre-Columbian Mexican Art objects and jewelry unearthed in archaeological excavations. He assembled and re-combined design elements from various sources in the development of his own unique portrayals.

Improved transportation facilities, particularly the development of the Pan American Highway, brought large numbers of tourists, fascinated by Mexico's exotic culture, to the area. Demand grew for Spratling's work. By 1940 he was employing 300 artizans to produce silver jewelry, flatware and holloware, tinware, textiles, and furniture made of wood and leather. (Morrill, *Silver,* Mar.-Apr. 1995, pp.12-13)

In 1944 he was sent to Alaska by the U.S. Dept. of Interior where he trained Alaskan Indians in the art of silversmithing. Spratling left behind a legacy of many silversmiths in both areas, trained in the highest standards of craftsmanship. He himself was killed in an automobile accident in August, 1967.

SPRINGFIELD SILVER PLATE CO.
Springfield, Massachusetts

Mark found on a silverplate figural napkin ring dating c.1870s.

SPRINGFIELD SILVER PLATE CO.
Springfield, Ohio

An 1896 account states: "The Springfield Silver Plate Co., Springfield, Ohio, have incorp. to mfg. casket hardware, novelties and to do electroplating. Incorporators are Ed. N. Lupfer, Charles H. Hiser, W.H. Reania, Paul A. Staley and W.W. Diehl. Lupfer has conducted a successful similar business for three years." (JC&HR 1-22-1896, p. 21)

GEORGE W. SPURR & CO.
Greenfield, Massachusetts
See Rogers & Spurr Mfg. Co.

STANDARD MFG. CO.
Winsted, Connecticut

An 1898 account notes: "The Standard Mfg. Co., Winsted, Conn., who began the mfg. of silverplated table knives, have increased their working capital and are turning out considerable quantities of goods." (JC&HR 3-16-1898, p. 40)

STANDARD SILVER CO. OF TORONTO
Toronto, Canada
See Acme Silver Company
See International Silver Co.
See International Silver Co. of Canada, Ltd.

When the Acme Silver Co. of Toronto was liquidated in 1893 it was sold to W.K. George and others who formed the Standard Silver Co., Toronto, Ltd., for the production of silverplated flatware and holloware and hotel ware.

According to *Unitt's Book of Marks,* the firm continued to use some of the Acme Silver Co. marks after the takeover. The company also produced Holmes & Edwards (q.v.) "inlaid silver flatware" under licence. (Unitt & Worrall,*Unitt's Book of Marks,* 1995, p.51)

Merged with International Silver Co. of Canada, Ltd. about 1912.

(E. P. on Copper.)

TRADE MARK FOR
HOLLOW WARE.

MONARCH SILVER CO.

G. RODGERS. A1

G RODGERS
12 DWT
TORONTO ONT

STANDARD SILVER WARE COMPANY
Boston, Massachusetts

Manufacturer of plated silverware. First appeared in the Boston City Directories in 1883, which probably means that it was founded the previous year. A catalog published by the company circa 1888 shows a selection of both holloware and flatware. The firm apparently obtained holloware "in the metal" from the Derby Silver Co. as a number of items shown in its catalog can also be found in Derby's 1883 catalog.

At least initially, the firm appears to have manufactured its own flatware. In addition to such standard patterns as Windsor, Tipped and Fiddle, the 1888 catalog also shows some attractive floral patterns, "Fuchsia", "Calla" and "Rose". "Fuschia" was patented June 13, 1882. The company also produced a variable engraved pattern named "Sterling Pattern", although it was manufactured in silverplate. For the Columbian Exposition in 1893 the firm manufactured its own demitasse souvenir spoons.

It used the name Crown Plate Co. on its triple plated flatware and its own name on "Full Plate Goods" (Quadruple plate)

In later years the firm marketed flatware patterns produced by other manufacturers.

Last listed in 1921. Edward C. Webb was head of the firm and was associated with it from about 1903 through 1921.

NEVADA SILVER METAL

STANDARD WATCH CO.
Location unknown

Mark found on a silverplate teapot dating circa 1890s.

STANLEY & AYLWARD, LTD.
Toronto, Canada

Wholesalers of plated silver holloware c. 1920.

STAR MANUFACTURING CO.
Location Unknown

Mark found on a silverplate medallion spoon dating c. 1870.

STAR SALT CASTOR COMPANY
Boston, Massachusetts

The basic concept of the star salt was developed by George B. Richardson of Boston, Mass. in 1867. He received Invention Patent No. 71,643 for this device on December 3 of that year, assigning the rights to the patent one third to himself, and one third each to Thomas T. Sanborn and William M. Cobb. At some undetermined point, the Star Salt Castor Company was formed to market the product.

In 1877 the company advertised its Star Salts in the *Jewelers' Circular and Horological Review*. A pronged pulverizer in the bottle was designed to automatically break up lumps and permit the salt to flow easily when the shaker was upended. The company claimed to be sole proprietors and manufacturers of their product, as reported in *Silver*, Sept.-Oct. 1990, p. 23.

The 1878 Meriden Britannia Co. catalog has a half page devoted to displaying various styles of Star Salts. The 1886-7 catalog shows two full pages of them. Whether the Meriden Britannia Co. was simply retailing these Star Salts, or whether it had arranged to purchase the Star Salt Castor Company has not yet been determined.

THEODORE B. STARR
New York, New York

In business c. 1900-1924. Succeeded by Reed & Barton.

STARR & MARCUS
New York, New York

Theodore B. Starr first appears in the New York City directories in 1862 as a jeweler. About 1865 he entered into a partnership with Herman Marcus. The firm is listed as jewelers and silversmiths for 1865 and 1866. "Silversmiths" in this case apparently meant silverplaters, as the mark illustrated below appears on a silverplated sugar shaker. Reed & Barton supplied the piece "in the metal", their mark being purposely defaced on this example.

Starr and Marcus apparently gave up manufacturing their own wares in 1867 when they began retailing solid silver and silverplate manufactured by Gorham. They ran numerous ads in the *New York Times* beginning in 1868. The company became a primary retail outlet for a number of major solid silver manufacturers.

By the close of 1877 the partnership had come to an end, as indicated by an ad run in *Harper's Weekly* in December of that year. Theodore B. Starr continued the business, retailing a wide variety of jewelry and fancy goods as well as continuing to serve as the retail sales agent for Gorham in New York City. He moved the shop from its former location at 22 John St. to No. 206 Fifth Avenue, Madison Square. (*Harper's Weekly*, Dec. 29, 1877, p. 1036)

Starr also appears to have turned to silver manufacturing again in the 1880s. Design Patent No. 13,143 for a flatware pattern featuring a *fleur de lis* on the handle was assigned to him in 1882.

Marcus apparently went into the jewelry manufacturing business, obtaining Design Patent No. 14,583 for a lace pin in 1884.

I.J. STEANE & CO.
Hartford, Connecticut
New York, New York
See Barbour Silver Co.

Isaac J. Steane, a watchmaker at Coventry, England, came to America about 1866 to collect a bad debt. He was forced to take over his debtor's stock, which he auctioned off at a profit of $6,000. He continued in the auction business for some time; returned to England, wound up his business affairs and came again to the United States where he formed the firm of Steane, Son

& Hall, consisting of Isaac J . Steane, Isaac J . Steane, Jr., and J.P. Hall. Mr. Hall retired in 1886 and the firm name was changed to I.J. Steane & Co.

Mr. Steane bought the Taunton Silver Plate Co. (q.v.), and took stock to New York for auction. He later bought the Albany Silver Plate Co., combining the affairs of these two companies with that of I.J. Steane & Co.

In the early 1880s, Mr. Steane purchased the old silverware stock of the Cromwell Plate Co. (q.v.), of Cromwell, Connecticut. The sale was made by A.E. Hobson, who in 1881 had left the Meriden Britannia Co. to become a salesman for Cromwell.

About this same time, the Barbour Bros. Co. was formed by S.L. Barbour, from Chicago, joined by his brother, Charles, who was in business in New Haven. I.J. Steane & Co. produced the goods that the Barbour Bros. Co. marketed. Mr. Hobson was associated with I.J. Steane at this time. At the suggestion of W.H. Watrous, the business was moved to Hartford and two years later the Hartford Silver Plate Company (q.v.) business was also acquired. Mr. Steane, Sr. retired and returned to England in 1888.

The I.J. Steane Co., the Barbour Bros. Co. and the Barbour Hobson Co., all of Hartford, united to form the Barbour Silver Company in 1892.

Steane introduced many European designs into this country by purchasing silver articles in Europe and bringing them to be copied here.

STEANE, SON & HALL
New York, New York
See Barbour Silver Co.
See I.J. Steane & Co.

THE STEEL-BRUSSEL CO.
New York, New York

Listed in JC 1896 in sterling silver section. Out of business before 1904.

H. STEINACKER
Baltimore, Maryland

Listed in 1868-1869 Baltimore City Directory as a silverplater.

GEORGE W. STEPHENSON
New York, New York

George W. Stephenson first appears in the New York City directory published in 1869 as the senior partner in the firm of Stephenson & Bayley, gold and silver platers. By 1870 he had gone into partnership with John Wright and the firm's name had changed to Stephenson & Wright. By the following year Stephenson was in business alone.

An ad in the New York City directory published in 1874 describes the firm's work in the following terms: "Particular attention given to repairing and re-plating Hotel and Restaurant Ware. Also Plumbers' Materials, Car Trimmings, Beer Pumps And Harness Trimmings. All work warranted." Not followed beyond 1874.

STERLING COMPANY
Derby, Connecticut

Published illustrated catalogs of fine silverware in 1893 and 1898. On the catalogs is the statement, "Established 1866."

THE STERLING COMPANY
Providence, Rhode Island
See Howard Sterling Co.

STERLING CRAFT
Toronto, Ontario, Canada

Sterling silver manufacturer (?) c. 1920. Related (?) to Spurrier & Co., London.

STERLING FOUNTAIN PEN COMPANY
Boston Massachusetts

An ad in a 1903 issue of *McClure's Magazine* indicates that the Sterling Fountain Pen Company was a subdivision of the Davidson Rubber Co. in Boston.

STERLING SILVER MFG. CO.
Baltimore. Maryland
See Klank Manufacturing Co.

An 1894 account states: "The Sterling Silver Manufacturing Company, Baltimore, Md. which by an infusion of new blood and fresh

capital, emerged from the Klank Mfg. Co., recently passed the first twelfth month of their existence with a good yearly record. They manufacture solid silver holloware and flatware, and a full line of white metal goods, beside doing considerable repairing and replating. Their new and original designs in hollowware have proved very taking. Factory at 110 W. Fayette St., office and salesroom at 17 N. Liberty St. " (JC&HR 2-14-1894, p. 27)

THE STERLING SILVER MFG. CO.
Providence, Rhode Island

Listed in the City Directories 1909-1932, Samuel A. Schreiber, president-treasurer; Max L. Jocby, vice-president; L.C. McCaffrey, sec. Manufacturing silversmiths. Made sterling flat and holloware and souvenir spoons.

Their flatware dies were purchased by Saart Bros.

STERLING SILVER PLATE CO.
Location unknown

Manufactured silverplate souvenir spoons for the Atlanta Exposition held in 1895.

STERLING SILVER SOUVENIR CO.
Boston, Massachusetts

In business before 1890. Advertised that they were makers of sterling silver souvenirs. Out of business before 1915.

LOUIS STERN CO., INC.
Providence, Rhode Island

Established in 1871 as chainmakers and silversmiths. Wholesalers of chains, bags, watch bracelets, bracelets, knives, buckles and jewelry. Last record found 1950.

LS. & Co.

S. STERNAU & CO.
Brooklyn, New York and New York, New York

Proprietors were Sigmund Sternau and Charles Nelson.

Listed in 1896 *Jewelers' Weekly* as manufacturer of plated silver chafing dishes and miscellaneous lines. Listed in KJI 1922 as a manufacturer of alcohol heating devices. Not found in KJI 1924.

STEVENS & LEITHOFF
Irvington, New Jersey

Listed JC 1915 in sterling silver section. Out of business before 1922.

STEVENS SILVER CO.
Portland, Maine
See Colonial Silver Co.
See Woodman-Cook Co.

CHRONOLOGY

Stevens & Smart	1879-1883
Stevens, Smart & Dunham	1884-1886
Stevens & Smart	1887-1890
Stevens, Woodman & Co.	1890-1891
Woodman-Cook Co.	1892-1893
Stevens Silver Co.	1893-1899

The firm of Alfred A. Stevens was listed in 1879 and known as Stevens & Smart (Alfred A. Stevens and Nehemiah Smart), manufacturers of britannia wares until 1883 when it was succeeded by Stevens, Smart & Dunham (Joseph Dunham). It became Stevens, Woodman & Co., (Fred H Woodman) in 1890. They advertised that they did silverplating. Woodman-Cook (q.v.) succeeded in 1892. They manufactured silverplated wares. Edward B. Cook was president; C. H. Fessenden, vice president and Fred H. Woodman, treasurer.

Alfred A. Stevens left the firm to form the Stevens Silver Co., which was incorporated in 1893. Alfred A. Stevens was president. That firm later became the Colonial Silver Co.

THE STIEFF COMPANY
Baltimore, Maryland
See Kirk Stieff Company

Founded in 1892 as The Baltimore Sterling Silver Company by Charles C. Stieff. In 1904 the corporation name was changed to The Stieff Company.

They are manufacturers of sterling silver flatware and holloware. Their "Rose" pattern is so identified with Baltimore that it is often called "Baltimore Rose." They are the exclusive makers of Williamsburg Restoration, Historic Newport and Old Sturbridge Village sterling silver and pewter reproductions.

Their appointment to make sterling silver holloware and flatware reproductions for Williamsburg was in September 1939.

They began the production of pewter August 19, 1951, after receiving the appointment, but because of the tin shortage caused by the Korean war, their first shipments were not made until August 1953.

They bought the Schofield Co. in 1967.

In 1979 the Steiff Company acquired S. Kirk & Son and formed a new corporation called The Kirk-Stieff Company.

In February 1990 Brown Forman Co. of Louisville, Kentucky, a whiskey distiller, purchased Kirk-Stieff from the Steiff family.

STIEFF STERLING

The above "Hallmark" is used on Williamsburg Restorations. It was used in Virginia in the 17th and 18th centuries as a shipper's or maker's mark. Used in England as early as the 16th century - apparently to indicate the highest quality.

Since 1901 the Stieff Company has used year markings on their sterling silver holloware.

Year	Mark		Year	Mark
1901	①		1929	♀ or 🖋
1902	②		1930	☆
1903	③		1931	♋ or ♂
to			1932	➤

Year	Mark		Year	Mark
1916	⑯		1933	⚓ or ⚓
1917	♀ or ◇		1934	⎵ or ⎴
1918	△		1935	✓ or ✓
1919	○		1936	A
1920	∩ or ⌒		1937	B
1921	—		1938	C
1922	✝		1939	D
1923	⧧ or + +		1940	E
1924	#		1941	F
1925	⬠		1942	G
1926	⬡ or ◇		1943	H
1927	☾ or ⌒		1944	J
1928	卍		1945	K

Year	Mark		Year	Mark
1946	L		1961	3
1947	M		1962	4
1948	N		1963	5
1949	O		1964	6
1950	P		1965	7
1951	R		1966	8
1952	S		1967	9
1953	T		1968	10
1954	U		1969	11
1955	W		1970	12
1956	X		1971	13
1957	Y		1972	14
1958	Z		1973	15
1959	1		1974	16
1960	2			

STIEFF-ORTH CO.
Baltimore, Maryland

Not listed in Baltimore City Directories which were checked from the 1890s through the 1930s. Listed in JC 1909 sterling silver section. Out of business before 1915.

JAMES H. STIMPSON
Baltimore, Maryland

Listed Baltimore City Directories 1851-1868, variously as "zink works," "chemist" and "manuf'g. chemist and patentee of ice pitcher, etc." James H. Stimpson was the son of James Stimpson, inventor of the double-wall ice pitcher. James H. Stimpson invented and patented a triple-wall ice pitcher and several styles of butter coolers. Though listed as a "chemist" the inventory of his estate revealed that his "chemical works" was actually a silverplating establishment.

(On britannia)

STIX & L'ALLEMAND
New York, New York
See L'Allemand Mfg. Co.
See E.H. Rowley & Co.

Firm formed by a Mr. Stix and Ernest A. L'Allemand in 1889. Manufacturers of silverplated ware. The firm succeeded E.H. Rowley & Co. (q.v.) It continued in business until August 31, 1893, When Ernest A. L'Allemand bought out his partner and formed the L'Allemand Manufacturing Co. (q.v.) (JC & HR 7-1-95, p. 10)

G.B. STOCKING
Tacoma, Washington

Jeweler, watchmaker, optician 1893-1896. Registered U.S. Trade Mark Patent No. 22,807, April 18, 1893 for manufacture of jewelry, spoons and other flatware.

RHODODENDRON

ARTHUR J. STONE
Gardner, Massachusetts
See Stone Associates

At least 14 slightly different Stone touchmarks are known. All include a small chasing hammer. Stone's earliest mark consisted of the hammer alone with the word STERLING. This was followed by the hammer with the S incised and then by Stone incised. Around 1908-09 several marks were used simultaneously with much overlapping of their use. Later marks (1910-1937) have greater uniformity and were cut by die-makers outside the silver shop. The marks shown below (from Chickering, *Silver,* Jan.-Feb. 1986, p. 11) date c.1901-1906 before he had assistants sign their work.

About 1906 other craftsmen joined him, and he began the practice of having them sign their work with an initial. At the same time, his mark became more standardized. (Chickering, ibid.)

STONE ASSOCIATES
Gardner, Massachusetts

Arthur J. Stone, founder, was born in Sheffield, England on the 26th of September 1847. At age 14 he began a seven-year apprenticeship with master silversmith, Edwin Eagle of Sheffield and studied evenings at the National School of Design, Sheffield. From 1868 to 1884 he worked as a silversmith in Edinburgh and Sheffield, work in the latter city being with James Dixon & Sons (q.v.)

In 1884 he emigrated to the United States where he worked three years for the William Durgin Company (q.v.), Concord, New Hampshire. In 1887 he moved to Gardner, Massachusetts to work for the Frank W. Smith Silver Company (q.v.) as designer and head of the holloware department.

Between 1895 and 1897 he was in partnership with Joseph.P. Howard, of Howard & Co. (q.v.) in New York. While there Stone began producing the first of his miniatures. Illustrations of seventy-five such toys, many probably made by Stone, were published by Howard in an 1895 catalog entitled *Novelties for Christmas/Solid*

Silver Toys. (Chickering, *Arthur J. Stone*, 1994, p.7)

In 1896 he married Elizabeth Bent Eaton of Gardner. After his return to that city he was self-employed as a designer. In 1901, with the assistance of his young wife, he established his own workshop in Gardner. Five years later he began hiring and training assistants.

In 1902 he received a prize from the Art Institute of Chicago. In 1904 he won another award at the Louisiana Purchase Exposition in St. Louis. (Chickering, *Silver*, July-Aug. 1995, p. 24)

Arthur J. Stone was one of the last independent designers and master silversmiths of New England to employ and train other masters and apprentices. Stone was one of the primary supporters of the Arts and Crafts Movement. He received awards from the Society of Arts and Crafts and others. More than 35 exhibitions have included Stone silver.

The characteristic features of Stone silver are its masterful design, curvilinear forms, technical perfection and skilfully chased ornamentation. The design motifs most frequently used on pieces are plants and flowers of the New England region.

Stone's works are also known for their functional design, weight and strength. (Chickering, ibid., p. 25) Over the years his shop produced a wide variety of flatware and holloware, as well as some ecclesiastical pieces. He also produced works in copper and cast bronze.

Stone suffered a mild stroke at age 78 which affected the functioning of his left hand, however, the shop continued to perform to his standards. From 1926 on he employed other designers, such as Charlotte D. Bone. (Chickering, ibid., p. 26)

Stone retired in 1937 on his ninetieth birthday and sold the shop to Henry Heywood. He died February 6, 1938.

When Stone began to hire and train apprentices and craftsmen they hammered out the flatware and holloware under his supervision while he did the designing, chasing and other decoration as well as his own forging and raising. When Stone was in charge of the shop he insisted that each craftsman should sign his own work, so that each had his initial stamped under the STERLING mark on holloware and after the STERLING on flatware.

On October 1, 1937 when the shop was sold and renamed "Stone Associates" the mark was temporarily changed to a chaser's hammer crossed by three S's:

Soon the familiar Stone mark was resumed with a lower case "h" in a small shield, added to differentiate it from Stone's 1901-1937 mark:

In 1957 when Stone Associates was disbanded Ernest W. Lehtonen, trained in the Stone Associates Shop, bought the Stone mark which he used on flatware, adding a capital "L" in a small shield:

STONE STERLING SILVER CO.
New York, New York

Registered their trademark U.S. Patent Office, No. 28,350, June 4, 1896 for silverware and jewelry. Listed in JC 1896. Out of business before 1904.

MAX H. STORCH
New York, New York

Registered trademarks for use on silverplated and sterling flatware and other tableware.

★Chase★

(Used since 1949)

(Used since 1950)

TABLE OF ASSISTANTS:

Date	Initial	Craftsman	Specialty
1906-1907	P	John H. Petty	Holloware
1906-1910	B	George P. Blanchard	Spoonmaker
1907-1911	O	Clinton B. Ogilvie	Holloware
1908-1909	• B •	William Blair	Holloware
1908-1937	T	Herbert A. Taylor	Holloware
1909-1912	L	Sylvanus E. Lamphrey	Spoonmaker, line chaser
1909-1919	C	David Carlson	Holloware
1909-1937	H	Arthur L. Hartwell	Holloware
1912-1937	B	Charles W. Brown	Spoonmaker
1912-1937	H•	Benjamin H. Harrison	Finisher
1912-1914	W	Alfred Wikstrom (or Wickstrom)	Flatware
1914-1916	P	Walter W. Pfeiffer	Flatware
1915-1932	E	George C. Erickson	Flatware
1920-1937	G	Herman W. Glendenning	Holloware, flatware
1921-1927	U	Earle H. Underwood	Holloware
ca. 1921		Thomas Holmes	
1922-1932	C	Magnus Carlberg	Holloware
1923-1933		Lawrence Carlberg	Apprentice
1924-1937	c	Edgar L. Caron	Holloware
1927-1929		Andrew Walker	Chaser
ca. 1929		Benjamin Holmes	Chaser
1928-1929		Charlotte Bone	Designer
1929-1933		Ernest C. Pearson	Finisher
1931-1937	B	Edward Billings	Chaser, designer
	C	Unidentified	Holloware
	B	Unidentified	Holloware

Chasers and designers rarely used initials.

STORRS BROS.
New York, New York

Charles & Augustus Storrs first appear in the New York City directories in the plated goods business in 1853, probably working for someone else. Although both appear in the directory published in 1854, no indication as to nature of their business is given. In 1855 and 1856 they are both listed as members of the firm of Storrs Bros., "commercial merchants and plated wares". Mason's Bros. Business Directory published in 1856 lists "C. A. and R. O. Storrs, Plated Wares" at the same address that year.

Storrs Bros. continued in business as merchants, sometimes listed as dealers in "fancy goods" at least through 1874. No specific mention of silver or plated wares is made in connection with the firm after 1856.

L.S. STOWE
Springfield, Massachusetts
See H. J. Webb & Co.

"Stowe was born August 9, 1834, and orphaned at the age of 12. He was "bound out" to a farmer. When he was 18 he began training in the jewelry trade. He started in business in Gardner, Massachusetts in 1855. He moved to Springfield in 1864. Sold out to Webb in 1900 and died in 1924," (Clipping from unidentified newspaper dated 1924)

A. STOWELL, JR.
Baltimore, Maryland

Silversmith c. 1855. Listed as member of firm Gould, Stowell & Ward in 1855-1856 Baltimore City Directory.

STRATHMORE CO.
Providence, Rhode Island

Manufacturers of sterling flatware and plated silverware, holloware, picture frames and gift shop novelties. Listed 1915 through 1927.

SOLID STRATHMORE SILVER
T.S. CO.
STRATHMORE MESH
DIAMOND MESH

NATHAN STRAUS-DUPARQUET INC.
New York, New York

Tradename filed Sept. 7, 1950 for use on silverplated flatware. Claims use since January 1931.

NASTRAUS

STRAUSS SILVER CO., INC.
New York, New York

Manufacturers and importers of solid and silverplated Dutch silver novelties. Late 1920s and 1930s.

R. STRICKLAND & CO.
Albany, New York

Ralph Strickland is listed in Albany City Directories 1857-1884 as a manufacturer of plated wares. On November 10, 1868 he received invention patent No. 84,018 for an "Improvement in Coffee and Tea-pots". His invention consisted of a weighted, hinged, internal screen cover for the spout that automatically fell into place when the pot was tilted, preventing grounds or tea leaves from flowing out into the user's cup.

Other holloware products included figural silverplate napkin rings.

R. STRICKLAND

ALBANY N.Y.

TRIPLE PLATE

STRONG & ELDER CO.
Location unknown

Listed in JC 1896 sterling section as out of business.

STRONG MFG. CO.
Winsted, Connecticut

In 1856, Markham and Strong of East Hampton, Connecticut made a small line of coffin tacks, screws and handles from white metal. Mr. Markham continued the business while the two Strongs, David and Clark were in the Union service. In 1866 David Strong bought out the company and moved to Winsted, Connecticut. The articles were considered of great beauty and were silver plated. It is reported that General Grant's casket was adorned with gold handles made by them. Also, handles and plates were furnished for the caskets of ex-president Harrison and Cornelius Vanderbilt. The company is last listed in 1934 city directory. No trademark has been located.

ARTHUR STUART COMPANY
Albuquerque, New Mexico
See Amston Silver Co., Inc.

The company was established in 1949 and operated, according to the 1959 Albuquerque City Directory, by Arthur H. Spiegel. The trademark below and the sterling flatware pattern names *Empress Carlotta* and *Fidelity* were registered on the same date. Four additional sterling silver flatware pattern names, *Queen of Scots, Ceremonial, Crescendo* and *Breath of Spring*, were registered November 10, 1949. The designs originated in Albuquerque and were sold on a direct mail basis from there. The silver was manufactured in Meriden, Connecticut by the Amston Company. When Amston went into bankruptcy in 1960, the Arthur Stuart Company was dissolved.

(Trade Mark No. 598,123, filed May 25, 1950; claims use since August 15, 1949.)

ROBERT STUART
Cincinnati, Ohio

Listed as manufacturers of hand-made silverware. (1931 Keystone)

STUDIO SILVERSMITHS
Division of Hannon & Smith Co., Inc.
Hawthorne, New Jersey

Founded in 1950 as Hannon & Smith Co. by Jack Hannon and Elmer Smith, both deceased. Subsequently owned by Elmer Smith's widow, since remarried, Margaret Smith Gunster. Manufacturers of 24k gold plate, silverplate, crystal combined with gold and silverplate. Products included holloware, salad bowls, salad servers, gold and silver footed crystal bowls, candelabra, centerpieces, etc. Recent (1995) attempts to contact the firm have been unsuccessful.

SSS

STURDY & MARCY
See Fred I. Marcy & Co.

SUCKLING, LTD.
Birmingham, England

Successor to Wm. Suckling & Sons between 1915-1922. Manufacturers of plated silverware.

"Founded by William Suckling in 1895 ... invented rubber punch that expanded within an undercut die ... making shapes otherwise impossible ... ceased trading in 1965." (Jones, *The Silversmiths of Birmingham and their marks: 1750-1980*, 1981, p. 315)

G.D. SULLIVAN & CO.
St. Louis, Missouri

Manufacturer of solid silver flatware circa 1842-1846.

WYNDHAM A. SULLIVAN
Baltimore, Maryland

Listed in Baltimore City Directories 1900-1915 as a silversmith in the firm of Ritter & Sullivan.

SUMMIT SILVER INC.
New York, New York

Advertised 1965-74. Advertising says "two-tone decorative silverplate that never needs any polishing...From the famous HOKA silversmiths in Western Germany." Distributors (?) only.

SUNDERLIN COMPANY
Rochester, New York

This silversmithing business began with three Burr brothers; Albert, who was apprenticed to Erastus Cook, and died shortly after starting his jewelry business; Alexander J., who was Albert's apprentice and Cornelius. The business went through a series of partnerships from 1838 and was known as C.A. Burr & Company after the death of the two brothers. In 1864 it was sold to Sunderlin & Weaver; became Sunderlin & McAllister; L. Sunderlin & Company and in 1944 was the Sunderlin Company. Out of business in 1952.

SUPERIOR SILVER COMPANY
See Middletown Plate Co.
See Wilcox Silver Plate Co.

The Superior Silver Co. marks were used by the Middletown Plate Co.

The Superior marks first read "Superior Silver Co." and later read "Superior Silver Plate Co." This change may have been after the Middletown Plate Company moved to Meriden

and the Superior line was transferred to Wilcox Silver Plate Company.

(RegisteredApril 3, 1906; first use claimed February 6, 1906; renewed in 1926)

SUPREME SILVER CO.
New York, New York

Manufacturers of sterling silver holloware and repair work c. 1930.

SUTTON HOO JEWELERS
Colorado Springs, Colorado

Founded November 1972 by Bob Newell and Charles Lamoreaux. They make one-of-a-kind jewelry and holloware of sterling silver and gold. The firm was joined in 1974 by Lewis Ridenour, silversmith, who concentrates on holloware and flatware. Bob Newell (b. December 6, 1940) received his education at the New Mexico Military Institute and studied the art of *cire perdue* with the master technician from New Gold Company. Charles Lamoureaux (b. December 26, 1950) received his education at the University of Kansas. Lewis Ridenour, (b. July 8, 1949) was educated at Northwest Missouri State College and the University of Kansas.

Bob Newell Charles Lamoreaux Lewis Ridenour

(Shop stamp)

THE SWEETSER CO.
New York, New York

Gold and silversmiths c. 1900-1915.

CHAS. N. SWIFT & CO.
New York, New York

Listed JC 1904 in the sterling silver section. Out of business before 1915.

SYRACUSE SILVER COMPANY
Syracuse, New York

First listed in Syracuse City Directory in 1940 as manufacturers of silverplated holloware, novelties, trophies, also plating. Ernest Kauer, owner. The 1946-56 Directories list Mrs. Edith O. Kauer as owner and the 1965-66 telephone directory lists only her home address.

SYRACUSE SILVER MFG. CO.
Syracuse, New. York
See Lesser & Rheinauer
See A.B. Schreuder

An 1895 account states: "The sterling silver manufacturing plant of A.B. Schreuder, which has been in existence for 40 years, goes into the hands of the Syracuse Silver Mfg. Co. The latter is a new organization formed by the partners in the firm of A. Lesser's Sons, wholesale jewelers. Members of the company are Simon Lesser, S. Harry Lesser and Benjamin Lesser. They will manufacture sterling silver novelties. Benjamin Lesser will be manager." (JC&HR 2-20-1895, p. 10)

Listed 1896-1904 in JC as manufacturers of sterling silverware. Syracuse Silver Mfg. Co. listed in Syracuse, New York, City Directories 1895-1900. Under the first listing, J. Barton French was president and business manager, A. Hubbs, Secretary and E. Elmer Keeler, treas. in 1896-1897. Benjamin F., Simon and Solomon H. Lesser were listed as owners. In 1898-1900, it was listed as Silverware Manufacturers, A. Lesser's Son. In 1900, the listing was A. Lesser Son, watch materials.

SYRATECH CORPORATION
East Boston, Massachusetts
See International Silver Co.
See Wallace Silversmiths
See Towle Silversmiths

Syratech Corporation was founded as a holding company in 1986 by Leonard Florence. In 1986 it purchased through its subsidiaries the International Silver Co. and Wallace Silversmiths from Katy Industries, Inc. of Elgin, Illinois. In 1990 through one of its subsidiaries, the company purchased Towle Silversmiths.

Syratech Corporation designs, manufactures, markets and distributes a wide range of consumer products under several well recognized trade names in both the tabletop and giftware markets. The company's tableware and giftware segment consists of sterling silver, silverplated and stainless steel flatware; sterling silver and silverplated holloware and giftware, a variety of well crafted picture frames and albums, as well as seasonal merchandise and glassware.

The company's products are marketed under such prestigious tradenames as: Wallace Silversmiths®, Towle Silversmiths®, International Silver Company®, Tuttle Sterling®, 1847 Rogers Bros.®,Wm. Rogers & Son®, Supreme Cutlery®, Westmoreland®, Melannco International®, Holiday Workshop™, and Elements®.

T

T.C. SHOP
Chicago, Illinois

Founded by Emery W. Todd (?) and Clemencia C. Cosio (?) 1910-1913. Todd had been employed by the Kalo Shop. He incorporated Clara Welles' styles into his handmade silver flatware and other domestic wares. He executed the designs of his partner, Clemencia Cosio, or had them made by Matthias Hamch, a Park Ridge craftsman. Todd also taught jewelry making at the Art Institute of Chicago 1927-1930.

TABER & TIBBITS, INC.
Wallingford, Connecticut

Listed in the City Directory 1919-1941. Makers of silverplated holloware and novelties. Trademark was a tabor (small drum).

The firm was started in 1919 by Charles H. Tibbits and R.H. Taber, his son-in-law. They were succeeded by Silvercraft Co.

FRANK TAGGART
Toronto, Ontario, Canada

Frank Taggart had served as general manager for the Charles Starke Co. before opening his own store in 1886. He produced a catalog offering sterling silver souvenir spoons. The firm also made gold and silver thimbles. Not found after 1887 (Unitt & Worrall, *Unitt's Book Of Marks*, 1995, p. 52)

TALBOT MFG. CO.
Providence, Rhode Island

Listed in KJI 1922 and 1924 as manufacturers of cigarette cases.

TALCO

H.H. TAMMEN CURIO CO.
Denver, Colorado

In business from c. 1881 to 1962. Was purchased by Con Becker in 1957 and is now (1975) the Thrift Novelty Company.

First begun by H.H. Tammen as a curio shop, the business was expanded to include the manufacture and wholesaling of souvenir novelties and jewelry. Among their widely distributed souvenirs were sterling silver spoons depicting people and places of the West. By 1887, after several moves for expansion, a museum established in connection with the business advertised that "it was lighted by electric light," and was considered a place no traveler should miss. The business managed to survive the panic of 1893 and went on to become the largest of its kind in the west.

TAUNTON BRITANNIA MANUFACTURING COMPANY
Taunton, Massachusetts
See Reed & Barton

The Taunton Britannia Manufacturing Company was the successor to Crossman, West & Leonard when the need for additional capital for expansion brought about the establishment of this joint-stock company on August 18, 1830.

There were eight shareholders in the new company. Of these, only William Crossman, Haile N. Wood, Daniel Cobb and William West were experienced in the britannia business. James Crossman had been a merchant tailor, real estate investor and was at that time a director of the Cohannet Bank in Taunton. Haile Wood, Sr., dealt in real estate and Horatio and Z.A. Leonard were prominent in the metal and textile trades.

Immediately a new factory at Hopewell, on the Mill River, was built. Water was planned as the main source of power, but the old steam engine from the Fayette Street shop was installed for power during summer droughts.

By 1831, the manufacturing of britannia ware had all been shifted to the new factory. Throughout that year, many additions to their product line were added. Among them were castor frames, tankards, church cups, christening bowls, soup ladles and candlesticks. In 1832, toast racks, soda dispensers and fruit dishes were added. Sales of the tea sets, that had been the backbone of the business, dropped after 1831.

The Taunton Britannia Manufacturing Company was noted for the production of some of the most beautiful lamps made in America. New designs in these lighting devices and an increased supply of whale oil on the market promoted their popularity.

Castor sets were to be found on every dining table in America; many of them were made by this company. Their revolving sets were considered the epitome of luxurious living.

In 1832, William Crossman, Willam West and Zephaniah Leonard sold their interests in the company to Horatio Leonard, and in 1833 Isaac Babbitt, superintendent of the plant, left the company.

On February 16, 1833, a new corporation, with Horatio Leonard, James Crossman, Haile Wood, Daniel Cobb and Haile N. Wood was formed under the same name - the Taunton Britannia Mfg. Company. General business uncertainty of the period, competition from other britannia ware establishments, as well as a strong preference for foreign articles brought about the total failure of the company in November, 1834.

Three people still had great faith in the enterprise. They were the company agent, Benjamin Pratt; Henry Reed, a spinner; and his friend, Charles E. Barton, the solderer. On April 1, 1835, they reopened the factory and eventually formed what is now Reed & Barton.

T. B. M. CO.
TAUNTON BRIT.
MANFG. CO.

TAUNTON SILVERSMITHS

A subsidiary of Lenox, Inc. The Taunton Collection, a line of silverplated holloware, is offered only to Lenox dinnerware dealers. Introduced late in 1974.

TAUNTON SILVERPLATE COMPANY
Taunton, Massachusetts

Founded in 1853 and stayed in business until 1859. They stamped their pieces with that name and also used the name Taunton Britannia and Silver Plate Co. since the base metal was britannia. George B. Atwood was president with Thomas Furness and John Fletcher being directors. These men had been brought from England to begin the silverplating of britannia. Their shop was on Cohannet Street in Taunton but they moved to a large building on Winthrop Street.

TAUNTON SILVER PLATE CO.
Taunton, Massachusetts
See I.J. Steane

This firm may be some form of continuation or re-organization of the previous one. The date of its founding is not known. In 1872 Oliver Ames served as president and George T. Atwood as treasurer, according to the New York City Directory.

The Taunton Silver Plate Co. sub-leased a portion of the Redfield & Rice showroom at 4 Maiden Lane, New York, in that year. The following year, after the Redfield & Rice bankruptcy, the Taunton Silver Plate Company took over the entire showroom area. John H. Swain replaced George T. Atwood as treasurer of the company. Not followed in detail beyond 1874. At some point, probably circa 1880, the firm was purchased by I. J. Steane.

The marks shown below were both found on pieces dating from the early 1870s.

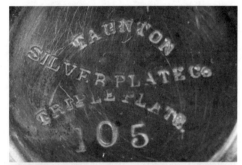

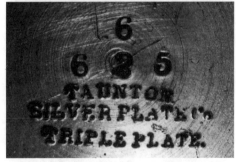

ANDREW A. TAYLOR
Newark, New Jersey

Listed from c. 1930 to 1973 as manufacturer of sterling silver holloware. No longer listed.

DAVID TAYLOR JEWELRY CO.
New York, New York

Registered trademark for use on flatware, holloware, insignia, service medals and costume jewelry made of or plated with gold, silver, or other precious metals, all for use of officers and enlisted men of the Armed Forces of the U.S.

(Used since April 15, 1945)

F.C. TAYLOR & CO.
Baltimore, Maryland

Listed in 1881 Baltimore City Directory as silverplaters.

TAYLOR & LAWRIE
Philadelphia, Pennsylvania
See Bailey, Banks & Biddle

Robert Taylor and Robert D. Lawrie established the firm of Taylor and Lawrie in 1837. The company began manufacturing silver for the firm of Bailey & Kitchen, a forerunner of Bailey & Co., and continued to provide silverware for that company. In 1852 Taylor and Lawrie established their own independent factory and went into business for themselves, although they apparently still, on occasion, supplied silver to Bailey & Co. (Soeffing, *Silver*, Nov.-Dec. 1995, pp. 13-15) Large quantities of silver bear the marks of both firms.

Taylor and Lawrie received Design Patent No. 512 for flatware on October 19, 1852.

The firm marked some of its goods from its independent period with a "U, Eagle, S" which may have been a quality standard mark, indicating that the items bearing it were of US Standard - .900 fine. (Soeffing, ibid.)

From about 1857 until the early 1870s, the firm was closely connected with George Sharp (q.v.) and others.

In addition to manufacturing solid silver, the firm also imported large quantities of silver and silverplate from England. (Soeffing, *Silver*, Sept.-Oct. 1988, pp. 18-19)

THE TENNANT COMPANY
New York, New York
See Hartford Sterling Co.
See Phelps & Cary Co.

Silversmiths before 1896. Makers of holloware and dresserware in sterling silver only. Trophies, presentation pieces. Succeeded (?) by Hartford Sterling Co. c. 1901. Trademark is identical to one used by Hartford Sterling Co. and by Phelps & Cary Co., with the exception of the initials in the shield.

THIERY & CO.
Newark, New Jersey

Listed JC as jewelers; out of business before 1909. Trademarks found on souvenir spoons.

THE THOMAE CO.
Attleboro, Massachusetts
See Watson Company

Chas. Thomae & Son, Inc. was established August 1, 1920 by the late Charles Thomae and his son, Herbert L. Thomae. They make novelty goods of 14k gold and sterling silver, religious medals, etch photos on gold and silver and make bronze memorial plates and signs.

Charles Thomae was superintendent of the Watson Co. for several years and developed enameling and a line of novelties and dresserware till it reached the importance of a separate business. The Thomae Co. was formed as a division of the Watson Co. In 1920, Charles Thomae resigned from both firms and started a new business with the name of Chas. Thomae & Son.

The firm's founder died in 1958. It is now (1975) run by his two sons Herbert L., President and Charles G. Thomae.

The trademark ⚔ has been used with little change since 1920 and was a personal mark used by Charles Thomae to mark his own work before that.

THOMPSON, HAYWARD & CO.
Mechanicsville, Massachusetts
See Walter E. Hayward Co., Inc.

THOMPSONS
ERNEST THOMPSON, JR.
Damariscotta, Maine

A husband and wife team, trained as silversmiths and jewelers in both the craft and design. They have a second generation joining their forces. They are involved primarily in silversmithing in the traditional manner but are also equipped for small productions.

They make reproductions of historical and domestic as well as ecclesiastical articles - monstrances, croziers, processional crosses, chalices, ciboria, pectoral crosses, candlesticks, pyxes, etc., in both traditional and contemporary designs. Their work is primarily handwrought.

The Thompsons also do designing to order, chasing, enameling, inlay and encrustation, engraving, spinning and finishing, and the other processes necessary to a complete silversmithing operation. (1975)

E.T. Thompson (intaglio; single or double line)

E.T. Thompson (cameo; single line)

Also Reproduction and Sterling Silver (cameo)

THORNTON & COMPANY
New York, New York

"William H. Thornton, salesman for Krementz & Co. (1892) started on the road for Rogers & Bro., then at 690 Broadway, N.Y. William H. Thornton was born near Louisville, Kentucky of English parents, on April 14, 1859. After graduating from Notre Dame College,

Notre Dame, Indiana, at about 19 years of age, he engaged with a retail jeweler in Louisville, acting as salesman and manager. Subsequently, he went to N.Y. and became house salesman for J.T. Scott & Co. At the end of two years he accepted the position of traveling salesman for Rogers & Bro. covering territory for them for 5 years. He left this house to go with Krementz & Co. for whom he has traveled 8 years, going west as far as San Francisco and south to New Orleans. He makes two trips a year to the Pacific Coast. Mr. Thornton is unmarried, and can thus accept all the advantages of the Manhattan Athletic Club, of which he is a member. He is an all-round athlete, being especially fond of yachting." (J-C 9-28-1892, p. 24)

An 1896 account states,"Receivers appointed for Thornton & Co., silversmiths. Action was brought by Wm. H. Thornton against Henrietta Williams, his partner. Thornton & Co. who started May 26, 1896, are the successors of Holbrook & Simmons and Holbrook & Thornton. Mrs. Williams was a special partner in the former, and a general partner in the latter firm, and Thornton & Co. their successors." (J-C 9-16-1896, p. 20)

H. & S.
Old Mark of
Holbrook & Simmons.

THORNTON BROTHERS
New York, New York

"The Thornton Brothers were established in 1877." (JW 4-6-1892) Listed 1927 JKD as manufacturers of emblems.

HENRY B. THORP
New York, New York
See Waters & Thorp

Henry B. Thorp first appears in the New York City directories in 1863 in partnership with Josiah C. Waters in the firm of Waters & Thorp, which produced silverplated holloware. The partnership lasted through 1867.

In 1868 Thorp went into business for himself. Not found after 1871.

ARTHUR THUMLER
San Francisco, California

Born in San Francisco in 1886, Arthur Thumler went to work for Shreve & Co. in 1903

as an errand boy, and soon became an apprentice in the holloware department. In 1906 he went east to work for Towle Silversmiths (q.v.). In 1911 he returned to San Francisco and Shreve & Co. but also set up a shop in his basement where he executed private commissions.

After serving in World War I, he decided to set up shop on his own. By 1920, along with his brothers Charles and Henry, he had formed the firm of Thumler Brothers. Although the major portion of the business was restoration and repair, Thumler also accepted commissions and made pieces for his family. He retired in 1968 and died the following year.

Thumler's work is scarce, but of high quality. His designs are sophisticated contemporary interpretations of colonial and Early American forms. Unlike many of his contemporaries, who preferred a less exacting hammered finish, he strove to achieve mirror-smooth surfaces on his pieces.

His work is usually marked "STERLING", "Thumler" and bears a conjoined "AT" touchmark. (Morse, in Morse ed., *Silver in the Golden State*, 1986, p. 22)

Mark is from Morse (ibid., p. 109)

TIFFANY & CO., INC.
New York, New York

CHRONOLOGY
Tiffany & Young	1837
Tiffany, Young & Ellis	1841
Tiffany & Company	1853
Tiffany & Co. Inc.	1868-present

Founded by Charles L. Tiffany in 1837 with John B. Young under the name Tiffany & Young. They first stocked their store with stationery, a broad selection of European goods, some Chinese bric-a-brac, fans, pottery, umbrellas and desks. They purchased their silverware from a variety of the major silver manufacturers of the day, among them Grosjean & Woodward, William Gale and Gorham. John C. Moore (q.v.) who had begun the manufacture of silverware in 1827 and who was later joined in business by his son, Edward C. Moore, was also a major supplier. In 1851, John C. Moore & Son entered into a special business relationship with Tiffany's. By the mid-1850's Tiffany's was recognized as the leading silverware house in New York.

In 1852 Tiffany introduced the English sterling silver standard to America for Tiffany silver. This standard was later adopted by the U.S. Government and made into Federal law determining the minimum amount of fine silver required for articles marked "Sterling Silver."

During the 1850s Tiffany & Co. produced some electroplated wares, but their greatest production of silverplate came after the Civil War. Tiffany used a variety of marks on their electroplated wares ranging from simply the company name to more complex marks which bear some resemblance to those on their sterling products. Electroplated wares were discontinued after 1931.

When the Civil War broke out, Tiffany's became an arsenal for the North. Guns, rifles and ammunition were imported from Europe. Uniforms, badges and swords were manufactured directly by the firm.

In 1868 when Tiffany was incorporated, the silverware factory of the Moores became part of the organization with Edward C. Moore becoming one of its directors. The silverware made in the factory bore not only the mark "Tiffany & Co." but also the letter "M." Following the death of Edward C. Moore in 1891, the surname initial of the incumbent president was included as part of the Tiffany trademark. This practice was discontinued after 1965.

For the almost 20 years (c. 1850 to 1869) before Tiffany made their own flatware, they retailed the flatware of other makers. This was usually marked with the maker's mark and Tiffany, Young & Ellis prior to 1853 or Tiffany & Co. after 1853.

1868 marked the opening of the firm's second foreign branch, in London. The Paris branch had been opened in 1850.

According to the findings of the Carpenters (see *Tiffany Silver*) the Adams & Shaw (q.v.) firm was absorbed into Tiffany & Co., probably in the 1880s with Mr. Shaw becoming superintendent of the Tiffany plant.

Over the years, prominent society figures made regular visits to Tiffany's. J. P. Morgan ordered gold and silver services from the company. Diamond Jim Brady made regular purchases of diamond jewelry.

During World War I, Tiffany's craftsmen suspended the manufacture of luxury articles and turned instead to round-the clock production of surgical instruments for the Government. During the Great Depression of the 1930s the firms products became more simplified and austere.

In 1940 Tiffany's opened their new store at 57th Street and Fifth Avenue. It was the first fully air-conditioned building in New York. The ground floor was built like a ballroom, and special lighting effects were used to enhance the appearance of the merchandise.

During World War II the company's silver factory in New Jersey turned to the production of precision airplane parts for the Government.

In 1955, Walter Hoving took over control of Tiffany & Co. from the Tiffany & Moore families. He brought in new designers, appointed an imaginative Display Director, and gave the advertising a new look. Instead of serving only the carriage trade, he endeavoured to emphasize that Tiffanys had quality merchandise that would appeal to a broad range of customers.

The company offered a large assortment of sterling silver flatware, holloware and jewelry, mostly of its own manufacture, plus many items in vermeil. Throughout the year noted designers and hostesses were invited to provide special displays combining Tiffany merchandise with their own furniture and objects for variety in the settings.

Since 1963, Tiffany has opened branch stores in Atlanta, Beverly Hills, Chicago, Dallas, Houston, Kansas City, and San Francisco. In 1972 the firm opened a Tiffany Salon in Tokyo in Mitsukoshi, the oldest and most prestigious department store in Japan. In 1979 the firm opened another Tiffany Salon in Mitsukoshi's store in Honolulu.

Tiffany & Co. became a wholly owned subsidiary of Avon Products, Inc. on April 25, 1979. On December 31, 1980, Walter Hoving retired as Chairman of the company. Under his control, annual sales had gone from $7,000,000 in 1955, to $100,000,000 in 1980. Henry B. Platt, a great-great-grandson of Charles L. Tiffany, had become President of the company in 1974. he retired as Vice Chairman in 1982.

Anthony D. Ostrom became President of Tiffany in 1981, and in 1984 William R. Chaney became Chairman of the Board.

Tiffany holloware and a few flatware marks include two numbers - the pattern number and the order number. The pattern number refers to the original drawing or pattern. These are roughly in consecutive order. The order number is an assigned number for a particular order. Occasionally there may be a third "decoration" number.These numbers are beyond the scope of this volume and the reader is referred to *Tiffany Silver* by Charles H. Carpenter, Jr. and Mary Grace Carpenter for a full discussion.

Pieces manufactured for various international expositions also received special marks. In addition to the three exposition marks shown below, there was also a special mark created for the Panama-Pacific Exposition in 1915, consisting of two "P"s back to back.

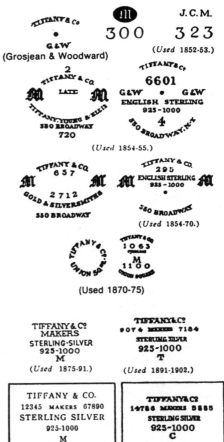

(*Used 1850-52.*)

TIFFT & WHITING

North Attleboro, Massachusetts
See Gorham Corporation
See Whiting Manufacturing Co.

CHRONOLOGY

Tifft & Whiting	1840-1853
Whiting & Gooding (& Co.)	1853-1858
Whiting, Fessenden & Cowan	1858-1859
Tifft, Whiting & Co.	1859-1864
Whiting, Cowan & Bowen	1864-1866
Whiting Manufacturing Co.	1866-1924

Originally a jewelry manufacturing company, the firm began producing silverware in 1847. William Dean Whiting, the junior partner, had been apprenticed to the earlier firm of Draper & Tifft.

In 1853 Albert C. Tifft decided to retire from the business and sold out to Whiting, who discontinued the jewelry business and focussed on the production of silver flatware and holloware. The firm continued under various partnerships until Tifft re-entered the business in 1859. Tifft retired again in 1864. The firm took on other partners, and was finally re-organized in 1866 as the Whiting Manufacturing Co. (q.v.)

Tifft & Whiting became a leader in the silver tableware industry through the use of improved machinery.

Sold to the Gorham Corporation in 1924. (Soeffing in Venable's *Silver in America,* 1994, biographical section, p. 322)

TILDEN-THURBER CO.

Providence, Rhode Island

Roots of Tilden-Thurber Company go deep into the history and business development of Rhode Island. In 1856, when the doors of the new firm opened, the sign above the window read GORHAM CO. AND BROWN. Gorham Thurber, great-grandfather of today's president, was listed as one of the officers. An unusually active man in business, in addition to his interest in Gorham Co. & Brown, he formed a copartnership with John Gorham, forming the firm of Gorham & Thurber, one of the predecessors of the Gorham Manufacturing Company.

In 1878, Gorham Co. & Brown moved across the street from its first location and changed its name to Henry T. Brown & Co. Members of the board were Mr. Brown, Henry Tilden and Gorham Thurber. The firm remained there until 1895 when it moved into the present Tilden-Thurber building. Gorham Thurber died shortly afterwards.

In March, 1880, the name of the firm was changed to Tilden-Thurber & Co. In the same year, William H. Thurber, grandfather of the present officers and son of Gorham Thurber, joined the firm, becoming a partner in 1885.

On June 23, 1892, the company became incorporated under the present name Tilden-Thurber Corporation. At this time Henry Tilden was elected President and William H. Thurber, Treasurer. William H. Thurber's contributions to the development of the company were an increased volume of business and addition of a number of new departments to the original line of jewelry and silverware. Following Mr. Tilden's death in 1907, Mr. Thurber was elected President and Treasurer.

Henry C. Tilden, son of Henry Tilden, joined the firm and became manager of the sterling silver department. In 1915, he moved to Chicago and joined Spaulding & Co., leading jewelers and eventually became president of that firm.

In 1956, when the company celebrated its 100th anniversary, Frederick B. Thurber was President and William Gorham Thurber, Treasurer. Tracy Gorham Thurber, son of W.G. Thurber, joined the company in 1951. Another son, William H. Thurber, is currently President. (1975)

Since 1878, Tilden-Thurber has been noted as the source of rare and beautiful importations. Fine paintings and etchings are displayed in the Tilden-Thurber Art Galleries.

Working with the Gorham Manufacturing Company, Tilden-Thurber furnished a complete sterling silver service for the Battleship *Rhode Island,* later placed on display in the State House. They also furnished the silver service for the Cruiser *Providence,* later exhibited at Brown University.

Service to the community and active interest in its employees have been outstanding characteristics of this company. This has been demonstrated in the establishment of a Brown University scholarship for a local student; assistance in the establishment of a rigorous educational and training program for jewelers; a company-paid pension plan and, most recently, a profitsharing plan for employees. (1975)

TILLINGHAST SILVER CO.
Meriden, Connecticut

Manufacturers of sterling silver hollow handle serving pieces. In business c. 1920-1935.

TILLINGHAST SILVER CO.

EDWARD TODD & CO.
New York, New York
See Mabie, Todd & Co.
See Smith & Todd

CHRONOLOGY
Smith & Todd	1851-1860
Mabie, Todd & Co.	1861-1870
Edward Todd & Co.	1871-1874+?

Edward Todd & Co. began as Smith & Todd in 1851, successors to Bard Brothers & Co. The changes have been from Smith & Todd to Mabie, Todd & Co. and then to Edward Todd & Co. They were manufacturers of sterling silverware, pencil cases, and gold pens.

The New York City Directories show that in addition to being partners in this firm, both Edward Todd and William P. Smith were individually, simultaneously, at various times in and out of other partnerships with John Mabie of Mabie, Todd & Co. (q.v.) Not yet followed in detail beyond 1874.

It was still listed in business in 1927.

Each of the companies is listed separately in this book with its own chronology in an effort to reduce the confusion.

EDWARD TODD CO.
New York, New York

Although this firm appears to have a similar name to the previous one and to have been in business at about the same time, the account given of its history is quite different.

"The Edward Todd Co. was formed in 1869. He had previously been with E.G. Bagley, which company was founded in 1843. It continued until 1851. C.F. Newton succeeded in 1859 and was succeeded by Newton, Kurtz & Co. which continued for 10 years when Edward Todd & Co. was formed. The company was incorporated in 1897." (JC-W 2-5-1919) JKD.

EUGENE S. TONER CO.
New York, New York

Manufacturers (?) of sterling silverware. Listed JC 1909 as out of business.

Note similarity of trademark to that of Depasse Mfg. Co.

JOHN TOOTHILL
Brooklyn, New York
See Metropolitan Silver Co.

John Toothill first appears in the Brooklyn City Directories as a silverplater in 1875. The times of change for the company's names and locations are not currently known.

The Toothill Silverware Co. mark shown below appears on a sugar bowl dating ca.1890s.

John Toothill was associated with the Metropolitan Silver Co. in New York City, which is listed in JC 1896-1904, and was out of business by 1915.

TOOTHILL & McBEAN SILVER CO.
Ottawa, Illinois

Listed JC 1898 in plated silver section. Out of business before 1904.

QUADRUPLE PLATE

TORONTO SILVER PLATE COMPANY
Toronto, Canada

Founded in 1882 by James A. Watts, formerly sales representative of the Meriden Britannia Co.

339

of Hamilton, Ontario, (q.v.) and others to manufacture a complete line of silverplated and sterling wares in Canada. Around 1885 they began the production of Holmes & Edwards flatware under license. In addition to their own productions they had some sterling silver made for them by Hendery & Leslie (q.v.), silversmiths in Montreal. This silver bears the marks **STERLING⊕⊞T.S.P.** Sterling was no longer produced after 1915.

The Toronto Silver Plate Co. was purchased by the Wm. A. Rogers Co. Ltd. (Canada) about 1914 and when that company was sold to Oneida in 1929 the Toronto company marks were no longer used

STERLING
STERLING⊕ ⊞T.S.P.

TORONTO SILVER PLATE CO.

TORSIL METAL
TORSIL STEEL
TORSIL E. P.—N. S.

JOHN TORSLEFF
Boston, Massachusetts

John Torsleff first appears in the Boston City Directory of 1857; at that time associated with Thomas Barker & Co., silverplated ware, along with one Charles Anthes. From 1858 through 1860 Torsleff and Anthes were in business together, and from 1861 through 1863 (the last listing) John Torsleff, silverplated ware, was in business at 334 Washington St. He lived in Chelsea, Mass. Either this John Torsleff or John Torsleff, Jr., died about 1869.

Some pieces of his manufacture are of thin sterling with decorative elements of cast brass, silverplated.

J. TOSTRUP
Oslo, Norway

Founded in 1832 by Jacob Ubrich Holfeldt Tostrup, great-grandfather of the present manager. Makers of all kinds of flatware and holloware. The firm has won many international awards for the excellence of its work. They were influential in the 19th century revival of filigree work and were especially noted for their *plique à jour* enamels.

(Both marks for use on flatware and holloware, made of or plated with metal. Registered in the U.S. in 1949. Norwegian registration 1947.)

A.H. TOWAR & CO.
Lyons, New York
See New Haven Silver Plate Co.

A.F. TOWLE & SON CO.
Greenfield, Massachusetts
See Lunt Silversmiths
See Rogers, Lunt & Bowlen
See Towle Silversmiths

A.F. Towle & Son, successors to Towle & Jones, were the links between the Moultons, of

Newburyport, and the Towle Silversmiths. Anthony F. Towle was an apprentice to William Moulton IV and bought his business and that of Joseph Moulton IV in 1873. In 1882, with others, the business was incorporated as Towle Silversmiths. Anthony F. Towle & Son moved to Greenfield, Massachusetts in 1890 and operated until 1902. At that time their business was taken over by Rogers, Lunt & Bowlen, now known as Lunt Silversmiths.

They were manufacturers of both sterling and plated silverware. Registered trademark, U.S. Patent Office, No. 27,286, November 19, 1895 for electroplated ware.

"Anthony F. Towle, b. Newburyport, Dec. 12, 1816. He learned silversmith trade with the late firm of N. & T. Foster, and in 1855 established the firm of Towle & Jones, jewelers and silversmiths. Subsequently the firm name was changed to Towle, Jones & Co. and A.F. Towle & Son. Under the last firm name, in 1880, the manufacture of silverware was established in this city (Newburyport) by the deceased. Mr. Towle retired from active business in 1892. He leaves three children. Mrs. E.B. Horn of Boston, and Edward B. and William A. Towle of Newburyport." (JC&HR 4-7-1897, p. 19)

E.J. TOWLE MFG. CO.
Seattle, Washington
See Cantrell Company
See Joseph Mayer & Bros.

Began as Joseph Mayer & Bros. 1895; became Joseph Mayer, Inc. in 1920; subsequently became Northern Stamping & Maunufacturing Co.which was purchased by E.J. Towle in 1945.

Were wholesalers of diamonds, watches, jewelry, sterling silverware, plated silver goods, cut glass and optical goods.

Medals and other presentation pieces were made. Some of the finest die work in the country was done by this company.

Their business evolved into the designing and manufacturing of silver jewelry, charms, religious goods, and souvenir silverware.

In 1980 the company was sold to Charles B. Cantrell and Raoul Leblanc who re-named and incorporated the firm as West Earth, Inc. (q.v.)

E. J. T. Co.

ESTABLISHED 1895

TOWLE SILVERSMITHS
Newburyport, Massachusetts
See Syratech Corporation

William Moulton II, born in 1664, settled in old Newbury, later Newburyport, to become the first silversmith in a long lineage of craftsmen now the Towle Silversmiths. He was succeeded by Joseph I, William III (who moved to Marietta, Ohio and became not only the first silversmith in The Northwest Territory, but also one of the founders of Marietta), Joseph II, Joseph III, Ebenezer, William IV, Enoch, Abel and Joseph IV - all silversmiths.

Anthony F. Towle and William P. Jones, apprentices of William IV, began business under the name Towle & Jones in 1857, later buying the business of William IV and Joseph IV. Anthony F. Towle and Edward F., his son, engaged in business as A. F. Towle & Son in 1873, and this partnership was the germ of the A.F. Towle & Son Co., Inc. in 1880, which in 1882 became the Towle Manufacturing Company, Anthony F. Towle and Edward F. Towle retiring. The company is now known as the Towle Silversmiths.

About 1890 the familiar "T enclosing a lion" was first used as a trademark. It is said to have been designed by Anthony Towle from the family coat of arms.

In 1890 the manufacture of holloware began at the Towle company under Richard Dimes who later went to Frank W. Smith, Gardner, and finally established his own business in Boston.

The Towle firm made plated flatware from 1906-1909. It was gradually discontinued, the last pattern was *Chester.* The stock was sold to Samuel Weare.

They have been leaders in establishing an exhibit gallery where artist-silversmiths skills are presented to the public. Other exhibits of silver craftsmanship have been prepared in cooperation with museums.

In the 1940s Mueck-Cary Co. was purchased by Towle and the trademark now belongs to them.

In 1978 the Leonard Silver Manufacturing Company was acquired by Towle and company headquarters were moved to Boston. Leonard Florence, founder of the Leonard company be-

came chairman and instituted sweeping changes in the Towle organization.

In 1990 Towle Silversmiths was purchased by Syratech Corporation (q.v.) through one of its subsidiaries.

(On plated silver)

La Fayette Silverware Paul Revere Silverware

STERLING

(On sterling silver)

(Mueck-Cary)

TOWLE MFG. CO.

THE MOULTON MAKER'S MARKS

WILLIAM MOULTON 1720–1793	W. MOULTON W. Moulton	WM W·M
JOSEPH MOULTON 1724–1795	I·MOULTON I·M	J·M
JOSEPH MOULTON 1744–1816	J·M MOULTON MOULTON I·MOULTON	
WILLIAM MOULTON 1772–1861	W. MOULTON W. MOULTON	WM
EBENEZER MOULTON 1768–1824	W. MOULTON W. MOULTON MOULTON	
ENOCH MOULTON 1780–1815	E. MOULTON E. MOULTON E. MOULTON	
ABEL MOULTON 1784–1840	AM · A.MOULTON	
JOSEPH MOULTON 1814–1903	I. MOULTON J·MOULTON	
TOWLE & JONES 1857–1873	TOWLE & JONES	
A. F. TOWLE & SON 1873 Inc. 1880 1882	A. F. TOWLE & SON	

NOW
THE TOWLE SILVERSMITHS

"Candelight" sterling flatware by Towle Silversmiths. (Photo courtesy of Towle Siulversmiths)

"Old Master" sterling flatware by Towle Silversmiths. (Photo courtesy of Towle Silversmiths)

IRA STRONG TOWN & J. TOWN
Montpelier, Vermont

Advertised 1830-1838 as clockmakers and silversmiths - "silver work of every description manufactured to order on short notice."

IRA S. TOWN & ELIJAH B. WITHERELL
Montpelier, Vermont

Successors to Ira Strong Town and J. Town. Formed a partnership that took over the business until it was dissolved in 1845. Advertised that "they made all the silverware bought at their shop and it was warranted to be the best quality."

THE TOWNSEND, DESMOND & VOORHIS CO.
New York, New York

Listed JC 1896-1904 in sterling section. Out of business before 1909.

T. D. & V. CO.
STERLING.

R. H. TRESTED
New York, New York

Richard H. Trested appears in the New York City directories as early as 1852 in partnership with Thomas Coombs (q.v.) in the firm of Coombs & Trested. By 1854 both men had gone into business on their own. Trested advertised frequently in the New York City Directories. While he continued to advertise "Silver Plating in All its Branches" his earlier ads in 1858 and 1859 placed major emphasis on silverplated hardware and replating services.

By 1864 he was offering, "Gold and Silver Plating in All its Branches, No. 38 White Street, N.Y. Plated goods of all kinds furnished to order. Families, Hotels and Restaurants can have their old wares re-plated equal to new, in the best possible manner, and at about one half the original cost and warranted; vis. all kinds of Tea Sets, Urns, Trays, Cake Baskets, Spoons and Forks, Castors, Candelabras, Candlesticks, Britannia-ware &c. &c."

By 1865 Trested was involved in the hat business as well as in silverplating. Not listed as a silverplater after 1865.

TRINAC METALCRAFTS INC.
Brooklyn, New York

Manufacturers of pewterwares. In business now. (1975)

J.W. TUCKER
San Francisco, California

John William Tucker arrived in San Francisco August 1849 from New York on board the ship **Panama.** He had trained as a carpenter, sold watches and made a fortune. He set up shop in August 1850 as "J.W. Tucker & Co., importing jeweler." In April 1874 the listing was changed to "Tucker Jewelry Manufacturing & Commercial Co." Many pieces bear his name though no known pieces can actually be attributed to his workmanship or to his shop.

Tucker died in July 1876 but the business was continued under his name for another ten years. The last listing being in 1886. Occasionally, directory entries mention "mfgr." before and after his death but may refer only to repair work or possibly special orders.

TUCKER & PARKERHURST CO.
Ogdensburg, New York

Successors to Bell Bros. in 1898. Out of business before 1904.

JAMES W. TUFTS
Boston, Massachusetts

Trademark registered February 2, 1875 for plated silverware by James W. Tufts, Medford, Massachusetts. Incorporated 1881. Out of business before 1915.

Tufts started his business career as an apprentice in the apothecary store of Samuel Kidder in Charlestown, Massachusetts. He soon went into business for himself and became the proprietor of a chain of three pharmacies. His interest in the concoction of syrups and other products sold at the soda fountain led to the manufacture of these products.

His next step was to branch out into the manufacture of the apparatus used in drugstores. The soda fountain of that time was a magnificent piece of equipment. Many were of Italian marble and the metal parts were silverplated. He received a number of patents relating to soda fountains.

From the silverplating of fountain parts, Tufts branched out in 1875 into the manufacture of an extensive line of silverplated items such as pitchers, dishes and bases. The business, which had been conducted under Tufts' name, was consolidated in 1891 with other soda fountain companies and became the American Soda Fountain Company, the largest in its field.

By 1895 Tufts turned the active management of his business over to others because of his health. In search of a more healthful climate

and atmosphere, he purchased 5,000 acres in the sandhills of North Carolina and founded the resort town of Pinehurst. He died there February 2, 1902.

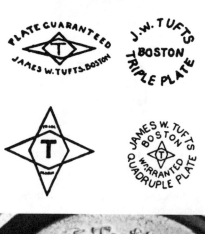

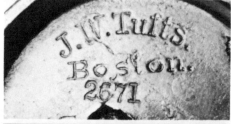

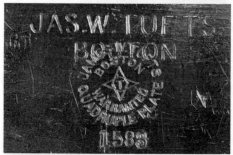

James W. Tufts glass lined fruit basket, commonly referred to as a "Bride's Basket" in the antiques trade as such items were frequently given as wedding gifts. The glass liner served both to enhance the appearance of the piece and to protect the silverplate portion from the destructive effects of the acids in fruits.

TUTTLE SILVER CO.
Boston, Massachusetts
See Tuttle Silversmiths

TUTTLE SILVERSMITHS
Boston, Massachusetts

In 1890, Boston silversmith Timothy Tuttle was first commissioned by wealthy families to copy old English silver. His original pieces were dated in the English custom with the crest of the reigning monarch. During the term of office of President Calvin Coolidge, Tuttle adopted this custom, marking each piece with a crescent and

the initials of the incumbent President of the United States. Today this date mark is unique with Tuttle.

The figure II below the initials of Ronald Reagan indicate a second term of office.

Timothy Tuttle used the Pine Tree Shilling symbol as his trademark. The Pine Tree Shilling was one of the earliest silver coins minted in the American colonies by Hull and Sanderson in 1652. Used as the Tuttle trademark, it is the stamp of quality and prestige appearing on all Tuttle sterling pieces, including authentic reproductions of Early American, European and modern design.

In 1915, the company was listed as Tuttle Silver Co. By 1922, it was incorporated.

In 1955 Tuttle Silversmiths was purchased by R. Wallace & Sons Mfg. Co. (now Wallace Silversmiths) and became an acquisition of the Hamilton Watch Company of Lancaster, Pennsylvania when Hamilton purchased Wallace Silversmiths in December 1959. Every piece of Tuttle silver is sterling. They make no plated silver.

Depending on the shape of each flatware piece, either pine tree is used.

TUTTLE
FINE STERLING
TUTTLE SILVERSMITHS

"Onslow" sterling flatware by Tuttle Silversmiths. (Photo courtesy of Tuttle Silversmiths)

"Hannah Hull" sterling flatware by Tuttle Silversmiths. (Photo courtesy of Tuttle Silversmiths)

"Beauvoir" sterling flatware by Tuttle Silversmiths. (Photo courtesy of Tuttle Silversmiths)

TYSON, TRUMP & CO.
Baltimore, Maryland

Listed in 1867-1868 Baltimore City Directory as silverplaters.

U

UNGER BROS.
Newark, New Jersey

CHRONOLOGY
Unger Brothers (William, George,
Frederick, Herman, Eugene) 1872-1879
Unger Brothers (Herman and Eugene) 1879-1904
Unger Brothers, Inc. (Herman and
Eugene; Philemon O. Dickinson) 1904-1919

William Unger was a partner of Thomas A. Edison from 1870 to 1872 in the Newark Telegraph Works. This firm was dissolved that year and the five brothers organized Unger Brothers for the manufacture and sale of pocket knives and hardware specialties. They began the manufacture of silver jewelry in 1878. Three of the brothers, William, George and Frederick, were reported to have died that year and the two remaining brothers, Herman and Eugene were reported to have reorganized the business, retaining the name Unger Brothers.

Hermann Unger received his first Design Patent, No. 11,237, on June 10, 1879, for an onyx bracelet decorated with a lily of the valley spray made in gold and set with pearls. This patent was assigned in equal thirds to himself and his brothers, Eugene and Frederick. The latter apparently had not died in 1878 after all.

When Eugene Unger married Emma L. Dickinson, daughter of Philemon Dickinson, in 1880, a new dimension was added to the firm. It was Dickinson who was the designer of the extensive line of Art Nouveau articles made by the Unger firm and now so avidly sought by collectors.

The company's products included at least 19 different flatware patterns, the designs for several of which were carried over into their novelties and holloware. Their wide range of sterling silver products included desk sets, toilet sets, sewing items, match boxes, ashtrays, bookmarks, letter openers, and various novelties. Some of the more unusual items were tabasco sauce, listerine and cheese holders. The company also manufactured its own cut glass.(Cramer, *Silver*, May-June 1987, pp. 13-15 based on Rainwater, *Sterling Silver Holloware*, 1973)

January 21,1904 the firm was incorporated. The last of the Unger brothers died in 1909 and by 1910 the dies for the Art Nouveau patterns were no longer used; a simpler, more rectilinear line being produced. In 1914 the firm ceased production of silver articles entirely to manufacture airplane parts. In 1919 the business was sold.

The trademark of the Unger Brothers, an interlaced U and B, was stamped on all Unger silver with the exception of some jewelry made after 1910. This jewelry is of light weight and of lesser quality than the original work.

U. S. STERLING
Location unknown

Mark found on silverplate souvenir spoons produced for the Columbian Exposition in 1893, and the San Francisco Mid-Winter Exposition in 1894.

UNITED STATES SILVER CO., INC.
New York, New York

Manufacturers of plated wares. First listing found was 1948. Still listed. (1986)

UNIVERSAL
See Landers, Frary & Clark

Mark used on Landers, Frary & Clark silverplated holloware.

UTOPIAN SILVER DEPOSIT & NOVELTY CO.
New York, New York

Listed JC 1915 in sterling silver section. Out of business before 1922.

ν

THOMAS J. VAIL
Hartford, Connecticut
See Curtisville Mfg. Co.

Thomas J. Vail first appears in the Hartford City Directories in 1859 after purchasing a major interest in the Curtisville Manufacturing Co. (q.v.) from its previous owners. He served as president of that silverplate manufacturing firm through 1863.

By 1864 he had apparently given up his interest in operating the silverplating company and become instead the President of the Connecticut Arms and Manufacturing Co. However, this firm had close ties with the Curtisville Manufacturing Co. Joseph A. Veazie, formerly a member of the board of the silverplating company, became the treasurer of the new firm, while George T. Thompson of Naubuc, Connecticut, the new president of the Curtisville Manufacturing Co., became the secretary of the arms company as well. Both firms shared the same Hartford office.

Vail continued as president of the arms company through 1866. In 1867 he served as president of the Hartford Life & Accident Insurance Co.

In 1868 he returned to the silverplating business, apparently on his own. His ad in the Hartford City Directory produced in that year reads: "Thomas J. Vail, Manufacturer of German Silver and Plated Ware, plated and steel spectacle frames and lenses: Manufactory at Naubuc (Glastenbury) Conn." There is no listing in the Hartford directories for this firm after 1868.

In 1871 Vail is reported to have sold his silverplating business to the American Sterling Co.

Although he continued to reside in Hartford, between 1869 and 1876 there is no occupation shown for him in the directories. By 1877 he had become the secretary of the National Turf Association, a post he continued to hold through at least 1881. Not followed beyond that date.

VALENTINE LINSLEY SILVER CO.
Wallingford, Connecticut
See Wallace Bros. Silver Co.
See The Wallingford Co.

Listed in the City Directory 1895-1899. Makers of plated silverware. Succeeded by The Wallingford Co. in 1899.

V. L.

(Silver Plated Hollowware.)

MADE AND PLATED BY WALLACE BROS. SILVER CO.

VAN BERGH SILVER PLATE CO.
Rochester, New York

Founded 1892 by Frederick W. Van Bergh and Maurice H. Van Bergh, who were President and Secretary, respectively. A third brother is said to have joined the firm in 1898 (not confirmed). The company was incorporated July 1, 1904. In 1925 all assets were transferred to a new corporation, the Van Bergh Silver Plate Company, Inc., set up by Oneida Community Limited. This new corporation was merged into Oneida Community Limited in 1926 and moved from Rochester to Oneida, New York.

MADE
AND GUARANTEED
— BY —
THE VAN BERGH S.P.CO.
ROCHESTER.N.Y
U.S.A

BRITANNIA METAL CO.

JAMES S. VANCOURT
New York, New York

When he first appears in the New York City directory in 1845, James S. Vancourt is listed as an independent silversmith. His shop was next door to Albert Coles silver manufactory, where Coles' nephew, William L. Coles worked for his uncle.

In 1848, William L. Coles and Vancourt formed a partnership that lasted until 1852. The partners produced a general line of flatware, specializing in hollow handled knives for butter, fruit and dessert.

Vancourt continued this specialization when he again worked on his own. One of his mid-1850s ads offers "Butter, Fish, Fruit, Dessert & Pie Knives, Crumb Scrapers, Ice Cream Slicers &c. on hand and made to order".

The fact that Albert Coles was skilled at producing hollow handled knives, coupled with the similarity of the style of the pseudohallmarks used by Vancourt to those used by Coles, suggests that Vancourt may have been apprenticed to or employed by Coles before establishing his own business. Vancourt's mark is (eagle) V

(head). The mark for Coles & Vancourt (q.v.) is (eagle) C&V (Head). (Soeffing, in Venable's *Silver in America*, 1994, biographical section, p. 322)

CLARENCE A. VANDERBILT
New York, New York

Manufacturers of sterling silverware, baskets, salt and peppers, cups, candlesticks, cigarette cases, vanity cases, picture frames, napkin rings and flasks from c. 1909-1935.

STERLING—V

STERLING

W.K. VANDERSLICE
San Francisco, California

William Keyser Vanderslice learned silversmithing in Philadelphia and began business there in 1857. He arrived in San Francisco in May 1858 bringing with him equipment he had brought around Cape Horn. He set up shop in a building owned by his brother-in-law, Charles H. Sherman, a carpet and upholstery dealer. By September 1860 he had formed a partnership with Sherman, expanding his operation and moving to a new location with the increased capital. The partnership lasted until 1865.

Vanderslice established his reputation early through exhibitions. In 1858 he received a diploma for a pitcher shown at the Industrial Exhibition of the Mechanics Institute. In 1859 his work received a "First" premium at the California State Agricultural Fair. Although he did not compete again, by 1872 he was receiving large annual contracts to produce the Fairs' awards. He also advertised heavily, as far away as Victoria, British Columbia, Canada.

The business grew. From a single employee in 1858, the shop expanded to employ 20 men and use 1,500 ounces of silver a month a decade later.

In 1868 Vanderslice went into partnership with Lucius Thompson, a jeweler and watchmaker, who previously had been a partner of George C. Schreve (q.v.) for a number of years. Thompson's experience as a retail jeweler and businessman blended well with Vanderslice's manufacturing knowledge. The new firm invested its money in dies and machinery and applied for its first flatware design patent. By 1871 Vanderslice was recognized as the leading firm in the region.

In 1872 the company moved its shop to the heart of the fashionable retail district. Although the firm obtained its second flatware design patent in 1874, it was also buying extensively from Gorham and Whiting.

The Depression of 1873 reached California in 1875. The destruction of Virginia City by fire that same year, taking two major mines out of operation, was followed by the collapse of production from the Comstock lode. Miners and speculators no longer had money to purchase luxury goods.

Vanderslice bought out his partner Thompson in 1878. He sold off much of his production at reduced prices and even auctioned some of his goods off, following a plan devised by the firm's financial officer, W.R. Drake, to get out of debt.

By January of 1881 the crisis had passed, but Vanderslice was no longer a major silver manufacturer. He took on a new partner, Kenneth Melrose, but retained only a token silver workforce. The firm gradually became more of a general jewelry and fancy goods retailing concern.

In 1893 Vandeslice had a leg amputated as a result of an accident. He suffered a stroke in 1895 and died in 1899.

The business was incorporated as W.K. Vanderslice & Co. in March 1897 with Melrose as vice president. Following Vanderslice's death in March 1899, Melrose became president. The business survived for a time, under various owners, as a fancy goods store, but succumbed to the great San Francisco earthquake of 1906. Only a token sum in insurance was recovered from the disaster.The business was sold to Shreve & Co. in 1908.

The firm produced a large and varied range of goods in its heyday. Between 1858 and 1885, at least 16 flatware patterns were introduced. Holloware items from napkin rings to giant epergnes were of comparable quality to those manufactured by major eastern firms. Many of the pieces followed the "Renaissance revival" style of the times and were copied from works by companies like Gorham and Tiffany. Others were in a sort of Queen Anne revival style, and still others in a style unique to Vanderslice himself. However the quality of the holloware designs declined after 1872, and seemed to be intended more to meet a price than an aesthetic ideal. (Morse, in Morse ed., *Silver in the Golden State*, 1986, pp. 5-8)

JOHN T. VANSANT
Philadelphia, Pennsylvania

CHRONOLOGY
John T. Vansant Mfg. Co.1881-1884
John T. Vansant & Bro.　1884-1886
Vansant Silver Co., Ltd.　1886-1892

The Vansant firms underwent their series of name changes due to financial difficulties which necessitated reorganizations. Stephen E. Vansant served as superintendent and manager of the Vansant Silver Co., Ltd.

The companies produced considerable quantities of flatware, both solid silver and silver plated, decorated with broad, bright cut, engraved patterns. They were also noted for their outstanding and unusual medallion work.

In 1892 the Vansant Silver Co., Ltd. was purchased by Simons, Bro. & Co., (q.v.) a firm that produced thimbles, cane heads and novelties and wanted to expand its offerings. (Soeffing, in Venable's *Silver in America,* 1994, biographical section, p. 322)

ERSKINE V. VAN HOUTEN
White Plains, New York

Listed 1931 to 1950 as manufacturers of table glassware (apparently silver deposit ware).

GEORGE & FREDERICK VANNESS
New York, New York
See Peter Vanness

George and Frederick Vanness were very likely relatives (sons?) of Peter Vanness (q.v.). In 1869 they worked as partners to manufacture silver at 4 Liberty Place. In 1870, only Frederick Vanness is shown in the directories.

In 1871 Frederick Vanness disappears from the Directories and George Vanness re-appears at the same location where he continues through 1873. Neither one is found in the directory published in 1874. Not followed beyond that date.

PETER VANNESS
New York, New York

Peter Vanness was working as a silversmith at least as early as 1848 when he and Abraham Wood (q.v.) jointly obtained Design Patent No. 170 for a flatware pattern. The two may have been in partnership then. Although he appears in the New York City Directories between 1852

and 1856, he does not appear to have had his own independent shop during that time.

In 1856 he opened a shop at 137 Elm, describing his business as "silverware". Two years later the shop moved to 39 Green St. By 1860 he had moved his business into the large silversmithing complex at 4,6,8 Liberty Place, where such prestigious firms as Albert Coles & Co. (q.v.) and, later, Theodore Evans & Co. (q.v.) were located.

He continued to work at that location until his death in about 1866. After he died, his widow, Jane Vanness, continued the business at the same location through 1869.

VAUGHAN PEWTER SHOP
Taunton, Massachusetts

Lester H. Vaughan was a manufacturer of pewterware c. 1930-1950. Originally L. H. Vaughan; later Vaughan Pewter Shop.

P.M. VERMASS
Minneapolis, Minnesota

Successors to F.L. Bosworth before 1921. They were jobbers who bought wares "in the metal" and plated them in their own shop. No record after 1922.

VERNAY & LINCOLN
Attleboro, Massachusetts

Silver manufacturers about 1877. "Vernay & Lincoln are doing quite a business. Their facilities for turning out work are excellent and their prices reasonable." *(Jeweler, Silversmith & Watchmaker, Oct. 1877)*

VICTOR SILVER CO.
See International Silver Co.

Trademark of the Derby Silver Co. on less expensive line. Variation used after 1922 by International on silverplated flatware for hotels, restaurants, etc.

VICTOR S. CO.

L.W. VILSACK & CO.
Pittsburg, Pennsylvania

Mark found on a silverplate bread tray dating from the 1900s.

VINEGAR BROS.
New York, New York

Listed 1927 KJI as manufacturers of silverware.

VINER'S OF SHEFFIELD
Sheffield, England

Founded in 1907. Britain's largest silver trades manufacturer. The plant is almost entirely automated. Their 1960 cutlery was 85% electroplate and in 1967, 75% stainless steel. They have factories in Hong Kong and in Japan. They bought two fine old Sheffield firms of cutlers, Thomas Turner and Harrison Bros. and Howson. They manufacture 60% of the current lightweight sterling tableware, mostly traditional designs. These are distributed in the United States through Raimond Silver Mfg. Co., Inc. (1975)

GEO. L. VOSE MFG. CO., INC.
Providence, Rhode Island

Successor to Geo. L. Vose & Co. between 1904-1915. Manufacturing jeweler. Last listed c. 1920.

J. WAGNER & SON, INC.
New York, New York

CHRONOLOGY

Central Sterling Co.	1909
Weber-Wagner Co.	Before 1915
Weber-Wagner & Benson Co.	1915
A.L. Wagner Mfg. Co. Inc.	1927
A.L. Wagner & Son, Inc.	1931
J. Wagner & Son, Inc.	1950

No longer listed. They were manufacturers of silverplated and sterling silver holloware.

Used since 1909

THE WALDO FOUNDRY
Bridgeport, Connecticut

Listed in JC 1896-1904. Out of business before 1915. Manufacturers of aluminum-gold flat and tableware.

Note similarity to trademarks of W.H. Glenny & Co. and H.H. Curtis & Co.

(*Aluminium-Gold Flat and Table Ware.*)

WALDORF SILVER CO.
See Woodman-Cook Co.

Trademark of Woodman-Cook Co.

WALDORF SILVER CO.

WALLACE BROS. SILVER COMPANY
Wallingford, Connecticut
See Wallace Silversmiths

ESSEX SILVER CO.
ESSEX SILVER CO.
QUAD PLATE

(Silver plated britannia)

MADE AND PLATED BY
WALLACE BROS. SILVER CO.

R. WALLACE & SONS. MFG. CO.
Wallingford, Connecticut
See Wallace Silversmiths

Successor to Wallace, Simpson & Co. in 1871. Name changed to Wallace Silversmiths in 1956.

"The first spoons made in this country of German or nickel silver were manufactured by Robert Wallace in 1835. From that date to January 1, 1897, we manufactured more than 5 million dozen nickel silver spoons, forks, etc. ...and not one single one bore our name or trademark - these goods having been made for other firms who have built up on our skill and workmanship a world-wide reputation for the quality and durability of such wares. On January 1, 1897, we began to place our nickel silver flatware on the market bearing our name, which is a guarantee of both the quality and durability of the goods

so stamped. They are plated with FINE SILVER, in the following grade: EXTRA or STANDARD which we plate 20 PER CENT heavier than the regular standard. TRIPLE and SECTIONAL PLATES.The stamps and trademarks are:

1835 R. Wallace A1 for Extra Plate
1835 R. Wallace XII for Sectional Plate
1835 R. Wallace 6, 9 or 12 for Triple Plate"
(Adv. JC 7-2-1898, p. 6)

1835
R·WALLACE"
(Flatware.)
(Used since 1897)

(Nickel Goods.)

(Hollowware.)

900
(Steel Flatware.)

Trade Mark.

R·W·&·S·
Sterling.

(On sterling silver knives about 1898)

NS

R. WALLACE
(Silver Soldered.)

SILVER SOLDERED

LUXOR PLATE
FORTUNE SILVER PLATE
ANDOVER SILVER PLATE CO.

MELFORD SILVERPLATE ON COPPER

ADAMS MANUFACTURING CO.
WALLINGFORD CO. SECTIONAL
WALLINGFORD CO. AI

MELFORD
SILVER PLATE

MELFORD **MELFORD**
E.P.W.M. **E.P.N.S.**

LUXOR PLATE—WALLACE

The Wallace silverplate flatware dies were sold to the International Silver Co. in 1954.

WALLACE SILVERSMITHS, INC.
Wallingford, Connecticut
See Syratech Corporation

CHRONOLOGY

Robert Wallace	1834-1855
Robert Wallace & Co.	1855-1865
Wallace, Simpson & Co.	1865-1871
R. Wallace & Sons Mfg. Co.	1871-1956
Wallace Silversmiths	1956-1984
Wallace Silversmiths, Inc.	1984-present

ROBERT WALLACE was born in Prospect, Connecticut in 1815. He was the grandson of James Wallace, who had come from Scotland and settled in Blandford, Mass., late in the 18th Century. At 16, Robert was apprenticed to Captain William Mix of Prospect to learn the art of making britannia spoons. Two years later, in 1833, he set up shop in an old grist mill to make spoons on his own. About a year later he saw a German silver spoon, made by Dixon & Sons of Sheffield, England. He recognized its superior strength and color and with Deacon Almer Hall (later head of Hall, Elton & Co.) began the manufacture of German silver spoons - the first in this country.

From 1834 to 1849 he made these spoons for Deacon Hall, for Hall, Elton & Co. and in 1849 entered into a co-partnership with J.B. Pomeroy to manufacture them on contract for Fred R. Curtis Co. of Hartford and made britannia spoons for Hall, Elton & Co. and Edgar Atwater of Wallingford.

In 1854, Robert decided to take up farming, but soon returned to Wallingford to continue the manufacture of German silver forks, spoons and similar articles with Samuel Simpson of Wallingford. This ten-year partnership was formed May 1, 1855, under the name of R. WALLACE & CO.

On May 15, 1855, Simpson's partners in the Meriden Britannia Co., H.C. Wilcox, W.W. Lyman and Isaac C. Lewis, were admitted, with the firm name remaining the same. This contract was terminated in 1865 when a new contract was made and the corporation WALLACE, SIMPSON & CO., was organized.

In 1870, Wallace purchased two-thirds of Simpson's interest and in 1871 bought the remainder. On July 17, 1871 the corporate name was changed to R. WALLACE & SONS MFG. CO. with his two sons, Robert B. and William J., and a son-in-law, W.J. Leavenworth members of the firm.

In 1871, Wallace introduced three sterling flatware patterns, *Hawthorne, The Crown* and *St. Leon.*

They made silverplated flatware from 1877 to 1941; production was resumed in 1981. The manufacture of silverplated hotel flatware continued until 1953.

In July 1875, Robert Wallace with his sons, Robert B., William J., Henry L., George H., Frank A. and sons-in-law W.J. Leavenworth and D.E. Morris formed a co-partnership under the name of WALLACE BROTHERS for the manufacture of silverplated flatware on a base of cast steel. Manufacture of silverplated holloware also began at this time. The manufacture of holloware ceased in 1986. On June 23, 1879, the corporation of R. WALLACE & SONS MFG. CO. acquired and took over the business and good will of WALLACE BROTHERS.

New machinery and mass production methods made possible great expansion. All types of flatware, holloware, dresser silver and practically all lines of articles in which silver is a component, as well as stainless steel, were added.

In 1924 a Canadian plant was opened in Cookshire, Quebec, for production of tinned spoons and forks. In 1944 sterling flatware was added to the line. In 1945 the Canadian branch was incorporated as R. WALLACE & SONS OF CANADA, LTD. It was sold in 1964.

In 1934, William S. Warren, designer for the company, conceived the idea of three dimensional flatware patterns - for which the Wallace Company is noted. The Watson Company of Attleboro, Mass. was bought by Wallace in 1955, moving to Wallingford in 1956. The name R. WALLACE & SONS MFG. CO. was changed to WALLACE SILVERSMITHS in 1956. The Tuttle Silver company and Smith & Smith were acquired by Wallace and moved to Wallingford.

Wallace Silversmiths, in 1959, was purchased by the Hamilton Watch Company of Lancaster, Pennsylvania, but in 1971 became a division of H.M.W. Industries and a Subsidiary of Katy Industries, Inc., Elgin, Illinois in 1983. It was bought by Syratech Corporation (q.v.) in 1986.

THE WALLINGFORD CO., INC.
Wallingford, Connecticut
See Wallace Bros. Silver Co.

The Wallingford Co. was listed in the City Directory 1903-1941.

ESSEX SILVER CO.

V. L.

MADE AND PLATED BY
WALLACE BROS. SILVER CO.

ESSEX SILVER CO.
QUADRUPLE PLATE

WALTHAM SILVER CO.
Waltham, Massachusetts?

Silverplate manufacturer. Mark found on a butter dish dated circa 1890s.

JOHN WANAMAKER
Philadelphia, Pennsylvania

Founded 1861 as Wanamaker & Brown. Became John Wanamaker in 1870. It was the first American system store - actually a collection of exclusive stores under one roof.

Like Marshall Field's, Macy's and others, they sold silverware stamped with their own trademark.

(On silverplate)

STERLING

JOHN WANLESS
Toronto, Ontario, Canada

Firm established in 1835 by William Bell in Niagara, and moved to Toronto in 1840 . In 1851 John Wanless came to Canada from Scotland and joined Bell. Wanless succeeded to the business in 1861. In 1890 he was joined by his son, John Jr. and the firm became Wanless & Co. In 1920 John Wanless Jr. was elected trea-

surer of The Canadian Jewelers Association. In addition to its own products, the firm also sold goods manufactured by Roden Bros. (Unitt & Worrall, *Unitt's Book of Marks*, 1995, p. 53)

 with Lion, Beaver and Crowned Head

ANDREW E. WARNER, JR.
Baltimore, Maryland

Listed in Baltimore City Directories as a goldsmith and silversmith from 1864 till 1893. Listed as Andrew E. Warner & Son, 1867-1870. Andrew E. is listed alone from 1874-1889. The listing from 1890-1893 is A.E. Warner.

ANDREW E. WARNER, SR.
Baltimore, Maryland

Andrew Ellicott Warner was born in 1786 and died in 1870. He was listed as a goldsmith and silversmith from c. 1805 till his death.

Andrew and Thomas H. Warner (1780-1828) worked together c. 1805-1812.

GEORGE C. WARNER
Baltimore, Maryland

Listed in 1855-1856 Baltimore City Directory as a silver chaser.

P. B. WARNER
Location unknown

Mark found on a silverplate spooner dating c.1890s.

THOMAS H. WARNER
Baltimore, Maryland

Thomas H. Warner c. 1780- 1828. He and Andrew Ellicott Warner worked together c. 1805 - 1812. From 1814 to 1824, and perhaps longer, Thomas H. Warner was assayer for the city of Baltimore. His duty was to "test silverwares to see that they were of no less fineness than eleven ounces pure silver to every pound troy."

WARNER MFG. CO.
Greenfield, Massachusetts

Manufacturers of silverplated flatware c. 1905-1909. They were among the first manufacturers to supply retail outlets with flatware stamped with private brand names.

WARNER SILVER MFG. CO.
Chicago, Illinois

Incorporated in March 1894 with Augustus Warner, P.B. Warner and Cassius C. Palmer. Out of business before 1915.

WARREN SILVER PLATE CO.
New York, New York
See Oneida Silversmiths
See Wm. A. Rogers, Ltd.

Warren Silver Plate Company was a trademark first used in 1901 by Wm. A. Rogers Company on their medium grade holloware. The name apparently was based on the fact that the New York Office was located at 12 Warren Street.

WARWICK STERLING CO.
Providence, Rhode Island

John F. Brady, treasurer of the company, registered the lower trademark, U.S. Patent Office No. 97,038 on May 19, 1914 to be used on sterling silver, flatware, holloware, tableware,

dresserware, desk articles, sewing articles, silver trimming for leather, glass, wood, metal, fabrics and jewelry. He stated that this trademark had been used continuously since January 1, 1913. No record after 1922.

GEORGE WASHINGTON MINT
New York, New York

Out of business by 1975.

WATERS & THORP
New York, New York
See J.W. Johnson

The silverplating firm of Waters and Thorp first appears in the New York City directories in 1863. Josiah C. Waters and Henry B. Thorp were the partners. The firm produced silverplated holloware. The partnership lasted through 1867.

In 1868 Josiah C. Waters was in business by himself at the firm's former location. Henry B. Thorp had moved out and established his own business. Waters is not found in the directories after 1868. However his business location at 14 John St. was taken over by J.W. Johnson (q.v.) suggesting that Johnson may have bought out his business. Thorp continued on in business by himself through 1871. Not found after that date.

WATROUS MFG. CO.
Wallingford, Connecticut
See International Silver Co.

Started as Maltby, Stevens & Company, later Maltby, Stevens and Curtiss. Incorporated as Watrous Mfg. Co. in 1896.

The largest part of their business had been the making of German silver spoon blanks which they had sold to others, where they were plated and trademarked for the market. When the

Watrous Co. was organized in 1896, most of the product was furnished to the Wm. Rogers Mfg. Co. in Hartford. After 1898 the spoons they made were distributed among several of the International Silver factories and they also added smaller articles and novelties which they made in sterling. Among these were vanity cases, dorine boxes, match boxes, belt buckles and small holloware. These were distributed through regular trade channels.

They were one of the original companies to become part of the International Silver Co. in 1898.

The "half circle" trademark was first used in 1921 and registered in 1923.

(Silver Plated on Nickel Silver Hollowware.)

ALEXANDRA SOLOWIJ WATKINS
Brunswick, Maine

Listed as a silversmith in the "Handcraft Trails in Maine," 1966 edition.

THE WATSON & BRIGGS CO.
Attleboro, Massachusetts

In the 1934 dresserware catalog, Watson & Briggs is given as the successor to the Thomae Co.

WATSON COMPANY
Attleboro, Massachusetts
See Wallace Silversmiths

CHRONOLOGY

Cobb, Gould & Co.	1874-1880
Watson & Newell	1880-1886
Watson, Newell & Co.	1887-1895
Watson & Newell Co.	1895-1920
Watson Company	1920-1955

The Watson Company traces its history back to November 1, 1874, when Clarence L. Watson, Fred Newell, Charles Cobb, Samuel Gold and W.A. Battey formed the jewelry manufacturing firm of Cobb, Gould & Co. This original firm produced a general line of jewelry goods, mainly gold plated. Battey left the firm in 1875, Cobb retired in 1879, and in January 1880 Gould withdrew from the partnership. Watson and Newell, the only ones left, formed a new partnership, and for the next seven years the company operated under their joint names.

Watson had been born in Smithfield, Rhode Island, in 1849. After attending local schools, he went to Providence, Rhode Island, where he worked in the Providence Tool Co. and later in other machine shops. After several years he moved to Attleboro, Massachusetts, to work for Bliss Brothers, one of the many jewelry manufacturing firms located in the town. Initially at least, his interest seems to have been in the mechanical side of the manufacturing process.

Newell was born in the village of Franklin, near Attleboro, in 1845. He attended local schools. When the Civil War broke out, he enlisted, and served for the duration. After returning, he worked in the straw shops of Franklin and Attleboro, putting aside his money so he could set up in business.

Cobb, Gould and Company had proved a successful venture from the start, and the firm continued to prosper as Watson & Newell. The company's product line featured the standard lever sleeve button in the 1880s. The firm also manufactured name pins in rolled plate with 30 different women's names available.

When Joseph R. Ripley of Taunton Massachusetts joined the firm in 1887, it became Watson, Newell & Co. Edward L. Gowen entered the partnership in 1891. By the early 1890s the company broadened its line to include lace, cuff and shawl pins.

Seeking larger quarters, in 1894 Watson purchased the old Mechanics Mill property. After extensive and costly renovations, the new factory finally opened in 1896. The firm's silversmithing activities apparently began about the time of the new factory's opening. The business became known as the Watson & Newell Co. at about the same time.

The old mill's name was used for a company subsidiary, the Mechanics Sterling Co., listed in jewelry publications for 1896.

Unfortunately the company's first attempt, in 1896, to patent a flatware design of its own backfired when Gorham sued for infringement. Despite this setback, the firm continued to prosper. In 1899, Clarence L. Watson obtained his only personal patent, a design for a spoon with two handles, a straight one above, and a curved handle below, similar to a baby spoon.

Over the years the company produced some 48 different regular flatware patterns and numerous souvenir spoons. Die sinkers Eustice Crees and Charles S. Court produced a notable set of fruit and flower designs for the company between 1902 and 1904, comprising 35 flowers or seeds and 12 different fruits. Joseph Straker contributed 16 designs to the company during the same period, comprising the "Wedding Rose" and "Mount Vernon" flatware patterns and 14 various designs for souvenir spoons.

By 1904 the business had become so large that Watson decided to split it into different operating units under one management umbrella. The sleeve and collar button division became the Standard Button Company, under the direction of Ripley & Gowen. This business under its later name of Ripley and Gowen was still going strong on the 100th anniversary of its founding in 1974.

In 1905 the Watson & Newell Co. was listed under Silversmiths in the business section of the Attleboro directory for the first time. Previously the directory had had only a jeweler's classification.

Newell's failing health forced him to retire from active participation in the firm shortly after the turn of the century, but he remained technically a partner until he died in 1910.

An undated catalog, titled *Souvenirs in Sterling Silver* from the Watson & Newell Co., possibly dating around 1915, illustrates literally hundreds of souvenir spoons depicting almost any imaginable subject.

"The Watson Co." was incorporated in 1920 to take charge of all the firm's silver operations.

The company continued to introduce new flatware patterns on a regular basis. Twelve were brought out in the 1920s, eleven in the 1930s, and three in the year 1940 alone.

Clarence Watson took an active interest in the welfare of his workers. He built houses and created a clubroom and social headquarters for them. He organized company picnics and social events, and even established the Watson & Newell Mutual Relief Association to financially assist employee members in time of sickness.

Watson died in 1930 and the management of the firm for the next 35 years was in the hands of his son-in-law, Grover Richards. When the business was sold to R. Wallace and Sons in 1955, Richards took an executive position with the Wallace Co.

In 1964 the company's souvenir spoon dies were sold to Whiting and Davis of Plainville, Massachusetts. In the 1970s they were purchased by the Inman Co. (q.v.) which currently is housed in the old Mechanics Mill in Attleboro. (Impastato, *Silver*, July-Aug. 1994, pp. 7-17)

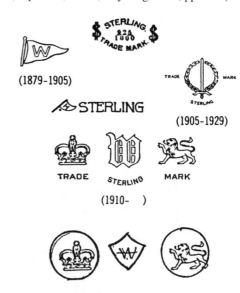

The above trademark was found on some souvenir spoons.

JAMES WATTS
Philadelphia, Pennsylvania

CHRONOLOGY

James Watts	1832-1839
J. & W. (William) Watts	1839-1852
Jas. Watts & Co.	1853-1859
Watts (James) & Harper (Henry)	1859-1862
James Watts	1862-1882
James Watts & Son (James & James W.)	1882-1887
James Watts (James W.)	1887-?

James Watts originally came from Ireland. Although company advertisements from the 1860's claim that his business had its beginnings

in 1832, the firm does not appear in the Philadelphia City Directories prior to 1835. Possibly the 1832 date refers to a currently unknown predecessor.

Despite its lengthy history, little is known about the firm. It supplied silver, especially flatware, to the retail trade, and did not have a high public profile.

"The Federal Industrial Census of 1850 reports that he had a capital of $42,000, employed twenty-two people, and fabricated an annual product worth $60,400. By contrast, his listing in 1880 shows a capital of only $9,000 with six employees and an annual product of $16,000." (Soeffing, in Venable's *Silver in America*, 1994, biographical section p. 323)

JULIUS R. WATTS & CO.
Atlanta, Georgia

Established in 1888 and listed in the Atlanta City Directories through 1958-1959. They are listed as watchmakers and more recently as jewelers and watch inspectors. The Uncle Remus trademark was stamped on souvenir spoons.

(On Souvenir Spoons.)

JOHN WAUBEL
Baltimore, Maryland

Listed in the 1864 Baltimore City Directory as a silverplater.

WAYNE SILVER CO.
Honesdale, Pennsylvania

An 1895 account reads: "The Wayne Silver Co. of Honesdale, Pa. was incorporated. Directors are: L.J. Dorflinger, Thomas B. Clark, Wm. B. Holmes, Walter A. Wood and Grant W. Lane. They manufacture fancy and useful articles of silver, not plated, with the possible exception of knives and forks." (JC&HR 3-13-1895, p. 14)

A short time later: "Operations began in the Wayne Silver Co.'s factory. The building is completed and mechanics are making models, dies, etc. Tea sets, berry sets, cake baskets and fancy and useful articles of various kinds will be made of sterling silver. E. Newton, formerly with Tiffany & Co., N.Y., is the manager of the factory." (JC&HR 9-25-1895, p. 14)

Listed out of business before 1904.

WAYNE SILVERSMITHS, INC.
Yonkers, New York

Makers of handwrought sterling silver articles from c. 1950 to the present.

J.P. WEATHERSTONE
Chicago, Illinois

Advertised in the *American Jeweler,* Sept. 1892, p. 3, as a manufacturer of sterling and coin silverware. He advertised that special pieces in silver could be made on short notice. Prices for making over old silver were quoted at 45¢ per ounce, an extra charge for hand engravings.

GEORGE W. WEBB
Baltimore, Maryland

George W. Webb was born in 1812 and died in 1890. The earliest record found for his goldsmithing and silversmithing was an advertisement stating that his business was established in 1850. He is listed in the Baltimore City Directories as George W. Webb until 1865-1866 when the name was changed to Webb & Company. G.W. Webb, A. Remick and W.H. Sexton, partners. This listing continued until 1877 when it changed to Geo. W. Webb & Co. The latter listing continued through 1886.

H.J. WEBB & CO.
Springfield, Massachusetts

Successors to L.S. Stowe & Co. between 1896 and 1904. Jobbers and retailers of silver and jewelry. Out of business before 1915.

JOHN WEBB
Baltimore, Maryland

John Webb is listed by Pleasants and Sill (see bibliography) as a silversmith in Baltimore c. 1827-1842. In the Baltimore City Directories John Webb is listed 1855-1856 as a goldsmith. The 1864 listing is in the name John Webb, Sr. The 1865-1866 listing is John Webb, jeweler.

WEB SILVER COMPANY, INC.
Philadelphia, Pennsylvania

Successors to the Web Jewelry Manufacturing Co. between 1950-1965. In 1952 they acquired the sterling flatware dies and patterns formerly used by the Weidlich Sterling Spoon Company, Bridgeport, Connecticut.

WEBER-WAGNER & BENSON CO., INC.
See J. Wagner & Son, Inc.

WEBER-WAGNER CO.
See J. Wagner & Son, Inc.

A.A. WEBSTER & CO.
Brooklyn, New York
See E.G. Webster & Son

Adelbert A. Webster was the brother of E.G. Webster, and was associated with him in the firms of E. G. Webster & Brother and the Webster Manufacturing Co. between 1865 and 1886. In 1886 he left to form the firm of A.A. Webster & Co., silversmiths, jewelers and opticians. That firm was succeeded by Clarence B. Webster before 1904.

The A.A. Webster & Co. trademark was the company name and address in concentric circles.

CLARENCE B. WEBSTER
Brooklyn, New York

CHRONOLOGY
Frederick S. Hoffman
Webster Brother & Co.
A.A. Webster & Co.
Clarence B. Webster

The company began as Frederick S. Hoffman, (q.v.) founding date not known; succeeded by Webster Brother & Co. Members of this firm apparently joined A.A. Webster to form A.A. Webster & Co. in 1886; became Clarence B. Webster before 1904.

Manufacturers of sterling silver goods, 14k and 18k gold novelties and leather goods with silver mountings.

E.G. WEBSTER & SON
New York, and Brooklyn, New York
See International Silver Co.

CHRONOLOGY

E.G. Webster	1859-1864
Webster & Dupree	1864-1865
E.G. Webster & Brother	1865-1866
Webster Manufacturing Co.	1866-1874
E.G. Webster & Brother	1875-1886
E.G. Webster & Son	1886-1928

Elizur G. Webster first appears in the New York City Directories listed as a clerk in 1859. By the following year he was operating his own silverplating business located at 175 Broadway.

About 1864 he entered into partnership with another silverplater, William Dupree, to form the firm of Webster & Dupree (q.v.), which was in business at 447 Broome, while E. G. Webster remained at 175 Broadway. This partnership was probably intended to serve as a factory for E.G. Webster.

Webster's brother, Adelbert A. Webster, joined him in 1865 to form the firm of E. G. Webster & Brother, and the business moved to 14 Maiden Lane. Webster & Dupree continued at 447 Broome.

From 1866 the partnership of Webster & Dupree no longer is found in the New York City directories. However, in 1866 a listing for the Webster Manufacturing Co. appears in the Brooklyn directories, apparently the new factory location for E.G. Webster & Brother. Dupree is shown in the Brooklyn directories as the factory's superintendent.

By 1867, the entire business had been incorporated as the Webster Manufacturing Co. with E.G. Webster as president and A.A. Webster as secretary. The firm continued to maintain the 14 Maiden Lane address as a showroom.

By 1875 the firm had changed its name back to E. G. Webster & Brother. The factory remained in Brooklyn, and the showroom in Maiden Lane.

In 1886, A.A. Webster left the firm to form A.A. Webster & Co. (q.v.). Elizur G. Webster went into partnership with his son, Fred H.Webster, to form the firm of E.G. Webster & Son. After his father's death in 1900, Fred H. Webster continued the business until the firm was sold to the International Silver Co. in 1928.

The company's main line was silverplated holloware. Elizur G. Webster himself received Design Patent No. 4,418 in 1870 for a design for a Tea & Coffee service. The firm was well known for its highly chased holloware and English reproductions.

When the business was brought to Meriden in 1928, it was combined with the Barbour Silver Co. factory "A". Fred H. Webster continued with the firm, but retired a few years before he died in 1941.

In 1961 the trademark was changed to Webster-Wilcox which continued to 1981 when the business was sold to Oneida Silversmiths.

(On sterling silver)

**Brooklyn S.P. Co. Quadruple Plate
(On napkin rings)**

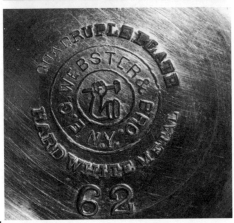

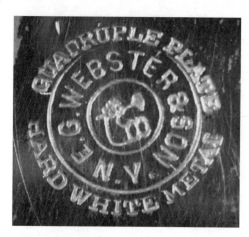

G.K. WEBSTER
North Attleboro, Massachusetts
See Reed & Barton
See Webster Co.

"G.K. Webster, North Attleboro, Born Wentworth, N.H., 1850. Attended common schools there until old enough to attend academy at Newbury, Vt. from which he graduated. In 1868 he went to New Jersey and worked for the then Raritan and Delaware railroad in the office of the repair shop. Later he went to Lawrence, Massachusetts and worked at the drug business for three years and in Boston for two years for a wholesale drug concern. He then moved to N. Attleboro and engaged in the drug business for himself. In 1879 he sold out and began manufacturing and making a general line (sterling and jewelry) and also novelties." (Obit. *Manufacturing Jeweler,* 10-2-1894, p. 60)

The company was succeeded by the Webster Co. soon after his death.

H.L. WEBSTER & CO.
Providence, Rhode Island
See J.B. & S.M. Knowles
See Gorham Corporation

Henry L. Webster was born in 1808. About 1829 he completed his apprenticeship as a silversmith under Lewis Cary of Boston, and went into business there manufacturing silver spoons. When he moved to Providence in 1831, he entered into partnership with Jabez Gorham forming a firm called Gorham and Webster. In 1837 they were joined by William G. Price, and the business became known as Gorham, Webster & Price. Although Price died shortly afterwards, the firm retained the name until 1840. Then the jewelry portion of the business was sold off and Webster took over the silver manufacturing portion.

In 1841, after accepting an interest in Newell Harding & Co. (q.v.) of Boston, Webster sold the business to his former partner Jabez Gorham. Jabez Gorham and his son John formed the firm of Gorham & Son, which went on to become Gorham & Co., one of the giants of the American silverware industry.

By 1852, Webster had returned to Providence and gone into business by himself as a silver spoon manufacturer. In 1854 Joseph B. Knowles joined the firm, and it became H. L. Webster & Co. Webster sold out his interest on November 7, 1864 and died two and a half weeks later.

With the departure of Webster, Knowles took on a new partner, Samuel J. Ladd, who had previously served as an employee of the firm, and the business became known as Knowles & Ladd. (Soeffing, *Silver*, Sept.-Oct. 1996, p. 30)

W.E. WEBSTER CO.
Providence, Rhode Island

Registered trademark U.S. Patent Office, No. 27,241, November 19, 1895 for sterling silver, rings, pins and ornamental jewelry. Out of business before 1904.

WEBSTER & DUPREE
New York, New York
See E.G. Webster & Son

Firm formed about 1864 by E G. Webster (q.v.) and William Dupree. Both men had previous experience in the silverplating business. The business was probably established to function as the factory for E. G. Webster. Not found in the New York City directories after 1865. A new factory called the Webster Manufacturing Co. was established in Brooklyn by 1866. Dupree became the superintendent there.

WEBSTER COMPANY
North Attleboro, Massachusetts
See Reed & Barton

See Frank W. Smith Silver Co., Inc.
See G. K. Webster Co.

Founded by George K. Webster in 1869 in North Attleboro under the name of G. K. Webster and Company. As the business grew, Mr. Webster purchased the interest of his partners. It operated under his direct supervision throughout his lifetime. After he died in 1894, the firm became the Webster Co.

On January 1, 1950 it became a subsidiary of Reed & Barton of Taunton, Massachusetts. It continues its independent operation as The Webster Company.

The principal product has always been articles made of sterling silver. They are mostly baby goods, dresserware and picture frames.

In October 1958 they purchased the Frank W. Smith Silver Co. Inc. and all the tools and dies, along with the tradename and trademark. The flatware portion of this business was moved to North Attleboro from the original location in Gardner, Massachusetts.

Trade mark now owned by the Webster Co. Division of Reed & Barton Silversmiths.

WEBSTER MANUFACTURING CO.
New York, and Brooklyn, New York
See E. G. Webster & Son

WEE CHERUB MFG. CO.
Houston, Texas

Manufacturers (?) of sterling novelties c. 1950.

C. WEETON MANUFACTURING CO.
Location unknown, (possibly Canada?)

Mark found on a silverplated mug dated circa 1890s.

THE WEIDLICH BROS. MFG. CO.
Bridgeport, Connecticut

Founded in 1901 in Bridgeport, Connecticut. Specialized in sterling and plated trophies. Went into voluntary dissolution in 1950. No connection with Weidlich, Inc., 140 Hurd Avenue, Bridgeport, Connecticut.

POMPEIAN GOLD
THE WARNER SILVER CO.

FVFR DRY
(On salt & pepper sets)

AVON
(On sterling)

MAYFLOWER
(On pewter)

WEIDLICH STERLING SPOON CO.
Bridgeport, Connecticut

Related to Weidlich Bros. Mfg. Co. of Bridgeport. Made sterling silver souvenir spoons

and sterling silver flatware (U.S. Trade Mark Patent 103,304, March 30, 1915). In 1952 the Web Jewelry Mfg. Co., now the Web Silver Co., Inc. silversmiths in Philadelphia, acquired the sterling flatware dies and patterns. No connection with present Weidlich, Inc., 140 Hurd Avenue, Bridgeport, Connecticut.

E.M. WEINBERG & CO.
New York, New York

Listed JC 1915 in plated silver section. Out of business before 1922.

Note similarity of trademark to that of F.G. Whitney & Co., Attleboro, Massachusetts.

WEINMAN CO.
Philadelphia, Pennsylvania

Manufacturers of plated silverware in Philadelphia c. 1900-1915.

BRAZIL SILVER

WEIZENNEGGER BROS.
Newark, New Jersey

Listed JC 1909-1922 in sterling silver section, manufacturers of mesh bags, dealers in diamonds. Also found in KJI 1922 and 1924.

WELCH & TROWERN
Toronto, Ontario, Canada

Manufacturing jewelers. Offered Silver lockets, Napkin rings, Masonic jewels, Trowels, Stick heads, Silver Prize cups etc. in 1880. Listed as manufacturers of cuff buttons and watch cases in gold and silver in 1882. A.H. Welch retired in 1886 (Unitt & Worrall, *Unitt's Book of Marks*, 1995 p. 54)

WELCH & TROWERN

WELLS, INC.
Attleboro, Massachusetts
See Canfield Bro. & Co.

Succeeded Canfield, Bro. & Co. about 1881. Wells manufactured charms and other fine jewelry.

In 1977 they were combined with Benrus to form Wells Benrus Corp. And, in 1978, Wells Benrus made the decision to leave the jewelry industry.

WELSH & BRO.
Baltimore, Maryland

An 1898 account reads:"Welsh & Bro. of Baltimore designed and manufactured the communion service presented by the Altar Guild of Mt. Calvary Protestant Episcopal Church to the Rev. Geo. A. Leakin." (JC&HR 4-20-1898, p. 28)

WENDELL MANUFACTURING COMPANY
Chicago, Illinois
See Mulford, Wendell & Co.

Founded by Charles Wendell c. 1850. Became the Wendell Mfg. Co. by 1885; incorporated May 1889. Manufacturers of sterling silver badges. Around 1896-97 they acquired some of the flatware patterns and dies of the Mauser Mfg. Co. Retail or wholesale outlet in New York listed as Wendell & Co. 1904-1909. Not listed in Chicago City Directories.

They made sterling wares for Marshall Field & Co., some of which were marked with trademarks of both. Discontinued flatware production c. 1900.

The upper of the two lion tradmarks was used prior to 1894.

J.R. WENDT & CO.
Boston Massachusetts
New York, New York

CHRONOLOGY

Rogers & Wendt	1853-1857
Rogers, Wendt & Lemme	1857-1858
John R. Wendt	1859-1860
Rogers, Wendt & Wilkinson	1860
J.R. Wendt & Co.	1860-1871

Johann Rudolph Wendt was born in Osnabruck, Germany in 1826. Between 1842 and 1847 he served as an apprentice to Dietrich Heinrich Stadt II in Osnabruck. He was admitted into the guild as a journeyman in 1847 and emigrated to the United States in 1848. This move was probably triggered by political unrest in Germany at the time.

Wendt appears in the Boston directories as a chaser in 1850. By 1853 he had entered into a manufacturing partnership with Augustus Rogers, forming the firm of Rogers & Wendt.

In a brief side venture in 1856, the firm of Rogers Wendt and Langdon was organized to manufacture watch cases.

In 1859, for a few months, Wendt worked alone.

In 1860 Rogers and Wendt joined with George Wilkinson, Gorham's chief designer, to form the firm of Rogers, Wendt & Wilkinson. Its purpose was to manufacture silverware for the firm of Ball, Black & Co. in New York which was then in the process of constructing a new building. For reasons unknown the partnership did not last, and Wilkinson returned to Gorham after only eight months.

The firm of John R. Wendt & Co. was formed, and when Ball, Black & Co.'s new building was completed, Wendt's manufacturing business occupied the fourth and fifth floors. Although the two firms had a special business relationship, they remained separate entities.

Wendt received two design patents for flatware. Two other patents were granted to "Rudolph Wendt", but it is unclear whether they are by him or a male relative under his employ.

In 1871 Wendt sold his business to his partners, Bernard D. Biederhase and Charles Witteck. Not much is known about Wendt after that time. His will is dated 1904 and gives an address on Staten Island. However, Wendt apparently died in Germany in 1907.

For most of his business life, Wendt worked under contract with a retailer, not using a manufacturing mark of his own. As a result , most pieces can only be attributed to him through analysis of their style and through his work for Ball, Black & Co. (Soeffing, in Venable's *Silver in America*, 1994, biographical section, p. 323)

Marks are from Cramer, *Silver*, May-June 1992, p. 12.

THE WESSELL SILVER CO.
New York, New York

An 1896 account reads:"The Wessell Silver Co. of 1945 Park Avenue, N.Y. made an assignment Wednesday. The company began business in July 1893. W. Emlen Roosevelt, president and Charles Wessell, secretary. The original incorporators were C.A. Wessell, R.A. Mead and Arthur Cristodoro. The company manufactured a composition metal called Wessell silver, which they recently began to make into spoons, forks and other tableware." (JC&HR 5-5-1896, p. 18)

WEST EARTH, INC.
Seattle, Washington
See Charles B. Cantrell
See E. J. Towle Co.

Firm formed by Charles B. Cantrell and Raoul Leblanc after they purchased the E. J. Towle Co. in 1980. The company produced jewelry and a limited number of collector spoons between 1980 and 1985. In 1985 Charles B. Cantrell bought out Raoul Leblanc's minority interest in the firm, and re-named the business Metal Arts Group, Ltd.

WEST SILVER CO.
Taunton, Massachusetts

Founded in Taunton, Massachusetts in 1883. F.B. Rogers successors before 1896.

WESTBROOK BRITANNIA COMPANY
Portland, Maine

Listed in 1869-1885 City Directories, William Wallace Stevens, owner.

WESTERLING COMPANY
Chicago, Illinois

Founded in 1944 by Jack Luhn, Les Hedge and Glenn Olmstead as the Easterling Co. A direct sales company handling only sterling silver flatware. Tableware lines were diversified to include china, crystal, cook-and-serve wares and others. The sterling inventory and pattern rights were sold to the Westerling Co. in March 1974. These six patterns are manufactured by the Gorham Company for Westerling.

WESTERN SILVER WORKS, INC.
New York, New York.

Listed 1927 KJI as manufacturers of silverplated ware.

JOHN L. WESTERVELT
Newburgh, New York

John L. Westervelt was born in 1826 on the family farm near the town of Newburg, New York. He served his apprenticeship in the small town of Walden, nearby. After completing his training in 1848, he returned to Newburgh and worked in the trade. He married Catherine Gorham in 1850.

In 1854 he opened his own silver manufacturing business at the corner of Fifth and Water Street. Although flatware was his main product, he also manufactured small holloware, particularly goblets, cups and salts. Some time before 1870 he also began producing gold rings. About

1870 he ceased using the "coin" standard for his pieces and adopted the "sterling" standard.(Soeffing, *Silver*, Sept.-Oct. 1992, pp. 12-13)

Westervelt's flatware was manufactured in a number of standard patterns such as Plain Fiddle, Plain Tipt, Fiddle Thread and Oval Thread. He also produced at least half a dozen fancier, die struck patterns, including a Medallion pattern. (Soeffing, *Silver*, Nov.-Dec. 1992, pp. 17-18)

His retail business was expanded about 1880 to include diamonds and jewelery, as well as silver produced by other manufacturers. His manufacturing business had declined due to his failure to adopt more modern mechanized means of production. Westervelt continued to manufacture silverware until his retirement in 1904, a year before his death. (Soeffing, *Silver*, Sept.-Oct. 1992, pp. 13-14.)

Mark illustrations based on Soeffing, *Silver*, Nov.-Dec. 1992, p. 16.

WESTMORLAND STERLING CO.
Wallingford, Connecticut

Westmorland was created in 1940 through the cooperative efforts of Wearever Aluminum Inc. and Wallace Silversmiths. War-time priorities made it necessary to diversify, hence the idea of selling sterling flatware on a direct-to-consumer basis was developed. Wearever developed the marketing programs and Wallace Silversmiths manufactured five sterling silver flatware patterns, exclusive to that organization. In 1966, Wallace assumed the marketing responsibility for Westmorland and reorganized the marketing program by establishing franchised dealers. It continues (1975) to manufacture the same five patterns.

Westmorland

C.A. WETHERELL & CO.
Attleboro, Massachusetts

Listed in Jeweler's Weekly, 1896 as manufacturers of sterling silverware. Listed in

Attleboro City Directories 1892-1897 as manufacturing jewelers.

DAVID HUDSON WHISTON
Halifax, Nova Scotia, Canada

David Hudson Whiston was born in Halifax, Nova Scotia, in 1834. After completing his apprenticeship with Michael Septimus Brown, he served as foreman of the silversmithing department for many years. He established his own business about 1864. In addition to manufacturing his own wares, he also provided silverware for T.C. Johnson, which he marked TCJ-H. He died in 1917 in the great Halifax explosion. (Unitt &Worrall, *Unitt's Book of Marks*, 1995, p. 24)

H.L. WHITE & CO.
Providence, Rhode Island

In business c. 1852. Succeeded by J.B. & S.M. Knowles in 1891.

WHITE SILVER CO.
Taunton, Massachusetts

Manufacturers of plated silver holloware, prize cups and pewterware c. 1900-1930.

FRANK M. WHITING CO.
North Attleboro, Massachusetts
See Ellmore Silver Co.

CHRONOLOGY

Holbrook, Whiting & Albee	?-1878
F.M. Whiting & Co.	1878-1891
F.M. Whiting	1891-1895
F.M. Whiting Co.	1895-1896
Frank M. Whiting & Co.	1896-1940

Frank M. Whiting, son of William D. Whiting, founder of the Whiting Mfg. Co. had been associated with his father in that company. Prior to 1878 he left the company and formed the firm of Holbrook, Whiting & Albee, which began the manufacture of silverware in North Attleboro, Massachusetts. In 1878, Frank M. Whiting

bought out his two partners and continued business under the firm name of F.M. Whiting & Co. In 1881 his father, William D. Whiting, became a partner, the firm name remaining the same until his father's death in 1891, when it was changed to F.M. Whiting. The following year Frank M. Whiting died and the business was continued by his widow, mother and two sisters. In 1895 it was converted into a stock company under the name F.M. Whiting Co. About 1940 it became a division of the Ellmore Silver Co. which went out of business c. 1960. The sterling flatware dies were bought by the Crown Silver Co., New York. It is believed that they are no longer being used.

Action brought by the Whiting Mfg. Co. against the F.M. Whiting Co. in 1896 resulted in F.M. Whiting agreeing to change their name to Frank M. Whiting & Co. The suit was to restrain the defendant company from using a griffin trademark which testimony showed led to confusion with the the the Whiting Mfg. Co. trademark.

(Not used after 1896)

WHITING & DAVIS CO., INC.
Plainville, Massachusetts

Began as a small chain manufacturing company c. 1876. Operated by William Wade and Edward P. Davis. C.A. Whiting, while still a young boy, entered the business as an unskilled worker. He worked as an artisan, salesman and partner, finally becoming owner in 1907.

Years of experimenting led to the development of the first chainmail mesh machine shortly after 1907. Whiting & Davis is now the world's largest manufacturer of mesh products including such items as safety gloves and aprons, mesh handbags and purse accessories, and jewelry. They also produce an outstanding line of antique reproduction jewelry—many pieces copies of museum masterpieces.

In 1964 they purchased the J.T. Inman Company and integrated the complete manufacturing facilities into their main plant. The souvenir spoon equipment, dies and tools were bought from the Watson Company by J.T. Inman. The balance of the business was sold to the Wallace Company.

These dies were used by Whiting & Davis to make souvenir spoons. There were approximately 3,000 designs, according to the Executive Vice President, George J. LeMire. They were stamped, whenever possible, with the Whiting & Davis registered trademark. In the 1970s the Wallace Dies were sold to the Inman Co., Inc.where they are currently (1995) not in use.

W. & D.

WHITING MANUFACTURING COMPANY

New York, New York
See Tifft & Whiting
See Gorham Corporation

CHRONOLOGY

Tifft & Whiting	1840-1853
Whiting & Gooding (& Co.)	1853-1858
Whiting, Fessenden & Cowan	1858-1859
Tifft, Whiting & Co.	1859-1864
Whiting, Cowan & Bowen	1864-1866
Whiting Manufacturing Co.	1866-1924

The Whiting Manufacturing Co., formed in 1866, traces its origins back to the firm of Tifft & Whiting (q.v.) Initially, William D. Whiting served as president; William M. Cowan, vice-president; and Charles E. Bulkley as treasurer. George E. Strong joined the firm about 1870 after Hebbard & Co., with which he was formerly associated, went out of business.

The Whiting Manufacturing Co. obtained the flatware dies of both Michael Gibney (q.v.) and Henry Hebbard (q.v.) possibly as a result of Strong's long-term connections with Hebbard, which extended back to at least 1854.

Hebbard & Co.'s demise may have been the result of its loss of its Tiffany & Co. account. Tiffany had purchased Edward Moore's silverware manufacturing firm in 1869, so that it could start producing its own wares, instead of being entirely dependent on outside manufacturers. (Soeffing, in Venable"s *Silver in America*, 1994, biographical section p. 324)

The Whiting Manufacturing Company's factory, like that of its predecessors, was initially located in North Attleboro, Massachusetts. When that plant was destroyed by fire in 1875, a refiner from Newark, New Jersey, F. Jones, obtained the property, salvaged what he could from the ruins, and moved all operations to New York City. (Soeffing, ibid.) Gorham purchased the company in 1924 and moved operations to Providence, Rhode Island, in 1926.

Charles Osborne served as chief designer for the firm during two different periods of its history. He obtained numerous patents for both flatware and holloware.

Although known primarily as a solid silver manufacturer, the Whiting Manufacturing Co. produced some silverplated pieces as well. Their silverplate mark shown below appears on a crumb knife in the company's "Honeysuckle" pattern, Osborne's Design Patent No. 7808, granted in 1874. The pattern is more commonly found in solid silver.

**WHITING M.F.G. CO
YEAR MARKS**

Mark	Year	Mark	Year
♣ •	1905	人 •	1915
⚘ •	1906	Y •	1916
⚘ •	1907	⊐ •	1917
⚭ •	1908	⌐ •	1918
⬦ •	1909	☐ •	1919
⚘ •	1910	X •	1920
⚘ •	1911	⊔ •	1921
人 •	1912	⌋ •	1922
△ •	1913	⊏ •	1923
⚘ •	1914	∟ •	1924

Whiting Tankard Yachting Trophy. The Whiting Manufacturing Co. made a specialty of producing all kinds of trophies to order and heavily advertised the fact. D. Albert Soeffing Collection. (Photo courtesy D. Albert Soeffing)

CHARLES WHITLOCK
Baltimore, Maryland

Listed in the 1850 Census as a silversmith in Baltimore. Born in Maryland.

JOHN H. WHITLOCK & CO.
Troy, and New York, New York

Listed in the New York City Directory for 1855 as manufacturers of white metal, britanniaware and rich plated ware. The firm had its factory in Troy, New York, and a showroom in New York City. Not found in the New York City directories after 1856.

F. G. WHITNEY & CO.
Attleboro, Massachusetts

Trademark registered July 12, 1881 for use on jewelry. Note similarity to trademark of E.M. Weinberg & Co. of New York.

WILLIAM H. WHITNEY
New York, New York

William H. Whitney first appears in the New York City directories in 1864 selling watches. From 1866 until 1874, as far as he has currently been followed, he is listed as a jeweler. The listings make no mention of him ever having been in the silverplating business. There is, nevertheless, a rather elaborate silverplate pedestaled compote bearing a disc mark with his name on it.

The compote has three figures of cherubs holding aloft bunches of grapes seated on the base of the pedestal, and a grape vine and high relief bunches of grapes around the bowl rim. It appears, stylistically, to date no later than the mid 1860s.

WHITNEY JEWELRY COMPANY
Boston, Massachusetts

First listed in the Boston City Directories in 1883; probably founded the previous year. It was first listed as Whitney Brothers, jewelers. The brothers were: Edwin A. Whitney of Watertown, Massachusetts, and later of Newton, Massachusetts, and Albert E. Whitney of Fitchburg, Massachusetts. Abert E. was not connected with the firm by 1894, when it was listed as E.A. Whitney Company, watches and jewelry. Was in business through 1911.

U.S. Trade Mark Patents No. 19,778 through 19,792 were registered in the name of Edwin A. Whitney, June 30, 1891, for use on gold, silver and plated flatware.

Columbus Before the Queen No. 19,778

Barbara Frietchie No. 19,788

Columbus and the Egg No. 19,779

Fort Smith No. 19,790

Monitor & Merrimac March 9, 1862 No. 19,791

Antietam, September 17, 1862, No. 19,992

Gettysburg, July 1863, No. 19,789

The Santa Maria, No. 19,780

The March to the Sea No. 19,781

Appomattox, April 9, 1865 No. 19,782

July 4, 1776, No. 19,784

Sheriden's Ride No. 19,783

General Stonewall Jackson, No. 19,785

"The Seven Days" battle used in spoon bowl, General Robert E. Lee is the trademark, No. 19,786

Signing the Emancipation Proclamation, January 1, 1863, No. 19,787

There is a discrepancy between the historical scenes listed in the trademark description and those actually shown. Numbers 19,784 and 19,790 are listed as "July 4, 1776" and "Fort Smith." The two scenes shown are actually of Harpers Ferry, Oct. 17, 1859 and Fort Sumpter, April 12, 1861.

H.F. WICHMAN
Honolulu, Hawaii

Designers and manufacturing jewelers and retail outlets. They began in 1887 as Gomes & Wichman. Became H.F. Wichman in 1891 and continues in business under that name.

His Majesty, King David Kalakaua, ruler of the Kingdom of Hawaii, gave an order for heroic medals to H.F. Wichman. This order provided the financial base for the beginning of the first jewelry store in the islands. Their craftsmen select the finest diamonds, sapphires, zircons, opals, cultured pearls and other precious stones and set them in distinctive mountings.

The original store and manufacturing facilities were in downtown on Fort Street. Following a disastrous fire, the main store was moved to Kalakaua Avenue. There are now branches in major hotels. The factory is located on Olohana Street.

H. F. WICHMAN

HENRY WIENER & SON
New York, New York

Distributors (?) of sterling silver mesh bags c. 1920. Listed in KJI 1922.

PICADILLY

CHAS. C. WIENTGE CO.
Newark, New Jersey

Charles C. Wientge designed silverware for the Howard Sterling Co. Providence, Rhode Is-

land, c. 1891-93 and was a silversmith working for himself in Newark, 1893-96; employed by Lebkuecher & Co., Newark in 1896.

H.C. WILCOX & CO.
Meriden, Connecticut
See International Silver Co.
See Meriden Britannia Co.

Organized in 1848 by Horace C. and Dennis C. Wilcox to market the products of Meriden's britannia ware producers. A forerunner of Meriden Britannia Co.

WILCOX & EVERTSEN
New York, New York
See International Silver Co.

Successors to Rowan & Wilcox, who started under that name the latter part of 1889. Became Wilcox & Evertsen in 1892 with Robert M. Wilcox and Henry H. Evertsen as partners. They were makers of sterling silver holloware. In 1896 the company was purchased by the Meriden Britannia Co. and moved to Meriden, Connecticut.

They made a beautiful line of sterling holloware and started a sterling flatware line. After the formation of the International Silver Co., in 1898, the tools and equipment for flatware were moved to Wallingford, Connecticut and used space in the Simpson Nickel Silver plant while the holloware was made in Meriden. When more room became necessary they consolidated in 1929 in Wallingford with other sterling lines in the old Simpson, Hall, Miller & Co. buildings.

For their flatware markings see the International Silver Co.

WILCOX & WAGONER
New York, New York

Listed in JC 1904 in sterling silverware and cut glass sections. Bought by the Watson Co. before 1905.

WILCOX BRITANNIA CO.
See International Silver Co.
See Wilcox Silver Plate Co.

WILCOX-ROTH CO.
Newark, New Jersey

Listed in JC 1909 in sterling silver section as out of business.

WILCOX SILVER PLATE CO.
Meriden, Connecticut
See International Silver Co.
See Superior Silver Co.

Organized in 1865 by Jedediah and Horace Wilcox, Charles Parker, Aaron Collins and Hezekiah Miller and others to make holloware as Wilcox Britannia Co. In 1867 the name was changed to Wilcox Silver Plate Co. In 1869 they purchased the Parker & Casper Co. They were one of the original companies to become part of the International Silver Co. in 1898.

In 1941 because of a metal shortage during World War II, the factory was closed. After the war, Wilcox Silver Plate Company designs were made in other International Silver Company factories. In 1961 the trademark was changed to Webster-Wilcox.

The "half circle" trademark was first used in 1921 and registered in 1923.

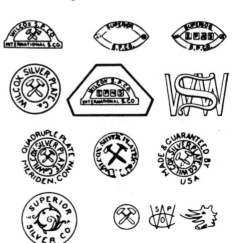

STERLING

PEWTER BY WILCOX
(Pewter Hollowware)

Wilcox Silverplate Company inkwell, c. 1880s, depicting a Kate Greenaway child and dog. The dog's head lifts to reveal the inkwell. Note the dog's glass eyes, a design feature popular in the 1880s. (Photo by Judy Redfield)

WILEY-CRAWFORD CO., INC.
Newark, New Jersey

Manufacturers of gold and sterling silver novelties, card trays and jewelry c. 1915-1922.

WILKINSON SWORD CO.
London and Sheffield, England

Founded in 1772 by Henry Nock, famous gunmaker. James Wilkinson, apprentice (?) inherited the business in 1805. James' son, Henry, took over in 1825. Became outstanding makers of top quality firearms.

Began the manufacture of swords in the 1840s. During WWI engaged in the production of armaments. Production of garden tools and fire protection equipment began after the war. In 1936 they marketed their double edge "wafer" razor with a stainless steel blade. In 1961 their revolutionary PTFE coated "Super Sword Edge" blade was introduced.

In 1981 the business was acquired by Allegheny International, Inc. (Culme, *The Directory of Gold & Silversmiths,* 1987, reprinted 1992, pp. 484-85)

Manufacturers of plated silver swords. Listed JC 1909- 1922.

WILLARD & HAWLEY
Syracuse, New York
See Joseph Seymour

Partnership formed in 1845 between William Ward Willard and John Dean Hawley.

William Ward Willard spent his life in and around the Syracuse area. He was born in Camillus, apprenticed in Manlius, and in the late 1820s or early 1830s set up a jewelry business in Cazenovia, New York, about fourteen miles from Syracuse. John D. Hawley was trained by Willard at this location in the late 1830's.

When Willard sold out the Cazenovia business in 1841 and moved to Syracuse, Hawley was almost certainly the purchaser. He stayed in Cazenovia until 1845 when he joined Willard in Syracuse.

Joseph Seymour (q.v.) from Hartford Connecticut joined the firm in 1846 and began the systematic production of silverware. An ad in the *Onondaga Standard,* September 2, 1846 proclaimed that the firm was "now prepared to furnish Silver Table Forks, Table Spoons, Tea Spoons, Cream Spoons, Sugar Spoons, Butter Knives, Gravy Ladles, Ice Cream Knives, Pickle forks, &c. &c. made of Silver, equal to dollars, and in the very best style of workmanship." (Soeffing, *Silver,* Nov.-Dec. 1989, p. 20)

By the following year, the company advertised that their wares had won awards at the County and State Fairs. Records of the County Fair award have not yet been found. The State Fair in 1846 awarded the company $5 and a diploma "for beautiful silverware".(Soeffing, *Silver*, July-Aug. 1991, p. 14) As a result of these awards, the firm added the word "Premium" to its marks.

In 1848 Joseph Seymour left to go into business on his own with Benjamin R. Norton as his partner. The firm became Willard, Hawley & Co. with the addition of Alexander C. Clarke, probably a financial backer. In 1849, L.D. Beebe from New York City took charge of the manufacturing department.

The 1855 New York State Industrial Census indicates that in that year Willard & Hawley employed four men and two women, used hand powered machinery, and produced about $10,000 worth of silver annually, making it a relatively small firm.

By 1864 the company had given up the manufacturing portion of the business. Without major mechanization it could not successfully compete with other firms.

The jewelry business continued as Willard & Hawley until 1870, when Willard retired due to ill health. He died in 1876. Hawley carried on the business, later admitting his son William and Frank H. Wells to ownership. About 1891, the Hawleys sold out to Wells. J.Dean Hawley then worked for a time for Joseph Seymour, Sons & Co., after which he served as a registry clerk in the Syracuse Post Office until his retirement. He died in 1913. (Soeffing, *Silver*, Nov.-Dec 1989, p. 21)

Marks are from Soeffing (ibid.) and Ives (*Silver*, Nov.-Dec. 1991, p. 15)

WILLARD&HAWLEY

WILLIAMS BROS. MFG. CO.
Naubuc, Connecticut
See American Sterling Co.
See F. Curtis & Co.
See Curtisville Mfg. Co.

James B. and William Williams bought the American Sterling Company and founded the Williams Bros. Mfg. Co., in 1880. Manufacturers of plated silver spoons, forks and a general line of flatware. They went out of business in June 1950.

American Sterling Co. used as a brand name on some of their silverplated ware.

ROGER WILLIAMS SILVER CO.
Providence, Rhode Island
See Gorham Corporation
See Mt. Vernon Co. Silversmiths, Inc.

The Roger Williams Silver Co. was successor c. 1900 to Howard Sterling Silver Co. It was merged in 1903 with the Mauser Mfg. Co. of New York and Hayes & McFarland of Mount Vernon, New York to form the Mt. Vernon Company Silversmiths, Inc. which was bought by the Gorham Corporation in 1913.

For a brief time c. 1911 control of the Roger Williams Silver Co. was transferred to the Silversmiths' Co. of New York, under the management of Theo Bender. Wm. Linker, from Davis & Galt, silversmiths of Philadelphia, was associated with the firm. The company received U. S. Trade Mark Patent No. 36,769, July 16, 1901, for certain named metalwares - whole or in part of silver.

 R & W

Trademark used continuously since June 1, 1901.

JAMES A. WILLIG
Baltimore, Maryland

Listed in the 1850 Census as a silversmith. Born in Pennsylvania.

JOHN W. WILLSON
Baltimore, Maryland

Listed 1867-1869 Baltimore City Directories as silverplaters.

WILMORT MFG. CO.
Chicago, Illinois

Manufacturers of sterling and plated silverware and novelties c. 1920-1930.

(Silver Plated Hollowware)

Dissolved March 21, 1930.

R. & W. WILSON
Philadelphia, Pennsylvania

Robert Wilson was listed in the New York City Directory in 1805 and Philadelphia City Directories 1816-1846. Robert Wilson and William Wilson (R. & W. Wilson) listed in Philadelphia Directories 1825-1850. Wm. Wilson & Son, silversmiths, Philadelphia, listed in *Jeweller, Silversmith & Watchmaker*, 1877.

Another account indicates that R. & W. Wilson were solid silver manufacturers in business from 1825 to 1883. Noted for their lively floral design. Particularly noted for pieces in the Rococo revial style, using robust curves and swirls of foliage to decorate opulent rounded forms. (Getz, *Silver* Jan.-Feb. 1988, p. 11)

Succeeded by William Wilson & Son.

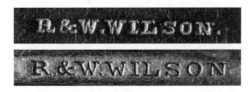

WM. WILSON & SON
Philadelphia, Pennsylvania

Patent Office records show the registration of two trademarks by William Wilson & Son in 1883. They were also listed in JC in 1896 and 1904 and were out of business before 1909.

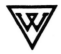

U.S. Trade Mark Patent No. 9,949, January 9, 1883 for sterling silverware.

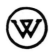

U.S. Trade Mark Patent No. 9,950, January 9, 1883 for electroplated wares.

WILTON BRASS FOUNDRY
Columbia, Pennsylvania

Manufacturers of articles that are "handcast in sand, hand-polished. The beauty and weight of pewter...(made of) a secret fusion of 10 metals..."

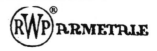

WINDSOR SILVER CO., INC.
Brooklyn, New York

Listed 1966-1973 JC-K under sterling and plated holloware. No reply to 1975 inquiry.

WINNIPEG SILVER PLATE CO., LTD.
Winnipeg, Manitoba

Listed JC 1915-1922 in plated silver section.

WOLF & KNELL
New York, New York

Manufacturers and importers c. 1900 of antique silver in Dutch, French and English designs. Decanters, tea and coffee sets, vases, spoons, tea strainers, etc. O. Buchholz, U.S. and Canadian representative. Factory at Hanau, Germany.

WOLFENDEN SILVER COMPANY
North Attleboro, Massachusetts
See Crown Silver, Inc.

Successor to J.W. Wolfenden Corp. Founded in 1919 by John W. Wolfenden and now (1975) a Division of Crown Silver Inc., New York. Dies and equipment were moved to the Crown factory in New York in 1955.

(Used since May 24, 1949)

A. & W. WOOD
New York, New York
See Coles & Reynolds

Abraham and William Wood operated a solid silverware manufacturing business in New York City between 1849 and 1871. Abraham Wood was involved in the silver business prior to that time, possibly in partnership with Peter Van Ness (q.v.) as on March 21, 1848 he and Van Ness were granted Design Patent Number 170 for a flatware pattern they had developed together.

Soeffing (*Silver*, July-Aug. 1990, p. 11) attributes a medallion flatware pattern, showing a bust of a woman with ringlets, to A. & W. Wood. The firm produced a variety of other flatware patterns as well.

Succeeded by Coles & Reynolds about 1872.

MRS. SARAH B. DICKINSON WOOD
Niagara Falls, New York

The House of Dickinson, well-known jewelry firm of Buffalo was founded by Thomas V. Dickinson in 1849. Associated with him were his wife, Elizabeth, and later his son, Alfred; his grandson, Alfred. Now (1975) the great grandson Alfred Dickinson is in charge of the business.

The founder was granted a trade mark patent on July 21, 1891 for the manufacture of silver, flat and tableware, using the buffalo head trademark that his daughter (later Mrs. Sarah B. Dickinson Wood) used on souvenir silverware. According to Alfred III, they have no records that the Dickinsons actually manufactured these items themselves. They were probably made for them by one of the many companies who did this sort of work and stamped it with the trademark of the wholesaler or retailer.

WOOD & BROTHER
New York, New York
See Roshore & Ketcham

Firm established about 1854 by Brewster Wood, Jr., and his brother, William J. Wood. Brewster Wood, Jr., had been manufacturing thimbles in partnership with John Roshore in the silver manufacturing center located a 4 Liberty Place since about 1850.

William J. Wood had been manufacturing gold pens at 16 Maiden Lane.

According to an ad in the New York City directory published in 1855, the new firm produced gold and silver pen and pencil cases, gold pens, lockets, thimbles etc. The brothers continued in partnership until about 1858. At that point Brewster Wood, Jr., continued with the production of small silver items, advertising "lockets" as his business in the directories. William J. Wood went into the jewelry business. Brewster Wood, Jr., is last found in the directory published in 1861. William J. Wood is last found in the directory published in 1859.

WOOD & HUGHES
New York, New York
See Gorham Corporation
See Graff, Washbourne & Dunn

CHRONOLOGY
Gale, Wood & Hughes	1833-1845
Wood & Hughes	1845-1899

In 1833 William Gale, Sr., formed a partnership with Jacob Wood and Jasper H. Hughes, under the name Gale, Wood & Hughes. Wood and Hughes had both served apprenticeships under Gale. In 1845 they left to form their own company.

Jacob Wood and Jasper H. Hughes remained in the partnership until Jacob Wood's death in 1850. Stephen T. Fraprie who had previously been employed by the firm, entered into partnership in 1850. Jasper H. Hughes retired in 1856.

Various other members of the Wood and Hughes families were admitted into partnership over the years. Soeffing (in Venable's *Silver in America*, 1994, biographical section, p. 324) indicates Charles Wood, brother of Jacob,was admitted prior to 1863; Henry Wood, brother of Jacob,was admitted 1863; Charles H. Hughes was admitted prior to 1863; and Dixon G. Hughes, son of Jasper W. Hughes, was admitted 1864. Charles Wood died in 1881, Charles H. Wood in 1883 and S.T. Fraprie in 1889.

The company manufactured a full line of solid silver tableware, with a particularly wide selection of ornamental flatware.

Loss of its southern accounts as an initial result of the Civil War posed a severe financial threat to the firm. However the subsequent northern economic boom enabled it both to recover and to prosper.

In the 1860s and 1870s Charles F. Richers designed and patented many flatware patterns for the company. Charles Witteck also worked for Wood & Hughes following the dissolution of the Biederhase firm (q.v.).

A disastrous fire in 1891 resulted in the loss of records, models and patterns. The company never fully recovered from this blow, and by 1899 the partners determined to sell out.

Mr. Frost of the retail firm Black, Starr & Frost, persuaded Clarence A. Dunn with his friends,Charles Graff and William L. Washbourne to buy out Wood and Hughes. Black Starr & Frost wanted to develop a special relationship with a quality silverware manufacturer. Graff, Washbourne & Dunn (q.v.) filled that role admirably. (Soeffing, ibid.)

Mark on the left is from a beaker dated c. 1840-1850 advertised in *Silver*, July - Aug. 1990, p. 2.

(*Used* 1833 *to* 1871.)

 WωH.
(*Used since* 1871.)

N.G. WOOD & SONS
Boston, Massachusetts

Registered trademark U.S. Patent Office, No. 20,515, December 29, 1891 for spoons, gold, silver and plated.

Listed JC 1896-1922 in sterling silver section. The trademark illustrated was for souvenir spoons made to commemorate the Boston Tea Party and was discontinued before 1922.

WOODBURY PEWTERERS
Woodbury, Connecticut

Founded in 1952 by R.C. Holbrook and L.R. Titcomb when they acquired the tools, etc. of the Merwin & Wilson Co., New Milford, Connecticut and the Danforth Pewter Co., Woodbury, Connecticut and used them as the nucleus for developing a product line of early American pewter reproductions, later expanded to include a separate line for the Henry Ford Museum.

The ATC Hallmark on Pewter indicates that the finest quality metal has been used in its manufacture. The Hallmark guarantees that the metal contains only tin, and very small percentages of copper and antimony, as hardening agents. It is the quality mark of Pewter!

(Under each mark)

WOODMAN-COOK CO.
Portland, Maine
See Stevens Silver Co.

Began as Stevens & Smart 1879-1883. Manufacturers of britannia ware. Became Stevens, Smart & Dunham 1884-1886; Stevens & Smart, 1887-1890; Stevens, Woodman and Company, 1891-1892 and Woodman-Cook Company 1893-1914. Manufacturers of plated silverwares. Edward B. Coon, president; C.H. Fessenden, vice-president; Fred H. Woodman, treasurer.

"Fred H. Woodman, of Woodman-Cook Co. Born Palmyra, Maine, December 28, 1855. At the age of 18 taught school and soon after he was engaged in the business department of a cotton mill. Later he bought an interest in the business of Stevens & Smart, manufacturers of silver plated ware, Portland. The business was founded in 1878 by Rufus (?) Dunham, who had been making Britannia ware since 1837. Later the firm became Stevens, Woodman & Co. and finally it was incorporated as Woodman-Cook Co." (JC&HR 3-1-1897, p. 19)

WALDORF SILVER CO.

STEPHEN WOODS
Newark, New Jersey
See Woods & Chatellier

RICHARD M. WOODS & CO.
New York, New York

Successor to Woodside Sterling Company in the mid to late 1920s. Makers of sterling silver holloware, dresserware and novelties. Around 1940 also listed as wholesalers.

WOODS & CHATELLIER
New York, New York

Successor to Stephen Woods before 1904. Manufacturers of sterling cases, novelties, boxes and jewelry. Listed JC 1904-1922 and KJI 1922 and 1924.

WOODS, SHERWOOD & CO.
Lowell, Massachusetts

The dates that this business was in operation are not precisely known, but between 1867 and 1874 the firm obtained numerous invention and design patents for objects fashioned out of twisted wire and then plated. In 1884 two more such patents were obtained. The objects were basically similar in form and function to pieces made in a more conventional manner in solid silver and silverplate, except for their openwork construction.

Pieces patented included a variety of breakfast and table casters, a pickle caster stand, fruit and cake baskets, a toilet stand, a card basket, a napkin ring and a matcholder. These items were designed primarily by E. P. Woods, Daniel Sherwood, George D. Dudley and Cyrus H. Latham. Horace C. Wilcox of the Meriden Britannia Co. also designed a dish stand for the firm.

Examples of these wire work pieces apparently were not marked on the frames. However, some, at least, of the caster bottles have "W S & Co" embossed on their bases.

WOODSIDE STERLING CO.
See Richard M. Wood & Co.

Listed 1896 Jewelers' Weekly. Listed 1904 JC. Listed in KJI 1922 and 1924 as manufacturers of sterling silver holloware, toiletware and novelties. Succeeded by Richard M. Woods & Co. in the mid to late 1920s.

JAMES T. WOOLLEY
Boston, Massachusetts

James T. Woolley was born in Providence, Rhode Island in 1864. He learned the silversmithing craft in The Gorham Company. For eighteen years he was foreman at Goodnow & Jenks (q.v.) in Boston. For two years he shared bench room with George J. Hunt at 79 Chestnut St. though they worked independently. Around 1908 he opened his own shop in the Studio Building in adjacent Lime Street. Many of his pieces are excellent adaptations of colonial silver.

WORDEN-MUNNIS CO., INC.
Boston, Massachusetts

Silversmiths and goldsmiths, founded in 1940. Makers of early American, English and Irish reproductions. The company was purchased in 1964 by Old Newbury Crafters who are producing the sterling holloware line. (1975)

WORLD HAND FORGED MFG. CO.
New York, New York

Manufacturers of silverplated wares c. 1950.

THE WORLD SILVER PLATE CO.
Location unknown

Manufacturer of silverplate holloware circa 1880. Mark found on a pickle caster frame of that date.

WORLD TABLEWARE INTERNATIONAL
Wallingford, Connecticut
See American Silver Company

In 1972 the Hotel Division of International Silver Company became a subsidiary of that company under the name of World Tableware International. This, in turn, was sold to two employees and private investors on October 1, 1983. They organized a new American Silver Company of which World Tableware International was a subsidiary. Their products were flatware and holloware in both silverplate and stainless steel, for hotels, restaurants, clubs, ships, institutions and other types of public dining.

The company grew substantially through the acquisition of two competitors, Brandware in 1988 and Host in 1990. In addition to flatware it also manufactured and imported china and other tabletop and food service accessory items.

In 1991 World Tableware International's parent company, Amsilco, established a joint venture with a firm called Vitrocrisa (Crissa Glassware) in Mexico, a division of Vitro S.A. Each firm agreed to purchase a 49 percent share of the other's flatware operations. The Mexican company's flatware subsidiary, Vitrocrisa Cubiertos S.A. operates the largest flatware factory in Mexico. (Zebora, *Meriden Record-Journal,* 7-25-91)

In 1995 Crissa purchased the remaining 51% of World Tableware International, and the name of the company was changed to WorldCrissa Corporation. It became a wholly owned subsidiary of the Crissa Glassware Division of Vitro, S.A. of Monterrey, Mexico. Crissa also owns Crissa Corporation in Dallas, Texas, which handles retail sales of the firm's glassware. There is a possibility that the new company's flatware, holloware and dinnerware may be retailed by this firm also. Raoul Herrero is the CEO of both Crissa and WorldCrissa.

World Tableware International Trademarks

World Tableware International Trademarks
International® Stainless (Flatware & Holloware)
International® Silverplate (Flatware & Holloware)
International® Silver Co. (Nickel Silverplated Holloware)
Victor S. Company (Nickel Silverplated Holloware)
World® Stainless (Flatware & Holloware)

INTERNATIONAL

"King George" International Silverplate by World Tableware. Their products are distributed only in the food service industry. (Photo courtesy of World Tableware International)

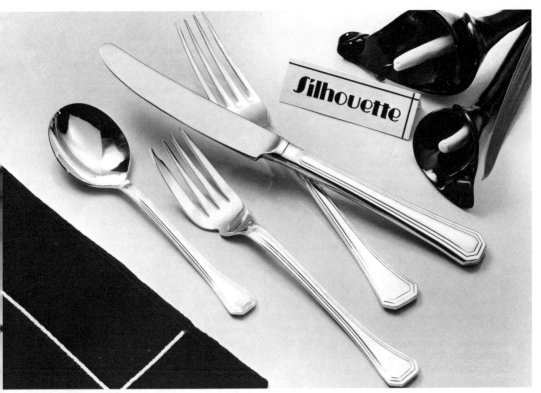

Above: *"Silhouette" International Silverplate by World Tableware. Their products are distributed in the food service inductry. (Photo courtesy of World Tableware International)*
Below: *Extra heavy hotel plate by World Tableware International. (Photo courtesy of World Tableware International)*

WORTZ & VOORHIS
New York, New York

Listed in JC 1896 in sterling silver section. Out of business before 1915.

Trademark identical to D. C. Bourquin

WÜRTTEMBERGISCHE METALLWARENFABRIK (WMF)
Geislingen, Germany

The firm traces its origins back to Daniel Straub, who was born in Geislingen in 1815. Having an interest in mechanical engineering, and being the son of a miller, his first efforts went toward improving the machinery at the mill. When a railroad was built through town in 1847, Straub not only invested in the scheme, but set up a workshop to repair the railway construction equipment. The success of this venture led him to establish an engineering works and iron foundry in 1850.

In 1853 he entered into partnership with Friedrich & Louis Schweitzer, forming the firm of Straub and Schweitzer to manufacture metal goods. By 1856 the firm was producing a variety of household articles. These items were manufactured out of either Sheffield Plate or copper patinated to look like bronze. The Sheffield plate items included both tableware and dresserware. In addition the firm produced a wide variety of cutlery.

The company took part in the International Exhibition in London in 1862 where it won a Prize Medal.

In 1866 the Schweitzer brothers withdrew from the firm, and it became known as Straub & Son. In 1868 the company opened a showroom in Berlin. It soon established others in major German Cities and foreign capitals. The business had grown to employ more than 100 workers. However, with the exception of simple equipment like lathes and rolling mills, the company relied heavily on manual labor.

Electroplated flatware was introduced to Europe at the 1867 Paris Exposition. Carl Haegele, working for Wieland & Co. in Ulm, developed a viable electroplating workshop for that firm. Then he and his brother-in-law, Alfred Ritter, formed A. Ritter & Co. in 1871 to manufacture electroplated goods, and moved the business to Esslingen the following year. The Ritter firm soon mechanized its manufacturing processes. It added a metal buffing shop in 1875

and its own britannia foundry in 1877. It earned prize medals at expositions in Vienna in 1873 and Munich in 1876, as well as at the 1876 Philadelphia Centennial Exhibition.

By 1880 it was apparent that A. Ritter & Co. needed room to expand, and Straub & Son needed to mechanize. A merger was arranged between the two firms, and the new company, named the "Wurttemburgische Metallwarenfabrik" was established at the site of the Straub works in Geislingen. The new firm worked hard to improve its electroplating process and to expand its markets. Daniel Straub retired as director of the company in 1881 and was succeeded by Carl Haegele.

In subsequent years the company expanded its focus. It established its own glassworks in 1883 to provide glass liners and other components for its products. It acquired an electrotyping firm in 1889, and became a leader in that field as well. One major commission was producing copies of antique solid siver pieces in the German Emperor's collection which were displayed at the St. Louis Exposition in 1904. Schauffler & Safft, a nickel plating factory, was acquired in 1897. By 1900 the company was printing its catalogs on its own presses in three different languages.

In 1905 the company acquired Orvit AG, a firm known for its Art-Nouveau pewter wares, and a major competitor of J.P. Kayser Sohn, makers of "Kayserzinn."

By 1914 the company employed 3500 workers and had shops in 24 cities in Germany. However World War I sharply curtailed the firm's business. Hugo Debach, who took over management of the firm in 1927 made it again a major producer of utilitarian and artistic glass and metal-ware.

Because the ostrich was the Straub family's heraldic animal, it was incorporated into the company's trade mark when Straub & Son combined with A. Ritter & Co. to form the Wurttembergische Metallwarenfabrik. (Dry, 1988 pp.ix-xxii; marks pp.xlvii-xlviii)

2013

WYMBLE MFG CO.
Newark, New Jersey

About 1886 a new method of depositing silver on non-metallic articles was discovered. Among the companies founded for the purpose of decorating articles by this process was the Wymble Mfg. Co. organized in September 1890. Justus Verschuur, artist and designer, was one of the founders. The firm set up a handsome and extensive display of its wares in the American jewelry and silverware exhibit at the World's Columbian Exposition held in Chicago in 1893-94. The company went into receivership in March 1895 and the Alvin Mfg. Co. purchased the entire stock and fixtures.

ϒ

YALE & CURTIS
New York, New York
See Curtis & Co.
See Shields & Casey

Partnership of Henry A. Yale and Stephen Curtis, Jr. in business at least as early as 1852. Manufacturers of britanniaware. In the late 1850s and early 1860s the firm is also listed in the New York City directories as dealing in lamps and metals. The 1866 listing for the company describes the business as dealing in plated ware. Succeeded by Curtis & Co. by 1867.

YORK SILVER CO.
New York, New York

Listed 1950 JC-K under sterling

PAT JANE

HIRAM YOUNG
New York, New York
See Manhattan Plate Co.,
See Henry C. Reed Jr. & Co.

CHRONOLOGY
Hiram Young	1856-1866
Hiram Young & Co.	1867
Hiram Young & Reed	1868-1869
Manhattan Plate Co.	1870-1871

Hiram Young appears in the New York City Directories in the early 1850s listed simply as an importer. In 1856 he established the Manhattan Plate Co. to manufacture his own private brand of silverplate, "Manhattan Plate." His business remained in his own name. A typical ad, from the New York Times, December 19, 1864, lists "Fine Plated Ware, Manufactured by the Manhattan Plate Company, Tea sets, urns, casters, wine casters, soup tureens, vegetable dishes &c. &c. In great variety. Hiram Young, No. 20 John St."

On May 7, 1861, Hiram Young received Design Patent No. 1,419 for a recessed style lid for teapots.

On January 3, 1865 he received Invention Patent No. 45,787 for a coffee pot that had a number of features similar to a modern percolator.

In 1868 he entered into a partnership with Henry C. Reed Jr. The firm name became Hiram Young and Reed. An ad from the New York City directory for 1869 indicates that the company's trade mark remained "Manhattan Plate Company."

The earlier report that the Reed who was in partnership with Hiram Young was Henry G. Reed of Reed and Barton is incorrect. Henry C. Reed Jr. and Henry G. Reed are listed separately in the New York City directories and have very different addresses. They are clearly not one and the same.

Billhead for Hiram Young showing his coffee percolator for which he received Invention Patent No. 45,787 on January 3, 1865. Courtesy Stephen N. Dennis.

Reed left the partnership in 1870. The firm was incorporated in that year as the Manhattan Plate Co. with Hiram Young as president. Young disappears from the New York City directories in 1872.

OTTO YOUNG & COMPANY
Chicago, Illinois

Established in 1865. Importers, manufacturers and wholesalers of all types of silverware and jewelers' merchandise.

Successors in 1880 to William B. Clapp, Young & Co.

An illustrated catalog of 1893 (courtesy of the Whittelsey Fund, Metropolitan Museum of Art) depicts silverware, jewelry, optical goods, clocks and watches.

Succeeded by A.C. Becken Co.by 1922.

C. H. ZIMMERMAN & COMPANY
New Orleans, Louisiana

Silverware manufacturers listed in New Orleans City Directory 1871.

J.A. ZANG
Location unknown

Mark found on a silverplated, twist handled butterknife dated circa 1890s.

ZELL BROS.
Portland, Oregon

Listed in 1950 JC-K under sterling. They advertise Reed & Barton collector's limited edition Damascene plates. These are made of sterling or silverplate.

UNASCRIBED MARKS

 STERLING

 STERLING

SILVER ON COPPER

 Rosebud STERLING

SILVER PLATED
JF
TRADE MARK

STERLING
WEIGHTED

HSTERLING

STERLING

STERLING

TRENT

SILVER ON COPPER

Quadruple Plate underneath. Location unknown.

Patent
Sterling
W. MOIR

Found on a Victorian pattern dessert set of flatware. Location unknown.

TRIPLE PLATE
R.B.&Co
SHELTON CT

RANDALL, HALL, & CO.

SHEFFIELD PLATE CO.

STERLING PLATE

PITTSBURGH
PLATE CO
TRIPLE PLATE.

QUADRUPLE PLATE
"TRIO"
SILVER CO.
408

HAMILTON
STERLING
WEIGHTED

W. S. CO.
WARRANTED
QUADRUPLE PLATE

EXTRA PLATE

S&B
STERLING

Silver on Copper

AMERICAN SOUVENIR CO. PAT.

B.G. UHER SILVER CO.
QUADRUPLE

E.P. EVANS U.S.

GUILD HOUSE
E.P. COPPER

BUCKINGHAM
X X X
HEAVY SILVER PLATE

EPNS
W.M. MOUNT'S

QUALITY

B&G
OLD ENGLISH
REPROD.

COPPER
LEAD MOUNTS

SILVER PLATED

LVERWARE
S.P.
PRODUCTS
165
44

ALPHABETICAL LISTING OF TRADE NAMES

A.1. NIKEL SILVER No. 210 ... ONEIDA
ACORN BRAND .. ALBERT PICK & CO.
ADAMS SILVER PLATE CO. ... R. WALLACE & SONS.
AETNA WORKS ... LANDERS, FRARY & CLARK
ALASKA METAL.. SEARS ROEBUCK & CO.
ALBANY SILVER PLATE ... INSILCO
ALDEN... DERBY SILVER CO.
ALPHA PLATE .. ONEIDA
ALUMINUM SILVER ... DANIEL & ARTER
AMERICAN BEAUTY .. WM. B. KERR & CO.
AMERICAN CLASSIC ... EASTERLING CO.
AMERICAN SILVER CO. .. INSILCO
AMERICAN SILVER PLATE CO. ... NORTHAMPTON CUTLERY CO.
AMERICAN SILVER PLATE CO. ... SIMPSON, HALL, MILLER & CO.
AMSILCO ... INSILCO
ANDOVER SILVER PLATE CO .. R. WALLACE & SONS
APOLLO .. BERNARD RICE'S SONS
ARGENLINE ... DANIEL & ARTER
ARMETALE ... WILTON BRASS FOUNDRY
ARROW PLATE ...GLASTONBURY SILVER CO.
A S .. AMITY SILVER INC.
A.S. CO. ... AMERICAN SILVER CO.
ATLANTIC SILVER PLATE CO. .. RUEFF BROS.
ATLAS SILVER PLATE .. INSILCO
AUTHENTIC STERLING .. GORHAM
AVON (on sterling) .. WEIDLICH BROS MFG. CO.
AVON SILVER PLATE .. INSILCO
AZTEC COIN METAL .. HOLMES & EDWARDS CO.
BALTCO ... BALTES-CHANCE CO.
B.B. & CO. .. BARDEN BLAKE & CO.
BANQUET PLATE ... GORHAM
B. C. S. CO. .. QUEEN CITY SILVER CO.
BEACON SILVER CO. ... AMERICAN SILVER CO.
BEACON SILVER CO. ... F.B. ROGERS SILVER CO.
BEAU STERLING ... BEAUCRAFT, INC.
BEAUXARDT ... BERNARD RICE'S SONS
BEN (small capitals: E placed over N) .. BENJAMIN F. LOWELL
BENGAL SILVER ... DANIEL & ARTER
BERKELEY .. BENEDICT MFG. CO.
BLISS ... NAPIER CO.
BONTON B SILVERPLATE ..L.D. BLOCH & CO.
BRAZIL SILVER ... WEINMAN CO.
BREWSTER ... INSILCO
BRIDGE ... SHAPLEIGH HARDWARE CO.
BRISTOL CUTLERY CO. ... AMERICAN SILVER CO.
BRISTOL PLATE CO. ... PAIRPOINT MFG. CO.
BRISTOL SILVER CORP. ... POOLE SILVER CO.
BRITANNIA ARTISTIC SILVER ... M.T. GOLDSMITH
BRITANNIA METAL CO. ... VAN BERGH SILVER PLATE CO.

BROOKLYN PLATE CO.	H. M. SCHADE & CO.
BROOKLYN S. P. CO.	E.G. WEBSTER & SONS
B.R.S. CO. SHEFFIELD, U.S.A.	BERNARD RICE'S SONS
B.S. CO.	BIRMINGHAM SILVER CO.
B.S. CO.	HOLMES & EDWARDS SILVER CO.
BS CO.	INSILCO
BURMAROID	DANIEL & ARTER
BUSTER BROWN	WM. A. ROGERS CO., LTD.
CAMBRIDGE SILVER PLATE	SEARS ROEBUCK & CO.
CAMELIA SILVERPLATE	INSILCO
CARAVELLE	SUMMIT SILVER CO.
CARBON	L.F. DUNN
CARBON	ONEIDA
CARLTON SILVERPLATE	ONEIDA
CARVEL HALL	CHAS. D. BRIDELL, INC.
CARV-EZE	INSILCO
C. B. M. C.	J. H. JOHNSTON & CO.
THE CELLAR SHOPS	RAYMOND BRENNER
CENTURY STERLING	INSILCO
CHASE	MAX H. STORCH
CHATSWORTH	R.H. MACY & CO.
CHICAGO SILVER PLATE CO.	ELGIN-AMERICAN MFG. CO.
CHIPPENDALE	BENEDICT MFG. CO.
COIN SILVER METAL	NIAGARA SILVER CO.
COLONIAL PLATE CO.	MELROSE SILVER CO.
COLUMBIA	MIDDLETOWN PLATE CO.
COLUMBIAN SILVER CO.	QUEEN CITY SILVER CO.
COMMONWEALTH	INTERNATIONAL-COMMONWEALTH SILVER CO.
COMMUNITY	ONEIDA
COMMUNITY PLATE	ONEIDA
CONNECTICUT PLATE CO.	ADELPHI SILVER PLATE CO.
CONNECTICUT PLATE CO.	J.W. JOHNSON
CORNWALL E. P. N. S.	MIDDLETOWN SILVER CO.
COURT SILVER PLATE	INSILCO
COVENANT	QUEEN CITY SILVER CO.
C. P. F.	J. H. JOHNSTON & CO
CRESCENT SILVER CO.	ALBERT G. FINN SILVER CO.
CROMWELL	WM. B. DURGIN CO.
CROSBY	A. COHEN & SONS
CROWN GUILD	ROCKFORD SILVER PLATE CO.
CROWN GUILD	JEWELERS' CROWN GUILD
CROWN PRINCE	G.I. MIX & CO.
CROWN PLATE CO.	STANDARD SILVERWARE COMPANY
CROWN SILVER CO.	AMERICAN SILVER CO.
CROWN SILVER CO.	INSILCO
CROWN SILVER PLATE CO.	AMERICAN SILVER CO.
CUNNINGHAM SILVER PLATE CO.	WM. ROGERS MFG. CO.
CUVEE	QUAKER VALLEY MFG. CO.
DEBUTANTE	MANDALIAN MFG. CO.
DEEP SILVER	INSILCO
DEERFIELD SILVER PLATE	INSILCO
DEKRA	ARGENTUM SILVER CO.
DEPOS-ART	CANADIAN JEWELERS
DIAMOND EDGE	SHAPLEIGH HARDWARE CO.
DIAMOND MESH	STRATHMORE CO.
DISCOVERY	WM. B. DURGIN CO.
DISTINCTION	HOME DECORATORS
DORANTIQUE	BERNARD RICE'S SONS
DOUBLE-TESTED SILVERPLATE	NATIONAL SILVER CO.

DU BARRY	NAPIER COMPANY
DUCHESS PLATE 1891	RODEN BROS, LTD.
DUCIMUS	C.E. BARKER MFG. CO.
DUNGEON ROCK	H.M. HILL & CO.
DUPLICATE WEDDING PRESENTS	J.H. JOHNSTON & CO.
DUNKIRK	GOLD RECOVERY & REFINING CORP.
DURO PLATE	ONEIDA
DUTCH SILVER NOVELTIES	JOHNSON, HAYWARD & PIPER CO.
DUTCHARDT	BERNARD RICE'S SONS
E A (picture of a bee) CO	E. A. BLISS CO.
EAGLE BRAND	SIMPSON, HALL, MILLER & CO.
EAGLE CUTLERY CO.	WM. A. ROGERS
EAMCO	ELECTROLYTIC ART METAL CO.
EASTERN SILVER CO.	AMERICAN SILVER CO.
EASTERN SILVER CO.	INSILCO
1847 ROGERS BROS.	INSILCO
1847 ROGERS BROS.	MERIDEN BRITANNIA CO.
1847 ROGERS BROS. STERLING	INSILCO
1857 WELCH-ATKINS	AMERICAN SILVER CO.
1857 WELCH-ATKINS	BRISTOL BRASS & CLOCK CO.
1857 "WORLD BRAND"	AMERICAN SILVER CO.
1865 WM. ROGERS MFG. CO.	INSILCO
E & J B	E. & J. BASS
ELKE	PREMIER CUTLERY INC.
ELMWOOD PLATE	GORHAM
EMBASSY SILVER PLATE	INSILCO
EMPIRE ART SILVER	E. & J. BASS
EMPIRE SILVER COMPANY	BENEDICT MFG. CO.
EMPRESS	SUMMIT SILVER, INC.
EMPRESS WARE	NEW YORK STAMPING CO.
ENGLISH SILVER	SIMPSON-BRAINERD CO.
ENGLISH STERLING	TIFFANY & CO.
ESCO	ELGIN SILVERSMITH CO., INC.
ESSEX SILVER CO.	WALLACE BROS.
ESSEX SILVER CO.	WALLINGFORD CO.
ESSEX SILVER PLATE CO.	WALLINGFORD CO.
ETCHARDT	BERNARD RICE'S SONS
EUREKA SILVER PLATE CO.	MERIDEN SILVER PLATE CO.
EVERWEAR	ALBERT PICK & CO.
EVOLUTION	NAPIER COMPANY
EXTRA (COIN SILVER # 12) PLATE	CARTER-CRUME CO.
EXTRA (COIN SILVER) PLATE	NIAGARA SILVER CO.
EXTRA (COIN SILVER NO. 12) PLATE	NIAGARA SILVER CO.
E-Z (in "lazy S") OPE	SCHARLING & CO.
FAIRFAX	WM. B. DURGIN CO.
FASHION PLATE	SEARS ROEBUCK & CO.
FASHION SILVER PLATE	SEARS ROEBUCK & CO.
F. N. & CO.	MAJESTIC MFG. CO.
FORMALITY	SILVER COUNSELORS OF HOME DECORATORS, INC.
FORTUNE SILVER PLATE	R. WALLACE & SONS MFG. CO.
FVFR DRY	WEIDLICH BROS. MFG. CO.
GATE HOUSE STERLING	HOME DECORATORS, INC.
GEE-ESCO	GLASTONBURY SILVER CO.
GEM SILVER CO.	INSILCO
GEORGIAN	BENEDICT MFG. CO.
GERMAN SILVER	HOLMES & EDWARDS
GERMAN SILVER (on mesh bags)	BRISTOL MFG. CO.
GMCO E. P.	GORHAM CORP

GOLD ALUMINUM	HOLMES & EDWARDS
GOLDEYE	J.T. INMAN & CO.
GOLDYN-BRONZ	REED & BARTON
GOLDEN WHEEL	REIBLING-LEWIS, INC.
GONDOLA SILVER	CALBERT MFG. CO.
GOPHER BRAND	F.L. BOSWORTH CO.
GRIFFON	A.L. SILVERSTEIN
GUILDCRAFT	NATIONAL SILVER CO.
HAMILTON	ROGERS & HAMILTON
HAMPSHIRE HOUSE	MURRAY L. SCHACTER & CO.
HAR-MAC	HARPER & MACINTIRE CO.
HARMONY HOUSE PLATE AA +	SEARS ROEBUCK & CO.
HARMONY HOUSE PLATE	SEARS ROEBUCK & CO.
HARVEST	ELLMORE SILVER CO.
HAVONE	ELGIN-AMERICAN MFG. CO.
H.B. & H. A1	HOLMES, BOOTH & HAYDENS
HEIRLOOM	CANADIAN WM. A. ROGERS CO. LTD.
HEIRLOOM	ONEIDA
HEIRLOOM	WM. A. ROGERS
HEIRLOOM	FRANK N. OSBORN
HEIRLOOM PLATE	ONEIDA
HEIRLOOM STERLING	ONEIDA
HEIRESS	MODERN SILVER MFG. CO. INC.
HESCO	HOLMES & EDWARDS SILVER CO.
HICKS SILVER CO.	A.R. JUSTICE CO.
HOLD-EDGE	INSILCO
HOLMES	RAND & CRANE
HOLMES & EDWARDS	INSILCO
HOLMES & TUTTLE	INSILCO
HOPE SILVER CO.	GEO. W. PARKS CO.
HOPEWELL SILVER CO.	REED & BARTON
H. & S.	A.B. SCHREUDER
H. & S.	THORNTON & CO.
H. & T. MFG. CO.	AMERICAN SILVER CO.
H. & T. MFG. CO.	BRISTOL BRASS & CLOCK CO.
H. & T. MFG. CO.	INSILCO
J. A. HOMMEDIEU	J. A. L'HOUMMEDIEU
IMPERIAL PLATE	NATIONAL SILVER CO.
IMPERIAL SILVER PLATE CO.	A.F. SMITH CO.
IMSICO PEWTER	DERBY SILVER CO.
INAUGURAL	SILVER COUNSELORS OF HOME DECORATORS, INC.
INDEPENDENCE BRAND	AMERICAN SILVER CO.
INDEPENDENCE TRIPLE	INSILCO
INDESTRUCTO	BENEDICT MFG. CO.
INDIANA BRAND	ANCHOR SILVER PLATE CO.
INDIAN SILVER	DANIEL & ARTER
INLAID	HOLMES & EDWARDS SILVER CO.
INLAID	INSILCO
INSICO	INSILCO
INTERNATIONAL	INSILCO
INTERNATIONAL	WORLD TABLEWARE INTERNATIONAL
INTERNATIONAL SILVER CO.	INSILCO
I.S.C.O.	INSILCO
I.S. CO.	INSILCO
JAPANESE SILVER	DANIEL & ARTER
J (CROWN) G	ROCKFORD SILVER PLATE CO.
J. C. M.	TIFFANY & CO.
J. D. - N. Y.	MAJESTIC MFG. CO.

JOR	RANDAHL SHOP
J. ROGERS & CO.	ONEIDA
JUST ANDERSON	MANDIX CO.
J. W. NICKLE SILVER	JOHN WANAMAKER
JOHN TOOTHILL	METROPOLITAN SILVER CO.
KENSICO	INSILCO
KENSINGTON SILVER PLATE	INSILCO
KIRBYKRAFT	MIDDLETOWN SILVER CO.
KRANSHIRE	A. COHEN & SONS
L. & A.	WM. LINK CO.
L'AIGLON	BERNARD RICE'S SONS
LADY BERKSHIRE	NATIONAL SILVER CO.
LAKESIDE BRAND	MONTGOMERY WARD & CO.
LA MILITAIRE	HARRY S. RAINS
LA PIERRE	INSILCO
LASHAR	INSILCO
L. A. W.	WM. LINK CO.
LAXEY SILVER	DANIEL & ARTER
LESCO	LEVINE SILVERSMITH CO.
LEVIATHAN	S.J. LEVI & CO.
LIFETIME	ROMAN SILVERSMITHS, INC.
LIFETIME	ZELL BROS.
LITTLE MEN & LITTLE WOMEN	ROGERS, LUNT & BOWLEN CO.
LONGCRAFT	THOMAS LONG CO.
LORALINE	BERNARD RICE'S SONS
LORD BERKSHIRE	NATIONAL SILVER CO.
L. STERLING	THE LENAU CO.
LULLABY STERLING	ALVIN
LUNA METAL	ROWLEY MFG. CO.
LUXOR PLATE	R. WALLACE & SONS MFG. CO.
LYONS SILVER CO.	MANHATTAN SILVER PLATE CO.
MALACCA PLATED	G. I. MIX & CO.
MANOR PLATE	INSILCO
MARIE LOUISE	R. BLACKINTON
MARION PEWTER	BERNARD RICE'S SONS
MARION PLATE CO.	BERNARD RICE'S SONS
MARION SILVERPLATE	INSILCO
MARTELÉ	GORHAM CORP.
MAYCREST	MAY DEPT. STORE CO.
MAYFLOWER	WEIDLICH BROS. MFG. CO.
M & B STERLING	DERBY SILVER CO.
MEDFORD CUTLERY CO.	A.R. JUSTICE CO.
MEDFORD SILVER CO.	R. WALLACE & SONS MFG. CO.
MEDFORD E. P. W. M.	R. WALLACE & SONS MFG. CO.
MEDFORD E. P. N. S.	R. WALLACE & SONS MFG. CO.
MELODY SILVER PLATE	INSILCO
MEXICAN CRAIG	HOLMES & EDWARDS SILVER CO.
MEXICAN SILVER	HOLMES & EDWARDS SILVER CO.
MIDDLESEX SILVER CO.	MIDDLETOWN SILVER CO.
MIDSILCRAFT	MIDDLETOWN SILVER CO.
MILDRED QUALITY SILVER PLATE	NATIONAL SILVER CO.
M. M. CO.	MACOMBER MFG. CO.
MONARCH SILVER CO.	STANDARD SILVER CO., TORONTO, LTD.
MONARCH SILVER CO.	KNICKERBOCKER SILVER CO.
MONARCH SILVER CO.	NATIONAL SILVER CO.
MOREWEAR PLATE	MAUTNER MFG. CO.
MONTAUK SILVER CO.	J. W. JOHNSON
MULTISILVER	E.H.H. SMITH SILVER CO.

NACO	NAPIER COMPANY
NARRAGANSETT PEWTER	QUAKER SILVER CO.
NASCO	NATIONAL SILVER CO.
NASTRAUS	NATHAN STRAUS-DUPARQUET INC.
NATIONAL CUTLERY CO.	ROCKFORD SILVER PLATE CO.
N. & D. O.	N. & D. ONDERDONK
N. E. S. P. CO.	INSILCO
NEVADA SILVER	DANIEL & ARTER
NEVADA SILVER METAL	DANIEL & ARTER
NEVADA SILVER METAL	STANDARD SILVERWARE CO.
NEW AMSTERDAM SILVER CO.	KNICKERBOCKER SILVER CO.
NEW ENGLAND CUTLERY CO.	AMERICAN SILVER CO.
NEW ENGLAND SILVER PLATE	AMERICAN SILVER CO.
NEW ENGLAND SILVER PLATE	INSILCO
NEW ENGLAND SILVER PLATE CO.	ADELPHI SILVER PLATE CO.
NEW ENGLAND SILVER PLATE CO.	BRISTOL BRASS & CLOCK CO.
NEWFIELD SILVER COMPANY	BRIDGEPORT SILVER PLATE CO.
NEWPORT STERLING	GORHAM
N. F. NICKEL SILVER CO., 1877	ONEIDA
NIAGARA FALLS CO., 1877	ONEIDA
NIAGARA SILVER CO.	WM. A. ROGERS, LTD.
NICKELITE SILVER	GOLDSMITH'S CO. OF CANADA, LTD.
NOBILITY PLATE	EMPIRE CRAFTS CORP.
NON-CORROSIVE (in a whale)	POPE'S ISLAND MFG. CORP.
NORMAN PLATE	STANLEY & AYLWARD
NORTH AMERICA	JAMES J. DAWSON CO.
NO-TARN	INSILCO
N. S. C.	NATIONAL SILVER CO.
O. C.	ONEIDA
O. C. EXTRA	ONEIDA
O. C. LUSTRA	ONEIDA
O. F. D.	ST. LOUIS METALCRAFTS, INC.
O. F. DINGELDEIN	ST. LOUIS METALCRAFTS, INC.
OHIO SILVER PLATE CO.	QUEEN CITY SILVER CO.
OLD COMPANY PLATE	INSILCO
OLD ENGLISH BRAND, B.	AMERICAN SILVER CO.
ONEIDA	ONEIDA
ONEIDA PAR PLATE	ONEIDA
ONEIDA RELIANCE PLATE	ONEIDA
ONEIDA SILVERPLATE	ONEIDA
ONEIDACRAFT	ONEIDA
ORIENTAL	HOLMES & EDWARDS SILVER CO.
OXFORD CUTLERY CO.	WM. A. ROGERS
OXFORD SILVER PLATE CO.	WM. A. ROGERS LTD.
PALACE BRAND	MONTGOMERY WARD & CO.
PALLADIANT	INSILCO
PALM BEACH	NAPIER COMPANY
PARAGON	SEARS ROEBUCK & CO.
PARAGON EXTRA	SEARS ROEBUCK & CO.
PATRICIA	BERNARD RICE'S SONS
PEQUABUCK MFG. CO.	AMERICAN SILVER CO.
PERFECTA	S.J. LEVI & CO.
PERMA-BRITE	NATIONAL SILVER CO.
PEW TER (in a "lazy S")	SCHARLING & CO.
PICADILLY	H. WIENER & SON
PILGRIM	FRIEDMAN SILVER CO.
PILLSBURY	OLD NEW ENGLAND CRAFTSMAN, INC.
PLETT	TH. MARTHINSEN SOLVVARE-FABRIKK

POMPEIAN GOLD	WEIDLICH BROS. MFG. CO.
PONTIFEX	R. BLACKINTON & CO.
POPPY	INTERNATIONAL-COMMONWEALTH SILVER CO.
POROUS PIG SKIN	MAX HIRSCH
PORTSMOUTH	OLD NEW ENGLAND CRAFTSMEN, INC.
PRESTIGE PLATE	HOME DECORATORS
PRINCE'S PLATE	MAPPIN & WEBB
"PROFESSIONAL" PATTERN	RUSSELL HARRINGTON CUTLERY CO.
PROVIDENCE SILVER PLATE CO.	AURORA SILVER PLATE CO.
PURITAN SILVER CO.	ONEIDA
QUEEN ESTHER	SALES STIMULATORS
R. & B.	INSILCO
R. C. CO.	INSILCO
R. COIN	A. DAVIS CO.
R. COIN	M.C. EPPENSTEIN
RED CROSS	J. B. & S. M. KNOWLES CO.
R. S. MFG. CO.	NIAGARA SILVER CO.
R. S. MFG. CO.	WM. A.. ROGERS
RELIANCE	ONEIDA
RELIANCE PLATE	ONEIDA
R SPECIAL	A. DAVIS CO.
REVELATION SILVER PLATE	INSILCO
REVERE	BENEDICT MFG. CO.
REV-O-NOC	HIBBARD, SPENCER, BARTLETT & CO.
REX PLATE	ONEIDA
RHODODENDRON	G. B. STOCKING
RICHFIELD PLATE COMPANY	HOMAN MFG. CO.
RIVERTON SILVER CO.	A.R. JUSTICE
R. M. CO.	RENOMMEE MFG. CO.
ROGERS CUTLERY CO.	INSILCO
ROGERS & HAMILTON	INSILCO
ROYAL CREST STERLING	EMPIRE CRAFTS CORP.
ROYAL FAMILY	SABEN GLASS CO.
ROYAL PLATE CO.	AMERICAN SILVER CO.
ROYAL PLATE CO.	BRISTOL BRASS & CLOCK CO.
ROYAL PLATE CO.	INSILCO
ROYAL PLATE CO.	J. W. JOHNSON
ROYAL SILVER	LEDIG MFG. CO.
R. S. MFG. CO.	NIAGARA SILVER CO.
SALEM SILVER PLATE	SEARS ROEBUCK & CO.
S. & B. S. F. CAL.	SCHAEZLEIN & BURRIDGE
SALOSICO WARE	ST. LOUIS SILVER CO.
S. E. B.	NATIONAL SILVER CO.
SECTIONAL PLATE XII	MERRY & PELTON SILVER CO.
SHADOARDT	BERNARD RICE'S SONS
SHEFFIELD F. B. R.	F. B. ROGERS
SHEFFIELD H. S. CO.	HEMILL SILVERWARE INC.
SHEFFIELD PLATED CO.	HOLMES, BOOTH & HAYDENS
SHEFFIELD PLATED CO.	INSILCO
SICK - CALL	HOMAN MFG. CO.
SILBRO	SILVER BROTHERS
SILVER ARTISTS COMPANY	REED & BARTON
SILVER CREST	SMITH METAL ARTS CO.
SILVERCRAFT	FARBER BROS.
SILVERCRYST	F. A. HERMANN CO.
SILVERGRAMS	CHICAGO MONOGRAM STUDIOS
SILVER HARVEST	ELLMORE SILVER CO.
SILVEROIN	BRISTOL MFG. CO.

SILVER METAL	ONEIDA
SILVERSEAL	ASSOCIATED SILVER CO.
SILVER SOLDERED	R. WALLACE & SONS MFG. CO.
SILVER WELD (knives)	INSILCO
SIPELIA	B. & J. SIPPEL LTD
SKYSCRAPER	BERNARD RICE'S SONS
SO. AM.	DAVID H. McCONNELL
SOCIAL SILVER	DELLI SILVERPLATE
SOLID STRATHMORE SILVER	STRATHMORE CO.
SOLID YUKON SILVER WARRANTED	RAYMOND MFG. CO.
SØLV	TH. MARTHINSEN SOLVVARE-FABRIKK
SO. MERIDEN SILVER CO. QUADRUPLE	C. ROGERS & BROS.
SOMERSET	W. BELL CO.
SOUTHINGTON COMPANY	INSILCO
SOVEREIGN PLATE	P. W. ELLIS
SQUIRREL BRAND	S.J. LEVI & CO.
STANDARD PLATE 4	MERRY & PELTON SILVER CO.
STANDISH	BENEDICT MFG. CO.
STAR CUTLERY CO.	ELGIN-AMERICAN MFG. CO.
STATE HOUSE STERLING	HOME DECORATORS
ST. JAMES	M. FRED HIRSCH CO., INC.
STERLINE	JAMES E. BLAKE CO.
STERLING B	BATTING & CO.
STERLING C R R	C. RAY RANDALL & CO.
STERLING G	F. S. GILVERT
STERLINGUARD	ALBERT PICK & CO.
STERLING INLAID	HOLMES & EDWARDS SILVER CO.
STERLING PLATE < B>	AMERICAN SILVER CO.
STER LING (in "lazy S")	SCHARLING & CO.
STERLING SILVER PLATE CO.	HOLMES, BOOTH & HAYDENS
STERLING SILVER PLATE CO.	INSILCO
STERLING T. S. P.	TORONTO SILVER PLATE COMPANY
STERLING V	C. D. VANDERBILT
STERLON	MILTON J. SCREIBER
STRAND	INSILCO
STRATFORD SILVER PLATE CO.	HOLMES & EDWARDS SILVER CO.
STRATFORD SILVER PLATE CO.	INSILCO
STRATFORD PLATE	HOLMES & EDWARDS SILVER CO.
STRATFORD PLATE	INSILCO
STRATFORD SILVER CO.	HOLMES & EDWARDS SILVER CO.
STRATFORD SILVER CO.	INSILCO
STRATFORD SILVERPLATE CO.	HOLMES & EDWARDS SILVER CO.
SUFFOLK SILVERPLATE	GORHAM
SUPERIOR	INSILCO
SUPERIOR	MIDDLETOWN PLATE CO.
SUPERIOR SILVER PLATE CO.	MIDDLETOWN PLATE CO.
SUPERIOR SILVER CO.	MIDDLETOWN PLATE CO.
SUPERIOR S. P. CO.	MIDDLETOWN PLATE CO.
SUPER-PLATE	INSILCO
SUPREME SILVER PLATE	INSILCO
SUREFIRE	NAPIER COMPANY
SUSAN B. ANTHONY	MILLIE B. LOGAN
SUSSEX	HEMILL SILVERWARE CO.
TABARD SILVER	BENEDICT MFG. CO.
TAUNTON SILVER PLATE CO.	I.J. STEANE & CO.
TENCO	T. E. NEILL CO.
THE CELLAR SHOPS	RAYMOND BRENNER
THE COLUMBIA	G. I. MIX & CO.

THE ESSEX SILVER PLATE CO.	WALLINGFORD CO.
THE NEW ENGLAND SILVER PLATE CO.	ADELPHI
THE WARNER SILVER CO.	WEIDLICH BROS. MFG. CO.
"TREASURE" SOLID SILVER	ROGERS, LUNT & BOWLEN CO.
TINY DINER	FINE ARTS STERLING SILVER LCO.
JOHN TOOTHILL	METROPOLITAN SILVER CO.
TORSIL METAL	TORONTO SILVER PLATE CO.
TORSIL E. P. - N. S.	TORONTO SILVER PLATE CO.
TORSIL STEEL	TORONTO SILVER PLATE CO.
TRIANON	NAPIER CO.
TRIPLE PLUS	ONEIDA
T. S. C.	STRATHMORE CO.
TUDOR PLATE	ONEIDA
TWINKLE STERLING	GORHAM
210 NEARSILVER	ONEIDA
UNION SILVER PLATE CO.	HOLMES, BOOTH & HAYDENS
UNION SILVER PLATE CO.	INSILCO
UNITED JEWELERS' CROWN GUILD	JEWELERS' CROWN GUILD
UNIVERSAL	LANDERS, FRARY & CLARK
U.S. SILVER CO.	ONEIDA
VIANDE	HOLMES & EDWARDS
VIANDE	INSILCO
VICTOR SILVER CO.	DERBY SILVER CO.
VICTOR S. CO.	INSILCO
VICEROY	NATIONAL SILVER CO.
VIKING BRAND	REED & BARTON
VIKING PLATE	LIPMAN-LEVINTER
VIOLET	M. FRED HIRSCH CO. INC.
VOGUE	GORHAM
WALDO	HOLMES & EDWARDS SILVER CO.
WALDO	WALDO FOUNDRY
WALDORF SILVER CO.	WOODMAN-COOK CO.
WALLACE BROS. SILVER CO.	THE WALLINGFORD CO.
WARNER SILVER COMPANY	WEIDLICH BROS. MFG. CO.
WARREN	WM. A. ROGERS
WARWICK	W. BELL CO.
WATTEAU	WM. B. DURGIN & CO.
WEARWELL	GOTHAM SILVER CO.
WMF	WÜRTTEMBERGISCHE METALLWARENFABRIK
WELCH SILVER	AMERICAN SILVER CO.
WELCH SILVER	BRISTOL BRASS & CLOCK CO.
WILCOX & EVERTSEN	INSILCO
WILCOX SILVER PLATE CO.	INSILCO
WM. ROGERS MFG. CO.	INSILCO
WM ROGERS & SON	INSILCO
WORLD	INSILCO
WROUGHT RIGHT	MARSHALL FIELD & CO.
X S TRIPLE	INSILCO
YOUREX	ASSOC. SILVER CO.
YOUREX	GOERGE E. HERRING
Y STERLING	W . F. CORY & BRO.
YUKON SILVER	CATTARAUGUS CUTLERY CO.
ZENITH	MARSHALL-WELLS HARDWARE CO.

Key to Unlettered Marks

 ADELPHI SILVER PLATE CO.

 E. & J. BASS

 ERNST GIDEON BEK, INC.

 BENEDICT MFG. CO.

 E. A. BLISS CO.

 BRISTOL MFG. CO.

 ADELPHI SILVER PLATE CO.
and
J. SCHIMPF & SONS

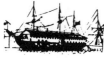 OTTO G. FABER

 J. H. HUTCHINSON
& CO.

OLD CONSTITUTION

 BARBOUR SILVER CO.

 MULHOLLAND BROS. INC.

 JACOBI & JENKINS

 TH. MARTHINSEN

PLETT

 MT. VERNON COMPANY
SILVERSMITHS, INC.

 ELLIS-BARKER SILVER
COMPANIES

 SUCKLING, LTD.

 E. & J. BASS

 WALTER S. BROWER

 THOMAS G. BROWN & SONS

 CONTINENTAL SHEFFIELD SILVER CO.

 GOLDFEDER SILVERWARE COMPANY, INC.

 HOMAN MANUFACTURING COMPANY

 THE MELROSE SILVER CO.

QUEEN CITY SILVER CO., INC.

 GEORGE W. SHIEBLER & CO.

 LAURENCE B. SMITH CO.

LAURENCE B. SMITH CO.

TORONTO SILVER PLATE CO.

E. G. WEBSTER & SON

 ALBANY SILVER PLATE CO.

 J. DIXON & SONS

 FENNIMAN CO.

 FEDERAL SILVER COMPANY

 BEN. SPIER

 WM. B. KERR & CO.

 FRANKLIN SILVER PLATE COMPANY

 C. F. KEES & CO.

 G. W. PARKS COMPANY

 PARKS BROS. & ROGERS

 WM. HUTTON & SONS, LTD.

 WM. KNOLL & CO.

 ST. LOUIS METALCRAFTS, INC.,

 REDDALL & CO., INC.

 WM. AND GEO. SISSONS

 SOCIÉTÉ PICARD FRERES

 TH. MARTHINSEN

 DAVIS & GALT

 POOLE SILVER CO.

 WM. B. KERR & CO.

 ELLIS-BARKER SILVER COMPANIES

 WILLIAM LINKER

 J. TOSTRUP

 JOSEPH MAYER & BROS.

 THE POTOSI SILVER CO.

 TOWLE SILVERSMITHS

 FINE ARTS STERLING SILVER COMPANY

 INTERNATIONAL SILVER CO.

 KENT & STANLEY CO., LTD.

OLD NEW ENGLAND CRAFTSMEN, INC.

 BROWN & WARD

BI-METAL
CUIVRE
ET
ARGENT PUR SOCIÉTÉ PICARD FRERES

 MERMOD, JACCARD & KING JEWELRY CO.

 DOMINICK & HAFF

397

 MERRIMAC
VALLEY
SILVERSMITHS

 H. H. CURTIS & CO.

 STERLING

MECHANICS
STERLING COMPANY
and
WATSON COMPANY

 THE MAUSER
MANUFACTURING
COMPANY

 BACHRACH & FREEDMAN

 REDLICH & CO.

 C. E. BARKER MFG. CO.

 SACKETT & CO., LTD.

 MISS SARAH B. DICKINSON
and
MRS. SARAH B. DICKINSON
WOOD

 THE MERRILL SHOPS

 JACK BOWLING

 A. L. SILBERSTEIN

 ALBERT FELDENHEIMER

A. L. SILBERSTEIN

 TILDEN-THURBER CO.

ELLIS-BARKER SILVER
COMPANIES

 BARKER BROS.SILVER
CO., INC.

 MAX HIRSCH

 POTOSI SILVER CO.

 LEHMAN BROTHERS
SILVERWARE CORP.

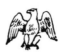 BLACK, STARR & FROST, LTD.

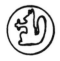 S. J. LEVI & CO., LTD.

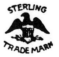 THORNTON & CO.

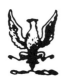 MAYO & CO.

 MERIDEN BRITANNIA COMPANY

 MANNING, BOWMAN & CO.

 OLD NEWBURY CRAFTERS, INC.

 A. G. SCHULTZ & CO.

 WM. B. DURGIN CO.

 J. T. INMAN & CO.

 WILLIAM C. FINCK CO.

 BARKER BROS. SILVER CO.

 SHREVE, CRUMP & LOW CO., INC.

 J. W. ROSENBAUM & CO.

 H. J. WEBB & CO.

 COLONIAL SILVER COMPANY, INC.

 HENRY C. HASKELL

 TUTTLE SILVERSMITHS

 MAJESTIC SILVER COMPANY

 TIMOTHY TUTTLE

 HAWTHORNE MFG. CO.

 GENOVA SILVER CO., INC.

 MERIDEN BRITANNIA COMPANY

 CHARTER COMPANY

 CHARTER COMPANY

 PRILL SILVER CO., INC.

 CHARTER COMPANY

 ST. LOUIS METALCRAFTS

 ECKFELDT & ACKLEY

 GEBRUEDER NOELLE

 LOTT & SCHMITT, INC.

 NEW ORLEANS SILVERSMITHS

 SIMEON L. & GEO. H. ROGERS CO.

 NEW ORLEANS SILVERSMITHS

 ELLIS-BARKER SILVER COMPANIES

 W. E. WEBSTER CO.

 STANDARD SILVER CO. OF TORONTO

 J. J. COHN

 NORBERT MFG. CO.

 GALT & BRO., INC.

 WATSON COMPANY

 MT. VERNON COMPANY

 MATHEWS & PRIOR

 GALT & BRO., INC.

 GALT & BRO., INC.

HANLE & DEBLER, INC.

 SCHULZ & FISCHER

 MEDALLIC ART COMPANY

 UTOPIAN SILVER DEPOSIT & NOVELTY CO.

 ROGER WILLIAMS SILVER CO.

 AUG. C. FRANK CO., INC.

 R. GLEASON & SONS

 HARRIS & SCHAFER

 ROMAN SILVERSMITHS, INC.

 SUTTON HOO JEWELERS

 MONTGOMERY BROS.

 L. KIMBALL & SON

H. G. HUDSON

 MILLIE B. LOGAN

 WITCH

DANIEL LOW & CO.

 E. A. BLISS CO.

 FERDINAND C. LAMY

 WILLIAM F. NEWHALL

 WILLIAM H. SAXTON, JR.

 N. G. WOOD & SONS

 H. G. HUDSON

 MERIDEN BRITANNIA COMPANY

STERLING FINE

 WILCOX & EVERTSEN

 H. H. TAMMEN CURIO CO.

401

 THOMAS F. BROGAN

 BROWN & BROS.

 COMMONWEALTH SILVER CO.

 HERBST & WASSALL

 THE FRANK KURSCH & SON CO.

 HERBERT COCKSHAW, JR.
and
HOWARD & COCKSHAW CO.

 BARKER BROS.
SILVER CO., INC.

 J. F. FRADLEY & CO.
TRADE MARK

 H. A. KIRBY

 ALBERT J. GANNON

 BASCH BROS. & CO.

 R. BLACKINTON & CO.

 DAY, CLARK & CO.

 M. EISENSTADT JEWELRY CO.

 FUCHS & BEIDERHASE

 SUTTON HOO JEWELERS

Sterlin E JAMES E. BLAKE CO.

 AUGUST DINGELDEN & SON

 ELLIS-BARKER
SILVER COMPANIES

 THE BASSETT JEWELRY CO.

 TOWLE SILVERSMITHS

 D. C. BOURQUIN

402

Glossary

Acanthus: A form of ornamentation taken from the acanthus leaf, originally used extensively on the Corinthian capital throughout the Renaissance period, 16th–17th centuries.

Ajouré: A French term applied to metalwork which is pierced through, perforated or open-work.

Alaska Silver: Base metal of secret composition. According to contemporary ads, "Its purpose is to imitate solid silver at a fraction of the cost." It is subject to damage if left 12 hours or more in acid foods, fats or grease. It is also a tradename used on silverplated flatware sold by Sears Roebuck & Co., c. 1908. In the 1908 catalog was the statement that Alaska Metal was their special formula of composition metal made to imitate solid silver. Contains no silver.

Albata: Alloy of nickel, copper, and zinc, forming a silvery white metal.

Alchemy: A superior pewter used in the 16th and 17th centuries for making spoons and plates; an alloy of tin and copper.

Alcomy: An alloy of various base metals.

Alfenide: "Spoons made of alfenide similar to finest English white metal. Contains no brass or German steel." (Clipping dated March 18, 1878, *St. Nicholas Magazine.*)

Alloy: A substance composed of two or more metals intimately united, usually intermixed when molten.

Alpacca: German silver and nickel silver; are synonymous trade names of an alloy of copper, nickel and zinc.

Aluminum Silver: A composition of aluminum and silver which is much harder than aluminum. It takes a high polish. Air does not affect the color. The proportion of ingredients varies. One of three parts silver and ninety-seven parts aluminum makes an alloy similar in appearance to pure aluminum but is much harder and takes a better polish.

Annealing: Reheating of silver to keep it malleable while it is being worked.

Anvil: An iron block on which metal is hammered and shaped.

Apocryphal: Classical term for a fake.

Applied: Certain parts, such as spouts, handles, covers, et cetera, are sometimes made separately and applied with solder.

Apprentice: One who is bound by indentures to serve another person with a view of learning a trade.

Argentine: An alloy of tin and antimony used as a base for plating; nickel silver; German silver; also "British plate"; known in China as Paktong. Bradbury says, "Credit [is] due to W. Hutton & Sons, of Sheffield, for being the first firm to manufacture spoons and forks from the newly-invented metal called Argentine, in the year 1833."

Assay: The test made to prove that the metal is of the required quality.

Baltimore Assay Marks: Starting in 1814, silver made in Baltimore was marked at a hall and identified by a date letter; this compulsory marking was abolished in 1830.

Base Metal: An alloy or metal of comparatively low value to which a coating or plating is normally applied.

Bat's-wing Fluting: Gadrooning, graduated and curved to resemble the outline of a bat's wing and encircling holloware.

Beading: A border ornament composed of small, contiguous, bead-like, half-spheres. Popular in late 18th century.

Beakhorn: A sharply pointed anvil.

Bell Metal: A variety of Sheffield Plate consisting of an unusually heavy coating of silver, introduced in 1789 by Samuel Roberts.

Black Pewter: An alloy of 60 per cent tin and 40 per cent lead. Used for making organ pipes and candle molds.

Bleeding: The technical term applied to pieces of plate whereon the copper base is exposed.

Bobèche: Flat or saucerlike rings placed around candle bases to stop wax drippings.

Bright-cut Engraving: A particular form of engraving popular about 1790, in which the metal is removed by bevelled cutting tools.

This gives a jewel-like, faceted sparkle to the surface.

Bright Finish: Highly polished, mirror-like finish produced by use of jeweler's rouge on a polishing wheel.

Britannia: A silver-white alloy composed largely of tin hardened with copper and antimony. Closely akin to pewter, yet differing in the higher proportion of tin, the addition of antimony and the omission of lead, resulting in a more silvery appearance than is possible with the pewter mixture. It often contains also a small quantity of zinc and bismuth. A common proportion is 140 parts of tin, three of copper and ten of antimony.

Bronze: An alloy chiefly of copper and tin.

Buffing: Removal of the outer layer of metal with a flexible abrasive wheel or a soft mop, exposing a shiny undersurface but imparting no additional hardness.

Burnisher: Tool with hard, polished working surface such as agate, for burnishing gold and silver.

Burnishing: Electro deposits consist of a multitude of small crystals, with intervals between them, and with facets reflecting the light in every direction. The deposited metal is hardened by burnishing and forcing into the pores of the underlying metal. The durability is thus increased to such an extent that, with the same amount of silver, a burnished article will last twice as long as one which has not been so treated.

Butler's Finish: Satin finish produced by a revolving wheel of wire which makes many tiny scratches, giving the article a dull appearance. Patented by James H. Reilly, Brooklyn Silver Co.

C: (See Coin.)

Cable: Molding like twisted rope, derived from Norman architecture.

Cast: Formed in a mold, i.e., handles, ornaments, et cetera are often cast separately.

Chafing-dish: One dish or vessel within another, the outer vessel being filled with hot water and in direct contact with the heat source and an inner container for food.

Chamber-candlestick: A tray candlestick in the form of a circular dish stand with a handle.

Champleve: Enameling by cutting troughs in the metal into which the frit is melted; the surface is ground flush and polished.

Chasing: A cold modeling process of ornamenting metal by hammers. Also called embossing.

Cloisonné: Enameling by melting the frit into areas defined by wire soldered to surface to be decorated.

Coin: By 1830, COIN, PURE COIN, DOLLAR, STANDARD, PREMIUM or C or D were used to indicate 900/1000 parts of silver.

Coin Silver: 900/1000 fine, with 100/1000 of copper. Used by early silversmiths to whom sterling was not available.

Commercial Silver: 999/1000 fine or higher.

Craig Silver: Similar to German silver. Used for making knives.

C-scroll: Usually applied to the shape of a handle in the form of the letter C; also called 'single scroll'.

Cut-cardwork: Silver work in which conventional designs of leaves and flowers are cut from thin sheet-silver and applied to a silver surface.

Cutler: One who makes, deals in, or repairs utensils or knives.

Cutlery: Knives having a cutting edge.

D: (See Coin.)

Date Letter; Date Mark: Proper assay marks on English silver, the date being indicated by a letter of the alphabet. Some American silver is date marked. (See Gorham, Kirk, Tiffany, and Tuttle.)

Dish Cross: An x-shaped support for a dish, some with spirit lamps for warming food.

Dish Ring: A silver stand particularly identified with Irish silver, and sometimes called a potato-ring.

Dollar: (See Coin.)

Dolphin: The sea dolphin used as a sculptured or carved motif.

Domed: Spheroid form of cover, first used in 1715 on tankards, teapots and coffeepots.

Domestic Plate: Silverware for home use.

Double-scroll: A sinuous line of S-shape, or composed of reverse curves, used especially in design of handles.

Drawing Irons: Metal parts of a drawing bench, through which silver is drawn.

Electrolysis: Conduction of an electric current by an electrolyte of charged particles.

Electroplate: Articles consisting of a base metal coated with silver by the process of electrolysis.

Electrotype: Copy of art object produced by electroplating a wax impression. Much used in the nineteenth century to reproduce antique objects. Now employed in the production of facsimile plates for use in printing.

Electrum: A natural pale-yellow alloy of gold and silver. Also, an imitative alloy of silver, 8 parts copper, 4 nickel, and 3½ zinc.

Embossing: Making raised designs on the surface of metal from the reverse side, strictly applicable only to hammered work (Repoussé).

Engraving: Cutting lines into metal with a scorper or graver.

EPC: Electroplate on copper.

EPBM: Electroplate on britannia metal.

Epergne: An elaborate centerpiece, especially for a dining table; an ensemble of cups and vases for holding fruits, flowers, et cetera.

EPNS: Electroplate on nickel silver.

E.P.N.S. — W.M.M.: Electroplate on nickel silver with white metal mounts.

EPWM: Electroplate on white metal.

Etching: Surface decoration bitten-in with acid.

Ewer: A jug or pitcher having a wide spout and a handle.

Feather Edge: Decoration of edge of spoon-handle with chased, slanting lines. An engraved, decorative design.

Fine Pewter: Eighty per cent tin and 20 per cent brass or copper. Used for making plates because of the smooth surface, attractive color and strength.

Fine Silver: Better than 999/1000 pure. It is too soft for practical fabrication, and is mainly used in the form of anodes or sheets for plating.

Flagon: Large vessel for serving wine or other liquors.

Flash Plate: Unbuffed, cheap plated ware.

Flat Chasing: Surface decoration in low relief. Popular in England in early 18th century, and widely used in America, 1750–1785.

Flatware: Knives, forks, spoons and serving pieces.

Fluted: A type of grooving.

Foreign Silver: Other than English sterling, is sometimes of uncertain silver content, in some instances running considerably below the coin standard. The fineness is often stamped on the article. In the Scandinavian countries and Germany solid silver tableware 830/1000 fine has been standardized, and the stamp "830" signifies this silver content.

Forging: The shaping of metal by heating and hammering.

Fusion: An act or operation of melting, as the fusion of metals. Usually accomplished by the application of intense heat.

Gadroon: A border ornament radiating lobes of curved or straight form. Used on rims and feet of cups, plates and other vessels from late 17th century.

German Silver: A silver-white alloy consisting principally of copper, zinc and nickel. During World War I this name was dropped by many and the term nickel silver used.

Gold Aluminum: A solid alloy used for flatware made by Holmes & Edwards Silver Co., Bridgeport, Connecticut. Marked with a trademark WALDO HE preceded by a symbol used by the Waldo Foundry which probably made the metal. Flatware made only in *Rialto* pattern which was also made in silverplate.

Gold Plating: The covering of an article with gold.

Goldsmiths' Company: The organization under whose jurisdiction and regulation the English silver industry has been conducted.

Graver: Tool used to engrave silver.

Hallmark: The official mark of the English Goldsmiths' Company used on articles of gold and silver to indicate their genuineness.

Hollow Handle (H. H.): Handles made of two halves soldered together. Knives, especially, need the thickness provided for comfortable use, controlled handle weight and balance.

Holloware: A general term for articles in the form of hollow vessels, such as mugs, ewers, teapots, coffeepots, bowls and pitchers also includes trays, waiters, meat and chop plates and flat sandwich trays.

Holloware Pewter: Eighty per cent tin and 20 per cent lead, used for making teapots, tankards, coffee pots and liquid measures.

Ingot: A bar of silver or other metal.

Katé: A Malayan weight equal to 11.73 ounces. Tea was sold by the kate (pronounced katde). It became "caddy" — hence tea caddy. Also spelled kati.

Lashar Silver: A process invented by Thomas B. Lashar of the Holmes & Edwards Silver Co., whereby the copper and zinc from the surface of nickel alloy was removed, leaving only the nickel exposed.

Latten: An alloy of copper and zinc; brass.

Limoges: Enamel painted on metal, covering the surface.

Maker's Mark: The distinguishing mark of the individual goldsmith.

Malleable: Capable of being extended or shaped by beating with a hammer; ductile.

Matted-ground: A dull surface made by light punchwork, to secure contrast with a burnished surface.

Metalsmith: One versed in the intricacies of working with metals.

Nickel Silver: An alloy of nickel, copper and zinc.

Niello: Deep-line engraving on gold or silver with the lines filled with copper, lead and sulphur in borax, forming a type of black enamel which is fired and polished.

Non-tarnishing Silver: Produced by alloying silver with cadmium or by the application of a thin plating of rhodium or palladium on the surface.

N.S.: Nickel silver.

Onslow Pattern: Design for flatware shaped as a volute scroll.

Ormolu: "Ground gold," literally. Ground gold leaf used as a gilt pigment. Also, brass made to look like gold.

Oxidizing: Accented beauty of ornamentation by the application of an oxide which darkens metal wherever applied. Shadows and highlights are created which give depth and character.

Patina: Soft luster caused by tiny scratches that come with daily use.

Pewter: An alloy of tin and copper or any alloy of the low-melting-point metals, including tin, lead, bismuth and antimony. Sad pewter is the heaviest, but not the best. The higher the tin content, the better the pewter.

Pinchbeck: An alloy of copper or zinc used to imitate gold. Invented by Christopher Pinchbeck (1670–1732), London. Also called "Chapman's" gold or Mannheim gold.

Pit Marks: Minute holes usually found on lead or soft metal borders.

Planishing: To make smooth or plain. Oval-faced planishing hammers are used to conceal hammer marks used in forming a piece.

Plate: Used in England and on the Continent when referring to articles made of precious metals.

Plique-à-jour: Translucent enamel without a metal backing, enclosed within metal frames, giving a stained glass or jewel-like effect

Premium: (See Coin.)

Pricking: Delicate needle-point engraving. Pricked initials were often used on early pieces.

Pseudo Hall-marks: Devices used to suggest English hall-marks.

Pure Coin: (See Coin.)

Raising: Formation of a piece of holloware beginning with a flat circle of silver. It is hammered in concentric circles over a succession of anvils with frequent annealings.

Rolled Plate: (See Sheffield Plate.)

Rope-molding: A type of gadroon bordering made up of reeds and flutes slightly spiralled.

R.P.: Rolled Plate.

Repoussé: Relief ornament hammered from the under or inner side of the metal. Usually given added sharpness of form by surface chasing of detail and outline. Has been practiced from early times. Introduced to this country by Samuel Kirk in 1828.

Satin Finish: (See Butler's Finish.)

Scorper: Small chisel for engraving. The blades are of various shapes.

Sheffield Plate: True Sheffield plate was produced by fusing, with intense heat, a thin sheet of silver to one or both sides of a thick sheet of copper. The composite metal was then rolled down to the proper thickness for fabrication. Invented by Thomas Boulsover about 1743 Frequently called "Old Sheffield Plate" to distinguish it from electroplate.

Silver Edge: An ornamental border of solid silver.

Silverite: "A combination of tin, nickel, platinum, etc." according to advertisements.

Silverplate: A base metal, usually either nickel silver or copper, coated with a layer of pure silver by electroplating.

Spinning: Process used for forming holloware. A metal plate is cut to proper size, placed against a chuck in a lathe, where pressure against it with a smooth revolving instrument produces the desired form.

Stake: An iron anvil or tongue, on which a silver object is formed.

Stamping: Impressing of designs from dies into the metal by means of heavy hammers. Often followed by hand chasing to sharpen up design details.

Stamping Trademarks and Stock Numbers: As early as 1867, the Meriden Britannia Co. had a system of stamping nickel silver, silver soldered holloware with a cipher preceding the number, and by 1893, nickel silver holloware with white metal mounts had as a part of the number two ciphers. That is, on a waiter with white metal, 00256, etc. would be stamped. This made it quickly understood by the number whether the piece was nickel silver, silversoldered or nickel silver with white metal mounts.

Standard: (See Coin.)

Sterling II: Flatware whose hollow handles are of sterling silver but tines, bowls and blades are stainless steel. Developed by Wallace Silversmiths.

Sterling Silver: 925/1000 fine, with 75/1000 of added metal, usually copper, to give it strength and stiffness. This is the standard set by the United States Government in the Stamping Act of 1906, and any article stamped "sterling" is of assured quality. It appears on Baltimore silver, 1800–1814, and after 1860, elsewhere.

Stoning: Polishing of silver with an emery-stone.

Swaged: Shaped by the process of rolling or hammering.

Tempering: Strengthening of metal by heat.

Touch: Maker's mark, impressed with a punch.

Touchstone: A hard siliceous stone or modern square of Wedgwood on which a piece of silver or gold of known quality can be rubbed to compare its mark with that of a piece being assayed.

Town Mark: The mark assigned to a city and applied as a hallmark to denote the location of manufacture.

Trademark: Symbol or tradename by which a manufacturer may be identified. Widely used in this country as a guarantee of quality. A distinction should be made between a trademark and a hallmark, as required by English and other European countries. Because the United States has never had a goldsmiths' or silversmiths' hall, there are no true hallmarks on American silver.

Trifle Pewter: Sixty per cent tin and 40 per cent lead. Of a darker color and softer than better grades of pewter, it was short lived. The alloy was altered to 83 parts tin and 17 parts antimony and was made into spoons, saltshakers, buttons and similar articles which could not be finished on a lathe. Workers in this alloy were called "triflers."

Vermeil: Gold plating process developed in France in the mid 1700s. France banned production of vermeil early in the 19th century because the process involved the use of mercury. Present-day vermeil is produced by a safe electrolytic process.

Victorian Plate: Plated silver ware made during the period c. 1840–1900 by the process of electrolysis.

Waiter: A tray on which something is carried; a salver.

White Metal: An alloy usually containing two or more of the following elements — tin, copper, lead, antimony and bismuth. The color depends on whether lead or tin predominates. The more tin the whiter the color.

Whitesmith: A planishing smith; superior workman in iron, comparable to the armorer. Also a worker in pure tin of the "block" variety, not cast, but hammered and battered, planished and "skum." Originally "whitster."

Silverplate Specifications

When plated silver production first began, some manufacturers either ignored indicating the quality or marked their products "Triple" or "Quadruple" plate. About this, the JEWELERS' CIRCULAR had this to say:

SILVER PLATED WARE

NOTE: — Manufacturers of silver plated flatware, in addition to their trade-mark, stamp the quality upon their goods, almost all of them adopting the same signs and figures. These quality signs and figures are as follows:

A.I.represents standard plate
XIIrepresents sectional plate
4represents double plate, tea spoons
6represents double plate, dessert spoons and forks
8represents double plate, table spoons
6represents triple plate, tea spoons
9represents triple plate, dessert spoons and forks.
12represents triple plate, table spoons.

There is an amount of cheap plated ware on the market stamped with the names of fictitious companies, such as "Quadruple Silver Plate Co." "Royal Sterling Plate Co.," etc. These goods are furnished, bearing no stamp, to department storekeepers, conductors of gift enterprises and jobbers of cheap merchandise, who stamp the goods themselves with such names as suit their fancy. It is, therefore, practically impossible to trace these stamps.

FOR FLATWARE

Half plate: 1 troy oz. per gross of teaspoons

Standard plate: 2 troy oz. per gross of teaspoons

Double plate: 4 troy oz. per gross of teaspoons

Triple plate: 6 troy oz. per gross of teaspoons

Quadruple plate: 8 troy oz. per gross of teaspoons

Federal specification: 9 troy oz. per gross of teaspoons

These specifications produce a thickness whose range is from 0.00015 to 0.00125 in. — the latter equivalent to 1 troy oz. per square ft. Federal specifications call for an average of 0.000125 in. thickness to be reinforced by silver to a minimum of 0.00180 in. on the backs of spoon bowls and fork tines.

FOR HOTELWARE – HOLLOWARE

Federal specification plate: 20 dwt. per sq. ft.

Extra heavy hotel plate: 15 dwt. per sq. ft.

Heavy hotel plate: 10 dwt. per sq. ft.

Medium plate: 5 dwt. per sq. ft.

Light plate: 2 dwt. per sq. ft.

The Federal specification is for 0.00125 in., the same thickness required for flatware. Light plate is 0.000125 in., slightly less than the half plate under flatware.

Table of Equivalents

TROY WEIGHT

POUNDS		OUNCES		PENNYWEIGHTS (dwts.)
1	=	12	=	240
		1	=	20

1 oz. avoir. = .91146 Troy oz. = 28.3495 gms.
1 oz. Troy = 1.0971 oz. avoir. = 31.103 gms.
1 lb. avoir. = 14.58 oz. Troy
1 lb. Troy = 13.165 oz. avoir.

SILVER STANDARDS

$.896 = 10.15$ (Used in Maryland c. 1840–c. 1860) $= \dfrac{10.75}{12}$

.892 Standard for U.S. coins 1792–1837

$.900$ (Standard for U.S. coins after 1837) $= 10.8 = \dfrac{10 \text{ oz. } 16 \text{ dwts.}}{12}$

$.917 = 11 = {}^{11}/_{12}$ Baltimore standard during Assay Office period. 1814–1830. Midway between coin and sterling.

$.925 = 11.1 = \dfrac{11 \text{ oz. } 2 \text{ dwts.}}{12}$ The sterling standard. Used often in Baltimore c. 1800–1814. Not used consistently elsewhere in the U.S. until c. 1865.

$.958 = 11.5 = \dfrac{11 \text{ oz. } 10 \text{ dwts.}}{12}$ The Britannia standard.

Bibliography

Aaron, Robert. "Gorham vs. Ellis," *Silver*, Sept.-Oct. 1985, pp. 20-21

Abbey, Staton. *The Goldsmiths and Silversmiths Handbook*. New York: Van Nostrand, 1952.

Adams, John P. Invention Patent No. 93,575, "Improved Revolving Ice-pitcher and Coffee-Pot." United States Patent Office, Washington, D.C., August 10, 1869.

"Adelphi Silver Company," *Silver,* Sept.-Oct. 1989, p. 13

Albany Silver. Albany, New York: Albany Institute of History and Art, 1964.

Alexander, S. E. "Tiffany's Sterling: History and Status," *National Jeweler*, June, 1963.

American Church Silver of 17th and 18th Centuries Exhibited at the Museum of Fine Arts, July to December, 1911. Boston: Boston Museum of Fine Arts, 1911.

"American Industries. - No. 22, The Manufacture of Silver-Plated Ware." *Scientific American,* vol. xli - No. 19, November 8, 1879, cover , p. 296

"American Silver," *American Magazine of Art,* August 1919, v. 10, p. 400.

Antiquarian Magazine. 1924-1933.

Antiques Digest. Frederick, Maryland: Antiques Publications, Inc., 1951-1952

Antiques Magazine. New York: 1922-1975

"Archibald-Klement Co. Silver Deposit Ware," *Silver,* Nov.-Dec. 1991, p. 39

Attleboro Daily Sun, Anniversary Edition. Attleboro, Mass.: 1964.

Avery, Clara Louise. "New York Metropolitan Museum of Art, American Silver of the 17th and 18th centuries. " *Metropolitan Museum of Art Bulletin*. 1920.

Avery, Clara Louise. "New York Metropolitan Museum of Art, Exhibition of Early American Silver." *Metropolitan Museum of Art Bulletin*. December, 1931.

Avery, Clara Louise. *Early American Silver*. New York: The Century Company, 1930.

Bacot, H. Parrott. "New Orleans Silver In The Anglo-American Art Museum. Part I, Tea Urn. *Silver,* Jan.-Feb. 1986, pp. 20-21.

Bacot, H. Parrott. "New Orleans Silver. Part II, Kettle on Stand," *Silver,* Mar.-Apr. 1986, pp. 17-18.

Bacot, H. Parrott, "Two Pieces of Early New Orleans Holloware," *Silver,* Sept.-Oct. 1986, pp. 22-23.

Bartlett, W. A. *Digest of Trade-Marks. (Registered in the U. S.) for Machines, Metals, Jewelry and the Hardware and Allied Trades*. Washington, D.C: Gibson Bros Printers, 1893.

Beattie, William C. Invention Patent No. 225,787 "Jewel Case." United States Patent Office, Washington, D. C. March 23, 1880.

Bent, Dorothy. "A Fascinating Biography of Knives and Forks. *"Arts and Decoration*. Vol . 25, June, 1926.

Bigelow, Francis Hill. *Historic Silver of the Colonies and its Makers*. New York: The Macmillan Company, 1917.

Biographical History of the Manufacturers and Business Men of Rhode Island at the Opening of the Twentieth Century. Providence, Rhode Island: J. D. Hall & Co., 1901.

Bishop, J. Oleander. *A History of American Manufacturers from 1808-1860*, 2 vols. Philadelphla: Young & Co., 1861.

Boger, H. Batterson and Boger, Louise Ade. *The Dictionary of Antiques and the Decorative Arts*. New York: Charles Scribner's Sons, 1957.

Bolles, Albert S. *Industrial History of the United States from the Earliest Settlements to the Present Time*. Norwich, Conn.: 1879.

Boston Evening Transcript, December issues, 1867-1868.

Bowman, Leslie Greene. "Arts and Crafts Silversmiths: Friedell and Blanchard, in Southern California," in Morse ed., *Silver in the Golden State*, 1986, pp.41-55.

Bradbury, Frederick. *History of Old Sheffield Plate*. J. W. Northend, Sheffield, England 1912; reprinted 1968.

Brix, Maurice. *List of Philadelphia Silversmiths and Allied Artificers*, 1682-1850. Philadelphia: Privately printed, 1920.

The Bromwell Story. Washington, D.C.: D . L. Bromwell, Inc., pamphlet, no date.

Buck, J. H. *Old Plate, Its Makers and Marks*. New York: Gorham Manufacturing Company, 1903.

Buhler, Kathryn C. "Silver 1640-1820," *The Concise Encyclopedia of American Antiques*. New York: Hawthorn Books, Inc., Vol. 1., no date.

Burton, E. Milby. *South Carolina Silversmiths 1690-1860*. Charleston: The Charleston Museum, 1942.

Bury, Shirley. *Victorian Electroplate*. Country Life Collectors' Guides. The Hamlyn Pub. Group, London, 1971.

Carlisle, Lilian Baker. *News and Notes*. Vermont Historical Society, no date.

Carlisle, Lilian Baker. *Vermont Clock and Watchmakers' Silversmiths and Jewelers' 1778-1878*. Burlington, Vermont, 1970.

Carlisle, Lillian Baker. "Rutland Vermont's 19th Cen-

tury Silversmiths, Part I," *Silver,* Jan.-Feb. 1988, pp. 18-22.

Carlisle, Lillian Baker. "Rutland Vermont's 19th Century Silversmiths, Part II," *Silver,* Mar.-Apr. 1988, pp. 8-11.

Carpenter, Charles H., Jr. *Gorham Silver.* Dodd, Mead & Co., New York. 1982.

Carpenter, Charles H., Jr. & Mary Grace Carpenter. *Tiffany Silver.* Dodd, Mead & Co . New York. 1978.

Carpenter, Ralph E., Jr. *The Arts and Crafts of Newport, Rhode Island*: Preservation Society of Newport County, Pittshead Tavern 1954.

Catalog of an Exhibition of Paintings by Gilbert Stuart, Furniure by the Goddards and Townsends, Silver by Rhode Island Silversmiths. Rhode Island School of Design, Providence Rhode Island: 1936

Century Magazine, Advertising Section, November 1893.

A Century of Gardner Sterling Silver, Gardner Museum, Gardner, Mass. 1991

Chickering, Elenita C. "Arthur J. Stone, Handwrought Silver, 1901-1937." Boston Athenaeum, 1981.

Chickering, Elenita. *Arthur J. Stone. Boston.* Boston Athaneum 1994.

Chickering, Elenita. "Arthur J. Stone's Silver Flatware 1901-1937," *Silver,* Jan.-Feb. 1986, pp. 10-19.

Chickering, Elenita. Domestic Silver of Arthur J. Stone in Gardner, Massachusetts," *Silver,* July-Aug. 1995, pp. 24-27.

"A Cincinnati Industry, Homan & Co., the largest manufacturers of fine silver-plated ware in the city," *The Watch Dial,* July 1888.

Clark, Victor S. *History of Manufacturers in the United States.* New York: Carnegie Institute of Washington, 1929.

Clarke, Hermann Frederick, *John Coney, Silversmith 1655-1722.* Boston: Houghton Mifflin Company, 1932.

Clarke, Hermann Frederick and Foote, Henry Wilder. *Jeremiah Dummer, Colonial Craftsman and Merchant 1645-1718.* Boston: Houghton Mifflin Company 1935.

Clarke, Hermann Frederick. *John Hull, Builder of the Bay Colony.* Portland, Me.: The Southworth-Anthoensen Press, 1940.

Clearwater, Alphonso T. *American Silver, List of Unidentified Makers and Marks.* New York: 1913.

A Collection of Early American Silver. New York: Tiffany and Company, 1920.

Colonial Silversmiths, Masters & Apprentices. Boston Museum of Fine Arts, 1956.

Comstock, Helen. "American Silver," *The Concise Encyclopedia of Antiques.* New York: Hawthorn Books, Inc.

Cormany, James R. "The Other John Campbell, An Alabama Silversmith & Jeweler," *Silver,* May-June 1992, pp. 8-11.

Cormany, James R. "J. Conning, Mobile," *Silver,* Jan.-Feb. 1993, pp. 10-13.

Cormany, James R. " 'At the Sign of the Big Watch,' Eutaw, Alabama," *Silver,* Nov.-Dec. 1994, pp. 37-39.

"The Craft of the Spoonmaker." *Antiques,* 1929.

Cramer, Diana. "Unger Brothers: Art Nouveau Specialists, " *Silver,* May-June 1987, pp. 13-15.

Cramer, Diana. "Peter L. Krider, The Marks," *Silver,* Jan.-Feb. 1988, pp. 31-34.

Cramer, Diana. "Cottle & Co. Gold & Silver Novelty Maker," *Silver,* May-June 1991, pp. 33-35.

Cramer, Diana. "William Gale and His Partners," *Silver,* May-June 1991, pp. 28-32.

Cramer, Diana. "John R. Wendt of Boston and New York," *Silver,* May-June 1992 p.12-13.

The Cosmopolitan. Advertising Section, December 1895.

Culme, John. *The Directory of Gold & Silversmiths,* Antique Collectors' Club, Ltd., Woodbridge, Suffolk. 1987, reprinted 1992.

Crosby, Everett Uberto. *Books and Baskets, Signs and Silver of Old Time Nantucket.* Nantucket, Mass.: Inquirer and Mirror Press, 1940.

Crosby, Everett Uberto. *95% Perfect.* Nantucket, Island, Mass.: Tetaukimmo Press, 1953.

Crosby, Everett Uberto. *The Spoon Primer.* Nantucket, Mass.: Inquirer and Mirror Press, 1941.

Currier, Ernest M. *Early American Silversmiths The Newbury Spoonmakers.* New York: 1929.

Currier, Ernest M. *Marks of Early American Silversmiths, List of New York City Silversmiths 1825-1841.* Portland, Me.: The Southworth-Athoensen Press. 1938; reprinted 1970 by Robert Alan Green.

Curtis, George Munson. *Early Silver of Connecticut and Makers.* Meriden, Conn.: International Silver Company, 1913.

Cutten, George Barton. *Silversmiths of Georgia.* Savannah, Ga.: Pigeonhole Press, 1958

Cutten, George Barton, *Silversmiths of Northampton, Massachusetts and Vicinity down to 1850.* Pamphlet.

Cutten, George Barton. *Silversmiths of North Carolina.* Raleigh, N. C.: State Department of Archives & History, 1948.

Cutten, George Barton and Cutten, Minnie Warren. *Silversmiths of Utica.* Hamilton, New York: 1936.

Cutten, George Barton. *Silversmiths, Watchmakers and Jewelers of the State of New York Outside New York City.* Hamilton, N. Y. Privately printed, 1939.

Cutten, George Barton. *Silversmiths of Virginia.* Richmond, Va.: The Dietz Press, 1952.

Cutten, George Barton. *Ten Silversmith Families of New York State.* Albany, New York State Historical Assoc., 1946.

Danbury (Conn.) News-Times, December 2, 1938.

Davis, Charles H. S. *History of Wallingford, Connecticut.* Published by author, 1870.

Davis, Fredna Harris and Deibel, Kenneth K. *Silver Plated Flatware Patterns.* Dallas, Texas: Bluebonnet Press, 1972.

Day, Clive. *Rise of Manufacturing in Connecticut, 1820-1850.* Yale University Press for Tercentenary of Conn.

Dennis, Stephen N. Personal Communication, August 10, 1997.

Depew, Chauncey M. *One Hundred Years of American Commerce.* D. O. Haynes & Co. 1895, Vol. 2.

Derby Silver Company. *Derby Silver Co's Illustrated Catalog and Price List.* Birmingham, Conn., 1883, Aaronson's Reprint n. d.

Descriptive Catalogue of Various Pieces of Silver Plate forming Collection of the New York Farmers 1882-1932.

Detroit Historical Society Bulletin. Detroit, Mich.: November, 1952.

"Douglas Donaldson Craftsman 1909-1972," *Silver,* Nov.-Dec. 1987, pp. 16-17.

Dreppard, Carl W. *The Primer of American Antiques.* Garden City, N. Y.: Doubleday & Company, Inc., 1954.

Dry, Graham. *Art Nouveau Domestic Metalwork from Würtemburgische MetallwarenFabrik, 1906.* Antique Collector's Club, Woodbridge, Suffolk, 1988.

Duhousset, Charles. *l'Art Pour Tous.* Paris: 1879.

Dun, R. G. & Co. Collection. Baker Library, Harvard University Graduate School of Business Administration. Various manuscript entries cited in text.

Durrett, Colonel Reuben T. *Traditions of the Earliest Visits of Foreigners.* (Filson Club Publications No. 23) Louisville, Kentucky: John P. Morton & Co., 1908.

Dyer, W. A. "Early American Silver," *Arts and Decoration.* VII (May 1917)

Eakins, Samuel. Invention Patent No. 13,125, "Improvement in Ice-Pitchers" United States Patent Office, Washington, D. C. June 26, 1855.

Early American Spoons and Their Makers. Editor and Publisher, Golden Anniversary Issue, July 21, 1934.

Early Connecticut Silver 1700-1830. Gallery of Fine Arts. New Haven, Conn.: Yale University Press, Connecticut Tercentenary Commission, 1935.

Early, Eleanor. *An Island Patchwork.* Boston: Houghton Mifflin Company, 1941.

Early New England Silver lent from the Mark Bortman Collection. Northampton, Mass.: Smith College Museum of Art, 1958.

Eaton, Allen H. *Handicrafts of New England.* New York: Harper & Brothers Publishers 1949.

Eberlein, H. D. "Early American Silver," *Arts and Decoration.* XI (August 1919).

Eberlein, Harold D. and McClure, Abbot. *The Practical Book of American Antiques.* Garden City, New York: Halcyon House, 1948.

Edmonds, Walter D. *The First Hundred Years, 1848-1948,* Oneida Community. Oneida, N.Y.: Oneida Ltd., 1958.

Ellis, Leonard Bolles, *History of New Bedford and its Vicinity, 1602-1892.* Syracuse, New York: D. Mason & Company, Publishers, 1892.

Englehardt, George W. *Baltimore City Maryland.* Baltimore, Md. n. d. c. 1895.

Ensko, Robert. *Makers of Early American Silver* New York: Trow Press, 1915

Ensko, Stephen. *American Silversmiths and Their Marks.* New York: Privately printed, 1927.

Ensko, Stephen. *American Silversmiths and Their Marks II.* New York: Robert Ensko, Inc., Privately printed, 1937.

Ensko, Stephen. *American Silversmiths and Their Marks III.* New York: Robert Ensko, Inc., Privately printed, 1948.

Exhibition of Old American and English Silver. Pennsylvania Museum and School of Industrial Art, 1917.

Evans, Paul. *Shreve & Co. of San Francisco.* Parts I & II. No date. Privately printed.

Fales, Martha Gandy. "Rich Silver," *Silver,* July-Aug. 1986, pp. 8-13.

Fennimore, Donald. "Gayle & Hayden Ewer," *Silver,* Mar.-Apr. 1985, p. 14.

Fisher, Leonard Everett. *The Silversmiths.* New York: Franklin Watts, Inc.

Flynt, Henry N. and Fales, Martha Gandy. *The Heritage Collection of Silver. Old Deerfield, Massachusetts*: The Heritage Foundation, 1968.

Forbes, Esther. *Paul Revere and the World He Lived In.* Boston: Houghton Mifflin Co., 1942.

Freedley, E. T. *Philadelphia and its Manufacturers,* 1857.

Freeman, Larry and Beaumont, Jane. *Early American Silversmiths and Their Marks.* New York: Walpole Society, 1947.

French, Hollis. *Jacob Hurd and His Sons Nathaniel and Benjamin, Silversmiths.* Printed by the Riverside Press for the Walpole Society, 1939.

From Colony to Nation, Exhibit. Chicago, Illinois: Chicago Art Institute, 1949.

Galt & Bro., Washington, D. C.: Pamphlet, no date.

Gebelein, J. Herbert. "George C. Gebelein and the Arts & Crafts Movement," *Silver,* July-Aug. 1985, pp. 22-28

Geer, Elihu. *Geer's Hartford City Directory,* Elihu Geer, Hartford. Issues for 1842-1881.

Getz, Gail M. "John Fritz, Ironmaster: A Testimonial in Silver," *Silver,* Jan.-Feb. 1988, pp. 8-11.

Gibb, George S. *The Whitesmiths of Taunton, A History of Reed and Barton.* Cambridge Mass.: Harvard University Press, 1946.

Gillespie, Charles Bancroft. *An Historic Record & Pictorial Description of the Town of Meriden.* Meriden, Conn.: Journal Pub. Co., 1906.

Gillingham, H. E. "Silver," *Pennsylvania Magazine of History and Biography,* 1930-1935.

Gobright, John C. *The New York Sketch Book and Merchants' Guide,* J. C. Gobright & Co., New York, 1859.

Goddard, Kingston. Invention Patent No. 97,390, "Improved Method of Constructing Water-Pitchers and Other Vessels," United States Patent Office, Washington, D.C. November 30, 1869.

Goddard, Kingston. Invention Patent No. 128,298, "Improvement in Water Coolers" United States Patent Office, Washington, D.C. June 25, 1872.

Gorham Silver Co. *The Gorham Manufacturing Company Silversmiths.* New York: Cheltenham Press, 1900.

Goyne, Nancy A. "Britannia in America, the introduction of a new alloy and a new industry," *Winterthur Portfolio II,* Winterthur, Delaware, The Henry Francis Dupont Winterthur Museum, 1965.

Graham, James Jr. *Early American Silver Marks.* New York: James Graham Jr., 1936.

Greene, Welcome Howard. *The Providence Plantations for Two Hundred and Fifty Years.* Providence, R.I.: J. A. & R. A. Reid Publishers, 1886.

Grimwade, A. G. "Silver," *The Concise Encyclopedia of Antiques.* New York: Hawthorn Books, Inc.

Halket, Constance A. "The Innovation That Changed an Industry," *Silver,* July-Aug. 1989, pp. 17-19.

Halsey, R. T. Haines. *New York Metropolitan Museum Catalogue of Exhibition of Silver Used in New York, New Jersey, and the South.* Metropolitan Museum of Art, 1911.

Hardt, Anton. *Souvenir Spoons of the 90's.* New York: Privately printed, 1962.

Harper's Weekly. December issues 1858-1883.

Harrington, Jessie. *Silversmiths of Delaware 1700-1850.* Delaware: National Society of Colonial Dames of America, 1939.

Hartsville Museum. Hartsville Museum, Hartsville, South Carolina. Pamphlet. n. d., c. 1980s

Heller, David. *History of Cape Silver, 1700-1750.* 1949.

Henderson, G. Clarke. *Hope & Henderson's (consolidated) Brooklyn City Directory for 1856-7.* Hope & Henderson, Brooklyn, New York.1856

Hiatt, Noble W. and Lucy F. *The Silversmiths of Kentucky.* Louisville, Ky.: The Standard Printing Co., 1954.

"Highlights of the House of Kirk," *Hobbies.* August, 1939.

Hill, H. W. *Maryland's Silver Service.* Baltimore, Maryland: Waverly Press, Inc., 1962.

Hipkiss, E. J. *Boston Museum of Fine Arts Phillip Leffingwell Spaulding Collection of Early American Silver.* Cambridge, Mass.: Harvard University Press, 1943.

Historical and Biographical Sketch of the Gorham Manufacturing Company. Reprint of booklet issued, 1878.

History of New Haven County, Connecticut. Edited by J. L. Rockey, Vol. One

History of the Spoon, Knife and Fork. Taunton Mass.: Reed & Barton, 1926.

Hittell, John S. *Commerce and Industries ot the Pacific Coast of North America.* San Francisco: A. L. Bancroft & Co., 1882.

Hoitsma, Muriel Cutten. *Early Cleveland Silversmiths.* Cleveland, Ohio: Gates Publishing Co., 1953.

Hollan, Catherine B. *Three Centuries of Alexandria Silver, Catalog and Exhibition by Catherine B. Hollan, October 28, 1994 - January 31, 1995.* The Lyceum, Alexandria, Virginia, 1994.

The House of Kirk, Our 150th Year, 1815-1965. Baltimore: Samuel Kirk & Son, Inc., 1965.

Hoving, Walter. "The History of Tiffany," *Christian Science Monitor.* April 9, 10, 1959.

"How America's $400 Million-a-Year Silver Manufacturing Industry Grew," *The Jewelers' Circular-Keystone,* Directory Issue. Phadelphia, Pa.: 1965.

Hower, Ralph Merle. *History of Macy's of New York, 1858-1919.* Cambridge, Mass.: Harvard University Press, c. 1943.

Hughes, G. Bernard. "Sheffield Plate," *The Concise Encyclopedia of Antiques.* New York: Hawthorn Books Inc., Vol. Two.

Hughes, Graham. *Modern Silver.* New York Crown Pub., Inc., 1967.

Humphreys, Mary Gay. "Maiden Lane of the Past and Present," *Jewelers' Circular & Horological Review,* Nov. 28, 1894.

Hungerford, Edward. *The Romance of a Great Store (Macy's).* New York: Robert M. McBride & Co., 1922.

Impastato, Nancy. "Paye & Baker Silversmiths," *Silver,* Sept.-Oct. 1990, pp. 32-35.

Impastato, Nancy. "Watson & Newell Co.," *Silver,* July-Aug. 1994, pp. 7-17.

Ives, R. David. "F. A. B. & Company," *Silver,* Mar.-Apr. 1990, pp. 20-22.

Ives, R. David. "Francis A. Bunnell and his successor Clemens Oskamp," *Silver,* Nov. - Dec. 1991, pp. 13-15.

Index of Trademarks Issued from the United States Patent Office, 1881.

Jacobs, Carl. *Guide to American Pewter.* New York: McBride, 1957.

James, George B., Jr. *Souvenir Spoons,* Boston Mass.: A. W. Fuller & Co., 1891.

Jayne, H. F. and Woodhouse, S. W., Jr. "Early Philadelphia Silversmiths," *Art in America.* IX (October 1921).

Jewelers' Buyers' Guide, A McKenna Publication. New York: Sherry Publishing Co., Inc., 1957, 1958, 1960.

The Jewelers' Circular & Horological Review. New York: D. H. Hopkinson, no date.

The Jewelers' Circular-Keystone. Philadelphia Pa.: Chilton Publications, 1869-1975.

The Jewelers' Circular-Weekly, 50th Anniversary Number. New York: Jewelers' Circular Pub. Co., 1919.

The Jewelers' Dictionary. New York: The Jewelers' Circular-Keystone, no date (c. 1950).

Jobbers' Handbook. 1936-1937.

Johnson, Bruce. "William Waldo Dodge: The Asheville Craftsman," *Silver,* July-Aug. 1994, pp. 32-33.

Johnson, J. Stewart. "Silver in Newark, A Newark 300th Anniversary Study," *The Museum,* New Series, Vol. 18, Nos. 3 & 4. The Newark Museum, 1966.

Jones E. Alfred. *Old Silver of Europe and America.* Philadelphia: Lippincott Co., 1928.

Jones, George. Invention Patent No. 84,830, "Coffee Urn." United States Patent Office, Washington, D. C. December 8, 1868.

Jones, Kenneth Crisp, Gen. Ed. *The Silversmiths of Birmingham and their Marks 1750-1980.* N. A. G. Press, Ltd., London, 1881.

Keddell, E. Avery. "Romance of the Spoon"' *Art Journal.* January 1907.

Keir, Robert M. *Manufactunng in Industries of America.* Roland Press, 1928.

Kelley, Etna M. *The Business Founding Date Directory, (1687-1915).* Scarsdale, N.Y.: Morgan & Morgan, 1954.

Kelly, Mackenzie L. "Cheese Knives 1830-1920," *Silver,* Mar.-Apr. 1991, pp. 16-20.

Kenny, D.J. *Kenny's Illustrated Exposition Guide to the Cincinatti Exposition of 1874.* Cincinatti. 1874.

"Kentucky Silversmiths before 1850," Filson Club History Quarterly. XVI, No. 2, April 1942, 111-126.

Kerfoot, J. B. *American Pewter.* Boston and New York: Houghton Mifflin Co., 1924.

The Keystone Jewelers' Index. Phila.: The Keystone Publishing Co.,1922,1924,1927,1931.

Kirk in U. S. Museums. Baltimore, Maryland: Samuel

Kirk & Son, Inc., 1961.

Kirk Sterling-A Complete Catalog of America's Finest Sterling by America's Oldest Silversmiths. Baltimore: 1956 (?).

Knittle, Rhea Mansfield. *Early Ohio Silversmiths and Pewterers 1787-1847*. (Ohio Frontier Series.) Cleveland, Ohio: Calvert-Hatch Company, 1943.

"Knives for a Nation," *Industry* September, 1961

Kovel, Ralph M. and Kovel, Terry H. *A Directory of American Silver, Pewter and Silverplate*. New York: Crown Publishers 1961.

Krekel-Aalberse, Anneleis. *Art Nouveau and Art Deco Silver*. Harry N. Abrams, Inc., New York, 1989

Lain, J. *The Brooklyn City Directory*. J. Lain & Company. Brooklyn, New York. 1857-1870 and 1873-1876.

Lambert, Isaac E. *The Public Accepts, Stories Behind Famous Trademarks, Names and Slogans*. Albuquerque, N. M.: Univ. of N. M. Press, 1941.

Langdon, John Emerson. *Canadian Silversmiths and Their Marks, 1667-1867*. Lunenberg, Vermont: The Stinehour Press, 1960.

Langley, Henry. "Silverplating in California," *The Pacific Coast Almanac for 1869*, San Francisco, 1869.

Lathrop, W. G. *The Brass Industry in the United States*. Mt. Carmel, Conn.: Wilson H. Lee Co., 1926.

Laughlin, Ledlie I. *Pewter in America*. Boston: Houghton Mifflin Co., 1940.

Leary, Peter. "William Schenk & Co.," in *Newark, N. J. Illustrated*, 1893.

Lunt, Colby. "Lunt Silversmiths," *Silver*, Sept.-Oct. 1985, pp. 26-29.

Macomber, Henry P. "The Silversmiths of New England," *The American Magazine of Art*. Oct. 1932.

Mason Brothers. *New York Mercantile and Manufacturers Business Directory for the Year Ending May 1, 1857*. Published for West, Lee and Bartlett. Mason Brothers, New York. 1856.

Masterpieces of New England Silver 1650-1800. Gallery of Fine Arts, Yale University, 1939.

May, Earl Chapin. *A Century of Silver 1847-1947*. New York: Robert McBride Co., 1947.

Mazulla, Fred M. and J. *The First Hundred Years, Cripple Creek and the Pikes Peak Region*. Denver, Colorado: A. B. Hirschfeld Press, 1956.

McGrew, John R. "The House Marks of John Owen and Walter Pitkin," *Silver*, May-June 1990, pp. 17-19.

Meeks, E. V. *Masterpieces of New England Silver*. Cambridge: Harvard University Press, 1939.

"Men Who Developed the Silver Plated Ware Industry," *The Jewelers' Circular & Horological Review*, Oct. 3, 1894.

Melrose Reporter. March 7 and October 1, 1901.

Meriden, the Silver City. Connecticut Tercentenary Committee, 1935.

The Meriden Daily Journal, 50th Anniversary Number. April 17, 1936.

Miller, Robert N. "Stuart Nye: Silver Craftsman," *Silver*, Mar.-Apr. 1996, pp. 40-42.

Miller, Robert N. "Stuart Nye Christmas in July," *Silver*, July-Aug. 1996, pp. 40-41.

Miller, V. Isabelle. *Silver by New York Makers, Late Seventeenth Century to 1900*. New York: Women's Committee of the Museum of The City of New York, 1938.

Miller, William Davis. *The Silversmiths of Little Rest*, Rhode Island: D. B. Updike, The Merrymount Press, 1920.

Moro, Ginger "Behind the Scenes at Georg Jensen USA, The War Years," *Silver*, Nov.-Dec. 1996, pp. 28-35.

Morrill, Penny C. "Spratling/Silson Jewelry," *Silver*, Mar.-Apr. 1995, pp. 12-14.

Morse, Edgar W. *San Francisco Silverware, A Preliminary List of Makers & Retailers*. 1977. Privately printed.

Morse, Edgar W., ed. *Silver in the Golden State*. The Oakland Museum History Department, Oakland 1986.

Morse, Edgar W. "Silver in the Golden State," in Morse, ed. *Silver in the Golden State,* 1986.

National Jeweler's Speed Book, No. 11, National Jeweler, c. 1930.

The National Jewelers' Trade and Trade-Mark Directory, 1918-19. Chicago: The National Jeweler, 1918.

Nationally Established Trade-Marks. New York: Periodical Publishers Assoc. of America 1934.

"New England Silversmiths, news items gleaned from Boston newspapers, 1704-1705." *Art in America*, (February 1922), 75.

The New England States. William T. Davis, Ed. Vol. II: 832,833.

"New Jersey Silver in the Newark Museum," *Silver*, Mar.-Apr. 1995 p. 30.

New York State Silversmiths. Eggertsville, N. Y.: Darling Foundation, 1965.

New York Sun. Antiques section.

New York Times. December Issues 1851-1852, 1858-1874.

New York Tribune. December Issues 1851-1852, 1867-1869.

Okie, Howard Pitcher. *Old Silver and Old Sheffield Plate*. New York: Doubleday, Doran and Company, 1928.

"Old American Silver" *Country Life in America*. February 1913-January 1915.

Ormsbee, Thomas H. *Know Your Heirlooms*. New York: The McBride Co., 1956

Pack, Robert. *Collector's Guide to Canadian Souvenir Spoons*. Argentum Cochlear Publishing, Vancouver 1988.

Parke-Bernet Galleries catalogue. January 1938-1975.

Elias Pelletreau, Long Island Silversmith and his Sources of Design. Brooklyn, N.Y.: Brooklyn Institute of Arts and Sciences, Brooklyn Museum, 1959.

"Pennsylvania Museum and School of Industrial Art Loan exhibition of Colonial Silver, special catalogue." *Pennsylvania Museum Bulletin*. No. 68, June 1921.

Percy, Randolph T. "The American at Work IV: Among the Silver-Platers," *Appleton's Journal*, New Series, No. 30. (Dec. 1878).

"Philadelphia Silver 1682-1800," *Philadelphia Museum Bulletin*, LI, No. 249 (Spring 1956).

Philbrick, Helen Porter. "Franklin Porter Silversmith

(1869-1835)," *Essex Institute Historical Collections, Annual Report, 1968-69*, Salem, Massachusetts.

Phillips, John Marshall. *American Silver*. New York: Chanticleer Press, 1949.

"Pioneers of the American Silver Plate Industry," *Hobbies*. April, 1947.

Pleasants, J. Hall and Sill, Howard. *Maryland Silversmiths, 1715-1830*. Baltimore: The Lord Baltimore Press, 1930; reprinted 1972 by Robert Alan Green.

Poret, Patricia H. "Herman Heilig, A Native Craftsman, Lapidarist and Silversmith," *Silver,* Nov.-Dec. 1996, pp. 34-37.

Porter, Edmund W. "Metallic Sketches," *Taunton Daily Gazette*. March 19, 1906-Sept. 28 1907.

Prime, Alfred Coxe. *The Arts & Crafts in Philadelphia, Maryland and South Carolina, 1721-1785*.

Prime, Alfred Coxe. *The Arts & Crafts in Philadelphia, Maryland and South Carolina, 1786-1800*.

Prime, Mrs. Alfred Coxe. *Three Centuries of Historic Silver*, Philadelphia: Pennsylvania Society of Colonial Dames of America,1938.

"John Prip: Master Metalsmith. An Exhibition at the Museum, Rhode Island School of Design," *Silver*, Nov.-Dec. 1987, pp. 24-25.

Purdy, W. Frank. "Developments in American Silversmithing," *The Art World*, May 1917.

"The Question Box," *Silver,* Jan.-Feb. 1993, p.35.

Rainwater, Dorothy T. *Sterling Silver Holloware*. A Catalog reprint, American Historical Catalog Collection. Princeton, New Jersey: The Pyne Press, 1973.

Rainwater, Dorothy T. "Kurt Eric Christoffersen Designer and Silversmith," *Silver*, July-Aug. 1995, pp.10-13.

Rainwater, Dorothy T. "Silversmith to Apprentice to Factory," *Silver,* Jan. Feb. 1996, pp. 16-17.

Rainwater, Dorothy T. and Felger, Donna H. *American Spoons, Souvenir & Historical*. Nashville, Tennessee: Thomas Nelson Inc. and Hanover, Pennsylvania: Everybodys Press, 1968.

Rainwater, Dorothy T. and Rainwater, H. Ivan. *American Silverplate*. Nashville, Tennessee Thomas Nelson Inc., and Hanover, Pennsylvania: Everybodys Press, 1972

Randolph, Howard S. F., "Jacob Boelen, Goldsmith of New York and his family circle," *New York Genealogical and Biographical Record*. October, 1941.

Redfield & Rice Manufacturing Co. Catalog. New York. n. d. c. 1870.

Report of the Eighth Industrial Exhibition of the Mechanics Institute, 1871. San Francisco 1872.

Retrospect, A publication of the Historical Society of Glastonbury, Conn. No. 10, Feb. 1948.

Revi, Albert Christian. *Nineteenth Century Glass*. New York: Thomas Nelson & Sons 1959.

Rhodes, Thomas C. Personal Communication. February 5, 1993.

Roach, Ruth Hunter. *St. Louis Silversmiths*. Privately printed, St. Louis, 1967.

Robertson, Constance, *The Oneida Community*. Pamphlet, no date.

Rode, Charles R. The New York City Directories 1852-

1854. Charles R. Rode, New York.

Roe, Joseph Wickham. *Connecticut Inventors*. Tercentenary Commission of Connecticut N.Y. Press, 1935.

Rogers, Edward S. *The Lanham Act and the Social Function of Trade-Marks, in Law and Contemporary Problems*. Durham, S. C. Quarterly, pub. by Duke Univ. School of Law, V. 14, No. 2, 1949.

"The Rogers Manufacturing Company ," *The American Jeweler,* March 1882.

William Rogers and his Brothers in the Silverware Industry. Philadelphia: Keystone, Keystone Publishing Company, August and September, 1934.

Romaine, Lawrence B. *A Guide to American Trade Catalogs, 1744-1900*. New York : R. R. Bowker Company, 1960.

Rosenbaum, Jeanette. Myer Myers, *Goldsmith*. Philadelphia: Jewish Publication Society of America, 1954.

Rumpp, Leaders for a Century in Fine Leather Goods. Philadelphia: C. F. Rumpp & Sons Inc., 1950.

Sabine, Julia. *Silversmiths of New Jersey*. Proc. of the New Jersey Historical Society, July-October, 1943 (Newark, 1943)

Saunders, Albert F. "The Designs of the George W. Shiebler Co. (1904-1907)," *Silver,* Jan.-Feb. 1990, pp. 7-9.

Schild, Joan Lynn. *Silversmiths of Rochester*. Rochester, N. Y.: Rochester Museum of Arts and Sciences, 1944.

Seeger and Guernsey. *Cyclopaedia of the Manufacturers and Products of the United States*. New York: 1890.

Selwyn, A. *The Retail Jeweller's Handbook*. New York: McBride Company, 1947.

Semon, Kurt M. *A Treasury of Old Silver*. New York: McBride Company, 1947.

"George Sharp," *Silver,* July-Aug. 1989, pp.36-37.

"Silver by New York Makers," *Museum of the City of New York*. New York: 1937.

Silver, Lori. "Cutlery Plant on Eastern Shore Gets a New Lease on Life," *Washington Post,* undated c. 1991.

Silver Magazine (formerly The Magazine SILVER and Silver-Rama). 1968-1996.

"The Silversmiths of New England," *American Magazine of Art*. October, 1932.

"The Silverware Industry in America," *The Jewelers' Circular-Keystone*. New York: November and December 1946.

"The Silverware Industry, Early Workers in Silver," *The Keystone*, November, 1899.

"Simpson, Hall, Miller & Co.," *Silver,* Nov.-Dec. 1990, pp. 30-35.

Smith, W. H. *Brooklyn Directory, Eastern District for the year ending May 1st, 1857*. Charles Jenkins, Brooklyn, 1856.

Sniffin, Philip L. *A Century of Silversmithing*. Reed & Barton Silversmiths. Taunton, Massachusetts: 1924.

Snow, Wm. G. "Early Silver Plating in America," *Metal Industry,* New York: June 1935.

Snow, Wm. G. "Silverplating in Connecticut, Its Early Days," *United States Investor*, May 18, 1935.

Soeffing, D. Albert. "Joseph Seymour," *Silver,* Nov.-

Dec. 1987, pp. 30-34.

Soeffing, D. Albert. *Silver Medallion Flatware*. New Books, Inc. New York City, 1988.

Soeffing, D. Albert. "Willard & Hawley," *Silver,* Nov.-Dec. 1989, pp. 20-22.

Soeffing, D. Albert. "Bunnelle & Schreuder: The Attribution of a Syracuse Hallmark," *Silver,* Jan.-Feb. 1990, pp. 16-18.

Soeffing, D. Albert. "A Medallion Attribution: Abraham and William Wood," *Silver,* July-Aug. 1990, p.11.

Soeffing, D. Albert. "Thomas Henry Marshall - Silversmith of Rochester, NY," *Silver,* Nov.-Dec. 1990, pp. 12-14.

Soeffing, D. Albert. "More Syracuse Silver - The Patterns of Hotchkiss & Schreuder and their Predecessors and Successors," *Silver,* Jan.-Feb. 1991, pp. 9-11.

Soeffing, D. Albert. "A Mark Attribution: Peter G. Perdriaux," *Silver,* Mar.-Apr. 1991, pp. 13-15.

Soeffing, D. Albert. "An Investigation of 'Premium' Marks," *Silver*, July-Aug. 1991 pp. 13-15.

Soeffing, D. Albert. "A Medallion Pattern by Clemens Oskamp," *Silver,* Nov.-Dec. 1991, pp. 16-17.

Soeffing, D. Albert. "Charles F. Hill, Silversmith of Owego," *Silver,* Jan.-Feb. 1992, pp. 14-16.

Soeffing, D. Albert. "Julius Hollister Silversmith of Owego," *Silver,* Mar.-Apr. 1992, pp. 10-13.

Soeffing, D. Albert. "Biographies of Selected Silver Producers and Retailers," in Venable, *Silver in America*, 1994.

Soeffing, D. Albert. "Satin Finish," *Silver,* July-Aug. 1995, pp. 14-19.

Soeffing, D. Albert. "Some Bailey & Co. Marks and their Significance," *Silver,* Nov.-Dec. 1995, pp. 12-15.

Soeffing, D. Albert. "Henry S. Brown and Charles C. Shaver Silversmiths of Utica, New York," *Silver,* Mar.-Apr. 1996, pp. 26-31.

Soeffing, D. Albert. "The Firms of Henry L. Webster, Knowles & Ladd, and J. B. & S. M. Knowles: History & Patterns," *Silver,* Sept.-Oct. 1996, pp. 30-33.

"Souvenir Sidelines," *Silver,* May-June 1991 pp. 36-38.

Souvenir Spoons of America. New York: The Jewelers Circular Publishing Co., 1891

The Spinning Wheel, Hanover, Pa.: 1945-1975

The Spoon from Earliest Times. Meriden, Conn: International Silver Company, 1915.

The Spooner's Forum, ed. William Boyd, 1974 -

"Star Salt Castor Company," *Silver* Sept.-Oct. 1990, p. 23.

Sterling Flatware Pattern Index. N. Y. and Phila.: Jewelers' Circular-Keystone, 1949.

Stieff Sterling Silver, The Stieff Company. Baltimore: Barton-Gillet, c. 1930.

The Story of Daniel Low. Salem, Mass.: Daniel Low & Co., Catalog for 1917.

The Story of the House of Kirk. Baltimore:Samuel Kirk & Son, Inc., 1914 and 1939.

The Story of Sterling. Newburyport, Mass.: The Towle Silversmiths, 1954.

The Story of Sterling. New York: Sterling Silversmiths Guild of America, 1937.

Stow, M. *American Silver*. New York: Barrow & Co. 1950.

Stutzenberger, Albert. *The American Story in Spoons*. Louisville, Ky.: Privately printed, 1953.

"Tammen Curio Company of Denver." *Denver Post*. January 29, 1957.

"Tammen's Curio Shop," *Rocky Mountain Life*. Denver, Colorado: March 1949.

Taylor, Emerson. *Paul Revere*. New York: Dodd, Mead & Co., 1930.

Taylor, Gerald. *Silver*. London: Unwin Brothers, Ltd. 1956.

Thorn, C. Jordan. *Handbook of American Silver and Pewter Marks*. New York: Tudor Publishing Company, 1949.

Those Green River Knives. Russell Harrington Cutlery Company (Reprinted in part from Indian Notes, Vol. IV, No. 4 Museum of the American Indian, Heye Foundation, New York: October, 1927.

"Three Centuries of European and American Silver," *M. H. de Young Memorial Museum Bulletin*. San Francisco: October 1938.

"Charles L. Tiffany and the House of Tiffany & Co.," *Jewelers' Circular & Horological Review*, February 7, 1894.

Tilton, George P. *Colonial History* (catalogues of Benjamin Franklin, La Fayette, Paul Revere Newbury and Georgian flatware patterns in addition to the histories of the persons and places.) Newburyport, Mass.: Towle Manufacturing Company, 1905.

"Trademarks: Fischel, Nessler & Co.," *Silver* July-Aug. 1992, pp. 37-38.

Trade Marks of the Jewelry and Kindred Trades New York and Philadelphia: Jewelers Circular-Keystone Publishing Co., 1869, 1896, 1898, 1904, 1910, 1915, 1922, 1943, 1950, 1965, 1969, 1973.

Tryon, R. M. *Household Manufactures in U. S.* Chicago: University Press, 1917.

"200th Anniversary for Porter Blanchard," *Silver,* Nov.-Dec. 1988, p. 31

Turner, Noel D. *American Silver Flatware, 1837-1910*. Cranbury, New Jersey: A. S. Barnes & Co., Inc., 1972.

Twyman, Robert W. *History of Marshall Field & Co., 1852-1906*. Philadelphia: University of Pennsylvania Press, 1954.

U. S. Bureau of the Census, Digest of Accounts of Manufacturing Establishments in the United States and of Their Manufactures. Washington, D.C.: 1823.

U. S. Tariff Commission. A Survey of the various types of silverware, the organization of the industry and the trade in silverware with special reference to tariff consideration. Washington, D. C.: U. S. Gov't Printing Office, 1940. Report No. 139, Second Series.

Unitt, Peter, and Ann Worrall. *Unitt's Book of Marks*, compiled and edited by Peter Unitt and Ann Worrall, Fitzhenry & Whiteside, Markham, Ontario, Canada, 1995.

Venable, Charles L. *Silver in America 1840-1940: A Century of Splendour*. Dallas Museum of Art. Harry N. Abrams, Inc. New York. 1994.

Wallace, Floyd, Sr. *Wallace News*. June 1947. Credit to Miss Emma Dray.

Wardle, Patricia. *Victorian Silver & Silver Plate*. Victorian Collector Series. Thomas Nelson & Sons, 1963.

Wendt, Lloyd & Kogen, Herman, *Give the Lady what She Wants*. History of Marshall Fields, Chicago: Rand McNally c. 1952.

Wenham, Edward. *Practical Book of American Silver*. New York and Philadelphia: J. B. Lippincott Co., 1949.

Westman, Habakkuk O. "The Spoon: Primitive, Egyptian, Roman, Medieval & Modern," *The Transactions of the Society of Literary and Scientific Chiffoniers*. New York: 1844.

White, Benjamin. *Silver, its History and Romance*. New York and London: Hodder & Stoughton. 1917.

White, Richard L. "A Century of Inventions for the American Home," *The Newcomen Society in North America*, lecture, 1955.

Williams, Carl Mark. *Silversmiths of New Jersey 1700-1825*. Philadelphia: G. S. McManus Co., 1949.

Williams, Charles C. "Ask a Question," *Silver,* Jan.-Feb. 1984, pp. 31-32.

Williams, Charles C. "Ask a Question," *Silver,* Jan.-Feb. 1986, p. 27.

Williams, Charles C. "Ask a Question," *Silver,* Mar.-Apr. 1986, p. 38.

Williams, Charles C. "Ask a Question," *Silver,* May-June 1998, p. 18.

Williams, Charles C. "Ask a Question," *Silver,* Mar.-Apr. 1991, pp. 30-31.

Wilson, H. Compiler. New York City Directories: 1853, 1855-1874. John F. Trow, New York.

Woolsey, Theodore S. "Old Silver," *Harper's Magazine*, 1896.

Wroth, Lawrence C. *Abel Buell of Connecticut, Silversmith, Typefounder, and Engraver.* 1926

Wyler, Seymour B. *The Book of Old Silver*. New York: Crown Publishers, 1937.

Wyler, Seymour B. *The Book of Sheffield Plate, Including Victorian Plate*. New York: Crown Publishers, 1949

Yeamans, Ira. Invention Patent No. 91,696, "Coffee Pot," United States Patent Office, Washington. June 22, 1869.

Young, Hiram. Invention Patent No. 45,787 "Improvement in Coffee Pots." United States Patent Office. Washington, D. C. January 3, 1865.

Zebora, Jim. "Boardman Up For Sale," *Meriden Record- Journal,* Meriden, Conn., October 25, 1991.